Russian Cloth Seals in Britain
Trade, Textiles and Origins

Russian Cloth Seals in Britain
Trade, Textiles and Origins

John Sullivan

Oxbow Books
Oxford and Oakville

Published by
Oxbow Books, Oxford, UK

© J. Sullivan, 2012

ISBN 978 1 84217 465 4

A CIP record for this book is available from the British Library

This book is available direct from

Oxbow Books, Oxford, UK
(Phone: 01865-241249; Fax: 01865-794449)

and

The David Brown Book Company
PO Box 511, Oakville, CT 06779, USA
(Phone: 860-945-9329; Fax: 860-945-9468)

or from our website

www.oxbowbooks.com

Library of Congress Cataloging-in-Publication Data

Sullivan, J. (John), 1937-
Russian cloth seals in Britain : trade, textiles and origins / John Sullivan.
 pages ; cm
 Includes bibliographical references and index.
 ISBN 978-1-84217-465-4
 1. Cloth seals (Numismatics)--Russia--History. 2. Cloth seals (Numismatics)--Russia--Catalogs. 3. Flax industry--Russia--History. 4. Hemp industry--Russia--History. 5. Russia--Commerce--Great Britain--History--18th century. 6. Great Britain--Commerce--Russia--History--18th century. 7. Russia--Commerce--Great Britain--History--19th century. 8. Great Britain--Commerce--Russia--History--19th century. I. Title.

CD6026.S85 2012
737'.60947--dc23

2012011052

Front cover: The Jessie of Perth at Riga*, Charles Slae, 1838.*
Courtesy of Perth Museum and Art Gallery, Perth and Kinross Council © 2011
Back cover: Nikolaevskiy bridge at the turn of the 19th–20th centuries
and a view of the English Embarkment (from a postcard of the time) © author.

Printed in Great Britain by
Short Run Press, Exeter

Contents

Acknowledgements ... viii
Introduction ... ix
Abbreviations, definitions and conventions .. xi
The Russian alphabet in the 18th and 19th centuries .. xii

PROLEGOMENA ... 1
1. Russian trade with Britain .. 1
 1.1 Russian maritime trade in the 18th century .. 1
 1.2 Russian flax and hemp trade with England .. 2
 1.3 Russian flax and hemp trade with Scotland ... 3
2. Russian ports .. 3
 2.1 St Petersburg .. 4
 2.2 Riga .. 5
 2.3 Archangel ... 5
3. Background to the use of lead-alloy seals ... 6
 3.1 Quality control (brack, bracque) in the Russian Empire ... 6
4. Grades of flax and hemp .. 8
 4.1 Terms used in grading .. 8
 4.2 Archangel flax .. 8
 4.3 St Petersburg flax ... 9
 4.4 St Petersburg hemp .. 9
 4.5 Riga flax grades .. 10
 4.6 Grades in other Baltic ports ... 11
 4.7 Russian hemp ... 11
 4.8 Summary of flax and hemp sorts ... 11
 4.9 Maps ... 13
 4.9.1 Russia 1740–1905 ... 13
 4.9.2 Northern and Central Russia ... 14
 4.9.3 St Petersburg and the Baltic .. 14
 4.9.4 Southern Russia ... 14

PART ONE: LEAD SEALS OF RUSSIAN ORIGIN ... 15
5. Russian seals and their characteristics ... 15
 5.1 Flax and hemp bundle seals ... 15
 5.1.1 Summary of flax and hemp seal types .. 16
 5.2 Characteristics of Russian seals ... 19
 5.2.1 Russian seals, 1740s–1760 .. 19
 5.2.2 Unprovenanced Russian seals, 1740s–1760 ... 19
 5.2.3 Russian seals, 1760s–1840s .. 20
 5.2.4 Obverse of Russian seals, 1760s–1840s ... 21
 5.2.5 Reverse of Russian seals, 1760s–1840s .. 21
 5.2.6 St Petersburg seals, 1830–early 1840s ... 23
 5.2.7 Seals with two surnames ... 24
 5.2.8 St Petersburg seals, 1840s–1850s ... 25

	5.2.9	Archangel seals	28
	5.2.10	Archangel seals, pre-1820s	29
	5.2.11	Archangel seals, 1820s–1839	29
	5.2.12	Obverse of Archangel seals, 1820s–1839	29
	5.2.13	Reverse of Archangel seals, 1820s–1839	30
	5.2.14	Archangel seals, 1838–1902	31
	5.2.15	Seals from adjacent provinces	34
	5.2.16	Russian words and abbreviations in Cyrillic on Archangel seals	36
	5.2.17	Quality control officers (desyatniki)	36
	5.2.18	Date of Russian flax and hemp seals	39
	5.2.19	Initials of producers/owners/agents	41
	5.2.20	Letters and digits on the reverse of Russian lead seals	42
	5.2.21	Initials on the obverse/reverse of St Petersburg seals	42
	5.2.22	Post numbers on Russian seals	42
5.3	Railway seals		43
5.4	Fur-trade seals		44
5.5	Miscellaneous Russian seals		45
	5.5.1	Seals with Russian State arms	45
	5.5.2	Seals with Russian city arms	45
	5.5.3	Seals bearing State arms	45
	5.5.4	Seals with St Petersburg city arms	46
	5.5.5	Seal with arms of Siberia	46
5.6	Russian trade seals		46
	5.6.1	Possible unidentified flax seals	46
	5.6.2	Seals with links to other commercial activities	46
	5.6.3	Individual and company names	47
	5.6.4	Seals from the Soviet period	47
5.7	Seals from the Russian Empire		48
	5.7.1	Riga flax seals	48
5.8	Other possible Baltic/Riga seals		50
5.9	Concluding remarks		52
5.10	Illustrations (Figures 1–93)		53

Part Two: Catalogue of Lead Seals .. 65
 6.1 Cyrillic letters on Russian seals .. 65
 6.1.1 Transliteration of Russian seals .. 65
 6.1.2 Conventions used in transcription .. 66
 6.2 Seals in Scottish museums .. 67
 6.3 Seals in English museums .. 100
 6.4 Seals in Private Collections ... 111
 6.4.1 Private owners/collectors: abbreviations .. 111
 6.5 Seals from incomplete or inaccurately reported source ... 126

Part Three: Appendices .. 127
 7.1 Archangel Quality Control Officers (Initials **APX, А. П.**) ... 127
 7.2 St Petersburg Quality Control Officers (Initials **S P B / С П Б / S P**) 128
 7.3 Other Quality Control Officers (Initials **N. P., W. K., W. U.**) ... 132
 7.3.1 Other Quality Control Officers (Provenance indeterminable) ... 137
 7.4 Dates of Russian flax and hemp seals ... 138
 7.5 Initials of producers/exporters/agents ... 151
 7.5.1 Initials of producers/exporters/agents on Archangel seals .. 151
 7.5.2 Initials of producers/exporters/agents on St Petersburg seals ... 152

7.6		Initials and digits on Russian seals	154
	7.6.1	Initials and digits on St Petersurg seals	154
	7.6.2	Initials and digits on seals of uncertain provenance (**N. P.**, **W. K.**, **W. U.**, **П Д.**, **И П**)	156
	7.6.3	Initials and digits on seals of undetermined origin	160
7.7		Initials on first line of St Petersburg and unprovenanced seals	161
	7.7.1	Initials on obverse (other than **Л. Д.**)	161
	7.7.2	Initials on reverse (other than **N. P.**)	163
7.8		Post numbers in final line of the obverse of seals	165

Index of Illustrations .. 173
Bibliography ... 177

Acknowledgements

This monograph owes a great deal to many people, archivists, librarians and curators who have encouraged and in their different ways helped me put together this guide and catalogue, in particular to Michael King of the Museum of County Down and former Curator of North-East Fife Museum Services which oversees St Andrews Museum, to the late Geoff Egan of the Museum of London who followed and encouraged the research and assisted with invaluable comments and to Dr Barbara Crawford of the University of St Andrews who read earlier versions and offered many valuable comments and suggestions.

Others have made facilities available for examining seals in their charge, sometimes enduring with kindness, patience and helpfulness repeat visits to their collections, especially David Alston of the Courthouse Museum, Cromarty, Steven Ashley of Norfolk Landscape Archaeology, Rachel Benvie of Montrose Museum, Angela Bolton, Senior Finds Liaison Officer for Warwickshire and Worcestershire, Dr Helen Geake, Finds Adviser in the Department of Archaeology at Cambridge University and formerly Finds Liaison Officer in the Museum Services, Suffolk and Ann Jones of Waverley Museum Services (Farnham). Special thanks are also due to a number of specialists in St Petersburg, at the Russian Academy of Sciences Institute of History, at the Russian National Library and in particular to Lyudmila Sesyolkina of the Russian State Historical Archive.

I wish also to acknowledge grants made to me to support the work I have carried out in the UK and in Russia by The British Academy, The Carnegie Trust for the Universities of Scotland, The Russell Trust Development Awards through the University of St Andrews and The Strathmartine Trust, Edinburgh.

My work has also been helped greatly by all those metal-detector users who have been in touch with me and either lent me their collections for study or have sent me photographs or scans. Without their assistance the results of this study would be greatly impoverished and I am deeply grateful to them. They are far too numerous to mention individually but in particular I must single out Jim Halliday of Norton in Yorkshire, who acted as a channel for many finds recovered by metal detector users in the north of England, to David Powell who sent illustrations of many unusual seals and to Chris Lasseter of Fife who allowed me to examine his substantial collection of finds from Fife.

Finally, to a group of individuals without whose help the book could not have been prepared: Dr Martin Sullivan, Alison Aiton and Dr John Ball who rendered invaluable advice and assistance with digital photography and computer technology. To Dr Michael Beetham who prepared the maps and spent many hours resolving computer problems which others over the years have been unable to solve I express my deepest gratitude. I am also greatly indebted to the editorial and production staff at Oxbow Books without whose help and perseverance the book would not have appeared.

Introduction

For many decades in the 18th and 19th centuries Russia was the world's greatest exporter of flax and hemp, and Great Britain its major customer. Most studies of flax and hemp and their associated industries have hitherto concentrated on the economic and historical events surrounding the rise and fall of these industries in Britain. The present study is based on a large body of new material consisting of Russian lead-alloy seals which were attached to bundles of flax and hemp exported from Russia, and aims chiefly to describe the different seals that were used and to explain the reasons why the lead-alloy seals were employed. Whilst specific information on the location of some finds is available, in most instances the lack of contextual evidence makes it impossible to offer more than a tentative description of the historical and commercial framework in which the individual seals occurred. Nevertheless, the study of Russian lead seals in the UK is of value in itself since it has opened up a valuable new source of material for analysing a different aspect of the history of commercial relations between Russia and Britain.

The seals had to conform to certain different criteria, having on the one hand to correspond to the technical standards of the day and on the other being required to differ in text, since it was their very function to distinguish goods, their quality and the place from where they were transported across national boundaries. The information contained on them therefore provides us with a picture of the manner in which the export of these products from Russia to Britain was handled. They allow us to make comparisons over different periods of time and to analyse the different systems of quality control used. They also enable us to record in part the geographical distribution of the Russian ports used for the export of flax and hemp to the UK. The spread of their distribution in Britain tells us something of the redistribution of flax and hemp imports once they reached Britain and provides an understanding, more detailed than hitherto, of the use their by-products were put to as part of the agricultural practices of the 18th and 19th centuries in some areas of the country.

This monograph which has grown out of the difficulties encountered over the last two decades in recognising and interpreting Russian lead-alloy seals offers a short history of their use, a guide to their identification and a catalogue of items recovered in Britain. It is not the work of a numismatist or specialist in sphragistics but of a Russian linguistic historian and palaeographer who has sought to decipher and explain the significance of the seals and some of the imprints on them.

Collections of flax and hemp lead-alloy bundle seals of Russian origin are found in museums throughout the UK, reflecting discoveries particularly in parts of east Scotland (Fife, Aberdeenshire, Inverness-shire (Cromarty and Dornoch), Arbroath, Montrose, Falkirk, Edinburgh and Dundee), some regions of Yorkshire (York, Knaresborough and Hull), Lancashire (Lancaster, Liverpool and Preston) and north Cheshire, parts of the Midlands (Warwick, Hereford and Nottinghamshire (Newark)) and a belt of country stretching from south-west England (Bristol, Gloucester, Lyme Regis, Exeter, Padstow and Taunton) through Salisbury, Newbury, Wallingford and Abingdon to London. Finds of flax and hemp seals have been recorded in Suffolk, Norfolk, Essex and Surrey and individual recoveries have been made in Ulster and South Wales.

Some museums house large numbers, others have individual examples. Many are retained in private collections, usually of metal detector users but sometimes of private landowners. Whilst clearly less attractive than collections of more valuable coins and earlier seals, they nevertheless form an important part of the commercial history of Russia and the UK and carry on them illuminating data. There is a great risk that such discoveries will be cast aside as the important contribution they can make to the economic and social history of Britain and Russia is totally unappreciated.

It is important to point out that many seals of Baltic origin are erroneously listed in museum collections as Russian, and some Russian seals are incorrectly described as flax/hemp bundle seals when they are more likely to have been attached to consignments of other products. The aim of this guide and catalogue is to provide assistance for finders and museum curators in identifying such objects correctly.

The monograph consists of an introductory section that discusses aspects of Russian and Russo-British commercial history important for a full understanding of the use of lead-alloy seals.

Discussion of the seals themselves is presented in three parts. Part One is the most important for scholars and general users wishing to interpret individual examples of seals which have been recovered in Great Britain. With the help of illustrations it guides the reader through the different types of seal so far recorded. The greatest difficulty has been the problem of presenting and describing the material for a readership lacking familiarity with the Cyrillic alphabet,

and this has been addressed in large part by transliteration given in parentheses after the Cyrillic form and by the provision of explanatory tables. Analysis is also conducted of the information found on all or most seals. Seals found in ports of the Russian Empire, such as Riga, are also briefly discussed.

A number of other types of Russian seal are also noted, but because of the paucity of clear information on them it is difficult to ascertain with which trades they were connected. The establishment of which trades are involved requires the identification of particular entrepreneurs and their business establishments, some of which appear only as initials.

The catalogue which forms Part Two of the Guide lists seals from all sources that were made available to the author for record and description by the beginning of 2007. The vast majority has been examined *de visu* and only a handful have been described solely on the basis of drawings or photographs. Seals posted on the website of the Portable Antiquities Scheme (PAS), have been omitted, with the exception of Suffolk, where all the seals had already been examined before being posted on PAS. Some other individual examples, which were similarly examined before the establishment of the PAS website, are included in Section 6.4 in the lists of museum holdings or of private collections.

The letters on the seals are transcribed exactly as they appear with Cyrillic and Roman letters (Section 6.1; Section 6.1.2; Section 6.2 (Scottish museums); Section 6.3 (English museums); Section 6.4 (Private collections); 6.5 (Anonymous)) and are transliterated into Roman letters following the conventions described in Section 6.1, Section 6.1.1, Section 6.1.2.

Part Three of the work consists of a number of appendices listing the different items of information relating to personnel, dates, locations, fibre grades and post numbers.

Abbreviations, definitions and conventions

Abbreviations

ABDMG	Aberdeen Museum and Gallery
ADMUS: A	Arbroath (Signal Tower) Museum, Arbroath
ADMUS: B	Montrose Museum, Montrose
ADMUS: M	Montrose Museum, Montrose
BRSMG	Bristol Museum and Gallery
CRMCH	Courthouse Museum, Cromarty
CUPMS	Fife Museum Service (East), Cupar, Fife
DRO	Dorset Record Office
DUMFM	Dumfries Museum
DUN	Dundee Museum and Galleries
DZSWS	Wiltshire Heritage, Devizes
EXEMS	Royal Albert Memorial Museum and Art Gallery, Exeter
FALKM	Falkirk Museum
FORMG	Forfar Museum and Art Gallery (Meffan Institute)
GRYEH	Great Yarmouth Museum
GLDM	Guildford Museum
HARGM	Harrogate Museum and Gallery
HFDMG	Hereford Museum and Gallery
INVMG	Inverness Museum and Gallery
KGGM	Kirriemuir Gateway to the Glens Museum, Kirriemuir
KINCM	Kingston upon Hull Museum and Art Gallery
KIRMG	Kirkcaldy Museum and Gallery
LCM	Lancaster Museum
LWMCH	Methil Cutural Heritage Centre, Methil, Fife
MM	Malton Museum, Yorkshire
MoL	Museum of London
NEBYM	West Berkshire Heritage Service, Newbury
NLA	Norfolk Landscape Archaeology, Gressenhall, Norfolk
NML	National Museums Liverpool
NMS	National Museums of Scotland
PRSMG	Harris Museum and Art Gallery, Preston
OXCMS	Abingdon (Court House) Museum, Abindgon
OXFAS	Ashmolean Museum, Oxford
PERMG	Perth Museum and Art Gallery, Perth
RGIA	Russian State Historical Archive, St Petersburg
StPII	St Petersburg Institute of History (Russian Academy of Sciences)
SBYWM	Salisbury and South Wiltshire Museum
SF	Suffolk Archaeological Service
WARMS	Warwick Museum
WAVMS	Waverley Museums (Farnham Museum)
WHITM	Whitby Museum
WHIT(W.A.)	Whitby: Abbey House (English Heritage)

Definitions and conventions

Configuration:	the arrangement of parts on a seal
Group:	the general form or character of the seals
Provenance:	the place or adjacent area in which a seal originated
Style:	the distinguishing features of the manner of presentation of information on a seal
Type:	the general form or character of the seal
Unprovenanced:	the place or adjacent area in which a seal originated has not been ascertained
Variant:	a seal exhibiting divergence from the group to which in all other respects it belongs
/	End of line
[–]	Letter illegible
[n]	The indicated letter is probable
–	A letter possibly missing
=	to be read as

The Russian alphabet in the 18th and 19th Centuries

The reform of Russian alphabet in 1918 had first been proposed in 1904 by two of Russia's leading linguists, Fortunatov and Shakhmatov. Republished in a somewhat modified form in 1912 the proposals were introduced by the Minister of Education in May/June, 1917 and finally enacted by decree in 1918 (Comrie 1978, 200–213). The reform resulted in the removal of four letters considered redundant, and the re-designation in use of a fifth. Since nearly all seals so far recovered pre-date the 1918 orthographic reform we have listed all the Cyrillic letters encountered in 18th- and 19th-century Russian, along with a guide to pronunciation. The vowels sounds indicated approximate to those occurring in stressed positions.

Some difficulties in transcribing Russian might be eased if one bears in mind the following orthographic conventions:

1. The letter Ъ (hard sign) cannot be used after a vowel and most frequently appears as the last letter of a word. On many seals, as in many manuscripts, it is often represented in a form similar to or identical with the letter Ь (soft sign).
2. By the 18th and 19th centuries a) the vowel Ы does not follow the consonants К, Г, Х; b) the vowel Я does not usually follow the consonants Ж, Ч, Ш and Щ.
3. the letter Й always follows a vowel and rarely occurs initially.
4. Because many seals are damaged the following letters may be difficult to distinguish: Г and Т; Ш and Щ; Л, Д and А; Н, И, К and Ч. Legibility may also be compromised by the imprint being in italicised script (Fig. 1a; Fig. 1a (detail)) or presented as a ligature (Fig. 1b; Fig. 1b (detail)), Fig. 2; Fig. 2 (detail)) Twelve letters are common to the Cyrillic and Roman alphabets: A, B, C, E, K, M, H, I, O, P, T and X, all but five (A, K, M, O and T) with different sounds. Since both Cyrillic and Roman letters are used on some seals it is occasionally difficult to determine which alphabet they represent. The letter T can appear with three downstrokes (Fig. 40) and on damaged seals can be confused with Ш. The letter Ѳ can be confused with О.

Cyrillic letters found on Russian lead seals

Cyrillic	Approximate English equivalent	Cyrillic	Approximate English equivalent
А, а	a (as in father)	С	s (sick)
Б	b (beer)	Т	t (tick)
В	v (veer)	У, Ȣ	oo (stool)
Г	g (gear)	Ф	f (fool)
Д	d (deer)	Х	kh (Scot. loch)
Е	ye (yes)	Ц	ts (bits)
Ж	zh (leisure)	Ч	ch (church)
З	z (zoo)	Ш	sh (shirt)
I	i (peek)	Щ	soft sh or shch (Ashchurch, posh ship)
И	i (peek)	Ъ	hard sign (no sound)
Й	y (boy)	Ы	i (pill)
К	k (kick)	Ь	soft sign (softens preceding consonant)
Л, л	l (lick)	Ѣ	ye (yen)
М	m (Mick)	Э	e (men)
Н	n (nick)	Ю	yu (tune)
О	o (more)	Ѳ	f (fool)
П	p (pick)	Я	ya (yam)
Р	r (rick)		

Prolegomena

1. Russian trade with Britain

In the second half of the 16th century Russian maritime trade was conducted through the ports of Archangel and Kholmogory (Map 4.9.1, Map 4.9.2). Records show that a variety of goods, including hemp, flax, timber, tallow and goatskins were exported to Britain and France in return for Spanish wine, sugar, raisins, grapes, pepper and herrings, as well as paper, lead, tin and saltpetre. Russian trade with Europe increased enormously after the accession of Peter the Great in 1689. Commodities in greatest demand were grain, flax, hemp, iron and timber. Flax was brought to market and purchased by buyers connected with the exporting houses. It was sorted or 'bracked' by them into its various qualities and tied in bundles, after which it was shipped to Britain, Ireland, France or Belgium.

Much more has been written about trade between Russia and Britain in the 18th century than in subsequent centuries and studies have tended to concentrate on the overall economic and commercial impact of the trade on England and Scotland. However, the publication of the import and export registers of the port of St Petersburg for 1764 (Demkin 1998a; 1998b) and the study of British merchants in Russia in the 18th century (Demkin 1998c) have given us additional interesting and important insights into the companies, merchants and agents themselves who were operating in Russia in the 18th century and the goods they were trading. Similar information was contained in the publication in 1981 of later 18th-century registers of the value of imports and exports by named merchants through the port of St Petersburg (*Vneshnyaya torgovlya* 1981).

1.1. Russian maritime trade in the 18th century

Most of the 18th-century increase in trade passed through the Baltic ports, and the all-but-total absence of a Russian merchant fleet at this time meant that this Baltic expansion presented huge opportunities to British and Dutch skippers. By the 1740s Britain was the recipient of over two thirds of exported Russian hemp and half its exports of flax, by far the largest part of this trade passing through St Petersburg-Kronstadt, a situation that endured until the mid-19th century, when overland transportation began to develop (Map 4.9.1, Map 4.9.3).

The Russia Company, founded by Royal Charter in 1555 as the Company of Merchant Adventurers, was by the 18th century active in encouraging trade with Russia. From its offices in London it maintained correspondence with agents in British towns and cities, such as Bristol, Dover, Edinburgh, Exeter, Hull, Lancaster, Liverpool, Lyme Regis, Newcastle, Stockton, Whitehaven and Yarmouth. In Russia it also helped in the control of quality, especially of hemp and flax. For example, Samuel Holden, Governor of the Company from 1728 to 1735, served as a member of several committees concerned with grading hemp, his duties involving much correspondence with agents in Russia because of abuses in the presentation of goods for inspection and difficulties with the quality control system (MacMillan 1971, 222, 226–27; Hunt 1955, 28–31).

Imports from Russia reached a new peak in the 1770s, reflected in the number of lead seals recovered in Britain from that decade. St Petersburg, Archangel and Riga exported the greater part of their flax to Britain, the smaller ports of Narva, Reval, Pernau and Libau sending the whole of their shipments of flax and hemp to Britain (Rimmer 1960, 242–243). During the Napoleonic campaigns more than three quarters of the United Kingdom's imports of flax originated in Russia and even after the war the figure stood at two thirds for a further forty years. In the year following the great conflict just over half of the ships trading at Kronstadt, in effect the port of St Petersburg, were British. They came to St Petersburg from a wide range of British and foreign ports, and many which are registered as arriving from a foreign port had in fact begun their journey in Britain.

The extent of British trade can been seen from the following reports in the official Government newspaper in 1814. During the period 19 July to 24 August, 1814, the number of British ships arriving at Kronstadt/St Petersburg comprised 59% of all arrivals. Most of these came from London. Hull sent just over half the number that London did, but ships also arrived from other British ports: Arbroath, Belfast, Berwick, Boston, Dundee, Glasgow, Grangemouth, Great Yarmouth, Greenock, Leith, Liverpool, Newcastle, Peterhead, Portsmouth, Sunderland and Whitby. Twenty-three vessels made their way to Russia via foreign ports, such as Hamburg, Reval and Bremen (*Sanktpeterburgskie vedomosti* 1814, no. 64, 11 August; no. 68, 25 August; no. 82, 13 October). For the slightly shorter period of the same year, from 3 to 22 August, by far the most frequently registered destination of just over 300 British ships departing for Britain was London (89%). The others were bound for Avonmouth, Boston, Bristol, Dundee, Exeter, Great Yarmouth, Guernsey, Hull, Leith, Liverpool, Limerick,

Newcastle, Newry, Padstow, Whitby and Whitehall. In addition British ports were also the registered destination of a number of departing foreign ships, one Lubeck, two Dutch and two Mecklenburg ships. One Bremen ship sailed to Jersey. Of the forty-four Russian vessels departing during this period twenty-one sailed for Britain, sixteen to London, and one each to Dundee, Lewes, Liverpool, Lyme Regis and Portsmouth (*Sanktpeterburgskie vedomosti* 1814, no. 80, 6 October; no. 83, 18 October; no. 86, 27 October).

A word of caution needs to be sounded when using Russian data since they can only provide a rough indication of the destination of exports from St Petersburg-Kronstadt. Many sources simply designated 'the Sound', the main channel at the southern end of the Kattegat leading to the Baltic sea, where the skippers would receive additional directives from agents in Elsinore regarding the onward passage of the goods in their charge (*Sanktpeterburgskie vedomosti* 19 December, 1848, 1146). For example, almost one half of the exports of flax, hemp and flax and hemp tow despatched from St Petersburg in 1780 were designated only as far as the Sound (StII, 36, 1, 570, fos 63–65v.). Difficulties in collecting accurate figures are multiplied by the fact that many companies placing orders in St Petersburg for Russian goods did not specify the exact destination of those goods. Although it would be helpful if we could link export data available in St Petersburg with imports of flax and hemp in Britain, the chances of linking finds of seals to individual importers of goods through Scottish and English ports are extremely remote, for there is no way of identifying with accuracy how much Russo-British commerce entered the country by way of ports far distant from the places where the raw materials were ultimately processed. We know, for instance, that some of the flax brought to Hull and other ports in England was subsequently shipped up to Scotland, but also that as early as 1748 the British Linen Company had decided to ship directly to Cromarty rather than re-ship consignments from another port in Britain.

1.2. Russian flax and hemp trade with England

Out of an extensive list of English ports which received ships from Russia the most significant port of entry for a whole range of goods imported in particular from St Petersburg was London. Flax and hemp products, as well as timber and iron, formed a large part of them. British naval requirements were supplied by Russian exports of raw materials – hemp, flax, furs, as well as finished products such as hemp ropes and sailcloth. Many authors frequently combine the totals of flax and hemp in their calculations which is not justifiable since hemp was used mainly in the production of ropes and cordage whilst flax was used mainly in the linen and sail-making industries. By 1751 the exports of a number of goods from St Petersburg-Kronstadt had shown a remarkable increase over what had been exported some twenty-five years earlier, in flax by 16%, in hemp by 137% and in sailcloth by 779%. In 1764 some two thirds of the total exports of a whole range of goods from Kronstadt were shipped to London, including 1777 tons of flax and 4121 tons of hemp. The same 1764 record shows that the only other British port for which a ship departed St Petersburg that year was Hull, which imported a cargo of 210 tons of bar-iron and shaped iron (Demkin 1998a). In other years Hull acted as an important additional port of entry for flax and hemp, eventually becoming England's main flax and hemp port.

Other centres were also occupied with flax and hemp imports in support of local commercial and industrial activities. In addition to London and Hull, the ports of Avonmouth, Boston, Bridport, Bristol, Ipswich, Lancaster, Lyme Regis, Liverpool, Milford, Newcastle, Portsmouth, Plymouth, Sunderland, Whitby, Whitehaven and Yarmouth were also recipients of Russian goods, amongst them hemp and flax. Belfast, Cork, Dublin, Limerick, Londonderry and Newry also handled imports from Russia, as did Guernsey and Jersey.

Evidence of this commercial activity survives on lead-alloy seals recovered from districts in the immediate hinterland of these ports or in nearby localities in which flax and hemp fibres were processed and refined.

In Dorset for example, a number of seals have been recovered near Lyme Regis and Bridport where there was an important rope-walk. The local manufacture of rope, twine, thread, small cordage, nets and sailcloth for the Royal Navy and other shipowners required a constant supply of hemp and flax which local producers simply could not meet. Some imports were brought in directly from Russia and the Baltic through the local ports, others were sent on from London.

Bridport harbour records for the later part of the 19th century show a preponderance of imports from Riga rather than Archangel or St Petersburg. For instance, in 1864, the total tonnage of shipping from Riga reached 1115 for flax and 1428 for hemp, but records of arrivals from other Russian ports list but one ship from Archangel, tonnage 186, carrying flax. There were none from St Petersburg. In the following year there is no record at all of imports from either Archangel or St Petersburg, but the tonnage of shipping carrying flax from Riga had risen to 1535, whilst hemp showed a sharp decline to about 600. By the 1870s, nineteen ships, with a total tonnage of 2854, arrived from Archangel carrying flax, in contrast to St Petersburg, imports from which were aboard only six merchantmen, carrying mainly hemp, flax and some oats. The total tonnage of the 99 ships from the port of Riga bringing hemp and flax to Bridport exceeded 13,011. After the 1870s the number of ships from St Petersburg and Archangel slumped dramatically, as did those from Riga, which sent only 47 ships. By the 1890s almost no ships were arriving from Archangel or St Petersburg, and the number from Riga had slumped to 23 (DRO N29a).

The reasons for such a decrease were several, including the removal of Navy rope-making to Chatham and the development of rail links between London and Bridport. Bridport Harbour itself experienced more and more difficulties coping with the larger steamships. In May 1889 the *SS Gwendoline* from Riga had collided against the east and west piers while in July of the same year the

Russian steamer, the *St Anna*, succeeded in demolishing one whole section of the east pier as it entered the port with its starboard anchor already hanging over its bow. The *SS Alfa* struck the jetty in 1904 and again in 1906 on its way from Riga and, as the Harbourmaster plaintively records in his Log, on the last occasion paid less than a third of the total cost of repairs (DRO N29a).

1.3. Russian flax and hemp trade with Scotland

The main activity in trade between Russia and eastern Scotland was the importation of textile fibres, of which flax imports outstripped those of tow and hemp by a considerable extent. The flax and hemp imports were brought to the ports on the east coast, for instance Leith, near Edinburgh, Grangemouth, Dysart and Kirkcaldy in Fife, Dundee, Arbroath and Montrose in Angus and further north to Aberdeen, Peterhead and the Cromarty Firth. Industries grew around these ports and along the rivers which flowed to them. Ports in the west of Scotland receiving Russian goods included Greenock and Glasgow. Despite the introduction of cotton in the west of Scotland which had hitherto concentrated on the finer end of the linen trade, it had little effect on the market in the east where linen continued to thrive. In Dundee Russian imports climbed from about 150 tons in the 1740s to some 3000 tons annually by the 1790s (Durie *Russia's Role*). By the 1830s imports to Dundee reached over 10,000 tons annually, a substantial part of which were Russian (Warden 608–609, 633; Jackson and Kinnear 7).

St Petersburg was the favoured port of the Scots despite the fact that its shallow waters forced larger vessels to berth at Kronstadt and unload or load there before transferring their wares to and from St Petersburg by lighter. It handled flax grown in the regions north east of Moscow by producers who were prevented by Government Decree from using the port at Archangel. The second most popular port, Riga, on the other hand, was more convenient for the flax-growing regions of Pskov, Estland, Livonia and Courland, and through them enjoyed the additional benefit of handling some of the best flax produced in the Russian Empire (Map 4.9.1, Map 4.9.3). After 1821 the number of ships from Riga increased rapidly and with the growth of the port of Dundee as much as 41% of its shipping came from Riga. By 1826 Dundee had overtaken Hull as Britain's premier flax port, its imports by 1828 representing a third of the British total. By 1829 Riga supplied 48% of the flax and 60% of the hemp imported through the port of Dundee for use in a wide variety of industries in the town and surrounding areas such as spinning, linen, rope-making and sail making (Jackson and Kinnear 7, 12).

However, the evidence of recovered seals from the later decades of the 19th century shows that the east coast of Scotland continued to maintain healthy trade links with the port of Archangel.

Commercial links with the other Baltic ports also developed, in particular Memel and Libau in the 1820s, and Narva and Pernau by 1836, when 262 vessels brought flax and 41 brought flax and other goods, principally timber, from Russia (Jackson and Kinnear 12).

2. Russian ports

For many centuries Russia remained essentially a land-locked and in winter ice-bound country whose quest for access to the sea brought many conflicts with neighbouring states, such as Sweden to the north west and the Ottoman Empire in the south. Most other ports, in the Pacific and Black Sea, were not fully developed until the mid 19th century. In any case, ports such as Vladivostok (founded in 1860) were too distant from commercial markets or faced problems of access, as did Odessa, founded in 1793 on the Black Sea, which depended on the passage of all its shipping through the Bosporus and the Dardenelles.

Russian trade with Europe, therefore, was directed through the Arctic Ocean (White Sea) in the north or the Baltic in the west (Map 4.9.1, Map 4.9.2, Map 4.9.3). Narva was the nearest port to Russia used by western merchants. Access to the Baltic lay either through the Western Dvina to Riga or by waterways to the south-east corner of the Gulf of Finland in the area known as Ingria. The mouth of the Western Dvina was for long too insecure for the Russians to rely on it, and indeed for a time in the early 17th century as a result of an unfavourable treaty in 1617 with Sweden they were actually deprived of any foothold at all on the Baltic.

Victory over Sweden in the Great Northern War and the Treaty of Nystadt in 1721 consolidated Russia's foothold on the Baltic Sea through the possession of Estland, Livonia and Ingria and placed her in control of the coastal area from Vyborg to Riga. Subsequently, as a result of the three partitions of Poland between 1772 and 1795, Empress Catherine made significant gains on the Baltic further securing the port of Riga.

However, passage through the Baltic continued to be hampered by occasional political difficulties, leading to tension and retaliatory measures by one of the Scandinavian powers. A most important factor in the development of trade via the Baltic ports was that during the winter months many of them were free of ice for a longer period than St Petersburg, despite their being fraught with natural and meteorological hazards, with ice, wind and fog proving treacherous. Reports from the mid-1840s, for example, show that in 1844 a strong south-west wind had brought the ice up as far as Kronstadt by the end of October and in November Riga too was hit by an unexpected eight degrees of frost. A number of ships were trapped in the harbour, among them the *Elisabeth* from Hull, master Richard Oxford, which was laden with 234 barrels of tallow. The ship was holed and sank, the crew escaping by walking across the ice. In 1846 the *British Queen*, carrying fruit from Messina, ran aground south of Kronstadt and had to be unloaded by lightermen in order to refloat her. The year 1848 was particularly grim. The *Undaunted* on passage from Hull to Kronstadt hit a reef in fog near Rostock Island and eventually broke up, whilst the *Queen of the Tyne* ran aground at Bornholm, which lies between Sweden and Prussia, and was only refloated after

throwing overboard part of her cargo of coal. On the same day in the same place three other ships from Newcastle ran aground on their way to Kronstadt.

The main Baltic ports used by British ships for the transport of Russian goods became St Petersburg, Riga, Narva, Pernau, Libau, Memel (Klaipeda) and Reval (Tallinn) (Carter 1919, 11). Only lead-alloy seals issued at the ports of St Petersburg, Riga and Memel have hitherto been identified with certainty. Other seals with probable connections to flax and hemp have been recovered but cannot be ascribed clearly to any of the other Baltic ports trading with Britain.

2.1. St Petersburg

The consolidation of access to the Baltic Sea in 1721 brought Russia not only such ports as Riga, Reval (Tallinn) and Pernau, but also a more secure location for St Petersburg itself. This finally allowed the expansion of the port at St Petersburg which had been established soon after the laying of the first stone of the city by Peter the Great in 1703. The first merchants' quarters, known in Russian as *Gostiny dvor*, forming a set of commercial buildings, warehouses and living quarters created originally for wholesale trade for foreigners and travelling merchants (*gosti*) and later from the second half of the 18th century as centres for permanent retail trade, arose on Trinity Square where the first market had come into being. In 1713 a two-storey adobe building was constructed to house the merchants' quarters which survived until 1737. Shops were situated on the lower floor and storerooms on the upper floor. In 1719 a second merchants' arcade was built on the corner of Nevsky Prospekt and the Moyka canal and in 1722 the construction of a stone Gostiny dvor was begun on St Basil's Island (*Vasilievsky ostrov*).

Wharves and moorings were established in many parts of the town, the most important of them in Peter I's time being the one at Trinity Square. Completed in 1735, ten years after his death, it was turned into a warehouse for export goods and called the merchants' harbour arcade (*Portovy Gostiny Dvor*). With the increase in population and buildings the town's centre shifted to the opposite bank of the Neva and the central merchants' arcade was moved there with it. After the fire of 1736 the cost of constructing the large stone two-storey Gostiny dvor at the corner of Nevsky Prospekt and Bol'shaya Sadovaya was borne by the merchants themselves. Between 1761 and 1785 a new building was constructed on the site that survives to this day in a somewhat changed form.

Rapid development of trade also led to the creation of an Exchange (*birzha*). Formed initially in 1703 as an assembly of merchants from Trinity Square, it was a commodity exchange where merchants were able to negotiate trade transactions. Later it was regulated by Government orders and additionally came to provide an opportunity for traders to familiarise themselves with the state of the market, with the addition in 1723 of special services offering information on prices within Russia and abroad. In 1724 a special stone building was constructed on Trinity Square, but it did not survive long and in 1731 the Exchange was transferred to St Basil's Island into the premises of the merchants' arcade, and later to the Port Customs house. In 1755 it was moved to a special stone building opposite the Customs House.

The supervision of trade in St Petersburg was undertaken by the Internal Customs and the Port Customs. In 1703 the St Petersburg Customs House was founded on Trinity Square, where all goods were assembled. Special Internal and Port Custom Houses came later, the final organisation being completed only in 1723 (Bogdanov and Ruban 93–94).

In 1731 the Internal and Port Customs Houses themselves were merged and from 1733 a single Customs Service existed on St Basil's Island close to the embankment near Customs Lane. At the same time the Customs Quay and Exchange were transferred to this same location, making St Basil's Island, especially its eastern end, the centre of Petersburg's external trade.

At the outset customs activity in all matters was run by elected representatives of the merchants of St Petersburg but from 1720 a permanent staff of officials was appointed, comprising Chief Customs Officers (*obertsolnery*), Customs Officers (*tsolnery*) and various Inspectors (*dosmotrshchiki*). However, this development did not totally exclude representatives of the St Petersburg merchants who were still drawn into customs matters even after these appointments.

In the early stages, after completing customs procedures in the Customs House merchants were granted the right to take back their goods and unload them in their own establishments, which led to rumours of all manner of abuses. Therefore, in 1723 special Customs Warehouses were constructed on Trinity Square where goods were stored under supervision once customs had been passed. Subsequently further warehouses were built on St Basil's Island, and on other banks of the Neva, for example, between 1764 and 1772 on Tuchkov Wharf (*Buyan*) huge hemp warehouses were constructed.

In 1785 Russian merchants were granted permission to open arcades for the storage and sale of goods or to establish shops and barns at their homes for the sale of goods throughout Russia.

The capital of Russia was moved from Moscow to St Petersburg in 1712, but its situation was far from ideal as a site for a busy commercial and naval port because of the shallowness of its waters. The capital was guarded by the fortress at Kronstadt on Kotlin Island, 24 kilometres to the west in the Gulf of Finland, fortification of which had been begun between 1703 and 1706. A harbour was also built there between 1712 and 1716 which developed separate wharves as naval and commercial ports. At the same time as the St Petersburg Customs House was built in 1703 the Kronstadt Port Customs House was also formed. Because large merchant ships of more than 2.4 metres draught could not reach the port in St Petersburg, cargo had to be unloaded in Kronstadt which helped develop the important role it went on to play in transferring goods by lighters and shallow boats by river to the port in the capital.

Although trade came from all parts of Europe and beyond,

Plate 1. Gostiny dvor in the early 20th century (from a postcard of the time).

Plate 2. The Jessie of Perth *at Riga. Painted by Charles Slae on one of three visits to Riga in 1838. Its joint owner and captain that year was James Harvey. The town of Riga is in the background. A ship named Jessie is twice recorded in Kronstadt in 1814. Courtesy of Perth Museum & Art Gallery, Perth & Kinross Council.*

Plate 3. The Nikolaevskiy bridge at the turn of the 19th–20th centuries and a view of the English Embankment (from a postcard of the time). It is the first permanent metal bridge over the Neva and was constructed between 1843 and 1850. It was first named the Annunciation bridge (after the square and church) but renamed the Nikolaevskiy bridge in 1855. It was subsequently redesignated as the Lieutenant Schmidt bridge.

Plate 4. Customs formalities were conducted in this building by the Streka, a flag flying above the building when it was open. It subsequently became the Institute of Russian Literature (Pushkin House).

Plate 5. The Senate. Built 1829–1834 according to a project by Rossi, the building has changed little since it replaced buildings which had stood on this site from 1714. It forms the first building on the English embankment, the name it had acquired by the end of the 18th century when a number of English subjects had settled amongst the Russian aristocratic families and dignitaries who had made this part of St Petersburg the main social quarter. It became the premises of the Russian State Historical Archive in the 20th century after the 1917 revolution when the government and capital returned to Moscow.

Plate 6. The British colony in St Petersburg was large enough to support its own church, started in 1753 and rebuilt in 1815. It came to be the church for the members of the British Embassy and was a meeting place for British residents who formed organisations, such as sports clubs, mutual credit societies and an English Governesses' Club.

Plate 7. The house of a successful businessman and who married the daughter of one of the city's most successful merchants. She received the house as a wedding present. The family were timber merchants and the building was large enough to house their business Clark and Co., which was also involved in the export of flax and cereals. The trading house had been transferred to St Petersburg from Archangel in the 1850s and by the time of his death in 1905 Clark was a bank director, chairman of the Onega timber trade board of management and a member of the council of the Volga and Kama Commercial Bank.

Plate 8. On the Neva at St Petersburg. Timber has for centuries been a major export of Russia. It was to control the quality of timber for export that the checking system which was subsequently extended to other goods such as flax and hemp was introduced.

British shipping played the largest role in the commercial activity of both ports, the number of ships reaching half of all that arrived in St Petersburg in the second half of the 18th century. The Russians themselves usually concentrated on the transfer of goods between Kronstadt and St Petersburg as the ports grew rapidly in the 18th century.

Nearly a century later almost all the goods intended for St Petersburg were still brought initially to Kronstadt which was now visited annually by 2500–3000 vessels, including 500 steamers. The height of commercial activity in Kronstadt was reached in 1860s–1880s which by 1869 had been fitted to contain about 600 ships. However, its commercial harbour had become so overcrowded that, according to contemporary accounts, vessels might wait for up to one month for space at the wharf or for lighters or tugs. So great was the problem that the attendant costs of shipping goods from the home port to Kronstadt were less than from Kronstadt to St Petersburg. In 1874 after the construction of a new canal to the sea the harbour of St Petersburg was established at Gutuev Island, but some goods, such as timber and coal, continued to be transported through Kronstadt.

2.2. Riga

Founded in the 13th century some 19 kilometres from the mouth of the Western Dvina Riga became a prosperous Hanseatic city, dominated by German merchants. It became a bone of contention for several nations throughout the 16th and 17th centuries. At the beginning of the 18th century it became part of the Russian Empire. By the end of that century its position had become secure enough for it to develop into the third most important commercial port in Russia, what was called in the 19th century the 'great emporium of the Russian empire', mopping up what St Petersburg did not take of foreign trade and handling exports of flax and hemp, as well as a range of other goods, such as tallow, turpentine and timber from Russia and the Baltic. Between 1866 and 1910 the value of exports from Riga show an almost constant growth from 31 million roubles to 190 million roubles, representing 15.6% of the value of external trade of all European Russia (*Adresny ukazatel' Rigi 1912*, 61). Flax and linseed occupied a prominent place in local trade, since Riga was the chief Russian port for the extensive high-quality flax regions of north-west Russia and Poland which lay some distance from St Petersburg. As rail links developed it also became the port of export for hemp brought by rail from the hemp-growing areas of the western part of central Russia and its population expanded rapidly.

Between 1840 and 1897 it increased six-fold. In 1840 it was about 47,000, but this had more than doubled to 102,590 by 1867 and increased further to 282,942 in 1897. By the beginning of the 20th century its population comprised 47% Germans, 25% Russians and 23% Latvians. In 1912, for example, the Committee of the Riga Exchange was totally dominated by members with Germanic, rather than Slavonic or Latvian names (*Adresny ukazatel' Rigi 1912*, 204).

2.3. Archangel

None of the Baltic ports could guarantee reliable and unmolested passage of goods since there was the risk of attack by privateers from Denmark and Sweden and of blockade during periods of political crisis. Consequently, imports were still sought through the port of Archangel, Russia's most northerly and, for just over a century, only port.

Located on the White Sea Archangel was founded in 1583 when as a result of the arrival in the White Sea of a number of traders from Holland and England a new harbour was laid out near the monastery of St Nicholas. Since the existing port of Kholmogory was situated too far from the sea Archangel soon began to thrive as it handled the import of foreign goods and the export of Russian goods from areas near the north. Its main exports were hemp and flax, flax yarn, canvasses, sailcloth, potash, Russia leather (*yuft*) and timber. In the 19th century a considerable amount of cereals, such as wheat, oats, rye, and barley were also exported.

By 1710 the quantity of flax exported through Archangel represented the total production of Russian merchants, but as the attractiveness of Archangel went into rapid decline for a time after the withdrawal of its privileges by Peter the Great it became merely a restricted alternative to St Petersburg. It was not only regarded as remote but was further disadvantaged by being inaccessible for the period November to May when it was ice-bound and remained so for a longer period than the ports on the Baltic. Access to the relatively ice-free port of Murmansk nearby was just too difficult until the construction of the railway in 1915. Ships which had not made port by the beginning of September were usually barred entry since it would not be possible to turn them round in time for a safe departure before the ice set in, unless the master were prepared to over-winter at Archangel. Although these difficulties gave more impetus to the search for more accessible ports, sailing to Britain from Archangel was safer and freight cheaper than through the Baltic and the Gulf of Finland.

However, the development of the port at St Petersburg had a serious detrimental effect on Archangel, especially since it was accompanied by a series of prohibitive decrees that from 1713 onwards aimed at diverting trade to this recently established port. The first decree, issued on 13 October, 1713, banned merchants and people of other ranks from transporting hemp and Russia leather (*yuft*) to Archangel and Vologda for the purposes of trade, and required them to be taken to St Petersburg. Whilst the result was a rapid increase in the number of foreign vessels using St Petersburg from 116 in 1712 to 914 in 1725, the year of Peter's death, the effect on Archangel was a catastrophic decline in trade and a drop in the number of ships berthing from 159 in 1710 to 19 in 1725 (Ogorodnikov 143–44). With such a substantial part of Archangel's trade being surrendered to St Petersburg, the decline had become so serious that Tsar Peter had been obliged as early as 1717 to begin to relax the restrictions, from then on requiring only two thirds of goods to be sent through the capital. By 1762 the same privileges

and benefits as were enjoyed in St Petersburg had been restored to Archangel with the result that by the beginning of the 19th century the number of visiting ships had risen to 160, increasing rapidly to 309 in 1810. A decade after the Napoleonic Wars the average number of ships using Archangel had risen to 350.

Once the early difficulties over St Petersburg privileges had been overcome, the number of ships visiting Archangel remained remarkably healthy. Certain years saw a reduction in numbers, but there were often other external factors influencing the passage of freight to and from Archangel, for example, the Treaty of Tilsit between the Russians and Napoleon as a result of which all trade with Britain stopped in 1808 and British ships in Russian ports were confiscated. In the summer of 1831 trade was affected by a serious outbreak of cholera in nearby Solombula when 700 people died.

In the 1850s–60s Archangel's trade stagnated. Trade barriers were erected because of the Eastern War with Turkey which allowed other ports to grow as they created more convenient routes for trade with Russia. The distance of Archangel from some areas of Russia which were rich in grain, as well as the poor lines of communication through lack of government finance proved detrimental. When the railways did appear the industrial centres were linked to other ports, not Archangel, and gradually St Petersburg began to dominate. However, exports of flax products, linseed oil, timber and tar through Archangel remained firm. The flax and tow exported from Archangel was highly regarded in the markets of Scotland and France and were preferred to St Petersburg and Riga products mainly because the obligatory inspection of quality remained in place in Archangel whereas by the mid-19th century it had been made voluntary in those other ports.

The development of Russian maritime commercial activity in the 18th and 19th centuries was rapid, leading to the development of the already existing ports of Riga and Archangel and the construction of the new ports at St Petersburg and Kronstadt. Goods were also exported from other Baltic ports, such as Narva, Pernau and Libau, but no definite evidence of seals from these ports has been hitherto identified (Demkin 1998c, 73, 75).

3. Background to the use of lead-alloy seals

Although the Russian seals that have come to light are of different types and intended for a variety of purposes, the vast majority of lead-alloy seals are being recovered from or near to the fields, gardens and ancient dwellings of those parts of Britain where flax and hemp products were produced, involving the linen, sail, net, twine, cordage and rope-making industries. They were attached to bundles imported to Britain from St Petersburg, Archangel and Riga and were eventually thrown out with the woody part of the stem to be mixed with night soil removed from the open streets or with manure, and sold to local farmers as fertiliser. Flax waste was regarded as an excellent fertiliser, especially when mixed with night soil, which explains why so many finds are made on farm land. Many seals have lain in the ground for over a century and have been damaged, sometimes severely, by corrosion and the results of ploughing.

One major difficulty when analysing present finds is the inability or reluctance of metal detector users to provide accurate identification of the location of their finds, making the compilation of any kind of distribution map virtually impossible. In its preliminary stages such a map indeed would perhaps not be a true representation of the overall distribution of the seals so much as a map of the activity of metal detector users willing to share information.

3.1. Quality control (brack, bracque) in the Russian Empire

In the 17th century ships arriving at Archangel had normally been kept under observation by Customs Officers during unloading and loading, but from 1704 a new official system of bracking was introduced, in the first instance to ensure the correct grading of mast timber for export (Ogorodniikov 1890, 136). The term *brakoval'nik* had already been registered by Tonnies Fenne in his *Low German Manual of Spoken Russian*, produced in 1607 and aimed at enabling foreign merchants to converse with Russians on their own terms. The term *brakoval'nik*, later to be replaced by the more Russian form *brakovshchik*, was translated into Low German as 'Wraker.'

In the early years, bracking procedures covered a whole range of goods in addition to timber, flax and hemp, such as linen, canvas, linseed, hemp-seed, ashes and wax. All the wares and raw materials were inspected and classified by officers known in English as 'brackers.' Brackers were appointed by the Government for that purpose, and sworn to the faithful performance of their duty. They used the same set of grades for each type of goods or materials which divided them into three sections, according to their qualities.

However, bracking also was important in other circumstances. For example, if a factor or agent could produce a certificate to show that the goods had been officially inspected or bracked he was not the person who could be held liable in the event of the goods being found on delivery to be of an inferior quality. Much of the certification was committed to paper and has subsequently been lost. What has survived is a considerable number of lead-alloy seals stamped with information and attached to bundles of flax and hemp when binding had been completed at the end of the bracking procedure.

Problems of fraudulent commercial activity had been evident from Russian sources as early as the seventeenth century when English merchants had frequently complained of the dishonest packing of hemp, citing stones, rotten hemp, wood, snow and other rubbish in bundles imported from Russia.

Malpractice was so widespread and serious that when *A Book on Poverty and Wealth* appeared in 1724, its author, Ivan Pososhkov, felt it necessary to include in his chapter entitled 'About Merchants' a complaint about merchants cheating and details of their activities, "… this ancient habit among the merchants is very unjust, that is they commit

wrong-doing among themselves and to others, for they cheat one another. Both Russian and foreign goods which appear good to look at are internally poorly made, and other goods, even the worst, are disguised with good ones and sold as good ones and an unfair price is taken ... and they give short weight and measure, ... and because of such wrong-doing they play many dirty tricks on unknowing people" (Pososhkov, 1911, 50).

The situation had already become so serious that Peter the Great established the position of *brakovshchik* (= bracker/bracquer, i.e. a person responsible for the conduct of *brak*) for certain exports, including flax, hemp, tow and herring. For other items bracking was voluntary. It is also clear that some of the merchants elected to the post of *brakovshchik*, many of them merchants of the First Guild, did not carry out the actual work of grading, but acted in a supervisory role or participated only in cases of dispute. In the later decades of the 19th century brackers were selected from the less fortunate merchants trading in the goods to be inspected, many of them bankrupts. In addition, in order to carry out the actual process of quality control a 'sub-bracker' (*podbrakovshchik*) or *desyatnik* was selected by the brackers themselves to work under their direct supervision, in other words he acted as a Quality Control Officer (StPII 36, 1, 578, fos 39v–41). Binders (*vyazal'shchiki*) were also appointed to oversee the proper binding of bundles of hemp and flax once quality control had been completed and the binding was fixed by the attachment of a lead-alloy seal.

The remuneration for *desyatniki* was about three quarters of that paid to *brakovshchiki*, and binders were paid on a quite different scale which took account not only of the quality, but also of the quantity of goods bound in one bundle.

To indicate that the process of sorting had been carried out the names of different Quality Control Officers are stamped alongside the designation *desyatnik* on the undated side of seals from Archangel. On seals from St Petersburg, however, names are given in the corresponding place but without the designation *desyatnik*. On the other side is stamped the grade of flax or hemp and the year-date when it was inspected.

In 1718 new rules for bracking hemp were laid down at St Petersburg and the number of brackers for hemp and flax was increased to twenty-four, comprising twelve Russians and twelve foreigners. For the sorting of the lower grades of flax, such as tow, however, four men were deemed adequate, two Russians and two foreigners. The aim was to guarantee the interests of traders, both sellers and buyers, by official certification of the quality of the goods on sale (Hunt, 30–31; StPII, 36, 1, 578. fo 39). Problems with quality continued to blight commercial links between British and Russian merchants throughout the 18th century despite intermittent attempts to remedy the shortcomings. In 1728 the Russian side elected sworn brackers to serve alongside one foreigner to grade hemp (*Polnoe sobranie zakonov* 1830: no. 5113, 1724, 3 June), but no matter how the duties were allocated among any number of Russians and foreigners the operation and development of the system were fundamentally flawed, since the bracker was elected from within the very body of merchants who traded in that particular commodity and could not be dismissed except at the request of the very merchants who had elected him (*Polnoe sobranie zakonov* 1830: no. 11082, 1760, 14 July).

The year 1734 and subsequent years saw further attempts to counter dishonesty with the introduction of a modified official system of Quality Control. Problems still persisted and by the later part of the 18th century concerns over cheating led to action at the highest levels as fear grew that foreign business confidence in Russia was being undermined by such misconduct and the danger arose that the considerable income from the export of fibres might be forfeited as foreigners sought their sources of flax and hemp elsewhere (StPII 36, 1, 563, fos 84–86). In 1788 the Head of the Commerce College, Count Vorontsov, sent a letter to the governors of a number of provinces informing them that whilst there had been some improvement in the quality of goods brought to St Petersburg for bracking, there nevertheless remained inadequacies and malpractices which must be corrected. The new malpractices focused upon were of a different kind from those which had largely been corrected. In order to increase the weight of hemp merchants and peasants would bring it to market in Winter after packing the inside with snow which in the Winter cold would not be noticed since in frosty weather the dampness contained in the goods did not affect their colour. In other cases weight was increased by soaking the goods in water. Consequently any damage done to the flax or hemp was difficult to detect before the goods had been sold on to other merchants. Indeed, the damage through rotting and discoloration would often become apparent only during the voyage at sea.

Vorontsov cites the example of the condition of the cargo aboard two ships from St Petersburg bound for Portsmouth in 1788. In a cargo shipped by Thomson, Peters and Bonar aboard the *Changeable* only 100, out of nearly 182 tons of hemp, arrived in good condition, and on the *Welcome Messenger* of 141 tons of hemp only 28 tons arrived in good condition, the rest having been spoiled by damp or damaged in some other way (StPII, 36, 1, 563, fo 101).

Other towns were also permitted to establish quality control (bracking) procedures in accordance with existing statutes in order to strengthen confidence and trust in their trade (*Zakonodatel'stvo* 1987, 73).

By the 19th century the Quality Control system was on the whole operated with laudable impartiality and exactness (McCulloch 1869, 614), but complaints still appeared. At the port of St Petersburg compulsory bracking was finally abolished in 1844, although some bracking was continued for a while by producers who desired it. However, by 1860s it had virtually ceased, as the increase in the number of possible routes and modes of transport rendered it almost impossible to maintain proper control over the process (Pokrovskiy 1902, 282).

Manufacturers purchased their raw materials either in a centre of production or at the port in which the fibre arrived in Britain. Some of them employed their own buyers in

Russia to visit or even to reside in the district where the flax or hemp were grown. A competent buyer not only had to be an expert judge of the raw material, but also experienced in the manners of the market in which he traded for it was imperative that he had an understanding of the spirit still more than the letter of the tariff and the Customs House regulations (McCulloch 1869, 1057–1058).

4. Grades of flax and hemp

The problems of purchasing the correct grade of flax and hemp were stressed in 1869, 'As a perfect knowledge of the qualities of hemp and flax can only be acquired by experience and attention, agents usually employ men constantly occupied in this business, by which means they are sure of getting goods of the best quality, and have the best chance of giving satisfaction to their principals: because although hemp is selected by sworn selectors, yet, owing to the quantity of business and the speed with which it must be executed etc, there are often great differences in the same sorts.' (McCulloch 1869, 696).

Of the two products flax was in general the more common fibre exported to European markets from Russia. Hemp exports reached significant amounts only at a relatively later date, and its turnover even then hardly ever reached the huge amounts characteristic of flax. One important reason was that the areas where hemp was produced lay in the central black-earth regions of Russia and the Ukraine and consequently had to be barged to their point of export over large distances, whereas flax was grown in areas nearer the ports of the Baltic and the White Sea to which barge transport had much shorter distances to travel.

The incorporation of Riga into the Russian Empire at the beginning of the 18th century and its rapid development as a port through which both flax, hemp and their products were shipped to the west introduced a system of bracking which differed markedly from those used in St Petersburg and Archangel. Considerable controversy and alarm arose amongst St Petersburg exporters of flax and hemp fibre in the 18th century during an investigation by the Russian Government of the possibility of introducing the Riga bracking system at the port of St Petersburg and opposition from the capital's producers and exporters who felt they would be severely disadvantaged was so intense that in the end no further action was taken.

4.1. Terms used in grading

The terms used in the grading of flax and hemp present a complex picture, since identical terms were not used in Archangel, St Petersburg and Riga, the three chief ports through which the goods were exported, and as the years went by the terms underwent changes in the way they were applied.

In 18th- and 19th-century Russian some terms used in grading flax were distinguished from those used with hemp, whilst others were used irrespective of whether the fibre was flax or hemp (*Tariff* 1767, 18, 26, 37). However, identical terms are found which have diverse meanings in different growing regions, even those in close proximity to one another. For example, strictly speaking, the word 'kudel'' (*tow*), which can be of flax or hemp, is the coarsest part, heckled out from the fine fibres into the shorter fibres (less than 40 cm.) which can be spun for such items as tea towels and tablecloths. However, in Archangel it could also refer to 'unheckled flax' and in nearby Vologda through which much traffic passed on its way to Archangel it was used to denote a definite measure of flax, hemp or wool. Whilst in Vologda the word 'kron' (*crown*) indicated the highest grade of flax (Myznikov 2006, 216), in other areas the recorded meaning is a 'large-fibre second-grade flax' (Dal' II, 507).

Many terms found in Russian press reports of flax and hemp sales are not recorded on lead seals. For example, *molochanka*, hemp produced by drying the plant in a special barn before threshing it, *polovaya*, a third-grade hemp and *sechka* which describes hemp from which the seed head has been cut off are terms frequently used in Exchange news published in the *St Petersburg Gazette* in the 19th century which never appear on seals. Other terms refer to both flax and hemp and are found on seals from Archangel.

Surviving Riga seals are of a quite different format from those of Archangel and St Petersburg in not recording the more detailed and complex system of marking grades which obtained in Riga as well as some other Baltic ports. Such Riga lead flax seals as have been recorded to date carry the marks used to record only the grade of fibre (1, 2 or 3). Other information about the nature of the fibre seem to have been confined to the documentation accompanying export consignments of flax and hemp (Section 5.7.1).

Russian flax was divided into two sorts reflecting the process to which the fibrous stems were subjected after being harvested. One method was dew-retting, when the flax was spread over the ground or on snow, the second, water-retting, involved steeping the flax stems in water either in specially prepared pits or in slow-flowing river backwaters.

4.2. Archangel flax

In Archangel the flax which was brought from areas in its hinterland (Vologda, Ustyug, Tot'ma, Kama, Vyatka and Yaroslavl) was usually dew-retted. It was then bracked into two sorts, 'select' which was soft, silk-like flax and 'crown' which was long-fibred. Each sort was subdivided into three grades. Judging by the small number of finds of seals indicating Select flax, relatively little was imported to Britain. Only three seals have been found, one in Fife, dated 1838 and two in Dorset, dated 1842 and 1848. Seals indicating Crown flax are far more common, and have been discovered mainly in Scotland. So far the earliest recorded, clearly identifiable seal which indicates the bundle contents as Crown flax bears the date 1841. Other seals testify to the import of all three grades of crown flax, as well as tow and codilla.

An additional fourth-grade Crown flax is found on Archangel seals from the mid-19th century. Although the earliest clearly dated seal with this designation is from 1863 (<CUPMS: 1999.54.12>), with other examples from 1877

(<KIRGM. 2006.271>) and the 1880s (<KIRMG. 2006.281> (1881), <KIRGM. 2006.195> (1881), <CUPMS: 1999.53.16> (1886)), Dundee records suggest that fourth-grade flax was already known by 1840 (*Issledovaniya*, 1847, 48).

A low-grade flax, referred to as Zabrack (*zabrak*), could also be divided into three grades. The term is recorded on twenty-seven Archangel seals with dates from between 1835 (<DUN: AHH.205.16.07>) and 1888 (<ADMUS: M: 1995.156>). They have all been discovered in Scotland. On most seals it seems that the term *zabrak* was sufficient to denote its quality, i.e. fourth-grade flax, as only seven of the seals show zabrack qualified by a grading number, either 1 or 2. Interesting, however, is the fact that the word to denote the grade on these seals is *ruka* rather than the usual *sort*. The designation *ruka* is usually found on Archangel seals which date from the 1830s (Section 5.2.12) when it was replaced by *sort*, but on seals with the designation *zabrak* the term *ruka* survived well into 1880s. Three seals show *zabrak* accompanied in the preceding line by the noun for flax: *len* (pronounced 'lyon'). Two of them are dated 1867, on the third the date is illegible.

Three other terms are encountered on seals from Archangel: 'tow' (*kudel'* or *kudelya*), 'codilla' (*paklya*) and *cheska* (pronounced 'choska'). Like their English counterparts, they can refer to flax or hemp.

'Tow' is divided into three grades (in Russian 1, 2 and 3 *sort*), and was usually exported in its raw, untreated state. The form *kudel'* and its variant *kudelya* are found on over 40 seals. On six seals we encounter its adjectival derivative stem: '*kudel'n- -*.' When it had been heckled for overseas export by cleaning and working the fibres, the residue was referred to in Russian as *cheska*, a term found on over 25 seals. It was the lowest grade of flax (Myznikov 2006, 555). The forms *kudel* and its variant *kudelya* are found on some forty-two seals, and on a further six we encounter its adjectival derivative stem: '*kudel'n- -*.'

The term *paklya* occurs in conjunction either with the word 'brack' (*brak*) (on three seals) or the word *cheska* (on seven seals).

4.3. St Petersburg flax

St Petersburg flax was either dew-retted or water-retted and bracked into bundles of three grades. Unlike seals from Archangel the nature and quality of the contents of these bundles were indicated by abbreviations in the form of letters or letters and digits. On seals with the initials SPB they were indicated by a series of letters (D H P H, C Z R H, G K R H, I R A H, O P P H) (Section 5.2.5.3).

By contrast, on over 300 seals dating from the 1760s to *c.* 1830 quality was shown by letters and the digits '12', '9' and '6', matching the terms 12-head, 9-head and 6-head used by British merchants for bundles made up of 12, 9 and 6 heads, or bobbins (Section 5.2.5.7). Twelve-head was the best and six-head the worst.

Unfortunately, these seals carry no immediately obvious indication of the port at which the bracking process was conducted and are marked with various initials in the first line of their dated side, in the overwhelming majority of cases by N. P. in Roman letters, but occasionally, on seals before 1801, with 'W. K.' and 'W. U'. (Section 5.2.18.3 (column 4)). Whilst it is tempting to regard the N P designation on so many seals from Russia as indicating Narva as the port of origin, a number of considerations weigh against such a conclusion. First, the fact that the initials in this position never appear in Cyrillic, whilst those of St Petersburg which had appeared as Roman letters from the earliest recorded seals, had by the end of the 18th century also begun to appear in Cyrillic (СПБ). Secondly, whilst written records show exports continued from Narva well into the 19th century the use of seals with N P comes to an abrupt end around 1829. When the initials N P are found after 1829, they occur in the second line of the reverse and may also appear in Cyrillic. However, in this position they appear on seals which are clearly designated SPB (St Petersburg) and at the same time use the new SPB system of grading flax (Section 5.2.5.11).

Furthermore, given the rapid decline in their numbers in the 1820s and the abruptness with which the classification by both numbers and letters ceased around 1830, one has to consider whether the two systems of marks – one found on St Petersburg seals and the other on N P seals – were concurrently in operation in St Petersburg until 1830 when both systems were replaced by a single system using 'No. 1', 'No. 2' and 'No. 3' and the designation N. P. abandoned.

4.4. St Petersburg hemp

St Petersburg hemp was sorted into three qualities, classified as 'clean hemp' or 'firsts', 'outshot' or 'seconds' and 'half-clean hemp' or 'thirds.' There was also 'hemp codilla.' However, relatively few seals are explicit in denoting the contents of their bundles as 'hemp': ПЕНЬКА [= pen'ka], (Fig. 15b).

On seven seals from St Petersburg and one from Archangel we find examples on which the hemp contents of the bundle were indicated on the reverse side, alongside the numeral 1, 2 or 3 to indicate quality. The Archangel seal, which has the date 1813, is the earliest legible dated Archangel seal so far recorded (Section 5.2.10), but the seals from St Petersburg are later with dates in the 1830s and early 1840s.

St Petersburg hemp seals all carry the initials П Д [= *P D*], indicating *penkovy dosmotr* (hemp inspection) in the first line of their obverse, followed in the second and third lines by the surname of the Quality Control Officer and in the last line by the number of the post at which he was working (Section 5.2.22; Section 7.8). The first line of the reverse has the initials of St Petersburg (SPB) in Cyrillic (*СПБ*) on all but one seal, sometimes followed in line two by the noun for 'hemp' ПЕНЬКА [= pen'ka], usually abbreviated to its first three or four letters which is then followed by a number indicating quality. On the third line are stamped the initials of the producer or owner of the goods and the fourth line shows the year of the inspection.

4.4.1. Hemp seals from St Petersburg and Archangel

Seal no.	Face	Transcription
GLDM: 29.2	obv	А– – / СТЕПА / – ОВЪ
	rev	АР– ПОР / ПЕНК. БРА / 2 [Г]Л Р / 1813
EXEMS: 69/2001.4	obv	П. Д. / [П][–]ЛЕ / ТЕЕВЪ / [Н] 15
	rev	С П / ПЕН / П[О] I [3] / 1841
TW 01	obv	[–][–][–] / НЕВЪ / N –
	rev	С П Б / НЕН. 3 / М С / 1835
NML. 2007.21.2	obv	– – / С. ТО / СТИК / Н 88
	rev	S P B / ПЕНЬ / I. I. / 1835
NMS 29.10.93 (1830s)	obv	П : Д / [–] : ГРЕЧ / – – [–]ИН / Н
	rev	[С]ПБ / [–]ЕН I / I Н / 183[–]
KINCM: 2000.102.20	obv	П Д / [–] В[А]У / Л–НЪ / Н 197
	rev	С П Б / [П]ЕН. 3 / Д. Х. / 180–
FALKM: 2003.3.2	obv	П. [Д] / МОР / [О]ЗОВЪ / Н 184
	rev	С П Б / ПЕН. 1 / Д. Х. / 1840
CRMCH: 1991.37	obv	П. Д / – ГАВ / –[–]ИНЪ / – 6
	rev	С П Б / ПЕН. 2 / А. П. / 1835
SFl 04	obv	П. Д / П: ПА / ШКО[В] / Н 2[–]
	rev	С П Б / ПЕН. 3 / Г. Б. / 1789
SFl 28	obv	– – / [Н]. –СА – – / НОВЪ / –Н 2[–]5
	rev	– П Б / ПЕН. 2 / Н. К. / 1833

4.4.2 Hemp seals from St Petersburg and Archangel (Transliteration)

Seal no.	Face	Transliteration
GLDM: 29.2	obv	A – – / STEPA / – OV"
	rev	AR– POR / PENK. BRA / 2 [G]L R / 1813
EXEMS: 69/2001.4	obv	P. D / [P][–]LE / TEEV" / [N] 15
	rev	S P / PEN / P[O]I [3] / 1841
TW 01	obv	[–][–][–][–] / NEV" / N –
	rev	S P B / NEN. 3 / M S / 1835
NML. 2007.21.2	obv	– – / S. TO / STIK / N 88
	rev	S P B / PEN' / I. I. / 1835
NMS 29.10.93 (1830s)	obv	P : D / [–] : GRECh / – – [–]IN / N
	rev	[S]PB / [–]EN I / I N / 183[–]
KINCM: 2000.102.20	obv	P D / [–] V[A]U / L–N" / N 197
	rev	S P B / [P]EN. 3 / D. Kh / 180–
FALKM: 2003.3.2	obv	P. [D] / MOR / [O]ZOV" / N 184
	rev	S P B / PEN. 1 / D Kh. / 1840
CRMCH: 1991.37	obv	P. D / –GAV / –[–]IN" / – 6
	rev	S P B / PEN. 2 / A. P. / 1835
SFl 04	obv	P. D / P: PA / ShKO[V] / N 2[–]
	rev	S P B / PEN. 3 / G. B. / 1789
SFl 28	obv	– – / [N]. –SA – – / NOV" / –N 2[–]5
	rev	– P B / PEN. 2 / N. K. / 1833

4.5. Riga flax grades

In Riga flax was bracked according to a different and more exacting system than that used in Archangel and St Petersburg. Since the greater part of the merchant population of the town was German or of German origin, it was this language that was used as the main commercial and taxation language of the port and town. When flax was bracked into its different sorts, the terms reflected the linguistic situation. Although the system had originally resembled the three-grade system followed in St Petersburg, by the mid-19th century the type of flax and its grade were designated by a string of letters indicating grade and place of origin. Many of the terms had closely cognate terms in English and Dutch and consequently the initial letters were easily transferred from German to one of the other languages where they were readily recognised and understood.

Although the system of grading was complex, more than the briefest indication of its complexities is unnecessary in the present work since such detailed information is not found on any seals so far recovered.

4.5.1

The base letter in the string indicated the type of flax. So, Riga Crown flaxes had the base mark K [= Kron, crown],

to which were added other letters which qualified the basic type: PK, FPK, SPK, HK, HPK, HSPK etc., where K = Crown, F = *fein*, fine, P = *Puik*, picked, S = *sanft*, sweet, superior, H = German: *hell*, Dutch *heel*, English light or yellow. The letter D represented *Dreibandt* [threeband]. The addition of the correct qualifying letters was important in that they affected the price of the flax (Carter 1919, 14). When using these marks shippers had the option of adding other marks, such as G [*grau*, grey], W [*weiss*, white] and R [*Risten*, bundles] (Warden, 1864, 328–29, 333). The letter W could also indicate *Wrack* [brack] flax, and when it was used as a base letter H could indicate German *Heide* [tow] (Carter 1919, 12–13). The system denoted more clearly the region in which the flax had been produced and whether by dew-retting or water-retting. In some instances the method by which the bundles had been tied was indicated.

4.5.2. Types of Riga flax
In general, the first and best sort of flax shipped from Riga was Crown flax, of which Marienburg was considered the most superior grade and known simply as Marienburg or Marienburg clean (M). First-class flax from the other provinces bore the name Rakitzer and included Druana (Drujaner) Rakitzer (DR), grown in White Russia and yielding long, fine loose threads and Lithuanian Rakitzer (LR), of which the best kind was Thiesenhausen Rakitzer (TR). Livonian flax was considered to be of a rather lower grade.

The 'Cut' (*Geschnitten*) flaxes were the rejects of the Crowns, the second quality flax from Marienburg being Marienburg Cut (MG). From the other provinces we find the 'Cuts' of flax, with a series of grades which in some instances resemble the Rakitzer Crowns themselves, for example, Lithuanian and Courland Rakitzer Crown (LRK and KRK), which in some grading systems fall into the first quality crown flaxes. The lowest of the Crown grades was Rakitzer Cut (*Geschnitten*) flax (RG). Other grades included a Drujaner and Courland flax referred to occasionally as Badstuben-Paternoster or Badstuben Cut (*Geschnitten*). Livonian *Hoffdreibandt*, Leiden *Dreibandt* and *Giligen* brack flax were also found.

The third, lowest quality flaxes which were the refuse of the rakitzer flaxes were tied in bundles made up of small rolls from which twelve or thirteen made up a ship pound. They were bound in a special way by tying with three bands which gave rise to their description as 'threeband' or '*Dreibandt*' (Grimm, vol. 2 1860, 371). This grade also included 'Badstub,' 'Badstub cut' (B and BG) and Paternoster (PN). Included in this sort were also Marienburg Risten Dreibandt, Lithuanian Dreibandt, Livonian Dreibandt and Drujaner Risten Dreibandt, Drujaner Dreibandt, Cut (*Geschnitten*) Risten Dreibandt, where *Riste* indicates a flax bundle (Grimm, vol. 8 1893, 1044–1045).

4.6. Grades in other Baltic ports
Other Baltic ports used similar methods, often using the same letters, for example Pernau flax used D and other grades such as Marienburg (M), Geschnitten (G), Risten (R), Hoffsdreibandt (HD) and Dreibandt (D). At Koenigsberg flax came to be graded in part according to the Riga system and in part according to an older classification system, as for example: FWPCM [= fine white picked Crown Marienburg] (Carter 1919, 22–25, 31–32). However, no seals have been recorded from which it is clear that they originated in any of these ports.

4.7. Russian hemp
Russian hemp was grown in the central regions of the country, somewhat distant from the main ports. The fibre was selected for its colour and quality. The terms used in its classification were changed over the decades and when Carter described the situation obtaining in 1919 he lists the longest and best hemp as being classified as Rein [Rhine] hemp. Rein hemps were marked as: RH = Rein Hemp, O = otbornoi [= select], S = superior, or also spinning, F = fine, G = German, N = Norwegian, P = Polish. So, SFSPRH would indicate 'superior fine spinning Polish rein hemp.' The shorter hemp was termed 'outshot' and marked OH and the still shorter hemp was denoted as 'pass hemp' and marked PH (Carter 1919, 31).

4.8. Summary of flax and hemp sorts
Flax and hemp sorts are summarized in 4.8.1 and 4.8.2.

4.8.1. Flax and hemp sorts or grades
4.8.1.1. ARCHANGEL

ЛЕН	Flax		
отборной	SELECT (otbornoy)	Кронъ	CROWN
1 сортъ	First grade	1 сортъ	First grade
2 сортъ	Second grade	2 сортъ	Second grade
3 сортъ	Third Grade	3 сортъ	Third Grade
КУДЕЛЬ, КУДѢЛЯ	**Tow**	**ЧЕСКА**	**HECKLED**
сырцовая	NATURAL	1 сортъ	First grade
1 сортъ	First grade	2 сортъ	Second grade
2 сортъ	Second grade	3 сортъ	Third Grade
3 сортъ	Third Grade		
ПАКЛЯ	**CODILLA**	**ЗАБРАКЪ**	**ZABRACK**
1 сортъ	First grade	1 сортъ	First grade
2 сортъ	Second grade	2 сортъ	Second grade
3 сортъ	Third Grade	3 сортъ	Third Grade

Note. Select (otbornoy) was silk-like, soft flax and Crown was of large fibres. Heckled tow was produced for overseas export by cleaning and working the fibres.

4.8.1.2. St Petersburg

ЛЕН	Flax	КУДЕЛЬ, КУДѢЛЯ	Tow
1 сортъ	First grade	1 сортъ	Best Grade
Чистый	Clean	проемная	Clean
12-головчатый	12-head		
2 сортъ	Second grade	2 сортъ	Second grade
9-головчатый	9-head	ческа	
3 сортъ	Third grade	3 сортъ	Lowest grade
6-головчатый	6-head	Бухара	

4.8.1.3. Riga

4.8.1.3.1	First sort. Crown flax
1.	Marienburg Crown
2.	Drujaner Rakitzer Crown
3.	Livonian Gerechtigkeit Dreibandt Crown
4.	Lithuanian Rakitzer Crown
5.	Courland Rakitzer Crown
6.	Rakitzer Cut (Geschnitten) flax
4.8.1.3.2	Second sort. Crown flax
1.	Marienburg Cut (Geschnitten)
2.	Drujaner Rakitzer Brack or Badstuben Geschnitten
3.	Drujaner Brack or Badstuben-Paternoster
4.	Courland Brack or Badstuben-Paternoster
5.	Lithuanian Brack or Badstuben-Paternoster
6.	Livonian Hoffdreibandt
7.	Giligen Brack

4.8.1.3.3	Third Sort. Dreibandt included
1.	Drujaner Dreiband
2.	Drujaner Risten Dreibandt
3.	Marienburg Risten-Dreibandt
4.	Cut Risten Dreibandt
5.	Lithuanian and Courland Rakitzer Dreibandt
6.	Leiden Dreibandt or Livonian Dreibandt
7.	Livonian Dreibandt
8.	Giligen Dreibandt
9.	Badstub
10.	Badstub Cut
11.	Badstub Cut
12.	Paternoster

4.9. Maps

4.9.1. Russia 1740–1905.

4.9.2. Northern and Central Russia.

4.9.3. St Petersburg and the Baltic.

4.9.4. Southern Russia.

Part One: Lead seals of Russian origin

5. Russian seals and their characteristics

Over 1000 Russian seals, fulfilling different functions, have been recorded in the museums of Scotland and England and in the private collections of metal detector users or landowners. All but approximately 6% had clear connections with the flax and hemp trade but a small number of others might still be confirmed to be flax or hemp seals, though there is nothing stamped on them that would permit us at present to identify a conclusive link with any particular trade. A number of undated seals (3%) are linked with the fur trade, four are railway seals with dates between 1902 and 1909 and one is associated with the import of balsam.

Flax seals on which the date can be read with certainty range from the 1740s to the start of the 20th century. The seal bearing the earliest legible date (1741) is housed in the Museum of London collection. The latest flax seal so far recorded has the date 1902 and is housed in North-East Fife Museums collection.

It is important to recognise that what is being analysed and described here is not so much the appearance of the seals but their existence as evidence of the manner in which quality control was handled. This evidence is set out in a very compressed form and shows the diversity in the way information has been presented at different Russian ports over the last 250 years.

Given that on the seals there is no obviously dominant side which one might designate as the obverse, the side bearing the surname of the *desyatnik* has been designated the obverse and the one carrying the date the reverse.
When identifying and categorising a given lead-alloy seal it is necessary first to ascertain its size and the number of lines stamped on each side. Having then taken account of the damage the seal might have suffered, especially at its outer edges, which may have resulted in the loss of one or more lines, the letters and digits stamped on the seal should be identified, along with any points (full stops) or colons occurring with them. The latter provide some guidance on what letters in a name are likely to represent initials of a forename or patronymic rather than the surname itself. They also help identify which parts of a series of letters and digits might be grouped together.

5.1. Flax and hemp bundle seals

Within two decades of their first appearance the dimensions and weight of the seals had changed, and the information presented on them became more detailed. The first modifications affected not only the presentation of information, but also the size and weight of the seals. Changes continued to be made for nearly two centuries, chiefly in the configuration of the seals, affecting the manner in which the information is arranged.

After the 1770s the obverse side of seals from the port of St Petersburg underwent relatively little alteration. It is, therefore, the data on their reverse side that enable us to distinguish different types. The basic types of flax and hemp bundle seal have been classified according to their date and place of origin. On the basis of these criteria, we can identify a number of clearly distinct types of flax and hemp bundle seals. The configuration of the majority of flax and hemp seals is summarised and, where appropriate, illustrated in Section 5.1.1. A more detailed description and discussion is given in the sections indicated.

5.1.1. Summary of flax and hemp seal types

Date of seals	Side	Number of lines		Description / section
1a. 1740s–1760 (St Petersburg)	obverse	0	Blank	5.2.1.1
1b. 1740s–1760 (St Petersburg)	reverse	3		5.2.1.1 5.2.1.1.1
2a. 1740s–1760 (unprovenanced)	obverse	1 or 2		5.2.1 5.2.2 5.2.2.1 5.2.2.2.1
2b. 1740s–1760 (unprovenanced)	reverse	3		5.2.2 5.2.2.2 5.2.2.2.1
3a. 1762–1769 (St Petersburg)	obverse	3 or 4		5.2.3.1 5.2.3.1.1
3b. 1762–1769 (St Petersburg)	reverse	3 or 4		5.2.3.1 5.2.3.1.1
3c. 1762–1769 (unprovenanced)	obverse	3 or 4		5.2.3.1 5.2.3.1.1
3d. 1762–1769 (unprovenanced)	reverse	3		5.2.3.1 5.2.3.1.1
4a. 1760s–1840s	obverse	4		5.2.4.1 5.2.4.2 5.2.4.3

4b. 1760s–1830s (St Petersburg)	reverse	3		5.2.5.1 5.2.5.2 5.2.5.3 5.2.5.4
4c. 1760s–1840s (unprovenanced)	reverse	3		5.2.5.6 5.2.5.7 5.2.5.8
4d. c. 1829–1840s (St Petersburg)	reverse	4		5.2.5.9 5.2.5.10 5.2.5.11 5.2.5.12 5.2.5.13
5a. 1830s–1840s (St Petersburg)	obverse	4		5.2.6 5.2.6.1 5.2.6.2 5.2.6.3 5.2.6.6.1
5b. 1830s–1840s (St Petersburg)	reverse	3		5.2.6 5.2.6.4 5.2.6.5 5.2.6.6 5.2.6.6.1
6a. Seals with two surnames	obverse	4		5.2.7 5.2.7.1 5.2.7.2
6b. Seals with two surnames	reverse	4		5.2.7 5.2.7.1 5.2.7.2
7a. 1840s–1850s (St Petersburg)	obverse	4		5.2.8 5.2.8.1 5.2.8.2 5.2.8.3 5.2.8.4 5.2.8.5
7b. 1840s–1850s (St Petersburg)	reverse	4		5.2.8 5.2.8.1 5.2.8.2 5.2.8.3 5.2.8.4 5.2.8.5

8a. Pre-1820s (Archangel)	obverse	3		5.2.10 5.2.10.1
8b. Pre-1820s (Archangel)	reverse	4		5.2.10 5.2.10.1
9a. 1820s–1839 (Archangel)	obverse	3		5.2.11 5.2.12 5.2.12.1 5.2.12.2 5.2.12.3 5.2.13.5
9b. 1820s–1839 (Archangel)	reverse	4		5.2.11 5.2.13 5.2.13.1 5.2.13.2 5.2.13.3 5.2.13.4 5.2.13.5
10a. 1838–1902 (Archangel)	obverse	4 or 5		5.2.14 5.2.14.1 5.2.14.2 5.2.14.3
10b. 1838–1902 (Archangel)	reverse	5		5.2.14.4 5.2.14.5 5.2.14.6 5.2.14.7 5.2.14.8
11a. Variants (Archangel)	obverse			5.2.14.9 5.2.14.10 5.2.14.10.1 5.2.14.11 5.2.14.11.1
11b. Variants (Archangel)	reverse			5.2.14.9 5.2.14.10 5.2.14.10.1 5.2.14.11 5.2.14.11.1
12. Seals from adjacent provinces (Vologda and Yaroslavl)				5.2.15 5.2.15.1 5.2.15.1.1 5.2.15.2 5.2.15.2.1 5.2.15.3 5.2.15.3.1 5.2.15.4 5.2.15.4.1

5.2. Characteristics of Russian seals

5.2.1. Russian seals, 1740s–1760

The dimensions of seals from the 1740s to 1760 are large by comparison with those that appeared from the 1760s onwards. They are typically about 32mm × 25mm, but whilst there are some as large as 35mm × 28mm, there are others measuring 28mm × 26mm. They can be divided into two groups, those which originated in the port of St Petersburg and carry the initials S P B and others which in all likelihood were also issued in St Petersburg but carry the initials N P, W K or W U (Section 4.3; Section 5.2.17.5).

Seals have been recovered which might carry earlier dates but in each case the date is uncertain.

5.2.1.1. Russian seals from St Petersburg, 1740s–1760

The obverse of seals dated 1740s–1750 so far recorded is blank. In the first line of their reverse side they carry the Russian abbreviation of St Petersburg in Roman letters (S P B). On the second line they carry abbreviations, of which at present A H which could be Roman or, less likely, Cyrillic [= A N], R H and G C have been recorded. In the final line there follows a date indicating when the goods were graded (1741, 1745, 1747 and 1749). They were recovered in different parts of England, from London, Bristol, Abingdon and the east part of Yorkshire.

One seal is stamped on the obverse with N and the numeral 25 and on its reverse with the Roman letters A N R A. Its date is 1760. Although its place of origin is not legible, this configuration suggests that it originated in St Petersburg (Section 5.2.5.3). When set alongside seals from the capital dated from 1740 to 1750 on which the obverse is blank it seems probable that seals from St Petersburg followed the same configuration as those unprovenanced seals in the 1760s (Section 5.2.2).

5.2.1.1.1. Russian seals from St Petersburg, 1740s–c. 1760

Seal no.	Face	Transcription
MoL: 88.107/43	obv	–
	rev	S P B / R H / 1741
KM 01	obv	–
	rev	S P B / A: H / 1745
BRSMG: T9407	obv	–
	rev	S P B / A [H] / 1747
DMP 01	obv	–
	rev	S P B / R : H / [I]747
JWa 01	obv	–
	rev	S P B / G C / 1749
Anon. 04	obv	N / 25
	rev	– – / A N R A / 1760

5.2.2. Unprovenanced Russian seals, 1740s–1760

The second group of large-dimension seals dating from the 1740s to 1760 do not bear the St Petersburg abbreviation (SPB). Ten of them have the initials N P (Fig. 4b) and a further eight have the initials W. U. (Fig. 3; Fig. 5b) or W. K. (Fig. 6b) (Section 5.2.2.2.1).

All but four of the seals in this early group have been recovered in England. Four were recovered from the London area, three of them from the Thames shoreline, one from Warwickshire, two from the docks in Bristol, and others from various parts of North Yorkshire, especially York, Knaresborough and Whitby. Four were found in Abingdon and were described in brief in 1985 (MacGregor, A. 1985, 156–157). Five of the Bristol seals were first described by DuQuesne-Bird in 1970 and again with a further Bristol seal, plus two from The Ulster Museum and the seal from Salisbury Museum in 1972 (DuQuesne-Bird 1970, 227–227; 1972, 276–277).

Four Scottish finds were made on the east coast of Scotland, one in Angus, probably near Dundee, but Dundee Museum can provide no provenance, two definitely from Cromarty on the Black Isle, and another from the Black Isle, possibly near Cromarty.

5.2.2.1. Obverse of unprovenanced Russian seals, 1740s–1760

The obverse of the seals differs from those described in Section 5.2.1.1 in being simply set out but carrying either the Roman abbreviation No, or the Cyrillic Н [= N] or Нo [= No], followed by a number, for example No. 5 (1752), No. 17 (1756), No. 57 (1757), No. 10 (1758), No. 23 (1759), No. 42 (1759), and No. 25 (1760). Evidence from the seals suggests that they indicate the post at which the Quality Control Officer worked when handling that particular batch of fibres (Fig. 4a; Fig. 5a; Section 5.2.6.3; Section 5.2.17.5; Section 5.2.22).

5.2.2.2. Reverse of unprovenanced Russian seals, 1740s–1760

The distinguishing marks of the reverse side of these seals are the initials which stand in the first and second lines of the reverse.

On thirteen seals the initials N P always appear in Roman letters. One seal attracts special attention. It is possible that the Cyrillic abbreviation И П [= I P] which appears on seal <IS 01> is an example of the lack of attentiveness on the part of the die-maker resulting in his cutting the letter in reverse, instances of which are also found in the cutting of the surnames of *desyatniki*, for example, <GL 01> which shows 'd' for 'b'. Two, possibly three, seals have the abbreviation W U (Fig. 3; Fig. 5b) and three have W. K. (Fig. 6b).

The second line of the reverse clearly shows a combination of letters and numbers, such as А И 9 П 9 [= A I 9 P 9] (Fig. 3), A N 12 A, A N 12 [H], S B 12. F S, S 12 B, [–] B 12 A O (Fig. 6b). It is not always possible to determine whether the letters are Cyrillic or Roman (Fig. 4b; Fig. 6b; Section 5.2.5.3).

The date in the last line indicates the year in which the quality control inspection took place (Fig. 3; Fig. 4b; Fig. 6b).

5.2.2.2.1. Unprovenanced Russian seals, 1740s–1760

Seal no.	Face	Transcription
MM: 2006.17	obv	No. 1[–]
	rev	N P / 12 / 174[8]
CRMCH: 1990.3.8	obv	No. 5
	rev	N : P / 1 2. B / 1752
WE 01	obv	No. 4
	rev	N : P / S 1 2. B / 1752
AJPC 01	obv	No. 4
	rev	N: P / S 1 2 B / 1752
AJPC 02	obv	No. 20
	rev	P / [S] 1 2. B / 1753
MM: 2006.1	obv	No. [1]6
	rev	N P / [K] B 12 [H] / 1753
OXFAS: 1980.273	obv	No. 5
	rev	. P / S– Θ. E / – –53
CD 01	obv	No. [2][–]
	rev	N P / B 12 [–] / 1755
BRSMG: O.4165	obv	N 17
	rev	N P / S B 12 F S / 1756
HARGM: 12706.1	obv	No. 57
	rev	W K / – B. 12. A O / 1757
BRSMG: O.4164	obv	N / 10
	rev	N P / A N 12 A / 1758
DUNMG: 2002.37	obv	N / I
	rev	N P / A N 12 A/ 1758
JC 01	obv	N 10
	rev	W [U] / А И 9 П 9 / 1758
JH (L) 03	obv	N / 19
	rev	W U / A N 9 Θ E / 1758
WHITM: SOH 420.1	obv	N 58
	rev	W. K / [A] N 9 P K / 1759
WHITM: SOH 420.2	obv	N 58
	rev	W. K / [A] N 9 P K / 1759
AJP 01	obv	N [–] / 42
	rev	N P– / A H 9 A O / 1759
IS 01	obv	N / 23
	rev	И П / И 12 М П / 1759
PC 01	obv	N / 2
	rev	NP / AN 12 P [S] / 1760
WmK 03	obv	N / [Д]
	rev	N [P] / AN 12 [H] / 1760
JH (L) 02	obv	N / 5
	rev	W K / [A] N 9 F F / 1760
JH (L) 04	obv	N / 5
	rev	W K / AN 9 F [H] / 1760
MM: 2006. 13	obv	No 25
	rev	W U / – 9 – / 175[–]
CRMCH: 1991.38.10	obv	No. 47
	rev	N P / [–] B 12 Θ P/ 175[3]

5.2.3. Russian seals, 1760s–1840s

The first evidence of a change in the general style of seal, including a reduction in size, comes at the beginning of the 1760s with discoveries from Lancashire and the West Midlands. Henceforth, seals typically measure between 19mm × 21mm or 23mm × 22mm and are similar not only in the manner and order in which the information provided on them is set out, but also in the style of their letters and digits.

With the exception of a small number of recoveries dating from between 1762 and 1769 (Section 5.2.3.1) as well as seals from Archangel (Section 5.2.9), the obverse of all seals stamped between 1760s and 1840s is identical in that the information is set out in four lines. Therefore, the division of the seals into different types is made on the basis of differences in the presentation of information on their reverse sides.

5.2.3.1. RUSSIAN SEALS, 1762–1769

On a small number of discoveries dating from between 1762 and 1769 information is provided in three lines both on the obverse and reverse. An exception is made where the length of the name of the Quality Control Officer (*desyatnik*) which usually appears in the second line of the obverse is so long as to require an extra line (for example, Vavilov, Larionov, Pirozhnikov). The final line carries the number of the post at which he was working.

On the reverse we find a diversity of initials in the first line both in Cyrillic: Д.А., Д.Л., Д.М., Д. І., Д І К, Д.Е. [= D.A., D.L., D.M., D. I., D I K, D. E.] and in Roman (WK and SPB in two instances each and N. P in four). The initials N. P came to replace all other initials except SPB by the turn of the 19th century. In the second line of the reverse stand initials indicating the content of the bales mainly in Roman letters and in the final line the date when the assessment of their quality was made.

5.2.3.1.1. Russian seals, 1762–1769

Seal no.	Face	Transcription
PRSMG: T 1960 (A145)	obv	/ I / ЕВЪ
	rev	/ O. 9 H / 1762
JH(L) 05	obv	Д. Л. / ВАВІЛОВЪ / NO 47
	rev	W. K / F L 9 H // 1762
JH(L) 06	obv	Д. М. / ВАВІЛОВЪ / N 47
	rev	W. K / M H 9 H // 1762
SWi 01	obv	– – / C [Б]Е[Р] NIKO / ВЪ / N 2[–]
	rev	N P / F L 12 H / 1763
DMP 02	obv	Д: I. К / МАСЛОВ / N. 164
	rev	S P B / S. S. R. H / 1764
JS 14	obv	Д. К. / ЛАРІОНО / ВЪ / N 18[–]
	rev	N P / П. S. 9 H / 1764
JS 15	obv	Д. К. / ЛАРІОНО / ВЪ / N 184
	rev	N P / Л. [O]. 12 H / 1764
ST 05	obv	Д. В / ГОРІНЪ / H 2[2]
	rev	N P / M F. 12 H / 1764
SWr 01	obv	Д / – – – КОВЪ /. НО 8
	rev	– К / – – 9 H / – – 64
AH 01	obv	Л [–] / СМІРНО[В] / H 133
	rev	N P / F L 9 H / 1765
MH 04	obv	Д. I / НАЛОБІН / H 9 I
	rev	N / P. S. 12 H / 176[5]
MH 02	obv	Д. К. / ЛАРІОНО / ВЪ /N 184
	rev	N P / P. M. 12 H / 1767
NLA (HER) 47349	obv	Д: А / Г[–]УШКОВЪ / N 71
	rev	S P B / P M [–] / 1767
TD 03	obv	– / – H [–] /. H [1]
	rev	N / I H 12 H / 1767
PERMG: 1992.140.3	obv	Д. Е / ПІРОЖИ[–]/ H 10
	rev	N P / I B. 12 H / 1768
NLA (HER) 40538	obv	Д. I / [К]ОПОВЪ / H 114
	rev	S P B / [H].C.R.I / 1769

5.2.4. Obverse of Russian seals, 1760s–1840s

As we have already stated, the characteristics of the obverse of the overwhelming majority of flax and hemp seals are common to all seals issued during this period, irrespective of the place of origin represented by the initials in the first line of their obverse.

5.2.4.1. OBVERSE: FIRST LINE

The first line can be read with certainty on approximately two fifths of the seals recovered. Nearly two thirds of the 29 different sets of initials that have been so far recorded are the Cyrillic initials Л. Д. [= L. D.] (Fig. 7a; Fig. 12a) and almost one fifth the initials П. Д. [= P. D.] (Fig. 8; Fig. 15a). On the obverse of 20 seals recovered from areas in or adjacent to Fife we find the initials П.и Л.П.Д. [= P.i L.P.D] (Fig. 19a; Fig. 20a; Section 5.2.6).

The letters Л Д [= L D] are abbreviations for Flax Inspection [l'nyanoy dosmotr = льняной досмотр] or Flax Inspector [l'nyanoy dosmotrshchik = льняной досмотрщик]. However, the letters П Д [= P D] probably represent Hemp Inspection [pen'kovy dosmotr = пеньковый досмотр] or Hemp Inspector [pen'kovy dosmotrshchik = пеньковый досмотрщик], but could stand for Port Inspection [portovy dosmotr = портовый досмотр [ПД = PD] or Tow Inspection [paklyanny dosmotr]. A small group of twenty seals from St Petersburg carry the initials ПиЛПД [= PiLPD] which represent either Hemp and Flax Port Inspection [pen'kovy i l'nyanoy dosmotr = пеньковый и льняной портовый досмотр] or Tow and Flax Port inspection [paklyanny i l'nyanoy dosmotr = паклянный и льняной портовый dosmotr] (Section 5.2.6.2). However, the significance of a number of other combinations of Cyrillic initials which occur on 68 seals, all but twelve of which date from the 1770s, when perhaps the system was not so strictly controlled, remains unresolved. For example we record: Д. И. [= D. I.], Д. А. [= D. A.] (Fig. 10a), Д. Д [= D. D.], Д В [D V], Д С [D S]. Although it is likely that D in these combinations represents 'dosmotr,' it is perhaps fanciful to regard the second initial as an indication of the location where bracking took place, for example D V could indicate a bracking post on St Basil's Island (Vasilievsky ostrov), i.e. dosmotr Vasilievsky.

5.2.4.2. OBVERSE: SECOND AND THIRD LINES

The second and third lines give the initials and surname of the Quality Control Officer (Section 5.2.17). Whilst many seals have suffered too much damage for the names on them to be listed with certainty, it is possible to distinguish over 330 names of Quality Control Officers. Examples from St Petersburg are: L. Nemilov (Fig. 7a), E. Erokhin (Fig. 8), Petelin (Fig. 10a), Churakov (Fig. 11a), G. Zamarin (Fig. 12a), D. Vorob'ev (Fig. 13a), M. Fedotov (Fig. 14a), and Morozov (Fig. 15a) and from other possible sources: E. Demyanov (Fig. 16a), Dedovnikov (Fig. 17a), A. Kuchkov (Fig. 18a), A. Chelpanov (Fig. 22a), I. Vinnik(ov) (Fig. 23a), Ya. Zaitsov (Fig. 24a) and A. Nasukhin (Fig. 25a).

5.2.4.3. OBVERSE: FOURTH LINE

The final line of the obverse has the letters Н [= N] or Нo [= No], in the majority of cases in Cyrillic, followed by one, two or three digits (Fig. 8: [H 43]; Fig. 10a [H 232]; Fig. 12a [H 17]; Fig. 13a [H 72]; Fig. 15a [H 184]; Fig. 20a [H 20]). The numbers indicate the post at which the Quality Control Officer worked (Section 5.2.6.3; Section 5.2.17.5; Section 5.2.22; Section 7.8).

5.2.5. Reverse of Russian seals, 1760s–1840

The division of seals into different types is made on the basis of differences on their reverse side.

5.2.5.1. REVERSE OF ST PETERSBURG SEALS, 1770s–1830s

Seals from St Petersburg carrying dates between 1770s and 1830s. are found in all the areas of England and Scotland where discoveries of seals have been made. The information is presented in three lines.

5.2.5.2. REVERSE: FIRST LINE

The first line carries the Russian abbreviation of the city of St Petersburg (SPB) (Fig. 7b; Fig. 9; Fig. 10b; Fig. 12b) or less frequently SP (Fig. 13b) in Roman letters on seals from 1770s to the 1830s and also in Cyrillic (СПБ or СП) from the beginning of the 19th century (Fig. 14b; Fig. 15b).

5.2.5.3. Reverse: second line

The main obstacle at present to providing a more detailed categorisation of the majority of seals of this size and date is that the significance of the letters occurring in the second line is not immediately obvious. The Cyrillic or Roman initials found there indicate the quality and type of goods in the bundle to which the seal was fixed, such as I C Z A H (Fig. 9), O P P H, I R A H, I H R H (Fig. 10b).

Since twelve letters are common to the Cyrillic and Roman alphabets, albeit in most instances with different sounds, difficulties arise in determining with certainty whether Cyrillic or Roman letters are being used, for example in P A [H] (<CRMCH: 1990.3.17>) which could also be read as Cyrillic [= R A [N]). In other cases we find clear examples of the use of both alphabets И Ф R H (<SFl 19>), И К R H (<CRMCH: 2002.004.07>) and А Г R H (<AL 01>), though we cannot rule out the possibility of error by the die-maker, especially with the letters R and Я, and N and И, since clear errors of this nature do occur. Consequently, combinations such as А Г R H could stand for A G R H or Cyrillic А Г Р Н or in the case of an error А Г R H for А Г Я Н.

On St Petersburg seals with the initials SPB the use of both letters and digits is uncommon before 1829 and where digits do occur they are in the majority of cases 1, 2, and 3, corresponding to the grades of the goods in the bale, i.e. grade 1, grade 2 and grade 3.

5.2.5.4. REVERSE: THIRD LINE

The last line shows the date when the goods were graded (Fig. 9; Fig. 10b; Fig. 11b).

5.2.5.5. Reverse of unprovenanced seals, 1760s–c. 1830
The reverse side of seals of this type carry information in three lines.

5.2.5.6. Reverse: first line
The first line carries the initials N P or W K, the exact significance of which has not yet been established. Since the initials stand in the place where on other seals we find the location of the bracking process it is natural to seek a location that these initials also designated. That they always occur as Roman letters over such a long a period is unusual since one would expect N. P. also to have appeared in Cyrillic, as happened with the abbreviation S P B. However, of the Roman initials W K, which have been recovered on other seals in much smaller numbers, the W could not have been rendered in Cyrillic other than by В [= V] or У [= U] and neither of these two Cyrillic letters is found in this position. The fact that W K is never found in Cyrillic might lead us to conclude that the seals were issued from an office or location where foreign merchants engaged in the export of flax or hemp.

5.2.5.7. Reverse: second line
The information consists of a series of letters and digits, such as I M Б 12 [–] (Fig. 16b) and F 12 H (Fig. 17b). As with the St Petersburg seals described in Section 5.2.5.3 it has not been possible to identify their exact significance.

Typical combinations of Cyrillic letters include: А Б 12 Н, С Ч 12 Н, И Ф 12 Н and П Ч 12 Н (Fig. 18b). Combinations with Roman letters are C Z 12 N, F W 12 H, I C Z 12, I C 12. Examples of the combination of Roman and Cyrillic occur infrequently in this group: N 12 Ч (1783). The problem of deciding whether some of the letters are Cyrillic or Roman was discussed in Section 5.2.5.3 (Fig. 22b). A more detailed discussion is found in Section 5.2.20.

Nine seals with H P written as a ligature date mainly from the 1770s–1790s, though examples are found from 1801 and 1825 (Fig. 2); two seals, both recovered from Lancashire, have ligatured NF (<JH (L) 11> (1790s); <AMH 01> (18th c)). The numerals 6, 9 and 12 are used to indicate quality on all but one of these seals which is dated 1798 and has only letters (H P R H) (<NLA (HER) 31194>).

5.2.5.8. Reverse: third line
The third line of the reverse carries the date when the goods were bracked (Fig. 17b; Fig. 18b; Fig. 23b).

5.2.5.9. Reverse of St Petersburg seals, c. 1829–1840s
On the reverse side of a group comprising St Petersburg seals dating from *circa* 1829 to early 1840s information is presented in four lines. They also provide evidence of the introduction on a wide scale of a different grading system.

5.2.5.10. Reverse: first line
The first line indicates the place of issue, SPB (Fig. 7b; Fig. 12b), S P (Fig. 13b) or СПБ (Fig. 14b).

5.2.5.11. Reverse: second line
It is the second line on about 90 seals, beginning from *circa* 1829 that contains in Roman or Cyrillic a quite different style of codification of the contents of the bundles from that found on earlier seals, for example: in Roman letters N–2 (Fig. 12b), N–2 (Fig. 13b), NP. 3 (Fig. 7b) or in Cyrillic Но П. 2 (Fig. 14b). The numerals recorded are 1, 2 and 3, indicating quality: Но 1; Но 2; Но 3; Но П 2; Но П 3; NP – 2 and NP – 3. Seals attached to bundles of hemp are marked ПЕН [= PEN], followed by the digit 1, 2 or 3, indicating quality (Fig. 15b; Section 4.7).

5.2.5.12. Reverse: third line
The third line of these St Petersburg seals has Cyrillic and Roman initials, usually occurring in pairs, for example W. H. (Fig. 12b), I P (Fig. 13b) and M C (Fig. 14b), which refer to the owner or exporter of the graded goods, or their agent.

Over 30 different sets of initials can be definitely identified. Cyrillic initials include:

А Б (19th c.)	А Г (1830s)	А И Г (1831)
А П (1830s)	В Ч (1843)	Г Б (1820s)
Д Х (1830s)	Е П (1830s)	М Ѳ Р (1784)
П П (1840s)	Я Ф (1830s)	

Roman initials include:

F W (1830s)	I S (1830s)	J H (1836)
L H (1830–33)	M S (1830s)	W H (1830s)

Combinations in which it is not possible to establish whether the letters are Cyrillic or Roman include:

A B (1833)	A H (1838)	B K (1830)
C K (1800s)	I C (1830)	I H (1830s)
I I (19thc)	I P (1830s)	M C (1830s)
P K (1830s)		

It should be noted that when in initial position the letter I in Cyrillic appears only before a vowel. A few Christian names exist which are written with initial I, among them Ieremeya (Jeremiah) and Iosif (Joseph). Since the names were not common, the combinations I C, I H, I I and I P in all probability represent Roman letters.

Cyrillic initials indicate a Russian exporter, producer or agent, whilst the Roman initials would suggest a foreign exporter or agent. However, it has not been possible to identify the traders or exporters indicated by the initials. The likelihood of matching them to any particular individual remains remote, since in Russian sources it is virtually impossible to distinguish Russian producers, exporters or agents, any one of whose names or initials might be recorded in the official documentation accompanying a batch of exports or in Export-Import statistics without clarification of their status.

5.2.5.13. Reverse: fourth line
The fourth line of the reverse indicates the year when the goods were graded (Fig. 7b; Fig. 12b; Fig. 13b; Fig. 14b).

5.2.6. St Petersburg seals, 1830s–early 1840s

Twenty seals, also from St Petersburg, are similar in format to pre-1829 seals in that the initials of the agent, owner or producer of the goods are absent from the reverse side. Information is carried on them in four lines on their obverse and three lines on their reverse sides. All the discoveries so far date from the 1830s and early 1840s, with twelve of them bearing a date 1831, 1832 or 1833.

This small group of seals is important since they allow us to ascertain the significance of the final line of the obverse of all Russian flax and hemp seals, as well as providing supporting evidence for the significance of the initials in the first line of the obverse of most seals.

5.2.6.1. Obverse: first line

They are characterised in the main by the initials ПиЛПД [=PiLPD] and ПЛПД [=PLPD] in the first line of their obverse. It is this combination with the lower-case letter 'и' [= 'i' = 'and'] which lends support to the view that the initials represent 'Hemp and Flax Port Inspection' [**P**en'kovy **i** **L**'nyanoy **P**ortovy **D**osmotr = **П**еньковый **и** **Л**ьняной **П**ортовый **Д**осмотр] or 'Tow and Flax Port Inspection' [**P**aklyanny **i** **L**'nyanoy **P**ortovy **D**osmotr = **П**аклянный **и** **Л**ьняной **П**ортовый **Д**осмотр] (Fig. 19a; Fig. 20a; Section 5.2.4.1).

5.2.6.2. Obverse: second and third lines

In the second and third lines the initial and surname of the Quality Control Officer is given (Fig. 19a (M. Kaltushkin); Fig. 20a (N. Selin); Section 5.2.6.6.1).

Nine seals carry the surname Kaltushkin, seven with the initial P and two with M, four have F. Sukhorukov and four Selin. Five Kaltushkin seals and two Sukhorukov seal have letters and numbers on their reverse which can be interpreted as I C B N 2, this codification always being accompanied by SPB in Roman letters, as is the codification that appears as F K 2 H. However, when the code appears as П Ш 2 Н, which occurs on seals with the name P. Kaltushkin and F. Sukhorukov, the abbreviation of St Petersburg is carried in Cyrillic.

Clues to the identity of these Quality Control officers are found in the Russian State Historical Archive in St Petersburg where four log books or registers have been preserved in which the names of the brackers of hemp and flax codilla along with the quantities inspected were recorded for the years 1840, 1842, 1843 and 1844 (RGIA, 19, 6, 136; RGIA, 19, 6, 137; RGIA, 19, 6,138; RGIA, 19, 6,139). The names of the different Quality Control Officers, all but one of which (Evstigney Zimichev) are known to us from the seals recovered in the UK and listed in this group, are as follows (Section 5.2.6.2.1).

5.2.6.2.1. Names of quality control officers registered 1840–1844

1840	1842	1843	1844
Petr Kaltushkin	Petr Kaltushkin	Petr Kaltushkin	Petr Kaltushkin
Fedor Sukhorukov	Fedor Sukhorukov	Fedor Sukhorukov	Fedor Sukhorukov
Vasilii Gorbunov	Vasilii Gorbunov	Vasilii Gorbunov	Vasilii Gorbunov
Daniilo Selin	Daniilo Selin	Daniilo Selin	Daniilo Selin
Ivan Sheravskoy	Ivan Sheravskoy	Ivan Sheravskoy	Ivan Sheravskoy
Rodion Shustov		Rodion Shustov	Rodion Shustov
Mikhailo Kaltushkin	Mikhailo Kaltushkin		
Evstigney Zimichev	Evstigney Zimichev	Evstigney Zimichev	

One seal carrying the surname Selin <CUPMS: 1999.56.8> has the initial N which therefore cannot represent the same individual as the one with the initial D found on seal <CUPMS: 1999.53.20> and on the journal list (Fig. 20a). The seal is dated in the 1830s and might represent a relative of Daniilo Selin.

The evidence of the lead seals recovered in the UK shows us that at least all but one of these Quality Control Officers had been at work for a period of at least ten or eleven years before the surviving written record of the port journal was made.

The brackers worked in pairs, which were arranged by drawing lots before each batch of goods were inspected. In 1844 Fedor Vanyukov, one of Russia's best-known and largest producers and the preceding year one of the representatives on the bracking panel where he is described as a merchant of the Second Guild from Sol'tsy Posad, found that when his produce was bracked by Petr Kaltushkin and Rodion Shustov it did not reach the required standard. This fact is noted in the register for 1844 and countersigned by the Senior Brackers (brakovshchiki) Leontii Zimin, Franz Kaul and the senior desyatnik Pavel Shatunov (RGIA, 19, 6, 139, 2) whose names also appear as Codilla Brackers in the St Petersburg address book of 1844 (AK, 1844. 120). Seals bearing the name Vanyukov (Fig. 32a; Fig. 33), one of which is dated 1847 (Fig. 32b) suggest that the producer was more successful three years later (Section 5.2.8.3).

5.2.6.3. Obverse: fourth line

The final line of the obverse has the letters H [= N] or Hо [= No], in the majority of cases in Cyrillic, followed by a number (Fig. 19a: [Hо 2]; Fig. 20 [Hо 1]), indicating the post at which the Quality Control Officer worked. The seals show that each bracker usually worked from the same position: Daniilo Selin at Post 1, Mikhailo Kaltushkin at Post 2, Petr Kaltushkin usually at Post 3, Vasilii Gorbunov at Post 4, Rodion Shustov at Post 5, Fedor Sukhorukov at Post 6 and Ivan Sheravskoy at Post 7. Given that both Petr Kaltushkin and Daniilo Selin are shown to have worked from an alternative position (No 9), it seems likely that Evstigney Zimichev worked at Post 8.

24 *Russian Cloth Seals in Britain*

5.2.6.4. Reverse: first line

The reverse side differs strikingly from that on other Russian flax/hemp seals.

In the first line they carry the initials of St Petersburg in Roman SPB and Cyrillic, СПБ (Fig. 19b; Fig. 20b).

5.2.6.5. Reverse: second line

A further distinctive feature of seals in this group is that the second line carries letters and digits in the style of pre-1829 St Petersburg seals, employing in place of the 12, 9, 6 system characteristic of seals before 1830 the 1, 2, 3 grading system found on other seals from the 1830s and 1840s, for example Л 3 1 Н from 1833 (Fig. 19b) and П Ш 2 from 1832 (Fig. 20b). It has not proved possible to match but a few of these combinations of letters and numbers with indications of the quality and types of flax in western sources (Warden, 333; Carter, 12–12; McCulloch, 614, 696).

5.2.6.6. Reverse: third line

The final line carries the inspection date (Fig. 19b; Fig. 20b).

5.2.6.6.1. St Petersburg Seals with initials PiLPD / PLPD.

Seal No.	Face	Transcription
CUPMS:1999.52.31	obv	П[и]ЛПД/– КАЛТ / УШКИ / Но 3
	rev	SP[B] / I.C.B.N. 2 / 1836
CUPMS:1999.52.32	obv	П. Л. П. Д./ [–] : СЕЛ/ ИНЪ / Но I
	rev	[С] П Б / [–]. 3. 2.Н. / 1832
CUPMS:1999.52.33	obv	П.Л.П.Д./ [–]: СЕЛ / ИНЪ / Но I
	rev	[С]ПБ / [–]. 3. 2.Н. / 1832
CUPMS:1999.52.34	obv	ПиЛ.ПД./И. ШЕР[А] / ВСКОИ / Но 7
	rev	[С]ПБ/ .Ш. 2 Н / [1]841
CUPMS:1999.52.35	obv	ПиЛПД/ П КАЛТ / УШК[ИН]/ Но 3
	rev	[S]PB/ [–] C.B.N. 2 / 1839
CUPMS:1999.53.17	obv	ПиЛ.ПД/ В. ГОРБ / УНОВЪ / Но 4
	rev	[С]Пб / П. Ш 2 Н/ 1833
CUPMS:1999.53.18	obv	ПиЛПД/ М КАЛТ /УШКН/ Но 2
	rev	СПБ/ Л. 3. 1. Н. / 1837
CUPMS:1999.53.19	obv	ПиЛПД/ П КАЛ[Т] /УШКИ/ Но 9
	rev	СПБ/ П.Ш.2.Н/ 1833
CUPMS:1999.53.20	obv	П[и]ЛПД / Д: СЕ[–] / ИНЪ/ Но 1
	rev	[–]Р[В] / . Н 2 Н / 183[8]
CUPMS:1999.53.22	obv	ПиЛПД/ П КАЛТ / УШКИ/ Но [3]
	rev	SPB / I C B N. 2 / 183[–]
CUPMS:1999.54.32	obv	ПиЛПД/ П. КАЛТ / УШКИ / Н.
	rev	–Р[В]/ I.C.B.N.2 / 183[–]
CUPMS:1999.54.34	obv	ПиЛПД/ [Ф] СУХО / РУКОВ / Но 6
	rev	СПБ/ П. Ш. 2. [Н] / 183[5]
CUPMS:1999.56.8	obv	П[и]Л.ПД./ Н: СЕЛ / ИНЪ/ Но I
	rev	СПБ/ П.Ш.2 / 1832
CUPMS:1999.56.9	obv	ПиЛПД/ М. КАЛТ / УШКИ / Но 2
	rev	SPB/ I C B N [2]/ 1831
CUPMS:1999.57.6	obv	ПиЛПД/ Р ШУС / ТОВЪ/ Н. 5
	rev	СПБ/ Л.3. 2 Н/ 1831
FALKM: 2002.43.02	obv	ПиЛПД / П КАЛТ / УШКИ / Но 9
	rev	S P B / F K 2 H / 1833
FALKM: 2002.43.03	obv	ПиЛП– / П КА[Л][Т] / УШКИ / Н [8]3
	rev	S P B / F K 2 [–] / 184[–]
LCM: 90.36/12	obv	ПиЛПД / Ф. СУХО / РУКО[В] / Но
	rev	S P B / I C B N 2 / 183[6]
DUN: АНН.2005–16–10	obv	ПиЛП– / Ф СУХО / РУКОВ / Но 6
	rev	S P B / I C B N 2 / 1831
DUN: АНН.2005–16–12	obv	ПиЛПД / Ф. СУХО / РУКО / Но 6
	rev	С П Б / Л 3. 2 Н / 1832
JS 103	obv	ПЛПД/ М. КАЛТ / УШКИ / Н 2
	rev	SPB/ F K 2 [Н] / –8[3][9]

5.2.7. Seals with two surnames

A number of other configurations are recorded, one of which is the appearance on each side of the seal of a surname. It is known from Russian sources that Quality Control Officers were required to work in pairs (RGIA, 19, 4, 104, fo 112v.), but usually only one surname is stamped on the seal. However, on some seals, resembling those from St Petersburg in font style, the names of two Quality Control Officers appear. The first is stamped on one side of the seal, the second on the other side, but on neither side is there any indication of the date or the quality of the goods. The seals carry four lines of information on each side, with the surname and initials occupying the middle two lines.

The names recorded are: A Pogankin and P. Balovanov (Fig. 21a; Fig. 21b) [–] Pogankin and P. Balovanov; F. Larionov and Tyurin; A. Piskarev and V. Tyurin, V. Tyurin

and A. Ulanov; A. Ulanov and –la– –v; Novo[–]ortsov and E. Budnikov; Navatov and N. Gavalgin; [–]arel'ev and K. Valin. On only two of the seals do we find identical the surnames (<CUPMS: 1999.55.27> and <KGGM: DBK.80–8d–vi>), but one surname, Ulanov, occurs twice on the same seal (<FALKM: 1999.431>) and on two others (<DMP 06>; <JM 04>) with Tyurin.

Some of the surnames are found on other seals stamped with the more usual configuration. The surname Pogankin is found on seals from Fife dated 1825, 1826 and 1833. The name Karelev which occurs on one seal from Bristol coincides with the name on one seal from Montrose, dated 1799 and although the other surname on this same seal, Valin, is shared with that on a seal from Cromarty, they have different first-name initials. The surname Larionov occurs with different Christian name initials on two other seals, from Great Yarmouth and Cromarty. The latter is badly damaged, one side being totally illegible and possibly blank, but it could also have been a seal with two surnames (<CRMCH: 1992.11.6>).

The initials which stand in the first lines differ from those occurring on other seals in this position are given in 5.2.7.1. On four seals one of the side is so badly damaged that its transcription must remain uncertain.

5.2.7.1. First-line initials

Seal number	Initials on side A	Initials on side B
CUPMS: 1999.55.27	Л П [= L P]	Л П С [= L P S]
CRMCH: 1990.3.2	Л П [= L P]	П С [= P I S]
KGGM: DBK.808-iv	– –	Л П – [= L P –]
PMn 01	П П [= P P]	Л П С [= L P S]
FALKM: 2003.3.3	П П [= P P]	– П С [= – P S]
FALKM: 1999.4.31	П П [= P P]	П [= P]
DMP 06	[I] П	П. Н. О [= P N O]
JM 04	П I П [= P I P]	Л П С [= L P S]
BRSMG: O.1749	– –	– П [С] [= P –]

5.2.7.2. Seals with two surnames

Seal no	Face	Transcription
CUPMS: 1999.55.27	obv	Л. П / А. ПОГА / НКИ[–][–] / Н. 3
	rev	Л. П. С. / П. БАЛО / ВАНОВЪ/ Н [3]
KGGM: DBK.808d-iv	obv	[–][–] / [–]. ПОГ[А] / [–][–]ИНЪ / Н. 2
	rev	Л. П. –. / П. БАЛО / ВАНОВЪ/ Н [–]
FALKM 1999.4.31	obv	П П / А. УЛА / ОВЪ
	rev	П / – – ЛА / – ВЪ
FALKM 2003.3.3	obv	П П / НОВО / [Т]ОРЦО / 1
	rev	[–] П. С. / Е. БУД / НИКО[В]
CRMCH: 1990.3.2	obv	Л. П / НАВА / ТОВЪ / Н 2
	Rev	П. I С / Н. ГАВА / ЛГИН– / [–]
BRSMG: O.1749	obv	[–] П. [О] / [–] АРЕ / ЛЬЕВЪ / Н I
	rev	К. ВА / ЛИНЪ / Н: I
PMn 01	obv	П. П. / Ф ЛАРI / ОНОВЪ / Н I I
	rev	Л. П. С. / – : ТЮР / ИНЪ / Н : I
DMP 06	obv	–. П. / А. УЛА / НОВЪ/ Н [8]
	rev	П. Н. О. / В: ТЮР / ИНЪ / Н
JM 04	obv	П. I П. / А ПИСК / АРЕВЪ / Н I
	rev	Л. П. С. / В: ТЮР / ИНЪ / Н. I

5.2.8. St Petersburg seals, 1840s–1850s

From the early 1840s the style of Russian seals from St Petersburg changed fundamentally, though their dimensions remained the same. The information about quality and the name of the producer or exporter is presented in a manner and order which differs significantly from the categories described. In particular, on these seals it is the exporting merchant's or agent's name which is given on the obverse and the grade of flax on the reverse of the seal.

5.2.8.1. Seals with the surname Damazki

A number of seals discovered in areas near the coast of Angus and Fife have the surname Damazki on one side. Almost all of them also have a St Petersburg abbreviation, StPB, quite clearly marked on one side of the seal, an abbreviation which is in itself unusual since it combines the normal Russian form (SPB) with the western form (StP) (Fig. 26a; 26b; Fig. 27a; Fig. 28a; Fig. 29a; Fig. 29b).

The surname, which is unusual in Slavonic countries, is stamped as a circumscription on the seal, usually in the form Damazki, but it also appears in variant forms. On one seal <KIRMG. 2006.207> it is in Cyrillic: ДАМАЦКОИ [= DAMATsKOI], showing the pronunciation of the voiced sibilant /z/ which is found on most other seals (DAMAZKI) as an unvoiced affricate /ts/ (Fig. 28a). This pronunciation is also suggested by the syllable 'MAT' on one other seal (<CUPMS: 1999.52.46>), which could be in Cyrillic or Roman. Consequently, the forms Damazki and Damatski suggest a surname with a German rather than an English or Polish provenance.

When the name appears in Cyrillic, it has the Russian adjectival ending -skoi which was the regular form in spoken Russian in the second half of the 17th century and 18th century, rather than the more literary form -ski which later assumed prominence in the Russian literary language and which appears in the transliteration found on seals with Roman letters (Cocron 117). The initials B. A. stand in the centre on nine of the seals in Cyrillic (Fig. 27a) or Roman letters (Fig. 26a; Fig. 29a), usually followed by the date. Of the seals so far recovered two date from 1846, three from 1847, five from 1848 and two from 1851. The exact nature of the business enterprise carried on by Damazki remains to be discovered, but it is clear from the examples recorded that part of his business at least involved the export of flax.

On the other side of the seals the grade of flax or hemp is given (Fig. 27b; Fig. 28b).

5.2.8.1.1. Seals with the surname Damazki (Damatski)

Seal number	Face	Transcription
KIRMG. 2006 282	obv	DAMAZKI, A. B / B A 1848 / StPB
	rev	Ho 2. / 1848
KIRMG. 2006.199	obv	DAMAZKI / Б. А. / 1848 / .PB
	rev	Ho 1. / – – / [Д] 12 П
KIRMG. 2006.207	obv	А [В] ДАМАЦКОИ / 1848 / С П Б
	rev	No 2 /–.–/ o . 9. П
KIRMG. 2006.341	obv	A. B. DAMAZKI / Б.А. / 1847 / St P B
	rev	2 –. С. / 9. П
ADMUS: A1988.296	obv	A B DA – – TSKI / Б А / 1846 / St P B
	rev	3й С / – – / 2 П
ADMUS: A1989.265	obv	A B – – – [K]I / Б.А. / 1851 / St P B
	rev	Ho 2 /. – – / 9 П
ADMUS: A1990.311	obv	A B DAMAZKI / B A / 1848 / StPB
	rev	Ho 2. / –.– / 19. П.
DUNMG: 1977.1048	obv	A [B] DAMAZKI / BA / 1847 / StPB
	rev	Ho. 1 / –.– / Л. 12 П
JBC 07	obv	MAZKI / БА / 1847 / StPB
	rev	2й С /. – – / 9 П
CUPMS: 1999.52.48	obv	A – DAMAZKI / Б. А. / 1846 / StPB
	rev	2й С /. – – 9 П
CUPMS: 1999.52.49	obv	A B DAMAZKI / B. A. / 1848 / StPB
	rev	Ho 2. / –.– / 9 П
CUPMS: 1999.52.46	obv	– – MAT – / [Б] A / 1851
	rev	Ho 2 – / [–] П

5.2.8.2. SEALS WITH THE SURNAMES DAMAZKI AND HILLS AND WHISHAW

Two seals which on one side have the name Damatski in Cyrillic (ДАМАЦКОИ) (Fig. 30a; Fig. 31a), with a partially illegible form beginning with Fedos'[e][i], the initials SPB in Cyrillic (СПБ) and the date 1847 carry as a circumscription on the other side the name of the firm 'Hills & Whishaw', surrounding the Roman numeral II (Fig. 30b; 31b). The Hill and Whishaw families were two of the most prominent British business families in Russia from the 18th to the beginning of the 20th centuries.

The Whishaw Family family had been connected with Russia since the 1770s and the firm of Hills & Whishaw founded by Bernard Whishaw early in the 19th century. Whilst James Whishaw in his history of the family claims once to have known the year of the firm's foundation and liquidation he admits that he cannot now remember the actual dates, though he feels 'certain that the firm liquidated in 1884.' (Whishaw 1935, 141) However, he does add that when he himself went to live permanently in St Petersburg (1877) (Whishaw 1935, 166), the firm of Hills & Whishaw was much the oldest in the City, since his father had his first training in the company of which his grandfather was senior partner (Whishaw 1935, 161).

The Whishaw family as a whole went on to form a number of successful companies, one in Archangel and many of the family members were granted Honorary Citizenship of the town in which they lived, becoming merchants of the First Guild. One, referred to in Russian as Boris Vasilievich, was a wholesale trader at the port of St Petersburg in the firm of Hills & Whishaw and had not only become a member of the First Guild in 1856 but by 1861 was also serving as a member of the committee overseeing the bracking of goods at the Department of Foreign Affairs. Alfred Whishaw, who was his junior by six years, was by 1861 a wholesale trader at the port of St Petersburg in the firm of A. G. Whishaw, having become a member of the First Guild in 1860 at the age of 30. Other members of the family became stockbrokers and one became a ship-broker and steamship agent (ASK, 1861, 6). Undoubtedly the shadow cast over commerce by the Crimean War led to the eventual departure of some of the Whishaw family from Russia. Bernhard left in 1854, having liquidated his Archangel affairs towards the end of 1855. Travelling by sledge from St Petersburg to Koenigsberg the family thence completed their ten-week journey by small ship to Dundee.

As was frequently the case in the British commercial community the Whishaw connection with the Hills was strengthened in 1814 by the marriage of Sarah who was born in St Petersburg in 1794 with Henry Hill who was resident at No. 268 in the Third Quarter of Vasiliev Island, a marriage

which produced twelve children and sixty grandchildren (*Sanktpeterburgskie Vedomosti* 1814, No. 73, 11 September, 1814; Whishaw 1935, 158).

The Hills had for long been involved in many business enterprises, at times joining forces with other partners, such as the Cazalet family, to extend their commercial activities or in the 19th century working in one of the Whishaw companies. Towards the end of the 19th century they were active in the export of flax, hemp, coal and peat (*Fabriki i zavody* 1904; Yablonskiy 1895, I, 566, II, 46).

5.2.8.2.1. Seals with the surnames Damazki and Hills and Whishaw

Seal number	*Face*	*Transcription*
CUPMS: 1992.52.50	obv	HILLS & WHISHAW / II /
	rev	А [–] ДАМАЦКОИ ФЕДОС[Е][–] / 1847 / СПБ
PERMG: 1992.142.1	obv	HILLS & – – – SHAW / II /
	rev	А [–]– – КОИ ФЕДОСЬИ / 1847 / СПБ

5.2.8.3. SEALS WITH THE SURNAME VANYUKOV

Two seals from the Montrose area, one dated 1847 and the other undated, have the surname Vanyukov, but they show different first names but identical patronymics: Fedor : Manuil[ovich] (<ADMUS; M.1989.98>) (Fig. 32a) and Timofey : Manuil[ovich] (<ADMUS: M 1995.161>) (Fig. 33). On the dated side the seal with the name Fedor, which was issued in 1847, indicates grade No 2 flax, but the second seal (with the name Timofey) is so badly corroded that this side is illegible (Fig. 32b).

The names Fedor and Timofey are recorded in the list of Members of the Second Guild in the Address Book of St Petersburg and Foreign Merchants, Stockbrokers and Brackers at the Port of St Petersburg for 1844 (*Adresnaya kniga* 1844, 32) along with a third named Ivan. The three members have the patronymic Manuilovich, offering the distinct probability that they were brothers, although Ivan is recorded as operating from near the Tuchkov Bridge in St Petersburg whilst Fedor and Timofey are listed as residents of Sol'tsy Posad where the Vanyukovs were a extensive, well-known business family. Sol'tsy Posad was situated some 29 kilometres from Shimsk station on the Novgorod railway line and some 109 kilometres from Novosel'e on the St Petersburg–Warsaw railway line. Flax from this area was usually exported through the port of St Petersburg, having been barged along the river Shelon', over Lake Il'men, up the Volkhov, through the Ladoga canal and down the Neva (*Svedeniya* 1870, 16).

In 1842 and 1843 Fedor Vanyukov is listed as being one of the representatives on the panel of brackers at the port of St Petersburg where he is also described as a member of the Sol'tsy Second Guild of Merchants but in 1844 he discovered that when his produce was bracked in St Petersburg it did not reach the required standard (Section 5.2.6.2).

The Vanyukovs continued to flourish. The data are too vague to allow exact relationships between the several later operatives to be established, but in 1879 a certain Fedor Mikhailovich Vanyukov is listed as a merchant in Sol'tsy Posad with an enterprise employing 350 workers, whilst Yakov Ivanovich owned a mill employing five men. By 1892 two members of the family with initials that might point to them being sons of Fedor had businesses in St Petersburg, I. F. Vanyukov operating at the port of St Petersburg and Ya. F. Vanyukov on the Tuchkov Wharf (Yablonskiy 1895, 566).

5.2.8.3.1. Seals with the surname Vanyukov

Seal Number	*Face*	*Transcription*
ADMUS: M1989.98	obv	ѲЕДОРА МАНУ[И]Л: / ВАНЮ / КОВА
	rev	No. 2 / 1847
ADMUS: M1995.161	obv	ТИМОФЕЯ / М[А]НУ[И]Л: / ВАНЮ / КОВА /
	rev	[illegible]

5.2.8.4. SEALS WITH THE SURNAME KOROLEFF

The name KOROLEFF / KOHOLEFF appears on seals dated 1844, 1848 and 1850. One is undated. They also relate to flax or hemp. They carry the initials И. Ф. К [= I. F. K], in which the K could also indicate Koroleff. If so, the initials I. F. would be those of the first name and patronymic. They were issued in St Petersburg (Fig. 34a; Fig. 35a). The reverse side of the three dated seals carries the form Но 2 [= No 2] which is found on many other flax seals from ports other than those from Archangel (34b, Fig. 35b) but the undated seal is similar in configuration to some of the seals with the name Damazki and has 2 C (=2 S = 2nd grade), followed by 9 П (= 9 P) (Section 5.2.8.1.1).

The seals also carry the initials И. Ф. К [= I. F. K], in which the K could also indicate Koroleff. If so, the initials I. F. would be those of the first name and patronymic. Hitherto it has not proved possible to discover with certainty where the Koroleff company main offices or any of its agents were situated, but a certain Ivan Korolev, a merchant of the Second Guild in Sol'tsy Posad, is listed as one of the bracking supervisors in St Petersburg in 1842 and 1843 (RGIA, 19, 6, 137, fo 8v; RGIA, 19, 6, 138, fo 4).

5.2.8.4.1. Seals with the surname Koroleff

Seal number	Face	Transcription
CUPMS: 1999.53.36	obv	KOROLEFF / И.Ф.К. / StP.B.
	rev	Ho 2 / – – / 1848
PERMG: 1992.140.4	obv	КОРО – – / [–]. Ф. К. / [–]tP[–]
	rev	2. / – . – / 1850
ADMUS: M1980. 3639	obv	KOHOLEFF / И.Ф.К. / St [P]
	rev	Ho 2 / –.– / 1844
ADMUS: M2007. 38	obv	KOROLEFF / И.Ф.К. / St P
	rev	2 C / 9 П
JS 21	obv	KOROLEFF / И Ф К / [S] P [–]
	rev	No. 1 / – – / 1850

5.2.8.5. SEALS WITH THE SURNAME CLASSEN

Two seals bear the name Georg Classen in Roman letters on their obverse and this is the only information carried on that side. The reverse of one of them carries the information in English: Zabrack 4[–], indicating Zabrack 4th grade (<ADMUS: A1989.246>). The second seal has the phrase SECOND CLASS, clearly visible on the reverse, referring to the quality of the flax in the bundle (<CUPMS: 2005.291>) (Fig. 36a; Fig. 36b). On neither seal is there any indication of the date, place of issue, or the position at which the goods were bracked, although the specific reference to 'zabrack' on the seal might suggest it originated in Archangel, rather than St Petersburg.

The Classen family, originally of German origin, were a long-established and well-known family with many different business interests in St Petersburg and Archangel. The name of one member of the Classen family, called Egor [= George], appears as one of the seven members of the First Guild of Merchants who were signatories on a document accompanying the gold chalice presented to the Emperor Alexander I on the occasion of his visit to Archangel in 1819 (Ogorodnikov 279–280). At present we have no certain way of connecting the two individuals. In some documents some members of the Classen family are listed as British subjects.

5.2.8.5.1. Seals with the surname Classen

Seal number	Face	Transcription
ADMUS: A1989.246	obv	CLASSEN, Georg
	rev	Zabrack / 4 [й] [c]
CUPMS: 2007.87	obv	CLASSEN, Georg
	rev	Second Class

5.2.8.6. SEAL WITH THE SURNAME KAHKOFF

One seal preserved in Montrose Museum, the reverse side of which suggests it was a flax-bundle seal, was issued in the 1853. Although its configuration resembles other seals of this period from St Petersburg which are more akin to trade advertisements, the stamping of No. 2 on the reverse probably indicates second-grade flax and suggests that the owner (propriétaire) whose surname, Kahkoff, is stamped in the French style of transliteration (with the surname in '-off' rather than '-ov', as is also found in Koroleff) (Section 5.2.8.4) had submitted his fibre to voluntary bracking (Fig. 37a; Fig. 37b). No further details of the commercial activity of the firm of Kahkoff have so far been uncovered.

5.2.8.6.1. Seal with the surname Kahkoff

Seal number	Face	Transcription
ADMUS: A1998.91	obv	PROPRIETAIRE KAHKOFF
	rev	No. 2 / 1853

5.2.9. Archangel seals

Finds have been made of three types of seals which originated in Archangel, over 180 of which carry legible dates covering the period from the 1820s to c. 1902. However, many seals are so damaged that the date is quite illegible or its transcription unreliable.

In almost all respects Archangel seals are quite distinct from other types described, being typically about 28mm × 27mm, though some are as large as 36mm × 28mm. They are distinguished from St Petersburg seals and others in carrying much clearer and fuller information about the contents of the bundle to which they were attached.

As described in Section 4.2, Archangel flax was bracked into two types, Select [Отборной = Otbornoi] (Fig. 38; Fig. 39; Fig. 40) and Crown [Крон = Kron] (Fig. 41). Each type is graded into Ческа [= Choska] (Fig. 42b; Fig. 50b; Fig. 51b; Fig. 52b), Кудель or кудѣля [= kudel' or kudelya /Tow] (Fig. 49b; Fig. 54b) and Пакля [= paklya / Codilla] (Fig. 43b; Fig. 44b) and occasionally Пакля Ческа [= Paklya Cheska] (Fig. 53b). A further grade Забрак [= Zabrack] was introduced later (Fig. 47b; Fig. 55b).

5.2.10. Archangel seals, pre-1820s

Only one seal has been recovered which dates from before the 1820s. It is held in Guildford Museum (<GLDM: 29.2>) and was recovered from the London area, although the exact location is unknown. It is distinguished from seals which were issued from the end of the 1820s by its smaller size (22mm × 20mm), more usually associated with seals from other Russian ports, such as St Petersburg. The obverse is badly erased, but shows A for Archangel in its first line followed by the surname of the Quality Control Officer which is Stepanov (Fig. 92a). However its reverse side is quite clear. The first line indicates that it was issued at the port of Archangel АР– ПОР [= Ar– Por]. Line two describes the bracking 'БРА' [= bra] of hemp 'ПЕНК.' [= penk.], and line three contains the initials of the producer or agent in an italicised ligature Г Л [= G L] straddled by the grade of the hemp '2 r', for '2 ruka' [*2nd grade* or 'seconds']. The date 1813 follows in the fourth line (Fig. 92b).

Until further examples of this type of Archangel seal come to light it is proposed that Archangel seals issued before the mid 1820s resembled seals issued in St Petersburg in size, but not in their configuration nor in the type of information contained on them. Towards the end of the 1820s they were replaced by the larger seals which continued in use for about a decade before themselves being superseded by seals with the configuration which in broad terms lasted until the turn of the 19th–20th centuries.

5.2.10.1. ARCHANGEL SEALS, PRE-1820s

Seal number	Face	Transcription
GLDM: 29.2	obv	А– –/ СТЕПА / – ОВЪ
	rev	АР ПОР. / ПЕНК. БРА / 2 ГЛ Р / 1813

5.2.10.2. ARCHANGEL SEAL FROM THE MID-1820s

The only Archangel seal so far recovered which can be dated with certainty to the 1820s (<CUPMS: 1999.52.19>) is unusual in that whilst the lay-out of information on its reverse resembles that found on most 1830s seals it carries below its date a circumscription too damaged to be fully deciphered but most probably indicating a link with the export of 'tow' (Fig. 91; Section 5.2.14.5). The contents of the bundle were 3rd grade and were inspected in 1825. Its obverse has been almost entirely erased.

While the seal is of a size which approaches that associated with later Archangel seals (26mm × 21mm) rather than the smaller seal described in Section 5.2.10, it is not possible in the absence of other seals which can be reliably dated to this period to ascertain whether its configuration is typical of the period in carrying such circumscriptions.

5.2.10.2.1. Archangel seal from the mid-1820s

Seal number	Face	Transcription
CUPMS: 1999.52.19	obv	– – / – –СЯ – –/ – – – –
	rev	А. П / ЛНА БРА / 3 ЯС Р / 1825 / [–] – [Д]ЕЛНАЯ

5.2.11. Archangel seals, 1820s–1839

From the late 1820s the size of seals from Archangel increased. A number of seals have been recovered dating from the late 1820s to 1839 which differ in their configuration and presentation of the information from those which began to appear from about 1838. Twenty-five seals of this type have so far been recorded.

On sixteen of them the decade and year digits are clear enough to enable accurate dating (between 1832 and 1839), but on five seals the year digit is damaged or erased. However, what remains legible on them is sufficient for four of them to be dated to the 1830s (<KIRMG. 2006.327>, <CUPMS: 1999.52.13>, <CUPMS: 1999.53.11>, <CUPMS: 1999.56.1>) and one to 1820s (<CUPMS: 1999.52.19>). On one seal the century numbers are legible but the remaining two seals are so damaged as to be illegible or to render transcription unreliable (<CUPMS: 1999.52.23>).

The letters and digits on seals in this group typically are stamped in a spindly semi-uncial font inclining to italic or cursive, but on three seals they are stamped with uncial or plain font letters on the obverse and on two other seals in uncial plain font on their reverse. At the end of the 1830s changes were introduced in the style of stamping seals but for a time the two ran concurrently (Fig. 43a; Fig. 44a; Fig. 46a). By the middle of the 1840s plain letters and digits had become firmly established on all seals except twelve bearing in italics the initial В [= V] and the abbreviation ЛЕД [= LED] (Section 5.2.13; Section 5.2.14.10; Fig. 39; Fig. 47b; Fig. 48b; Fig. 49b; Fig. 52b).

5.2.12. Obverse of Archangel seals 1820s–1839

On the obverse there are usually three lines of information.

5.2.12.1. OBVERSE: FIRST LINE

The first line carries the initials А. П. [= A. P] denoting Archangel Port as the port where the bracking took place (Fig. 44a; Fig. 45a).

5.2.12.2. OBVERSE: SECOND LINE

In the second line is stamped the rank of desyatnik. This noun appears either with the 'TS' written as two consonants

in the form 'DESyATSKOI' or one of its curtailed variants, or in the majority of instances with 'TS' represented by the single consonant 'Ц' [= Ts] (Fig. 43a; Fig. 44a; Fig. 45a) where it is written as 'DESyATsKOI' or one of its curtailed variants, chiefly 'DESyATsKO'. The abbreviated forms which 'desyatnik' can adopt in Russian are listed in Section 5.2.16 (3a–3d). One seal has simply *desiask*. (<DUN: AHH.2004.25>.

5.2.12.3. OBVERSE: THIRD LINE

On Archangel seals belonging to this group it is only the initials of the Quality Control Officer that appear rather than his full name (Fig. 43a; Fig. 45a; Fig. 46a). Of some fourteen different sets of initials so far recorded E M and K 3 [= K Z] are the only ones that occur more than once.

5.2.13. Reverse of Archangel Seals 1820s–1839

Four lines are used to provide information of their reverse side. The seals show great diversity in the way the information is set out in the second, third and fourth lines, but no matter what order of presentation is employed they all include an indication of the contents of the bundle, their quality, the initials of the producer and the date.

5.2.13.1. REVERSE: FIRST LINE

In the first line of the reverse of these seals the initials A. П. [= A. P = Archangel Port] appear in the same position as on the obverse (Fig. 45b; Fig. 46b).

5.2.13.2. REVERSE: SECOND LINE

The second line indicates that the process of bracking has taken place, using either the abbreviation 'лнян брак' [= lnyan brak] for 'Flax Bracking' (Fig. 45b), 'пак. брак' [= pak. brak] for 'Codilla Bracking' (Fig. 43b; Fig. 44b) or 'ленъ' [=len / lyon] for 'Flax' (Fig. 55b).

5.2.13.3. REVERSE: THIRD AND FOURTH LINES

The third and fourth lines indicate the quality of the goods, the initials of the producer or agent and the year in which the bracking took place. They also refine the definition of the contents of the bundle on those seals which have indicated in line two that 'flax bracking' has been performed. On these seals the noun used to denote 'quality' is 'РУКА' [= ruka], abbreviated to Р or РУ [= R or RU = hand, quality] (Fig. 43b). The use of *ruka* to indicate quality, as opposed to 'СОРТЪ' [= sort], is a particular feature of seals in this group.

The majority of seals falls into one of two configurations, in which the date straddles either the quality symbols (Section 5.2.13.4) or the initials of the owner/producer (Section 5.2.13.5).

Seals on which the initials of the producer are straddled by the quality indicators have been recovered more frequently than other types. Only five different sets of initials have so far been recorded, of which the two most frequent are В Д [= V D] and М П [= M P]. Other initials include А Р [= A R], М П [= M P] and Е П [= E P].

Where the initials are straddled by quality indicators, as in, for example: 1 В Д Р [= 1 V D R], the sequence is read as 'V D 1st grade'. Other examples are 2 А Р РУ [= 2 A R RU], read as 'A R 2nd quality' (Fig. 43b) and 1 Е П Р [= 1 E P R, = 'E P 1st quality'] (Section 5.2.13.4) (Fig. 44b). In these instances the date is given in the fourth line (Fig. 44b; Fig. 45b).

On other seals it is the date that straddles the producers' initials: 18 M П 35 (M P 1835) (Fig. 46b). The initials M P are more frequently straddled by the date and of the eight seals recorded with these initials, five are examples of initials straddled by the date, for example, 18 МП 35 [= 18MP35] (Section 5.2.13.5; Fig. 46b). One seal has the initials В Д [= V D] straddled by the date (Section 5.2.13.6).

A further variation is found on two seals on which the date stands alongside the initials of the producer, for example: on one seal we note [1]831 В Д [= 1831 V D] (<ADMUS: M1998.163>), whilst on the other seal (<CUPMS: 1999.54.30>) the date follows the initials on the producer, but they themselves are preceded by the first syllable of the noun ПАКЛЯ [= PAKLYA = 'codilla'], the second syllable of which (-KLYA) appears in the fourth line (Section 5.2.13.6).

5.2.13.4. ARCHANGEL SEALS 1820s–1839 (CONFIGURATION 'QUALITY/INITIALS')

Seal number	Face	Transcription
DUN: AHH.2004.25	obv	А. П. / ДЕСЯСК. / Е. М.
	rev	– * – / ЛНЯН БР / 1. ВД. Р / 1835
KIRMG. 1999.211	obv	А П / ДЕСЯТС / –. [К]
	rev	ЛНЯН Б[Р] / 2 ВД Р / 1833
KIRMG. 2006.327	obv	А. П. / [–]ЕСЯЦКО / ПР [ПР as ligature]
	rev	А. П / ЛНЯН БРАК[Ъ] / 2 М. П. / 183[–] [МП as ligature]
KIRMG. 2006.328	obv	А. – / ДЕСЯТ / [–] П [[–]Р as ligature]
	rev	А. П. / ЛНЯН БР[–][–][–] / 2 ВД Р / – –
CUPMS: 1999.52.13	obv	А.П. / ЕСЯЦКО / Н. Т.
	rev	А. П / ЛНЯН БРАК / 2 ВД Р / [–]83[–]
CUPMS: 1999.52.15	obv	А П / ДЕСЯЦКО / Т. З.
	rev	А П / ПАК. БРАК / 2 АР РУ / 1837
CUPMS: 1999.52.17	obv	А. П. / ДЕСЯЦК / [Г] С.
	rev	А [–] / ПАК. БР. / 1 ЕП Р / 1836
CUPMS: 1999.52.19	obv	– – / – – СЯ – – / – –
	rev	А. П / ЛНА БРА / 3 ЯС Р / 182–/[–]– – К. ЛНАЯКО

CUPMS: 1999.53.11	obv	А:П: / ДЕС.ЯС.К. / .Е. М
	rev	А. П. / ЛНЯН.БРАКЪ / 1 ВД Р / 183[–]
HARGM: 12706. 13	obv	А П / ДЕСЯТ / М К
	rev	АП / [Л]НЯН БРАК / 2 МП Р / 1839
RB 02	obv	А П / ДЕСЯЦКОI / Г С
	rev	А П / Л[Н] БРАК / 1 ЕП Р / 1836
JBC 02	obv	А П / ДЕСЯЦКО / П П
	rev	А П / ЛНЯ БР / 2 ЕП Р / 1836
JS 06	obv	А П / ДЕСЯЦКО / Ф К
	rev	А П / ЛНЯН БРАК– / 3 ВД Р / 1832

5.2.13.5. ARCHANGEL SEALS 1820S–1839 (CONFIGURATION 'DATE/INITIALS')

Seal number	*Face*	*Transcription*
KIRMG. 2006.253	obv	А. П. / ДЕСЯС / Е. М /
	rev	ЛНЯН. БР / 18 МП 35 / [–]АК.Р
CUPMS: 1999.52.16	obv	А П / ДЕСЯЦКО / К. З.
	rev	А. П. / ЛНЯН БРА / 18 МП 35 / З. ПАК.Р
CUPMS: 1999.52.18	obv	А. П. / ДЕСЯЦК / К. З.
	rev	А П / ЛНЯН БРАК / 18 МП 38 / – ПАК [–]
CUPMS: 1999.54.31	obv	/ ДЕСЯЦК / Г. [Б] /
	rev	/ ЛНЯН. БРАК / 18 МП 32 / [3] ПАК. Р
CUPMS: 1999.55.5	obv	.А.[П]. / ДЕСЯТС / Е П
	rev	/ 18 МП 34/ 1 ПАК. Р
CUPMS: 1999.56.1	obv	А. П. / ДЕСЯЦКО / / А. А.
	rev	А. / ЛНЯН.Б / 18.В.Д 3 / 2 ПАК Р
CUPMS: 1999.58.1	obv	А. П. / ДЕСЯЦК / К. З
	rev	– – П / МП 33 / 2 ПАК Р

5.2.13.6. ARCHANGEL SEALS 1820S–1839 (OTHER CONFIGURATIONS)

Seal number	*Face*	*Transcription*
CUPMS: 1999.52.21	obv	А. П. / ДЕСЯЦКОЙ / [К] У
	rev	/ М. П. / – ПАК Р
CUPMS: 1999.52.23	obv	А. П. / ДЕСЯЦКОЙ / П. К.
	rev	[А]. [П] / ЛНЯН. БРАК / М. П / 18– –
CUPMS: 1999.54.30	obv	А П / ДЕС – – / – – К
	rev	А. П. / НН.БРАК / ПА ВД 1833 /КЛЯ
CUPMS: 1999.54.57	obv	А. П. / ДЕСЯТ[С][К]О / [–][–]
	rev	–НЯН. БРАК / В[Д] / ПАКЛЯ / – – –
ADMUS: M1998.163	obv	А. П. / ДЕСЯТСК / ВЗ (ВЗ as ligature)
	rev	А П / ЛЬНЯН. БР / 831 ВД / ПАКЛЯ

5.2.14. Archangel seals, 1838–1902

Most recoveries of seals originating in Archangel date from the later 1830s to the early part of the 20th century, in particular the 1860s and 1870s. Their configuration, in which information is presented in four lines on the obverse and five on the reverse, differs in its clarity and relative simplicity from Archangel seals dated before the late 1830s.

5.2.14.1. OBVERSE: FIRST LINE

In the first line of the obverse we find an indication of either the place of export, where Archangel (Архангельск) is usually shortened to АРХ [= ARKh] (Fig. 42a; Fig. 47a; Fig. 49a) and Port (ПОРТЪ) to ПОР [= POR] (Fig. 42a; Fig. 48a) or of the completion of quality control which is indicated on many seals using the Cyrillic form of 'Brak' (БРАКЪ) or more usually one of its abbreviated forms (Section 5.2.16 (2); Fig. 55a).

5.2.14.2. OBVERSE: SECOND LINE

On the second line we find an indication of the rank of the individual who has carried out the bracking process for the particular bundle to which the seal is attached. The rank can appear variously as shown in Section 5.2.14.2.1 (Fig. 42a (desyatsk); Fig. 48a; Fig. 50a (desyat); Fig. 49a (desyatnik); Fig. 53a (desyat'nik")).

5.2.14.2.1. Forms of 'desyatnik' recorded on Archangel seals

A	ДЕСЯТН.	desyatn.
	ДЕСЯТНИКЪ	desyatnik"
	ДЕСЯТЬНИКЪ	desyat'nik"
B	ДЕСЯЦК.	desyatsk.
	ДЕСЯЦКО	desyatsko
	ДЕСЯЦКОИ	desyatskoi
C	ДЕСЯСК	desyask
	ДЕСЯТС.	desyats.
	ДЕСЯТСК	desyatsk
D	ДЕС	des
	ДЕСЯТ	desyat

5.2.14.3. OBVERSE: THIRD AND FOURTH LINES

The third and fourth lines carry the name of the Quality Control Officer, consisting of his Christian name, sometimes abbreviated, and his surname, often abbreviated (Section 7.1; Fig. 42a (Vasilii Babikov); Fig. 48a (Yakov Dupaev); Fig. 50a (Petr Mart'yan[ich]; Fig. 51a (Foma Popov-

Vedenskiy); Fig. 52a (Matvey Vedenskoy); Fig. 54a (Stepan Ivoninskoi)). The use of the Christian name rather than his initials is a feature that distinguishes Archangel seals from the overwhelming majority of seals from St Petersburg and other locations (Section 7.1; Section 7.2; Section 7.3; Section 7.3.1).

5.2.14.4. REVERSE: FIRST LINE

Confirmation that the bundles of fibres had completed the process of quality control is found in the first line on the reverse of the seal, alongside the place where the inspection took place (Section 5.2.16 (1); Section 5.2.16 (2); Fig. 47b).

The process of quality control is indicated on many seals using the Cyrillic form of 'БРАК' [= BRAK] or more usually one of its abbreviated forms (Section 5.2.16 (1); Fig. 38; Fig. 39; Fig. 47b). It may also appear with Archangel, abbreviated to 'АРХАНГЕЛ' [=ARKhANGEL] or АРХАНГ [= ARKhANG]. alongside the abbreviation 'POR' indicating 'port' (Fig. 51b).

5.2.14.5. REVERSE: SECOND LINE

The second line indicates the contents of the bundle. Though we occasionally find direct reference to flax on the seals, and to hemp in a few other cases, we also note other terms, such as 'tow' and 'codilla', which are similar to English in not distinguishing between flax and hemp, and indicate rather a stage in the processing of the fibre. A list of contents recorded is listed in Section 5.2.14.5.1 and illustrated in Fig. 41 [kron = crown], Fig. 49b, Fig. 54b, [kudel', kudelya = tow], Fig. 55b [lyon = flax], Fig. 46b [lnyan br = flax brack], Fig. 38, Fig. 39 [otbornyi = select], Fig. 53b [paklya = codilla], Fig. 15b [pen = hemp], Fig. 42b, Fig. 51b, Fig. 52b, Fig. 53b [cheska = low-grade heckled flax] and Fig. 55b [zabrack].

5.2.14.5.1.

1.	КРОНЪ	kron	Crown
2.	КУДѢЛЯ	kudelya	
	КУДЕЛЬ	kudel'	Tow
	КУДЕЛЬН	kudel'n	
3.	ЛЕНЪ	lyon"	Flax
	ЛНА БРАК	lna brak	Flax brack
	ЛНЯН БРАК	lnyan brak	Flax brack
4.	НИЖНОСУХОНСКОИ	Nizhnosukhonskoi	Flax from the Lower Sukhona region
5.	ОТБОРНЫИ	otbornyi	Select
6.	ПАКЛЯ	paklya	Codilla
7.	ПЕН.	pen.	Hemp
	ПЕНЬКА	pen'ka	Hemp
8.	ЧЕСКА	Cheska	low-grade heckled flax
9.	ВИЛЕГОДСКОИ	Vilegodskoi	Flax from the region of the Vilegda river
10.	ВЕЛИКОСЕЛЬСКОИ	Velokosel'skoi	Flax from the region of the village of Velikoe
11	ЗАБРАКЪ	Zabrak	Lowest quality flax, Zabrak, Zebrack

5.2.14.6. REVERSE: THIRD LINE

In the third line there follows an indication of the quality or grade of the goods being exported, usually employing the noun СОРТЪ [= sort 'grade, sort'] (Fig. 51b; Fig. 52b; Fig. 54b).

The use of the form 'ruka' rather than 'sort' to indicate quality, which is characteristic of earlier Archangel seals (Section 5.2.13.3) is recorded only on two later seals, both of which denote the contents as 'zabrak' <CUPMS: 1999.52.2> (1884) – 'zabrak 2 i ruki' [= Zabrack No 2] and <CUPMS: 1999.53.2> (1877) – 'zabrak 1 i ruki' [= Zabrack No 1]. None of the other eight seals with 'zabrak', which range in date from 1847 to 1874, carries any indication of quality.

5.2.14.7. REVERSE: FOURTH LINE

The fourth line carries the initials of the owner or producer, such as Cyrillic Ф.Р. [= F.R.] (Fig. 41b), Е П [= E. P] (Fig. 50b), Я П В [= Ya P V] (Fig. 51b) and Я К [= Ya K] (Fig. 55b), or in Cyrillic or Roman M K [= M K] (Fig. 42b).

5.2.14.8. REVERSE: FIFTH LINE

The date showing the year when the bracking process took place stands in the final line of the reverse (Fig. 41; Fig. 42b; Fig. 48b; Fig. 49b; Fig. 53; Fig. 54b).

5.2.14.9. ARCHANGEL VARIANTS

The majority of recorded Archangel seals match the descriptions given above, but there are a few seals issued at this port which differ in detail. In one case we have the name of a producer or agent, in a second the names of the *desyatnik*.

5.2.14.10. SEALS WITH В ЛЕД [= V LED]

A number of seals indicate the owner/producer/agent on the reverse by means of the initial V and the abbreviation LED of the surname (Fig. 47b; Fig. 48b; Fig. 49b; Fig. 52b). Since there are over eighteen possible surnames beginning with Led– and no surname beginning with this combination is cited by either Ogorodnikov or Krestinin in their histories of Archangel it is fruitless to speculate about which surname is represented (Ogorodnikov, 1890, Krestinin, 1792). Eleven of the seals so far recorded are unusual in using italicised forms, whilst in all other respects resembling the vast majority of seals stamped in Archangel from the 1840s onwards (Fig. 52b; Fig. 47b; Fig. 49b). On three seals, dating from 1859, 1862 and 1864 V LED is stamped in plain font (Fig. 49b).

5.2.14.10.1. Seals with V LED

Seal number	Face	Transcription
ADMUS: A1990.315	obv	– – – БРА / ДЕСЯТ / –РО[–][–]ИН / ВЪ– –
	rev	АРХ. [–][–] / КУДЕЛЬ / 2 СОРТЪ / В. ЛЕД / 1868
KIRMG. 1999.207	obv	/ ДЕСЯТ / АЛЕКС. / – УМАК
	rev	ЧЕСКА / 2 СОРТ[–] / В. ЛЕД / 1864
KIRMG. 1999.208	obv	/ ДЕСЯТ / ИВАН / – – –
	rev	АРХ. БР. / КРОНЪ / 2 СОРТЪ / В ЛЕД / 1843
KIRMG. 2006.257	obv	/ ДЕСЯ– / МАТВЕИ / ВЕДЕНСК /
	rev	АРХ. БР / КУДЕЛЬН / 1 СОРТЪ / В. ЛЕД / 18[4][0]
KIRMG. 2006.213	obv	– – – / ДЕСЯТ[Н] / АЛЕКСА – – / ШОРСК – –
	rev	АРХ. БР. / ЗАБРАК / В. ЛЕД / 1839
KIRMG. 2006.216	obv	– – – ОР– / – – / – –/ – –
	rev	– – – – / [К]РОНЪ / СОРТЪ / [В] ЛЕД / 1845
CUPMS: 1986. 983	obv	[АРХ.] БРА /ДЕСЯТН. / ПЕТРЪ / ЖУКО/ВЪ
	rev	АРХ. БР./ ЧЕСКА / 2.СОРТЪ / В [Л]ЕД/1864
CUPMS: 1999.52.1	obv	О / СЯТ/НИКЪ/ В М АТВЕИ/ ВЕДЕНС/КОИ
	rev	АРХ. Б / ЧЕСКА/ 2 СОРТЪ/ В ЛЕ[Д]/ 1851
CUPMS: 1999.52.14	obv	ПОР./ ЕСЯТ / [–]КОВЪ / –ДУПАЕ / ВЪ
	rev	/ ЧЕСКА/ 3 СОРТ / В: ЛЕД / 1857
CUPMS: 1999.54.11	obv	.АРХ.БРА. / ДЕСЯТ:/ [Д]МИТРИ / –ОГОВЪ
	rev	АРХ. Б– / КУДЕЛЬ / 2 СОРТЪ / [В] ЛЕД / 1862
CUPMS: 1999.54.14	obv	АРХ. ПОР. / ДЕСЯТНИК / –АМАНЪ / ЕРОФЕ / ЕВЪ
	rev	АРХ.БР./ КУДЕЛЬ / 2 СОРТЪ / В. ЛЕД / 1859
CUPMS: 1999.55.2	obv	– –Х. ПОР / [Д]ЕСЯТ./ – Р–АТ– / – О –
	rev	АРХ. Б. / ЗАБРАК / В ЛЕД / 1848
CUPMS: 1999.55.3	obv	/ ДЕСЯТ / АЛЕК. ЛОП / ОТОВСКОИ
	rev	АРХ. БР. / КУДЕЛЬН. / 2 СОРТЪ / В ЛЕД / 1838
CUPMS: 1999.56.2	obv	АРХ. / ДЕСЯТСК / ФЕДОРЪ / СО[–]О[–][–][–]
	rev	АРХ. БР. / ЗАБРАК. / В.ЛЕД / 1847
JBC 11	obv	/ ДЕСЯТ / АНТИ[П][А][–][–] / ТУ [В][О]
	rev	АРХ. Б / КУДЕЛ / 1 СОРТ / В. ЛЕД / 1849
HAW 02	obv	/ ДЕСЯТ[С] / ГРИ. СО / ШКОВЪ
	rev	АРХ. / ОТБОРН / 2 СОРТЪ / В ЛЕД / [1]842

5.2.14.11. Seals with the surname Tevelev

Six seals have so far been recovered in Fife bearing the first name Egor and the surname Tevlev, a probable abbreviation of the more usual surname Tevelev (Fig. 53a). They are dated between 1860 and 1890s and on their obverse side have a format quite distinct from that usually found on Archangel seals of this period.

On their obverse four have a circumscription at the top of the seal, giving the rank 'ДЕСЯТЬНИКЪ' [= DESyAT'NIK"], with a soft sign after the 'T' and a hard sign after the 'K', and five show that bracking had been completed at Archangel (Арх. Бр = Arkh. Br) in the last line rather than the first line of the seal. The name Egor Tevelev sits in the centre. One seal, which in format is closer to most of the other seals found in the second half of the 19th century (<CUPMS: 1999.54.12>) is further unusual in being stamped in a font similar to that encountered on seals dating from the late 1820s to 1839 (Section 5.2.13).

Their reverse sides do not differ from others of the period in that they present their information in five lines (Fig. 53b), though one seal (<CUPMS: 1999.54.13>) requires only four since the quality of the goods is assumed in the noun 'zabrack' (Section 4.2) and one seal (<CUPMS: 1999.55.4>) has six lines since 'paklya choska' is written as two nouns on two separate lines, not in one line as occurs on one of the other Tevelev seals (<CUPMS: 1999.57.2>).

5.2.14.11.1. Seals with the surname Egor Tevelev

Seal number	Face	Transcription
CUPMS: 1999.53.10	obv	ДЕСЯТЬНИКЪ / ЕГОРЪ / ТЕВЛЕВЪ / АРХ. БР.
	rev	АРХ. БР. / ЧЕСКА / 2. СОРТЪ / Ф. Р. / 189[–]
CUPMS: 1999.53.16	obv	ДЕСЯТ[Ь]Н– – / ЕГОРЪ / ТЕВЕЛ[В] / АРХ. [–]Р
	rev	АРХ.БРА. / КРОНЪ / 4 СОРТЪ / Д. П. / 1886
CUPMS: 1999.54.12	obv	АРХ.БРА. / ДЕСЯТН / ЕГОРЪ. ТЕ / ВЛЕВЪ
	rev	АРХ. БР. / КРОНЪ / 4 СОРТЪ / Ф. Р./ 1863
CUPMS: 1999.54.13	obv	– – – / ЕГОРЪ / ТЕВЛЕВЪ / АРХ. БР.
	rev	АРХ. ПО / ЗАБРАКЪ / Ф Р / 1874
CUPMS: 1999.55.4	obv	ДЕСЯТЬНИКЪ / ЕГОРЪ [Т]ЕВЛЕВЪ / АРХ. БР.
	rev	АРХ. БР. / ПАКЛЯ. / ЧЕСКА. / 2. СОРТЪ / .Я.К. /189[–]
CUPMS: 1999.57.5	obv	ДЕСЯТНИК / ЕГОРЪ / ТЕВЛЕВЪ / АРХ. БР
	rev	АР– – – / ПАКЛЯ ЧЕСКА / 2 СОРТЪ / Я. [К] / 1894
JS 64	obv	АРХ / ДЕСЯТН / ЕГОРЪ ТЕ / ВЛЕВЪ
	rev	АРХ Б[Р] / ЗАБРАК / В ЛЕД / 1864

5.2.15. Seals from adjacent provinces
The transportation of raw materials and finished goods and artefacts from the interior of Russia to the port of Archangel is well-documented. It is perhaps surprising therefore that relatively few seals have been recovered in Britain which show in which of these other provinces or regions the goods originated. Seals revealing points of origin in the interior of Russia are usually seals connected with Russian railway companies or with the fur trade (Section 5.3; Section 5.4).

However, four flax seals have been recorded which show the original location of the contents of the bundles of flax as other provinces adjacent to or close to the Province of Archangel. Three seals are from the Province of Vologda, south of Archangel, which lay on the main route from the Russian interior to Archangel and one from the Province of Yaroslavl.

The Vologda Province was the second largest in European Russia, in area slightly smaller than Sweden and larger than Britain. To the south east of Vologda lies the Province of Yaroslavl, one of the smallest in European Russia, rich in inland waterways and the starting point of the vast Volga river system. The Volga has 240 tributaries within Yaroslavl Province itself, and there are up to 110 lakes in an area of some 364,000 sq. metres (ES. 13 (VII), 61, ES, 82 (XIa), 820).

5.2.15.1. VOLOGDA
The town of Vologda, an important and strategic trading centre, through which a wide range of goods for export passed, became particularly active after Russian trade links were established with England and Holland in the 1550s during the reign of Ivan the Terrible. With no other port to offer competition Archangel had become the most important port in Russia and Vologda on the main river route to Archangel a most important storage point both for imported goods, and those intended for export. It is a distance of some 1125 kilometres by river from Archangel. It was also able to take full advantage of being situated on a main trade route from Moscow to Siberia which consequently opened up markets to the south and east (Map 4.9.1., Map 4.9.2).

Transportation by water was not particularly difficult, thanks to the many rivers in northern Russia which formed a series of vital arteries in the commercial transportation system of the country. The 558-kilometre-long Sukhona was one of the main tributaries of the Northern Dvina which flows into the White Sea at Archangel. The source of the Sukhona was Lake Kubin from which the river flows south east past Vologda and then turns north west. For one stretch of its journey, as it turns north-east, it is known as the Lower Sukhona. At this point it is on average 180 metres wide and is excellent for navigation, except for a short period in summer when the river occasionally becomes too shallow. Filled by more tributaries it flows on to become the Great Sukhona until its confluence with the River Vychegda where the two then flow north west as the Northern Dvina. Most of the flax fibre produced annually in this region was floated on rafts down the Northern Dvina to Archangel from where it went for export. However, a small amount was retained in Russia and was sent on to factories in Yaroslavl and Kostroma (ES, 13 (VII), 65).

Vologda conducted trade with both Archangel and from the 18th century with St Petersburg, predominantly with the former. Although road traffic existed the roads were particularly prone to becoming seas of mud in the Spring and Autumn. A letter from a St Andrews exporter to his agent in Vologda (now lost) at the being of the 19th century described the problems faced by the agent when dealing with a delayed consignment of salted herring destined for the market in Moscow. The whole consignment of goods had been brought to a halt by the impassable condition of the roads which had turned to mud as the snow melted.

With the foundation of the ports of St Petersburg and Kronstadt, Vologda's situation changed and as the importance of Archangel waned, its close links with the northern port led to a decline in its own fortunes.

Many merchants whose names appear in Archangel sources as holders of senior positions were not only also active commercially in Vologda but were also residents of the town. Some of their surnames occur several decades later on Archangel seals designating their ranks as that of quality control officers, for example Vedensky, Popov-Vedensky and Sveshnikov, which might reflect a decline in the commercial fortunes of a given enterprise and the attendant social decline of the family associated with it.

5.2.15.1.1. Vologda seals
Several seals have been recovered which bear the name of Vologda. However, they give no indication of where the actual bracking procedure took place. The seals differ from Archangel seals in presenting the name of the location in the last line of the undated side rather than in the first line of both sides. However, it is not possible to state with certainty whether this simply signifies that the goods originated in Vologda or whether they were also bracked there. It seems likely that they were bracked in Vologda and then transported by river to the sea port at Archangel (Map 4.9.2).

The first line of the obverse indicates the contents of the bundle, followed in the second by their grade or type. The third line carries the name Vologda. In this lay-out the obverse bears partial resemblance to Tevelev seals (Section 5.2.14.11) which span a period of some 30 years from the 1860s to 1890s, whereas Vologda seals so far recovered are dated 1864 or 1867.

In addition to the date on their reverse the seals carry the name of the enterprise which produced the goods or handled their export. The seals carry in Cyrillic the name of the company Hills and Whishaw, established in Archangel around 1842 by William Whishaw. Section 5.2.8.6.2 (Whishaw 1935, 162).

5.2.15.1.2. Vologda seal (transcripton)

Seal number	Face	Transcription
KIRMG. 2006.208	obv	ЛЕНЪ / КРОНЪ – С / ВОЛОГДА
	rev	И И / ХИ[–] / ИВИ[Ш] [–][–] / 1867
DMP 07	obv	КУДЕЛЬ / Ии СОРТЪ / ВОЛОГДА
	rev	Г Г / ХИЛЛС И ВИШАУ / 1864
DMP 08	obv	КУДЕЛЬ / 2 СОРТЪ / ВОЛОГДА
	rev	Г Г / ХИЛЛС И ВИШАУ / 1864

5.2.15.2. Nizhnaya Sukhona

One seal has been recovered attesting bracking procedures at Archangel, and in addition indicating the specific area where the flax originated, designating the contents of the bundle as Lower Sukhona flax (Fig. 56a; Fig. 56b). It is preserved in the Royal Albert Memorial Museum in Exeter.

On its obverse the seal clearly shows the abbreviation of Archangel Port in its first line 'А П' [= A P], in the second line the rank of Quality Control Officer, described here as 'ДЕСЯЦК' [= 'DESyATsK'], and in the final line his initials, 'М П' [= M. P.]. In its configuration it resembles Archangel seals issued in the 1830s (Section 5.2.12; Section 5.2.13).

However, on its reverse side in place of the information we customarily find on Archangel seals giving the contents, their quality and the year the bracking was conducted, it carries the single adjectival form: 'nizhnosukhonskoi', indicating the type of flax produced in this area of the river Sukhona.

Dew-retted flax from Vologda was famous for its high quality and was cultivated either in fields and forest clearings resulting from slash and burn or in sparse thickets along the rivers Vilegda and Sukhona where the best grades of flax were obtained. Vilegda flax came from the Solvychegodsk region and Lower Sukhona flax from the Lower Sukhona area of the Ustyug region (Map 4.9.2).

5.2.15.2.1. Nizhnaya Sukhona seal

Seal Number	Face	Transcription
EXEMS: 99/1932	obv	А П / ДЕСЯЦК / М П
	rev	НИЖНОСУХОНСКОИ

5.2.15.3. Vilegda seal

The obverse of the seal which is in poor condition is either blank or totally erased.

On the reverse only the last three syllables of the adjectival form 'Vilegodskoi', derived from the river name Vilegda, are legible (Fig. 57), revealing a seal attached to a bundle of flax from the banks of the river Vilegda in the small administrative division of Il'insko-Podolsk situated in the Sol'vychegodsk region (Map 4.9.2).

Vilegda flax was one of the best grades cultivated in this area, along with that from the area around the two rivers Lower Sukhona (Section 5.2.15.2) and Yug. No seals attesting imports from the Yug river area in the Nikol'sky region have yet been recorded. The main market for this area was held in the town of Velikiy Ustyug, situated some 480 kilometres from Vologda (ES 13 (VII), 65; ES 69 (XXXV), 57).

5.2.15.3.1. Vilegda seal

Seal Number	Face	Transcription
KIRMG. E585 04	obv	[Blank]
	rev	– – ЛѢГОДС / КОИ

5.2.15.4. Velikoe (selo) seal

One flax seal, preserved in the Falkirk Museum, shows the original location of the contents of the bundles of flax as the village of Velikoe, some 32 kilometres to the south of the town of Yaroslavl, the main centre of the Province of the same name and an important and strategic trading centre through which a wide range of goods for export passed (Fig. 58).

The most important and widely cultivated crop for trade in Yaroslavl province was flax, especially in the area around the village of Velikoe, and the discovery of this seal provides evidence that flax grown in this area was exported to Britain. The relative scarcity of recoveries of seals of this type is explained in part by the fact that most of the flax fibre produced in Yaroslavl Province was retained in Russia for the production of yaroslavl linen ((Map 4.9.2).

The seal is similar in lay-out to the Lower Sukhona (Section 15.2.15.2), having on its obverse the abbreviation of Archangel Port (А. П.) [= A. P.] in its first line, the rank of Quality Control Officer, described here as 'ДЕСЯЦК' [DESyATsK] in the second line. The two letters in the final line 'Н И' [= N I] are probably the initials of the Quality Control Officer.

In place of the information giving the contents, their quality and the year the bracking was conducted, on its reverse side it carries on two lines the adjectival form: –ЕЛИКОСЕЛСКОИ' ([V]elikosel'skoi), derived from the combination 'Velikoe selo' indicating the type of flax produced in this area of the village (*selo*) of Velikoe (ES, 82 (XLIa), 824–825).

5.2.15.4.1. Velikoe (selo) seal

Seal Number	Face	Transcription
FALKM: 2002.43.08	obv	А П / ДЕСЯЦК / Н И
	rev	– / ЕЛИКО / СЕЛСКОИ

5.2.16. Russian words and abbreviations in Cyrillic on Archangel seals

	Russian forms	**Transliteration**	**Meaning**
1.	А.	A.	
	АРХ.	ARKh	
	АРХА	ARKhA	Archangel
	АРХАНГ	ARKhANG	
	АРХАНГЕЛ.	ARKhANGEL.	
2.	Б.	B.	
	БР.	BR.	
	БРА.	BRA.	Brack, Quality control
	БРАКЪ	BRAK"	
3a.	ДЕСЯТН.	DESyATN.	
	ДЕСЯТНИКЪ	DESyATNIK"	
	ДЕСЯТЬНИКЪ	DESyAT'NIK"	A low-ranking official charged with supervising the quality control of exported goods.
3b.	ДЕСЯЦК.	DESyATsK	
	ДЕСЯЦКО	DESyATsKO	
	ДЕСЯЦКОИ	DESyATsKOI	
3c.	ДЕСЯСК	DESyASK	
	ДЕСЯТС.	DESyATS.	
	ДЕСЯТСК	DESyATSK	
3d.	ДЕС	DES	
	ДЕСЯТ	DESyAT	
4.	КРОНЪ	KRON"	High-quality flax; Crown
5.	КУДЕЛЬ	KUDEL'	
	КУДѢЛЯ	KUDELyA	Tow
	КУДЕЛЬН	KUDEL'N	
6.	ЛЕНЪ	LYON	Flax
7.	ЛНА БРАК	LNA BRAK	Flax Brack
8.	ЛНЯН БРАК	LNyAN BRAK	Flax Brack
9.	НИЖНОСУХОНСКОИ	NIZHNOSUKHONSKOY	Flax from the region of the Lower Sukhona river
10.	ОТБОРНЫИ	OTBORNYI	Select
11.	ПАКЛЯ	PAKLyA	Codilla
12.	ПЕН	PEN	Hemp
	ПЕНЬКА	PEN'KA	
13.	П	P	Port
	ПО	PO	
	ПОРТЪ	PORT"	
14.	P	R	Grade, Class
	РУ	RU	
	РУКА, РУ, Р	RUKA, RU, R	
15.	С	S	Sort, Kind, Grade
	СОРТ	SORT	
	СОРТЪ	SORT"	
16.	ЧЕСКА	CHOSKA	Low-grade heckled Flax
17.	ВИЛЕГОДСКОИ	VILEGODSKOI	Flax from the region of the Vilegda river.
18.	ВЕЛИКОСЕЛСКОИ	VELIKOSEL'SKOI	Flax from the region of the village of Velikoe
19.	ВОЛОГДА	VOLOGDA	Vologda
20.	ЗАБРАКЪ	ZABRAK	Lowest quality flax, Zabrak, Zebrack

5.2.17. Quality control officers (desyatniki)

The number of legible surnames recorded on Russian seals exceeds 650. Flax and hemp seals from virtually all Russian sources carried on their obverse side the surname of the *desyatnik* (Quality Control Officer) responsible for overseeing the grading of the fibres presented by merchants and agents after which they were bound by a trained binder (*vyazal'shchik*) before being loaded for export. They worked under the guidance and supervision of a bracker (*brakovshchik*), to whom they would refer any goods failing to reach the required standard (Section 3). The *brakovshchik* was a merchant of some standing in the business community who was elected to this onerous but undoubtedly tedious task by other merchants. An even number of Russian and foreign merchants were elected at any one time, their number increasing or decreasing at different periods. The names of brackers are recorded in a number of sources. In 1823, for example, Aller recorded some twenty-eight names of flax and hemp brackers, of which twelve are not Russian, alongside 33 names of brackers of other goods, such as caviar, wax, glue, bristles, potash, herring and tobacco (Aller 1822, 514–515).

By contrast, Quality Control Officers (*desyatniki*) are named infrequently in written sources, which makes Russian lead-alloy seals a vitally important source of information about those more lowly officers whose daily occupation was the bracking of flax, hemp, tow and codilla in Russia from the mid-18th to the early 20th centuries. The surnames of

a few *desyatniki* are found in the records of the '*Committee on the Supervision of Bracking in the years 1825–1885*', but the surnames which have come down to us are those of unfortunate hemp or flax inspectors who had either fallen into debt between 1838–1871 (Mikhail Belenkov, Matvey Petyshev, Aleksey Protopopov, Petr Samuilov and Ivan Nemilov) or had defaulted in the payment of their debts (Emelyan Filatov, Anton Shelkov and Afanasiy Astrakhov) (RGIA 19, 6, 1825–1885). However, it is interesting to note that nearly all these surnames, if not the individuals themselves, are known to us from lead seals recovered in the UK.

5.2.17.1. Determining the surnames of desyatniki (quality control officers)

On many seals the surname cannot be determined, owing either to its total illegibility or, quite commonly, to the illegibility of certain crucial letters. However, even when the seal is barely legible, a certain degree of reconstruction can be made which will enable the surname on the seal to be deciphered with sufficient confidence. The problems which might arise are caused by a number of different factors.

There are several instances of die-makers omitting letters from a particularly long surname. Instances of abbreviations which occur on seals include 'Kudyaev' for 'Kudryaev', (<ADMUS: A2000.212>), 'Vaviov'' for 'Vavilov'' (<CRMCH: 1991.38.7>) and Skoroogatov' for 'Skorobogatov' (<GMcA 13>; <CUPMS: 1999.53.21.>).

Whilst it is in some cases possible to suggest the surname of the Quality Control Officer either on comparative grounds or grounds of statistical likelihood, in many cases the options are so varied or numerous as to render transcription impracticable. For example, on one seal (<CRMCH: 1996.037.04>) all that can be deciphered of the surname are the first two and last two letters (KO- and -OV). Judging by the space where other letters have been erased there were probably two middle letters. At least 24 six-letter surnames with KO- and -OV can be put forward, some of them quite common (Koblov, Kovrov, Kozlov, Koskov and Kotkov). By contrast, in a situation such as obtains with the seal <FF 22> on which we can read the letters Kher[–][–]kov, the only likely surname is Kheraskov, the 18th-century Russianised version of the Romanian surname Herescu (Unbegaun, 360). In some cases, probability or other evidence on the seal, such as the Post number, might favour one name rather than another but a degree of uncertainty must remain. For example, on the seal <JS 07> the letters that can be read with certainty are VOL–OV. The surname can be read as Volkov, which is recorded on five other seals, but other possibilities (Volkhov, Volgov or Volnov) exist and consequently our interpretation of the name as Volkov must remain tentative. However, in this particular case the interpretation Volkov in place of Volkhov, Volgov or Volnov is greatly strengthened by the fact that in this and the other four recorded instances of the surname Volkov the seal was issued from the same post, No. 78.

Errors or spelling variations on the dies used for stamping surnames raise a different type of problem in establishing the identity of the *desyatnik*. The die-maker seems to have used the spoken form of the surname, either direct from the Quality Control Officer or from a list of Quality Control Officers prepared on the basis of the spoken form. Bearing in mind further that in the later 18th and early 19th centuries the level of literacy among a large part of the population in Russia was not high and that Russian orthography was still to some extent fluid, variations in spelling are to be expected. These were brought about in the main by the fact that the quality of a number of vowels was modified according to the position in which they occurred in a word or phrase in spoken Russian. A few surnames appearing in slightly different forms may be regarded as the same surname. The most important modifications were:

1. Unstressed 'O' in an initial position could be pronounced as 'A'; e.g. the surname Orlov, stressed on the second syllable would be pronounced Arlov (<ABDM. 072683> (Arlov); <KIRMG. 2006.223> (Arlov); cf HARGM.12706.5 (Orlov)).
2. 'O' in the syllable immediately preceding the stressed one would be pronounced as 'A'; e.g. the surname Morozov would be pronounce as Marozov (<NLA (HER) 25178> (Marozov); <CUPMS: 1999.54.33> (Marozov); cf <FALKM. 2003.3.2> (Morozov)); and Pogankin as Pagankin (<CRMCH: 1999.38.3> (Pagankin); cf <CUPMS: 1999.57.11> (Pogankin)).
3. Unstressed 'O' could less frequently be pronounced as 'A'; e.g. the surname Korolev which is stressed on its final syllable could appear as Karalev (<HARGM.13606.6> (Karalev); cf <MoL 2006.7/5> (Korolev).
4. Unstressed 'E' could be pronounced as 'I' (Cyrillic 'И'); e.g. the surname Levshev which is stressed on its final syllable could appear as Livshev (<ADMUS: M.1998.156> (Livshev); <MM. 2006.12> (Livshev); cf AMu 09 (Levshev).
5. Stressed 'E' before a hard consonant, especially when following 'Zh' (Cyrillic 'Ж'), 'Sh' (Cyrillic 'Ш') or 'Shch' (Cyrillic 'Щ'), was pronounced as 'O'; e.g. the name Shchegolev, which is stressed on its first syllable, could appear as Shchogolev (<CUPMS: 1999.55.23> (Shchogolev); <JH(L) 07 (Shchogolev);>; <AHM 01> (Shchogolev); cf KIRMG. 2006.297> (Shchegolev)).
6. Stressed E after the consonants 'Zh' (Cyrillic 'Ж'), 'Ch' (Cyrillic 'Ч'). 'Sh' (Cyrillic 'Ш'), 'Shch' (Cyrillic 'Щ') and 'Ts' (Cyrillic 'Ц') can appear as 'O'; e.g. the name Shipachev, stressed on its final syllable, appears as Shipachov (<KIRMG. 2006.303> (Shipachov); cf <ST 03> (Shipachev').

5.2.17.2. Surnames of desyatniki (quality control officers)

Of the surnames so far recorded, 13% appear on seals from the port of Archangel (Section 7.1), 38% on St Petersburg seals carrying the abbreviation S P B (Section 7.2), 42% on seals with initials N P (Section 7.3) and 7% on seals with the intials W U or W K (Section 7.3.1). Of these surnames only 36 occur on seals from more than one of the places of origin listed.

The single initial which sometimes accompanies the surname is that of the Christian name. On very few occasions do we find a second initial, that of the patronymic derived from the Christian name of the Officer's father. Regrettably, initials are not always included or are frequently

illegible. The patronymic is essential, but not conclusive in determining any possible close family connection between Quality Control Officers with the same surname working at different posts, in different ports or at different periods. A different second initial would be a clear indication of different fathers. However, identical second initials raise no more than the possibility of a close relationship since officers sharing the same second initial might have had fathers with different Christian names beginning with the same letter, for example, Alesksandr, Aleksei, Andrei, Anatolii, Anton.

By contrast, on later seals from Archangel the surname is accompanied by a Christian name, either in full or in an abbreviated form.

5.2.17.3. ARCHANGEL DESYATNIKI (QUALITY CONTROL OFFICERS)

On Archangel seals dating from 1813 to 1839 the identity of the *desyatnik* is conveyed only by his initials, which is insufficient for us to ascertain his Christian name and surname.

However, from the late 1830s, seals carry a surname, often accompanied by a Christian name. The surnames may appear in full as with Vasilei Babikov (Fig. 42a) or in an abbreviated form, for example, as Shary for Sharypov (Fig. 55a) or Petr Martya for Petr Martyanov or Martyanychev (Fig. 50a). On a total of over 190 Archangel seals so far recovered 88 carry surnames which belong to 56 different individuals (Section 7.1). The most frequently recorded are Matvey Vedenskoy whose name appears on seven seals from the 1840s and 1850s (Fig. 52a) and Egor Tevelev whose surname, abbreviated to Tevlev, is found on six seals dated between 1863 and 1890s (Fig. 53a). A number of merchants by the name of Vedenskoy who used the port of Archangel are recorded as residents of Vologda (Vorontsov, 571, 298). We have several records of the names Petr Zhukov, Popov-Vedenskoy (Fig. 51a) and Mitrofan Sharypov (Fig. 55a). The surname Bulychev occurs on four seals with three different first names Aleksei, Ivan and Vasilii. The absence of a patronymic or its initial prevents us from determining whether the brackers were in any way related. Absence of a patronymic also hinders our interpretation in the case of Vasilii Bryukhanov, a name which occurs on one seal dated 1847 and another dated 1870, raising problems in judging whether his career as Quality Control Officer spanned at least 23 years or whether we have two different, albeit possibly related, officers.

5.2.17.4. ST PETERSBURG DESYATNIKI (QUALITY CONTROL OFFICERS)

On over 360 seals from St Petersburg surnames are legible on more than 260 of them, out of which approximately 170 different surnames are recorded (Section 7.2) Several occur more than once, e.g. Tarpchinov, I. Chupyatov, S. Filatov, Klyuev and U. Khramtsov.

As with Archangel seals some surnames which are listed more than once occur with different initials (Section 7.2). The surname Vorob'yev occurs on four seals but with two sets of initials (A or D). We know from other sources that both Petr and Mikhailo Kaltushkin worked as brackers of tow in the early 1840s, but have no way of establishing with certainty whether they had any family relationship. The surname Kostin is recorded with five different initials and Kudryaev with four.

The surname which appears on one seal (<SFl 03>) as Egor'evo seems to be an error in which the hard sign normally occurring at the end of a surname otherwise ending in a consonant has been replaced by 'o', usually reserved in Russian for place-names. Although surnames in 'ovo' do occur they number less than ten and are derived from nicknames in the form of adjectives, whereas the parent stem of Egor'evo is the Christian-name form Egoriy, one of the Russian forms of the name 'George' which usually motivates the surname Egor'ev.

5.2.17.5. Other desyatniki (quality control officers)

Seals bearing initials, such as N P, W U and W K, number over 400 and provide us with 157 different surnames on seals with the initials N P (Section 7.3) and 6 surnames on the 10 seals with the initials WU or WK (Section 7.3).

On other seals with N P we note the surnames Pirozhnikov which occurs eight times, twice with the initial I but more commonly with V. A. Other recurring surnames include Ivanov, Kononov, Mesnikov, Nikiforov, Plotnik, Shchogolev, Shyrovskoi, Simanov, I. Vinnik(ov) and Zemskoi.

On one seal, dated between 1800 and 1809, the surname Shchogolev is found in its feminine form, with the initial P: Shchogoleva. Whilst one seal in the Museum of London (<MoL: 81.522/40>) also indicates a woman at the head of an enterprise: M. I. Odnoushevskaya and Sons (Section 5.6.3.3) the likelihood is small that the name Shchogoleva in this case refers to a woman carrying on her own duties or those of her husband, since it is improbable that a woman would take on employment as a Quality Control Officer engaged in the day-to-day manual task of grading flax and hemp (<ADMUS: M1995.157>). Consequently we have to acknowledge the likelihood of an error, as we find with Egorovo (Section 5.2.17.3), or perhaps the puzzling use of the masculine genitive singular.

On some seals where the surname is legible, it is not possible with certainty to identify their port of origin (Section 7.3.1). Some are found on seals whose provenance can either be clearly established, such as Chernikov, Larionov, Nadezhin and Prototopov which are found on SPB seals (Section 7.2) or proposed, as with Babonin, Chernikov, Dem'yanov, Ivanov, Malygin and Vinnik(ov) on seals with N. P. (Section 7.3). The surname Shchogolev/Shchegolev is found either with the initials V. or P. Alternative spellings are quite acceptable from the phonetic viewpoint (Section 5.2.17.1).

It is certain that many *desyatniki* worked from the same Post number throughout much of their working life. The data shown in Section 7.8 not only paint a striking picture of individuals working for decades from the same numbers, but also allow us to track the movements of the individual if he were transferred from one post to another.

For example, on the basis of the information contained on five seals with the name Vavilov we can assume that Vavilov was working at Post 47 from at least 1762 (2 seals have this date (< JH(L) 05>; <JH(L) 06>) and another 1765 (<BR(B) 01>). A fourth carries a date in the 1770s (<HAW 04>), suggesting that he spent at least from the beginning of the 1760s to some time in the 1770s working from the same post. Two seals stamped with the later date 1779 show him working from Post 24 (<CRMCH: 1991.38.7>; <NMS 25.9.93. F1>). From other seals we know that by 1785 Post 47 which had figured so much in Vavilov's career was occupied by an Officer called Zemskoi (<JSm 01>). It seems therefore that Vavilov transferred from Post 47 to Post 24 sometime in the early or mid-1770s. Intriguing questions remain concerning whether by 1785 he had actually left the service, had died or was working elsewhere or was still at Post 24. Later references to Post 24 so far recorded relate to 1816 and 1818 and show that it was by then occupied by Yurkovskiy in 1816 (<NMS (Stoney Hill)>) and Drozhdin in 1818 (<AC 01>).

A number of seals provide important evidence for the identification of the port of origin of seals bearing the initials N P, W K or W U in the first line of their reverse. They carry identical initials and surnames and were stamped either with initials SPB and NP or with NP and WK.

Their contents can be summarized as follows:

On S P B and N P seals:

Surname	Post no.	SPB seals	NP seals
Aref'ev, N.	88	FALKM 2002.43.01 (1830); KIRMG. 2006.288 (1837))	LWMCH No. 2 (1790)
Erokhin, S.	49	CUPMS: 1998.6.3 (1830s)	CUPMS: 1999.54.4 (1820s)
Nadezhin, I.	4	ADMUS: M1995.163 (1833)	CUPMS: 1999.54.8 (1820s); CUPMS: 2000 (5) (1820s); WmK 02 (1800)
Pogankin	27	CUPMS: 1999.52.28 (1833)	CUPMS: 1999.52.38 (1825); CUPMS: 1999.54.48 (1826); LCM. 90.36/7 (1818)
Polovokhin, P.	81	CUPMS: 1999.57.11 (19th c.)	CUPMS: 1999.52.36 (1825)
Volkov	78	KIRMG. 2006.285 (no date); CUPMS: 1999.53.38 (1843)	KIRMG. 2006.229 (1821); JS 07 (1820)
Zamarin	17	CUPMS: 1999.52.29 (1839)	HARGM: 13606.2 (1810s)

and on W K and N P seals:

Surname	Post no.	W / W. K. seals	NP seals
Annibal, S.	86	CRMCH: 1990.3.5 (1775); CRMCH: 1990.3.19 (1775); CRMCH: 1990.3.20 (1775); CRMCH: 1991.04.7 (1775)	CRMCH: 1991.29.04 (1775)
Vavilov	47	JH(L) 05 (1762); JH(L) 06 (1762);	BR(B) 01 (1765); HAW 04 (1770s)

Although we might be inclined to dismiss these cases as examples of the coincidence of surnames and initials, we cannot but be struck by the fact that the number stamped in the last line of their obverse side is the same in the case of each surname. Given that this number represents the post at which the individual Quality Control Officer worked, as was shown in Section 5.2.6.3, the coincidence of these numbers in each case would suggest that these particular Officers worked from the same point throughout the whole or part of their careers, in the case of Vavilov for at least a period of 23 years and in that of Aref'ev for a period of some 40 years.

Consequently, it is evident that the initials N P also refer to the port of St Petersburg. When the system which required *desyatniki* to work from the same number for a long period is set alongside evidence from the distribution of dates on the seals which shows that the cessation of use of the initials N P was quite abrupt (Section 5.2.18), we must conclude that seals with the initials N P were also issued in St Petersburg. Furthermore, recorded seals with the name Annibal, four with the initials W. K, and two with N. P, all of which have the same post number, confirm the view that seals with W K and W U also originated in St Petersburg. The five 1775 seals with the name Annibal were found in Cromarty, and a sixth, dated 1776, was recovered from School Lane, Kirkham, near Preston (PG 16, Section 6.5 (a05)).

5.2.18. Date of Russian flax and hemp seals
The table in Section 5.2.18.3 includes Russian seals recorded in Britain, which were attached in the binding of bundles of flax and hemp. A detailed breakdown of the dates is given in Section 7.4. None of the flax seals from Riga bears a date (Section 5.7.1).

Seals connected with other trades and occupations have been recorded but not included in Section 5.2.18.3. Four seals, the precise commercial activity connected with which is not clear, were used by different Russian railway

companies. Three carry dates from the first decade of the 20th century (Section 5.3). Some 35 undated seals from Vladimir province are connected with the fur trade, along with five seals indicating Siberia as the origin of the pelts (Section 5.4), but none of these carries a date.

The function of a number of other Russian seals cannot be definitely identified and the commercial activity connected with some of the others is not clear. The fact that they carry no dates suggests that they were not used as part of any official control but were rather a way of identifying the firm by which they were issued or were simply a means of advertising its goods (Section 5.6).

5.2.18.1. DATES AND PLACE OF ISSUE OF RUSSIAN FLAX SEALS
It is clear from the table in Section 5.2.18.3 that the different styles of flax and hemp seal fall into quite distinct periods, some quite short, some spanning many decades. Seals with the initials N. P. form the largest group and range in date from the 1770s to an abrupt cessation towards the end of the 1820s. Seals with the initials SPB appear concurrently with them until the end of the 1820s when recoveries adopted a modified configuration which itself ceases in the 1840s. The situation is similar to the picture painted by Petrov in his study of Customs seals issued in south Russia between the 1860s and 1910s which also show an abrupt change of style, in the 1880s, the decade when both the earlier and later styles were used (Petrov, 1988, 296–97).

From the last three decades of the 18th century 64.5% of recoveries of flax/hemp seals bear the initials N P, whilst 35.5% have SPB. With the exception of a few early examples, seals from St Petersburg bearing the initials SPB fall mainly in the period 1770s to 1840s, most commonly in the 1830s. When the evidence from the second line of their reverse sides which shows two distinct systems of codification, one associated with the initials SPB (Section 5.2.5.3) and the other in the main with the initials NP (Section 5.2.5.7) is linked with the abrupt way in which records of NP seals ceased, one is drawn to the conclusion that the seals with the initials NP are earlier or variant forms of St Petersburg seals on which the initials SPB were not stamped. Further evidence suggests that seals with the initials WK, WU etc were also issued in St Petersburg (5.2.17.5). For five decades prior to 1830 the two styles existed in parallel, with more seals carrying N P than SPB. However, in 1829–30, the two styles of describing goods and their quality were replaced by a single system in which the N P initials were discontinued.

Recoveries of Archangel seals cover a definite, albeit longer period mainly from the 1830s to the turn of the century, with a decrease in the 1850s. However, the discovery of a single hemp seal from 1813 which in size resembles those from St Petersburg, provides evidence that in some cases lead seals had also been issued in Archangel at least from the end of the Napoleonic Wars. Their size increased at the end of the 1820s and their configuration changed at the end of the 1830s.

No goods were shipped from Russian ports in 1854–55 as a consequence of the blockade imposed during the Crimean War (ES, 34 (XVIIa), 544) when large quantities of Russian flax found its way to Prussian ports whence it was exported to Britain. Details of the Archangel seals recovered from the 1850s shows three dated 1851, one from 1852 and none from the period 1853–1856, with a stuttering resumption from 1857 with three recoveries, followed by three dated 1859.

5.2.18.2.
A word of caution needs to be sounded if one attempts an investigation of the distribution of the seals in the UK, since recoveries are often concentrated in certain areas of the country. Of all the seals recorded with dates in 1770s about one half were recovered from the area around Cromarty on the Black Isle, north of Inverness where flax spinning had been introduced and carried on in the 18th century, but by contrast very few recoveries were made from the 1790s. Early examples have also been recovered in the area around Preston and the Lune Valley where a spinning mill at Kirkham, a small borough close to Preston, was inherited by Thomas Langton in 1762. His wide commercial activities which included trade with the Baltic and St Petersburg are reflected not only in the number and dates of finds, but also the other information stamped on them. The Harris Museum in Preston and members of the local Metal Detectors' Club have 23 seals dating from 1758 to 1826, seven of which are from 1760s, five from 1770s and 1780s and six from 1790s. By contrast the relatively nearby museums of Lancaster hold eleven seals, four from the late 18th century and six from the early 19th century. The only Archangel seal in these collections, which was found at Green Ayre, Lancaster is dated 1846 and reveals the continuance of trade well into the middle of the 19th century. The paucity of later finds reflects the decline in Lancaster's maritime trade and its sail and cordage industries after 1800. However, we must bear in mind that such a distribution might be a reflection of the metal detecting activity in one area rather than another, even a neighbouring one, which has lead to a somewhat distorted picture of their geographical and chronological distribution and of flax and hemp industrial activity.

Four fifths of the recoveries of seals dating from 1820 onwards have been made in Scotland, two thirds of which were made in Fife. The third decade of the 19th century witnesses an almost total shift of recoveries to Scotland.

Furthermore, of the Scottish discoveries from this decade the majority (71%) was recovered from sites in central and north-east Fife, an overwhelming majority of the finds from central Fife being recovered from a single area in which much metal detecting activity has taken place.

5.2.18.3. Dates of Russian flax and hemp seals

Decade	*1 Arch	2 St P	3 NP	4 WK/ WU	5 Origin unclear	Decade Total
1740–49	0	5	1	0	0	6
1750–59	0	0	15	4	2	21
1760–69	0	5	16	5	3	29
1770–79	0	33	46	6	6	91
1780–89	0	30	35	0	9	74
1790–99	0	24	74	1	14	113
18th c.	0	7	9	2	3	21
1800–09	0	27	69	1	12	109
1810–19	1	18	33	0	9	61
1820–29	1	36	88	0	13	138
1830–39	26	129	0	0	9	164
1840–49	27	28	0	0	2	57
1850–59	17	3	0	0	0	20
1860–69	**27	0	0	0	0	27
1870–79	33	0	0	0	0	33
1880–89	27	0	0	0	0	27
1890–99	13	0	0	0	0	13
19th c.	13	20	13	0	7	53
1900–10	1	0	0	0	0	1
Date Indet.	12	21	14	0	44	91
Total	198	386	413	19	133	1149

* Column 1 Archangel; Column 2, St Petersburg; Column 3 Unprovenanced NP; Column 4 Unprovenanced WK / WU; Column 5 Origin indeterminable
** includes four seals from Vologda
*** includes three seals with flax from Nizhnyaya Sukhona, Vilegda and Velikoe.

The entry marked 'Origin Indeterminable' lists seals cropped or otherwise damaged in such a way that no port or town of origin can be determined and the line marked 'Date Indeterminable' lists seals damaged in such a way that the date cannot be read with certainty.

5.2.18.4.

Overall, the seals reveal considerable economic activity in the late 18th century and again following the Napoleonic Wars in the 1820s and 1830s. Trade through the port of Archangel was quite substantial until 1851 when the deterioration in British-Russian relations eventually led to the outbreak of war in the Crimea rendering Russian ports unavailable to British mercantile shipping. In addition, the compulsory system of quality control of hemp, flax and tow which had originally given rise to the use of lead-alloy seals was abolished in the port of St Petersburg in January, 1860. In part this was because the system had been breaking down since the 1840s, a fact reflected in the scarcity of seals from St Petersburg from this period onwards.

There was a sharp decline in the number of St Petersburg seals from the 1840s, though trade through the port of Archangel continued up to 1851, picking up again in 1857 after the signing of the peace treaty in Paris brought an end to the war in the Crimea in 1856. The reduction in the quality of flax at St Petersburg which foreign merchants commented on led to buyers themselves losing confidence in the brack system which resulted in their seeking sources elsewhere. The amount of flax and hemp exported to Britain had fallen from 14,299 and 35,587 tons, respectively, in 1838 to 7,505 and 22,781 tons by 1841. However, the bracking system continued to be strictly observed in Archangel and Riga, and the quality and quantity of goods exported from these ports reflected this (Warden 1864, 327).

However, these factors in themselves are not sufficient to explain the decline in the use of seals from as early as the 1840s. Amongst a series of other causes which played their part, one was the increase in imports of jute from India especially to Dundee, one of the immediate consequences of the Napoleonic Wars when difficulties in obtaining flax and hemp led to a marked decrease in the import of these fibres. A further problem was undoubtedly the economic crises which Britain experienced in the 1840s, especially 1841, which resulted in a general cessation of trade, and in 1847 when international trade in general suffered. However, there were years, such as 1848, 1849 and 1850, when exports seem to have held up.

Natural disasters appear to have had little impact on the export of goods. The most serious flood in St Petersburg in November, 1824 when the Neva rose more that four metres and submerged a large part of the capital seems to have occurred late enough in the year not to have affected the export of flax to any large extent, and a cholera outbreak in St Petersburg in 1831 had no major impact on the number of seals dated 1831 and 1832.

Finally, a further important development which led to the eventual abandonment of a compulsory bracking system and the lead-alloy seals associated with it was the extension of the railway network which towards the end of the 19th century opened many more possible border crossings, making the system unmanageable and uncontrollable.

5.2.19. Initials of producers/owners/agents

Legible sets of initials standing in the third line of the reverse side of Archangel seals number thirteen and span the period from the 1830s to the beginning of the 20th century (Section 7.5.1). Although five of them consist of letters which also occur in the Roman alphabet, from a stylistic viewpoint they all resemble Cyrillic initials. The most frequent are Е П [= E P] (44 seals), Ф Р [= F R] (30 seals), Я К [= Ya K] (19 seals), Я П В [= Ya P V] (19 seals), В Д [= V D] (12 seals), А Р [= A R] (11 seals), М П [= M P] (10 seals) and M K [= M K] (8 seals). A number of seals from Archangel adopt the abbreviation of the surname, preceded by a single initial: В ЛЕД [= V LED] (Section 5.2.14.10).

Alterations around 1829 to the format of St Petersburg seals carrying the SPB abbreviation introduced sets of initials denoting agents or producers on these seals too. Some 37 different initials have so far been recorded (Section 7.5.2). The most frequent are I H (18 seals), P K (9 seals), I P (9 seals), M C [= M S] (8 seals), Д Х [= D Kh] (7 seals), F W (8 seals) and А И Г [= A I G] (6 seals).

Regrettably, sources do not make clear the status of the individuals whose initials are recorded and it is impossible to ascertain the exact standing or activity of the individuals or companies indicated.

Three sets of initials appear on St Petersburg and

Archangel seals: Е П [= E P], М К [= M K] and М С [= M S], but there is no reason to believe that this is but coincidental.

5.2.20. Letters and digits on the reverse of Russian lead seals

Until the late 1820s seals originating in ports other than Archangel carried in the third line of their reverse a series of letters and numerals which formed a codification of the contents and grades of fibre contained in the bundles to which they were attached (Section 5.2.5.3; Section 5.2.5.7; Section 5.2.5.12).

The number of legible combinations is extensive, in the region of 145 on seals stamped S P B and 220 on seals stamped N P, W K and W U. However, a far greater number of seals are not completely legible owing to corrosion and other damage to the seals over the last two centuries. Combinations, which can be read with certainty, are listed in Section 7.6.

The difficulties in determining whether some of the letters are Cyrillic or Roman raise the same problem of decipherment as was discussed in Section 5.2.5.3. Strings of initials which could be Cyrillic or Roman include O P P H (1825) and I B P H (1806) (Section 5.2.5.3; Section 5.2.6.5).

On St Petersburg seals with the initials S P B the use of both letters and digits is rare before 1829. Where digits do occur they are in the majority of cases 1, 2, and 3, corresponding to the grades of the goods in the bale, i.e. grade 1, grade 2 and grade 3. Combinations with Roman letters include A G P H (1816), D H R H (1789), I H R H (1770s) (Fig. 10b), P B A H (1792), P F A H (1790s) and T L A H (1824). A number of strings also contain letters which include both Cyrillic and Roman letters, e.g. А Ш R H (1794), И Ф R H (1821), Ф H R H (1782) and М Б R H (1818).

Information stamped on seals with N P, W K and W U consists of a series of both letters and digits, in which the latter are 12, 9 or 6: I M Б 12 (Fig. 16b) and F 12 H (Fig. 17b). Typical combinations of Cyrillic letters are: А Б 12 Н (1819), А С Х 12 Н (1777 and 19th c), С Ч 12 Н (1804), А Ч 12 Н (1778–1814), Ф К 12 (1780s), И Ф 12 Н (1814) and П Ч 12 Н (1826) (Fig. 18b). Combinations with Roman letters are: C Z 12 N, (1779–88), F W 12 H (1813) (Fig. 23b), I C Z 12 (1782), I C 12 (1826), O P 12 H (1813), P L 12 H (1825). The combination of Roman and Cyrillic is infrequent in this group: A N 9 Ѳ E (1753) and N 12 Ч (1783).

From the end of the 1820s the configuration of seals which had hitherto been stamped with S P B, N P or W K etc was modified. Uniformity was introduced in a way that affected in particular the second line of the reverse. From now on seals carry a different style of codification in Roman or Cyrillic letters of the contents of the bundle. The new style is quite different from that found on those earlier seals which used the Roman letters N P (Fig. 7b, Fig. 13b) or less frequently No P or in Cyrillic Но П. (Fig. 14b). The numerals recorded are 1, 2 and 3, e.g. Но 1; Но 2; Но 3; Но П 2; Но П 3; NP – 2 and NP – 3 (Section 7.6.1).

5.2.21. Initials on the obverse and reverse of St Petersburg seals

The significance of the initials which stand in the first line of the obverse and reverse of seals issued in St Petersburg was discussed in Section 5.2.3.1, Section 5.2.4.1, Section 5.2.6.1, Section 5.1.5.2 and Section 5.2.5.6. In the vast majority of cases the first line obverse carries the initials Л Д [= L D] indicating 'flax inspection'. The initials П. Д. [= P D], indicating 'hemp inspection' also occur frequently. With the exception of the initials П Л П Д [= P L P D] the significance of the other initials which are noted on the obverse is not clear. On the reverse we find the initials indicating the locality of the inspection S P B for St Petersburg, but the exact location of N P within St Petersburg or its significance remains unidentified.

A different combination of letters is found on seals bearing two surnames (Section 5.2.7, Section 5.2.7.1).

5.2.22. Post numbers on Russian seals

The numerals which appear in the last line of the obverse on St Petersburg flax and hemp seals have been interpreted in various ways, having been more frequently considered to be the number of the sealing irons issued to the *desyatnik*, or even the number of the wharf at which he worked (DuQuesne-Bird, 1970, 227; DuQuesne-Bird, 1972, 277; MacGregor 1985, 157).

The evidence provided by the seals themselves suggests that they indicate the Post from which the *desyatnik* worked. As was demonstrated in Section 5.2.6 and Section 5.2.17.5, in many instances the number remained the same irrespective of whether the intials stamped in the first line of the reverse were S P B, N P or W K. They reveal that many *desyatniki* worked from the same position for a period of several years. For example, in the following examples it is possible to establish a date by which the officer had started working at a post and a date when he was still working there: S. Filatov at Post 2 between 1831 and 1838, U. Khramtsov at post 6 from 1787 to the 19th century, Malygin at Post 23 from 1819 to 1825, Molchanov at Post 36 from 1803 to 1806 and Vasil Istin at Post 332 from 1778 to 1784. There is also evidence that members of the same family occupied the same Post, e.g. Ya and P Kuchkov both worked at Post 62, one in 1794, the other in 1802.

On the other hand, the data for some posts is so varied that no period of time for any individual *desyatnik* can be established. L. Lobkov is recorded at post 8 in 1822 and another Lobkov, whose initial we do not have, in 1838. However, by 1831 this post was occupied by P. Shcherbakov, who perhaps was working alongside one of the other two, or he might have replaced L. Lobkov by 1831, only for himself to be replaced by a different Lobkov (son or brother?) some seven years later.

However, as we saw with Vavilov in Section 5.2.17.5, it is possible to track the movements of an individual officer over a period of several decades.

5.3. Railway seals

With the development of the Russian railway system in the second half of the 19th century when nearly twenty major railway lines were constructed in European Russia, goods were at times transported in special, sealed packaging or in sealed wagons. Four Russian railway seals have been recovered from quite different parts of the UK and were used for sealing either the wagon in which the goods were dispatched or the container being shipped to Britain.

Collections of railway seals which have inscriptions giving the name of the station, the railway company or line and the date when the seal was stamped are held by a number of Russian museums. Most seals which have been recovered in Russia appeared from the 1870s onwards, the largest number of finds dating from the first two decades of the 20th century. Many of the seals dated 1917 were connected with Russian rail transport in World War I (Ogneva 1993, 18; Petrov, 1988, 298).

5.3.1.

One example was recovered in Britain at Cambuskenneth, near Stirling, and is now housed in the museum in Falkirk. It measures 28mm × 27mm. Its obverse shows that it was issued on 26 August, 1903 at the station in the Crimean town of Taganash which lies 19 km. to the NNE of Simferopol' (*Al'bom*, 1944, Map 44) (Fig. 59a). Its reverse indicates that it was issued by the Kursk-Kharkov-Sebastopol Railway and gives a control number A767, in which the A is the serial number and 767 the number of the entry in the Register kept at the station where the contents of the sealed wagon would have been entered (Fig. 59b). There is no way of discovering the exact contents of the wagons unless the original Register Books can be traced. At this stage we have to be content with the knowledge that Taganash was a salt-producing area and consequently the station handled a great deal of salt, but other important commodities in the region were grain and to a smaller extent timber (Semenov 1907, 673).

5.3.2.

The data on the second seal, preserved by Wiltshire Heritage in the museum at Devizes, are less clear. The seal was issued by the Vladikavkaz Railway Company at the station on the Vladikavkaz railway line stamped as Plastunovka. The southern-most starting point of the line was the city of Vladikavkaz in Northern Ossetia in the Caucasus. The only station on the line to which this could refer is Plastunovskaya, situated some 40 km. NNE of Ekaterinodar (Krasnodar) near the furthest end of the line from Vladikavkaz. The contraction of Plastunovskaya to Plastunovka is perfectly acceptable in Russian from a linguistic viewpoint, and would be a convenient way of adapting a name consisting of thirteen letters to a seal measuring only 23mm × 21mm. It shows the control number K 18[5]. Although no date is visible, from the penultimate letter of the word for 'station' which was one of the letters discarded in the 1918 orthographic reform, we can assume that the seal was issued before 1918.

5.3.3.

The third seal was recovered from Spofforth, near Harrogate, in North Yorkshire. It measures 30mm × 28mm and is 8mm thick. It was issued at Poltava in the Ukraine on 26 November, 1909 (Fig. 60a). The railway abbreviation M. K. V. Zh. D in the first line of its reverse indicates that it was issued by the Moscow-Kiev-Voronezh Railway Company (*Skhema Zh. D*. 1910). It is stamped with the control number A38, in which the A is the serial number and 38 the number of the entry in the Register kept at Poltava where the contents of the sealed wagon would have been entered. The final line of the reverse has No 1 (Fig. 60b).

In addition to the large network of State railway companies the private railway companies of Russia by the 1890s had formed into five large enterprises, of which the Kiev-Voronezh Company was one. The station stamp indicates Poltava, now in the Ukraine, which became part of the Russian Empire in the mid 17th century. Its population was mainly Orthodox Christian, but there was a sizeable minority of Jews in the town, as well as Russians, Poles and Germans. Its significance as a centre of trade increased sharply after 1865 when the Ilyinsky Fair was transferred from the town of Romny some 160 kilometres south east to Poltava. Although the Fair which was held annually between 1 and 31 July specialized in horses, hides, and pelts, the area's main export was timber. In the wider province of Poltava barley, rye and both winter and spring wheat were grown, along with hemp, rape and sunflower seeds. Without further evidence it is not possible to ascertain which product was in the wagon to which the recovered seal was attached.

5.3.4.

The exact recovery spot of the fourth seal is unknown beyond that it was discovered in Scotland, probably in the Lothians or Fife. It measures 27mm × 23mm and is 4mm thick at its slightly raised edges. The abbreviation P. K. P. indicates that it was issued by the Polish State Railways (Polskie koleje panstwowe). Rail transport in Poland had begun in the first half of the 19th century when different regions were ruled by Prussia, Russia and Austria, the three powers who had benefited from the partitions of the country in the later 18th century.

The condition of the seal is poor and some of the transcription offered remains speculative. The date of the seal, which is crucial in ascertaining the exact place of issue and the use to which it might have been put, is badly worn.

If the date is May 1875 it was issued at a period when much of Poland formed part of the Russian Empire. If it is 1915, then we face the problem that at that particular time Warsaw was occupied by the Germans. If the seal was issued after the declaration of Poland's independence from Russia by the Russian Provisional Government in 1917 then it should not be included in a catalogue of seals of the Russian Empire.

The initials that can be read on the undated (obverse) side are, in the first line, DYR – – MERSKA and in the second the control number [C] 35, the number of the entry

in the Register kept at at the station where the goods were sealed. The Polish State Railway initials P K P stand in the third line. In some respects the seal, therefore, resembles the three Russian seals described earlier. The significance of the form DYR – – MERSKA, whether one or two words, the first one possibly abbreviated, remains unclear. The abbreviation DYR would seem to be that of the noun DYREKCJA [= headquarters, management]. The following form is adjectival (-SKA) but of the preceding five letters the first two are illegible. On the dated (reverse) side the first line has the form [Z]IABK –, the small station where it was issued and where a water pump for engines was located, the second line carries the date 2[8]. V. 75 or 2[8].V. I5, and the third is illegible. A seal dated 1875 would have been issued only a year or so after the Warsaw–Vienna line had been connected to the broad-gauge lines of the Russian railway network by the construction of a bridge over the Vistula river, ultimately reaching St Petersburg.

5.3.5. Railway seals

Seal accession number	Face	Transcription
FALKM 2003.3.1	obv	КОНТРОЛЬ / А767 / К. Х. С. Ж. Д
	rev	СТАНЦ. / 26 АВГ 1903 / ТАГАНАШЪ
DZSWS.1995.68	obv	ВЛАДИКАВК / К 18[–] / Ж Д
	rev	СТАНЦIЯ / .–. / [П]ЛАСТУНОВКА
HARGM: 13606.17	obv	М. К. В. Ж. Д / А 38–. / No 1
	rev	СТ. / 26 [–]ОЯ / 09 / ПОЛТАВА
GMcA 03	obv	DYR – – [M]ERSKA / [C] 35 / P.K.P
	rev	[Z]IABK / 2[8].V / – – [7]5

5.3.6.
Intriguing questions surround such discoveries. That these particular seals were isolated instances, brought to the UK by chance, can be dismissed on the grounds that with the recovery of four such seals the likelihood of their being casual losses is greatly diminished. More likely, they provide us with an albeit modest insight into possible links between the British and Russian Railway systems and the carriage of sealed goods between distant towns in Russia and Britain.

5.4. Fur trade seals
Of particular interest is a collection of 34 seals which were connected with the fur trade. They give no indication of being used for the purposes of quality control and have all been discovered in the south of England.

They are all similar in format and indicate the producer and his place of origin. A number of different surnames and a number of different place-names have been recorded. One example is in private hands <MD 01>, but most of them are preserved in Farnham Museum (Section 6.3.5).

5.4.1.
The majority of the seals originated in the village of Goritsy in the Shuya region of the Province of Vladimir (Fig. 61b). In Russia the fur trade was mainly developed in the provinces of Vladimir and Nizhnii Novgorod.

At the end of the 19th century hunting and dressing sheepskins, as well as making up fur coats and sheepskin jackets was the occupation of a few hundred residents of the Province of Vladimir whilst in the Province of Nizhnii Novgorod one of the principal fairs for the sale of furs was held annually. Around Dunilovka, Goritsy and eight surrounding villages in Vladimir Province some 1120 men and women were occupied in the dressing of hare skins obtained from customer clients in the Provinces of Nizhnii Novgorod and Kostroma (Semenov, 1899, 155–156).

Commercial houses of fur distributors had been established in the village of Goritsy where it was cheaper to dress furs, and as a consequence fur coats and hats produced there were less expensive. Hare skins were also distributed. The products from this area were exported to England where seals have been mainly recovered in Surrey, with individual examples from Kent and Hampshire.

5.4.2.
Many of the seals are badly damaged and much of the text is illegible. However, in those instances where only a partial reading is possible it is not difficult to reconstruct the text because of the limited amount of information carried on the seals and on grounds of similarity with other seals of this type.

The seals so far recovered fall into two groups, depending on their size and decoration. Seventeen range from 22mm to 18mm and seventeen are between 17mm and 14mm. On the smaller seals on one side the centrepiece is indented and carries two initials within the indentation and on their other side, where there a correspondingly raised centre, there is a floral motif.

On the grounds that the the final letter, the 'hard sign', used in the three legible surnames was abolished in this final position in the 1918 reform of the Russian alphabet, we can date the seals to before 1918.

5.4.3.
Eighteen seals which carry the surname КОБЕЛЬКОВЪ [= Kobel'kov"] and the initials И. С [= I. S.] were issued in Goritsy (Fig. 61a). References exist to the Kobel'kov family business activities in Goritsy in the fur and pelt trade. Varzar lists the firm of I. E. Kobel'kov who had 127 workers in 1910–11 and a turn-over of 260, 000 roubles.

5.4.4.
Eight of the seals carry the initials Г M [= G M] and although many of them are badly damaged it is possible to reconstruct the surname as ВАШУРИНЪ [= VAShURIN"]. Three seals with this surname are of the smaller type, about 15mm ×

15mm, but they carry the same information as the larger ones. These seals were also issued in the village of Goritsy.

5.4.5.
On one seal the name АНТОНОВЪ [= Antonov"] is quite clear, with the initials М. П. [= M. P]. The seal originated in the village of Lunidovo, a name which occurs on three other seals on which the surnames are illegible.

5.4.6.
One seal is double-stamped on one side which is in consequence illegible. On its other side which gives the name of the village in which it originated, only the first two letters PU and the last three letters 'OVO' are legible. Owing to the considerable damage the seal has suffered it is not possible to ascertain with certainty the number of illegible letters.

5.4.7. Fur-trade seals from Siberia
Six seals from South Wales measuring between 22mm × 20mm and 19mm x 18mm carry the English form SIBERIA within a rectangle in the centre of the seal. The letter Z and the numbers 5, 9 and 11 are stamped around the perimeter of the rectangle (Fig. 62a). The significance of the digits and the letter Z is not clear. On their other side they all bear a blazon consisting of a Crown held by two arms above a numeral (Fig. 62b). On none of the six examples is it possible to determine whether there is a shield between the two arms, but on one seal the digit 2 stands between them. The seals were in all probability employed in the extensive pelt and fur trade with Siberia, where these symbols denote bundles of pelts imported from Russia to South Wales.

The view that they are connected with the pelt trade is strengthened by the fact that they are identical in format to four seals, two conserved in Biggar Museum (<LS32>; <LS33>) which carry the designation CANADA, with the letter V, and the digits 16, 9 and 04 around the perimeter of the rectangle in the same position as on the seals marked SIBERIA, and two with the same format marked COLUMBIA with the letters S and Z and the digits 15, 12, 18 and 17, 0, 16 (Austin, 8, 11). The two main sources of furs imported into Britain were Siberia and Canada, whilst Columbia was the source of more exotic skins. The fact that the three sets of seals are identical in configuration might suggest that they were attached to the bundles after their arrival in Britain.

5.5. Miscellaneous Russian seals

The exact role of several seals recovered in the UK is not immediately apparent. They are oval or round, ranging in size from 25mm × 23mm to 24mm × 21mm and therefore larger than normal Customs seals.

It was laid down by decree that a Customs seal must bear the Arms of the State or a town, as well as the date and place of the Customs examination. A trade seal, on the other hand, carried the name of a firm, a coat of arms or other imprint, and at times supplementary information (Petrov, 295).

The stamping of factory and trade items came to be regulated in Russia, and only those merchants who satisfied the rules required for the design of trademarks were permitted to register them. They had to contain either the forename and patronymic of the owner of the trade or industrial enterprise or at least their initials, or the name of a firm. The location of the enterprise had also to be indicated. The stamp had to be durable and the letters in Russian, though inscriptions in other languages were permitted as supplementary data (Ogneva, 16–17). In addition to the literal and numerical symbols recorded on trade seals, other images are also found, in particular the double-headed eagle and the six-pointed star (Petrov, 298). However, only one seal with a six-pointed star has so far been discovered in Britain <GRYEH: 1981.74.1>. Since it stands within a partially erased circumscription reading –РБУРГ [= –RBURG] it is probable that it originated in St Petersburg.

5.5.1. Seals with Russian state arms
Seals bearing the state arms of Russia, a double-headed eagle usually holding an orb and sceptre which is straddled or surmounted by the date, were used in an official capacity, mainly by the Customs Service (Fig. 63a, Fig. 63b).

They were round and measured from 13mm to 17mm in diameter. On one side the arms of the Russian state were depicted and above it the inscription 'ТАМОЖНЯ' [= TAMOZhNyA = Customs]. In the centre of the reverse side is a Cross with a circumscription containing the date and the name of the town where the Customs office was located (Ogneva, 18). However, it is possible that some seals were issued by a sub-department of the Customs service, since the Russian government at different times held a monopoly on or were the sole exporters of certain goods from which they derived the tax. Some of the seals recovered in Britain might, therefore, have been attached to consignments of goods that fell under the jurisdiction of State Customs, such as potash, timber and leather. They are relatively few in number and bear no indication of their place of issue.

5.5.2. Seals with Russian city arms
Recoveries of seals bearing the arms of Russian cities or provinces are more frequent, the main cities being the capital St Petersburg and Riga. Seals from Riga are described in Section 5.7.1, Section 5.7.1.2, Section 5.7.1.4 and Section 5.8.

Seals bearing the arms of St Petersburg or St Petersburg Province which were established in the reign of Catherine II (1762–1796) show a crossed anchor and grapnel, sometimes with a sceptre laid over them (Fig. 64, Fig. 65). Most are stamped with the name St Petersburg, in full or usually abbreviated form, and some have the abbreviation ПОР [= POR for PORT]. They do not specify the goods inspected.

5.5.3. Seals bearing state arms

Seal accession number	Face	Transcription
NMS:AMcC (18th c)	obv	17 [Arms: double-headed eagle holding orb and sceptre] /–
	rev	[Blank]
MoL: 81.522/40	obv	М. И. ОДНОУШЕВСКАЯ / С / СЫНОВЬЯМИ
	rev	[Arms: double-headed eagle]

5.5.4 Seals bearing St Petersburg city arms

Seal accession number	Face	Transcription
CRMCH: 1990.4.5	obv	РБУРГ ПОР / [Crossed anchor and grapnel]
	rev	[Blank]
DUMFM: 2001.32.2	obv	1799 / [Crossed anchor and grapnel]
	rev	[Illegible]
BRSMG: T.9416	obv	С ПЕТЕРБУРГСКОИ [outside double-headed eagle]
	rev	- - - - / С
GLDM: 29.04	obv	ПЕТЕРБУРГ / 18 [arms] [1]9
	rev	[Blank]
MoL: 88.427/15	obv	[Crossed anchor and grapnel] С–НКТП[Е][Т]РБУ: ПОР/179[7]
	rev	[Blank]
FF. 16	obv	ПЕТЕРБУРГ - - - / О А / 17 - -
	rev	[Illegible]
PM 02	obv	[Н] / ИВ: СО[–] / РОВ
	rev	[Anchor with C to its right]

5.5.5. Seals with arms of Siberia

One seal or token <MT 1> presents problems of interpretation since its condition is so poor that the identification of the animals depicted on it, which are essential in order to ascertain its city of origin, remain in doubt. The most likely interpretation is that the seal depicts the arms of Siberia: two sables rampant standing either side of crossed arrows holding a bow and a crown. However, the animals can also be construed as two bears facing a throne with two crossswords in which case the seal is from Novgorod.

5.6. Russian trade seals

A number of seals have been recovered which are connected with the commercial activities of firms in Russia. Some indicate a Russian enterprise exporting goods and others suggest British-owned enterprises operating out of Russia.

The number of Britons resident in St Petersburg in 1782–83 was 409. The 1890 Russian Census shows that the British totalled 1940, almost a fivefold increase since the late 19th century, whilst the Germans numbered 13274 and the French 2100 (*Perepis' 1890*, 88–91). As many as 829 (43%) of the Britons had been born in Russia. Despite their smaller number compared with the French and Germans they were very influential in the financial and commercial life of the country. Many of them, such as the Whishaws and the Hills took an active part in a wide range of different enterprises in the capital and elsewhere in Russia. Others acted as brokers, shipping agents or, like the Thorntons, were factory owners exporting their wares to the UK and beyond. Two of the most remarkable business families combined to create Russia's largest Department Store, Muir & Mirrilees, with its main offices in Moscow, supplying a vast range of goods, in the later decades by mail (Pitcher 4–6, 132–151).

5.6.1. Possible unidentified flax seals

One seal, measuring 22mm × 21mm, carries on one side letters and digits suggesting a connection with the flax trade: Но 2 [= *No 2*] and the number - - 7, which might indicate a flax seal attached to a bundle with second-grade flax and an inspection date of 1847 (<CUPMS: 1999.53.37>) (Fig. 66b).

The other side carries a circumscription '- -ХОВСКАГО' [= –KhOVSKAGO] in which the first letters are illegible. It encircles a ligature consisting of two initials (Fig. 66a).

A further seal which is dated 1845 also has N 2 on its reverse side and carries the initials И З [= I Z] on its obverse (<ADMUS: A1988.292>) (Fig. 67a; Fig. 67b).

5.6.2. Seals with links to other commercial activities

While most of the Russian seals examined so far were used in the export of flax, hemp and their by-products, attention should be drawn to other uncommon types of seal which have also been recovered in individual examples. Since many of them show the names of traders or producers, sometimes in Roman letters, we are most probably dealing with seals designed to mark a trade, tradesman or company. Where port of origin is shown, they nearly all originated in St Petersburg but do not resemble seals used for flax and hemp quality control or any of the other seals so far described. Regrettably many are in extremely poor condition and much of the imprint on them is illegible. A brief description of them follows:

a. one seal, measuring 24mm × 21mm, carries the initials Б Ф [= B F], but its reverse side is illegible (<CUPMS: 1999.56.19>)) (Fig. 68).

b. three seals, two of which have the initials Б Н [= B N] on one side in Cyrillic, with the initial I. above W. M on the other side (<KIRMG. 2006.240>, <KIRMG. 2006.364>, (Fig. 69)). The third has the same Roman initials but Cyrillic Ф А [= F A] on the other side (<NMS: K1998.503>).

c. one seal, measuring 25mm × 23mm, carries the word БАНК [= *bank*] on one side alongside ПЕЛ and the numeral 7 [= *PEL BANK* / 7] (<CUPMS: 1999.58.2>) (Fig. 70).

d. one seal, 23mm × 19mm, has a circumscription only part of which can be deciphered НОВА–СК [= *nova–sk*] with 'МЕЛЬНИЦА' [= *mel'nitsa* = 'mill'] in the centre, indicating the name of a mill, the location or ownership of which remains unknown. The reverse side is in Roman letters, but only part of it is legible (<CUPMS: 1999.54.60>) (Fig. 71a, Fig. 71b).

e. one seal, measuring 31mm × 18mm, is quite different

from the others in that it is larger, almost rectangular and is stamped on one side with the Cyrillic initials Я А П [= yA A P] and on the other with K 10 (<KIRMG. 2006.362>) (Fig. 72a, Fig. 72b).

5.6.3. Individual and company names
Some seals carry a person's name which might be that of an individual or a company, for example A. I. Andronov (Section 5.6.3.1), and Efim Yagodnikov (Section 5.6.3.2). In other instances it is quite clear that we are dealing with the name of a company, for example, M. I. Odnoushevskaya & Sons (Section 5.6.3.3).

5.6.3.1. A. V. ANDRONOV
One seal, smaller in size than most others of this sort (19mm x 18mm) bears the name of A.V. Andronov and a barely legible reference on one side to the town of Penza which had a number of hemp- and tow-spinning mills. It has no date (Fig. 73a, Fig. 73b).

A similar lay-out is described by Ogneva relating to a seal issued by the stock-share association of Vasilii Klimushin which has the words 'GLAVNAYA KONTORA V MOSKVE.' (= Main Office in Moscow) (Ogneva: *private communication*). On the Andronov seal the word at the foot of the inscription is illegible except for two letters which are –OH– [= –ON–]. They are very likely therefore to be part of the noun 'kontora' ('office'), since the adjective agrees with it in gender, as well as case and number. The inscriptions would therefore indicate the firm of A. V. Andronov with their main office in Penza. Unfortunately, it has not proved possible so far to discover with certainty any details about the individual or his business activities.

5.6.3.2. EFIM YAGODNIKOV
One seal recovered in Suffolk, measuring 28mm x 18mm, bears the name Efim Yagodnikov, but the data on the seal which might give some indication of its origin is badly damaged (Fig. 74a, Fig. 74b).

The name Petr Yagodnikov is found on a list of merchants in Vologda in the late 18th century (Vorontsov, 579) and the firm 'Sons of Petr Yagodnikov' was trading in 1791. It is not unlikely that this seal belonged to a descendant of this family. In many respects it resembles seals from the Vologda area decribed in Section 5.2.15.1, Section 5.2.15.2, Section 5.2.15.3 and Secion 5.2.15.4.

5.6.3.3. M. I. ODNOUSHEVSKAYA AND SONS
One seal, housed in the Museum of London, provides rare non-literary evidence of the involvement of women in Russian commerce. Russian women had since the 18th century been able to keep control of their own property and were accepted as members of the Russian merchant class (Joffe and Lindenmeyr 1998, 95–96, 103–04). Although in the 18th century they were not allowed to participate in State affairs, they were permitted to inherit property and wealth and were also eligible for admission to one of the merchant guilds which had been created during the reign of Peter the Great, a procedure determined purely by the extent of an individual's capital. Some women actively continued their own business interests, others handed over control of their wealth to their spouses. Many became property owners and landladies (Broytman and Krasnova, *passim*, Broytman and Dubin, *passim*, Solov'eva, 86 and *passim*). A large number were heavily involved in charitable works, either through the Church or through their own or their husband's business enterprises and some wives actually conducted all or part of the business whilst their spouse was engaged on other matters.

Female names are identified in Russian by their ending – either in 'A', when the husband's surname ended '-OV,' 'EV' or '-IN', or in 'SKAYA', when the husband's surname ended in 'SKIY' (Krasnov / Krasnova, Shchegolev / Shchegoleva, Bolotin / Bolotina, Vedenskiy / Vedenskaya).

The existence of the firm of M. I. Odnoushevkaya and Sons is attested by the MoL seal, but hitherto no further information about the identity of the family or the nature of the business they conducted has come to light. The fact that it is registered as Odnoushevskaya and Sons might indicate a widow continuing in her former husband's enterprise until one of her sons had come of age or had gained sufficient experience in commerce to take over the reins himself.

It is not clear whether the seal originated in St Petersburg, Moscow or elsewhere (Section 5.5.3).

5.6.4. Seals from the Soviet period
Two seals have been recorded on which the inscription shows them to be from the Soviet period. Neither of them carries a date.

It is possible to give an approximate date to one seal on the basis of evidence contained on the seal itself. It was issued by State Trade which organised the trade system of the ministries of Trade and the Workers' Supply Department, as well as the trade system of non-industrial ministries. Its remit also encompassed state urban trade, including catering services. It is possible that the seal had some connection with the latter. Around a centre-piece consisting of a rosette or five-pointed star such as is found on Russian seals from the earliest 18th-century, one side carries as a circumscription the abbreviation ГОСТОРГ [= Gostorg], i.e. State Trade, to which are added the initials Н К Т [= N K T] (Fig. 75a). If the initials N K T represent 'Narodny komissariat torgovli' [Народный Комиссариат Торговли = the People's Commissariat of Trade], the seal dates from the period October 1917 to 1946. Formed in October, 1917 the People's Commissariats were reformed into ministries in 1946. The other side of the seal carries a circumscription ХОЛОДИЛЬНИК [= Kholodil'nilk (refrigerator)), with the additional letters С. К [= S K] around a centre containing Г. П [= G. P.] (<DMP 03>) (Fig. 75b).

The second seal which is small in comparison with the usual Russian seals recorded (15mm × 15mm) was discovered north of Ipswich in Suffolk and carries on one side the inscription СКЛАД No 1 [= Sklad No 1 = Warehouse No 1] and on the other, around a centre-piece consisting of a rosette or five-pointed star, the noun ТРАНСПОРТ [= Transport] (<SF 746/6172>). Although no other data

are given, the seal probably relates to unspecified goods delivered from a warehouse in the USSR by the Transport Ministry.

5.6.4.1. Seals from the Soviet period

Seal	Face	Transcription
DMP 03	obv	ХОЛОДИЛЬНИК. С. К. / Г. П.
	rev	ГОСТОРГ. Н. К. Т.
SF 746/6172	obv	СКЛАД / No 1
	rev	ТРАНСПОРТ

5.7. Seals from the Russian Empire

The expansion of the Russian Empire along the Baltic coast from St Petersburg in the 18th century brought many commercial ports under the sway of Tsarist Russia.

Amongst these by far the most important from the point of view of Britain's commercial relations were Riga and Narva, both of which acted as outposts of St Petersburg-Kronstadt, especially in years when the Gulf of Finland was frozen for a much longer period that at Narva or Riga. By the second half of the 19th century as a commercial port Riga occupied third place in Russia, after Odessa and St Petersburg. Its export trade expanded nearly threefold between 1866 and 1905.

5.7.1. Riga flax seals

Riga seals connected with the flax trade have been recovered in substantial numbers from many sites in Britain, but because they have not been properly identified, they have been set aside, many lying unaccessioned in museum collections. The present section provides a description of their configuration. Over 25 examples have been recorded, a selection of which is given in Section 5.7.1.1, but this is clearly not exhaustive.

Their distinctive characteristic is their motif, derived from the Arms of the town of Riga: the town gates with a raised portcullis under which lies a crowned lion's head; the two towers have pennants, between which are Cross Keys and above them a Cross surmounted by an open crown. On each the side of the walls the double-headed eagle of the State Russian Arms can be seen (Fig. 76).

When the arms occurred in the watermarks of paper produced in Riga, they took two forms. Before Riga came to form part of the Russian Empire they were presented without the supporting eagle (Fig. 78) but from the early 18th century after the town had fallen within the Russian Empire its arms are encompassed by the supporting double-headed eagle (Fig. 79). However, on the lead seals recovered in Britain, which on one side are usually blank, only a detail of the city arms is depicted – the central area above the main gate and its portcullis, consisting of the Cross Keys and the Cross which stands below the open crown (Fig. 76; Fig. 77).

In addition, between the heads of the two keys stands a number indicating the quality of the goods inspected (1, 2 or 3), number 1 being the most frequently recorded (Fig. 80 (Grade 1); Fig. 81 (Grade 2); Fig. 82 (Grade 3)).

Some examples are listed in Section 5.7.1.1, others can be found in Section 6. They carry no date and are virtually identical, save the different number used to indicate the grade of flax (1, 2, 3). In some instances recorded seals carry the initial B to one side of the crossed keys. On one seal the numeral '4' is stamped on the side that is usually blank (Fig. 83a; Fig. 83b).

5.7.1.1. Selection of Riga flax seals
1. Arbroath (Signal Tower) Museum

R01	ADMUS: A1988.301/	obv	+ / (Cross Keys) / 3
		rev	(Blank)
R02	ADMUS: A1988.287/	obv	/ (Cross Keys) / 1
		rev	(Blank)
R03	ADMUS: A1988.294/	obv	+ / (Cross Keys) / 1
		rev	(Blank)
R04	ADMUS: A 2000.87.3/	obv	+ / (Cross Keys) / 2
		rev	(Blank)
R05	ADMUS: A 2003.53/	obv	+ / (Cross Keys) / 1
		rev	(Blank)
R06	ADMUS: DBM:4217a/	obv	+ / (Cross Keys) / 2
		rev	(Blank)

2. Falkirk Museum

R01	FALKM: 2003.3.4	obv	+ / (Cross Keys) / 1
		rev	(Blank)
R02	FALKM: 2003.3.5	obv	+ / (Cross Keys) / –
		rev	(Blank)

3. Kirkcaldy Museum and Art Gallery

R01	KIRMG. 2006.342	obv	+ / (Cross Keys) / –
		rev	(Blank)
R02	KIRMG. 2006.343	obv	+ / (Cross Keys) / –
		rev	(Blank)
R03	KIRMG. 2006.344	obv	/ (Cross Keys) / 1
		rev	(Blank)
R04	KIRMG. 2006.345	obv	/ (Cross Keys) / 2
		rev	[Blank]

Part One: Lead seals of Russian origin

R05	KIRMG. 2006.351	obv	/ (Cross Keys) /
		rev	(Blank)
R06	KIRMG. 2006.371	obv	/ (Cross Keys) /
		rev	(Blank)

4. Montrose Museum

R01	ADMUS: M1987.769	obv	+ / (Cross Keys) / 1 / B
		rev	(Blank)
R02	ADMUS: M1995.164	obv	+ / (Cross Keys) / 1
		rev	(Blank)
R03	ADMUS: M1998.6	obv	+ / (Cross Keys) / 1
		rev	(Blank)
R04	ADMUS: M1998.96	obv	+ / (Cross Keys) / 1 / B
		rev	(Blank)
R05	ADMUS: M1998.164	obv	+ / (Cross Keys) / –
		rev	(Blank)
R06	ADMUS: M2000.60	obv	+ / (Cross Keys) / 2
		rev	(Blank)

5. Perth Museum and Art Gallery

R01	PERMG: 1979.1244	obv	+ / (Cross Keys) / 3
		rev	(Blank)
R02	PERMG: 1992.140.5	obv	+ / (Cross Keys) / 1
		rev	(Blank)
R03	PERMG: 2000.243.9	obv	+ / (Cross Keys) / 3
		rev	(Blank)

6. Kingston upon Hull Museum and Art Gallery

R01	KINCM: 2000.101.149	obv	+ / (Cross Keys) / 1
		rev	(Blank)

7. Private Collections

R01	AJPC 08	obv	+ / (Cross Keys)
		rev	(Blank)
R02	WE 08	obv	+ / (Cross Keys) / 2
		rev	(Blank)
R03	GGD 01	obv	+ / (Cross Keys)
		rev	4
R04	GMcA 01	obv	+ / (Cross Keys) / 1
		rev	(Blank)
R05	SFl 30	obv	+ (Cross Keys) / B
		rev	(Blank)

5.7.1.2. Riga balsam seal

One seal, measuring 21mm × 20mm, recovered from Ferryden, by Montrose, is important in two respects. First, it is the only clearly stamped seal attached to a consignment of black Riga balsam so far recorded, reflecting the export of medicinal wares to the east of Scotland from the Baltic.

Secondly, it has in Russian the name of the contents on one side of the seal 'Black Riga Balsam' (ЧЕРНЫЙ РИЖСКИЙ БАЛЬЗАМЪ) (Fig. 84a; 84b) and on the opposite side a motif with crossed keys and the date 1893, providing us with further evidence that the Cross Keys represent Riga (Fig. 84c).

R07	ADMUS: M1998.94	obv	ЧЕРНЫЙ / РИЖСКИЙ / БАЛЬЗАМЪ
		rev	[Б]Е . ПРА[А] / + (Cross Keys) / 1893

5.7.1.3. Riga balsam

Riga balsam was imported in two forms, white and black and was an aromatic oily or resinous medicinal preparation, used for external application in the treatment of wounds or in soothing rheumatic and dental pain (AKVF, 370). It was a translucent white fluid obtained by distillation from the young shoots of the Siberian stone-pine (pinus cembra). However, black balsam became available from the 18th century onwards also in the form of an alcoholic beverage of somewhat more than average potency, nowadays consisting of 45% proof.

In the novel *Peter Simple* by Captain Marryat, published in 1834, the following dialogue takes place between Simple and the quartermaster Swinburne who was commenting that seventy men on the ship had been drunk one afternoon and the first lieutenant had been quite unable to discover the reason:

"Indeed, Swinburne, you must let me into that secret."
" – Don't you know there's a famous stuff for cuts and wounds called balsam?"
"What, Riga balsam?"
"Yes, that's it; well, all the boats will bring that for sale as they did to us in the old *St George*. Devilish good stuff it is for wounds, I believe; but it's not bad to drink, and it's very strong. We used to take it inwardly, Mr Simple, and the first lieutenant never guessed it."
"What! You all got tipsy upon Riga balsam?"
"All that could – ."

(Marryat 1895, 434–435).

5.7.1.4. Other Riga seals

Five other seals bearing the Imperial Arms of Russia and other markings which indicate that they are also from Riga are recorded, but they present greater difficulties since they are badly damaged and it is not clear from their format with which trade they are connected. Two are dated 1787, one 1797, and the other 1802 (Section 5.7.1.4.1.

5.7.1.4.1. Other Riga seals

ADMUS: A1988.288	obv	РИЖ / 17.87 / (Arms)
	rev	(Blank)
ADMUS: B1988.9	obv	РИГА ПОРТ / 17.97 / ОТА / (Arms)
	rev	(Blank)
ADMUS: M1998.95	obv	ПОТ РИГА[–][–] КОХ / 1802
	rev	(Blank)
CRMCH: 1992.12	obv	17 91 [Arms] / 5 / РИ СКО
	rev	(Blank)
FALKM. 1985.74.4	obv	РИЖ / 1787 / (Double-headed eagle holding orb and sceptre) / П Р Т / (Key)
	rev	(Blank)

5.8. Other possible Baltic/Riga seals

A substantial number of other seals are known which have Roman letters on them which in all probability also denote the quality of flax or hemp, but it is has not proved possible to ascertain with any degree of certainty the town or port where they were issued.

On one side they carry two initials, the most frequently encountered of which are the initials: RB (Fig. 87a; Fig. 84b), GH, IK (Fig. 88a; 89a), HW, AR. The initials stand above or beneath the numeral and letter combination 12 K, 12 H, 9 K, indicating the quality of flax (e.g. 12-head) in the bundle to which they were attached. On the other side of these seals is a quartered shield each quarter containing four, five or six pellets (Fig. 87b; Fig. 88b; Fig. 89b). The establishment of which town or province had this emblem in its arms would identify the origin of this group of seals. A number of seals which might have been stamped in the same port or town occur with a heavier cross on one side, with pellets in each quarter (<KIRMG. 2006.200>, <HARGM: 13606.23>.<HARGM: 13606.24.>), (Section 5.8.1; Fig. 90).

5.8.1. Other possible Baltic/Riga seals

Seal	*Face*	*Transcription*
ABDMS: 072700	obv	R B / 12 K
	rev	(Arms consisting of a quartered shield)
ABDMS: 072701	obv	A B / – –
	rev	(Arms consisting of a quartered shield)
KIRMG. 2006.200	obv	I G / – –
	rev	(Arms consisting of shield with heavy cross and pellets in each quarter)
KIRMG. 2006.201	obv	I [–] / 12 K
	rev	–
KIRMG. 2006.202	obv	M / 12 K
	rev	(Arms consisting of a quartered shield)
KIRMG. 2006.203	obv	I K / –
	rev	–
KIRMG. 2006.241	obv	R B / 12 K
	rev	(Arms consisting of a quartered shield)
KIRMG. 2006.242	obv	R B / 12 K
	rev	(Arms consisting of a quartered shield)
KIRMG. 2006.243	obv	R B / 12 K
	rev	(Arms consisting of a quartered shield)
KIRMG. 2006.244	obv	R B / 12 K
	rev	(Arms consisting of a quartered shield)
KIRMG. 2006.245	obv	R B / 12 K
	rev	(Arms consisting of a quartered shield)

KIRMG. 2006.246	obv	[H] W / [–] 2 K
	rev	(Arms consisting of a quartered shield)
KIRMG. 2006.247	obv	A R / 12
	rev	(Arms consisting of a quartered shield)
KIRMG. 2006.248	obv	A R / 12
	rev	(Arms consisting of a quartered shield)
KIRMG. 2006.249	obv	AR –2
	rev	(Arms consisting of a quartered shield)
KIRMG. 2006.250	obv	A [–]
	rev	(Illegible)
KIRMG. 2006.251	obv	A R / 1 [2]
	rev	(Illegible)
KIRMG. 2006.346	obv	A R / – 2
	rev	(Illegible)
KIRMG. 2006.347	obv	A R / 12
	rev	(Arms consisting of shield)
KIRMG. 2006.348	obv	A R / 1[2]–
	rev	(Arms consisting of a quartered shield with 5 pellets)
KIRMG. 2006.349	obv	A R / 12
	rev	–
KIRMG. 2006.350	obv	A R / 12
	rev	(Illegible]
KIRMG. 2006.352	obv	R B / 12 [M]
	rev	(Arms consisting of a quartered shield)
KIRMG. 2006.353	obv	R B / – 2 K
	rev	(Arms consisting of a quartered shield)
KIRMG. 2006.354	obv	R B / – 2 K
	rev	(Arms consisting of a quartered shield)
KIRMG. 2006.355	obv	R B / 1 –
	rev	(Arms consisting of a quartered shield)
KIRMG. 2006.356	obv	R B / 12 K
	rev	(Arms consisting of a quartered shield with 5 pellets)
KIRMG. 2006.357	obv	I G / 12 K
	rev	(Arms consisting of a quartered shield with 5 pellets)
KIRMG. 2006.358	obv	H W / 12 K
	rev	(Arms consisting of a quartered shield with 5 pellets)
KIRMG. 2006.359	obv	H W / 12 K
	rev	(Arms consisting of a quartered shield with 5 pellets)
KIRMG. 2006.360	obv	H W / 2 [–]
	rev	(Arms consisting of a quartered shield)
KIRMG. 2006.361	obv	I K / 12 K
	rev	(Arms consisting of a quartered shield)
KIRMG. 2006.373	obv	R B / 12 [–]
	rev	(Arms consisting of a quartered shield)
KIRMG. 2006.241	obv	R B / 12 K
	rev	(Arms consisting of a quartered shield)
KIRMG. 2006.248	obv	A R / 12
	rev	(Arms consisting of a quartered shield with 4 pellets)
KGGM: DBK – 808f. – iii	obv.	H W / 12 K
	rev.	(Arms consisting of a quartered shield)
HARGM: 13606.18	obv	H W / 12 K
	rev	(Arms consisting of a quartered shield with pellets)
HARGM: 13606.19	obv	12 K / L T
	rev	(Arms consisting of a quartered shield with pellets)
HARGM: 13606.20	obv	12 K / GH
	rev	(Arms consisting of a quartered shield with pellets)
HARGM: 13606.21	obv	[9] K / GH
	rev	(Arms consisting of a quartered shield with pellets)
HARGM: 13606.22	obv	–2 K / G H
	rev	(Arms consisting of a quartered shield with pellets)
HARGM: 13606.23	obv	– / C R
	rev	(Arms consisting of shield with heavy cross and pellets in each quarter)
HARGM: 13606.24	obv	– / [–] H
	rev	(Arms consisting of shield with heavy cross and pellets in each quarter)

5.9. Concluding Remarks

This monograph set out with the aim of introducing the important role that the study of Russian lead-alloy seals can play in completing our picture of Russo-British commercial relations since the mid-18th century. Owing to the absence of other studies in the field our task has essentially been both to identify and assemble the raw material and then to interpret it. Russian lead-alloy seals cast light on the many varied commercial links that Russian or Russian-based businesses maintained with enterprises throughout Britain and additionally carry material which enables us to discern more clearly the actual way in which export business and trade operated in the last two and a half centuries at its lower levels.

Russian sources themselves are almost silent on these artefacts, some major archaeological centres such as the State Historical Museum in Moscow and The Hermitage in St Petersburg denying knowledge of them, others admitting that they do not know if their unaccessioned stocks of artefacts contain any at all. Russian archival and archaeological material which might help us shed light on some of the difficult questions surrounding the origin of the seals and the significance of some of the imprints on them remains to be examined thoroughly, since preliminary investigations have failed to uncover any practical information on the conduct of quality control that sheds further light on the problems encountered in interpreting some of the imprints on the seals.

Trade with Russia had probably been conducted for several centuries before the appearance of the lead-alloy seals. Evidence from finds in Britain so far recorded indicates were introduced in the 18th century. The main function of flax and hemp seals was to indicate that goods intended for export had passed through quality control procedures and to specify the nature and quality of the goods examined. Whilst the configuration of the seals changed as time went by, essentially the same information was stamped on them. Seals from Archangel, which appear at a relatively late period, present their information clearly and in a form which can be comprehended without difficulty, but those from other centres use codification systems which in part still remain to be resolved. Importantly, they provide us with the names of over 400 operatives which would otherwise remain unknown to us. They also provide evidence that members of the same family, brothers, sons and uncles, frequently earned their livelihood in the conduct of quality control.

Seals connected with other commercial activities, such as the fur trade, are unclear in the specific function they fulfilled, but often carry either the names of owners, producers or agents or the locality in which the goods were produced, or both. A small number of seals reflect the role of wives and daughters in the commercial activities of the family, the study of which has hitherto remained undeveloped. Based on their portrayal in literary works, especially of such influential playwrights as Gogol and Ostrovsky whose dramatic settings were often the merchant class, the role of women in the 19th century has traditionally been presented as one of subservience and idleness and their nature frivolous. However, a few of the seals support the view now emerging which shows them to have played an active part of the business life of St Petersburg and Moscow, being particularly well-known as landladies and owners of large and imposing properties in these towns.

It is natural that the evidence provided by around 1100 lead-alloy flax and hemp bundle seals mainly in England and Scotland should clearly reflect the economic and political events of the 18th and 19th centuries. The transfer of business interests from one part of Britain to another is occasionally reflected in the information contained on the seals, indicating that whilst a commercial enterprise had been sold, the new owners continued to deal with the same Russian agents or suppliers as the previous owners.

A reduction in the number of finds from the periods of the Napoleonic and Crimean wars, the latter producing no seals at all, is also evident. The shift of 19th-century finds from England to Scotland was brought about by the development in Angus and Fife of the linen, flax and hemp spinning industries in the late 18th and early 19th centuries and in the end it was largely owing to the increasing difficulties in obtaining flax imports during the Napoleonic and Crimean Wars that the replacement of linen by jute in the major city of Dundee occurred. However, the sharp fall in the number of recoveries of lead-alloy seals originating in St Petersburg from the 1840s onwards was also a direct result of the abolition of compulsory bracking in that port in that decade.

The seals allow us to judge the magnitude of Russia's external trade with the UK, in particular the relations between individual firms. They not only complement the information derived from trade archives but actually replace the large number in Russia which have been lost or destroyed either during the Bolshevik period or by the widespread devastation caused during World War II.

It is clear that such a valuable research resource should be preserved and accurately catalogued. To this end this monograph will aid the description and cataloguing of the seals. It will also improve familiarity with one of the vital tools in interpreting finds, namely the historical development of the Cyrillic alphabet in Russia from the beginning of the 18th century insofar as it is relevant to lead-alloy seals and provide a corpus of material on the basis of which further research will be possible. However, The fact that so little about artefacts that have been in existence for no more than two-and-a-half centuries has been recorded underlines the problems engendered by modern trends in the preservation of our heritage and also highlights the short-sightedness of casting aside material on the basis solely of its date, without regard to the political or historical context in which it was produced and whether that society or culture has undergone fundamental change, in some cases beyond restoration. The earliest Russian lead seals date from the 18th century, the transitional century from the relatively mediaeval society of Moscovite Russia to its stumbling progress towards Europeanisation.

Part One: Lead seals of Russian origin 53

5.10 Illustrations

Fig. 1a CUPMS: 1999.53.11 obv (+ detail)

Fig. 1b CUPMS: 1999.53.11 rev (+ detail)

Fig. 2 CUPMS: 1999.54.39 rev (+ detail)

Fig. 3 JC 01 rev

W [U]
А И 9 П 9
1758

No. 16

N P
[K] B 12 [H]
1753

Fig. 4a MM: 2006.01 obv

Fig. 4b MM: 2006.01 rev

No. 25

W. U
9
175[–]

Fig. 5a MM: 2006.13 obv

Fig. 5b MM: 2006.13 rev

No. 57

W. K
– B 12 A O
1757

Fig. 6a HARGM: 12706.1 obv

Fig. 6b HARGM: 12706.1 rev

Fig. 7a CUPMS: 1999.54.22 obv	Л. Д. Л: НЕМ IЛОВЪ N 24	Fig. 7b CUPMS: 1999.54.22 rev	S P B N P . 3 I. H. 183–
Fig. 8 JS 04 obv	П Д Е. ЕРО ХИНЪ Н 43	Fig. 9 AJPC 04 rev	S P B I C Z. A H 177[–]
Fig. 10a JC 09 obv	Д: А. ПЕТЕ ЛИНЪ Н 232	Fig. 10b JC 09 rev	S P B IH RH 177[–]
Fig 11a MM: 2006.14 obv	[Л] Д ЧРА КОВЪ Н 57	Fig. 11b MM: 2006.14 rev	S. P. [B] L [–] W R 1781
Fig. 12a CUPMS:1999.52.29 obv	Л. Д. Г. ЗАМА РИНЪ Н 17	Fig. 12b CUPMS:1999.52.29 rev	S P B [N] P. –2 W. H [1]839
Fig. 13a CUPMS: 1998.6.6 obv	– – Д. ВОР[О] БЬЕВЪ Н 72	Fig. 13b CUPMS: 1998.6.6 rev	S P N P. –2 I. P. 1830
Fig. 14a CUPMS:1999.52.24 obv	Л. Д. М ФЕДО ТОВЪ Н 41[–]	Fig. 14b CUPMS: 1999.52.24.rev	С П Б Но. П. 2 М. С. [1]833

П Д
– МОР[О]
–ЗОВЪ
Н. 184

Fig. 15a FALKM: 2003.3.2 obv

С П Б
ПЕН. 1
Д. Х.
1840

Fig. 15b FALKM: 2003.3.2 rev

Л Д
Е: ДЕМ
ЯНОВЪ
Н [–]0

Fig. 16a CUPMS: 1999.52.37 obv

N. P.
I М Б 12[–]
1818

Fig. 16b CUPMS: 1999.52.37 rev

Л Д
– ДЕДО
ВНИКО
Н 79

Fig. 17a CUPMS:1999.54.46 obv

N P
F 12 Н
1822

Fig. 17b CUPMS:1999.54.46 rev

Л Д
А: КУЧ
КОВЪ
Н 2

Fig. 18a KIRMG.2006.305 obv

N P
П Ч 12 Н
1826

Fig. 18b KIRMG.2006.305 rev

ПиЛПД
М КАЛТ
УШКН
Но 2

Fig. 19a CUPMS: 1999.53.18 obv

С П Б
Л. З. 1 Н
1837

Fig. 19b CUPMS: 1999.53.18 rev

ПиЛПД
Н: СЕЛ
ИНЪ
Но I

Fig. 20a CUPMS: 1999.56.8 obv

С П Б
П.Ш 2
1832

Fig. 20b CUPMS: 1999.56.8 rev

Л.П.С.
П. БАЛО
ВАНОВЪ
Н [–]

Fig. 21a CUPMS 1999.55.27 obv

Л. [–]
А. ПОГ
НК[–][–]
Н. 3

Fig. 21b CUPMS 1999.55.27 rev

Л Д
А ЧЕЛ
ПАНО[В]
Н 54

Fig. 22a CUPMS: 1999.53.29 obv

N P
M M 9 H
1799

Fig. 22b CUPMS: 1999.53.29 rev

Л Д
И ВИН
НИКОВ
Н 20

Fig. 23a CUPMS 2005.282 obv

N P
F W 12 H
1813

Fig. 23b CUPMS 2005.282 rev

Л Д
Я. ЗАИ
ЦОВЪ
Н 7

Fig. 24a CUPMS 1999.216.2 obv

N P
A K 12 H
1806

Fig. 24b CUPMS 1999.216.2 rev

Л Д
А: НАСУ
ХИНЪ
Н 95

Fig. 25a AMu 01 obv

N P
I C Б 12 H
1821

Fig. 25b AMu 01 rev

A B DAMAZKI
B A
1847
ST P B

Fig. 26a KIRMG: 2006.341

Fig. 26b KIRMG: 2006.341 (detail)

A B DA - - T[S]KI
Б.А
1846
ST P B

Fig. 27a ADMUS: A1998.296 obv

3 й С
-.-
2 П

Fig. 27b ADMUS: A1998.296 rev

А.Б. ДАМАЦКОИ
1846
С. П. Б

Fig. 28a KIRGM. 2006.207 obv

No. 2
-.-
o. 9 p

Fig. 28b KIRGM. 2006.207 rev

A B DAMAZKI
B A
1848
ST P B

Fig. 29a ADMUS: A1990.311

Fig. 29b ADMUS: A1990.311 (detail)

– – МАЦКОИ.
1847
С П Б
ФЕДОС[Е][И]

HILLS &
II
WHISHAW

Fig. 30a CUPMS: 1999.52.50 obv

Fig. 30b CUPMS: 1999.52.50 rev

А [–] ДАМАЦКОИ.
1847
С П Б
ФЕДОС[Е][И]

HILLS &
II
WHISHAW

Fig. 31a PERMG. 1992.142.1 obv

Fig. 31b PERMG. 1992.142.1 rev

МАНУ[И]Л
ФЕДОРА
ВАНЮ
КОВА

Ho 2
–.–
1847

Fig. 32a ADMUS: M1989.98 obv

Fig. 32b ADMUS: M1989.98 rev

М[А]НУ[И]Л
ТИМОФЕЯ
ВАНЮ
КОВА

Fig. 33 ADMUS: M1995.161 obv

KOHOLEFF
И Ф К
St [P[

Ho 2
–.–
1844

Fig. 34a ADMUS: M1980.3639 obv

Fig. 34b ADMUS: M1980.3639 rev

KOROLEFF
И Ф К
St P B

Ho 2
–.–
1848

Fig. 35a CUPMS: 1999.53.36 obv

Fig. 35b CUPMS: 1999.53.36 rev

Georg

Classen

Fig. 36a ADMUS. A 1989 246a

Zabrack
4 [th]

Fig. 36b ADMUS. A 1989.246b

PROPRIETAIRE
*
KAHKOFF

Fig. 37a ADMUS: M1998.91a

No. 2
–.–
1853

Fig. 37b ADMUS M1998.91b

АРХ. БР
ОТБОРНЫ
1 СОРТЪ
М К.
1848

Fig. 38 HAW 01

АРХ. БР
ОТБОРН[Ы]
2 СОРТЪ
В. ЛЕД
[1]842

Fig. 39 HAW 02

АРХ. Б
ОТБОРНЫ
3 СОРТЪ
В. Д.
1838

Fig. 40 KIRMG. 2006.209 rev

АРХ. БР.
КРОНЪ
3 СОРТЪ
Ф.Р.
1875

Fig. 41 KIRMG. 2006.210 rev

АРХ. ПОР
ДЕСЯТСК
ВАСИЛЕИ
БАБИКО
ВЪ

Fig. 42a CUPMS: 1999.52.10 obv

АРХ. БР
ЧЕСКА
2 СОРТЪ
М. К.
1851

Fig. 42b CUPMS 1999.52.10 rev

А П
ДЕСЯЦКО
Т З

Fig. 43a CUPMS: 1999.52.15 obv

А П
ПАК. БРАК
2 АР ру
1837

Fig. 43b CUPMS: 1999.52.15 rev

А П
ДЕСЯЦК
[Г] С

Fig. 44a CUPMS: 1999.52.17 obv

А –
ПАК. БР.
1 ЕП Р
1836

Fig. 44b CUPMS: 1999.52.17 rev

Part One: Lead seals of Russian origin

Fig. 45a JS 06 obv	А. П. ДЕСЯЦКО Ф К	Fig. 45b JS 06 rev	А П ЛНЯН БРАК 3 ВД Р 1832
Fig. 46a CUPMS: 1999.52.16 obv	А П. ДЕСЯЦКО К 3	Fig. 46b CUPMS: 1999.52.16 rev	А. П. ЛНЯН БРА 18 МП 35 3. ПАК. р
Fig. 47a CUPMS: 1999.56.2 obv	АРХ ДЕСЯТСК ФЕДОРЪ СО–О–	Fig. 47b CUPMS: 1999.56.2 rev	АРХ. БР. ЗАБРАК В. ЛЕД 1847
Fig. 48a CUPMS: 1999.52.14 obv	ПОР ДЕСЯТ ЯКОВЪ ДУПАЕ ВЪ	Fig. 48b CUPMS: 1999.52.14 rev	ЧЕСКА 3 СОРТЪ В: ЛЕД 1857
Fig. 49a CUPMS: 1999.54.14 obv	АРХ. ПОР ДЕСЯТНИК – АМАНЪ ЕРОФЕ ЕВЪ	Fig. 49b CUPMS: 1999.54.14 rev	АРХ. БР КУДЕЛЬ 2 СОРТЪ В. ЛЕД 1859
Fig. 50a CUPMS: 1999.52.9 obv	АРХ. Б ДЕСЯТ ПЕТРЪ МАРТЬЯ	Fig. 50b CUPMS: 1999.52.9 rev	АРХ. БР. ЧЕСКА 1 СОРТЪ Е.П. 1877
Fig. 51a CUPMS: 1999.52.7 obv	[А]РХ. БРА [Д]ЕСЯТСК. [Ф]ОМА ПОПОВЪ – [Е]ДѢНСКIИ	Fig. 51b CUPMS: 1999.52.7 rev	АРХАНГ. ПОР. ЧЕСКА 2 СОРТЪ Я.П.В. 1878

Fig. 52a CUPMS: 1999.52.1 obv

О
СЯТ
НИКЪ
МАТВЕЙ
ВЕДЕНС
КОИ

Fig. 52b CUPMS: 1999.52.1 rev

АРХ. Б
ЧЕСКА
2: СОРТЪ
В. ЛЕ[Д]
1851

Fig. 53a CUPMS: 1999.57.5 obv

ДЕСЯТЬНИКЪ
ЕГОРЪ
ТЕВЛЕВЪ
АРХ. БР

Fig. 53b CUPMS: 1999.57.5 rev

АР- - -
ПАКЛЯ ЧЕСКА
2 СОРТЪ
Я. [К].
1894

Fig. 54a CUPMS: 1999.216.1 obv

- - Х -РАК
ДЕСЯТНИК
СТЕПАНЪ
[И]ВОНИНСКОИ

Fig. 54b CUPMS: 1999.216.1 rev

АРХ. БР
КУДЕЛЯ
1 СОРТЪ
[А]. Р.
1902

Fig. 55a CUPMS: 1999.53.13 obv

[А][Р]Х. БРА
ДЕСЯТ
МИТРОФА
ШАРЫ

Fig. 55b CUPMS: 1999.53.13 rev

А- -. ПОР.
ЛЕНЪ
ЗАБРАКЪ
Я. К.
1863

Fig. 56a EXEMS: 99/1932 obv

А П
ДЕСЯЦК
М П

Fig. 56b EXEMS: 99/1932 rev

НИЖНОСУ
ХОНСКОЙ

Fig. 57 KIRMG: E585.04 rev

- -ЛѢГОДС
КОИ

Fig. 58 FALKM. 2002.43.8 rev

[Е]ЛИКО
СЕЛСКОИ

Fig. 59a FALKM: 2003.3.1 obv

СТАНЦ
26 АВГ 903
ТАГАНАШЪ

Fig. 59b FALKM: 2003.3.1 rev

КОНТРОЛЬ
А 767
К.Х.С.Ж.Д

Part One: Lead seals of Russian origin 61

СТ.
26 [–]ОЯ 09
ПОЛТАВА

Fig. 60a HARGM: 13606.17 obv

М. К. В. Ж. Д
А 38–
No 1

Fig. 60b HARGM: 13606.17 rev

СЕЛО
ГОРИЦЫ

Fig. 61a WAVMS: A003.3 obv

И С
КОБЕЛЬКОВЪ

Fig. 61b WAVMS: A003.3 rev

5 9
SIBERIA. Z
11

Fig. 62b GGAT 10a

(Crown held aloft by
two hands)

Fig. 62b GGAT 10b

РИЖ
17*87
(Russia: State Arms)
(Double-headed eagle
holding orb and sceptre)
П Т К (Key)

Fig. 63a FALKM 1985.74.4 a

17*87
(Double-headed eagle
holding orb and sceptre)

Fig. 63b FALKM 1985.74.4 a (detail)

(St Petersburg Arms)

(Crossed anchor and
grapnel with sceptre)

Fig. 64

1799
(Crossed anchor
and grapnel)

Fig. 65 DUMFM: 2001.32.2

– –ХОВСКАГО
(Ligatured initials)
ОКАГО

Fig. 66a CUPMS: 1999.53.37 obv

Но 2
Н [–] 7

Fig. 66b CUPMS: 1999.53.37 rev

И З

Fig. 67a ADMUS: A1988.292 obv

N 2
1845

Fig. 67b ADMUS: A1988.292 rev

Fig. 68 CUPMS: 1999.56.19 — ЯП – – НА – Р– / Б Ф

Fig. 69 KIRMG. 2006.364b — Б Н

Fig. 70 CUPMS: 1999.58.2 — – ПЕЛ БАНК / 17

Fig. 71a CUPMS: 1999.54.60 obv — НОВА – – СК / МЕЛЬНИЦА

Fig. 71b CUPMS: 1999.54.60 rev — – – asters / Ar[a]ns

Fig. 72a KIRMG. 2006.362 obv — Я А П

Fig. 72b KIRMG. 2006.362 rev — К. 10

Fig. 73a PERMG: 1992.140.10a — А. В. / АНДРОНОВЪ

Fig. 73b PERMG: 1992.140.10b — ГЛАВНАЯ / ВЪ / [П][Е][Н]ЗѢ / [–]ОН[–] – –

Fig. 74a JS.18a — Д / ЕФИМ[Ъ] / ЯГОДНИ / КОВЪ

Fig. 74b JS 18b — C H . / – C H A N – / [O] – – / A [П]

Fig. 75a DMP 03a — ГОСТОРГ / Н.К.Т

Fig. 75b DMP 03b — ХОЛОДИЛЬНИК / Г. П. / С. К.

Fig. 76 Arms of Riga

Fig. 77 Arms of Riga (detail)

Fig. 78 Watermark: Arms of Riga

Fig. 79 IP 04 Arms of Riga

Fig. 80 ADMUS: A1988.287

Fig. 81 WE 08

Fig. 82 PERMG: 2000.243.9

(Cross Keys surmounted by a Cross)

Fig. 83a GGD 01a

4

Fig. 83b GGD 01b

Fig. 84a ADMUS: M1998.94 obv

ЧЕРНЫЙ
РИЖСКІЙ
БАЛЬЗАМЪ

Fig. 84b ADMUS: M1998.94 obv

[Б]. ПРА
+ (Cross Keys)
1893

Fig. 84c ADMUS: M1998.94 rev

64 *Russian Cloth Seals in Britain*

	ПО Т РИГА 1802 КОХ		РИГА ПОРТ 17.97 – – ОТА / (Arms of Russia)
Fig. 85 ADMUS: M1998.95 obv		Fig. 86 ADMUS: B1988.9 obv	
	R B 12 M		(Quartered shield with pellets)
Fig. 87a KIRMG. 2006.352 obv		Fig. 87b KIRMG. 2006.352 rev	
	I K 12 K		(Quartered shield with pellets)
Fig. 88a KIRMG. 2006.361 obv		Fig. 88b KIRMG. 2006.361 rev	
	I K 9 K		(Quartered shield with pellets)
Fig. 89a ADMUS: M1997.136a		Fig. 89b ADMUS:M 1997.136b	
			А. П. ЛНА БРА 1 ЯС Р 1825 –[Д]ЕЛНАЯ [Н]
Fig. 90 KIRMG. 2006.367b		Fig. 91 CUPMS: 1999.52.19 rev	
	А– – СТЕПА – ОВЪ		АР– ПОР ПЕНК. БРА 2 ГЛ Р 1813
Fig. 92a GLDM.29.02 obv		Fig. 92b GLDM.29.02 obv	
	ХИЛЛС И ВИШАУ 1864		КУДЕЛЬ 2 СОРТЪ ВОЛОГДА
Fig. 93a DMP 08 obv		Fig. 93b DMP 08 rev	

Part Two. Catalogue of lead seals (Cyrillic and Roman)

The Catalogue records seals reported to the author before the end of 2009. However, those reported and described under the Portable Antiquities Scheme are excluded, unless they had already been examined and catalogued before being posted on PAS.

6.1. Cyrillic letters on Russian lead seals

Cyrillic	Approximate English equivalent	Transliteration	Cyrillic	Approximate English equivalent	Transliteration
А,а	a (as in father)	A	С	s (sick)	S
Б	b (beer)	B	Т	t (tick)	T
В	v (veer)	V	У, Ѵ	oo (stool)	U
Г	g (gear)	G	Ф	f (fool)	F
Д	d (deer)	D	Х	kh (Scot. loch)	Kh
Е	ye (yes)	E	Ц	ts (bits)	Ts
Ж	zh (leisure)	Zh	Ч	ch (church)	Ch
З	z (zoo)	Z	Ш	sh (shirt)	Sh
І	i (peek)	I	Щ	shch or long soft sh (Ashchurch, posh shop)	Shch
И	i (peek)	I	Ъ	hard sign (no sound) (indicates that the preceding consonant is hard)	"
Й	y (boy)	Y	Ы	i (pill)	Y
К	k (kick)	K	Ь	soft sign (indicates that the preceding consonant is soft)	'
Л	l (lick)	L	Ѣ	ye (yen)	yE
М	m (Mick)	M	Э	e (men)	E
Н	n (nick)	N	Ю	yu (tune)	yU
О	o (more)	O	Ѳ	f (fool)	Th
П	p (pick)	P	Я	ya (yam)	yA
Р	r (rick)	R			

6.1.1. Transliteration of Russian seals
NOTES ON TRANSLITERATION

An ideal transliteration system should enable the reader to reconstruct the original text from which the copy was made. However, owing to a number of differences in the manner in which the writing systems of Russian and English function, it is not possible to devise a transliteration system which would permit simple reconstruction to take place without the involvement of accents or other unfamiliar signs. The system adopted here therefore has a number of limitations.

The Roman alphabet adopted for English now has twenty-six symbols, corresponding to thirty-three symbols of Modern Russian and to thirty-six in Russian from the late eighteenth century until the spelling reform of 1918. One of these letters is not found on Russian seals so far recovered, which date from 1740s to the early twentieth century.

Some Cyrillic and Roman letters coincide in form and approximate sound (A, K, M, O, T), whilst others have recognisable shapes but represent different sounds (B [= V], E [= yE], H [= N], I [= ee]. P [= R]. S [= S]. Y [= oo], X [= Kh]. The remaining letters are not found in the Roman alphabet, though six, derived from Greek, are familiar to many readers.

With the exception of two letters the remaining letters represent sounds which occur in English where they are written in a combination of two or more consonants. Although the transliterated text in general is presented in capital letters, as found on the seals, such sounds are shown with a capital letter followed by a lower case one in the case of consonants (Ch, Kh, Sh, Shch, Ts), and a lower case 'y' followed by a capital letter in the case of vowels (yA, yE, yU).

The following additional points should be noted:

a) the consonants transliterated as 'Zh', 'Kh', 'Ts' 'Ch', 'Sh' and 'Shch' are single consonantal sounds in Russian.

b) the letter Y occurs in three situations:

 i. to represent the Russian middle vowel 'i' when it occurs after a consonant: BULYCHEV;

 ii. to represent the consonant 'y', when it occurs after a vowel: VEDENSKOY;

 iii. to indicate that the consonant preceding the vowels represented by the combinations 'yA', 'yO' and 'yU' is soft: TyURIN, a surname which is similar to the pronunciation in English of 't' in the Italian city 'Turin,' cf. 't' in 'touring.'

c) the vowel 'E' is always pronounced 'ye' and softens the preceding consonant, so 'Belyaev' is pronounced as 'Byelyayev.' 'Erofeev' as 'Yerofyeyev.'

d) The function of the hard sign (") is to indicate that the preceding consonant is hard, that of the soft sign (') to indicate that it is soft. The system of hard and soft consonants extends to all but five of the Russian consonants, and creates a picture which bears some similarity to the one observed in the following pairs in British English, but in which the softness in Russian is a feature of the consonant rather than the vowel: 'tune' and 'town', 'beauty' and 'booty', 'cute' and 'coot', 'due' and 'do', 'fuel' and 'fool', 'hue' and 'who', 'lieu' and 'loo', 'mew' and 'moo', 'knew' and 'know'.

e) Punctuation marks, the stop (.) and colon (:), are given where they occur on the seals, since they are an aid in two situations: to clarify the division of letters representing the initials of a forename from those forming the surname, or to divide the string of letters occurring on some seals which represent a codification of the contents of the bundle and its quality (TP:9H, MC:PH, IK:PH, IGK:PH etc.).

6.1.2. Conventions used in transcription

Conventions used in the transcription and transliteration of Russian seals are:

Symbol		*Significance*
–	en	Indicates the possible presence of letter
[–]	en in square brackets	Indicates the illegibility of a letter or letters in this position
[*a*]	letter within square brackets (for example, *a*)	Indicates the probable presence of the letter enclosed within the square brackets
()	text within round brackets	Encloses transcriber's comment or description
/	slash	Indicates the end of a line

6.2. Seals in Scottish museums
6.2.1 Aberdeen Museum and Art Gallery [ABDMS]

No.	Seal accession number	Face	Transcription	Transliteration
1	ABDMS: 072679	obv	П Д / [–]: НЕЛ/ [Ю]БОВ / Н 3	P D / [–]: NEL/ [yU]BOV / N 3
		rev	S P B / C H A H / 1821	S P B / C H A H / 1821
2	ABDMS: 072680	obv	Л. Д. / Я ШИ / ЛОВЪ / Н 5	L. D. / yA ShI / LOV" / N 5
		rev	С П Б / Но П. 1 / Н. Ш. / 1831	S P B / No P. 1 / N. Sh. / 1831
3	ABDMS: 072681	obv	– – / – – / СТИН / [Н]. 84	– – / – – / STIN / [N]. 84
		rev	– Р В / Но П 2 / А. И. Г. / 1833	– P B / No P 2 / A. I. G. / 1833
4	ABDMS: 072682	obv	. Н / Н [–] КИ / СОВ[–] / Н 10	. N / N [–] KI / SOV[–] / N 10
		rev	. В / – М R [H] / 178[–]	. B / – M R [H] / 178[–]
5	ABDMS: 072683	obv	М И АР / ЛОВЪ / Н 59	M I AR / LOV" / N 59
		rev	С П Б / Но П. 2 / I. М. Б / 183–	S P B / No P. 2 / I. M. B / 183–
6	ABDMS: 072684	obv	Л Д / П. ЩЕ[–] / БАКО[–] / – –	L D / P. ShchE[–] / BAKO[–] / – –
		rev	– – / 183[–]	– – / 183[–]
7	ABDMS: 072685	obv	Д / Л А / ЕВ / Н 57	D / L A / EV / N 57
		rev	Р В / N Р – 3. / – . W / 1832	P B / N P – 3. / – . W / 1832
8	ABDMS: 072686	obv	/КАВ[–] / [–]ЗИНЬ / [H] 36	/KAV[–] / [–]ZIN" / [N] 36
		rev	Р В / – Р. I / I. Н. / 1831	P B / – P. I / I. H. / 1831
9	ABDMS: 072687	obv	Л Д / РА / [–] ОВЪ / Н 0	L D / RA / [–] OV" / N 0
		rev	N Р / С 12 Н / [1]82[7]	N P / C 12 H / [1]82[7]
10	ABDMS: 072688	obv	– – / ЕСЯТ / МАТВЕИ / ВЕДЕНСКОI]	– – / ESyAT / MATVEI / VEDENSKOI]
		rev	– – / ДЕЛЬН / [1] СОРТЪ / Е П / 1844	– – / DEL'N / [1] SORT" / E P / 1844
11	ABDMS: 072689	obv	Л Д / СИН[–] / [–]НОВЬ /	L D / SIN[–] / [–]NOV" /
		rev	– –	– –
12	ABDMS: 072690	obv	АРХ. ПОР / ДЕСЯТН / КСАНД] / РИГ[–][–]	ARKh. POR / DESyATN / KSAND] / RIG[–][–]
		rev	АРХ. БР / КУДЕЛЬН / 2 СОРТЪ / Е. П. / 18– –	ARKh. BR / KUDEL'N / 2 SORT" / E. P. / 18– –
13	ABDMS: 072691	obv	Л Д / Я. КУЧ / КОВЬ / Н 62	L D / yA. KUCh / KOV" / N 62
		rev	N Р / I Б 12 Н / 1794	N P / I B 12 H / 1794
14	ABDMS: 072692	obv	Л. Д. / К РЯБ / ОВЪ /	L. D. / K RyAB / OV" /
		rev	С П Б / Но П – / П. Ч. / 1831	S P B / No P – / P. Ch. / 1831
15	ABDMS: 072693	obv	– – / ЛО[Г] / НОВЪ / Но 2[–]	– – / LO[G] / NOV" / No 2[–]
		rev	– – / N Р 2 / I. Р. / 1833	– – / N P 2 / I. P. / 1833
16	ABDMS: 072694	obv	Л Д / И: ШИ[–] / ВСКОИ / Н	L D / I: ShI[–] / VSKOI / N
		rev	N Р / – Р 12 Н / – 0–	N P / – P 12 H / – 0–
17	ABDMS: 072695	obv	– Д / [Д] ЕДО / НИКО / – –	– D / [D] EDO / NIKO / – –
		rev	S P / N P – / I. H. / 183–	S P / N P – / I. H. / 183–
18	ABDMS: 072696	obv	– / – – O / – Х – / – – –	– / – – O / – Kh – / – – –
		rev	(Illegible)	(Illegible)
19	ABDMS: 072697	obv	+ (Cross Keys) / 1	+ (Cross Keys) / 1
		rev	(Blank)	(Blank)
20	ABDMS: 072698	obv	+ (Cross Keys) / 1	+ (Cross Keys) / 1
		rev	(Blank)	(Blank)
21	ABDMS: 072699	obv	–(Cross Keys) / 1	–(Cross Keys) / 1
		rev	(Blank)	(Blank)
22	ABDMS: 072700	obv	R B / 12 K	R B / 12 K
		rev	(Arms consisting of a quartered shield)	(Arms consisting of a quartered shield)
23	ABDMS: 072701	obv	A B / – –	A B / – –
		rev	(Arms consisting of a quartered shield)	(Arms consisting of a quartered shield)

6.2.2. Arbroath (Signal Tower) Museum [ADMUS]

No.	Seal accession number	Face	Transcription	Transliteration
1	ADMUS: A1988.287	obv	+ (Cross Keys) / 1	+ (Cross Keys) / 1
		rev	(Blank)	(Blank)
2	ADMUS: A1988.288	obv	РИЖ / 17.87 / (Arms)	RIZh / 17.87 / (Arms)
		rev	(Blank)	(Blank)
3	ADMUS: A1988.289	obv	[Л] Д. / М. ПИ / КИНЬ / [Н] 35	[L] D. / M. PI / KIN" / [N] 35
		rev	N P / [–] P 12 [–] / 1797	N P / [–] P 12 [–] / 1797
4	ADMUS: A1988.290	obv	– – / ОРЕХ / ОВЪ / Н 114	– – / OREKh / OV" / N 114
		rev	N P / [Н] O 12 K / 1785	N P / [N] O 12 K / 1785
5	ADMUS: A1988.291	obv	Л. Д. / А. ВОЛ / КОВЪ / Но 5	L. D. / A. VOL / KOV" / NO 5
		rev	N P / A G 12 [–] / 1818	N P / A G 12 [–] / 1818
6	ADMUS: A1988.292	obv	И 3	I Z
		rev	N 2 / 1845	N 2 / 1845
7	ADMUS: A1988.294	obv	+ / (Cross Keys) / 1	+ / (Cross Keys) / 1
		rev	(Blank)	(Blank)
8	ADMUS: A1988.296	obv	А. В. DA[–][–]T[S]KI / Б А / 1846 / StPB	A. B. DA[–][–]T[S]KI / B A / 1846 / StPB
		rev	ЗЙ С / 2. П	ZY S / 2. P
9	ADMUS: A1988.297	obv	АРХ. БРА / ДЕСЯТЬ / АЛЕКСЕИ / –[Л]ЫЧЕВЪ	ARKh. BRA / DESyAT / ALEKSEI / –[L]YChEV"
		rev	– – / К[У]ДЪ[Л]Я] / 2 СОРТЪ / Ф. Р. / 1869	– – / K[U]DyEL[yA] / 2 SORT" / F. R. / 1869
10	ADMUS: A1988.298	obv	. Д: О / ЧЕРН / ЦОВЬ / Н 231	. D: O / ChERN / TsOV" / N 231
		rev	. W. К / I М 1 2 Н / 1777	. W. K / I M 1 2 H / 1777
11	ADMUS: A1988.299	obv	[Л] [–] / – – – – / ОЛЕВ / Н[4]0	[L] [–] / – – – – / OLEV / N[4]0
		rev	[N] Р / [–] Н [–] / 182[0]	[N] P / [–] N [–] / 182[0]
12	ADMUS: A1988.300	obv	– – / И [М] ВИ / ННИКОВЪ / Н 56	– – / I [M] VI / NNIKOV" / N 56
		rev	[N] Р / [Ч] 12 Н / [1]8[–]3	[N] P / [Ch] 12 H / [1]8[–]3
13	ADMUS: A1988.301	obv	+ / (Cross Keys) / 3	+ / (Cross Keys) / 3
		rev	(Blank)	(Blank)
14	ADMUS: A1988.302	obv	Л Д / [–]АЩ / [–][И]КОВ / Н 17	L D / [–]AShch / [–][I]KOV / N 17
		rev	N P / A P 12 [–] / -18[–]	N P / A P 12 [–] / -18[–]
15	ADMUS: A1988.303	obv	[Л] Д. / [–] ГРУ[3] / ИНИ[Н] / Н 8	[L] D. / [–] GRU[Z] / INI[N] / N 8
		rev	N P / [Р] F 12 Н / Я. Ф. / -81[–]	N P / [P] F 12 H / Ya. F. / -81[–]
16	ADMUS: A1989.246	obv	GEORG CLASSEN	GEORG CLASSEN
		rev	ZABRACK / 4 [Й] [С]	ZABRACK / 4 [Y] [S]
17	ADMUS: A1989.247	obv	Л Д / А. КАЗ / ЛОВЪ / Но [–]	L D / A. KAZ / LOV" / No [–]
		rev	С ПБ / No.П. 2 / П. Ш / 183–	S PB / No.P. 2 / P. Sh / 183–
18	ADMUS: A1989.263	obv	АРХ. БРА. / ДЕСЯТ / СТЕПАНЬ / [–]УНИ[–]	ARKh. BRA. / DESyAT / STEPAN" / [–]UNI[–]
		rev	АРХ. ПОР. / ЗАБРАКЪ / Я. К. / 1869	ARKh. POR. / ZABRAK" / yA. K. / 1869
19	ADMUS: A1989.264	obv	Л. Д. / [–] [–]О[–] / [–]ЕКО[В] / Н 20	L. D. / [–] [–]O[–] / [–]EKO[V] / N 20
		rev	N. Р / Р. 9 Н / 1822	N. P / P. 9 H / 1822
20	ADMUS: A1989.265	obv	А В DAMAT[–]КУ / [–] А. / 1851 / StPB	A B DAMAT[–]KY / [–] A. / 1851 / StPB
		rev	Но 2 / 9 П	No 2 / 9 P
21	ADMUS: A1989.266	obv	Л. Д. / П. СОБО / ЬЯНОВЬ / Н 3–	L. D. / P. SOBO / 'yANOV" / N 3–
		rev	S P [B]. / N P – 2 / I. H. / 1833	S P [B]. / N P – 2 / I. H. / 1833
22	ADMUS: A1989.267	obv	Л. Д / P: ДА[–] / ЫДОВЬ / Н 17	L. D / P: DA[–] / YDOV" / N 17
		rev	N. Р. / [–] К 9 Н / 1822	N. P. / [–] K 9 H / 1822

Part Two. Catalogue of lead seals (Cyrillic and Roman) 69

	Seal accession number	Face	Transcription	Transliteration
23	ADMUS: A1990.311	obv	А. В. DAMAZKI / В. А. / 1848 / StPB	A. B. DAMAZKI / B. A. / 1848 / StPB
		rev	Но 2. / – – / 9 П	No 2. / – – / 9 P
24	ADMUS: A1990.313	obv	Л. Д. / [Л] КОС / ТИНЬ. / Н 122.	L. D. / [L] KOS / TIN". / N 122.
		rev	N P. / [А] Б 12 Н /–8[2][–]	N P. / [A] B 12 H /–8[2][–]
25	ADMUS: A1990.315	obv	– – – БРА / ДЕСЯТ /–РО[–][–]ИН / ВЪ–	– – – BRA / DESyAT /–RO[–][–]IN / V"–
		rev	АРХ. [–][–] / КУДЕЛЬ / 2 СОРТЪ / В. ЛЕД / 1868	ARKh. [–][–] / KUDEL' / 2 SORT" / V. LED / 1868
26	ADMUS: A2000.212	obv	– – Н. КУД / РЯЕВЪ / [–][–]	– – N. KUD / RyAEV" / [–][–]
		rev	S P B / N P. – 3 / [–] P / 1835	S P B / N P. – 3 / [–] P / 1835
27	ADMUS: A2002.87.2	obv	– Д / [–] ВИНО / КУРОВ / Н 58	– D / [–] VINO / KUROV / N 58
		rev	S P B / N P – [3] / F. W. / 1828	S P B / N P – [3] / F. W. / 1828
28	ADMUS: A2002.87.3	obv	+ (Cross Keys) / 2	+ (Cross Keys) / 2
		rev	(Blank)	(Blank)
29	ADMUS: A2002.87.4	obv	[–][–] / [–]. ВОРО / БЬЕВЪ / Н 98	[–][–] / [–]. VORO / B'EV" / N 98
30	ADMUS: A2002.87.5	rev	S P B / N P [–] / [–][–] / – – –	S P B / N P [–] / [–][–] / – – –
		obv	– – / ВОРО / БЬЕВЪ / Н 72	– – / VORO / B'EV" / N 72
		rev	– – / Р. – 3 / [М] С / 1834	– – / P. – 3 / [M] C / 1834
31	ADMUS: A2003.53	obv	+ (Cross Keys) / 1	+ (Cross Keys) / 1
		rev	(Blank)	(Blank)
32	ADMUS: DBA3393/a	obv	Л Д / .ДОЛ / [–]–]Ь[К] / [–]	L D / .DOL / [–][–]'[K] / [–]
		rev	N P / HP 9 Н / 182[3] (HP as ligature)	N P / NR 9 N / 182[3] (NR as ligature)
33	ADMUS: DBA3393/b	obv	(Illegible)	(Illegible)
		rev	/ Б 12 / 180[–]	/ B 12 / 180[–]
34	ADMUS: DBA3393/c	obv	Л. Д. / Л: ЛОБ / КОВЪ / Н 8	L. D. / L: LOB / KOV" / N 8
		rev	N P. / В 12 Н / 1822	N P. / B 12 H / 1822
35	ADMUS: DBA3393/d	obv	АР–. ПО / ДЕСЯТН / АЛЕКСЕ. / ОЗЯПКИ / Нъ	AR–. PO / DESyATN / ALEKSE. / OZyAPKI / N"
		rev	АРХ. БРА / КУДЕЛЬ / 1 СОРТЪ / Я П В / 1839	ARKh. BRA / KUDEL' / 1 SORT" / yA P V / 1839
36	ADMUS: DBA3393/e	obv	/ – – – [Р]ОВ / [–]–[–]8	/ – – – [R]OV / [–]–[–]8
		rev	(Illegible)	(Illegible)
37	ADMUS: DBA3393/f	obv	Л. Д. / П: [Щ]И / ЛОВЪ / [–][–]2	L. D. / P: [Sh]I / LOV" / [–][–]2
		rev	S P / N P. – 2 / I [Н] / 1838	S P / N P. – 2 / I [H] / 1838
38	ADMUS: DBA3393/g	obv	/ ДЕСЯТНИКЪ / МИХАИЛЪ / – – – – ЕВЪ	/ DESyATNIK" / MIKhAIL" / – – – – EV"
		rev	АРХ. БР / З[А]БРАК / 2 РУКИ / Ф.Р. / 1889	ARKh. BR / Z[A]BRAK / 2 RUKI / F.R. / 1889
39	ADMUS:DBM 4217(a)	obv	+ (Cross Keys) / 2	+ (Cross Keys) / 2
		rev	(Blank)	(Blank)
40	ADMUS:DBM 4217 (b)	obv	Л. Д. / [–] СОБ[И] / НЧОВЪ / Н 5–	L. D. / [–] SOB[I] / NChOV" / N 5–
		rev	С П [Б] / No П – / Н – / 1835	S P [B] / No P – / H – / 1835

6.2.3. The Courthouse Museum, Cromarty [CMRCH]

No.	Seal accession number	Face	Transcription	Transliteration
1	CRMCH: 1990.3.1	obv	Л. Д / Д. ДОЛ / [–][–]ВЪ / [–] 12	L. D / D. DOL / [–][–]V" / [–] 12
		rev	S P B / T Ф R / 1799	S P B / T F R / 1799
2	CRMCH: 1990.3.2	obv	Л. П / НАВА / ТОВЪ / Н 2	L. P / NAVA / TOV" / N 2
		rev	П. I С / Н. ГАВА / ЛГИН– / [–]	P. I S / N. GAVA / LGIN– / [–]
3	CRMCH: 1990.3.3	obv	– – / – – – / НЫП	– – / – – – / N'P
		rev	[П] / 17 – –	[P] / 17 – –

4	CRMCH: 1990.3.4	obv	/ ЦОВ / Н 6	/ TsOV / N 6
		rev	S P B / [8]00	S P B / [8]00
5	CRMCH: 1990.3.5	obv	Д : А / С АННИБ / Н : 86	D: A / S ANNIB / N: 86
		rev	. W. K. / НР : 6. К. / 1775 (НР as ligature)	. W. K. / NR : 6. K. / 1775 (NR as a ligature)
6	CRMCH: 1990.3.6	obv	. ПД. / Е: СВИ / Н[И]Н] / –	. P. D. / E: SVI / N'[N] / –
		rev	S. P. B. / B. I. N. / [1]798	S. P. B. / B. I. N. / [1]798
7	CRMCH: 1990.3.7	obv	П. Д. / НЕХО / РОШЕВ / [–] 04	P. D. / NEKhO / ROShEV / [–] 04
		rev	S P B / Н Ш Р / 1818	S P B / N Sh R / 1818
8	CRMCH: 1990.3.8	obv	No 5	No. 5
		rev	N: P / . 12. B / 1752	N: P / . 12. V / 1752
9	CRMCH: 1990.3.9	obv	Д [–] / ЗЕМС . / КОЙ . / N 51	D [–] / ZEMS . / KOI . / N 51
		rev	N P / П С: 6 / 1777	N P / P S: 6 / 1777
10	CRMCH: 1990.3.10	obv	П Д / РА / – – О	P D / RA / – – O
		rev	/ Б – / 180[–]	/ B – / 180[–]
11	CRMCH: 1990.3.11	obv	П Д / – ШИ / ИКОВ / – 320	P D / – ShI / IKOV / – 320
		rev	S P B / [I] М Б А / 1827	S P B / [I] M B A / 1827
12	CRMCH: 1990.3.12	obv	А. / ТАРП / [Ч]ИНЬ / Н 20	A. / TAR.P / [Ch]IN" / N 20
		rev	S P B / . R . P H / 1776	S P B / . R . P H / 1776
13	CRMCH: 1990.3.13	obv	Д. / [Д]О[Л]Г / ОПО[Л]О / ВЪ . / 37	D. / [D]O[L]G / OPO[L]O / V" . / 37
		rev	S P B / [–] К [–] Н / 1781	S P B / [–] K [–] H / 1781
14	CRMCH: 1990.3.14	obv	Д. Д. / КАН / –ЕВЪ / [Н] – – .	D. D. / KAN / –EV" / [N] – – .
		rev	. S : P . / В С 1 [–] / 178[–]	. S: P . / B C 1 [–] / 178[–]
15	CRMCH: 1990.3.15	obv	. П Д / И СЫР / ОМЯТ .	. P D / I SYR / OMyAT .
		rev	S P B . / C S 1 [–] / [1]815	S P B . / C S 1 [–] / [1]815
16	CRMCH: 1990.3.16	obv	. Д. М. / ЗЕМС / КОЙ . / [– –]	. D. M. / ZEMS / KOI . / [– –]
		rev	N. P. / П С : 6 Н / 177[–]	N. P. / P S : 6 H / 177[–]
17	CRMCH: 1990.3.17	obv	[–] Д / Л. НОВ / ОТОРЖ / Н. 95	[–] D / L. NOV / OTORZh / N. 95
		rev	. S. P. B. / R A [Н] / 1797	. S. P. B. / R A [N] / 1797
18	CRMCH: 1990.3.18	obv	Д. Д. / КЛЮ / ЕВЬ / . . .	D. D. / KLyU / EV" / . . .
		rev	. S : P . / П П Т Н . / 1779	. S: P . / P P I N . / 1779
19	CRMCH: 1990.3.19	obv	Д. А. / С АННИБ / Н : 86	D. A. / S ANNIB / N: 86
		rev	W / L G K 6 K / .1775 .	W / L G K 6 K / .1775.
20	CRMCH: 1990.3.20	obv	Д. А. / С АННИБ / Н : 86	D. A. / S ANNIB / N: 86
		rev	W . / D H. 6 [K] / 1775	W . / D H. 6 [K] / 1775
21	CRMCH: 1990.3.21	obv	П Д / [–] ДЕМ / ИДОВ: / [–] 96 .	P D / [–] DEM / IDOV: / [–] 96 .
		rev	[S P B] / М М Р Н / [1]804 . / Н 4 .	[S P B] / M M P H / [1]804 . / N 4 .
22	CRMCH: 1990.3.22	obv	– Д / П: ЛГА . / ЛИНЬ / . Н. 55	– D / P: LGA . / LIN" / . N. 55
		rev	. S P B . / П. А С Р. Н / 1789.	. S P B . / P. A S R. N / 1789.
23	CRMCH: 1990.3.23	obv	К [–] / [Р][Х] / Е[–]ОВЪ / – 88 .	K [–] / [R][Kh] / E[–]OV" / – 88.
		rev	S P B / D. H. P. H. / .1775.	S P B / D. H. P. H. / .1775.
24	CRMCH: 1990.3.24	obv	[П] Д: / М БОЛ / ОШЕВ / Н 11	[P] D: / M BOL / OShEV / N 11
		rev	[S] P B / [– – –] / 1799 / [–] 9	[S] P B / [– – –] / 1799 / [–] 9
25	CRMCH: 1990.3.25	obv	Д А / [–] РЕК[–] / [–]НЪ. / [–]	D A / [–] REK[–] / [–]N" . / [–]
		rev	N. P. / I. K. 6. H / 1777	N. P. / I. K. 6. H / 1777
26	CRMCH: 1990.3.26	obv	[– –] / [М]ОШ / НИКОВ / Н 327	[– –] / [M]OSh / NIKOV / N 327
		rev	. N. P. / Н. Р. 6. Н. / 1775	. N. P. / H. P. 6. H. / 1775

Part Two. Catalogue of lead seals (Cyrillic and Roman)

27	CRMCH: 1990.3.27	obv	П. Д. / П. КОЗ / УЛИ[Н]	P. D. / P. KOZ / ULI[N]
		rev	S. P. B. / P. I. N. / [1]790	S. P. B. / P. I. N. / [1]790
28	CRMCH: 1990.3.28	obv	Л. Д. / [-] А – Н[Н]	L. D. / [-] A – N[N]
		rev	Р [-] / А [-] / 1[-]76	P [-] / A [-] / 1[-]76
29	CRMCH: 1990.3.29	obv	ЛД / [З] О[Л]О– / АРЕВЪ / Н. 70	L D / [Z] O[L]O– / AREV'' / N. 70
		rev	S. P. B. / [-] C. P. [-] / 1775	S. P. B. / [-] C. P. [-] / 1775
30	CRMCH: 1990.3.30	obv	[Д] И / Р[-] ДЫЛ / ЕВЪ . / Н. 72	[D] I / R[-] DYL / EV'' . / N. 72
		rev	. S P B / I R P H /. 17[-][-]	. S P B / I R P H /. 17[-][-]
31	CRMCH: 1990.4.1	obv	+ (Cross Keys)	+ (Cross Keys)
		rev	(Blank)	(Blank)
32	CRMCH: 1990.4.5	obv	РБУРГ ПОР(around the arms of St Petersburg)	RBURG POR(around the arms of St Petersburg)
		rev	–	–
33	CRMCH: 1990.29 1	obv	. Д. [S] . / СЫСОЕ / ВЪ / Н [-][-]	. D . [S] . / SYSOE / V'' / N [-][-]
		rev	. N. P. / D. Н 6. К. / 1777	. N. P. / D. H 6. K. / 1777
34	CRMCH: 1990.29 2	obv	[П] Д. / [-] ЛАТЫ / ШЕВЪ / Н 16	[P] D. / [-] LATY / ShEV'' / N 16
		rev	S P B / А Г [-] / Н / 1823	S P B / A G [-] / N / 1823
35	CRMCH: 1990.29 3	obv	П. Д. / [-] БУТ / ЫЛКИ / Н 192	P. D. / [-] BUT / YLKI / N 192
		rev	S P B / G K. P K / [1]805	S P B / G K. P K / [1]805
36	CRMCH: 1990.29 4	obv	П Д / . СОМ / ОВЪ / Н 34	P D / . SOM / OV'' / N 34
		rev	S P [B] / C F A [-] / 1799	S P [B] / C F A [-] / 1799
37	CRMCH: 1991.04.1	obv	Д: – / ОБРАЗ / ЦОВЪ / Н. 17	D: – / OBRAZ / TsOV'' / N. 17
		rev	. S – – / Д Н : Р : Н / 1778	. S – – / D N : R: N / 1778
38	CRMCH: 1991.04.2	obv	. П Д. / М ШЕР / АПО[В] / –	. P D. / M ShER / APO[V] / –
		rev	S P B / I M P H / 1823	S P B / I M P H / 1823
39	CRMCH: 1991.04.3	obv	– Д. / Б: ВА / ЛИН / 286	– D / B: VA / LIN / 286
		rev	S [–] В / В А Р [Н] / . 1805 .	S [–] B / V A R [N] / . 1805 .
40	CRMCH: 1991.04.4	obv	. П Д / В ШВЕ / ЦОВЪ / Н 161	. P D / V ShVE / TsOV'' / N 161
		rev	S P B / К К А [Н] / 180[0]	S P B / K K A [H] / 180[0]
41	CRMCH: 1991.04.5	obv	. П. / Л: [С][–] / ДОВ / Н 29	. P / L: [S][–] / DOV / N 29
		rev	S P B / И [Н] Р Н / [1]814	S P B / I [H] P H / [1]814
42	CRMCH: 1991.04.6	obv	П – / – – – / ВЪ / N 385	P – / – – – / V'' / N 385
		rev	S P B / М С. Р Н / 1778	S P B / M C. P H / 1778
43	CRMCH: 1991.04.7	obv	Д: А / АННИБ / Н 86	D: A / ANNIB / N 86
		rev.	W. K. / НР: 6 К / 1775 (НР as ligature)	W. K. / NR: 6 K / 1775 (NR as a ligature)
44	CRMCH: 1991.23.01	obv	. Д Л 1 / ПЛОТЬ / Н[И]КОВЪ / 250	. D L I / PLOT'' / N[I]KOV'' / 250
		rev	N: P / L G K 6 [K] / 1777	N: P / L G K 6 [K] / 1777
45	CRMCH: 1991.23.02	obv	П. Д. / И: НЕЧ / АЕВЪ / Н 83	P. D. / I: NECh / AEV'' / N 83
		rev	S P B / F. R. H / –. – / 1798	S P B / F. R. H / –. – / 1798
46	CRMCH: 1991.27.1	obv	П Д. / В. [–]ЛС[–] / ЛАПО / . Н: 4	P D / V. [–]LS[–] / LAPO / . N: 4
		rev	. S P B / M M – / [–]77[2]	. S P B / M M – / [–]77[2]
47	CRMCH: 1991.29.01	obv	Д / [А] Р / ЕВЪ / [N] 2 .	D / [A] R / EV'' / [N] 2 .
		rev	[S] P. / [–] Б 1 Н / [1]777	[S] P. / [–] B 1 H / [1]777
48	CRMCH: 1991.29.02	obv	П. Д. / В. КО[С] / ТИНЪ / Н 13	P. D. / V. KO[S] / TIN'' / N 13
		rev	. S P B / Т Н А Н / 1801	. S P B / T H A H / 1801
49	CRMCH: 1991.29.03	obv	Д: Г. / ГОЛБЯ / ТНИКОВЪ / Н: 8I	D: G. / GOLUByA / TNIKOV'' / N: 8I
		rev	. S. P. B. / I G K. P H / 1775	. S. P. B. / I G K. P H / 1775

50	CRMCH: 1991.29.04	obv	. Д : А / С АННИВ / Н : 8	. D : A / S ANNIB / N : 8
		rev	. N Р / С Ғ. К 9 К / . 1775 .	. N P / C F. K 9 K / . 1775 .
51	CRMCH: 1991.29.05	obv	Д / ЕМ[К] / - - / 07	D / EM[K] / - - / 07
		rev	S Р В / [-] Н Р Н / 1785	S P B / [-] H P H / 1785
52	CRMCH: 1991.29.06	obv	. Д. Д. / - КЛЮ / ЕВЪ / Н - -	. D. D / - KLyU / EV" / N - -
		rev	. S Р / ПП1 [-] / - [1]779	. S P / P P 1 [-] / - [1]779
53	CRMCH: 1991.29.07	obv	- - / А / [C]О – В / 26	- - / A / [S]O – V / 26
		rev	– Р В / М Ѳ Р / [–]784	– P B / M Th R / [–]784
54	CRMCH: 1991.37	obv	П. Д. / – ГАВ/ –[–]ІНЪ / – 6	P. D. / – GAV/ –[–]IN" / – 6
		rev	СПБ / ПЕН 2 / А. П. / 1835	S P B / PEN 2 / A. P. / 1835
55	CRMCH: 1991.38 1	obv	– Д / П АЛМ / [–]ИМАН / Н. 14	– D / PALM / [–]IMAN / N. 14
		rev	[S] Р В. . – Н Р Н / 1817	[S] P B . – H P H / 1817
56	CRMCH: 1991.38 2	obv	. Д / МАЛ[Е] / НКОИ: / Н. 52	. D / MAL[E] / NKOI: / N. 52
		rev	W. K / I R. 6 K / 1775	W. K / I R. 6 K / 1775
57	CRMCH: 1991.38 3	obv	П. Д. / Д: ПАГ / АНКИ[Н] / Н 179	P. D. / D: PAG / ANK[I]N] / N 179
		rev	S. Р. В. / Р. F. А. / . – . / 1799	S. P. B. / P. F. A. / . – . / 1799
58	CRMCH: 1991.38 4	obv	–	–
		rev	S Р / I. S. Н. [–] . / .1775.	S P / I. S. H. [–] . / .1775.
59	CRMCH: 1991.38 5	obv	Д [–] / ВАЛА / [–]ЕВЪ. / Н 97	D [–] / VALA / [–]EV". / N 97
		rev	S Р В / Д Н Р Н / 1781	S P B / D N R N / 1781
60	CRMCH: 1991.38 6	obv	Д : А / П АП[О] / ВЪ. . / Н. 37	D : A / P AP[O] / V". / N. 37
		rev	S [–] В / I К : Р Н. / 177 [–]	S [–] B / I K : P H. / 177 [–]
61	CRMCH: 1991.38 7	obv	Д. А / ВАВИ / ОВЪ / Н24	D. A / VAVI / OV" / N24
		rev	N. Р. / ЯВ 6 / 1779	N. P. / yA V 6 / 1779
62	CRMCH: 1991.38 8	obv	. П Д / С. АРЕ / ФЬЕВЪ / Н 121	. P D / S. ARE / FEV" / N 121
		rev	S Р В / Я С Р Н / 1807	S P B / yA S R N / 1807
63	CRMCH: 1991.38 9	obv	. Д С / [Ч][–]АР[К] / ОВЪ / Н 32	. D S / [Ch][–]AR[K] / OV" / N 32
		rev	N Р / 6 Н / 17[7]8	N P / 6 H / 17[7]8
64	CRMCH: 1991.38 10	obv	No. 47	No. 47
		rev	N Р / [–] В 12 Ѳ Р / 175[3]	N P / [–] B 12 Th R / 175[3]
65	CRMCH: 1991.38 11	obv	. Д / [–][–] / [Е]ВЪ . / .	. D / [–][–] / [E]V" . / .
		rev	[Т] Н Р / 177[3]	[T] H P / 177[3]
66	CRMCH: 1991.38 12	obv	Д / О / Р	D / O / R
		rev	– – / РН / 1775	– – / RN / 1775
67	CRMCH: 1991.60.1	obv	П. Д / ЧЕРТ / КОВЪ / 163	P. D / ChERT / KOV" / 163
		rev	S. Р. В. / Н – 2. / Р. К. / 1838	S. P. B. / N – 2. / P. K. / 1838
68	CRMCH: 1991.60.2	obv	[–]Д / [–][–][ТС[–] / ОР[–]В / Н 34	[–]D / [–][–][TS[–] / OR[–]V / N 34
		rev	S Р В / Т – – Н / 1789	S P B / T – – H / 1789
69	CRMCH: 1991.60.3	obv	П. Д. / [И]. ЖУК / [О]ВЪ / [Н] 149	P. D. / [I]. ZhUK / [O]V" / [N] 149
		rev	S Р В / – F 2 Н / 1806	S P B / – F 2 H / 1806
70	CRMCH: 1991.60.4	obv	[Г] М[Ъ] / – – ОВЪ / Н 24	[G] M[yE] / – – OV" / N 24
		rev	N Р / . . F.6 / [1][7][7][–]	N P / . . F.6 / [1][7][7][–]
71	CRMCH: 1992.11.1	obv	Д. – / НЕМИ / ЛОВЬ / N 286	D. – / NEMI / LOV" / N 286
		rev	S Р В / М С : Р Н / 1778	S P B / M C: P H / 1778
72	CRMCH: 1992.11.2	obv	. П Д / К : КУ / [–]РЯЕВ / Н 28	. P D / K : KU / [–]RyAEV / N 28
		rev	S Р В / Е С Р Н / 1804	S P B / E C P H / 1804

Part Two. Catalogue of lead seals (Cyrillic and Roman)

73	CRMCH: 1992.11.3	obv	Д – / ЩИПА / ЧЕВЪ / Н 403	D – / ShchIPA / ChEV" / N 403
		rev	S P Б / [–] О Р Н / 1781	S P B / [–] O P H / 1781
74	CRMCH: 1992.11.4	obv	.П Д / А [–]В[А] / СИЛЕВ / [Н] 295	.P D / A [–]V[A] / SILEV / [N] 295
		rev	S P Б / 1 С [В] Р Н / 1815	S P B / 1 C [B] P H / 1815
75	CRMCH: 1992.11.5	obv	П Д / [–] СИМ / АНОВ / . . .	P D / [–] SIM / ANOV / . . .
		rev	S P Б / [А][К] – – / 18– –	S P B / [A][K] – – / 18– –
76	CRMCH: 1992.11.6	obv	.П П. . / П. ЛАРІ / О[Н]ОВЪ / –	.P P. . / P. LARI / O[N]OV" / –
		rev	–	–
77	CRMCH: 1992.11.7	obv	– Д / В. ТЕ / ПИНЪ / [Н] 72	– D / V. TE / PIN" / [N] 72
		rev	.S P Б. / М М Р Н / 1823	.S P B. / M M P H / 1823
78	CRMCH: 1992.11.8	obv	[–][/] ТАР[Е] / [–][–] / Н 2	[–][/] TAR[E] / [–][–] / N 2
		rev	S [Р] Б / [–] З Р 17[–][6]	S [P] B / [–] Z P 17[–][6]
79	CRMCH: 1992.11.9	obv	– – В / ъ.	– – B / ".
		rev	[S] Р Б / [–] Н Р [Н] / [–]801	[S] P B / [–] N R [N] / [–]801
80	CRMCH: 1992.12	obv	17 91 / (Arms 5 / РИ СКО	17 91 / (Arms) 5 / RI SKO
		rev	–	–
81	CRMCH: 1996.32.01	obv	.П Д. / П КОЧЕ / [В]СКОИ / 235	.P D. / P KOChE / [V]SKOI / 235
		rev	S P Б / Н. І. / І. Н. / 1829	S P B / H. I. / I. H. / 1829
82	CRMCH: 1996.32.02	obv	Д. И. / –ДЫЛ / – –В / – –79	D. I. / –DYL / – –V / – –79
		rev	С П Б / І – : Р Н / 1775	S P B / I – : P H / 1775
83	CRMCH: 1996.32.03	obv	.П / М БОГО / МОЛО[В] /	.P / M BOGO / MOLO[V] /
		rev	–	–
84	CRMCH: 1996.037.01	obv	Д. В. / СИМА / ОВЪ / Н 216	D. V. / SIMA / OV" / N 216
		rev	S P Б / L G К Р Н / . 1775	S P B / L G K P H / . 1775
85	CRMCH: 1996.037.02	obv	Д / – – АМИНЪ / Н(Б)І	D / – –AMIN" / N(B)I
		rev	(in NB the Б is superscript and to the right of Н) [S] Р Б / С Е Н Н / 1775	(In NB the B is superscript and to the right of N) [S] P B / C E H N / 1775
86	CRMCH: 1996.37.03	obv	[–] Д / [–] БАЛА/ ШЕВЪ / Н 309	[–] D / [–] BALA/ ShEV" / N 309
		rev	S P Б / Н. 3 / W Н / 18– –	S P B / H. 3 / W H / 18– –
87	CRMCH: 1996.37.04	obv	[–] КО[–] / – ОВЪ / Н 51	[–] KO[–] / – OV" / N 51
		rev	S Р Б / – Р[А]Н / 18– –	S P B / – P[A]H / 18– –
88	CRMCH: 1996.37.05	obv	.П Д / С. ТОЛ / СТИКО / Н 88	.P D / S. TOL / STIKO / N 88
		rev	S P Б / Т L А Н / 1824	S P B / T L A H / 1824
89	CRMCH: 1996.37.06	obv	П. Д. / С: С[Е] / ЛИН[Ъ]	P. D. / S: S[E] / LIN["]
		rev	S Р [В] / J Н Р [Н] / 1825	S P [B] / J H P [H] / 1825
90	CRMCH: 1996.37.07	obv	Д: – / ОВ	D: – / OV
		rev	S. Р / [–][–]Н / 1775	S. P / [–][–]H / 1775
91	CRMCH: 1996.37.08	obv	1792 (Arms: eagle)	1792 (Arms: eagle)
		rev	–	–
92	CRMCH: 2002.003.01	obv	П. Д. / Н. ЗАР / НОВЪ / Н 343	P. D. / N. ZAR / NOV" / N 343
		rev	S Р Б / W Н А [–] / 1823	S P B / W H A [–] / 1823
93	CRMCH: 2002.003.02	obv	Д. А. / ШАМИНЪ / НБ (in NB the Б is superscript to the right) .S Р. / Р. С. І. Н / 1775	D. A. / ShAMIN" / NB (In NB the B is superscript and to the right of N) .S P. / P. C. I. H / 1775
		rev		
94	CRMCH: 2002.004.01	obv	П. Д. / [–] ЧЕР / НЫШО / Н 8[–]	P. D. / [–] ChER / NYShO / N 8[–]
		rev	S P Б / Т L А Н / 1825	S P B / T L A H / 1825

	Seal accession number	Face	Transcription	Transliteration
95	CRMCH: 2002.004.02	obv	П. / Д. ПО[–] / НЕ[В]Ь / – 7[9]	P. / D. PO[–] / NE[V]" / – 7[9]
		rev	S P B / Б. А. / 18[3][–]	S P B / B. A. / 18[3][–]
96	CRMCH: 2002.004.03	obv	П. Д. / И. ЧУП / ЯТОВ / Н 251	P. D. / I. ChUP / yATOV / N 251
		rev	S P B / O P P H / 1825	S P B / O P P H / 1825
97	CRMCH: 2002.004.04	obv	П. П. / Б. ДАМ / АНОВ / Н. I	P. P. / B. DAM / ANOV / N. I
		rev	–	–
98	CRMCH: 2002.004.05	obv	Д. С. / [В] КЛ[Я] / П[І]НЬ	D. S. / [V] KL[yA] / P[I]N"
		rev	–	–
99	CRMCH: 2002.004.06	obv	Л. Д. / И МАКА / РЕВИЧ / Н. [9]0	L. D. / I MAKA / REVICh / N. [9]0
		rev	N P / I H 12 / 1818	N P / I H 12 / 1818
100	CRMCH: 2002.004.07	obv	.П Д. / А.К: С. / ЛАНИ / Н I09	.P D. / A.K: S. / LANI / N I09
		rev	S P B / И [К] R H / 18– –	S P B / I [K] R H / 18– –
101	CRMCH: 2002.004.08	obv	П. Д: / – – – / – – – / Н 339	P. D: / – – – / – – – / N 339
		rev	– . / Т. Н. А. Н. / 1789	– . / T. H. A. H. / 1789
102	CRMCH: 2002.005	obv	– – / Р. К / Н 80[–]	– – / P. K / H 80[–]
		rev	– – / 179[–]	– – / 179[–]
103	CRMCH: 2002.012.1	obv	.Л Д. / В. КУД / РЯЕВ / Н I	.L D. / V. KUD / RyAEV / N I
		rev	S P B / A K A – / 179–	S P B / A K A – / 179–
104	CRMCH: 2002.012.2	obv	/[–]ЕЛ / – ИНЬ /	/[–]EL / – IN" /
		rev	П / Л З I Н / 18[0]8	P / L Z I N / 18[0]8
105	CRMCH: 2002.012.3	obv	Д Е / ДМИТ / РЕВЬ / – – 3	D E / DMIT / REV" / – – 3
		rev	. S. P. B / L I W P H / 1787	. S. P. B / L I W P H / 1787
106	CRMCH: 2002.012.4	obv	П. П / СЕДО / ВЬ / Н. 3	P. P / SEDO / V" / N. 3
		rev	Ш / Б Д / [К]КОВ / [Н] 3	Sh / B D / [K]KOV / [N] 3

6.2.4. Dumfries Museum [DUMFM]

No.	Seal accession number	Face	Transcription
1	DUMFM: 2001.32.2	obv	1799 / (Crossed anchor and grapnel)
		rev	(Blank)

6.2.5. Dundee Arts and Heritage (McManus Galleries) [DUN]

No.	Seal accession number	Face	Transcription	Transliteration
01	DUN:1976.2267	obv	–ДЕСЯ / МИХАИЛ / – ЕШНИКОВ /	–DESyA / MIKhAIL / – EShNIKOV /
		rev	– – / КУДЕЛ– / 1 СОРТЪ / А. Р. / 1844	– – / KUDEL– / 1 SORT" / A. R. / 1844
02	DUN:1977.1048	obv	A. R. DAMAZKI / B. A. / 1847 / StPB	A. R. DAMAZKI / B. A. / 1847 / StPB
		rev	Ho. I. / – –. / Л. 12. П.	No. I. / – –. / L. 12. P.
03	DUN:1978.1430(1)	obv	H W / – 2 K	H W / – 2 K
		rev	(Arms)	(Arms)
04	DUN:1978.1430(2)	obv	Д [Д] / П [Л] ОТ / ХОВЪ / Н 48	D [D] / P [L] OTU / KhOV" / N 48
		rev	N: P: / 1 K 1. 2 H / 1777	N: P: / 1 K 1. 2 H / 1777
05	DUN:1978.1430(3)	obv	Л Д / Т. ХО [–] / [–] ОВЪ	L D / T. KhO [–] / [–] OV"
		rev	[S] [P] [B] / Но П 2 / Г. Б. / 1838	[S] [P] [B] / No П 2 / G. B. / 1838
06	DUN:1978.1430(4)	obv	Л Д / Ф БО[–] / АРОВ /	L D / F BO[–] / AROV /
		rev	[N] [P] / – НР 9 К / 1801 (НР as ligature)	[N] [P] / – NR 9 K / 1801 (NR as a ligature)

Part Two. Catalogue of lead seals (Cyrillic and Roman)

07	DUN:1978.1430(5)	obv	Л. Д. / [–]АН / ТЮХИ / [Н] 95	L. D. / [–]AN / TyUKhI / [N] 95
		rev	–Р– / No П 3 / В. К. / 1830	–P– / No P 3 / V. K. / 1830
08	DUN:1984.91	obv	П. П. / А КАШ / ЕВАРО / Н	P. P. / A KASh / EVARO / N
		rev	–	–
09	DUN:1989.66 (1)	obv	Л. Д. / [–]: ЧУIЯ / ТОВЪ / Н. I[–]	L. D. / [–]: ChUPyA / TOV" / N. I[–]
		rev	[С] П Б / НоП 3 / М. С. / 1836	[S] P B / No P 3 / M. S. / 1836
10	DUN:1999.21 (1)	obv	Л. Д. / ДЕДО / НИК / Н [3]	L. D. / DEDO / NIK / N [3]
		rev	П Б / П. 2 /	P B / P. 2 /
11	DUN:1999.21 (2)	obv	В. ПРО/ НИНЪ / Н 28	V. PRO/ NIN" / N 28
		rev	S P B / N. P. – 2 / Р. К. / 1829	S P B / N. P. – 2 / P. K. / 1829
12	DUN:1999.21 (3)	obv	Д / ВИНО – [К]УРО[В]Ъ / Н: 18	D / VINO / [K]URO[V] / N: 18
		rev	С П Б / НоП 3 / М. С. / – – –	S P B / No P 3 / M. S. / – – –
13	DUN:1999.21 (4)	obv	– – / ДЕСЯТН. / ИВАНЪ / КУКТИНСК	– – / DESyATN. / IVAN" / KUKTINSK
		rev	[–]РХ БР / ЗАБРАК / 1 РУКИ / Е. П / 1883	[–]RKh BR / ZABRAK / 1 RUKI / E. P / 1883
14	DUN:1999.21 (5)	obv	/ ИГА / ЧЕВЪ. / Н [–][–]	/ IGA / CheV". / N [–][–]
		rev	/[–] 12 Н / 18[3][–]	/[–] 12 H / 18[3][–]
15	DUN:1999.21 (6)	obv	(+ Cross Keys) / 2	(+ Cross Keys) / 2
		rev	(Blank)	(Blank)
16	DUN:2002.37	obv	* N * / * I * /	* N * / * I * /
		rev	N P / [–] N 9. – 0 / 1758	N P / [–] N 9. – 0 / 1758
17	DUN:АНН.2004.24	obv	НГЕЛЛОРТ / –ЕСЯТСКИЙ / –ЛЕКСАНД./.–. / – НЪ	NGEL. PORT / –EsyATSKIY / –LEKSAND./.–. / – N"
		rev	АРХ. БР / КУДЪЛЯ / 2 СОРТЪ / Е. П. / 1879	ARKh. BR / KUDyElyA / 2 SORT" / E. P. / 1879
18	DUN:АНН.2004.25	obv	А. П. / ДЕСЯСК. / Е. М.	A. P. / DESyASK. / E. M.
		rev	– * – / ЛНЯН БР / 1. ВД. Р / 1835	– * – / LNyAN BR / 1. VD. R / 1835
19	DUN:АНН2005-16. 01	obv	ДЕСЯ– / АЛЕКСЕ / ОРЕХОВЪ	DESyA– / ALEKSE / OREKhOV"
		rev	АРХ. БР / ЗАБРАКЪ / В.Д. / 1839	ARKh. BR / ZABRAK" / V.D. / 1839
20	DUN:АНН2005-16. 02	obv	АРХ. ПОР. / ДЕСЯТН. / АЛЕКСЕЙ / ГРИБЫН	ARKh. POR. / DESyATN. / ALEKSEY / GRIBIN
		rev	АРХ. Б– / КУДЕЛЬ[Н] / 2: СОРТЪ / Ф: Р / 1853	ARKh. B– / KUDEL[N] / 2: SORT" / F: R / 1853
21	DUN:АНН2005-16. 03	obv	АРХ. БРА / ДЕСЯТ / МИТРОФА / ШАРЫ	ARKh. BRA / DESyAT / MITROFA / ShARY
		rev	АРХ. БР. / ЧЕСКА / 2. СОРТЪ / Е. П. / 1869	ARKh. BR. / ChESKA / 2. SORT" / E. P. / 1869
22	DUN:АНН2005-16. 04	obv	АРХ. ПОР. / ДЕСЯТСК. / ПЕТРЪ / ПЛОТНИКОВЪ	ARKh. POR. / DESyATSK. / PETR" / PLOTNIKOV"
		rev	АРХ. БР. / ЗАБРАКЪ / Ф. Р. / 1870	ARKh. BR. / ZABRAK" / F. R. / 1870
23	DUN:АНН2005-16. 05	obv	– –ОР / ДЕСЯТ / / ФАРУТИ / НЪ	– –OR / DESyAT / FARUTI / N"
		rev	–РХ БР / КУДЕЛЬ / СОРТЪ / – – / 1853	–RKh BR / KUDEL' / SORT" / – – / 1853
24	DUN:АНН2005-16. 06	obv	/ДЕСЯТСК / ПАВЕЛЪ / [–][–]ЕДОВЪ	/DESyATSK / PAVEL' / [–][–]EDOV"
		rev	АРХ. БР / КУДЪЛЯ / 1 СОРТЪ / Н. С. / 1893	ARKh. BR / KUDyElyA / 1 SORT" / N. S. / 1893
25	DUN:АНН2005-16. 07	obv	(Illegible)	(Illegible)
		rev	/ ДЪЛ / СОРТ / Н. С. / 1895	/ DyEL / SORT / N. S. / 1895
26	DUN:АНН2005-16. 08	obv	РХ БРА / ДЕСЯТ / –АСИЛ / ЛЕПИ[Н]	RKh BRA / DESyAT / –ASIL / LEPI[N]
		rev	АРХ. БР. / КРОНЬ / 3 СОРТЪ / Я. К. / – – –	ARKh. BR. / KRON' / 3 SORT" / yA. K. / – – –
27	DUN:АНН2005-16. 09	obv	Л. Д / И. М. ЕРЕ / МЕЕВЪ / Н [–]П	L. D / I. M. ERE / MEEV" / N [–]П
		rev	S P B / N P. – 3 / I. B. / 1829	S P B / N. P. – 3 / I. B. / 1829
28	DUN:АНН2005-16. 10	obv	П и Л П Д / Ф СУХО / РУКОВ / No 6	P i L P D / F SUKhO / RUKOV / No 6
		rev	S P B / I C B N. 2 / 1831	S P B / I C B N. 2 / 1831
29	DUN:АНН2005-16. 11	obv	Л: Д / А. РУД[О] / МЕТО[В] / Н – –	L: D / A. RUD[O] / METO[V] / N – –
		rev	С П [Б] / НоП. 2 / А.И.Г. / 1831	S P [B] / No P. 2 / A.I.G. / 1831

30	DUN:AHH2005-16.12	obv	П и Л П Д / Ф СУХО / РУКО / Но 6	P i L P D / F SUKhO / RUKO / No. 6
		rev	С П Б / Л З. 2 Н / 1832	S P B / L Z. 2 H / 1832
31	DUN:AHH2005-16.13	obv	Л Д. / Г. МЕС / НИКОВ / Н 1–	L.D. / G. MES / NIKOV / N 1–
		rev	С П Б / Но П. 3 / [Н] Ш / –832	S P B / No P. 3 / [N] Sh / –832
32	DUN:AHH2005-16.14	obv	[Л] Д / [–]. [М]ЕР / КУЛО[В] Н 28	[L] D / [–]. [M]ER / KULO[V] N 28
		rev	. N [P] / [I] B 12 / 1821	. N [P] / [I] B 12 / 1821
33	DUN:AHH2005-16.15	obv	Л: Д / Д. ВОР[О] / БЬЕВЪ / . Н [7][–]	L: D / D. VOR[O] / BEV" / . N [7][–]
		rev	N P / I S 12 H / 1801	N P / I S 12 H / 1801

6.2.6. Edinburgh (National Museums of Scotland) [NMS]

No.	Seal accession number	Face	Transcription	Transliteration
1	NMS: Henderson. 086 (1964)	obv	АРХ. БРА / ДЕСЯТ / ИВАНЬ / БУЛЫЧЕВЪ	ARKh. BRA / DESyAT / IVAN' / BULYChEV"
		rev	АРХ. ПОРЪ / КУДЕЛЬ / 1. СОРТЪ / Я П В / 1891	ARKh. POR". / KUDEL' / 1. SORT" / yA P V / 1891
2	NMS: Henderson. 087 (1963)	obv	— / ДЕСЯТ / ПАВЕЛЪ / [–] Е[П]ИХИНЪ	— / DESyAT / PAVEL' / [–]E[P]IKhIN"
		re	АРХ. БР. / ЗАБРАКЪ / 2И РУКИ / Я П [В] / 1881	ARKh. BR. / ZABRAK" / 2I RUKI / yA P [V] / 1881
3	NMS: Henderson. 090 (n.d.)	obv	— / П НАВ / НСКОИ / Н 13	— / P NAV / NSKOI / N 13
		rev	П / Но П 2 / М. С. / 1829	P / No P 2 / M. S. / 1829
4	NMS: H.NM 222	obv	Д – / – – / – ЕВ / – – 9	D – / – – / – EV / – – 9
		rev	N P / I F E 12 [H] / 1785	N P / I F E 12 [H] / 1785
5	NMS: K1998.503	obv	I / W M / [–] Co	I / W M / [–] Co
		rev	Ф А	F A
6	NMS: (Horseley Hill)	obv	Р / – – Е – / Н–ВЪ. /	P / – – E – / N–V" . /
		rev	[I] G H 12 H / 1785	[I] G H 12 H / 1785
7	NMS: 19.10.91.F1	obv	П Д / [–] П: Б[–] / – – –	P D / [–] P: B[–] / – – –
		rev	–	–
8	NMS: 23.10.93. F3 (1775)	obv	. Д'ЕМИХ / ЛЕВЬ / Н 230	. DEMIKh / LEV' / N 230
		rev	N. P. / P: 6. К / 1775	N. P. / P: 6. K / 1775
9	NMS: 23.10.93. F3 (n.d.)	obv	. П Д / [–][–][–]РА – Ъ / [–][–][–]	. P D / [–][–][–]RA – " / [–][–][–]
		rev	–	–
10	NMS: 25.9.93. F1 (1779)	obv	Л Д / ВАВИ / ЛОВЪ / Н: 24	L D / VAVI / LOV" / N: 24
		rev	N. P. / C C H / 1779	N. P. / C C H / 1779
11	NMS: 29.10.93. F1(183–)	obv	П: Д / [–]: ГРЕЧ / – – [–]ИН / Н	P: D / [–]: GREСh / – – [–]IN / N
		rev	[С]ПБ / [–]ЕН I / I H / 183[–]	[S]PB / [–]EN I / I H / 183[–]
12	NMS: 29.10.93. F2	obv	+ (Cross Keys) / 3	+ (Cross Keys) / 3
		rev	(Blank)	(Blank)
13	NMS: (Stoney Hill) (1816)	obv	П. Д. / А ЮР/КОВС / Н 24	P. D. / A yUR/KOVS / N 24
		rev	. S P B . / A G P H / 1816	. S P B . / A G P H / 1816
14	NMS: (Stoney Hill) (1813)	obv	Л. Д. / И ВАР / АК[Р] / – – –	L. D. / I VAR / AK[R] / – – –
		rev	N P / ОП 12 H / 1813	N P / OP 12 H / 1813
15	NMS: Edi bag 3 (1782)	obv	Д. М. / ЗЕМС / КОИ / Н 51	D. M. / ZEMS / KOI / N 51
		rev	N. P. / I C Z 12 / 1782	N. P. / I C Z 12 / 1782
16	NMS: RM 9.11.94 (1814)	obv	П: Д / В[–][–]О / МОВЬ / Н 3 [–][–]	P: D / V [–][–]O / MOV" / N 3 [–][–]
		rev	S P B / A G R H / 1814	S P B / A G R H / 1814

Part Two. Catalogue of lead seals (Cyrillic and Roman)

		obv	Л Д / [П] ЛЕБ / ЕДЕВЬ / Но [1][-]	L D / [P] LEB / EDEV" / No [1][-]
17	NMS: RM 9.11.94 (1827)	rev	N P / P 12 К / 1827	N P / P 12 K / 1827
18	NMS: RM 18.6.96 (1811)	obv	Л. Д. / СОЛ / [-]ОНИК / Н 13	L. D. / SOL / [-]ONIK / N 13
		rev	R H / [-]1811	R H / [-]1811
19	NMS: PSin (n.d.)	obv	Д / - - - / ВЕ / - -	D / - - - / BE / - -
		rev	S P B / S P B (double stamp)	S P B / S P B (double stamp)
20	NMS: PSin (1791) (Dingwall) 1a 19.11.94	obv	П Д / М ПА[-] / КОВЬ / Н 102	P D / M PA[-] / KOV" / N 102
		rev	N. Р. / О Н А I / 1791	N. P. / O H A I / 1791
21	NMS: PSin (1774) (Dingwall) 1b 19.11.94	obv	A / ШАМИНЬ / -	A / ShAMIN" / -
		rev	S: P / [-] K 2 H / 177[4]	S: P / [-] K 2 H / 177[4]
22	NMS: PSin (Dingwall) 1c 19.11.94 NMS:AMcC (18thc)	obv	- / 17 - - - / (Arms: double-headed Eagle holding Orb and Sceptre)	- / 17 - - - / (Arms: double-headed Eagle holding Orb and Sceptre)
		rev	(Blank)	(Blank)

6.2.7. Falkirk Museum [FALKM]

No.	Seal accession number	Face	Transcription	Transliteration
1	FALKM 1985.74.4	obv	РИЖ / 1787 / (Arms: Double-headed eagle holding orb and sceptre) / П Р Т / (Key)	RIZh / 1787 / (Arms: Double-headed eagle holding orb and sceptre) / P R T / (Key)
		rev	(Blank)	(Blank)
2	FALKM 1997.13.9	obv	Л Д. / Е. САР / ЫНИ[Н]/ Н15	L D. / E. SAR / YNI[N] / N 15
		rev	NP/ [H] Z 12 H / [1]790	NP/ [H] Z 12 H / [1]790
3	FALKM 1997.13.10	obv	Л Д / Н. ЗАХ / АРОВЬ / Но 4	L. D / N. ZAKh / AROV" / No 4
		rev	N Р. / I. K. 12 / 1791	N P. / I. K. 12 / 1791
4	FALKM 1997.13.11	obv	Л Д / Ф. [-]ЕВ / [-]ДО[В]	L D / F. [-]EV / [-]DO[V]
		rev	[-][-] / [-] I H 12 / [1]79[-]	[-][-] / [-] I H 12 / [1]79[-]
5	FALKM 1999.4.31	obv	П П. / А. УЛА / ОВЬ	P P. / A. ULA / OV"
		rev	Л - П / [У] ЛА / НОВЬ	L - P / [U]LA / NOV"
6	FALKM 2000.4.10	obv	Л Д / К БАЩ / ЕНКОВЬ / Н 84	L D / K BAShch / ENKOV" / N 84
		rev	N P / I H 12 H / 1790	N P / I H 12 H / 1790
7	FALKM 2002.43.01	obv	Л Д / Н: АРЕ / ФЬЕВЬ / Н 88	L D / N: ARE / F'EV" / N 88
		rev	S P B / N P. - 2 / L. H. / 1830	S P B / N P. - 2 / L. H. / 1830
8	FALKM 2002.43.02	obv	П и Л П Д / П КАЛТ / УШКИ / Но 9	Pi L P D / P KALT / UShKI / No 9
		rev	S P B / F K 2 H / 1833	S P B / F K 2 H / 1833
9	FALKM 2002.43.03	obv	П и Л П - / П КА[Л][Т] / УШКИ / Н 3	Pi L P - / P KA[L][T] / UShKI / No 3
		rev	S P B / F K 2 [-] / 184[-]	S P B / F K 2 [-] / 184[-]
10	FALKM 2002.43.04	obv	- - / Б В[Л] / КОВ / Н 2	- - / [B] V[L] / KOV / N 2
		rev	- [-] / В / -о. П 3 / Д. Х. / 1836	- [-] B / -o. P 3 / D. Kh. / 1836
11	FALKM 2002.43.05	obv	Л Д / В БЕ[Л] / КОВЬ / Н: 37	L D / V BE[L] / KOV" / N: 37
		rev	[S] P B / - Р. - 3 / F. W. / [1]832	[S] P B / - P. - 3 / F. W. / [1]832
12	FALKM 2002.43.06	obv	Л. Д./ ЧЕ[-]Л / КОВЬ / [Н] 86	L. D. / ChE[-]L / KOV" / [N] 86
		rev	S P B / N P. - 3 / M. S. / 183[-]	S P B / N P. - 3 / M. S. / 183[-]
13	FALKM 2002.43.07	obv	/ ДЕСЯТ / ИЛЬЯ СО / БОЛЕВЬ	/ DESyATsK / IL'yA SO / BOLEV"
		rev	РХ Б / 2[С][Т]	RKh B / 2[S][T]
14	FALKM 2002.43.08	obv	А П / ДЕСЯЦК / N I	A P / DESyATsK / N I
		rev	- / ЕЛИКО / СЕЛСКОИ	- / ELIKO / SELSKOI

15	FALKM 2003.3.1	obv	СТАНЦ. / 26 АВГ 1903 / ТАГАНАШЪ
		rev	КОНТРОЛЬ / A767 / К. Х. С. Ж. Д
16	FALKM 2003.3.2	obv	П. Д / МОР[О] / ЗОВЪ / Н. 184
		rev	С П Б / ПЕН. I / Д. Х. / 1840
17	FALKM 2003.3.3	obv	П П / НОВО / [Т]ОРЦО / Н 1
		rev	[–] П. С. / Е. БУД / НИКО[В]
18	FALKM 2003.3.4	obv	+ (Cross Keys) / 1
		rev	(Blank)
19	FALKM 2003.3.5	obv	+ (Cross Keys) / 1
		rev	(Blank)
20	FALKM: 2003.3.58	obv	Д. Л. / ЧУГАД/АЕВЪ Н 33[1]
		rev	N P / А К 12 Н / 1782
21	FALKM: 2003.3.59	obv	Л. Д / Н. – – – / – – – / Н. 6
		rev	N. P / N 12 Ч / 1783
22	FALKM: 2006.4.20	obv	Л. Д / ВО – / КОВ – / – – 7
		rev	– – / – – – / Ц / [1]838

15	FALKM 2003.3.1	obv	STANTs. / 26 AVG 1903 / TAGANASh"
		rev	KONTROL' / A767 / K. Kh. S. Zh. D
16	FALKM 2003.3.2	obv	P. D / MOR[O] / ZOV" / N. 184
		rev	S P B / PEN. I / D. Kh. / 1840
17	FALKM 2003.3.3	obv	P P / NOVO / [T]ORTsO / N 1
		rev	[–] P. S. / E. BUD / NIKO[V]
18	FALKM 2003.3.4	obv	+ (Cross Keys) / 1
		rev	(Blank)
19	FALKM 2003.3.5	obv	+ (Cross Keys) / 1
		rev	(Blank)
20	FALKM: 2003.3.58	obv	D. L. / ChUGAD/AEV" N 33[1]
		rev	N P / A K 12 H / 1782
21	FALKM: 2003.3.59	obv	L. D / N. – – – / – – – / N. 6
		rev	N. P / N 12 Ch / 1783
22	FALKM: 2006.4.20	obv	L. D / VO – / KOV – / – – 7
		rev	– – / – – – / Ts / [1]838

6.2.8. Fife Museums
6.2.8.1. KIRKCALDY MUSEUM AND ART GALLERY [KIRMG]

No.	Seal accession number	Face	Transcription	Transliteration
1	KIRMG. 1999.207	obv	/ ДЕСЯТ / АЛЕКС. / – УМАК	/DESyAT / ALEKS. / – UMAK
		rev	ЧЕСКА / 2 СОРТ[–] / В. ЛЕД / 1864	ChESKA / 2 SORT[–] / V. LED / 1864
2	KIRMG. 1999.208	obv	/ ДЕСЯТ / ИВАН / – – –	/DESyAT / IVAN / – – –
		rev	АРХ. БР. КРОНЪ / 2 СОРТЪ / В ЛЕД / 1843	ARKh. BR. KRON" / 2 SORT" / V LED / 1843
3	KIRMG. 1999.209	obv	/ ДЕСЯТ / КОСТ. Б / ГИНЪ	/DESyAT / KOST. B / GIN"
		rev	АРХ. БР. КУДЕЛЬН / 1 СОРТЪ / А [Р]/ 1840	ARKh. BR. / KUDEL'N / 1 SORT" / A [R]/ 1840
4	KIRMG. 1999.210	obv	/ ДЕСЯТ / КАПИТО[Н] / [Н]ЯЯ[Н]	/DESyAT / KAPITO[N] / [N]yA[N]
		rev	АРХ. БР. / ЗАБРАК / Е. П. / 1873	ARKh. BR. / ZABRAK / E. P. / 1873
5	KIRMG. 1999.211	obv	А П / ДЕСЯТС / –. [К]	A P / DESyATs / –. [K]
		rev	ЛНЯН Б[Р] / 2 ВД Р / 1833	LNyAN B[R] / 2 VD R / 1833
6	KIRMG. 1999.212	obv	Л [Д] / А. К[–] / ЛОВ / [Н] 4	L [D] / A. K[–] / LOV / [N] 4
		rev	С П Б / NP. – 2 / Т. [–] / 183[–]	S P B / NP. – 2 / T. [–] / 183[–]
7	KIRMG. 1999.213	obv	Л. Д. / А. ЕРО / ХИНЪ / Н 71	L. D. / A. ERO / KhIN" / N 71
		rev	S P B / No. – 2 / T – / – [–]83[–]	S P B / No. – 2 / T – / – [–]83[–]
8	KIRMG. 1999.214	obv	Л. Д. / М. ЕРЕН / [–]ЕВСКОЙ / Н 16	L. D. / M. EREN / [–]EVSKOI / N 16
		rev	S P / N: P 2 / I. Н. / – [–]83[1]	S P / N: P 2 / I. H. / – [–]83[1]
9	KIRMG. 1999.215	obv	Л. Д. / М. ВЕРЕ / ВКИНЬ / Н [–]	L. D. / M. VERE / VKIN" / N [–]
		rev	N P / PF 12 Н / 1818	N P / PF 12 H / 1818
10	KIRMG. 1999.216	obv	–. Д. / [–] ТАРА/ БУКИНЪ / Н 4	–. D. / [–] TARA/ BUKIN" / N 4
		rev	N P / [–] К 12 Н / 1804	N P / [–] K 12 H / 1804
11	KIRMG. 1999.217	obv	– – / ВИ[Н][О]/ КУРО[В] / Н [–][–]	– – / VI[N][O]/ KURO[V] / N [–][–]
		rev	N – / – Н / [–]– J07	N – / – H / [–]–]07
12	KIRMG. 2006.195	obv	Х / ДЕСЯТН / МИТРОФ / ШАРЫПОВ	Kh / DESyATN / MITROF / ShARYPOV
		rev	АРХ. БРА / КРОНЬ / 4. СОРТЪ / Е.П. / 1881	ARKh. BRA / KRON" / 4. SORT" / E.P. / 1881

Part Two. Catalogue of lead seals (Cyrillic and Roman)

13	KIRMG. 2006.196	obv	—
		rev	АРХ. БР / КУДЕ[Л]– / 2 СОРТЪ / А[Р] / 1849
			ARKh. BR / KUDE[L]– / 2 SORT" / A[R] / 1849
14	KIRMG. 2006.197	obv	Л. Д / ДЕДО / НИКО / [?]––
		rev	П Б / No П 3 / Д. Х. / 1838
			L. D / DEDO / NIKO / [?]––
			P B / No P 3 / D. Kh. / 1838
15	KIRMG. 2006.198	obv	АРХ. РА / СЯТ / [М]ИХАИЛО / КАРПО[В]
		rev	РХ Б / КРОН / 3 СОРТЪ / М. К. / 1845
			ARKh. RA / SyAT / [M]IKhAILO / KARPO[V]
			RKh B / KRON / 3 SORT" / M. K. / 1845
16	KIRMG. 2006.199	obv	DAMAZKI / Б.А. / 1848 / –РВ
		rev	—
			DAMAZKI / B.A. / 1848 / –PB
17	KIRMG. 2006.207	obv	Но I / –– / Л 12 П
		rev	А. Б. ДАМАЦКОЙ / 1846 / С ПБ
			No. I / –– / L 12 P
			A. B. DAMAtsKOI / 1846 / S P B
18	KIRMG. 2006.208	obv	No. 2 / –– / О. 9. П.
		rev	ЛЕНЬ / КРОНЪ – С / ВОЛОГДА
			No. 2 / –– / O. 9. P.
			LEN" / KRON" – S / VOLOGDA
19	KIRMG. 2006.209	obv	I [Т] / ХИ И ВИШ[–][–] / 1867
		rev	/ ДЕСЯТ / АНДРЕИ / ПР[У]СКОВ
			I [T] / Khl I VISh[–][–] / 1867
			/ DESyAT / ANDREI / PR[U]SKOV
20	KIRMG. 2006.210	obv	АРХ. Б. / ОТБОРНЫ / 3 СОРТЪ / В. Д. / 1838
		rev	АРХ. БРАК. / ДЪСЯТН / ПЕТРЪ / ЖУКОВЪ
			ARKh. B. / OTBORNY / 3 SORT" / V. D. / 1838
			ARKh. BRAK / DyESyATN / PETR" / ZhUKOV"
21	KIRMG. 2006.211	obv	АРХ. БР. / КРОНЬ / 3 СОРТЬ / Ф. Р. / 1875
		rev	А–ХАН / ДЕСЯТНИК / ВАСИЛИИ / [З]ЯТ[–][–][–]
			ARKh. BR. / KRON" / 3 SORT" / F. R. / 1875
			A–KhAN / DESyATNIK / VASILII / [Z]yAT[–][–][–]
22	KIRMG. 2006.212	obv	АРХ. БР. / КРОНЬ / 2 СОРТЬ / Я. К. / 1880
		rev	––– / ДЕСЯТН. / НИКОЛАИ / –– ЛЬГИНЬ
			ARKh. BR. / KRON" / 2 SORT" / yA. K. / 1880
			––– / DESyATN. / NIKOLAI / –– L'GIN"
23	KIRMG. 2006.213	obv	АРХ. БР. / ЗАБРАК / [–] РУКИ / Е. П. / 1878
		rev	/ ДЕСЯТ[Н] / АЛЕКСА –– / ШОРСК ––
			ARKh. BR. / ZABRAK / [–] RUKI / E. P. / 1878
			/ DESyAT[N] / ALEKSA –– / ShORSK ––
24	KIRMG. 2006.214	obv	А. П. / ДЕСЯТНК / Ф К
		rev	АРХ. БР. / ЗАБРАК / В. ЛЕД / 1839
			A. P. / DESyATNK / F K
			ARKh. BR. / ZABRAK / V. LED / 1839
25	KIRMG. 2006.215	obv	А: П / ЛНЯН: БРА[–] / ––– / ––– / 18[–][–]
		rev	/ ДЕСЯТ / –– ТОРЬ / НА / –– Х[–]
			A: P / LNyAN: BRA[–] / ––– / ––– / 18[–][–]
			/ DESyAT / –– TOR" / NA / –– Kh[–]
26	KIRMG. 2006.216	obv	Х / [–]РОНЬ / [–] СОРТЬ / .Д. / [8]–9
		rev	–– ОР – / –/ –/ –/ –
			Kh / [–]RON" / [–] SORT" / .D. / [8]–9
			–– OR – / –/ –/ –/ –
27	KIRMG. 2006.217	obv	Л Д / [–] ИМИ / [Л]ОВЪ / Н 23
		rev	–– / [К]РОНЬ / СОРТЬ / [В] ЛЕД / 1845
			L D / [–] IMI / [L]OV" / N 23
			–– / [K]RON" / SORT" / [V] LED / 1845
28	KIRMG. 2006.218	obv	S P B / N P. 3 / С. Т. / [–][–][–]3
		rev	Л Д / ВОРО / БЬЕВЪ / Н 72
			S P B / N P. 3 / C. T. / [–][–][–]3
			L D / VORO / B'EV" / N 72
29	KIRMG. 2006.219	obv	/ Но П. 2 / Н. Т. / 1841
		rev	Л Д / [–]: [Д]АТ / [–]ИНЬ / N 83
			/ No P. 2 / N. T. / 1841
			L D / [–]: [D]AT / [–]IN" / N 83
30	KIRMG. 2006.220	obv	S P B / N P. 3 / С. Т. / 1836
		rev	– Д / Н. Е[Т]ЕЦ[–] / [–]ЛКИН / [Н] 33
			S P B / N P. 3 / C. T. / 1836
			– D / N. E[T]EP[–] / [–]LKIN / [N] 33
31	KIRMG. 2006.221	obv	[S] P B / N P. 3 / I. C. / 1843
		rev	–– / ––– Т / –––
			[S] P B / N P. 3 / I. C. / 1843
			–– / ––– T / –––
32	KIRMG. 2006.222	obv	S P B / ––– Р / 18 ––
		rev	Л Д / А: ЧЕР / НИКО[В] / Н [–]6
			S P B / ––– P / 18 ––
			L D / A: ChER / NIKO[V] / N [–]6
33	KIRMG. 2006.223	obv	S P B / No P 2 / 18[2][9]
		rev	––– / [–]АР / [–]ОВЪ
			S P B / No P 2 / 18[2][9]
			––– / [–]AR / [–]OV"
34	KIRMG. 2006.224	obv	––– / N P – 3 – / C / 183[–]
		rev	Л – / Е: –– Л / ТНЕ[В][Ъ] / Н 63
			––– / N P – 3 – / C / 183[–]
			L – / E: –– L / TNE[V][''] / N 63
35	KIRMG. 2006.225	obv	N P / I P 12 H / 1825
		rev	–– / П КО – ЛОВЪ / Н 94
			N P / I P 12 H / 1825
			–– / P KO – LOV" / N 94
			N P / [–] 12 H / 1825

36	KIRMG. 2006.226	obv	Л: Д / : ВАР / [-]ОВЬ / Н 31	L: D / : VAR / [-]OV" / N 31
		rev	- - / РF 12 Н / - - / 1820	- - / PF 12 H / - - / 1820
37	KIRMG. 2006.227	obv	ЛД / П САВЕ- / ТЬЯНО / Н 81	L D / P SAVE- / T'yANO / N 81
		rev	N Р / Л М 12 Н / -821	N P / L M 12 H / -821
38	KIRMG. 2006.228	obv	ЛД / [Л] - - - / Т - - - / Н 91	L D / [L] - - - / T - - - / N 91
		rev	N. Р / М Б 12 Н / 1821	N. P / M B 12 H / 1821
39	KIRMG. 2006.229	obv	Л - / В: ВО- / КОВЪ / Н 78	L - / V: VO- / KOV" / N 78
		rev	* N P / МС 12 Н / 1821	* N P / M C 12 H / 1821
40	KIRMG. 2006.230	obv	ЛД / [Е] ПЕТУ / НОВЪ / Н 115	L D / [E] PETU / NOV" / N 115
		rev	N Р / I С Б 12 Н / 182[-]	N P / I C B 12 H / 182[-]
41	KIRMG. 2006.231	obv	ЛД / К: КАН / АВАЛОВ / Н 26	L D / K: KAN / AVALOV / N 26
		rev	N Р / I Ч 12Н / 1806	N P / I Ch 12 H / 1806
42	KIRMG. 2006.232	obv	Л - / А: ШП / ОЧЕВЪ / Н 2-	L - / A: ShP / OChEV" / N 2-
		rev	*N P * / [-] Ч 9 /179[-]	*N P * / [-] Ch 9 /179[-]
43	KIRMG. 2006.233	obv	ЛД / А [-]-[-]-И / ЧЕВЪ /	L D / A [-]-[-]-I / ChEV" /
		rev	N Р / [-] 12 Н / - -26	N P / [-] 12 H / - -26
44	KIRMG. 2006.234	obv	ЛД / Л ВОЛ / КОВЪ / Н 1[[8]	L D / L VOL / KOV" / N 1[[8]
		rev	[N] Р / С 12 Н / [1]801	[N] P / C 12 H / [1]801
45	KIRMG. 2006.235	obv	- - - / - - А - / - - - В / - - - -	- - - / - - A - / - - - V / - - - -
		rev	N Р / [-] С12 Н / 1820	N P / [-] C12 H / 1820
46	KIRMG. 2006.236	obv	[-]: - - ЕВ / НЕВ / Н 17	[-]: - - EV / NEV / N 17
		rev	N Р / - К 12 Н / 1805	N P / - K 12 H / 1805
47	KIRMG. 2006.237	obv	Л. Д. / Я. ХОХ / ЛОВЪ / Н 3-	L. D. / yA. KhOKh / LOV" / N 3-
		rev	N Р / - Х [12] - / 17 [8][2]	N P / - Kh [12] - / 17 [8][2]
48	KIRMG. 2006.238	obv	ЛД / [-] БАБ / ОНИНЬ / - -	L D / [-] BAB / ONIN" / - -
		rev	- - / А Ч 12 - / 1813	- - / A Ch 12 - / 1813
49	KIRMG. 2006.239	obv	- Д / [Ы] / [О]ВСКО / Н 85	- D / [Y] / [O]VSKO / N 85
		rev	N Р / АР 9 Н / 1811	N P / AR 9 H / 1811
50	KIRMG. 2006.240	obv	I / - - / W. M. / & CO	I / - - / W. M. / & CO
		rev	Б. Н	B. N
51	KIRMG. 2006.252	obv	ЕГОР	EGOR
		rev	ЧЕСКА / [-] СОРТЪ / В Д. / 1838	ChESKA / [-] SORT" / V D. / 1838
52	KIRMG. 2006.253	obv	А. П. / ДЕСЯС / Е. М /	A. P. / DESyAS / E. M /
		rev	ЛНЯН. БР / 18 МП 35 / [-]АК.Р	LNyAN. BR / 18 MP 35 / [-]AK.R
54	KIRMG. 2006.254	obv	АРХ. / ДЕСЯТ / КОСТАН / [-]-[-]ЗРИГ[И] / НЪ	ARKh. / DESyAT / KOSTAN / [-]-[-]ZRIG[I] / N"
		rev	А [-] / [К][У]ДЪЛЬН / [-] СОРТЪ / М. К. / 1845	A [-] / [K][U]DyEL"N / [-] SORT" / M. K. / 1845
55	KIRMG. 2006.255	obv	АРХ. - / ДЕСЯТ / НИК [-] / [М]ИХАИЛА / ЛЕПИХИНЪ	ARKh. - / DESyAT / NIK [-] / [M]IKhAILA / LEPIKhIN"
		rev	А[-]. БР. / КРОНЪ / 1 СОРТЪ / А. Р. / 1846	A[-]. BR. / KRON" / 1 SORT" / A. R. / 1846
56	KIRMG. 2006.256	obv	АРХ. ПО[Р] / ДЕСЯТН / ФРАННЪ / [Р]ЮТОР. / [-] Ъ	ARKh. PO[R] / DESyATN / FRANN" / [R]OTOR. / [-] "
		rev	АРХ. Б[Р]. / КУДЕЛЬН / - СОРТЪ / М. К. / 1849	ARKh. B[R]. / KUDEL"N / - SORT" / M. K. / 1849
57	KIRMG. 2006.257	obv	/ДЕСЯ- / МАТВЕИ / ВЕДЕНСК /	/DESyA- / MATVEI / VEDENSK /
		rev	АРХ. БР / КУДЕЛЬН / 1 СОРТЪ / В. ЛЕД / 18[4][0]	ARKh. BR / KUDEL"N / 1 SORT" / V. LED / 18[4][0]
58	KIRMG. 2006.258	obv	..Х ПОР / -СЯТНИК / [М]АТВЕИ/...	..Kh POR / -SyATNIK / [M]ATVEI/...
		rev	Х / ЧЕСКА / 3: СОРТЪ / Е: П / 1859	Kh / ChESKA / 3: SORT" / E: P / 1859
59	KIRMG. 2006.259	obv	АРХ. БРА / ДЕСЯТ: / АЛЕКСЕИ / БУЛЫЧЕВЪ	ARKh. BRA / DESyAT: / ALEKSEI / BULYChEV"
		rev	АРХА / ЗАБРА[К] - / Я. П. В. / 18 - -	ARKhA / ZABRA[K] - / yA. P. V. / 18 - -

Part Two. Catalogue of lead seals (Cyrillic and Roman)

60	KIRMG. 2006.260	obv	АРХ. БР / ДЕСЯ / МАТ [-]	ARKh. BR / DESyA / MAT [-]
		rev	--- / 3 [-][-]Р[-] / Ф. Р. / 1861	--- / 3 [-][-]R[-] / F. R. / 1861
61	KIRMG. 2006.261	obv	/ ДЕСЯТ: [М]ИТРОФА / ШАРЫ	/ DESyAT: [M]ITROFA / ShARY
		rev	АР – Б / ЧЕ - –А / 2. СОРТЪ / Ф.Р. / 1862	AR – B / ChE - –A / 2. SORT" / F. R. / 1862
62	KIRMG. 2006.262	obv	АРХ БРА / СЯТ / --- ПА / – ТЬЕ	ARKh BRA / SyAT / --- PA / – T'E
		rev	АРХ. Б / КУДЕЛЬ / 2: СОРТЪ / Е. П. / 1863	ARKh. B / KUDEL' / 2: SORT" / E. P. / 1863
63	KIRMG. 2006.263	obv	БРА / ДЕСЯТ: / ЯКОВЪ / – – ПАТ /	BRA / DESyAT / yAKOV" / – – PAT /
		rev	АРХ. ПО – / ЛЕНЬ / ЗАБРАКЪ / Я. К. / 1863	ARKh. PO – / LEN" / ZABRAK" / yA. K. / 1863
64	KIRMG. 2006.264	obv	АРХ: / ДЕСЯТН. / АЛЕКСАНДРЪ / --ТАП[-]ОВ	ARKh: / DESyATN. / ALEKSANDR" / --TAP[-]OV
		rev	АНГ. БРА / КУДЪЛ / 2 СОРТЪ / Ф. Р. / 1869	ANG. BRA / KUDyEL / 2 SORT" / F. R. / 1869
65	KIRMG. 2006.265	obv	АРХ. БРА / ДЕСЯТ / НИКОЛ / ШЕРИНИ	ARKh. BRA / DESyAT / NIKOL / ShERINI
		rev	АРХ. Б / [К]УДЪЛЯ / 2 СОРТЪ / Е. П. / 1864	ARKh. B / [K]UDyELyA / 2 SORT" / E. P. / 1864
66	KIRMG. 2006.266	obv	ЯТ ВАС / ИЛЕИ СТ[Е] / [-]АНОВЪ	yAT VAS / ILEI ST[E] / [-]ANOV"
		rev	АР . / КУДЕЛЬ / 2 СОРТЪ / Е. П. / 1852	AR. / KUDEL' / 2 SORT" / E. P. / 1852
67	KIRMG. 2006.267	obv	АРХ. БРА / ДЕСЯТ / ИЛЬЯ / –ХОП[О]–	ARKh. BRA / DESyAT / IL'yA / –KhOP[O]–
		rev	АРХ. БР / КУДЕЛЬ / 1: СОРТЪ / Е. П. / 1861	ARKh. BR / KUDEL' / 1: SORT" / E. P. / 1861
68	KIRMG. 2006.268	obv	А …. / ДСЯТ / ВАСИЛ / БРЮХАН / ОВЪ	A …. / DSyAT / VASIL / BRyUKhAN / OV"
		rev	А / КУД / СОРТ / Е. П. / 1870	A / KUD / SORT / E. P. / 1870
69	KIRMG. 2006.269	obv	П. / ДЕСЯ[Т] / ИВАНЬ / КОРНА / ОВЪ	P. / DESyA[T] / IVAN" / KORNA / OV"
		rev	Х БР / [З]АБРАКЪ / Е. П. / 1873	Kh BR / [Z]ABRAK" / E. P. / 1873
70	KIRMG. 2006.270	obv	[Д]ЕСЯТ	[D]ESyAT
		rev	.. /.../ ……	... /.../ ……
71	KIRMG. 2006.271	obv		–
		rev	АРХ. Б / КРОНЬ / 4. СОРТЪ / Ф.Р. / 1877	ARKh. B / KRON" / 4. SORT" / F. R. / 1877
72	KIRMG. 2006.272	obv	ДЕСЯТ / РО[В]	DESyAT / RO[V]
		rev	АРХ. Б / КРОНЬ / 3 СОРТЪ / –8[5][5]	ARKh. B / KRON" / 3 SORT" / –8[5][5]
73	KIRMG. 2006.273	obv	АРХ. БР / ДЕСЯТ. / … / …	ARKh. BR / DESyAT. / … / …
		rev	АРХ. ПО / КУДЪЛЯ ./ 2 СОРТЪ / Я. – / 187[5]	ARKh. PO / KUDyELyA ./ 2 SORT" / yA. – / 187[5]
74	KIRMG. 2006.274	obv	ДЕСЯТ / / ОВЪ	DESyAT / / OV"
		rev		
75	KIRMG. 2006.275	obv	АРХ БР / ДЕСЯТН / ПЕТРЬ / ЖУКОВЪ	ARKh BR / DESyATN / PETR" / ZhUKOV
		rev	АРХАНГ. ПО / КРОНЬ / 3 СОРТЪ / Я.П.В. / 1881	ARKhANG. PO / KRON" / 3 SORT" / yA.P.V. / 1881
76	KIRMG. 2006.276	obv	ДЕС–ТКО[И] / Н Т	DES–TKO[I] / N T
		rev	АРХ. Б / ЧЕС / 3: СОР / Е. [П] / 1850	ARKh. B / ChES / 3: SOR / E. [P] / 1850
77	KIRMG. 2006.277	obv	АРХ. БР / ДЕСЯТ / ПАВЕЛЬ / ШУЛЬБГН	ARKh. BR / DESyAT / PAVEL / ShULyEG/N
		rev	АРХ. ПОР. / ЗАБРАКЪ / Я. К. / [1]8[7]3	ARKh. POR. / ZABRAK" / yA. K. / [1]8[7]3
78	KIRMG. 2006.278	obv	АР - – / ДЕСЯТ / ИТА	AR - – / DESyAT / ITA
		rev	АРХ Б / КРОНЬ / 3 СОРТЪ / Е. П. / 1881	ARKh B / KRON" / 3 SORT" / E. P. / 1881
79	KIRMG. 2006.279	obv	ДЕСЯТ / АЛЕКСАНД[Р] / [Ш][А]	DESyAT / ALEKSANDR[R] / [Sh][A]
		rev	АРХ …. / КУДЪ [Л][-] / 1 СОРТЪ / Я П В / 1881	ARKh …. / KUDyE[L][-] / 1 SORT" / yA P V / 1881
80	KIRMG. 2006.280	obv		–
		rev	АРХ. БР. / КРОНЬ / 3. СОРТЪ / Е. П. / 1882	ARKh. BR. / KRON" / 3. SORT" / E. P. / 1882
81	KIRMG. 2006.281	obv	ДЕСЯТЬ АЛЕКСАНДРЪ ПЛУТЕЛЬНОЙ	DESyAT" / ALEKSANDR" PLUTEL'NOI
		rev	АРХ. БРА. / КРОНЬ / 4 СОРТЪ / Е. П. / 1881	ARKh. BRA. / KRON" / 4 SORT" / E. P. / 1881
82	KIRMG. 2006.282	obv	[-] R DAMAZKI / В.А. / [-]-[-]48 / [S]ТРВ	[-] R DAMAZKI / B.A. / [-]-[-]48 / [S]tPB
		rev	Но 2 / – – / [1]848	No. 2 / – – / [1]848

83	KIRMG. 2006.283	obv	Л Д / – ЗАИ / ЦОВЪ / Н 4	L D / – ZAI / TsOV" / N 4
84	KIRMG. 2006.284	rev	С П Б / Но П 3 / Н К / 182[–]	S P B / No P 3 / N K / 182[–]
		obv	[Г][–]Е / ИКОВ / Н – –	[G][–]E / IKOV / N – –
		rev	ПБ / П. 3 / Б / – – – 9	PB / P. 3 / B / – – – 9
85	KIRMG. 2006.285	obv	– Д / [В] ВОЛ / КОВЪ / Н 78	– D / [V] VOL / KOV" / N 78
		rev	С П Б / Но П. 2 / Ф . Д . / – – –	S P B / No P.2 / F. D. / – – –
86	KIRMG. 2006.286	obv	Л. Д. – РЯБ / ОВЪ / Н 5[0]	L. D. – RyAB / OV" / N 5[0]
		rev	S P B / N. P – 2 / F. W. / 1831	S P B / N. P – 2 / F. W. / 1831
87	KIRMG. 2006.287	obv	/ ВИ[–] / –РА[–] / – – –	/VI[–] / –RA[–] / – – –
		rev	S P B / N / H. / 1834	S P B / N / H. / 1834
88	KIRMG. 2006.288	obv	Л. Д / Н АР[Е] / ФЬЕВЪ / Н 88	L. D / N AR[E] / F'EV" / N 88
		rev	[–] Б / Но П / Д. Х. / 1837	[–] B / No P / D. Kh. / 1837
89	KIRMG. 2006.289	obv	Д / [–]. – –МА / РИНЬ / Н 17[3]	D / [–]. – –MA / RIN" / N 17[3]
		rev	– – – – / 183[7]	– – – – / 183[7]
90	KIRMG. 2006.290	obv	М ЕР–][–] / [–]ЕВСКО / Н. 16	M ER–][–] / [–]EVSKO / N. 16
		rev	С П Б / Но П 2 / П. П. / 184[–]	S P B / No P 2 / P. P. / 184[–]
91	KIRMG. 2006.291	obv	Л Д / М. ТАР / [П][Ч] ИНО /	L D / M. TAR / [P][Ch] INO /
		rev	С / Н. / В / 182–	S / N. / B / 182–
92	KIRMG. 2006.292	obv	Л Д / Г. РЫБ[–] ИКОВЪ / – –	L D / G. RYB[–] / IKOV" / – –
		rev	S P B / No 2 – / I. P. / 1841	S P B / No 2 – / I. P. / 1841
93	KIRMG. 2006.293	obv	Л. / ВАСИЛ / ИСТИНЬ / Н 332	. L. / VASIL. ISTIN" / N332
		rev	[N] P / HP 12 H / 1774	[N] P / HP 12 H / 1774
94	KIRMG. 2006.294	obv	[Л] Д / ЛЕПТ – / ВЪ / Н : 2	. [L] D / LEPT – / V" / N : 2
		rev	N P / A Ч 12 H / 1777	. N.P. / A Ch 12 H / 1777
95	KIRMG. 2006.295	obv	Л Д. / – : ЧЕЛ / [Ш]А[Н]О[В	L D. / – : CheL / [P]A[N]O[V] /
		rev	/ –Р 12 H / 1794	/ –P 12 H / 1794
96	KIRMG. 2006.296	obv	Д / – – Л / ОВЪ / [Н] 25	D / – – L / – OV" / [N] 25
		rev	/ Р К 12. / 1796	/ P K 12 / 1796
97	KIRMG. 2006.297	obv	Л: Д. / В: ЩЕ[Г] / ОЛЕ[В] / Н 64	L: D / V: ShchE[G] / OLE[V] / N 64
		rev	N P. / [–] P [2] К / 1794	N P / [–] P 1[2] K / 1794
98	KIRMG. 2006.298	obv	– – . А. ЕРО / ХИНЬ / Н 7	– – . A. ERO / KhIN" / N. 7
		rev	[–]–[–]Б / No 3 / [–] . ПР / [1]783	[–]–[–][B] / No. 3 / [–]. P. R. / [1]783
99	KIRMG. 2006.299	obv	– – МОЛЧ / АНОВЪ / Н 34	– – MOLCh / ANOV" / N 34
		rev	S.P.B. / – Ш 12 H / 1806	S.P.B. / – Sh 12 H / 1806
100	KIRMG. 2006.300	obv	Л Д / С ШИР / ЯЕВЪ / Н 62	L D / S ShIR / yAEV" / N 62
		rev	– – – – / Н 12 / 1808	– – – – / H 12 / 1808
101	KIRMG. 2006.301	obv	Л Д / М: ЕР[–] / МЕЕВ[ь] / 4	L D / M: ER[–] / MEEV["] / 4
		rev	N P. / [Ц] [–] / 181[6]	N P / [I] [–] / 181[6]
102	KIRMG. 2006.302	obv	Л. Д: / Я: ГР – / [Д]Ц[–] /	L. D: / yA: GR – / [D]Ц[–] /
		rev	N P / A Ч 12 H / 1818	N P / A Ch 12 H / 1818
103	KIRMG. 2006.303	obv	Л Д. / [–] ШИП / АЧОВЪ /	L D. / [–] ShIP / AChOV" /
		rev	N. P. / М М 12 [–] / [1]818	N. P. / M M 12 [–] / [1]818
104	KIRMG. 2006.304	obv	– – – / – Н – / – – – /	– – – / – N – / – – – /
		rev	NP / Н 12 H / 1821	NP / H 12 H / 1821
105	KIRMG. 2006.305	obv	Л.Д. / А. КУЧ / КОВЪ / Н 2	L.D. / A. KUCh / KOV" / N 2
		rev	. NP. / П Ч 12 H / 1826	.NP. / P Ch 12 H / 1826

106	KIRMG. 2006.306	obv	Л Д / А: ПЫ / ЖОВЬ / Н 11[4]	L D / A: PY / ZhOV" / N 11 [4]
		rev	- - - / А Б 9 Н / 1827	- - - / A B 9 H / 1827
107	KIRMG. 2006.307	obv	Л Д / - ДЕДО / ВНИКО[В] / Н 79	L D / - DEDO / VNIKO [V] / N 79
		rev	N P / I S 12 H / 1818	N P / I S 12 H / 1818
108	KIRMG. 2006.308	obv	Л.Д. / М. К[О]Н / ОН[О]В / Н 15	L D / M K[O]N / ON[O]V / N 15
		rev	N P / I В 12 Н / [1]804	N P / I B 12 H / [1]804
109	KIRMG. 2006.309	obv	Л Д / -: МЕС / НИКОВ / Н -18	L D / -: MES / NIKOV / N -18
		rev	. N P. / - C F 12 [H] / - - - -	. NP. / - C F 12 [H] / - - - -
110	KIRMG. 2006.310	obv	- - / Но - - / No 8	- - / N o - - / No 8
111	KIRMG. 2006.311	obv	N P / М - - / [1]82[2]	NP / M - - / [1]82[2]
		rev	- - - - / ИН[О][В] / Но 82	- - - - / IN[O][V] / N 82
112	KIRMG. 2006.312	obv	- - - / 12 Н / - - - -	- - - / 12 H / - - - -
		rev	Л [Д] / И: ВА[-] / ЛОВЬ / Н –	L [D] / I: VA[-] / LOV" / N –
			- Р В / Р 2 /	- P B / P 2 /
113	KIRMG. 2006.313	obv	/ O / H	/ O / N
		rev	- Р - / П / 184[2]	- P - / P / 184[-]
114	KIRMG. 2006.314	obv	Л. Д. / [М] И: АР / [Л]ОВЬ / Н 32	L D / [M] I: AR / [L]OV" / N 32
		rev	S P B / - - - - / - 8 - -	S P B / - - - - / - 8 - -
115	KIRMG. 2006.315	obv	- Д. / [-] / ОВЬ /	- D / [-] / OV["]
		rev	/ Но П 2 / [-] [-] / 184[-]	/ No P 2 / [-] [-] / 184[-]
116	KIRMG. 2006.316	obv	- - / ДЕСЯТ / ИВАНЬ / [Ш]УЛЬГИН	- - / DESyAT. / IVAN" / [Sh]UL'GIN
		rev	АРХ. БР. / ЗАБРАКЪ / Е. П. / 1871	ARKh. BR. / ZABRAK" / E. P. / 1871
117	KIRMG. 2006.317	obv	АРХ. ПОР / ДЕСЯТН / СЕМЕНЬ / ШУБИНЬ	ARKh. POR / DESyATN / SEMEN" / ShUBIN"
		rev	АРХ. - - / ЧЕСКА / 2 СОРТЪ / Е. П. / 1880	ARKh. - - / ChESKA / 2 SORT" / E. P. / 1880
118	KIRMG. 2006.318	obv	АРХ. ПОР / ДЕСЯТСКИЙ / НИКОЛАЙ / НАКРО - -	ARKh. POR / DESyATSKII / NIKOLAI / NAKRO - -
		rev	АРХ. БР / КРОНЬ / 3 СОРТЪ / Я. К. / 1881	ARKh. BR / KRON" / 3 SORT" / yA. K. / 1881
119	KIRMG. 2006.319	obv	АРХ. ПОР / [- - - - -] / [-] [-]РЕ[-] / [-] НИНО	ARKh. POR / [- - - - -] / [-] [-]RE[-] / [-] NINO
		rev	АРХ. БР / КРОНЬ / [1] СОРТЪ / А. Р. / 1845	ARKh. BR / KRON / [1] SORT" / A. R. / 1845
120	KIRMG. 2006.320	obv	- ПОР	- POR
		rev	АРХ. БР / ЗАБРАКЪ / М. К. / 1848	ARKh. BR / ZABRAK" / M. K. / 1848
121	KIRMG. 2006.321	obv	АРХАНГЕЛ. ПОР / ДЕСЯТСКИЙ / АЛЕКСАНД / - -	ARKhANGEL. POR / DESyATSKII / ALEKSAND / - -
		rev	АРХ. БР / КРОНЬ / [-] СОРТЪ / Е. П. / 1882	ARKh. BR / KRON" / [-] SORT" / E. P. / 1882
122	KIRMG. 2006.322	obv	- - / ДЕСЯТН	- - / DESyATN
		rev	АРХА- - ОР / ЧЕСКА / 2 СОРТЪ / Я. П. В. / 188[-]	ARKhA- - OR / ChESKA / 2 SORT" / yA. P. V. / 188[-]
123	KIRMG. 2006.323	obv	- -ЕСЯТ / ИВАНЬ / - [Е]ТОВЬ	- -ESyAT / IVAN" / - [E]TOV"
		rev	АРХ. БР / КУДЪБЛ[-] / 2 СОРТЪ / Е. П. / 1885	ARKh. BR / KUDyEL[-] / 2 SORT" / E. P. / 1885
124	KIRMG. 2006.324	obv	АРХ. Б. / ДЕСЯТ / - - - - / - ОНДА[-] - -	ARKh. B. / DESyAT / - - - - / - ONDA[-] - -
		rev	АР / КРОНЬ / 3 СОРТЪ / Я. К. / 1878	AR / KRON" / 3 SORT" / yA. K. / 1878
125	KIRMG. 2006.325	obv	АР - - / ДЕСЯТ	AR - - / DESyAT
		rev	АР - - / ЛЕНЬ / ЗАБРАКЪ / Я. К. / 18- -	AR - - / LEN" / ZABRAK" /yA. K. / 18- -
126	KIRMG. 2006.326	obv	АР - - / ДЕСЯТ - / -О-НАН- / -ОВЬ	AR - - / DESyAT- / -O-NAN- / -OV"
		rev	АРХ. ПОР / КУДЪЕЛЯ / 1 СОРТЪ / Я. К. / 1854	ARKh. POR / KUDyELyA / 1 SORT" / yA. K. / 1854
127	KIRMG. 2006.327	obv	А. П. / [-]ЕСЯЦКО / ПР (ПР as ligature)	A. P. / [-]ESyATSKO / PR (PR as ligature)
		rev	А. П / ЛНЯН БРАК["] / 2 М. П. / 183[-] / (М П as ligature)	A. P / LNyAN BRAK["] / 2 M. P. / 183[-] / (M P as ligature)
128	KIRMG. 2006.328	obv	А. - / ДЕСЯТ / [-] П ([-]П as ligature)	A. - / DESyAT / [-] P ([-]P as ligature)
		rev	А. П. / ЛНЯН БР[-][-] / 2 В Д Р / - -	A. P. / LNyAN BR[-][-] / 2 V D R / - -

129	KIRMG. 2006.329	obv	– – / – НО / –УТОВЪ / Н [–]8
		rev	– – / – NO / –UTOV" / N [–]8
130	KIRMG. 2006.330	obv	– – / [N] Р 2 / Р. К. / 18[–]1
		rev	– – / [N] P 2 / P. K. / 18[–]1
131	KIRMG. 2006.331	obv	Л.Д. / А. КУЧ / КОВЪ / Н 62
		rev	L.D. / A. KUCh / KOV" / N 62
132	KIRMG. 2006.331	obv	. –[P]. / М Б 12 Н / 1820
		rev	. –[P]. / M B 12 H / 1820
133	KIRMG. 2006.331	obv	Л.Д. / В. ВЕН / ЕДНХ / Н 52
		rev	L.D. / V. VEN / EDNKh / N 52
131	KIRMG. 2006.331	obv	N P / G 1 F 12 K / 1795
		rev	N P / G 1 F 12 K / 1795
132	KIRMG. 2006.332	obv	Л.Д. / М. КОС / ТИНЬ / Н 32
		rev	L.D. / M. KOS / TIN" / N 32
		obv	N P / Л Г 12 К / 1802
		rev	N P / L G 12 K / 1802
133	KIRMG. 2006.333	obv	Л Д / И: ПЛЮ / ТНИК / Н 69
		rev	L D / I: PLO / TNIK / N 69
		obv	N P / А К 9 Н / 1811
		rev	N P / A K 9 H / 1811
134	KIRMG. 2006.334	obv	Л Д / П: ТЮР/ –[–]НЬ / Н 8
		rev	L D / P: TyUR / –[–]N" / N 8
		obv	N P / Н [Н] 12 [Н] / [–]1794
		rev	N P / H [H] 12 [H] / [–]1794
135	KIRMG. 2006.335	obv	Л Д / – –ИД– 3 / 1 /
		rev	L D / – –ID – Z / 1 /
		obv	N P / [А] Ф 12 Н / 1821
		rev	N P / [A] F 12 H / 1821
136	KIRMG. 2006.336	obv	– – / Д. СОЛ / ОУХИ / Н 45
		rev	– – / D. SOL / OUKhI / N 45
		obv	– – / [С] [Н] 12 [–] / 1804
		rev	– – / [C] [H] 12 [–] / 1804
137	KIRMG. 2006.337	obv	Л – / С. УЛЬ / ЯНОВ / Н 7
		rev	L – / S. UL' / yANOV / N 7
		obv	N P / В К 12 Н / 1805
		rev	N P / B K 12 H / 1805
138	KIRMG. 2006.338	obv	– Д / [–] ЛАТН –[–]НЬ / Н 97
		rev	– D / [–] LATN –[–]N" / N 97
		obv	(Illegible)
		rev	(Illegible)
139	KIRMG. 2006.339	obv	Л.Д. / М. КОС / ТИНЬ / Н –
		rev	L. D. / M. KOS / TIN" / N –
		obv	N Р / В [Н] 12 Н / 179[–]
		rev	N P / B [H] 12 H / 179[–]
140	KIRMG. 2006.340	obv	Л.Д. / М. КОС / ТИНЬ / Н [–] 3
		rev	L.D. / M. KOS / TIN" / N [–] 3
		obv	– – / П 3 / [–] [–] / 18– –
		rev	– – / P 3 / [–] [–] / 18– –
141	KIRMG. 2006.341	obv	А. В. DAMAZKI / В.А. / 1847 / StPB
		rev	A. B. DAMAZKI / B.A. / 1847 / StPB
		obv	2 – С/ –.– / 9. П
		rev	2 – C/ –.– / 9 P.
142	KIRMG. 2006.342	obv	+ (Cross Keys) / –
		rev	+ (Cross Keys) / –
		obv	(Blank)
		rev	(Blank)
143	KIRMG. 2006.343	obv	+ (Cross Keys) / –
		rev	+ (Cross Keys) / –
		obv	(Blank)
		rev	(Blank)
144	KIRMG. 2006.344	obv	(Cross Keys) / 1
		rev	(Cross Keys) / 1
		obv	(Blank)
		rev	(Blank)
145	KIRMG. 2006.345	obv	(Cross Keys) / 2
		rev	(Cross Keys) / 2
		obv	(Blank)
		rev	(Blank)
146	KIRMG. 2006.351	obv	(Cross Keys) / –
		rev	(Cross Keys) / –
		obv	(Blank)
		rev	(Blank)
147	KIRMG. 2006.362	obv	Я А П.
		rev	yA A P.
148	KIRMG. 2006.364	obv	К. 10
		rev	K. 10
		obv	I / W. M.
		rev	I / W.M.
149	KIRMG. 2006.371	obv	Б Н.
		rev	B N.
		obv	(Cross Keys) / –
		rev	(Cross Keys) / –
		obv	(Blank)
		rev	(Blank)
150	KIRMG. E585.01	obv	Л Д / И. [–][–][Б] / ОКОВ[Ъ] / Н
		rev	L D / I. [–][–][B] / OKOV['] / N
		obv	– – – / – Р – 3 / I. Н. / 1830
		rev	– – – / – P – 3 / I. H. / 1830
151	KIRMG. E585.02	obv	Л Д / А ЧЕР / НИКОВ / Но 2[6]
		rev	L D / A ChER / NIKOV / No 2[6]
		obv	N P / [О] Р 12 Н / –807
		rev	N P / [O] P 12 H / –807

Part Two. Catalogue of lead seals (Cyrillic and Roman)

152	KIRMG. E585.03	obv	– – / ДЕСЯТ / АЛЕКСЕЙ / ЛЬIЧЕВ	– – / DESyAT / ALEKSEY / LYChEV
		rev	АРХ. ПОР / КРОНЪ / 4. СОРТЪ / Я. К. / 1873	ARKh. POR / KRON" / 4. SORT" / yA. K. / 1873
153	KIRMG. E585.04	obv	(Blank)	(Blank)
		rev	– – / ЛЬГОДС / КОИ	– – / LyEGODS / KOI
154	KIRMG. E585.05	obv	+ (Cross Keys) / 3	+ (Cross Keys) / 3
		rev	(Blank)	(Blank)
155	KIRMG. E585.06	obv	Л. Д. / – ТАРА / БУКИНЪ / Н [4]	L. D. / – TARA / BUKIN" / N [4]
		rev	– Р / К 12 Н / 1804	– P / K 12 H / 1804

6.2.8.2. METHIL HERITAGE CENTRE [LWMCH]

No.	Seal Accession Number	Face	Transcription	Transliteration		
1	LWMCH:Unaccess. No. 01	obv	Л. Д. / Е. МАР / ТИНО / [Н] 63	L. D. / E. MAR / TINO / [N] 63		
		rev	/ – 3 / W. H. / 1831	/ – 3 / W. H. / 1831		
2	LWMCH:Unaccess. No. 02	obv	Л Д / Н. АРЕ / ФЬЕВЪ / Н 88	L D / N. ARE / F'EV" / N 88		
		rev	N Р. / – F 12 H / [17]90	N P. / – F 12 H / [17]90		
3	LWMCH:Unaccess. No. 03	obv	АРХ БРА / ДЕСЯТСК / МАТВЕИ / МУТЬЯН	ARKh BRA / DESyATSK / MATVEI / MUT'yAN		
		rev	АРХ БРА / ЧЕСКА / 3 СОРТЪ / Е. П. / 1879	ARKh BRA / ChESKA / 3 SORT" / E. P. / 1879		
4	LWMCH:Unaccess. No. 04	obv	С НЕЛ / ОВЪ / Н 43.	S NEL / OV" / N 43.		
		rev	/ Н / 18[–]–	/ N / 18[–]–		
5	LWMCH:Unaccess. No. 05	obv	Л Д / И ФИЛА / ТОВЪ / Н .	L D / I FILA / TOV" / N .		
		rev	N Р / А К. 9 H / 18[–]	[–]	N P / A K. 9 H / 18[–]	[–]

6.2.8.3. NORTH EAST FIFE MUSEUMS SERVICE (CUPAR) [CUPMS]

No.	Seal accession number	Face	Transcription	Transliteration				
1	CUPMS: 1986. 983	obv	[АРХ.] БРА / ДЕСЯТН. / ПЕТРЪ / ЖУКО/ВЪ	[ARKh.] BRA / DESyATN. / PETR" / ZhUKO / V"				
		rev	АРХ. БР./ ЧЕСКА / 2.СОРТЪ / В [Л]ЕД/1864	ARKh. BR./ ChESKA / 2.SORT" / V [L]ED / 1864				
2	CUPMS: 1998.6.1	obv	–Д / ДЕМИ/ДОВЪ / Н 55	–D / DEMI/DOV" / N 55				
		rev	СП[Б] / Но. П 3 / А. П. / 183[–]	SP[B] / No. P 3 / A. P. / 183[–]				
3	CUPMS: 1998.6.3	obv	Л – / С. ЕРО / ХИНЪ / Н 49	L – / S. ERO / KhIN" / N 49				
		rev	С П Б / Но П. 3 / Я. Ф. / 183[–]	S P B / No P. 3 / yA. F. / 183[–]				
4	CUPMS: 1998.6.4	obv	Л. Д. / П. ЩЕР / БАКО / Н 8	L. D. / P. ShchER / BAKO / N 8				
		rev	– / [–] 3 / Я. Ф. / 1831	– / [–] 3 / yA. F. / 1831				
5	CUPMS: 1998.6.5	obv	Л. Д. / [П]: ЩЕР / [–]АКО / [–] 6	L. D. / [P]: ShchER / [–]AKO / [–] 6				
		rev	С.П.Б. / Но П 3 / А. И. Г. / [1]831	S.P.B. / No P 3 / A. I. G. / [1]831				
6	CUPMS: 1998.6.6	obv	– / Д. ВОР[О] / БЬЕВЪ / . Н. 72	– / D. VOR[O] / B'EV" / . N. 72				
		rev	S P / N.P. – 2 / I. P. / 1830	S P / N.P. – 2 / I. P. / 1830				
7	CUPMS: 1998.6.7	obv	Л Д / И. ТАР / ПЧИН / N 11	L D / I. TAR / PChIN / N 11				
		rev	S P B / N P. 3 / P. K. / 18[–]	[–]	S P B / N P. 3 / P. K. / 18[–]	[–]		
8	CUPMS: 1998.6.9	obv	Л. Д. / [–]. НОВГО / [–]ЦОВЪ	L. D. / [–]. NOVGO / [–][D]TsOV"				
		rev	[S] P B / [N] P. 2 / – Н. / – – 38	[S] P B / [N] P. 2 / – H. / – – 38				
9	CUPMS: 1998.6.10	obv	Л. Д. / А. ВОРО / БЬЕВ– / Н. [–] 8	L. D. / A. VORO / B'EV– / N. [–] 8				
		rev	[С] П Б / Но П 3. / Н К / 1836	[S] P B / No P 3. / N K / 1836				
10	CUPMS: 1998.6.11	obv	[–]	[–] / Н: ВАЛ	АШЕВ / Н 3 –	[–]	[–] / N: VAL	AShEV / N 3 –
		rev	N Р . / [–] / К 12 Н / 1825	N P . / [–] / K 12 H / 1825				

11	CUPMS: 1998.6.12	obv	Л. Д./ [А]. НА[В]/НСКО/ . Н 13	L. D./ [A]. NA[V]/NSKO/. N 13
12	CUPMS: 1998.6.13	rev	[N]. P. / [-] F 12 H / [1]82[7]	[N]. P. / [-] F 12 H / [1]82[7]
		obv	-/ [-][] ИГ / [-] / Н 61	-/ [-][] IG / [-] / N 61
13	CUPMS: 1998.6.14	rev	--- /.N.P [-] / --- / [1]83[-]	---/.N.P [-]/ --- / [1]83[-]
		obv	Л Д / К. САНИ / ТИНЬ / Н 113	L D / K. SANI/ TIN"/ N 113
14	CUPMS: 1998.6.15	rev	S P B / N P – 3 / I. H. / ---	S P B / N P – 3 / I. H. / ---
		obv	Л. Д. / [И] М: ЕРЕ / МЕЕВЪ / Н 41.	L. D. / [I] M: ERE / MEEV" / N 41.
15	CUPMS: 1998.6.16	rev	S P B / N P – 3 / --- / 183[5]	S P B / N P – 3 / --- / 183[5]
		obv	Л. Д / РЫ[–][–] / КО[В] / [–] 8	L. D / RY[–][–] / KO[V] / [–] 8
16	CUPMS: 1998.6.17	rev	/ / 1836	/ / 1836
		obv	Л. [Д] / [Н] КОС/ТИН[Ъ]/ Н 3[2]	L. [D] / [N] KOS/TIN["]/ N 3[2]
17	CUPMS: 1998.6.18	rev	– / Но П / Е. П. / 183[3]	– / No P / E. P. / 183[3]
		obv	Л Д / С. МАС/ ЛЕНИН / N. 10	L D / S. MAS/ LENIN / N. 10
18	CUPMS: 1999.52.1	rev	С П Б / – П. 3 / А. П. / 183[-]	S P B / – P. 3 / A. P. / 183[-]
		obv	О / СЯТ/НИКЪ/ М АТВЕЙ/ ВЕДЕНС/КОИ	O / SyAT/NIK"/ M ATVEY/ VEDENS/KOI
19	CUPMS: 1999.52.2	rev	АРХ– –АК/ ДЕСЯТН[–][–]/ ВАСИЛИИ/ ЗВЯГИНЬ	ARKh– –AK/ DESyATN[–][–]/ VASILII/ ZVyAGIN"
		obv	-РХ. БР / [З]АБРАКЪ / 2И РУКИ/ Я.П.В./1884	-RKh. BR / [Z]ABRAK" / 2I RUKI/ yA.P.V./1884
20	CUPMS: 1999.52.3	rev	АРХ. ПОР./ДЕСЯТС[–][–]/ ПЕТР–/АБРАМО[–][–]	ARKh. POR./DESyATS[–][–]/ PETR–/ABRAMO[–][–]
		obv	– / КУД[–][–][–] / 2 СОРТЪ / Ф Р. / 1872	– / KUD[–][–][–] / 2 SORT" / F R. / 1872
21	CUPMS: 1999.52.4	rev	АРХ. БРА / ДЕСЯТ: / КАРПО– / КЛАФТ	ARKh. BRA / DESyAT: / KARPO– / KLAFT
		obv	АРХ. ПОР./ ПАКЛЯ / ЧЕСКА / 2 СОРТЪ / Я. К. / 1863	ARKh. POR./ PAKLyA / ChESKA / 2 SORT" / yA. K. / 1863
22	CUPMS: 1999.52.5	rev	АРХ. ПОР./ДЕСЯТС[–][–][–]/НИКОЛАЙ РЫКО[В][Ъ]	ARKh. POR./DESyATS[–][–][–]/NIKOLAI RYKO[V]["]
		obv	АРХ. БР./ КУДЪЛЯ / 2 СОРТЪ / Ф. Р. / 1871	ARKh. BR./ KUDyElyA / 2 SORT" / F. R. / 1871
23	CUPMS: 1999.52.6	rev	–Р ПОР./ДЕСЯТ. / [М]АТВЕЙ[К]О / К[А][М]АРЕ / ВЪ	-R POR./DESyAT. / [M]ATVEY[K]O / K[A][M]ARE / V"
		obv	АРХ. БР / ЧЕСКА / 3: СОРТЪ / Ф. Р. / 1859	ARKh. BR / ChESKA / 3: SORT"/ F. R. / 1859
24	CUPMS: 1999.52.7	obv	[А]РХ. БРА. / [Д]ЕСЯТСК. / [Ф] ОМА/ ПОПОВЪ/-[Е]ДЪНСКИЙ	[A]RKh. BRA. / [D]ESyATSK. / [F]OMA / POPOV"/–[E]DyENSKII
		rev	АРХАНГ. ПОР. / ЧЕСКА / 2 СОРТЪ / Я.П.В. / 1878	ARKhANG. POR. / ChESKA / 2 SORT" / yA.P.V. / 1878
25	CUPMS: 1999.52.8	rev	–/ДЕСЯТСК / ФЕДОРЪ/ ---	–/DESyATSK / FEDOR"/ ---
		obv	АРХ. БР. / КУДЪЛЯ / 1. СОРТЪ / Ф. Р. / 1892	ARKh. BR. / KUDyElyA / 1. SORT" / F. R./ 1892
26	CUPMS: 1999.52.9	rev	АРХ. БР./ ПЕТРЪ/ МАРТЬЯ	ARKh. BR./ PETR"/ MART"yA
		obv	АРХ. БР./ЧЕСКА / 1 СОРТЪ / Е. П. / 1877	ARKh. BR./ ChESKA / 1 SORT" / E. P. / 1877
27	CUPMS: 1999.52.10	rev	АРХ. ПОР. / ДЕСЯТСК/ ВАСИЛИЕИ / БАБИКО / ВЪ	ARKh. POR. / DESyATSK / VASILEI / BABIKO / V"
		obv	АРХ. БР. / ЧЕСКА / 2: СОРТЪ / М. К. / 1851	ARKh. BR. / ChESKA / 2: SORT" / M. K. / 1851
28	CUPMS: 1999.52.11	rev	АРХ. БР. / ДЕСЯТН. / МИТРОФ./ П[–]Р[–]ТОВ	ARKh. BR. / DESyATN. / MITROF. / P[–]R[–]TOV
		obv	АРХ[–][–]Г. БР. / ЧЕСКА / 2 СОРТЪ / Е. П. / 1870	ARKh[–][–]G. BR. / ChESKA / 2 SORT" / E. P. / 1870
29	CUPMS: 1999.52.12	rev	АРХ.БР./ДЕСЯТ/АЛЕКСАНДР/–[П][Р]ИБОВЪ	ARKh.BR./DESyAT / ALEKSANDR / –[P][R]IBOV"
		obv	АРХАН. / КУД[Ъ][–] / 2 СОРТЪ / Я.П.В. / 189[9]	ARKhAN. / KUDyEl[–] / 2 SORT" / yA.P.V. / 189[9]
30	CUPMS: 1999.52.13	rev	А.П./ ЕСЯЦКО / Н. Т.	A.P./ ESyaTSKO / N. T.
		obv	А. П / ЛНЯН БРАК / 2 ВД Р / [–][83][–]	A. P / LNyAN BRAK / 2 VD R / [–][83][–]
31	CUPMS: 1999.52.14	rev	ПОР./ ДЕСЯТ / ЯКОВЪ / ДУПАЕ / ВЪ	POR./ DESyAT / yAKOV" / DUPAE / V"
		obv	/ ЧЕСКА / 3 СОРТЪ / В: ЛЕД / 1857	/ChESKA / 3 SORT" / V: LED / 1857
32	CUPMS: 1999.52.15	rev	А П / ДЕСЯЦКО / Т. З.	A P / DESyATsKO / T. Z.
		obv	А П / ПАК. БРАК. / 2 АР РУ / 1837	A P / PAK. BRAK. / 2 AR RU / 1837
33	CUPMS: 1999.52.16	rev	А П / ДЕСЯЦКО / К З	A P / DESyATsKO / K Z
		obv	А. П / ЛНЯН БРА / 18 МП 35 / 3. ПАК.Р	A. P / LNyAN BRA / 18 MP 35 / 3. PAK.R

Part Two. Catalogue of lead seals (Cyrillic and Roman)

34	CUPMS: 1999.52.17	obv	А. П. / ДЕСЯЦК / [Г] С.	A. P. / DESYATsK / [G] S.
		rev	А [-] / ПАК. БР. / 1 ЕП Р / 1836	A [-] / PAK. BR. / 1 EP R / 1836
35	CUPMS: 1999.52.18	obv	А. П. / ДЕСЯЦК / К. З.	A. P. / DESYATsK / K. Z.
		rev	А П / ЛНЯН БРАК / 18 МП 38 / – ПАК [-]	AP / LNyAN BRAK / 18 MP 38 / – PAK [-]
36	CUPMS: 1999.52.19	obv	– – / –Ся – / – – – / –	– – / –SyA – / – – – / –
		rev	А. П / ЛНА БРА / 3 ЯС Р / 1825 / [-] – [Д]ЕЛНАЯ	A. P / LNA BRA / 3 yA S R / 1825 / [-] – [D]ELNAyA
37	CUPMS: 1999.52.20	obv	– / ДЕСЯТНИК / ФЕДОРЪ / БУГАЕВЪ[']	– / DESyATNIK / FEDOR" / BUGAEV[']
		rev	АРХАНГ. ПОР. / КУДБЛЬ / [2] СОРТЪ / [Я] П. В. / 1892	ARKhANG. POR. / KUDyEL' / [2] SORT" / [yA] P. V. / 1892
38	CUPMS: 1999.52.21	obv	А. П. / ДЕСЯЦКОЙ / [K] У	A. P. / DESyATsKOY / [K] U
		rev	/ М. П. / – ПАК Р	/ M. P. / – PAK R
39	CUPMS: 1999.52.22	obv	– / ДЕСЯТ / МАТВЕИ / ВЕДЕНСКО	– / DESyAT / MATVEI / VEDENSKO
		rev	[А]РХ. БР./ ДБЛЬН. / [-] [С]О[Р]ТЪ / А Ч	[A]RKh. BR./ DyELN. / [-] [S]O[R]T" / A Ch
40	CUPMS: 1999.52.23	obv	А. П. / ДЕСЯЦКОЙ / П. К.	A. P. / DESyATsKOY / P. K.
		rev	[А] [П] / ЛНЯН. БРАК. / М. П 2 / 18 – –	[A] [P] / LNyAN. BRAK. / M. P / 18 – –
41	CUPMS: 1999.52.24	obv	Л. Д. / М. ФЕДО / ТОВЬ / Н 4 –][-]	L. D. / M. FEDO / TOV" / N 4 –][-]
		rev	С П Б / Но П. 2 / М. С. / [1]833	S P B / No P. 2 / M. S. / [1]833
42	CUPMS: 1999.52.25	obv	Л. Д. / ФИЛ / [А]ТОВ / Н 2–	L. D. / FIL / [A]TOV / N 2–
		rev	[С] П Б / Но П. 2 / М. К. / 1836	[S] P B/ No P. 2 / M. K. / 1836
43	CUPMS: 1999.52.26	obv	Л. Д. / С. ШИР / ЯЕВЬ / Н 68	L. D. / S. ShIR / yAEV / N 68
		rev	С П Б / Но П 3. / А. Б / 1833	S P B / No P 3. / A. B / 1833
44	CUPMS: 1999.52.27	obv	Л: Д. / И. ВАР / ЗОВЬ / Н 31	L: D. / I. VAR / ZOV" / N 31
		rev	С П [Б] / Но П. 2 / Г. Б. / 1829	S P [B] / No P. 2 / G. B. / 1829
45	CUPMS: 1999.52.28	obv	Л Д / [-] / ПОГ[А] / НКИНЬ / Н 27	L D / [-] / POG[A] / NKIN" / N 27
		rev	С П Б / Но П 3 / М. С. / 1833	S P B / No P 3 / M. S. / 1833
46	CUPMS: 1999.52.29	obv	Л: Д. / Г. ЗАМА / РИНЬ / Н. 17.	L: D. / G. ZAMA / RIN" / N. 17.
		rev	S P B / N P. – 2 / W. H. / [1]839	S P B / N P. – 2 / W. H. / [1]839
47	CUPMS: 1999.52.30	obv	Л Д / Г. ШИ / ЛОВЬ / [Н] 4[0]	L D / G. ShI / LOV" / [N] 4[0]
		rev	S P B / N P 3 / 1 Н.	S P B / N P 3 / 1 H.
48	CUPMS: 1999.52.31	obv	П [и] Л П Д / [-] КАЛТ / УШКИ / Но 3	P [i] L P D / [-] KALT / UShKI / No 3
		rev	S P [B] / I.C.B.N. 2 / 1836	S P [B] / I.C.B.N. 2 / 1836
49	CUPMS: 1999.52.32	obv	П.Л.П [Д] / [-]: СЕЛ / ИНЬ / Но 1	P.L.P [D] / [-]: SEL / IN" / No 1
		rev	S P [B] / F K 2 H / 1833	S P [B] / F K 2 H / 1833
50	CUPMS: 1999.52.33	obv	П. Л. П. Д. / [-] : СЕЛ ИНЬ / Но I	P. L. P. D. / [-] : SEL/ IN" / No I
		rev	[С] П Б / [-]. З. 2. Н. / 1832	[S] P B / [-]. Z. 2.H. / 1832
51	CUPMS: 1999.52.34	obv	П и Л.П.Д. / И. ШЕР[А] / ВСКОИ / Но 3	P i L.P.D. / I. ShER[A] / VSKOI / No 3
		rev	[С] П Б / [-]. Ш. 2 Н / [1]841	[S] P B / [-]. Sh. 2 H / [1]841
52	CUPMS: 1999.52.35	obv	П и Л.П.Д. / П КАЛТ / УШКИН / Но 3	P i L.P.D. / P KALT / UShKIN / No 3
		rev	S P B / I C.B.N. 2 / 1839	S P B / I C.B.N. 2 / 1839
53	CUPMS: 1999.52.36	obv	Л. Д. / П ПОЛ / ОВОХИ / . Н 81 .	L. D. / P POL/ OVOKhI / . N 81 .
		rev	.N.P. / I B 12 [-] / 1825	.N.P. / I B 12 [-] / 1825
54	CUPMS: 1999.52.37	obv	Л Д. / Е : ДЕМ/ЯНОВЬ/ Н[-]0	.L D. / E : DEM/yANOV" / N[-]0
		rev	N P / I M Б 12 / 1818	N P / I M B 12 / 1818
55	CUPMS: 1999.52.38	obv	– – / ПО[-] / [А]НКН / Но 27	– – / PO[-] / [A]NKН / No 27
		rev	.N. Р. / Р [К] 12 Н / 1825	.N. P. / P [K] 12 H / 1825
56	CUPMS: 1999.52.39	obv	Л. Д. / – – – / РО[-]О / Н 6[3]	L. D. / – – – / RO[-]O / N 6[3]
		rev	N Р / I M Б 9 / – –[-]2	N P / I M B 9 / – –[-]2

87

57	CUPMS: 1999.52.40	obv	Л. Д. / С. Г[У] / РОВЪ / Н 30	L.D. / S. G[U] / ROV / N 30
		rev	.N Р. / А К 12 Н /1[8]26	.N P. / A K 12 H /1[8]26
58	CUPMS: 1999.52.41	obv	– Д / И НОВ / ИКОВ	– D / I NOV /IKOV
59	CUPMS: 1999.52.42	obv	С П [Б] / Но П 3 /18–[1]	S P [B] / No. P 3 /18–[1]
		rev	– Д. / А КОП / ТЕВЪ / Н [2] I	– D. / A KOP / TEV" / N [2] I
60	CUPMS: 1999.52.43	obv	/[–] О – / Д. Х. /1832	/[–] O – / D. Kh. /1832
		rev	/П Н[–][Ъ] / НСКО[В] / Н I[8]	/P N[–][yE] / NSKO[V] / N I[8]
61	CUPMS: 1999.52.44	obv	С П Б / Но. П. 2 / А П /	S P B /No. P. 2 / A P /
		rev	Л [–] / И. Я. ЛУЧ / НИКОВЬ / Н [–]	L [–] / I. yA. LUCh / NIKOV" / N [–]
62	CUPMS: 1999.52.45	obv	.N [P] / 1 [S] [–] – Н /	.N [P] / 1 [S] [–] – H /
		rev	[Л] / И. ШЕ[–] / НОВЬ / Н 19	[L] / I. ShE[–] / NOV" / N 19
63	CUPMS: 1999.52.46	obv	СП[–] / Но П 2 / М С /18 [–]1	SP[–] / No. P 2 / M S /18 [–]1
		rev	DAMATSKI / Б А / 1851	DAMATSKI / B A / 1851
64	CUPMS: 1999.52.47	obv	/Но 2 / -.-. / [–] П	/No. 2 / -.-. / [–] P
		rev	– /П	– / P
			– / М С /	– / M S /
65	CUPMS: 1999.52.48	obv	А [–] DAMAZKI / Б.А. / 1848 / StPB	A [–] DAMAZKI / B.A. / 1848 / StPB
		rev	2Й С / 9	2Y S / 9
66	CUPMS: 1999.52.49	obv	А В DAMAZKI / В.А. / 1848 / StPB	A B DAMAZKI / B.A. / 1848 / StPB
		rev	Но 2/ -.-. / 9	No. 2/ -.-. / 9
67	CUPMS: 1999.52.50	obv	[–] [–] ДАМАЦКОЙ. ФЕДОС[Е][–]. . / 1847 / С П Б	[–] [–] DAMATsKOI. FEDOSE[–]. . / 1847 / S P B
		rev	HILLS & WHISHAW / II	HILLS & WHISHAW / II
68	CUPMS: 1999.53.1	obv	АРХ. БРА / ДЕСЯТ / ВАСИЛI / Л – – – И–	ARKh. BRA / DESyAT / VASILI / L – – – I–
		rev	АРХ. БР. / ЗАБРАКЪ / Ф. Р. / 1862	ARKh. BR. / ZABRAK" / F. R. / 186
69	CUPMS: 1999.53.2	obv	– / – / – /	– / – / – /
		rev	АРХ. БР. / ЗАБРАКЪ / 1И РУКИ. / Е П. /1877	ARKh. BR. / ZABRAK" / 1I RUKI. / E P. /1877
70	CUPMS: 1999.53.3	obv	– ДЕСЯТ / ИВАНЪ / –УЛЫЧЕВ	– DESyAT / IVAN" / –ULYCheV
		rev	АРХА– – – Р / КРОНЪ /2 СОРТЪ. /Я.П.В. /1880	ARKhA– – – R / KRON" /2 SORT". /yA. P. V. /1880
71	CUPMS: 1999.53.4	obv	АР– / ДЕСЯТН / МИХАИЛО / СВЕЩНИ / КОВЪ	AR– / DESyATN / MIKhAILO / SVEShNI / KOV"
		rev	АРХ Б / ЧЕСК[А] / 3 СОР[T][Ъ] / М К / 1857	ARKh B / ChESK[A] / 3 SOR[T]["] / M K / 1857
72	CUPMS: 1999.53.5	obv	АРХ. ПОР. / ДЕСЯТНИ[К] / ФЕДОРЪ / БУГАЕВЪ	ARKh. POR. / DESyATNI[K] / FEDOR" / BUGAEV
		rev	АРХ. БР. / ПАКЛЯ. / ЧЕСКА. / 2. СОРТЪ / Я.К. / 18[9][–]	ARKh. BR. / PAKLyA. / ChESKA. / 2. SORT" / yA.K. / 18[9][–]
73	CUPMS: 1999.53.6	obv	АРХ. БР / ДЕСЯТН. / СЕРГIИ / СЕДЕЛ[Ь]Н	ARKh. BR / DESyATN. / SERGII / SEDEL["]N
		rev	АРХ. БР. / ЗАБРАКЪ / Ф. Р. / 1871	ARKh. BR. / ZABRAK" / F. R. / 1871
74	CUPMS: 1999.53.7	obv	АРХ. БР / ДЕСЯТН. / ПАВЕЛЪ / МУРО[–][–]	ARKh. BR / DESyATN. / PAVEL" MURO[–][–]
		rev	АРХ. БР. / ЗАБРАКЪ / 2Й РУКИ. / Е. П. / 1880	ARKh. BR. / ZABRAK" / 2Y RUKI. / E. P. / 1880
75	CUPMS: 1999.53.8	obv	/ДЕСЯТ / ПЕТРЪ / МАРТЕ–][–]ОВ	/DESyAT / PETR" / MARTE–][–]OV
		rev	АРХ. БР. /КУДЫЛЯ / 2. СОРТЪ / Я. К. / 1892	ARKh. BR. /KUDyELyA / 2. SORT" / yA. K. / 1892
76	CUPMS: 1999.53.9	obv	БР / ДЕСЯТ. / ИВАНЬ / БУЛЫЧЕВЬ	BR / DESyAT. / IVAN" / BULYCheV
		rev	[А][Р]Х. / КУДЫЛЯ / 1 СОРТЪ / Ф. Р. / 1874	[A][R]Kh. / KUDyELyA / 1 SORT" / F. R. / 1874
77	CUPMS: 1999.53.10	obv	ДЕСЯТЬНИКЪ / ЕГОРЪ / ТЕВЛЕВЬ / АРХ. БР.	DESyAT'NIK" / EGOR" / TEVLEV" / ARKh. BR.
		rev	АРХ. БР. / ЧЕСКА / 2. СОРТЪ / Ф. Р. / 189[–]	ARKh. BR. / CheSKA. / 2. SORT" / F. R. / 189[–]
78	CUPMS: 1999.53.11	obv	:А:П: / ДЕС.ЯС.К. / .Е. М	:A:P: / DES.yAS.K. / .E. M
		rev	А. П. / ЛНЯН.БРАКЪ / 1 ВД Р / 183[–]	A. P. / LNyAN.BRAK" / 1 VD R / 183[–]
79	CUPMS: 1999.53.12	obv	/ДЕСЯТСК/ МАТВЕИ / С[И]МУТ[–][–][–]	/DESyATSK/ MATVEI / S[I]MUT[–][–][–]
		rev	/КУДЕЛЯ/ 1. СОРТЪ / Е. П. / 1880	/KUDELyA/ 1. SORT" / E. P. / 1880

Part Two. Catalogue of lead seals (Cyrillic and Roman) 89

80	CUPMS: 1999.53.13	obv	[А][Р]Х. БРА. / ДЕСЯТЬ / МИТРОФА / ШАРЫ	[A][R]Kh. BRA. / DESyAT' / MITROFA / ShARY
		rev	А[Р][Х]. ПОР./ ЛЕНЬ / ЗАБРАКЪ / Я. К. / 1863	A[R][Kh]. POR./ LEN" / ZABRAK" / yA. K. / 1863
81	CUPMS: 1999.53.14	obv	АРХ. ПО[—] / ДЕСЯТ / НИКЪ / МАТВЕ[И] / ВЕДНС / КО[И]	ARKh. PO[—] / DESyAT / NIK" / MATVE[I] / VEDNS / KO[I]
		rev	АРХ.БР./ КУДЕЛЬ/ 2 СОРТЪ/ А. Р. / 1847	ARKh.BR./ KUDEL'/ 2 SORT"/ A. R. / 1847
82	CUPMS: 1999.53.15	obv	А[Р][—] / ДЕСЯТ / МИХАИЛО / КАРПО / ВЪ	A[R][—] / DESyaT / MIKhaILO / KARPO / V"
		rev	АРХ.БР. / ЗАБРАК / А. Р / 1847	ARKh.BR. / ZABRAK / A. R / 1847
83	CUPMS: 1999.53.16	obv	ДЕСЯТ[Ь]Н— — / ЕГОРЬ / ТЕВ[Л][Е] / АРХ. [—]Р	DESyAT'[']N— — / EGOR" / TEV[L][E] / ARKh. [—]R
		rev	АРХ.БРА. / КРОНЬ / 4 СОРТЬ / Д. П. / 1886	ARKh.BRA. / KRON" / 4 SORT" / D. P. / 1886
84	CUPMS: 1999.53.17	obv	П и Л.П.Д / В. ГОРЬ / УНОВЪ / Но 4	P i L.P.D / V. GORB / UNOV" / No 4
		rev	[С] П Б / П. Ш. 2. Н / 1833	[S] P B / P. Sh. 2. H / 1833
85	CUPMS: 1999.53.18	obv	П и Л.П.Д / М КАЛТ / УШКН / Но 2	P i L.P.D / M KALT / UShKN / No 2
		rev	С П Б / Л. З. 1. Н. / 1831	S P B / L. Z. 1. H. / 1831
86	CUPMS: 1999.53.19	obv	П и Л.П.Д / П КАЛ[Т] / УШКИ / Но 9	P i L.P.D / P KAL[T] / UShKI / No 9
		rev	С П Б / П.Ш.2.Н / 1833	S P B / P.Sh.2.H / 1833
87	CUPMS: 1999.53.20	obv	П[и]ЛПД / Д : СЕ[—] / ИНЪ / Н 9—	P[i]LPD / D : SE[—] / IN" / N 9—
		rev	[—] Р [В] / — Н 2 Н / 183[8]	[—] P [B] / — H 2 H / 183[8]
88	CUPMS: 1999.53.21	obv	Л. Д / Г. СКОРО/ОГАТОВ / Н 65	L. D / G. SKORO/OGATOV/ N 65
		rev	S Р В / N Р. 2. / F. W. / 1839	S P B / N P. 2. / F. W. / 1839
89	CUPMS: 1999.53.22	obv	П и Л.П.Д / П КАЛТ / УШКИ / Но [3]	P i L.P.D / P KALT / UShKI / No [3]
		rev	С П Б / 1 С В N. 2 / 183[—]	S P B / 1 C B N. 2 / 183[—]
90	CUPMS: 1999.53.23	obv	Л / Е. ИВ[А] / НОВЬ / [Н] 75.	L / E. IV[A] / NOV" / [N] 75.
		rev	N: P: / Н 12 К / 1794	N: P: / H 12 K / 1794
91	CUPMS: 1999.53.24	obv	Л. Д. / А. ПЛО/ТНИК / Н 69	L. D. / A. PLO/TNIK / N 69
		rev	.N P. / Е С 12 К / 17[—]6	.N P. / E S 12 K / 17[—]6
92	CUPMS: 1999.53.25	obv	. Д / [—]: ЩОГ / ОЛЕВ / Н – –	. D / [—]: ShchOG / OLEV / N – –
		rev	.N. Р / Р В 12 . [Н] / 1794	.N. P / P B 12 . [H] / 1794
93	CUPMS: 1999.53.26	obv	Л. Д. / М. ЛЕВ / ШЕВЬ. / Н 37.	L. D. / M. LEV / ShEV". / N 37.
		rev	.N Р. / А Р 12 Н / 1799	.N P. / A R 12 H / 1799
94	CUPMS: 1999.53.27	obv	Л. Д. / Е. КОЗ / ЛОВЪ. / [—] 6 [—]	L. D. / E. KOZ / LOV". / [—] 6 [—]
		rev	.N Р. / С. Н 9 /182[—]	.N P. / C. H 9 /182[—]
95	CUPMS: 1999.53.28	obv	[Л].Д / [—] ЗЕМ / СКОИ / Н 33	[L].D / [—] ZEM / SKOI / N 33
		rev	N P. / НР 1 [2] / . 179[—] (НР is monogramme)	N P. / NR 1 [2] / . 179[—] (NR is a monogramme)
96	CUPMS: 1999.53.29	obv	Л. Д. / А. ЧЕЛ / ПАНО[В] / Н 54	.L. D. / A. ChEL / PANO[V] / N 54
		rev	N Р. / М М. 9 Н. / 1799.	N P. / M M. 9 H. / 1799.
97	CUPMS: 1999.53.30	obv	Д. / И ПЛО / ТНИК / Н 69	D. / I PLO / TNIK / N 69
		rev	.N Р. / Н Ш 12 / [1]8– –	.N P. / N Sh 12 / [1]8– –
98	CUPMS: 1999.53.31	obv	Л.Д. / С. ГУ/РОВЪ / Н 30	.L.D. / S. GU/ROV" / N 30
		rev	N Р. / НР 1 [2] / .18[—][—] (НР is monogramme)	.N P / NR 1 [2] /18[—][—] (NR is a monogramme)
99	CUPMS: 1999.53.32	obv	Л. Д. / И. ШЕ / РАПО/ Н 38	L. D. / I. ShE / RAPO/ N 38
		rev	.N.Р. / А К 12 Н / 1788	.N.P. / A K 12 H / 1788
100	CUPMS: 1999.53.33	obv	Л. Д. / Т БАБ / ОНИНЬ / Н 7[3]	.L. D. / T BAB / ONIN" / K 7[3]
		rev	N Р / I С 12 Н / 1800	N P / I S 12 H / 1800
101	CUPMS: 1999.53.34	obv	[Л]. Д / И: ВИ[Н] / НИКО[В]	[L]. D / I: VI[N] / NIKO[V]
		rev	.N Р. / —][— 12 Н / 1809.	. N. P. / —][— 12 H / 1809.
102	CUPMS: 1999.53.35	obv	Л. / Н. ХРА[—] / [—]ВСКО— / Н. 38	L. / N. KhRA[—] / [—]VSKO— / N. 38
		rev	[—][—]Б / П. 2. / М. С. / 1838	[—][—]B / P. 2. / M. S. / 1838

103	CUPMS: 1999.53.36	obv	KOROLEFF / И.Ф.К. / ST Р.В.	KOROLEFF / I.F.K. / St P.B.
		rev	Но. 2. / -. -. / 1848	No. 2. / -.-. / 1848
104	CUPMS: 1999.53.37	obv	- - - ЯХОВОКАГО- - / [- -] / ОКАГО	P - - YAKhOVOKAGO- - / [- -] / OKAGO
		rev	Но 2 / Н. [-]7	No 2 / N. [-]7
105	CUPMS: 1999.53.38	obv	Л. Д. / В. ВОЛ / КОВЪ / Н 78	L. D. / V. VOL / KOV" / N 78
		rev	С П Б / Но П. [2] / В. Ч. / 1843	S P B / No P. [2] / V. Ch. / 1843
106	CUPMS: 1999.53.39	obv	Л. Д. / А Н Ф[Е] / ДО[Р]ОВ / Н 8	L. D. / A N F[E] / DO[R]OV / N 8
		rev	: [-] : Р / Р[Н] [-] / 12 Н / - - / 1793	: [-] : P / P[H] [-] / 12 H / - - / 1793
107	CUPMS: 1999.53.40	obv	Д / [-] ПЛО[-]НИК / 76	D / [-] PLO[-]NIK / 76
		rev	/ - К 1 - / 180[0]	/ - K 1 - / 180[0]
108	CUPMS: 1999.53.41	obv	Л. Д. / Н. КОН / ОНО[В] / Н [-]2	L. D. / N. KON / ONO[V] / N [-]2
		rev	/ - С. 9. К / .1801	/ -. C. 9. K / .1801
109	CUPMS: 1999.53.42	obv	[Л] Д. / Е: ДЕМ/[Я]НОВ/ [Н] 70	[L] D. / E: DEM/[yA]NOV/ [N] 70
		rev	. / - 3/ I. Р / 1830	. / - 3/ I. P / 1830
110	CUPMS: 1999.54.1	obv	- / ШЫР / - - СКО / Н 85	- / ShYR / - - SKO / N 85
		rev	N [-]. / [А] К 12 К / 1823.	N [-]. / [A] K 12 K / 1823.
111	CUPMS: 1999.54.2	obv	Л. [-] / И: ШЫ[Р] / ОВСКО / Н 85.	L. [-] / I: ShY[R] / OVSKO / N 85.
		rev	. N Р / О Р 12 - / 182-	. N P / O P 12 - / 182-
112	CUPMS: 1999.54.3	obv	Л. Д. / И: ШЫР / ОВСКО / Н 85.	L. D. / I: ShYR / OVSKO / N 85.
		rev	. N Р. / -] К 12 К / [1]82[7].	. N P. / -] K 12 K / [1]82[7].
113	CUPMS: 1999.54.4	obv	Л. Д. / [Я] ЕР[О] / Х[И]НЬ / Н 49	L. D. / [yA] ER[O] / Kh[I]N" / N 49
		rev	. N Р / Г Б 12 / . 182[-]	. N P / G B 12 / . 182[-]
114	CUPMS: 1999.54.5	obv	Л. Д. / И: М[Ъ][-] / ННИ[К]О / Н 5[0]	L. D. / I: M[yE][-] / NNI[K]O / N 5[0]
		rev	. N Р. / P L 12 Н / 1825	. N P. / P L 12 H / 1825
115	CUPMS: 1999.54.6	obv	Л. Д. / [-][-]ОЛ / [-]ОВЪ / - -	L. D. / [-][-]OL / [-]OV" / - -
		rev	П Б / . П. 2. / И. Г / - -] [-]	PB/ . P. 2. / I. G / - -] [-]
116	CUPMS: 1999.54.7	obv	Л. Д. / В: ПРО / НИНЬ / [Н] 28	L. D. / V: PRO / NIN" / [N] 28
		rev	[N] [Р] / Ч 12 Н / 1826	[N] [P] / Ch 12 H / 1826
117	CUPMS: 1999.54.8	obv	. Л. Д. / И. НАДЕ / ЖИНЬ / Н 44	. L. D. / I. NADE / ZhIN" / N 44
		rev	. N [Р] / F W 12 / 182-	. N [P] / F W 12 / 182-
118	CUPMS: 1999.54.9	obv	Л. Д. / И. МИЛО / [-]Е[Р]ДО	L. D. / I. MILO / [-]E[R]DO
		rev	N Р / Р К 1 / 18- -	N P / P K 1 / 18- -
119	CUPMS: 1999.54.10	obv	Л. Д. / [-]. ЕРЕ / [-]ЕЕВЪ/ [Н] 30	L. D. / [-]. ERE / [-]EEV"/ [N] 30
		rev	. N Р. / АР 9 К / 1803.	. N P. / A P 9 K / 1803.
120	CUPMS: 1999.54.11	obv	.АРХ.БРА. / ДЕСЯТ: / [Д]МИТРИ / - ОГОВЪ	.ARKh.BRA. / DESyAT:/ [D]MITRI / - OGOV"
		rev	АРХ. Б- / КУДЕЛЬ / 2 СОРТЪ / [В] ЛЕД / 1862	ARKh. B- / KUDEL / 2 SORT" / [V] LED / 1862
121	CUPMS: 1999.54.12	obv	АРХ.БРА. / ДЕСЯТН / ЕГОРЪ. ТЕ / ВЛЕВЪ	ARKh.BRA. / DESyATN / EGOR". TE / VLEV"
		rev	АРХ. БР. / КРОНЪ / 4 СОРТЪ / Ф. Р. / 1863	ARKh. BR. / KRON" / 4 SORT" / F. R. / 1863
122	CUPMS: 1999.54.13	obv	- - - / ЕГОРЪ / ТЕВЛЕВЪ / АРХ. БР.	- - - / EGOR" / TEVLEV" / ARKh. BR.
		rev	АРХ. ПО / ЗАБРАКЪ / Ф Р / 1874	ARKh. PO / ZABRAK" / F R / 1874
123	CUPMS: 1999.54.14	obv	АРХ. ПОР. / ДЕСЯТНИК / - АМАНЪ / ЕРОФЕ / ЕВЪ	ARKh. POR. / DESyATNIK / - AMAN" / EROFE / EV"
		rev	АРХ. БР / КУДЕЛЬ / 2 СОРТЪ / В. ЛЕД / 1859	ARKh. BR / KUDEL / 2 SORT" / V. LED / 1859
124	CUPMS: 1999.54.15	obv	- РХ. БРА. / [Д]ЕСЯТ. / - В ДЪИ / - ФОН	-RKh. BRA. / [D]ESyAT. / -V DyEI / -FON
		rev	- - - / ЧЕСКА / 3: СОРТЬ / Е. П. / 1863	- - - / ChESKA / 3: SORT" / E. P. / 1863
125	CUPMS: 1999.54.16	obv	АРХ. / ДЕСЯТ / [Д]МИТ / З[В][Я] - -	ARKh. / DESyAT / [D]MIT / Z[V][yA]- -
		rev	АРХ. БР. / КУДЕЛ. / СОРТЪ / Е. П. / 1871	ARKh. BR. / KUDEL. / SORT" / E. P. / 1871

Part Two. Catalogue of lead seals (Cyrillic and Roman)

126	CUPMS: 1999.54.17	obv	– – – / [Д]ЕСЯТ / ДМИТРЕ / ШУЛГИ–/ – – –	– – – / [D]ESyAT / DMITRE / ShULGI–/ – – –
		rev	АРХ. Б. / КРОНЪ / 2: СОРТЪ / Ф. Р. / 1857	ARKh. B. / KRON" / 2: SORT" / F. R. / 1857
127	CUPMS: 1999.54.18	obv	– – – / ДЕСЯТ / ЕФИМЪ / СОРОКИН / – –	– – – / DESyAT / EFIM" SOROKIN / – –
		rev	АР. ПОР / КРОНЪ / 3 СОРТЪ / Ф. Р. / 1851	AR. POR. / KRON" / 3 SORT" / F. R. / 1851
128	CUPMS: 1999.54.19	obv	БР. / ДЕСЯТСК / [Ф]ОМА ПОПО–/ – –ДЪН[С]К]	BR. / DESyATSK / [F]OMA POPO–/ – –DyEN[S][K]
		rev	[АРХ.] ПОР. / КУДҌЛ. / 2 СОРТЪ / Я.П.В. / 1878	[ARKh.] POR. / KUDyEL. / 2 SORT" / yA.P.V. / 1878
129	CUPMS: 1999.54.20	obv	АРХ. – – / ДЕСЯТ. / АЛЕКСАН[Д] / НАУГОЛЬ / НОЙ	ARKh. – – / DESyAT. ALEKSAN[D] / NAUGOL' / NOY
		rev	АРХ. БР. / ЗАБРАК[–] / А. Р. / 1847	ARKh. BR. / ZABRAK[–] / A. R. / 1847
130	CUPMS: 1999.54.21	obv	Л. Д. / [И] МАШ / КОВЪ / Н 59	L. D. / [I] MASh / KOV" / N 59
		rev	S P B / N P.-3. / –.N. / [–]-[3][–]	S P B / N P.-3. / –.N. / [–]-[3][–]
131	CUPMS: 1999.54.22	obv	Л. Д. / Л: НЕМ / ИЛОВЬ / N 24	L. D. / L: NEM / ILOV" / N 24
		rev	S P B / NP. 3 / I. H. / 183[–]	S P B / NP. 3 / I. H. / 183[–]
132	CUPMS: 1999.54.23	obv	/МЕР- / –НОВЬ / Н[–][–]	/MER- / –NOV" / N[–][–]
		rev	S P B / N P. 3 / I. H / 183[1]	S P B / N P. 3 / I. H / 183[1]
133	CUPMS: 1999.54.24	obv	Л. Д. / ПАНФ / ИЛОВЬ / – –	L. D. / PANF / ILOV" / – –
		rev	S P / N P – / I. S / 18- –	S P / N P – / I. S / 18- –
134	CUPMS: 1999.54.25	obv	Л. Д / И НАДЕ / ЖИНЬ / Н. 4[–]	L. D / I NADE / ZhIN" / N. 4[–]
		rev	С П Б / Но. П. 3 / А. [–] / 183[–]	S P B / No. P. 3 / A. [–] / 183[–]
135	CUPMS: 1999.54.26	obv	Л. Д. / А -[[-]И / НОВЬ/ Н: 54	L. D. / A -[[-]I / NOV" / N: 54
		rev	С. П Б / Но П.3. / Г. Б. / 183[–]	S. P B / No P.3. / G. B. / 183[–]
136	CUPMS: 1999.54.27	obv	Л. Д. / П: ЩеР / БАКО / –	L. D. / P: ShchER / BAKO / –
		rev	С. П. Б. / Но П. 3. / А. И. Г. / 1831	S. P. B. / No P. 3. / A. I. G. / 1831
137	CUPMS: 1999.54.28	obv	Л.Д. / Я: ШЕ / ЛОВЬ / . Н 5	.L. D. / YA: ShE / LOV". N 5
		rev	[П][Б] / Но П. [–] / И. [–] / В / 1830	[P][B] / No P. [–] / I. [–] / V / 1830
138	CUPMS: 1999.54.29	obv	Л. Д. / [–] ВАР / ЗОВЬ / -3-	L. D. / [–] VAR / ZOV" / –3–
		rev	– – / Но. П. 2 / Д. Х. / 1837	– – / No. P. 2 / D. Kh. / 1837
139	CUPMS: 1999.54.30	obv	А П / ДЕС- – / К	A P / DES- – / K
		rev	А. П. / НРН.БРАК / ПА ВД 1833 /КЛЯ	A. P. / NRN.BRAK / PA VD 1833 /KLyA
140	CUPMS: 1999.54.31	obv	/ ДЕСЯЦК / Г. [Б] /	/DESyATsK / G. [B] /
		rev	/ ЛНЯН. БРАК / 18МП32 / [3] ПАК. Р	/LNyAN. BRAK / 18MP32 / [3] PAK. R
141	CUPMS: 1999.54.32	obv	Пи Л П Д / П. КАЛТ / УШКИ / Н. [3]	Pi L P D / P. KALT / UShKI / N. [3]
		rev	– Р [В] / I.C.B.N.2 / 183- –	– P [B] / I.C.B.N.2 / 183- –
142	CUPMS: 1999.54.33	obv	–П. Д. / К: МА[–] /ОЗО[В] / Н 26	–P. D. / K: MA[–] /OZO[V] / N 26
		rev	– Р В / Р.Ғ.А.Н / -.-. / 1799	– P B / P.F.A.H / -.-. / 1799
143	CUPMS: 1999.54.34	obv	П и Л П Д / [Ф] СУХО / РУКОВ / Но 6	Pi L P D / [F] SUKhO / RUKOV / No 6
		rev	С П Б / П. Ш. 2. [Н] / 183[5]	S P B / P. Sh. 2. [N] / 183[5]
144	CUPMS: 1999.54.35	obv	Л. Д. / Е САФР / ОНОВЬ / Н 59	L. D. / E SAFR / ONOV" / N 59
		rev	S P B / N P. - 2 / I. S. / 1836	S P B / N P. - 2 / I. S. / 1836
145	CUPMS: 1999.54.36	obv	Л.Д. / 3: ТЕМ/КИНЬ / [Н] –2.	.L.D. / Z: TEM/KIN" / [N] –2.
		rev	S.P.B. / N P. – 2 / Р. К. / 18[–]-	S.P.B. / N P. – 2 / P. K. / 18[–]-
146	CUPMS: 1999.54.37	obv	Л. Д. / -ЕДО /-ИНЪ / Н 7	L. D. / -EDO /-IN" / N 7
		rev	Р В / - 3 / I Н / 1837	P B / - 3 / I H / 1837
147	CUPMS: 1999.54.38	obv	Л. Д. / С: ФИЛ / АТОВЪ / [Н] 2	.L. D. / S: FIL / ATOV/ [N] 2
		rev	С. П. / Но П / А. И. Г. / 1831	S. P. / No P / A. I. G. / 1831
148	CUPMS: 1999.54.39	obv	Л. Д. / Г: НИК / ИФОРО / – –	.L. D. / G: NIK / IFORO / – –
		rev	.N. P. / НР 12 Н / . 179[–] (НР is monogramme)	.N. P. / NR 12 H / . 179[–] (NR is a monogramme)

149	CUPMS: 1999.54.40	obv	Л.Д. / [-] ИВА / НОВЬ / – 75	.L.D. / [-] IVA / NOV" / – 75		
		rev	N.P.: / – 12 Н / 1794	N.P.: / – 12 H / 1794		
150	CUPMS: 1999.54.41	obv	Л Д / Ф: ФО / КИНЬ / Н II	L D / F: FO / KIN" / N II		
		rev	.N Р / Т Н 12 – / 180[–]	.N P / T H 12 – / 180[–]		
151	CUPMS: 1999.54.42	obv	[Л] Д / – МЕС / НИКО[В] / Н 118	[L] D / – MES / NIKO[V] / N 118		
		rev	. N Р / I Н 12 [Н] / 1824	. N P / I H 12 [H] / 1824		
152	CUPMS: 1999.54.43	obv	Л.Д./ И ПЕ[Л] / ЕШЕ[В]– / Н 19	L.D./ I PE[L] / EShE[V]– / N 19		
		rev	N. Р. / [Т] 12 Н / 1825	N.P. / [T] 12 H / 1825		
153	CUPMS: 1999.54.44	obv	Л.Д./ И СИ[–] / [–]ВИН[–] / Н –01	L.D./ I SI[–] / [–]VIN[–] / N –01		
		rev	N. Р. / Н Ш 12 / 182[–]	N.P. / N Sh 12 / 182[–]		
154	CUPMS: 1999.54.45	obv	Л.Д./ Л КОП / ТЕВЬ / Н 91	L.D./ L KOP / TEV" / N 91		
		rev	N. Р / F W 9 H / 1825	N. P / F W 9 H / 1825		
155	CUPMS: 1999.54.46	obv	Л.Д./ А ДЕДО / ВНИКО / Н 79	L.D./ A DEDO / VNIKO / N 79		
		rev	N. Р / F 12 Н / 1822	N. P / F 12 H / 1822		
156	CUPMS: 1999.54.47	obv	Л.Д./ Б УКРО / ТСКО / Н 27	L.D./ B UKRO / TSKO / N 27		
		rev	N. Р / I S 12 Н / 182–	N. P / I S 12 H / 182–		
157	CUPMS: 1999.54.48	obv	[–] .Д. / – ПОГ / АНКИ / Н 27	[–] .D. / – POG / ANKI / N 27		
		rev	N Р. / Т 12 Н / 1826	N P. / T 12 H / 1826		
158	CUPMS: 1999.54.49	obv	Л. Д. / В: САВО / СТИНЬ / N 32	L. D. / V: SAVO / STIN" / N 32		
		rev	.N Р. / [–] G 9 H / [1]82[6]	.N P. / [–] G 9 N / [1]82[6]		
159	CUPMS: 1999.54.50	obv	[Л]: Д. / N: ЧЕБ / ЛОКОВ / Н 86	[L]: D. / N: ChEB / LOKOV / N 86		
		rev	N Р. / I М В 12 / 182[6]	N P. / I M B 12 / 182[6]		
160	CUPMS: 1999.54.51	obv	Л. Д. / Т. МАЛ / ЫГИН / Н 123	L. D. / T. MAL / YGIN / N 123		
		rev	N Р. / А В 12 Н / 1819	N P. / A B 12 H / 1819		
161	CUPMS: 1999.54.52	obv	Л.Д. / П. ЛЕ[–] / Е[–]	[–]	L.D. / P. LE[–] / E[–]	[–]
		rev	N. Р / –[–]I В 9 [Н] / 182[–]	N. P / –[–]I B 9 [H] / 182[–]		
162	CUPMS: 1999.54.53	obv	Л.Д. / А: НЬМ / [Ц]ОВЬ/ – [0] 4	L.D. / A: NyEM / [Ts]OV"/ – [0] 4		
		rev	– / I С 12 / 1826	– / I C 12 / 1826		
163	CUPMS: 1999.54.54	obv	– / С ИВА / ОВЬ. / [Н] 43	– / S IVA / OV". / [N] 43		
		rev	N [–] / С Н 12 / 182[–]	N [–] / C H 12 / 182[–]		
164	CUPMS: 1999.54.55	obv	– /А / НИ / Н 2	– /A / NI / N 2		
		rev	– Р/– 12 Н / [1]823	– P/– 12 H / [1]823		
165	CUPMS: 1999.54.56	obv	Л.Д./ Н КЛА / ДУХИНЬ / [Н]. 122	L.D./ N KLA / DUKhIN" / [N]. 122		
		rev	N [Р] ./ Ф 9 Н / [–]826	N [P] ./ F 9 H / [–]826		
166	CUPMS: 1999.54.57	obv	А. П. / ДЕСЯТ[С][К]О / [–]-[–]	A. P. / DESyAT[S][K]O / [–]-[–]		
		rev	–НЯН. БРАК / В [Д] / ПАКЛЯ / – – –	–NyAN. BRAK / V [D] / PAKLyA / – – –		
167	CUPMS:1999.54.58	obv	– /АМС / –	– /AMS / –		
		rev	– /Д /	– /D /		
168	CUPMS:1999.54.59	obv	– /[А]МС / –	– /[A]MS / –		
		rev	– /С / –	– /S / –		
169	CUPMS:1999.54.60	obv	– НОВА – – – СК / МЕЛЬНИЦА	– NOVA – – – SK / MEL'NITsA		
		rev	…ASTERS / АR[А]N	…ASTERS / AR[A]N		
170	CUPMS: 1999.55.1	obv	АРХ. БРА/ ДЕСЯТ. / [И]ВАНЬ / –ГОВ[Ъ]	ARKh. BRA/ DESyAT. / [I]VAN" / –GOV["]		
		rev	АРХ. БР. / ЧЕСКА / 2. СОРТЬ / Ф. Р. / 189[–]	ARKh. BR. / ChESKA / 2. SORT" / F. R. / 189[–]		
171	CUPMS: 1999.55.2	obv	– –Х. ПОР / [Д]ЕСЯТ./ –Р–АТ–/ – О –	– –Kh. POR / [D]ESyAT./ –R–AT–/ – O –		
		rev	АРХ. Б. / ЗАБРАК / В ЛЕД / 1848	ARKh. B. / ZABRAK / V LED / 1848		

Part Two. Catalogue of lead seals (Cyrillic and Roman)

172	CUPMS: 1999.55.3	obv	/ ДЕСЯТ / АЛЕК. ЛОП / ОТОВСКОИ	/ DESyAT / ALEK. LOP / OTOVSKOI
173	CUPMS: 1999.55.4	obv	АРХ. БР. / КУДЕЛЬН. / 2 СОРТЪ / В ЛЕД / 1838	ARKh. BR. / KUDEL'N. / 2 SORT" / V LED / 1838
		rev	ДЕСЯТЬНИКЪ / ЕГОРЪ [Т]ЕВЛЕВЪ / АРХ. БР.	DESyAT'NIK" / EGOR" [T]EVLEV" / ARKh. BR.
174	CUPMS: 1999.55.5	obv	АРХ. БР. / ПАКЛЯ. / ЧЕСКА. / 2. СОРТЪ / .Я.К. / 189[–]	ARKh. BR. / PAKLyA. / ChESKA. / 2. SORT" / .yA.K. / 189[–]
		rev	.А.[П]. / ДЕСЯТС / Е П / 18 МП 34/ 1 ПАК. Р	.A.[P]. / DESyATS / E P / 18 MP 34/ 1 PAK. R
175	CUPMS: 1999.55.6	obv	Л. Д./ Е. УКРОП / ВСКОИ / [Н] 28[–]	L. D./ E. UKROP / VSKOI / [N] 28[–]
		rev	[S] P B / P. 2 / 1 Н. / 1838	[S] P B / P. 2 / 1 H. / 1838
176	CUPMS: 1999.55.7	obv	Л. Д./ Д. КОС / ТИНЬ / [Н] 13	L. D./ D. KOS / TIN" / [N] 13
		rev	[С] П Б / No П 3. / [А] .Г. / [1]829	[S] P B / No P 3. / [A] .G. / [1]829
177	CUPMS: 1999.55.8	obv	Л. Д./ С ФИЛАТОВЪ/ Н 2	L. D./ S FIL / ATOV" / N 2
		rev	С П Б / No П 2 / А: П / [1][8]38	S P B / No P 2 / A.: P / [1][8]38
178	CUPMS: 1999.55.9	obv	Л: Д. / [Г] ЗИМ / АНОВЪ/ Н. 82.	L: D. / [G] ZIM / ANOV" / N. 82.
		rev	N. P. / – Ч 12 Н / 1826	N. P. / – Ch 12 H / 1826
179	CUPMS: 1999.55.10	obv	Л Д. / [–] СИНЯ / [–]ОВЪ / Н. 4[3].	L D. / [–] SINyA / [–]OV" / N. 4[3].
		rev	N. P. / P Ч 12 Н / 182[–]	N. P. / P Ch 12 H / 182[–]
180	CUPMS: 1999.55.11	obv	Д / – – – Въ / [Н][o][6]	D / – – – V" / [N][o][6]
		rev	N. P. / I S 12 [Н] / 182[–]	N. P. / I S 12 [H] / 182[–]
181	CUPMS: 1999.55.12	obv	Д / В: ЗАИ / ЦОВ[–] / Н: 9–	D / V: ZAI / TsOV[–] / N: 9–
		rev	N. P. / С К 12 / 1809	N. P. / S K 12 / 1809
182	CUPMS: 1999.55.13	obv	Л. Д. / И ПЛ[О] / ТНИ[К] / – –	L. D. / I PL[O] / TNI[K] / – –
		rev	N. P. / P F 12 / – – /18[–][–]	N. P. / P F 12 / – – /18[–][–]
183	CUPMS: 1999.55.14	obv	[–] Д / Т МАЛ / ЫГИН / Н 23[1]	[–] D / T MAL / YGIN / N 23[1]
		rev	.N. P. / Н 12 Н / 1825	.N. P. / H 12 H / 1825
184	CUPMS: 1999.55.15	obv	Л. [Д] / В [–]АВО /–ГИНЬ / Н 32	L. [D] / V [–]AVO –GIN / N 32
		rev	N. P/ Н 12 Н / 1827	N. P/ H 12 H / 1827
185	CUPMS: 1999.55.16	obv	Л. Д./ –[[–[М][И][Л] / – – ОВ / 61	L. D./ –[[–[M][I][L] / – – OV / 61
		rev	. N [Р] / М С 12 [–] / 1822	. N [P] / M S 12 [–] / 1822
186	CUPMS: 1999.55.17	obv	.Л Д. / Л КО[П] / ТЕВЪ / Н 9[–]	.L. D. / L KO[P] / TEV" / N 9[–]
		rev	.N P. / [А] Б 12 Н / [–]823	.N P. / [A] B 12 H / [–]823
187	CUPMS: 1999.55.18	obv	Л. Д. / Л: КОС / [Т]ИНЬ / [Н] 122	L: D / L: KOS / [T]IN" / [N] 122
		rev	.N P / [Н] Г 12 Н / [8]24	.N P / [N] G 12 H / [8]24
188	CUPMS: 1999.55.19	obv	[Л] Д/ Д [Б][А][Д / АНО[В]	[L] D/ D [B][A]GD / ANO[V]
		rev	N.P. / Н 12 Н / [1][8]27	N.P. / H 12 H / [1][8]27
189	CUPMS: 1999.55.20	obv	[Л]. Д./ В ЛАК / –ИНЬ. / N [–]7	[L]. D./ V LAK / –IN". / N [–]7
		rev	[N] P / Ф 12 Н / – [–]27	[N] P / F 12 H / – [–]27
190	CUPMS: 1999.55.21	obv	Л. Д. / А: ПЕТ / УНОВЪ / Н 108	L. D. / A: PET / UNOV" / N 108
		rev	N. P. / – С 12 Н / 1825	N. P. / – C 12 H / 1825
191	CUPMS: 1999.55.22	obv	– –Д / Н ЧЕРН / ИКОВЬ / Н 123	– –D / N ChERN / IKOV" / N 123
		rev	S / N [Р] / Т. L / 1830	S / N [P] / T. L / 1830
192	CUPMS: 1999.55.23	obv	Л – / В. ЩОГ/ОЛЕВ. / Н 64	L – / V. ShchOG/OLEV. / N 64
		rev	N [Р] / К К 12 Н / .1803.	N [P] / K K 12 H / .1803.
193	CUPMS: 1999.55.24	obv	Д/ [–][–][–] / Ц[Е] – – / Н[–][–]	D / [–][–][–] / Ts[E] – – / N[–][–]
		rev	Л. /	L. /
194	CUPMS: 1999.55.25	obv	[Л]: С[–] / ЫНI / НЬ	[L]: S[–] / YNI / N"
		rev	/ Н 12 Н / 1821	/ H 12 H / 1821

195	CUPMS: 1999.55.26	obv	(Illegible)	(Illegible)				
		rev	АРХ.БР. / ЧЕСКА / 3 СОРТЪ / Е: П / 18[–]	[6]	ARKh.BR. / ChESKA / 3 SORT" / E: P / 18[–]	[6]		
196	CUPMS: 1999.55.27	obv	Л. П / А. ПОГА / НКИ[–]	[–]	/ Н. 3	L. P / A. POGA / NKI[–]	[–]	/ N. 3
		rev	Л. П. С. / П. БАЛО / ВАНОВЬ / Н [3]	L. P. S. / P. BALO / VANOV" N [3]				
197	CUPMS: 1999.56.1	obv	А. П. / ДЕСЯЦКО / А. А.	A. P. / DESyATsKO / A. A.				
		rev	А. / ЛНЯН.Б / 18.В.Д 3 / 2 ПАК Р	A. / LNyAN.B / 18.V.D 3 / 2 PAK R				
198	CUPMS: 1999.56.2	obv	АРХ. / ДЕСЯТСК / ФЕДОРЪ / СО[–]О[–]	[–]	ARKh. / DESyATSK / FEDOR" / SO[–]O[–]	[–]		
		rev	АРХ. БР. / ЗАБРАК. / В. ЛЕД / 1847	ARKh. BR. / ZABRAK. / V. LED / 1847				
199	CUPMS: 1999.56.3	obv	АРХ. ПОР. / ДЕСЯТН. / ВАСИЛИИ / БРЮХАН / ОВ[Ъ]	ARKh. POR. / DESyATN. / VASILII / BRyUKhAN / OV["]				
		rev	АРХ. БР. / КУДЕЛЬ / 1 СОРТЪ / А. Р. / 1847	ARKh. BR. / KUDEL' / 1 SORT" / A. R. / 1847				
200	CUPMS: 1999.56.4	obv	/ ДЕСЯТ/	/DESyAT/				
		rev	АРХ. БР. / ЗАБРАКЪ / Е. П. / 1874	ARKh.BR. / ZABRAK" / E. P. / 1874				
201	CUPMS: 1999.56.5	obv	/ДЕСЯТ. / [А][Л][уЕ][К[С]Е / НАМА[Т] / ОВЪ	/DESyAT. / [A][L][yE][K[S]E / NAMA[T] / OV"				
		rev	Р / КУДЕЛЬ / 1 [С]ОРТЬ / Ф. Р. / 1857	R / KUDEL' / 1 [S]ORT" / F. R. / 1857				
202	CUPMS: 1999.56.6	obv	АРХ. ПО / ДЕСЯТ– / [И][В][А][Н][Ъ] / ПОПО / ВЪ	ARKh. PO / DESyAT– / [I][V][A][N]["] / POPO / V"				
		rev	АРХ. Б[Р] / КРОНЬ / 3 СОРТЪ / Е П / 1845	ARKh. B[R] / KRON" / 3 SORT" / E P / 1845				
203	CUPMS: 1999.56.7	obv	АРХ. БР. / ДЕСЯТ/ ПАВЕЛЪ / –[–]	[–]	КХИНЪ	ARKh. BR. / DESyAT:/ PAVEL" / –[–]	[–]	KhIN"
		rev	АРХ. БР. / КУДЪЛЯ / 2. СОРТЪ / Ф. Р. / 1873	ARKh. BR. / KUDyElyA / 2. SORT" / F. R. / 1873				
204	CUPMS: 1999.56.8	obv	П[и] Л. П Д. / Н: СЕЛ / ИНЪ / Но I	P[i] L. P D. / N: SEL / IN" / No I				
		rev	С П Б / П. Ш. 2 / 1832	S P B / P. Sh. 2 / 1832				
205	CUPMS: 1999.56.9	obv	П и Л П Д / М. КАЛТ/УШКН / Но 2	P i L P D / M. KALT/UShKN / No 2				
		rev	S P B / I C B N [2] / 1831	S P B / I C B N [2] / 1831				
206	CUPMS: 1999.56.10	obv	Л. Д: / З. ШИР / ЯЕВЪ / Н 68	L. D: / Z. ShIR / yAEV" / N 68				
		rev	С П Б /Но П. 3 / А. И. Г. / 1833	S P B / No P. 3 / A. I. G. / 1833				
207	CUPMS: 1999.56.11	obv	Л. Д. / Г. ТЕМ / КИНЬ / Н –[–]	L. D. / G. TEM / KIN" / N –[–]				
		rev	[S] P [B] / NP. – 3 / I. Р. / 1831	[S] P [B] / NP. – 3 / I. P. / 1831				
208	CUPMS: 1999.56.12	obv	.Л. Д. / А: ЕСЬ / КОВЪ / Н 8.	.N P. / A: ES' / KOV" / N 8.				
		rev	.N P. / А Б 12 Н / 1805	.N P. / A B 12 H / 1805				
209	CUPMS: 1999.56.13	obv	Л. Д / С ФИЛ / АТОВ . Н 2	L. D / S FIL / ATOV / . N 2				
		rev	– / [–] Р. – / I. Н / 1838	– / [–] P. – / I. H / 1838				
210	CUPMS: 1999.56.14	obv	Д / С ДЕМ / ЬЯНОВ / . Н. I – –	D / S DEM / yANOV / . N. I – –				
		rev	N. P. / F 12 Н / .–. –. / [1]806	N. P. / F 12 H /.–.–. / [1]806				
211	CUPMS: 1999.56.15	obv	Л. Д. / I ЛИГА / ЧЕВЪ	L. D. / I LIGA / ChEV"				
		rev	N. P. / А П 12 / 182–	N. P. / A P 12 / 182–				
212	CUPMS: 1999.56.16	obv	Л. Д / [–] КАР / ЦЕВЬ / Но [–]	L. D / [–] KAR / TsEV" / No [–]				
		rev	[N] P / К 9 Н / .–. –. / [1]826	[N] P / K 9 H / .–.–. / [1]826				
213	CUPMS: 1999.56.17	obv	Л. Д. / Л: СИНЯ / КОВЪ / Но 43	L. D. / L: SINyA / KOV" / No 43				
		rev	.N. P. / С Н 12 / 182[–]	.N. P. / C H 12 / 182[–]				
214	CUPMS: 1999.56.18	obv	Л: Д: / А. НЕМ / ИЛОВЪ/ N 2 –	L: D: / A. NEM / ILOV" / N 2 –				
		rev	.N P / A R 12 / 182–	.N P / A R 12 / 182–				
215	CUPMS: 1999.56.19	obv	ЯП – – НА – – Р – – / Б Ф	yAP – – NA – – R – – / B F				
		rev	(Blank)	(Blank)				
216	CUPMS: 1999.57.1	obv	[–][–] ПОР. / ДЕСЯТСКИИ /ГРИГОРИИ / КИСЕЛЕВЬ	[–][–] POR. / DESyATSKII /GRIGORII / KISELEV"				
		rev	АРХ.БР. / ЧЕСКА / 2. СОРТЬ / Ф. Р. / 1897	ARKh.BR. / ChESKA / 2. SORT" / F. R. / 1897				
217	CUPMS: 1999.57.2	obv	АРХ [–]Р / ДЕСЯТНИК / ВАСИЛЕИ / ТИМКИНЪ	ARKh [–]R / DESyATNIK / VASILEI / TIMKIN"				
		rev	АРХ. БР. / КУДЪЛЯ / 1 СОРТЬ / Е. П. / 1866	ARKh. BR. / KUDyELyA / 1 SORT" / E. P. / 1866				

Part Two. Catalogue of lead seals (Cyrillic and Roman)

218	CUPMS: 1999.57.3	obv	АРХ. ПОР. / ДЕСЯТН. / ГАВРИЙЛО / ОНИСИМОВЪ	ARKh. POR. / DESyATN. / GAVRIILO / ONISIMOV"
219	CUPMS: 1999.57.4	obv	АРХ. БР. / ПАКЛЯ / ЧЕСКА / 2. СОРТЪ / Я. К. / 1898	ARKh. BR. / PAKLyA / ChESKA / 2. SORT" / yA. K. / 1898
		rev	АРХ. ПОР/ДЕСЯТСК/[В][А][С]ИЛЕИ/[-]-[Х]ЛАН / [О] /К[У]ДЕ[-]Ь / 2 СОР[Т]Ъ / Е П / 184[-]	ARKh. POR/DESyATSK/[V][A][S]ILEI/[-]-[Kh]LAN / [O] /K[U]DE[-]' / 2 SORT[T]" / E P / 184[-]
220	CUPMS: 1999.57.5	obv	ДЕСЯТЬНИК / ЕГОРЪ / ТЕВЛЕВЪ / АРХ. БР	DESyAT'NIK / EGOR" / TEVLEV" / ARKh. BR
		rev	АР- - - / ПАКЛЯ ЧЕСКА / 2 СОРТЪ / Я. [К] / 1894	AR- - - / PAKLyA CHESKA / 2 SORT" / yA. [K] / 1894
221	CUPMS: 1999.57.6	obv	П и Л П Д / Р ШУС / ТОВЪ / Н. 5	P i L P D / R ShUS / TOV" / N. 5
		rev	С П Б / Л. З. 2 Н / 1831	S P B / L. Z. 2 H / 1831
222	CUPMS: 1999.57.7	obv	.Л. Д. / 3 ТЕМ / КИНЪ	.L. D. / Z TEM / KIN"
		rev	[S] Р В / Р. - 3. / I. Н. / [1]831	[S] P B / P. - 3. / I. H. / [1]831
223	CUPMS: 1999.57.8	obv	Л Д/ [-]: ЗАИ / ЦОВЪ/ Н 17	.L [D]/ [-]: ZAI /TsOV"/ N 17
		rev	S Р В / N Р – / I [-] / 183[-]	S P B / N P – / I [-] / 183[-]
224	CUPMS: 1999.57.9	obv	П. Д. / [Ф] ШЕТ / НО[В][Ъ] / –	P. D. / [F] ShET / NO[V]["] / –
		rev	S Р В / Л З 1 / 18[3][5]	S P B / L Z 1 / 18[3][5]
225	CUPMS: 1999.57.10	obv	[Л].Д. / [-] ЛОБ / КОВЪ / Н 8	[L].D. / [-] LOB / KOV" / N 8
		rev	S Р В / – Р. 2 / – Т / – –38	S P B / – P. 2 / – T / – –38
226	CUPMS: 1999.57.11	obv	Л. Д. / [П] ПОЛ / ОВОХИ / Н 81.	.L. D. / [P] POL / OVOKhI / N 81.
		rev	[С][[П][Б] / [-]о П. 2. / – Б. / 1800	[S][P][B] / [-]o P. 2. / – B. / 1800
227	CUPMS: 1999.57.12	obv	Л.Д./ М. КОН / ОНОВ / Н 83	.L.D./ M. KON / ONOV / N 83
		rev	.N P / I S 12 H / .1800.	.N P / I S 12 H / .1800.
228	CUPMS: 1999.57.13	obv	Л. Д. / САРЫ / ПИНЪ / Н 184	.L. D. / SARY / PIN" / N 184
		rev	N Р / Ф К 12 [Н] / 1785	N P / F K 12 [H] / 1785
229	CUPMS: 1999.57.14	obv	Л. Д. / И ШИП / АЧЕВЪ / Н 6 .	.L. D. / I ShIP / AChEV" / N 6 .
		rev	– Р. / – Н 9 [К] / 1806	– P. / – H 9 [K] / 1806
230	CUPMS: 1999.57.15	obv	Л. Д. / М СИМ / АНОВЪ / – –	.L. D. / M SIM / ANOV" / – –
		rev	N Р / T L 12 H / 182[6]	N P / T L 12 H / 182[6]
231	CUPMS: 1999.57.16	obv	Л. Д. / [-]СИК / [А]ВИН / Н 10–	L. D. / [-]SIK / [A]VIN / N 10–
		rev	N Р/ Н 12 Н / [1]827	N P/ H 12 H / [1]827
232	CUPMS: 1999.57.17	obv	Л Д / [-] СА[-] / [-]ИН / N. 13	L D / [-] SA[-] / [-]IN / N. 13
		rev	.N Р / A С Х 12 Н / 1808	.N P / A S Kh 12 H / 1808
233	CUPMS: 1999.58.1	obv	А. П. / ДЕСЯЦК/ К. 3	A. P. / DESyATsK/ K. Z
		rev	– – П / МП33 / 2 ПАК Р	– – P / MP33 / 2 PAK R
234	CUPMS: 1999.58.2	obv	(Illegible)	(Illegible)
		rev	– ПЕЛ БАНК ТО[В] / 17.	– PEL BANK TO[V] / 17.
235	CUPMS:1999.216.1	obv	АР- -РАК/ДЕСЯТНИКЪ/ СТЕПАНЪ / [И]ВОНИСКОИ	AR- -RAK/DESyATNIK" / STEPAN" / [I]VONISKOI
		rev	АРХ. БР. / КУДЪЛЯ / 1 СОРТЪ / [А]. Р / 1902	ARKh. BR. / KUDyELyA / 1 SORT" / [A]. R / 1902
236	CUPMS:1999.216.2	obv	Л. Д / Я. ЗАИ / ЦОВЪ / Н –7	L. D / yA. ZAI / TsOV" / N –7
		rev	N. Р. / А К 12 [Н] / 180	N. P. / A K 12 [H] / 180
237	CUPMS:1999.216.3	obv	/ДЕСЯТ. / АЛЕКСЕ / – Г[А]ПРСК	/DESyAT. / ALEKSE / – G[A]PRSK
		rev	/КРОНЪ / 2 СОРТЪ / А. Р / 1841	/KRON" / 2 SORT" / A. R / 1841
238	CUPMS: 1999.216.4	obv	– Д / [Г] САР /АФАНИ / Н 104	– D / [G] SAR /AFANI / N 104
		rev	N – / 1 М Б /1821	N – / 1 M B /1821
239	CUPMS: 1999.216.5	obv	Л Д / А. КАЗ / ЛЮВЪ / Н [-] 6	L D / A. KAZ / LOV' / N [-] 6
		rev	С П Б / Но П 2 / В. Н / 1832	S P B / No P 2 / V. N / 1832
240	CUPMS: 1999.216.6	obv	Л Д / [А] СИНЯ / КОВЪ / Н – [7]	L D / [A] SINyA / KOV" / N – [7]
		rev	/[-] 12 Н / 1826	/[-] 12 H / 1826

241	CUPMS: 1999.216.7	obv	Л: [Д] / И. ПИР / ЖНИ / [-] [-] 3	L: [D] / I. PIR / ZhNI / [-][-] 3
242	CUPMS: 1999.217.1	rev	N P. / В 12 [К] / 1800	N P. / V 12 [K] / 1800
		obv	АРХ. БРА. / ДЕСЯТ: / МИХАИЛ / ПЯТ[К][-]	ARKh. BRA. / DESyAT: / MIKhAIL / PyAT[K][-]
243	CUPMS: 1999.217.2	rev	АРХ. ПОР./ПАКЛЯ/ЧЕСКА/3 СОРТЪ/Я. К./186[-]	ARKh. POR./PAKLyA/ChESKA/3 SORT" yA. K./186[-]
		obv	Л. Д. / А: МЫЛ / ЬНИКО / Н 72	.L.D. / A: MYL 'NIKO / N 72
244	CUPMS: 1999.217.3	rev	. N Р. / Т Н 12 / 180[-]	. N P. / T H 12 / 180[-]
		obv	Л Д / П. КУЧ / КОВЬ / Н 62	L D / P. KUCh / KOV' / N 62
245	CUPMS: 2005.276	rev	. N Р. / Т Р. 9 Н / 1802	. N P. / T P. 9 H / 1802
		obv	Д С / РОМА / НОВЬ / Н 85	D S / ROMA / NOV" / N 85
246	CUPMS: 2005.281	rev	N Р / Д Н 12 Н / 1775	N P / D N 12 H / 1775
		obv	– КО[П] /Т ЕВЬ / Н 2	– KO[P] /T EV" / N 2
247	CUPMS: 2005.282	rev	[S]P[B] / [N] P. 3 / Р. К. / 1838	[S]P[B] / [N] P. 3 / P. K. / 1838
		obv	Л. Д. / И ВИН / НИКОВ / Н 20	L. D. / I VIN / NIKOV / N 20
248	CUPMS: 2005.283	rev	. N Р. / F W 12 Н / .1813.	. N P. / F W 12 H / .1813.
		obv	– – [П]ОР / ДЕСЯТ / МАТВЕИ / ВЕДНСКО	– – [P]OR / DESyAT / MATVEI / VEDNSKO
249	CUPMS: 2005.284	rev	АРХ Б[–] / КУДЕЛЬ / 1 СОРТЬ / Е П / 184[–]	ARKh B[–] / KUDEL' / 1 SORT" / E P / 184[–]
		obv	– Д. . / ДЕД / КОВЬ / Н[2]6.	– D. . / DED / KOV" / N[2]6.
250	CUPMS: 2005.285	rev	С П Б / Ho. П 2 / А Б / 18[–][–]	S P B / No. P 2 / A B / 18[–][–]
		obv	Л. Д. / Л. ПОГА / НКИНЪ / Н 3[1]	L. D. / L. POGA / NKIN" / N 3[1]
251	CUPMS: 2005.286	rev	. N Р / [–] С 12 – / 1802	. N P / [–] C 12 – / 1802
		obv	Л. Д. / С: ЧУПЯ / ТОВЬ / Н 106	L. D. / S: ChUPyA / TOV" / N 106
252	CUPMS: 2005.287	rev	С П Б / Ho Р. / I С. Б / 182[–]	S P B / No P. / I C. B / 182[–]
		obv	Л Д / И НАДЕ / ЖИНЬ / Н – 4	.L D / I NADE / ZhIN" / N – 4
253	CUPMS: 2005.288	rev	N. Р. / С Ч 12 Н / [1]802	N. P. / S Ch 12 H / [1]802
		obv	. Л. Д. / К. СИМ / АНОВ / Н. 54	. L. D. / K. SIM / ANOV / N. 54
254	CUPMS: 2005.289	rev	N Р / А [I] 12 Н / 1809	N P / A [I] 12 H / 1809
		obv	Л Д / Т ЛАРИ / ОНОВ[Ъ] / – – –	L D / T LARI / ONOV["] / – – –
255	CUPMS: 2005.290	rev	С П Б / Ho П 3 / – / 1832	S P B / No P 3 / – / 1832
		obv	Д [–] / ТАМИЛ / ИНЪ / Н 330	D [–] / TAMIL / IN" / N 330
256	CUPMS: 2007.87	rev	[–][–] / D H 2 K / 1777	[–][–] / D H 2 K / 1777
		obv	GEORGE CLASSEN	GEORGE CLASSEN
257	CUPMS: 2007.89	rev	SECOND SORT	SECOND SORT
		obv	[Л] Д / Ф. ЗАИ / ЦОВЬ / Н 12	[L] D / F. ZAI / TsOV" / N 12
258	CUPMS: 2007.90	rev	N Р / С Б 12 Н / – [8][–]	N P / S B 12 H / – [8][–]
		obv	Л Д / КУЧ / КОВЬ / Н 62	L D / KUCh / KOV' / N 62
259	CUPMS: 2007.91	rev	N Р / К 12 Н / [1][793	N P / K 12 H / [1]793
		obv	– – / Г. ЛЕН / ТЕЕВЬ / Н 151	– – / G. LEN / TEEV" / N 151
260	CUPMS: 2007.92	rev	S Р – / Н. [–] 1 / I. Р. / 1831	S P – / N. [–] 1 / I. P. / 1831
		obv	– – / С МИХ / АЛЕВ / Н 59	– – / S MIKh / ALEV / N 59
261	CUPMS: 2007.93	rev	N Р / Н 12 К / [1][793	N P / H 12 K / [1]793
		obv	(Erased)	(Erased)
		rev	S Р – / П: П / 17[9][8]	S P – / P: P / 17[9][8]

6.2.9. Meffan Institute Forfar Museum and Gallery [FORMG]

No.	Seal accession number	Face	Transcription	Transliteration
1	FORMG 2006.24	obv	– – / [Л] ВОЛ / КОВЪ / Н 1 0	– – / [L] VOL / KOV" / N 1 0
		rev	– В / [Н] П 3 / [-][-] / –832	– B / [N] P 3 / [-][-] / –832

6.2.10. Inverness Museum and Gallery [INVMG]

No.	Seal accession number	Face	Transcription	Transliteration
1	INVMG: 2003.120.059	obv	Д. Д. / КЛЮЕВ / N 27	D. D. / KLyU / EV / . N 27
		rev	S P. / [Н] П I Н / 1777	S P. / [N] P. I. Н / 1777

6.2.11. Kirriemuir Gateway to the Glens Museum [KGGM]

No.	Seal accession number	Face	Transcription	Transliteration
1	KGGM: DBK. 808d. vi	obv	[-][-] / ПОГ[А] / [-]ИНЬ / Н 2	[-][-] / POG[A] / [-]IN" / N 2
		rev	Л П [-] / П БАЛО / ВАНОВЪ / Н [-]	L P [-] / P BALO / VANOV" / N [-]
2	KGGM: DBK. 808f. viii	obv	. АРХ. БРА / ДЕСЯТ: / АВДѢИ / [-]АФОН–	. ARKh. BRA / DESyAT: / AVDyEI / [-]AFON–
		rev	АРХ. БР. / ЧЕСКА / 3. СОРТЪ / Ф[Р] / 1888	ARKh. BR. / ChESKA / 3. SORT" / F[R] / 1888
3	KGGM: DBK. 808f. xiii	obv	АРХ БРА / ДЕСЯТСК / ФЕДОР / – – –[Н]ХИН	ARKh BRA / DESyATSK / FEDOR / – – –[N]KhIN
		rev	А – – – – / КУДѢЛЯ / 2 СОРТЪ / Я. К. / 1879	A – – – – / KUDyELyA / 2 SORT" / yA. K. / 1879

6.2.12. Montrose Museum [ADMUS]

No.	Seal accession number	Face	Transcription	Transliteration
1	ADMUS: B1987.23	obv	/ДЕСЯТСК / АД[Л][Е]КСАНДР / РОГОВЪ	/DESyATSK / A[L][E]KSANDR / ROGOV"
		rev	АРХ. Б[Р] / КУДѢЛ[-] / 2 СОРТ / Ф. Р. / 1887	ARKh. B[R] / KUDyEL[-] / 2 SORT / F. R. / 1887
2	ADMUS: B1988.8	obv	/ДЕСЯТ / СТЕПАНЬ / ИВОНИНСК	/DESyAT / STE[P]AN" / IVONINSK
		rev	АРХ. / ЧЕСКА / 2 СОРТ / ЯП В / 1887	ARKh. / ChESKA / 2 SORT / yA P V / 1887
3	ADMUS: B1988.9	obv	РИГА ПОРТ – – – ОТА – – – / 1797 / (Arms)	RIGA PORT – – – OTA – – – / 1797 / (Arms)
		rev	(Blank)	(Blank)
4	ADMUS: M1980.3639	obv	KOHOLEFF / И.Ф.К. / St [P]	KOHOLEFF / I.F.K. / St [P]
		rev	Но 2 / -.- / 1844	No. 2 / -.- / 1844
5	ADMUS: M1980.3582	obv	Л. Д. / С: ЕРО / ХИНЬ / Н –[9]	L. D. / S: ERO / KhIN" / N –[9]
		rev	N. P. / Г 12 Н / [1]807	N. P. / G 12 H / [1]807
6	ADMUS: M1987.769	obv	+ / (Cross Keys) / 1 / В	+ / (Cross Keys) / 1 / B
		rev	(Blank)	(Blank)
7	ADMUS: M1987.780	obv	Л. Д. / И. ПИР / ОЖНИ / [Н] 23	L. D. / I. PIR / OZhNI / [N] 23
		rev	N. P. / I S 12 Н / [1]775	N. P. / I S 12 H / [1]775
8	ADMUS: M1987.781	obv	Л. Д. / [-] ВОРО / [-]ЬЕВЪ / Н 72	L. D. / [-] VORO / [-]'EV" / N 72
		rev	С П Б / No П [3] / Д. Х. / 183[-]	S P B / No P [3] / D. Kh. / 183[-]
9	ADMUS: M1989.98	obv	ФЕДОРА МАНУ[И]Л: / ВАНЮ / КОВА /	FEDORA MANU[I]L: / VANyU / KOVA /
		rev	No. 2 / 1847	No. 2 / 1847
10	ADMUS: M1995.155	obv	Л. Д. / И. ШЫР / ОВСКО / [Н] 85	L. D. / I. ShYR / OVSKO / [N] 85
		rev	[N] [P] / – S 12 Н / 1814	[N] [P] / – S 12 H / 1814

11	ADMUS: M1995.156	obv	АРХ [Б]РА / ДЕСЯТНИК / СТЕПАНЪ / ШУБИНЪ	ARKh [B]RA / DESYATNIK / STEPAN" / ShUBIN"
		rev	[АРХ.] БР. / ЗАБРАКЪ / Е. П. / 1888	[ARKh.] BR. / ZABRAK" / E. P. / 1888
12	ADMUS: M1995.157	obv	Л. Д. / П. ЩОГО / ЛЕВА / No. 45	L. D. / P. ShchOGO / LEVA / No. 45
		rev	N [P] / М Б 12 / 1828	N [P] / M B 12 / 1828
13	ADMUS: M1995.159	obv	— — / ДЕСЯТ / ИВАНЬ / —НСИМО / ВЪ	— — / DESYAT / IVAN" / —NSIMO / V"
		rev	АРХ. БР. / ЗАБРАКЪ / 2И РУКИ / Я П В / 188[0]	ARKh. BR. / ZABRAK" / 2I RUKI / yA P V / 188[0]
14	ADMUS: M1995.160	obv	АРХ. БРА / ДЕСЯТСК. / ВАСИЛЕЙ / БУЛЫЧЕВЪ	ARKh. BRA / DESyATSK. / VASILEI / BULYCheV"
		rev	АРХ. БР. / КУДБЛЯ / 1 СОРТЪ / Ф. Р. / 1877	ARKh. BR. / KUDyELyA / 1 SORT" / F. R. / 1877
15	ADMUS: M1995.161	obv	ТИМОФЕЯ М[А]НУ[И]Л: / ВАНЮ / КОВА /	M[A]NU[I]L. TIMOFeyA / VANyU / KOVA /
		rev	(Illegible)	(Illegible)
16	ADMUS: M1995.162	obv	– Д / С. ЛЕВ / АШЕВ / Н –	– D / S. LEV / AShEV / N –
		rev	N. P. / P B 12 H / 180[0]	N. P. / P B 12 H / 180[0]
17	ADMUS: M1995.163	obv	Л. Д. / И. НАДЕ / [Ж] ИНЪ / Н –[4]	L. D. / I. NADE / [Zh] IN" / N –[4]
		rev	S P B / N P 2 / L. H. / 1833	S P B / N P 2 / L. H. / 1833
18	ADMUS: M1995.164	obv	+ (Cross Keys) / 1	+ (Cross Keys) / 1
		rev	(Blank)	(Blank)
19	ADMUS: M1995.165	obv	Л. Д. / [П]АНФ / ИЛОВЪ / [–] 2	L. D. / [P]ANF / ILOV" / [–] 2
		rev	– P. – / N. P. – / 1 H / 1839	– P. – / N. P. – / 1 H / 1839
20	ADMUS: M1995.166	obv	Л Д / – – – –	L D / – – – –
		rev	– P B / A. V. I. H. / 180[4]	– P B / A. V. I. H. / 180[4]
21	ADMUS: M1996.66	obv	Л. Д. / Г. ЗАМА / РИНЪ / Н 7	L. D. / G. ZAMA / RIN" / N 7
		rev	С П Б / Но П 3 / [–] [–]	S P B / No P 3 / [–] [–]
22	ADMUS: M1996.67	obv	[Л] Д / А МОЛЧ / АНОВЪ / Н. 34	[L] D / A MOLCh / ANOV" / N. 34
		rev	. N P / [–] С 12 H / 1803	. N P / [–] C 12 H / 1803
23	ADMUS: M1997.137	obv	Л. Д. / И. НОВИКОВ / Н	L. D. / I. NOVIKOV / N
		rev	S P B / / N P – 2 / P. K. / – – – –	S P B / / N P – 2 / P. K. / – – – –
24	ADMUS: M1998.6	obv	+ (Cross Keys) / 1	+ (Cross Keys) / 1
		rev	(Blank)	(Blank)
25	ADMUS: M1998.91	obv	PROPRIETAIRE – [K]АНКOFF	PROPRIETAIRE – – [K]ANKOFF
		rev	No 2 / 1853	No 2 / 1853
26	ADMUS: M1998.94	obv	ЧЕРНЫЙ / РИЖСКIЙ / БАЛЬЗАМЪ	ChERNYY / RIZhSKIY / BAL'ZAM"
		rev	[Б]Е . ПРАВ[А] / + (Cross Keys) / 1893	[B]E . PRAVlA] / + (Cross Keys) / 1893
27	ADMUS: M1998.95	obv	. ПОТ РИГА [–][–] КОХ / 1802	. POT RIGA [–][–] KOKh / 1802
		rev	(Blank)	(Blank)
28	ADMUS: M1998.96	obv	+ (Cross Keys) / 1 / В	+ (Cross Keys) / 1 / B
		rev	(Blank)	(Blank)
29	ADMUS: M1998.156	obv	Л. Д. / М. ЛИВ / ШЕВЪ / [Н] 37	L. D. / M. LIV / ShEV" / [N] 37
		rev	N. P. / НР 12 К. / 1804 (HP as ligature)	N. P. / NR 12 K. / 1804 (NR as ligature)
30	ADMUS: M1998.157	obv	[Л] Д. / ДАРА / ФБЕВЪ / Н. 15:	[L] D. / DARA / FyEEV" / N. 15:
		rev	[С] [П] Б / – P. 3 / I. H. / 1831	[S] [P] B / – P. 3 / I. H. / 1831
31	ADMUS: M1998.158	obv	Л. Д. / Д: КАР / ЕЛЕВЪ / Н 66	L. D. / D: KAR / ELEV" / N 66
		rev	N. P. / НР 12 К. / 1799 (HP as ligature)	N. P. / NR 12 K. / 1799 (NR as ligature)
32	ADMUS: M1998.159	obv	Л. Д. / Н: ШИЛ: / ОВЪ: / Н 51	L. D. / N: ShIL: / OV": / N 51
		rev	[S] P [B] / N. P. – 3 / Р. К. / 1829	[S] P [B] / N. P. – 3 / P. K. / 1829
33	ADMUS: M1998.160	obv	Л. Д. / П. ФИЛА / ТОВЪ / Н [–]	L. D. / P. FILA / TOV" / N [–]
		rev	[N] [P] / И Ч 12 [–] / 1819	[N] [P] / I Ch 12 [–] / 1819
34	ADMUS: M1998.161	obv	Л. Д. / П. ЛЕБ / ЕДЕВЪ / Н 61	L. D. / P. LEB / EDEV" / N 61
		rev	N. P. / M M 12 / 179[–]	N. P. / M M 12 / 179[–]

Part Two. Catalogue of lead seals (Cyrillic and Roman)

35	ADMUS: M1998.162	obv	Л. Д. / А. РИ / [-]О[В][Ъ] / Н 90	L. D. / A. RI / [-]O[V][''] / N 90
		rev	S P B / N P – 3 / P. K. / 1829	S P B / N P – 3 / P. K. / 1829
36	ADMUS: M1998.163	obv	А. П. / ДЕСЯТСК / ВЗ (ВЗ as ligature)	A. P. / DESyATSK / VZ (VZ as ligature)
		rev	А П / ЛЬНЯН. БР / 831 ВД / ПАКЛЯ	A P / LNyAN. BR / 831 V D / PAKLyA
37	ADMUS: M1998.164	obv	+ (Cross Keys) / –	+ (Cross Keys) / –
		rev	(Blank)	(Blank)
38	ADMUS: M1998.166	obv	Л. Д. / Е. МА[Р] / ТИН / Н–	L. D. / E. MA[R] / TIN / N–
		rev	S P B / N P. 3 / E [–]	S P B / N P. 3 / E [–]
39	ADMUS: M1998.167	obv	– – / ПОЗ / [Р]Е[К]ОВЪ / Н 20	– – / POZ / [R]E[K]OV'' / N 20
		rev	[S] P B / [N] P. 2 / [M] С. / [–][8]36	[S] P B / [N] P. 2 / [M] S. / [–][8]36
40	ADMUS: M1998.168	obv	Л. Д / – – / ОВ / – –	L. D / – – / OV / – –
		rev	– Р / Р [Н] 12 / 180[–]	– P / P [H] 12 / 180[–]
41	ADMUS: M2000.60	obv	+ (Cross Keys) / 2	+ (Cross Keys) / 2
		rev	(Blank)	(Blank)
42	ADMUS: M2007.38	obv	KOROLEFF / И Ф К / St P B	KOROLEFF / I F K / St P B
		rev	2 С / – . – / 9 П	2 S / – . – / 9 P

6.2.13. Perth Museum and Art Galleries [PERMG]

No.	Seal accession number	Face	Transcription	Transliteration
1	PERMG: 1974. 18	obv	АРХ. БРА / ДЕСЯТ. / АЛЕКСА / [-]УНИ[-]	ARKh. BRA / DESyAT. / ALEKSA / [-]UNI[-]
		rev	АРХ. ПОР. / ПАКЛЯ / ЧЕСКА / 2 СОРТЪ / Я. К. / 1862	ARKh. POR. / PAKLyA / ChESKA / 2 SORT'' / yA. K. / 1862
2	PERMG: 1979.1244	obv	+ (Cross Keys) / 3	+ (Cross Keys) / 3
		rev	(Blank)	(Blank)
3	PERMG: 1992.140.1	obv	–	–
		rev	[– – –] / [– – –] / М [К] / 1849	[– – –] / [– – –] / M [K] / 1849
4	PERMG: 1992.140.2	obv	–	–
		rev	– / ЧЕСКА / 3 СОРТЪ / Е. П. /18[5]0	– / ChESKA / 3 SORT'' / E. P. /18[5]0
5	PERMG: 1992.140.3	obv	. Д. Е. / ПИРОЖН[–] / ОВЪ / N 10	. D. E. / PIROZhN[–] / OV'' / N 10
		rev	N P / А I В 12 Н / 1768	N P / A I B 12 H / 1768
6	PERMG: 1992.140.4	obv	/ КОРО/ [-]. Ф. К. / [-]ТР[–]	/ KORO/ [-]. F. K. / [-]TP[–]
		rev	2. / – . – / 1850	2. / – . – / 1850
7	PERMG: 1992.140.5	obv	+ (Cross Keys) / 1	+ (Cross Keys) / 1
		rev	(Blank)	(Blank)
8	PERMG: 1992.140.10	obv	А. В. / АНДРОНОВЪ	A. V. / ANDRONOV''
		rev	ГЛАВНАЯ / ВЪ / [П][Е]Н] ЗѢ / [-]ОН[-]–	GLAVNAYA / V'' / [P][E]N]ZyE / [-]ON[-]–
9	PERMG: 1992.142.1	obv	А[–] ДАМАЦКОИ . ФЕДОСЬ[Е][И] / 1847 / С.П.Б	A[–] DAMAtsKOI . FEDOS'[E][I] / 1847 / S.P.B
		rev	HILLS & WHISHAW / II	HILLS & WHISHAW / II
10	PERMG: 2000.243.9	obv	+ (Cross Keys) / 3	+ (Cross Keys) / 3
		rev	(Blank)	(Blank)
11	PERMG: 2000.243.10	obv	– Д / [-] А. [-] / НСКОИ / Н 13	– D / [-] A. [-] / NSKOI / N 13
		rev	N [P] / – – – / – – – / – – –	N [P] / – – – / – – – / – – –
12	PERMG: 2000.243.11	obv	/ ЯТ / – – – КСЕИ / – –[Л]ЫЧЕВЬ	/ yAT / – – – KSEI / – –[L]YCHEV''
		rev	АРХ. БР. / КРОНЪ / 1 СО[Р][Т][Ъ] / Е. [-] / 18– –	ARKh. BR. / KRON'' / 1 SO[R][T][''] / E. [-] / 18– –
13	PERMG: 2001.754.6	obv	– – / МИХАИЛ / [-][-]ЕПИНЪ /	– – / MIKhAIL / [-][-]EPIN'' /
		rev	– – / КРОНЪ / 2 СОРТЪ / Ф. Р. / 1853	– – / KRON'' / 2 SORT'' / F. R. / 1853

6.3. Seals in English Museums

6.3.1. Abingdon Museum [OXCMS]

No.	Seal accession number	Face	Transcription	Transliteration
1	OXCMS.1985.214.1	obv	П Д / М: ПУ/ [–]ыIРЕВ/ Но 7	P D / M: PU/ [–]YREV/ No 7
		rev	– Р / * */ Д Н Р Н / 1789	– P / * */ D H R H / 1789

6.3.2. Bristol Museum and Art Gallery [BRSMG]

No.	Seal Accession number	Face	Transcription	Transliteration
1	BRSMG: O 1421	obv	Д : П / ЯКОВЬ / – – АЕВЪ / Н 160	D : P / yAKOV" / – – AEV" / N 160
		rev	S. P В / LW – – / 1776	S. P B / LW – – / 1776
2	BRSMG: O.1749	obv	[–] П. [О]/ [–] АРЕ/ ЛЬЕВЬ / Н 1	[–] P. [O]/ [–] ARE/ L'EV" / N 1
		rev	К. ВА / ЛИНЪ / Н: I	K. VA / LIN" / H: I
3	BRSMG: O.4164	obv	* N / 10	* N / 10
		rev	N. P / A N 12 A / 1758	N. P / A N 12 A / 1758
4	BRSMG: O.4165	obv	* N / 17	* N / 17
		rev	*N. P * / S В.12. F. S / 1756	*N. P * / S B.12. F. S / 1756
5	BRSMG: T.9395	obv	– – / С ДЕМЬ / ЯНОВЪ / – 32	– – / S DEM' /yANOV" / – 32
		rev	П / [А][М]12[Н] / 1786	P / [A][M]12[H] / 1786
6	BRSMG: T.9396	obv	А: КУ / ИНЬ	A: KU / IN"
		rev	–: 12 Н / . – / 1795	–: 12 H / . – / 1795
7	BRSMG: T.9407	obv	[О] –	[O] –
		rev	S P В / А[R] (or Н): 1 / 1747	S P B / A[R] (or H): 1 / 1747
8	BRSMG: T. 9416	obv	С ПЕТЕРБУРГСКОИ (outside double headed eagle)	S PETERBURGSKOI (outside double–headed eagle)
		rev	– – – / С	– – – / S

6.3.3. Devizes Museum (Wiltshire Heritage) [DZSWS]

No.	Seal accession number	Face	Transcription	Transliteration
1	DZSWS.1995.68	obv	ВЛАДИКАВК / – / ЖД	VLADIKAVK / – / ZhD
		rev	СТАНЦIЯ /. – . / [П]ЛАСТУНОВКА	STANTsIyA /. – . / [P]LASTUNOVKA

6.3.4. Royal Albert Memorial Museum, Exeter [EXEMS]

No.	Seal accession number	Face	Transcription	Transliteration
1	EXEMS: 69/2001.4	obv	П. Д / [П] [–]ЛЕ / ТЕЕВЬ / [Н] 15	P. D / [P] [–]LE / TEEV" / [N] 15
		rev	С П / ПЕН / П[О]Ц[3]. / 1841	S P / PEN / P[O] I[3]. / 1841
2	EXEMS: 69/2001.5	obv	. П* / АРI / ОВЬ	.P* / ARI / OV"
		rev	–	
3	EXEMS: 99/1932	obv	А П / ДЕСЯЦК / М П	A P / DESyATsK / M P
		rev	НИЖНОСУ / ХОНСКОИ	NIZhNOSU / KhONSKOI

6.3.5. Farnham Museum [WAVMS]

No.	Seal accession number	Face	Transcription	Transliteration
1	WAVMS: A001.38	obv	СЕЛО * ГОРИЦЫ	SELO * GORITsY
		rev	И. С. * КОБЕЛЬКОВЪ	I. S. * KOBEL'KOV"
2	WAVMS: A003.3	obv	СЕЛО * ГОРИЦЫ	SELO * GORITsY
		rev	И С * КОБЕЛЬКОВЪ	I S * KOBEL'KOV"
3	WAVMS: A003.4	obv	СЕЛО * ГОРИЦЫ	SELO * GORITsY
		rev	* ИС * КОБЕЛЬКОВЪ	* I S * KOBEL'KOV"
4	WAVMS: A003.5	obv	СЕЛО * ГОРИЦЫ	SELO * GORITsY
		rev	* И С * КОБЕЛЬКОВЪ	* I S * KOBEL'KOV"
5	WAVMS: A003.6	obv	СЕЛО * ГОРИЦЫ	SELO * GORITsY
		rev	* И С * КОБЕЛЬКОВЪ	* I S * KOBEL'KOV"
6	WAVMS: A003.7	obv	* ГОРИЦЫ	* GORITsY
		rev	*** Г М * ВАШУР	*** G M * VAShUR
7	WAVMS: A003.8	obv	Л[–]	L[–]
		rev	И И [С] О[Р]ИТ	I I [S] O[R]IT
8	WAVMS: A003.9	obv	СЕЛО * ГОРИЦЫ	SELO * GORITsY
		rev	* И С * КОБЕЛЬКОВЪ	* I S * KOBEL'KOV"
9	WAVMS: A003.10	obv	СЕЛО * ГОРИЦЫ	SELO * GORITsY
		rev	* И С * КОБЕЛЬКОВЪ	* I S * KOBEL'KOV"
10	WAVMS: A003.11	obv	СЕЛО * ГОРИЦЫ	SELO * GORITsY
		rev	* И С * КОБЕЛЬКОВЪ	* I S * KOBEL'KOV"
11	WAVMS: A003.12	obv	СЕЛО * ГОРИЦЫ	SELO * GORITsY
		rev	* И С * КОБЕЛЬКОВЪ	* I S * KOBEL'KOV"
12	WAVMS: A003.13	obv	СЕЛО * ГОРИЦЫ	SELO * GORITsY
		rev	* И С * [К]ОБЕЛЬ[К]ОВЪ	* I S * [K]OBEL'[K]OV"
13	WAVMS: A003.14	obv	СЕЛО * ГОРИЦЫ	SELO * GORITsY
		rev	* И С * КОБЕЛ[–][–]ОВЪ	* I S * KOBEL[–][–]OV"
14	WAVMS: A003.15	obv	* ГОРИЦЫ	* GORITsY
		rev	Г М ВАШУРИНЪ	G M VAShURIN"
15	WAVMS: A003.16	obv	* С ГОРИ[Ц]	* S GORI[Ts]
		rev	Г М ВАШУР	G M VAShUR
16	WAVMS: A003.17	obv	(Illegible)	(Illegible)
		rev	Г М / ШУ[Р]––Ъ	G M / ShU[R]––"
17	WAVMS: A003.18	obv	[Г]О[Р]–[Ц]–	[G]O[R]–[Ts]–
		rev	ВА –	VA –
18	WAVMS: A003.19	obv	ГОРИЦЫ	GORITsY
		rev	И С / КОБЕЛЬ––	I S / KOBEL'––
19	WAVMS: A003.20	obv	СЕЛО / ГОР[И]––	SELO / GOR[I]––
		rev	И С / [Б]ЕЛЬКОВЪ	I S / [B]EL'KOV"
20	WAVMS: A003.21	obv	СЕ–––––ИЦЫ	SE–––––ITsY
		rev	И С КОБЕЛ –––[В]Ъ	I S KOBEL –––[V]"
21	WAVMS: A003.22	obv	СЕЛО *	SELO *
		rev	* И С *	* I S *
22	WAVMS: A003.23	obv	* СЕЛО * / ГОРИЦЫ	* SELO * / GORITsY
		rev	* И С / * [К][О]––––––К––Ъ	* I S / * [K][O]–––––––K––"

23	WAVMS: A003.24	obv	* С / ГОРИЦ–	* S / GORIts–
		rev	Г М / ВАШУРИ– –	G M / VAShURI– –
24	WAVMS: A003.25	obv	[Г][Р] ОМС[–]	[G][R] OMS[–]
		rev	1Й	1Y
25	WAVMS: A003.26	obv	* [–][–][* [–][–][
		rev	/ ВАШ–Р	/ VASh–R
26	WAVMS: A003.27	obv	/ ЛУ–I[Д][–[В]О	* LU–I[D][–[V]O
		rev	Я И – – – –	yA I – – – –
27	WAVMS: A003.28	obv	* СЕЛО / КО	* SELO / KO
		rev	И Е / ПР– – –ОВЪ	I E / PR – – –OV"
28	WAVMS: A003.29	obv	С. ОРИЦЫ	S. ORItsY
		rev	– – / ЕЛЬКОВЪ	– – / EL'KOV"
29	WAVMS: A003.31	obv	ГОРИ	GORI
		rev	Г ВАШ	G VASh
30	WAVMS: A003.38	obv	СЕЛО * ГОРИЦЫ	SELO * GORItsY
		rev	И С * КОБЕЛЬКОВЪ	I S * KOBELKOV"
31	WAVMS: A003.41	obv	* * * С. ЛУНИ[Д]ОВО	* * * S. LUNI[D]OVO
		rev	* * * М. П. АНТОНОВЪ	* * * M. P. ANTONOV"
32	WAVMS: A003.42	obv	С. ГОРИЦЫ	S. GORItsY
		rev	Сь. С М / ТД /[–][–]	S'. S M / TID /[–][–]
33	WAVMS: A003.43	obv	С. ЛУНИ–[–]–]О	S. LUNI–[–]–]O
		rev	[–][–][–]	[–][–][–]
34	WAVMS: A003.44	obv	* СЕЛО –УН– –В–	* SELO –UN– –V–
		rev	* Ф В [–][–] – – – –	* F V [–][–] – – – –

6.3.6. Great Yarmouth Museum [GRYEH]

No.	Seal accession number	Face	Transcription	Transliteration
1	GRYEH.1981.45.2	obv	Д. А. / ВАСИЛ / ИСТИН / Н 332	D. A. / VASIL / ISTIN / N 332
		rev	N. P. / I C Z 12 H / 1784	N. P. / I C Z 12 H / 1784
2	GRYEH.1981.45.4	obv	П. Д. / У. ХРАМ / ЦОВЬ / Н [6]	P. D. / U. KhRAM / TsOV" / N [6]
		rev	S P B / I M R H / 1792	S P B / I M R H / 1792
3	GRYEH.1981.53	obv	– – / Н. [–] У [–] / [–] ИКО / Н [–] / [–]	– – / N. [–] U [–] / [–] IKO / N [–] / [–]
		rev	S P B / M M B / 1797	S P B / M M B / 1797
4	GRYEH.1981.74.1	obv	– – – РБУРГ / (Six-point star)	– – – RBURG / (Six-point star)
		rev	(Blank)	. (Blank)
5	GRYEH.1981.74.2	obv	.Л Д / В: ЛАР[–] / ОНОВ[–] / – – 9	. L D / V: LAR[–] / ONOV[–] / – – 9
		rev	.W. K. / L I W 12 K / 17[–][–]	.W. K. / L I W 12 K / 17[–][–]
6	GRYEH.1982.34.2	obv	П Д / Т. ШИ[Т] / ИКОВ / Н 82	P D / T. ShI[T] / IKOV / N 82
		rev	. S P B / C H R H / 182[–]	. S P B / C H R H / 182[–]

6.3.7. Guildford Museum [GLDM]

No.	Seal accession number	Face	Transcription	Transliteration
1	GLDM: 29.01	obv	– Д / – – НОВЪ / [–] 45	– D / – – NOV" / [–] 45
		rev	S P B / C Г F P H / 1795	S P B / C I F P H / 1795
2	GLDM:29.02	obv	– – / СТЕПА / – ОВЪ	– – / STEPA / – OV"
		rev	АР– ПОР / ПЕНК. БРА / 2 [Г] Л Р / 1813	AR– POR / PENK. BRA / 2 [G] L R / 1813

3	GLDM: 29.03	obv	Д / - - -М - - / НОВЪ / Н - - 2	D / - - -M - - / NOV" / N - - 2
		rev	N P / M M 12 H / 1781	N P / M M 12 H / 1781
4	GLDM:29.04	obv	ПЕТЕРБУРГ / 18 (Arms) [1]9	PETERBURG / 18 (Arms) [1]9
		rev	(Illegible)	(Illegible)
5	GLDM: 29.05	obv	No. 50	No. 50
		rev	N P / S.B.12.M.[-] / 1753	N P / S. B. 12. M [-] / 1753

6.3.8. Harrogate Museum [HARGM]

No.	Seal accession number	Face	Transcription	Transliteration
1	HARGM: 12706. 1	obv	No. 57	No. 57
		rev	W K. / [-]B 12 AO / 1757	W K. / [-]B 12 AO / 1757
2	HARGM: 12706. 2	obv	ЛД / Ф: ФО / КИНЪ / Н 1 I	L D / F: FO / KIN" / N 1 I
		rev	N P / 1 I W 12 K / 1801	N P / 1 I W 12 K / 1801
3	HARGM: 12706. 3	obv	Л Д / А: ШИ[П] / ОЧЕВ / Н 19–	L D / A: Shi[P] / OChEV / N 19–
		rev	[N] P / [-] 1 W 12 K / 1802	[N] P / [-] 1 W 12 K / 1802
4	HARGM: 12706. 4	obv	Л: Д / С З АИ / ЦОВЪ / Н 19	L: D / S ZAI / TsOV" / N 19
		rev	N P / A P 12 H / 1796	N P / A P 12 H / 1796
5	HARGM: 12706. 5	obv	Л [Д] / М И : ОР / ЛЮВЬ / Н 32	L [D] / M I : OR / LOV" / N 32
		rev	N P / I F 12 H / 1814	N P / I F 12 H / 1814
6	HARGM: 12706. 6	obv	- Д / [-] ФИЛА / ТОВЪ / Н 89	- D / [-] FILA / TOV" / N 89
		rev	N P / A K 12 / 181[-]	N P / A K 12 / 181[-]
7	HARGM: 12706. 7	obv	Л. Д. / С. ЗАИ / ЦОВЪ / Н 19	L. D. / S. ZAI / TsOV" / N 19
		rev	NP / Ф К 12 Н / [1]7[-]6 /	NP / F K 12 H / [1]7[-]6 /
8	HARGM: 12706. 8	obv	Л. Д. / З: ПА / ЛОВ / Н 6[-]	L. D. / Z: PA / LOV / N 6[-]
		rev	N P / M M 12 H / 1796	N P / M M 12 H / 1796
9	HARGM: 12706. 9	obv	Л. Д. / Е. МАР / ТИНО / Н. [3]	L. D. / E. MAR / TINO / N. [3]
		rev	N. P. / -Q 12 K / -[7]92	N. P. / -Q 12 K / -[7]92
10	HARGM: 12706. 10	obv	Л. Д. / [-]. РА[-] / ОВЪ / Н 50	L. D. / [-]. RA[-] / OV" / N 50
		rev	.P. [-] / P. K. / 1836	.P. [-] / P. K. / 1836
11	HARGM: 12706. 11	obv	Л. Д. / [-] [Щ]ЫР / [O]ВСО / –	L. D. / [-] [Sh]YR / [O]VSO / –
		rev	N P / [-] 9 H / [-]1.	N P / [-] 9 H / [-]1.
12	HARGM: 12706. 12	obv	. Л Д / Е. ИВА / НОВЪ / - -5	. L D / E. IVA / NOV" / - -5
		rev	N P / P F 12 / 1801	N P / P F 12 / 1801
13	HARGM: 12706. 13	obv	А П / ДЕСЯТ / М К	A P / DESyAT / M K
		rev	АП / [Л]НЯН БРАК / 2 МП Р / 1839	AP / [L]NyAN BRAK / 2 MP R / 1839
14	HARGM: 13606.1	obv	– Д / [-] МАЛ / БІГИН / Н 12[-]	– D / [-] MAL / YGIN / N 12[-]
		rev	–/ – – [2] H / – 8 – –	–/ – – [2] H / – 8 – –
15	HARGM: 13606.2	obv	Л.Д. / Т. ЗАМА / РИНЪ / Н 17	L. D. / T. ZAMA / RIN" / N 17
		rev	. N. P. / A K 12 [H] / 181[-]	. N. P. / A K 12 [H] / 181[-]
16	HARGM: 13606.3	obv	Л.Д. / [-] ПОЗ / – ЕКОВ / Н 20	L. D. / [-] POZ / – EKOV / N 20
		rev	N P / E R 12 H / 1822	N P / E R 12 H / 1822
17	HARGM: 13606.4	obv	Л.Д. / [Р] : КРА / СИКОВ / [-][-]	L D / [R] : KRA / SIKOV / [-][-]
		rev	. N P / БА 12 [Н] / 179[-]	. N P / BA 12 [H] / 179[-]
18	HARGM: 13606.5	obv	Л.Д. / С: ЛЕВ / АШЕВ / Н 57	L. D. / S: LEV / AShEV / N 57
		rev	. N P / L 1 W 12 K / -800	. N P / L 1 W 12 K / -800

No.	Seal accession number	Face	Transcription	Transliteration
19	HARGM: 13606.6	obv	Л. Д. / Н: КАР / АЛЕВ / Н 4[3]	L. D. / N: KAR / ALEV / N 4[3]
		rev	N P / Ч 12 Н / –803	N P / Ch 12 H / –803
20	HARGM: 13606.7	obv	Л. Д. / И: КОН / [О]НОВ / – –[0]	L. D. / I: KON / [O]NOV / – –[0]
		rev	.N P . / C H 12 H / [1]812	.N P . / C H 12 H / [1]812
21	HARGM: 13606.8	obv	Л. Д. / – УТО / ЧкИНЪ / – 3–	L. D. / – UTO / ChkIN" / – 3–
		rev	.N P . / L I W 12 K / 178[–]	.N P . / L I W 12 K / 178[–]
22	HARGM: 13606.9	obv	– –[–][–]И [–] / [–]ЛЕВ / Н 59	– –[–][–]I [–] / [–]LEV / N 59
		rev	– – / О Н 12 [–] / 17– –	– – / O H 12 [–] / 17– –
23	HARGM: 13606.10	obv	– – / –Д[Е]Д– / В – – / Н [1]9	– – / –D[E]D– / V – – / N [1]9
		rev	N P / [Д][–] 12 Н / – – – 1	N P / [D][–] 12 H / – – – 1
24	HARGM: 13606.11	obv	[–] – / [Б] [Л] – – / иНЪ / N –7	[–] – / [B] [L] – – / IN" / N –7
		rev	– – / N [P]. [2] / J. H / 1838	– – / N [P]. [2] / J. H / 1838
25	HARGM: 13606.12	obv	Л. Д. / [–]А [–] / Н 18	L. D. / [–]A [–] / N 18
		rev	N P / N Sh 9 H / –[8]23	N P / N Sh 9 H / –[8]23
26	HARGM: 13606.13	obv	– –/–ИН / – – –	– –/–IN / – – –
		rev	– Р / – – – 2[Н] / [1][8] – –	– P / – – – 2[H] / [1][8] – –
27	HARGM: 13606.14	obv	– – / – – / УНОВЬ	– – / – – / UNOV"
		rev	S P B / L Z 3 I H / 1820	S P B / L Z I H / 1820
28	HARGM: 13606.15	obv	Л. Д. / [С] ДЕМ / ьЯНОВЪ / Но I[–]	L. D. / [S] DEM / 'yANOV" / No I[–]
		rev	N. P / F E 12 H / 1790	N. P / F E 12 H / 1790
29	HARGM: 13606.16	obv	(Illegible)	(Illegible)
		rev	N /–Sh I – / 18[2]–	N / –Sh I – / 18[2]–
30	HARGM: 13606.17	obv	СТ. / 26 [–]ОЯ / 09 / ПОЛТАВА	ST. / 26 [–]OyA / 09 / POLTAVA
		rev	M. K. B. Ж. Д / A 38–. / No 1	M. K. V. Zh. D / A 38–. / No 1

6.3.9. Hereford Museum and Art Gallery, Hereford [HFDMG]

No.	Seal accession number	Face	Transcription	Transliteration
1	HFDMG: 1980–82	obv	Д. Л. / ПЛОТЬ / НИКОВ / Н. 250	D. L. / PLOT' / NIKOV / N. 250
		rev	N. P. / C Z 12 H / 1779	N. P. / C Z 12 H / 1779
2	HFDMG: 1987–19/1	obv	.Д I / С ЕЛИ / НСКОЙ / .Н 32[1]	.D I / S ELI / NSKOI / .N 32[1]
		rev	.N P / I R 12 K / 1783	.N P / I R 12 K / 1783

6.3.10. Kingston upon Hull Museum and Art Gallery [KINCM]

No.	Seal accession number	Face	Transcription	Transliteration
1	KINCM:1339.1986.564	obv	П. Д. / [–] САМО / ИЛОВ / Но 3	P. D. / [–] SAMO / ILOV / No 3
		rev	S P B / Н. – 3 / [–]. S. / 1836	S P B / N. – 3 / [–]. S. / 1836
2	KINCM:1339.1986.565	obv	.Д. / ЕРЕ – [М] – ЕВ / Н 328	.D. / ERE – [M] – EV / N 328
		rev	S P B / [–] P [–] / – – –	S P B / [–] P [–] / – – –
3	KINCM:2000.100.4	obv	.Л Д / В. [М]И – / [–]ИНЪ / Н 48	.L D / V. [M]I – / [–]IN" / N 48
		rev	N P / A Ш 12 / 1802	N P / A Sh 12 / 1802
4	KINCM:2000.100.5	obv	– – / С: ЛЕВ / АШЕВ / Н 57	– – / S: LEV / AShEV / N 57
		rev	N P / C H 12 K / 1802	N P / C H 12 K / 1802
5	KINCM:2000.101.149	obv	+ (Cross Keys) / 1	+ (Cross Keys) / 1
		rev	(Blank)	(Blank)
6	KINCM:2000.102.20	obv	П Д / [–] В[А]У / Л–НЪ / Н 197	P D / [–] V[A]U / L–N" / N 197
		rev	С П Б / [П]ЕН. 3 / Д. Х / 180–	S P B / [P]EN. 3 / D. Kh / 180–

Part Two. Catalogue of lead seals (Cyrillic and Roman) 105

6.3.11. Lancaster Museum [LCM]

No.	Seal accession number	Face	Transcription	Transliteration
1	LCM: 86.16	obv	Л Д / И: ЩИ / РАПО / Н 58	L D / I: ShI / RAPO / N 58
		rev	N P / П С 12 К / 1791	N P / P S 12 K / 1791
2	LCM: 86.72	obv	АРХ [П] / ДЕСЯТ/НИК / МАТВЕИ / ВЕДЕН / СКОИ	ARKh [P] / DESyAT/NIK / MATVEI / VEDEN / SKOI
		rev	- - - / КУДЕЛ[Ь] / 1 СОРТЪ / А. Р. / 1846	- - - / KUDEL[ʹ] / 1 SORT" / A. R. / 1846
3	LCM: 90.36/1	obv	Л. Д. / [-]-[-]-[-][Б] / -ОКОВ	L. D. / [-]-[-]-[-][B] / -OKOV
		rev	/ Е Р 12 / 1818	/ E R 12 / 1818
4	LCM: 90.36/7	obv	Л Д / Л ПОГ / АНКИ / Н 27	L D / L POG / ANKI / N 27
		rev	N P / F W 12 [-] / 1818	N P / F W 12 [-] / 1818
5	LCM: 90.36/9	obv	Л Д / М. МАР / КОВЪ / -[0] 5 [-]	L D / M. MAR / KOV" / -[0] 5 [-]
		rev	S P B / N P 2 / I. P. / 1837	S P B / N P 2 / I. P. / 1837
6	LCM: 90.36/10	obv	Л Д / С. КЛА / ДУХИ[Н] / Н 42	L D / S. KLA / DUKhI[N] / N 42
		rev	N P / [-] G F 12 H / 1804	N P / [-] G F 12 H / 1804
7	LCM: 90.36/11	obv	- Д / [-]-[-] ЧЕЛ / НОВ / - -	- D / [-]-[-] ChEL / NOV / - -
		rev	N P / Ф К 12 / 17[-]	N P / F K 12 / 17[-]
8	LCM: 90.36/12	obv	П и Л П Д / Ф. СУХО / РУКО[В] / Но	P i L P D / F. SUKhO / RUKO[V] / No
		rev	S P B / I C B N 2 / 183[6]	S P B / I C B N 2 / 183[6]
9	LCM: 94.27/1	obv	Л Д / Л: ПИ / РОЖНI / [Н] 2	L D / L: PI / ROZhNI / [N] 2
		rev	N / М Θ 1 / 1790	N / M Th 1 / 1790
10	LCM: 94.27/2	obv	Л / С СО[-] / О[-]ХО / Н 45	L / S SO[-] / O[-]KhO / N 45
		rev	N P / S 12 H / [1]814	N P / S 12 H / [1]814
11	LCM: 96.81	obv	Л Д / А Ш[-]Р / ОЧЕВ / Н 12	L D / A Sh[-]P / OChEV / N 12
		rev	N P / I. Ф 12 / 1788	N P / I. F 12 / 1788

6.3.12. National Museums Liverpool (NML)

No.	Seal accession number	Face	Transcription	Transliteration
1	NML. 2007.21.1	obv	П. Д. / Г ЩУК / ИНЪ / Н 1*	P. D. / G ShchUK / IN" / N 1*
		rev	SPB / [-] H R H / 1787	S P B / [-] H R H / 1787
2	NML. 2007.21.2	obv	- -/ С. ТО / СТИК / Н 88	- -/ S. TO / STIK / N 88
		rev	SPB / ПЕНЬ / I. I. / 1835	S P B / PENʹ / I. I. / 1835
3	NML. 2007.21.3	obv	П. Д. / И М БУ / ЩЕВЬ / N 314	P. D. / I M BU / ShEV" / N 314
		rev	SPB / F W R H / [1]826	S P B / F W R H / [1]826

6.3.13 Museum of London [MoL]

No.	Seal accession number	Face	Transcription	Transliteration
1	MoL: 81.266/31	obv	П. Д. / [-] : ГОН / [-]-[-] КО / [-] 4[-]	P. D. / [-] : GON / [-]-[-] KO / [-] 4[-]
		rev	S P B / A K R H / 182[2]	S P B / A K R H / 182[2]
2	MoL: 81.522/40	obv	М.И. ОДНОУ[Ш]ЕВСКАЯ / С / СЫНОВЬЯМИ	M.I. ODNOU[Sh]EVSKAYA / S / SYNOVyAMI
		rev	(Arms of the Russian State)	(Arms of the Russian State)
3	MoL: 88.107/42	obv	(Blank)	(Blank(
		rev	S P B / R H / 1741	S P B / R H / 1741
4	MoL: 88.427/15	obv	(Arms: Anchor) С- -НКТПЕ[Т]РБУ : ПОР / 179[7]	(Arms: Anchor) S- -NKTPE[T]RBU : POR / 179[7]
		rev	(Blank)	(Blank)

106　　　　　　　　　　　　　　　　　　　　*Russian Cloth Seals in Britain*

5	MoL: 8543	obv	. N. / 25	. N. / 25
		rev	N P / AN 12 П [9] / 1759	N P / AN 12 P [9] / 1759
6	MoL: Q39	obv	[Д]. О. / [Ц]МАН / ОВЪ / Н 289	[D]. O. / [Ц]MAN / OV" / N 289
		rev	S P B / C F K R H / 177[8]	S P B / C F K R H / 177[8]
7	MoL: Q40	obv	Д М / НАМЕС / [–]ОВСКОI / Н 92	D M / NAMES / [–]OVSKOI / N 92
		rev	. N: P. / C F K 12 K / 1780	. N: P. / C F K 12 K / 1780
8	MoL: 2006.6	obv	Л Д / СИНЯ / [–]ОВЪ / – [–]	L D / SINyA / [–]OV" / –[–]
		rev	N Р. / М В 9 Н / 1812	N P. / M B 9 H / 1812
9	MoL: 2006.7/1	obv	П. П. / И ПУЗ / ЫРЕВ / Н 1	P. P. / I PUZ / YREV / N 1
		rev	(Illegible)	(Illegible)
10	MoL: 2006.7/2	obv	– Д / [–] : ЛО / [–] ГИН / Н 32[–]	– D / [–] : LO / [–] GIN / N 32[–]
		rev	S P B / С. У. R. Н. / 1800	S P B / S. U. R. H. / 1800
11	MoL: 2006.7/3	obv	Д А / НЕӨ[–] / ДОВЪ / Н 32	D A / NETh[–] / DOV" / N 32
		rev	N P / A K 12 H / 1778	N P / A K 12 H / 1778
12	MoL: 2006.7/4	obv	[–]Д / – СЕД / ОВЪ / Н 8	[–]D / – SED / OV" / N 8
		rev	S P B / I C Z R H / 1787	S P B / I C Z R H / 1787
13	MoL: 2006.7/5	obv	– – / KOR / OЛEB / Н [7]8	– – / KOR / OLEV / N [7]8
		rev	N P / W S 12 H / 18[2]–	N P / W S 12 H / 18[2]–
14	MoL: 2006.7/6	obv	Л Д / I : ТАР / АСОВ / Н 72	L. D. / I : TAR / ASOV / N 72
		rev	N P / T H 12 H / 1793	N P / T H 12 H / 1793
15	MoL: 2006.7/7	obv	Д. А. / СИМ[–] / НОВЪ / Н 162	D. A. / SIM[–] / NOV" / N 162
		rev	S P B / C Z R H / 1787	S P B / C Z R H / 1787
16	MoL: 2006.7/8	obv	– [–] / ШЕР / А[П]ОВ / Н 5[–]	– [–] / ShER / A[P]OV / N 5[–]
		rev	– – – / – – – H / 1789	– – – / – – – H / 1789

6.3.14. Malton Museum [MM]

No.	Seal accession number	Face	Transcription	Transliteration
1	MM: 2006.1	obv	No. [1]6	No. [1]6
		rev	N. P. / [К] В 12. [Н] / 1753	N. P. / [K] V 12. [H] / 1753
2	MM: 2006.2	obv	П. Д. / А. [–]АХ / ОВЪ / N 185	P. D. / A. [–]AKh / OV" / N 185
		rev	S.P.B. / [–] M R H / [1]78[–]	S. P. B. / [–] M R H / [1]78[–]
3	MM: 2006.3	obv	Д [–] / [–] П[–]А / ЛЕВЪ / Н280	D [–] / [–] P[–]A / LEV" / N280
		rev	[N]Р / Н I [К] 12 Н / 1776	[N]P / H I [K] 12 H / 1776
4	MM: 2006.4	obv	Д [П] / ТАМИ / ЛИНЬ / Н 2[–]	D [P] / TAMI / LIN" / N 2[–]
		rev	N. P. / IAC 12 K / 1786	N. P. / IAC 12 K / 1786
5	MM: 2006.5	obv	Л Д / А БАБ / А[Н]ОВ / Н 10	L D / A BAB / A[N]OV / N 10
		rev	К 12 К / 1787	K 12 K / 1787
6	MM: 2006.6	obv	Л Д / И. [–][–]Н / НИКОВ / Н 20	L D / I. [–][–]N / NIKOV / N 20
		rev	W K / [Я] С 12 Н / 1795	W K / [yA] S 12 H / 1795
7	MM: 2006.7	obv	Д [–] / [–]РЕХОВЪ / No 1[2]	D [–] / [–]REKhOV" / No 1[2]
		rev	/ [–] К 12 К / 1796	/ [–] K 12 K / 1796
8	MM: 2006.8	obv	П. ЛЕБ / ЕДЕВ /	P. LEB / EDEV /
		rev	– – – – / 17[9]6	– – – – / 17[9]6
9	MM: 2006.9	obv	Л Д / [–] ПИ / ИНЬ / [–] 35	L D / [–] PI / IN" / [–] 35
		rev	[N] Р. / [–] Ч 12 Н / 1804	[N] P. / [–] Ch 12 H / 1804
10	MM: 2006.10	obv	Л Д / М. МЕР / КУЛОВ / Н. 28	L D / M. MER / KULOV / N. 28
		rev	N. P. / Сч 12 Н / 1804	N. P. / S Ch 12 H / 1804

Part Two. Catalogue of lead seals (Cyrillic and Roman) 107

11	ММ: 2006.11	obv	Л. Д. / [–] МЕС / НИКОВ / Н 1[–]8	L. D. / [–] MES / NIKOV / N 1[–]8
		rev	Н. Р. / CGF 12 / 181[3]	N. P. / CGF 12 / 181[3]
12	ММ: 2006.12	obv	Л. Д. / М. ЛИВ / ШЕВ / Н 37	L. D / M. LIV / ShEV / N 37
		rev	[–] / [–] М Б 6 Н / 1812	[–] / [–] M B 6 H / 1812
13	ММ: 2006.13	obv	No. 25	No. 25
		rev	W.U. / 9 / 175[–]	W.U. / 9 / 175[–]
14	ММ: 2006.14	obv	[Л] Д / ЧꙊРА / КОВЬ / Н. 57	[L] D / ChURA / KOV" / N. 57
		rev	S. P. [B] / L [–] W R / 1781	S. P. [B] / L [–] W R / 1781
15	ММ: 2006.15	obv	– – / С: УЛЬ / ЯНОВ / N 10	– – / S: UL' / yANOV / N 10
		rev	N P. / –Р 12Н / 1814	N P. / –P 12H / 1814
16	ММ: 2006.16	obv	– – – / [П] Щ[Е]Г / ОЛЕВ / Но 32	– – – / [P] Shch[E]G / OLEV / No 32
		rev	[N] Р / АР 12 Н / 1794	[N] P / AP 12 H / 1794
17	ММ: 2006.17	obv	No. 1[–]	No. 1[–]
		rev	N. P. / 12 / 174[8]	N. P. / 12 / 174[8]
18	ММ: 2006.18	obv	Л / А ГУ[–] / [–]ОВЬ / – [2]	L / A GU[–] / [–]OV" / – [2]
		rev	Р / А. Ч 12 Н / 1814	P / A. Ch 12 H / 1814
19	ММ: 2006.19	obv	Л. / – Т[А]М / [–]ЛИН / Н –	L. / – T[A]M / [–]LIN / N –
		rev	N Р / [–] Н 12 Н / 1793	N P / [–] H 12 H / 1793
20	ММ: 2006.22	obv	Л Д / П: ЛЕБ / ЕДЕВ / Н 6[1]	L D / P: LEB / EDEV / N 6[1]
		rev	[N] Р. / [–] М 12 Н / 1796	[N] P. / [–] M 12 H / 1796
21	ММ: 2006.23	obv	Л. Д. / В: ЩОГ / О[Л][Е][В]	L. D. / V: ShchOG / O[L][E][V]
		rev	Р / [–] 12 Н / 1794	P / [–] 12 H / 1794

6.3.15. *Newbury Museum (West Berkshire Heritage Service) [NEBYM]*

No.	Seal accession number	Face	Transcription	Transliteration
1	NEBYM: A1299	obv	* П * / У: ХРА / МЦОВ / * Н . 6 *	* P * / U: KhRA / MTsOV / * N . 6 *
		rev	*S Р В * / И Ч А / * 1801*	*S P B * / I Ch A / * 1801*
2	NEBYM: 1981.96.6	obv	–	–
		rev	N Р / [А][N][9][А]О / –7 – –	N P / [A][N][9][A]O / –7 – –
3	NEBYM: Loan D2902 (A)	obv	[Л] [Д] / А Г	[L] [D] / A G
		rev	[П] [Б] / В КА[Н] / ЛИН / Н 3 [–]	[P] [B] / V KA[N] / LIN / N 3 [–]
4	NEBYM: Loan D2902 (B)	obv	.П / [А] ПР[О]/ [О]ПО[В]/ Н [–]3	.P / [A] PR[O]/ [O]PO[V] / N [–]3
		rev	[–]2[К] / D – / –8[–] –	[–]2[K] / D – / –8[–] –

6.3.16. *Norfolk Landscape Archaeology, Gressenhall [NLA]*

No.	Norfolk Historic Environment Record number	Face	Transcription	Transliteration
1	NLA (HER) 10399	obv	Л Д . / — — — Д - / — ЛЕВЪ / Н — —	L D . / — — — D - / — LEV" / N — —
		rev	[-] [П] / [— —] Е [— —] / В. [B] / 1837	[-] [P] / [— —] E [— —] / V. [V] / 1837
2	NLA (HER) 13603	obv	Д [-] / А. ЛАБ / ИШЕВЪ / Н 308	D [-] / A. LAB / IShEV" / N 308
		rev	N P / A: Ч12: Н / 1778	N P / A: Ch 12: H / 1778
3	NLA (HER) 16554	obv	Л. Д. / — — — / О — — . / N 132	L. D. / — — — / O — — . / N 132
		rev	N P / M M 12 Н / 1781	N P / M M 12 H / 1781
4	NLA (HER) 23698	obv	П [-] / М: Б[У] / ШЕВЪ / Н 23	P [-] / M: B[U] / ShEV" / N 23
		rev	S P B / [S] R H / 97	S P B / [S] R H / 97
5	NLA (HER) 24811	obv	— — / — / О. И. / N 132	— — / — / O. I. / N 132
		rev	1794	1794
6	NLA (HER) 25178	obv	Д:И / МАРО / ЗОВЪ / Н 66	D: I / MARO / ZOV" / N 66
		rev	S P B / A Ч R H / 1776	S. P. B / A. Ch. R. H. / 1776
7	NLA (HER) 28040	obv	П: Д / [И] [-]ЕРО / ТНЕВЪ / Н [-]28	P: D / [I] [-]ERO / TNEV" / N [-]28
		rev	S P B / A K R H / 1812	S P B / A K R H / 1812
8	NLA (HER) 31194	obv	[П] Д / Ф КРИ / ВОШЕ / Н 9[-]	[P] D / F KRI / VOShE / N 9[-]
		rev	— / Н Р R Н / 1798 (HP is a ligature)	— / H P R H / 1798 (HP as a ligature)
9	NLA (HER) 31883	obv	Д — / [C]ИМАНОВЪ / Н 67	D — / [S]IMANOV" / N 67
		rev	S P B / C T R H / 1769	S P B / C T R H / 1769
10	NLA (HER) 34589	obv	/ М Б[-] [-] / ШИНЬ / Н 235	/ M B[-] [-] / ShIN" / N 235
		rev	S P B. / [-] F . R H / 1798	S P B. / [-] F . R H / 1798
11	NLA (HER) 36591	obv	[-] [-] / И СО[-] / РЕЛЬС / Н 1 —	[-] [-] / I SO[-] / REL'S / N 1 —
		rev	(Illegible)	(Illegible)
12	NLA (HER) 36633	obv	Д. В. / ЕРШЕ / [-]ОВ / Н 1 I 6	D. V. / ERShE / [-]OV / N 1 I 6
		rev	N. P. / [[П]К 12 Н / 1778	N. P. / [[П]K 12 H / 1778
13	NLA (HER) 39269	obv	Д. Ф. / [Л][-] [Л]КОNО / В / Н 137	D. F. / [L][-] [L]KONO / V / N 137
		rev	N P / I C Z 12 H / 1762	N P / I C Z 12 H / 1762
14	NLA (HER) 39393	obv	Л Д / [Д]Д[Е][Д][-] / [-]-] [-]РЕВЪ / Н 222	L D / [D]D[E][D][-] / [-]-] [-]REV" / N 222
		rev	[[S][[P][B]/ N 2 / I H / 1841	[S][[P][B]/ N 2 / I H / 1841
15	NLA (HER) 40538	obv	Д. I / [К]ОПОВЪ / Н 114	D. I / [K]OPOV" / N 114
		rev	S P B / [Н]. С. R. I / 1769	S P B / [H]. C. R. I / 1769
16	NLA (HER) 40934	obv	[Л] Д. / ШЕЛ / [К]ОВЪ / Н 4	[L] D. / ShEL / [K]OV" / N 4
		rev	S P B / M. C. R. I / 180–	S P B / M. C. R. I / 180–
17	NLA (HER) 42579	obv	П: Д / Е: НОВ / ГОРО[Д] / Н 136	P: D / E: NOV / GORO[D] / N 136
		rev	S P B / I S R [Н] / 1802	S P B / I S R [H] / 1802
18	NLA (HER) 42590	obv	Л: Д / М. ЛОЗ / ГИНЬ / Н 2[6]	L: D / M. LOZ / GIN" / N 2[6]
		rev	S – / Ф K R H / 179–	S – / F K R H / 179–
19	NLA (HER) 42901	obv	— — / — — / Н 12[-]	— — / — — / H 12[-]
		rev	S P B / Н Р [-] Н (HP is ligatured)	S P B / H P [-] H (HP is ligatured)
20	NLA (HER) 47349	obv	Д: А / Г[-]УШКОВ / N 71	A: A / G[-]UShKOV / N 71
		rev	S P B / P М [-] Н / 1767	S P B / P M [-] H / 1767

6.3.17. Ashmolean Museum, Oxford [OXFAS]

No.	Seal accession number	Face	Transcription	Transliteration
1	OXFAS: 1980.271	obv	Д. В. / МАСЛЕ / –НКОВЪ / Н 208	D. V. / MASLE / –NKOV" / N 208
		rev	S P B / –М. Р Н * / 1778	S P B / –M. P H * / 1778
2	OXFAS: 1980.272	obv	* П. Д. / А ПОЯ / КОВЪ/ Н22	* P. D. / A POyA / KOV" / N22
		rev	S P B / D H R H / 179–	S P B / D H R H / 179–
3	OXFAS: 1980.273	obv	No 5	No 5
		rev	. Р / S – Θ Е / – –53	. P / S – Th. E / – –53
4	OXFAS: 1987.179	obv	*П. Д / У: ХРАМ / ЦОВ / Н. [6]	*P. D / U: KhR AM / TsOV / N. [6]
		rev	[S]PB / G K R H / [1]787	[S]PB / G K R H / [1]787
5	OXFAS: 1987.188	obv	* Д. I. I. / ГА[Р][Ч]УКОВ / * 24[–]	* D. I. I. / GA[R][Ch]UKOV / * 24[–]
		rev	S P B / М Р А Н / 1771	S P B / M P A H / 1771
6	OXFAS: 1998.105	obv	Л: Д / Д Е: НАДЕЖ[Н] / Н –	L: D / D E: NA/DEZh[N] / N –
		rev	[А]К. – Н / 1787	[A]K. – H / 1787
7	OXFAS: 1998.106	obv	Д *. / [С] . ДОЛ[–]ОПО. / Н 68	D *. / [S] . DOL[–]OPO. / N 68
		rev	S P B / S Ch R I / 1803	S P B / S Ch R I / 1803

6.3.18. Harris Museum and Art Gallery, Preston [PRSMG]

No.	Seal accession Number	Face	Transcription	Transliteration
1	PRSMG: T1960 (A145)	obv	/ 1 / ЕВЪ	/ 1 / EV"
		rev	/ О. 9 Н / 1762	/ O. 9 H / 1762
2	PRSMG: T1961	obv	Д Т / ПРИМ / ЯКИНЪ / Н 336	D T / PRIM / yAKIN" / N 336
		rev	N. P / HP: 6: К / 1777 (HP is a ligature)	N. P / HP: 6: K / 1777 (HP is a ligature)
3	PRSMG: T1962 (A144)	obv	– Д / Ф Т[–]Г / ОДАЕ / Н 63	– D / F T[–]G / ODAE / N 63
		rev	N Р / М М 12 Н / 1796	N P / M M 12 H / 1796
4	PRSMG: T1963 (A146)	obv	Д 8 / СЫСОЕ / ВЪ / Н 10	D 8 / SYSOE / V" / N 10
		rev	N. Р. / 1 М К 12 Н / 1776	N. P. / 1 M K 12 H / 1776

6.3.19. Salisbury and South Wiltshire Museum [SBYWM]

No.	Seal accession number	Face	Transcription	Transliteration
1	SBYWM: ii.E.435	obv	Д Л / ЗЕМОВ/ [–][–][–]	D L / ZEMOV/ [–][–][–]
		rev	N Р / С С 12 Н / 1775	N P / C C 12 H / 1775

6.3.20. Suffolk

No.	Seal data base number	Face	Transcription	Transliteration
1	SF 746/6172	obv	СКЛАД / No 1	SKLAD / No 1
		rev	ТРАНСПОРТ	TRANSPORT
2	SF 869/7053	obv	Л Д / С[А]ЛОВ / [У]ХИНЪ / Н 326	L D / S[A]LOV / [U]KhIN" / N 326
		rev	–	–

3	SF 869/7380	obv	ЛД / И М ВИ / ННИКО– / Н 5[6]	L D / I M VI / NNIKO– / N 5[6]
		rev	N P * / P F 12 H / 1809*	N P * / P F 12 H / 1809*
4	SF 906/7241	obv	М ТАР / ПЧИНО / N I I	M TAR / PChINO / N I I
		rev	SP.B / NP. – [-] / F. W. / 183[-]	SP.B / N P. – [-] / F. W. / 183[-]
5	SF (SMR) LUD misc MSF 23230	obv	П. Д. / КРЮ / КОВЪ / [Н] 19.	P. D. / KRyU / KOV" / [N] 19
		rev	. S P B / [-]Ш А Н / 1805	. S P B. / [-] ShAN / 1805
6	SF MISTLEY	obv	Л.Д / [-].[Н] А [-] / [-] ЕВЪ / –	L.D / [-].[N] A [-] / [-] EV" / –
		rev	S. P. / N. P. – [3] / F. W. / 183[-]	S. P. / N. P. – [3] / F. W. / 183[-]
7	SF (SMR) COR 050	obv	Л.Д / Б НЕМ– / ЛОВЪ / Н 20[1]	L.D / B NEM– / LOV" / N 20[1]
		rev	S. P. B. / W S A H / 1805	S. P. B. / W S A H / 1805

6.3.21. Wallingford Museum [WALM]

No.	Seal accession number	Face	Transcription	Transliteration
1	WALM 2005–13–1	obv	[Д]. Т. / [К]АНДРАТЬ / ЕВЪ / Н 137	[D]. T. / [K]ANDRAT' / EV" / N 137
		rev	N P / S S 12 H / 1768	N P / S S 12 H / 1768
2	WALM 2005–13–2	obv	Л Д. / С: ВАР / ЗОВЪ / – 14	L D. / S: VAR / ZOV" / – 14
		rev	N P / P B 9 H / 1796	N P / P B 9 H / 1796

6.3.22. Warwick Museum [WARMS]

No.	Seal accession number	Face	Transcription	Transliteration
1	WARMS: Brailes (Slides 62)	obv	[Л] [Д] / [Л] ТАМИ /ЛИНЪ / .7.	[L] [D] / [L] TAMI /LIN" / .7.
		rev	.N. / Н Р I [К] / 179[7]	.N. / H P I [K] / 179[7]

6.3.23. Whitby Museum [WHITM]

No.	Seal accession number	Face	Transcription	Transliteration
1	WHITM: SOH 420.1	obv	N / 58	N / 58
		rev	W. К. / [А] N 9 Р К / 1759	W. K. / [A] N 9 P K / 1759
2	WHITM: SOH 420.2	obv	N / 58	N / 58
		rev	W К. / [А] N 9 Р К / 1759	W K. / [A] N 9 P K / 1759

6.3.24. Whitby: Abbey House [WHIT (W.A.)]

No.	Seal accession number	Face	Transcription	Transliteration
1	WHIT(W.A.): 9711601	obv	Д [I] / – – [Д] / ДОВЪ / Н – 7	D [I] / [D] / DOV" / N – 7
		rev	N P / D H 12 – / 177–	N P / D H 12 – / 177–

6.4. Seals in Private Collections

6.4.1. Private owners/collectors: Abbreviations

Abbreviation	Catalogue Number
ARDG	1–2
GGAT	3–10
WE	11–17
GB	18–24
LB	25
RB	26–32
AJPC	33–42
AC	43
JC	44–55
JBC	56–71
AD	72–83
CD	84
GD	85–86
GGD	87–88
MD	89
PD	90–93
TD	94–96
DF	97–99
FF	100–114
SFl	115–144
JG	145–147
WG	148
AH	149
CH	150
JH(L)	151–162
MH	163–169
GI	170–171
RI	172
CK	173
WK	174–177
AL	178–179
GL	180–183
JL	184–185
GMcA	186–199
PMcA	200
AHM	201–204
AMu	205–213

JM	214–224
KM	225
KMo	226
PM	227–228
PMn	229
RM	230
RN	231
AJP	232
BP	233
DP	234
DMP	235–242
IP	243–246
JP	247
NP	248
BR	249–250
BR(B)	251–252
MR 01	253
PR	254
WR	255
IS	256
JS	257–282
JSm	283
JT	284
MT	285
NMT	286–288
ST	289–299
EW	300–305
HAW	306–313
JW	314
JWa	315–316
JWh	317–318
MW	319
TW	320–321
TWh	322
WEW	323–327
SWi	328
SWr	329

Anonymous seals	a	a01–a05	–

6.4.2. Private Collections

No.	Seal number	Face	Transcription	Transliteration
1	ARDG –01	obv	АРХ / ДѢСЯТС / ПЕТРЪ / ЖУКОВЬ	ARKh / DyESyATS / PETR" / ZhUKOV"
		rev	ПОР / КРОНЬ / 3 СОРТЪ / Я. П. В. / 1871	POR / KRON" / 3 SORT" / yA. P. V. / 1871
2	ARDG – 02	obv	АРХ БРА / ДЕСЯТ / МИТР / ОГОВЬ	ARKh BRA / DESyAT / MITR / OGOV"
		rev	ПОР / КУД[Ъ]Л – / [3] [О – Т С] / – – П / 1871	POR / KUDyEL – / [3] [O – T S] / – – P / 1871
3	GGAT 01	obv	Д: В. / ЕРШЕ / ВЬ / Н I 16	D: V. / ERShE / V" / N I 16
		rev	N Р / PN 12 H / 1774	N P / PN 12 H / 1774
4	GGAT 02	obv	5 / 9 / SIBERIA. Z / 11	5 / 9 / SIBERIA. Z / 11
		rev	(Crown held aloft by two hands)	(Crown held aloft by two hands)
5	GGAT 03	obv	– Д / Е. МАН / УХИН / Н 281	– D / E. MAN / UKhIN / N 281
		rev	– – – / [–] M I M – / [1]781	– – – / [–] M I M – / [1]781
6	GGAT 09	obv	5 / 9 / SIBERIA. Z / 11	5 / 9 / SIBERIA. Z / 11
		rev	(Crown held aloft by two hands)	(Crown held aloft by two hands)
7	GGAT 10	obv	5 / 9 / SIBERIA. [Z] / 11	5 / 9 / SIBERIA. [Z] / 11
		rev	(Crown held aloft by two hands)	(Crown held aloft by two hands)
8	GGAT 11	obv	5 / 9 / SIBERIA. Z / 11	5 / 9 / SIBERIA. Z / 11
		rev	(Crown held aloft by two hands)	(Crown held aloft by two hands)
9	GGAT 12	obv	5 / 9 / SIBERIA. Z / 11	5 / 9 / SIBERIA. Z / 11
		rev	(Crown held aloft by two hands)	(Crown held aloft by two hands)
10	GGAT 13	obv	[5] / 9 / SIBERIA. Z / 11	[5] / 9 / SIBERIA. Z / 11
		rev	(Crown held aloft by two hands)	(Crown held aloft by two hands)
11	WE 01	obv	No. 4	No. 4
		rev	N : Р / S. 1. 2. B / 1752	N : P / S. 1. 2. B / 1752
12	WE 02	obv	П Д / [M] ГОР / БУНОВ / Н 195	P D / [M] GOR / BUNOV / N 195
		rev	S P B / C F P H / 1800	S P B / C F P H / 1800
13	WE 03	obv	П Д / И О– / КIAXO– / Н – 2	P D / I O– / KIAKhO– / N – 2
		rev	. S P B . / I B P H / 1806	. S P B . / I B P H / 1806
14	WE 04	obv	П Д / Г: ТАБА / ЛИНЬ / Н 25	P D / G: TABA / LIN / N 25
		rev	S P B / Ch A N / –799	S P B / Ch A N / –799
15	WE 05	obv	ДА / [–] АРА[–] / [–]ИНЬ	D A / [–] ARA[–] / [–]IN"
		rev	[N] Р / – B – [N] / –768	[N] P / – B – [N] / –768
16	WE 06	obv	Д И / КРуТОI / Н: 6	D I / KRUTOI / N: 6
		rev	N P / D H 6 K / 1775	N P / D H 6 K / 1775
17	WE 08	obv	+ (Cross Keys) / 2	+ (Cross Keys) / 2
		rev	(Blank)	(Blank)
18	GB 01	obv	–[–][–] / ФОРО / – –	–[–][–] / FORO / – –
		rev	N P / F 1 K / 17[–]6	N P / F 1 K / 17[–]6
19	GB 02	obv	Л Д / И: СИВ / ЦОВЬ / Н 27	L D / I: SIV / TsOV" / N 27
		rev	N Р / MΘ 12 H / 179[8]	N P / M Th 12 H / 179[8]
20	GB 03	obv	Л Д / СИМ / [–][–] / [–] 59	L D / SIM / [–][–] / [–] 59
		rev	N Р / 12 / 179[–]	N P / 12 / 179[–]
21	GB 04	obv	Л Д / M: КОН / ОНОВ / Н 83	L D / M: KON / ONOV / N 83
		rev	. N Р / II W 12 / 179[8]	. N P / II W 12 / 179[8]

Part Two. Catalogue of lead seals (Cyrillic and Roman) 113

22	GB 05	obv	Л Д / Г. НИК / ИѲОР[–] / Н [–]	L D / G. NIK / IFOR[–] / N [–]
		rev	N Р / И. Ч 12 / [1]796	N P / I. Ch 12 / [1]796
23	GB 06	obv	Л.Д. / И: СИВ / ЦОВЬ / N 27	L.D. / I: SIV / TsOV" / N 27
		rev	N.Р. / М Ѳ 12 Н / 1798	N.P. / M Th 12 H / 1798
24	GB 07	obv	Л Д / А: ШИП / ОЧЕВЬ / Н 12	L D / A: ShIP / OChEV" / N 12
		rev	N Р / [–] Ч 12 Н / 1797	N P / [–] Ch 12 H / 1797
25	LB 01	obv	Л.Д. / М [–]И[–] / КИNЬ	L.D. / M [–]I[–] / KIN"
		rev	N. Р. / Е С – – / 1806	N. P. / E C – – / 1806
26	RB 01	obv	Л. Д. / Е. Б: ДЕ / МЬЯN / [Н] 70	L. D. / E. B: DE / M'yAN / [N] 70
		rev	N Р / [L] G K 12 К / 1800	N P / [L] G K 12 K / 1800
27	RB 02	obv	А П / ДЕСЯЦКОI / Г С	A P / DESyATsKOI / G S
		rev	А П / [P]АК БРАК / 1 ЕП Р / 1836	A P / [P]AK BRAK / 1 EP R / 1836
28	RB 03	obv	П Д / [–]ИNО/ ЬЕВЬ / [Н] 70	P D / [–]INO/ 'EV" / [N] 70
		rev	S P B / N. –[–] / J.H. / 1836	S P B / N. –[–] / J.H. / 1836
29	RB 04	obv	– – / ДЕСЯТ / – – – / РОТ[–] – –	– – / DESyAT / – – – / POT[–] – –
		rev	АРХ. БР. / КУДЪБЛЯ / 2 СОРТЪ / Е. П. / 1869	ARKh. BR. / KUDyELyA / 2 SORT" / E. P. / 1869
30	RB 05	obv	АРХ. / ДЕСЯ – – / ПАВЕЛЪ / –ЕП – – –Нъ	ARKh. / DESyA – – / PAVEL" / –EP – –N"
		rev	АРХ. Б. / КРОNЬ / 4 СОРТЪ / Ф. Р. / 18[–][–]	ARKh. B. / KRON" / 4 SORT" / F. R. / 18[–][–]
31	RB 06	obv	– – / СЯ / АЛЕКСАN[–][–][–] / ПРЯНИШN	– – / SyA / ALEKSAN[–][–][–] / PRyANIShN
		rev	АРХ. БР. / ЧЕСКА / 2 СОРТЪ / М. К. / 1850	ARKh. BR. / CheSKA / 2 SORT" / M. K. / 1850
32	RB 07	obv	– – / NГ БРАК / ДѢСЯТЬN / ПЕТРЪ / – –ТКОВЬ	– – / NG BRAK / DyESyAT'N / PETR" / – –TKOV"
		rev	АР[–] – – / КУДЪБЛЯ / 1 СОРТЪ / Я. П. В. / 1889	AR[–] – – / KUDyELyA / 1 SORT" / yA. P. V. / 1889
33	AJPC 01	obv	No 4	No 4
		rev	N: P / S 1. 2 В / 1752	N: P / S 1. 2 B / 1752
34	AJPC 02	obv	No 20	No 20
		rev	–Р / [S] 1. 2 В / 1753	–P / [S] 1. 2 B / 1753
35	AJPC 03	obv	Д З / СыСОЕВЬ / Н 10	D Z / SYSOEV" / N 10
		rev	N Р / 1 F 12 H / 1777	N P / 1 F 12 H / 1777
36	AJPC 04	obv	Д – / ГОЛУБЪЯ / TNИКОВЪ / Н: 81	D – / GOLUBYA / TNIKOV" / N: 81
		rev	S: P B / 1 C Z. A H / 177[–]	S: P B / 1 C Z. A H / 177[–]
37	AJPC 05	obv	– Д / ШЕЛ[Е] / ПИNЬ / Н 354	– D / SheL[E] / PIN" / N 354
		rev	N Р / C F К 12 К / 1780	N P / C F K 12 K / 1780
38	AJPC 06	obv	Д N / УТАЧКI / Nь / Н 155	D N / UTAChKI / N" / N 155
		rev	N Р / C Н: 12 К / 1780	N P / C H: 12 K / 1780
39	AJPC 07	obv	П Д / И. М. БУ / ШЕВЬ / Н 31	P D / I. M. BU / ShEV" / N 31
		rev	S P B / 1 M B R / 182–	S P B / 1 M B R / 182–
40	AJPC 08	obv	+ / (Crossed keys)	+ / (Crossed keys)
		rev	(Blank)	(Blank)
41	AJPC 09	obv	1 S / 12 K	1 S / 12 K
		rev	(Shield quartered by heavy Cross and pellets)	(Shield Quartered by heavy Cross and pellets)
42	AJPC 10	obv	[A] R / 12 K	[A] R / 12 K
		rev	(Shield Quartered by heavy Cross and pellets)	(Shield Quartered by heavy Cross and pellets)
43	AC 01	obv	П.Д. / В: ДРО / ЖДИН / Н 24	P.D. / V: DRO / ZhDIN / N 24
		rev	S P B / B K R [H] / 1818	S P B / B K R [H] / 1818
44	JC 01	obv	N / 10	N / 10
		rev	W[U] / А И 9 П 9 / 1758	W[U] / A I 9 P 9 / 1758

45	JC 02	obv	П Д / И: Д: БУ / ШЕВЬ / [Н] 72
		rev	S P B / И. ФАН / 1816
46	JC 03	obv	Л: Д: / А. КОН / ДРАТЬ / Н 9
		rev	. N. P. / C Z 12 Н / 1788
47	JC 04	obv	Л: Д: / В А. ПИ / РОЖН[І] / Н 9
		rev	. N. P. / П А С 12 [-] / 1788
48	JC 05	obv	Л [Д] / И. М. ВИ / ННИК[-] / Н 5[6]
		rev	N P. / [L] 12 Н / 1826
49	JC 06	obv	П Д / [B]: СИМ / АНОВ / [-]
		rev	S P B / [І] К І N / 180[-]
50	JC 07	obv	[-] Д - / Д. [-]РЕХОВЬ / N 32
		rev	N P. / Ѳ 12 Н / [-]79[0]
51	JC 08	obv	. Л Д . / Е. МАР / ТИНО / -
		rev	N P / P F 9 Н / -[8]06
52	JC 09	obv	Д: А. / ПЕТЕ / ЛИНЬ / Н 232
		rev	S P B / І Н R Н / 177[-]
53	JC 10	obv	- Д / Г: МА - / [-]ЕНИ[Н] / Н 14[-]
		rev	S P B / M Ѳ R Н / 1799
54	JC 11	obv	. П Д / И: М: С- /МОН / Н [1]3
		rev	. S P B / . P B [-] / [-] 17 [-] / [-]
55	JC 12	obv	Л Д / [-][-][Ч]И / Нь . / Н432
		rev	. NP. / Т Ѳ 12 Н / [1]78[-]
56	JBC 01	obv	Л Д / К САНИ / ТИНЬ / Н 13-
		rev	N P / [H] 12 Н / -824
57	JBC 02	obv	А П / ДЕСЯЦКО / П П
		rev	А [П] / ЛНЯ БР / 2 ЕП Р / 1836
58	JBC 03	obv	W M / 12 K
		rev	(Arms: quartered shield with pellits)
59	JBC 04	obv	Л Д / Т КО3 / [Л]ОВЬ / Н –
		rev	N P / C G F 12 / 182–
60	JBC 05	obv	– – / Г В[-][-] / КУР[-][-] / Н – –
		rev	– – Ho П – . / [А] Б / 183[-]
61	JBC 06	obv	Л Д / Г БАЖ / ЕНОВЬ / Н 80
		rev	– Р / Н 12 Н / -794
62	JBC 07	obv	– – – / MAZKI / Б.А. / 1847 / StPB
		rev	2й С / – . – . / 9. П.
63	JBC 08	obv	Л Д / – КО3 / ЛОВЬ / Н 5[-]
		rev	N P / Ш 12 Н / – –05
64	JBC 09	obv	Л Д / – ПИР / ЖНИ / Н 2*
		rev	N P / Н 12 Н / –808
65	JBC 10	obv	Л. Д. / С ЗАС / ОРИ[Н] / Н 8[1]
		rev	N P / T Н 12 [H] / 179–
66	JBC 11	obv	/ ДЕСЯТ / АНТИ[ПА- –] / ТУ[ВО]
		rev	АРХ. Б / КУДЕЛ / 1 СОРТ / В. ЛЕД / 1849
67	JBC 12	obv	АРХ. Б / ДЕСЯ- - - /ПЕТР / МАРТІ
		rev	АРХ. П / КУДѢЛ. / 2 СОРТЬ / Я. П. В. / 1883

45	JC 02	obv	P D / I: D: BU / ShEV" / [N] 72
		rev	S P B / I. FAN / 1816
46	JC 03	obv	L: D: / A. KON / DRAT" / N 9
		rev	. N. P. / C Z 12 Н / 1788
47	JC 04	obv	L: D: / V A. PI / ROZhN[I] / N 9
		rev	. N. P. / P A S 12 [-] / 1788
48	JC 05	obv	L [D] / I. M. VI / NNIK[-] / N 5[6]
		rev	N P. / [L] 12 Н / 1826
49	JC 06	obv	P D / [V]: SIM / ANOV / [-]
		rev	S P B / [I] K I N / 180[-]
50	JC 07	obv	[-] D - / D. [-]REKhOV" / N 32
		rev	N P. / Th 12 Н / [-]79[0]
51	JC 08	obv	. L D . / E. MAR / TINO / -
		rev	N P / P F 9 Н / -[8]06
52	JC 09	obv	D: A. / PETE / LIN" / N 232
		rev	S P B / I H R H / 177[-]
53	JC 10	obv	- D / G: MA - / [-]ENI[N] / N 14[-]
		rev	S P B / M Th R H / 1799
54	JC 11	obv	. P D / I: M: S- /MON / N [1]3
		rev	. S P B / . P B [-] / [-] 17 [-] / [-]
55	JC 12	obv	L D / [-][-][Ch]I / N" . / N432
		rev	. NP. / T Th 12 Н / [1]78[-]
56	JBC 01	obv	L D / K SANI / TIN" / N 13-
		rev	N P / [H] 12 Н / -824
57	JBC 02	obv	A P / DESyAtsKO / P P
		rev	A [P] / LNyA BR / 2 EP R / 1836
58	JBC 03	obv	W M / 12 K
		rev	(Arms: quartered shield with pellits)
59	JBC 04	obv	L D / T KOZ / [L]OV" / N –
		rev	N P / C G F 12 / 182–
60	JBC 05	obv	– – / G V[-][-] / KUR[-][-] / N – –
		rev	– – /No P – . / [A] B / 183[-]
61	JBC 06	obv	L D / G BAZh / ENOV" / N 80
		rev	– P / H 12 Н / -794
62	JBC 07	obv	– – – / MAZKI / Б.А. / 1847 / StPB
		rev	2y S / – . – . / 9. P.
63	JBC 08	obv	L D / – KOZ / LOV" / N 5[-]
		rev	N P / Sh 12 Н / – –05
64	JBC 09	obv	L D / – PIR / ZhNI / N 2*
		rev	N P / H 12 Н / –808
65	JBC 10	obv	L. D. / S ZAS / ORI[N] / N 8[1]
		rev	N P / T H 12 [H] / 179–
66	JBC 11	obv	/ DESyAT / ANTI[PA- –] / TU[VO]
		rev	ARKh. B / KUDEL / 1 SORT / V. LED / 1849
67	JBC 12	obv	ARKh. B / DESyA- - - /PETR / MARTI
		rev	ARKh. P / KUDyEL. / 2 SORT" / yA. P. V. / 1883

Part Two. Catalogue of lead seals (Cyrillic and Roman) 115

68	JBC 13	obv	АР / ДЕСЯТ /-КОВ / Л—ОВ	AR / DESyAT /-KOV / L—OV
		rev	АР / КУДъЛ / 1 СОРТъ / Е. П / 1875	AR / KUDyEL / 1 SORT" / E. P / 1875
69	JBC 14	obv	АРХ. БР / ДЕСЯТНИК / НИКОЛАИ / ТУЛМИ	ARKh. BR / DESyaTNIK / NIKOLAI / TULMI
		rev	АРХ БР / ЗАБРАКъ / 2и РУКИ / Я. П. В. / 1877	ARKh BR / ZABRAK" / 2i RUKI / yA. P. V. / 1877
70	JBC 15	obv	Д. Д. / КОЛМIА / КОВ / Н 177	D. D. / KOLMIA / KOV / N 177
		rev	N P / PM 12 H / 1770	N P / PM 12 H / 1770
71	JBC 16	obv	Л. Д. [Н] ЗАХ / АРОВЪ / Н – –	L. D. [N] ZAKh / AROV" / N – –
		rev	N P / [-] P 12 H / 1792	N P / [-] P 12 H / 1792
72	AD 01	obv	ЛД / И: ПИР / ОЖНИК / Н 23	L D / I: PIR / OZhNIK / N 23
		rev	N – – 12 H / 1802	N – – 12H / 1802
73	AD 02	obv	ЛД / – ЛОБ / КОВЪ / Н 8	L D / – LOB / KOV" / N 8
		rev	N P / А Ш 12 К / –80[0]	N P / A Sh 12 K / –80[0]
74	AD 03	obv	– Д / – ОМ[-] / ЛИНЪ / Н 29	– D / – OM[-] / LIN" / N 29
		rev	N P / ЛГ 12 H / 180–	N P / LG 12 H / 180–
75	AD 04	obv	ЛД / Т: БАБ / ОНИНЪ / Н 23	L D / T: BAB / ONIN" / N 23
		rev	– – / М М 12 / [1]802	– – / M M 12 / [1]802
76	AD 05	obv	Л Д / А. АР[-] / [–]НИНЪ / Н – –	L D / A. AR[-] / [–]NIN" / N – –
		rev	S P B / А Р R Н / 1794	S P B / A P R H / 1794
77	AD 06	obv	Л. Д / ВОРО / БЕВЪ / [-][-]	L. D / VORO / "EV" / [-][-]
		rev	N P / Ш 12 K / [1]802	N P / Sh 12 K / [1]802
78	AD 07	obv	ЛД / Д. КАВ / ЕЛЕВЪ / Н 6[6]	L D / D. KAV / ELEV" / N 6[6]
		rev	[-] P / I. Н 12 Н / 1802	[-] P / I. H 12 H / 1802
79	AD 08	obv	Л – / [Р] : ЗАБ / [–]НИНЪ / Н 76	L – / [R] : ZAB / [–]NIN" / N 76
		rev	N P / Н 12 Н / 18–2	N P / H 12 H / 18–2
80	AD 09	obv	ЛД / С ВОРО / БЬЕВЬ / Н – –	L D / S VORO / B'EV" / N – –
		rev	[N] P / 12 H / [-][-]2	[N] P / 12 H / [-][-]2
81	AD10	obv	Л – / И М[Е]С / НИКОВ / Н 1[1][8]	L – / I M[E]S / NIKOV / N 1[1][8]
		rev	N [P] / 1 Н 12 / 1809	N [P] / 1 H 12 / 1809
82	AD 13	obv	Л: Д / С: ЛЕВ / АШЕВ / Н [8][3]	L: D / S: LEV / AShEV / N [8][3]
		rev	N P / C H 12 [K] / 181[0]	N P / C H 12 [K] / 181[0]
83	AD 14	obv	Л: Д / [-][-]ШИР / ЯЕВЪ / - 68	L: D / [-][-]ShIR / yAEV" / - 68
		rev	N P / C G F 12 [H] / 182[0]	N P / C G F 12 [H] / 182[0]
84	CD 01	obv	No [2][-]	No [2][-]
		rev	N P / В 12 [-] / 1755	N P / B 12 [-] / 1755
85	GD 01	obv	Л Д / К МЕР / КУЛОВ / Н 28	L D / K MER / KULOV / N 28
		rev	NP / [-] С Б 12 [-] / 182[-]	NP / [-] S B 12 [-] / 182[-]
86	GD 02	obv	ЛД / [С] ШИР / ЯЕВЪ / Н [-][-]	L D / [S] ShIR / yAEV" / N [-][-]
		rev	S P B / NP – 2 / [P] K / [1][8][3][8]	S P B / NP – 2 / [P] K / [1][8][3][8]
87	GGD 01	obv	+ (Cross Keys)	+ (Cross Keys)
		rev	4	4
88	GGD 07	obv	-[Д] / [-][-]ТО[Н] / – – – НОВ	-[D] / [-][-]TO[N] / – – – NOV
		rev	Illegible	Illegible
89	MD 01	obv	С. ПУН / ОВО	S. PUN / OVO
		rev	П А / П [А] / ОВЪ (double stamped)	P A / P [A] / OV" (Double stamped)
90	PD 9/01	obv	Д. К. / СТРҰН / НИКОВ / Н: 7	D. K. / STRUN / NIKOV / N: 7
		rev	S P B / A: K R: H / 178[-]	S P B / A: K R: H / 178[-]

				
91	PD 9/02	obv	Д.А / ЧУГАД / АЕВЪ / Н 7	D.A / ChUGAD / AEV" / N 7
		rev	N. P. / I. F. 12. Н / 1778	N. P. / I. F. 12. H / 1778
92	PD 9/03	obv	Л Д / КОР / ОЛЕВ / Н 78	L D / KOR / OLEV / N 78
		rev	[N]. P. / [-]Н 9 Н / 96*	[N]. P. / [-]H 9 H / 96*
93	PD 9/04	obv	I 1 / 2. К	I 1 / 2. K
		rev	(Quartered shield)	(Quartered shield)
94	TD 01	obv	[Д] / [А]НДР / ОНОВЪ / -- 77	-[D] / -- [A]NDR / ONOV" / --77
		rev	S P B / Н 3 / [I] [Н] / 1838	S P B / N 3 / [I] [H] / 1838
95	TD 02	obv	-- / ОА -[-] / ЕВЪ / -- 19	-- -- / O[-]A / [-]EV" / --19
		rev	-- / I К 12 / 1780	-- / I K 12 / 1780
96	TD 03	obv	-- / Н [V] / Н 1	-- / H [V] / H 1
		rev	N / I Н 12 Н / 1767	N / I H 12 H / 1767
97	DF 01	obv	Л Д / И РАСТ / ЕПАЕ	L D / I RAST / EPAE
		rev	N P / A P 12 / 179--	N P / A P 12 / 179--
98	DF 02	obv	Л [Д] / А: ШИ[П] / ОЧЕВ / Н 12	L [D] / A: ShI[P] / OChEV / N 12
		rev	N P / -- K 9 Н / 1799	N P / -K 9 H / 1799
99	DF 03	obv	Л. Д. / В ПИР / ОЖН. / Н [-]	L. D. / V PIR / OZhN. / N [-]
		rev	. N P. / R P 9 K / -- 79	. N P. / R P 9 K / --79
100	FF.02	obv	Л: Д / Ф: СА[-] / РОВ[-] / Н 73	L: D / F: SA[-] / ROV[-] / N 73
		rev	N P / P 9 H / 1806	N P / P 9 H / 1806
101	FF.03	obv	-- А. [-][-] / ХОВЪ / -- --	-- A. [-][-] / KhOV" / -- --
		rev	S P B / / 1781	S P B / / 1781
102	FF.04	obv	-- / ШЕ [Т] / ЕВЪ / Н 32	-- / ShE [T] / EV" / N 32
		rev	N P / Н Р 12 Н / 1781	N P / H P 12 H / 1781
103	FF.05	obv	-- / Л: В[-] / [-] О -- ВЪ / Н 12	-- / L: V[-] / [-] O -- V" / N 12
		rev	N P / [-][-] 12 Н / 1770	N P / [-][-] 12 H / 1770
104	FF.06	obv	Д. [И] / [-][-] / ДОЛГ / ПОЛОВ / Н 30[0]	D. [I] / [-][-] / DOLG / POLOV / N 30[0]
		rev	S P B / М М R Н / 1781	S P B / M M R H / 1781
105	FF.09	obv	Л. Д / [-] ШП / [О]ЧЕВ / Н 7 [-]	L. D / [-] ShIP / [O]ChEV / N 7 [-]
		rev	N P / T Н [9] Н / [-]806	N P / T H [9] H / [-]806
106	FF.10	obv	П Д / [-]. СА/ МУИЛ / -- 375	P D / [-]. SA/ MUIL / -- 375
		rev	S P B / V A. A / 17 / 17	S P B / V A. A / 17 / 17
107	FF.11	obv	-[Д] / -- -[-]ЛА / ТОВЪ / Н. 2[3]	-[D] / -- -[-]LA / TOV" / N. 2[3]
		rev	S P B / Ф [Н] R Н / 1782	S P B / F [N] R H / 1782
108	FF.13	obv	-- / -Е -/ -- [Н] [-]0	-- / -E -/ -- [N] [-]0
		rev	-- / Н 12 Н / 1775	-- / H 12 H / 1775
109	FF.14	obv	-- [-] / -- -[-] И[Н] / Н 27	-- [-] / -- [-] I[N] / N 27
		rev	-- / -- -- / 08	-- / -- -- / 08
110	FF.16	obv	ПЕТЕРБУРГ -- -- -- / О А / 17 --	PETERBURG -- -- -- / O A / 17 --
		rev	(Blank)	(Blank)
111	FF.18	obv	-- / УЧч[И] / -- [-] ВЪ / --	-- / U[Ch][I] / -- [-] V" / --
		rev	-- / [-] Н 1[-] Н / 1809	-- / [-] H 1[-] H / 1809
112	FF.19	obv	-- / [Б] -- / СОВЪ / Н 246	-- / [B] -- / SOV" / N 246
		rev	[-] Б / М Б R Н / 1[8]18	[-] B / M B R H / 1[8]18
113	FF.21	obv	-- / [-][-] О[-]IX-] / [-][-]	-- / [-][-] O[-] [Kh-] / [-][-]
		rev	-- / С Н -- / -- --	-- / C H -- / -- --

114	FF.22	П. Д. / А: ХЕР / [-]-]ОВЪ / - -	P: D / A: KhER / [-][-]OV" / - -
		S P B / [-]-[-]	S P B / [-]-[-]
115	SFl.01	П. Д. / [-][-]ЕР[-] / ТЕНО / [Н] 23	obv
		S P B / [-][-]Б Р [-] / 1814	P. D. / [-][-]ER[-] / TENO / [N] 23
			S P B / [-][-]B R [-] / 1814
116	SFl.02	П. Д. / Г. ЛАТЫ / ШЕВЪ / Н 6	P: D / G. LATY / ShEV" / N 6
		S P B / А И Г Р Н / 182[-]	S P B / A I G R N / 182[-]
117	SFl.03	П. Д. / А. ЕГО / РЬЕВО / Н 202	P. D. / A. EGO / RьEVO / N 202
		[P] [B] / Н. - 2. / Р. К. / 1833	[P] [B] / N. - 2. / P. K. / 1833
118	SFl.04	. П Д / П: ПА / ШКО[В] / Н 2[-]	.P D / P: PA / ShKO[V] / N 2[-]
		С П Б / ПЕН. 3 / Г. Б. / 1789	S P B / PEN. 3 / G. B. / 1789
119	SFl.05	Д. [-] / А ДО[-][-] / ШЕВ- / N 224	D. [-] / A DO[-][-] / ShEV- / N 224
		. Р. / W P Н / 1777	. P. / W P H / 1777
120	SFl.06	Д. К. / П ТН[-] / - - - ВЪ / N 138	D. K. / P TN[-] / - - - V" / N 138
		N P / D G 6 Н / 1778	N P / D G 6 H / 1778
121	SFl.07	П. Д. / Ф БАБ / ОШИН / -	P. D. / F BAB / OShIN / -
		S P B / F B 1 N / .18[-]1	S P B / F B 1 N / .18[-]1
122	SFl.08	[-] - / - МОШ / [N]ИКОВ / Н 327	[-] - / - MOSh / [N]IKOV / N 327
		N P / C Fe К 6 (double stamped N & С)	N P / C Fe K 6 (double stamped N & C)
123	SFl.09	П Д / И: ЧУП / ЯТОВ / Н 251	P D / I: ChUP / yATOV / N 251
		S Р [-] / - - - / 1777 (Double stamped. Date is stamped in reverse)	S P [-] / - - - / 1777 (double stamped. Date is stamped in reverse)
124	SFl.10	П / - - - - / НИКО / Н 66	P / - - - - / NIKO / N 66
		- - В / - - R Н / 180-	- - B / - - R H / 180-
125	SFl.11	П Д / С ПОЯ / КОВ / Н 30	P D / S POyA / KOV / N 30
		S P B / М С А Н / [1]824	S P B / M C A H / [1]824
126	SFl.12	-	-
127	SFl.13	S P B / Но - 3 / I. Н. / 1830	S P B / No - 3 / I. H. / 1830
		Л. Д. / - - И - - / ХОВЪ	L. D. / - - I - - / KhOV"
128	SFl.14	S P B / Т Н А Н / 1824	S P B / T H A H / 1824
		Д. Д. / -ЛЮ / ЕВЪ / . N	D. D. / -LyU / EV" / . N
		. S P. / Р. I. Н / 177-	. S P. / P. I. H / 177-
129	SFl.15	Л. Д. / [Е] БУДИ / [-]КИН / Н 192	L. D. / [E] BUDI / [-]KIN / N 192
		N P / I Н R / 1813	N P / I H R / 1813
130	SFl.16	. П Д / И: ВЕ[-] / ЕИТ[-]Н / Н 38	.P D / I: VE[-] / EIT[-]N / N 38
		- - / С К / .180	- - / C K / .180
131	SFl.17	Д. Д. / -ЛЮ / [Е]ВЪ / - -	D. D. / -LyU / [E]V" / - -
		S P / [N] П П Н / 1779	S P / [N] P I N / 1779
132	SFl.18	П. Д. / И ВЛА / СОВЪ / - - -	P. D. / I VLA / SOV" / - - -
		S P B / D Ш П Н / . 1815	S P B / D Sh I N / . 1815
133	SFl.19	П / Н. НЕ[-] / ИЛО[В] / Н 7[2]	P / N. NE[-] / ILO[V] / N 7[2]
		S P B / I F R Н / 1821	S P B / I F R H / 1821
134	SFl.20	P: Д. / Я. ЧУРА / КОВЪ / . Н 85	P: D. / yA. ChURA / KOV" / . N 85
		S P B / P. B A Н / 1792	S P B / P. B A H / 1792
135	SFl.21	Д. - / - - МЕС / ТОВСКОІ / Н 92	D. - / - - MES / TOVSKOI / N 92
		N. P. / H G K: 6K / 1779	N. P. / H G K: 6K / 1779
136	SFl.22	П Д / МІЛО / - ЯГИН / Н 26	P D / MILO / - yAGIN / N 26
		S P B / B K P [-] / . 181[-]	S P B / B K P [-] / . 181[-]

Part Two. Catalogue of lead seals (Cyrillic and Roman) 117

137	SFl.23	obv	П. Д. / К. КАРА / ПКОВЪ / No 32[0]	P. D. / K. KARA / PKOV" / No 32[0]
		rev	S P B / C. FE – A H / 1792	S P B / C. FE – A H / 1792
138	SFl.24	obv	Л. Д. / С. КОС / ТИНЪ / Н 76	L. D. / S. KOS / TIN" / N 76
		rev	S P / H. – 2 / I. C. / 1833	S P / N. – 2 / I. C. / 1833
139	SFl.25	obv	П. Д. / В. ПРО / ТОПО / Н. 9[2]	P. D. / V. PRO / TOPO / N. 9[2]
		rev	S P B. / F W P H / 1828	S P B. / F W P H / 1828
140	SFl.26	obv	[П] Д. / М. ПАП / КОВЪ / Н 5	[P] D. / M. PAP / KOV" / N 5
		rev	– P B / A I Г A H / 1823	– P B / A I G A H / 1823
141	SFl.27	obv	П Д / Н. КУД / РЯЕВЪ / Н 24	P D / N. KUD / RyAEV" / N 24
		rev	S P B / A K A – / 1794	S P B / A K A – / 1794
142	SFl.28	obv	– – [Н]. СА – – / НОВЪ / Н 2[–]5	– – [N]. SA – – / NOV" / N 2[–?]5
		rev	П Б / ПЕН 2. / Н. К. / 1833	P B / PEN 2. / H. K. / 1833
143	SFl.29	obv	:Д. Д. / А В Т – – / ХОВЪ /	:D. D. / A V T – – / KhOV" /
		rev	П Д / А М I Н / 1786	P D / A M I H / 1786
144	SFl.30	obv	+ (Cross Keys) / В	+ (Cross Keys) / B
		rev	(Blank)	(Blank)
145	JG 01	obv	П Д / И ВАСИ / ЛЬЕВЪ	P D / I VASI / LEV"
		rev	S P B / Г В И Н / 1815	S P B / G V I N / 1815
146	JG 02	obv	Л Д / МЕ[С][–] / ИНОВЪ / 8	L D / ME[S][–] / INOV" / 8
		rev	N P / E R 12 [H] / 181[7]	N P / E R 12 [H] / 181[7]
147	JG 03	obv	Л Д / [–][–][–] / [–] [У]ОВ / Н 28	L D / [–][–][–] / [–] [U]OV / N 28
		rev	(Illegible)	(Illegible)
148	WG 01	obv	Л Д / А [Н][–]Л / П[Л][–][–] / [–] 5	L D / A [N][–]L / P[L] [–][–] / [–] 5
		rev	* N P / L – K [1]2 / 179[–]	N P / L–K [1]2 / 179[–]
149	AH 01	obv	Л [–] / СМIРНО[В] / Н 133	L [–] / SMIRNO[V] / N 133
		rev	N P / F L / 9 H / 1765	N P / F L / 9 H / 1765
150	CH 01	obv	АРХ. БР. / ДЕСЯТН. / ПАВЕЛЬ / МУРГИНЪ	ARKh. BR. / DESyATN. / PAVEL" / MURGIN"
		rev	АРХАНГЕЛ. ПОР./ КРОНЬ/ 2. СОРТЪ / Я.П.В. / 1877	ARKhANGEL. POR./ KRON"/ 2. SORT" / yA.P.V. / 1877
151	JH(L) 01	obv	Л Д / САР[–] / [–] НIН /	L D / SAR[–] / [–] NIN /
		rev	N P / B A 12 K / 1789	N P / V A 12 K / 1789
152	JH(L) 02	obv	W. K. / [A] N 9 F F / 1760	W. K. / [A] N 9 F F / 1760
		rev	N / 5	N / 5
153	JH(L) 03	obv	N / 19	N / 19
		rev	W U / A N 9 Θ E / 1758	W U / A N 9 Th E / 1758
154	JH(L) 04	obv	N / 5	N / 5
		rev	.W. K. / A N 9 F [H] / 1760	.W. K. / A N 9 F [H] / 1760
155	JH(L) 05	obv	Д Л / ВАВIЛОВЪ / No 47	D L / VAVILOV" / No 47
		rev	W K / F L 9 H / 1762	W K / F L 9 H / 1762
156	JH(L) 06	obv	Д М / ВАВIЛОВЪ / N 47	D M / VAVILOV" / N 47
		rev	W. K / M H 9 H / 1762	W. K / M H 9 H / 1762
157	JH(L) 07	obv	Л Д / В. ЩОГ / ОЛЕВ / Н 6[–]	L D / V. ShchOG / OLEV / N 6[–]
		rev	N P / H P 12 K / 1797 (H P is a ligature)	N P / N R 12 K / 1797 (N R as a ligature)
158	JH(L) 08	obv	Л Д / И ВИН / НИКОВ / Н 20	L D / I VIN / NIKOV / N 20
		rev	/ P B 12 [–] / 1789	/ P B 12 [–] / 1789
159	JH(L) 09	obv	Л Д / Е ИВА / НОВЪ / Н 75	L D / E IVA / NOV" / N 75
		rev	N P / T X 12 H / 1791	N P / T Kh 12 H / 1791

Part Two. Catalogue of lead seals (Cyrillic and Roman) 119

160	JH(L) 10	obv	Д / [–]АЛИ / НКОИ / Н 52	D / [–]ALI / NKOI / N 52
		rev	N P / A H 12 K / 1780	N P / A H 12 K / 1780
161	JH(L) 11	obv	Д / ИВА / [Н]ОВЬ / [–]–[–] 5	D / IVA / [N]OV" / [–]–[–] 5
		rev	N: P / HF 12 / [–]79[–] (H F is a ligature)	N: P / HF 12 / [–]79[–] (H F as a ligature)
162	JH(L) 12	obv	Д / И МЕ[–] / НИКОВ / Н 1	D / I ME[–] / NIKOV / N 1
		rev	N P / H P 12 K / 17[8]2	N P / H P 12 K / 17[8]2
163	MH 01	obv	No. [2] 5	No. [2] 5
		rev	W. K / [–] N 6 P K / 0	W. K / [–] N 6 P K / 0
164	MH 02	obv	Л [К] / ЛАРІОНО / ВЬ / N 184	L [K] / LARIONO / V" / N 184
		rev	N P / Р. М. 12 Н / 1767	N P / P. M. 12 H / 1767
165	MH 03	obv	–	–
		rev	– – – –. 9 Н / 1766	– – – –. 9 H / 1766
166	MH 04	obv	Д І / НАЛОБІН / Н 91	D I / NALOBIN / N 91
		rev	N / P S 12 H / 176[5]	N / P S 12 H / 176[5]
167	MH 05	obv	Л Д / М. ЛЕВ / ШЕВЬ / Н 37	L D / M. LEV / ShEV" / N 37
		rev	N P / I Ch 12 H / 1803	N P / I Ch 12 H / 1803
168	MH 06	obv	Л Д / Т. ЖУК / ОВЬ / Н 83	L D / T. ZhUK / OV" / N 83
		rev	N P / T. K 12 K / 1793	N P / T. K 12 K / 1793
169	MH 07	obv	Л / N ЧЕ[–] / ЛОВ[–] / Н [–]-[–]	L / N ChE[–] / LOV[–] / N [–]–[–]
		rev	– –/ 12 H / [1]826	– –/ 12 H / [1]826
170	GI 01	obv	Д – / ВОРО / БЬЕВ[Ъ]	D – / VORO / BEV["]
		rev	* N P / A I B 12 H / 1774	* N P / A I B 12 H / 1774
171	GI 02	obv	* Д М. / БОЛО / ТИНЪ / Н 15	* D M. / BOLO / TIN" / N 15
		rev	S P B / C T. R. H / 1774	S P B / C T. R. H / 1774
172	RI 01	obv	Л. Д. / [–] ПОЛ / ОВОХИН / [Н][–]–]	L. D / [–] POL / OVOKhIN / [N][–]–]
		rev	. N P / H Ф 12 H / 1819	. N P / H F 12 H / 1819
173	CK 01	obv	П Д. / [–] СИ[–] / КОВСК[–] / Н 261	P D / [–] SI[–] / KOVSK[–] / N 261
		rev	S P B / A Ш: R H / 1794	S P B / A Sh: R H / 1794
174	WK 01	obv	Л.Д. / М. МЕР / КУЛОВ / Н 28	L.D. / M. MER / KULOV / N 28
		rev	N. P. / [С] Ч 12 H / 1805	N.P. / [S] Ch 12 H / 1805
175	WK 02	obv	[Л] [Д] / [И] НАДЕ / ЖИНЬ / Н 4	[L] [D] / [I] NADE / ZhIN" / N 4
		rev	N P. / A K 12 H / 1800	N P. / A K 12 H / 1800
176	WK 03	obv	N [–] / Д	N [–] / D
		rev	N [P] / A N 12 [H] / 1760	N [P] / A N 12 [H] / 1760
177	WK 04	obv	Л.Д. / [–]-[–]АН / ОН / Н 36	L.D. / [–]-[–]AN / ON / N 36
		rev	N. / [Я] C 12 /1798	N. / [yA] S 12 /1798
178	AL 01	obv	П. Д. / П. Я. В[А] / ЛИН / Н 49	P. D. / P. yA. V[A] / LIN / N 49
		rev	S P B / A Г R H / 1822	S P B / A G R H / 1822
179	AL 02	obv	Л Д / В ВОЛ / КОВЬ / –	L D / V VOL / KOV" / –
		rev	N P / W H 12 H / 1825	N P / W H 12 H / 1825
180	GL 01	obv	Д С / Д [Е] Md / ЯНОВЬ / Н 328 (d for ь)	D S / D [E] Md / yANOV" / N 328 (d for ъ)
		rev	N P / I C Z 12 [H] / 1786	N P / I C Z 12 [H] / 1786
181	GL 02	obv	Д. И. / [Я] РОСЛА / ВЦОВЬ / Н 127	D. I. / [yA] ROSLA / VTsOV" / N 127
		rev	S P B / I R A H / 1777	S P B / I R A H / 1777
182	GL 03	obv	– –/ ТRE[К] / Нь / Н 307	– –/ TRE[K] / N" / N 307
		rev	N P / Н. P 9 H / 1775	N P / H. P 9 H / 1775

183	GL 04	obv	Д / [-] РАС[-][-]NI / КОВЪ / Н 207	D / [-] RAS[-][-]NI / KOV" / N 207
		rev	N P / 12 H / 177[2]	N P / 12 H / 177[2]
184	JL 01	obv	К – / НЕВЪ / Н.I*	K – / NEV" / N.I*
		rev	[-][P][-] / S H. 3 / A. I I / - -37	[-][P][-] / S H. 3 / A. I I / - -37
185	JL 02	obv	[-][-] / Д ТА / ЛНН / Н 35[9]	[-][-] / D TA / LNN / N 35[9]
		rev	[-][-][-] / [-] [H]R - / 182[7]	[-][-][-] / [-] [H]R - / 182[7]
186	GMcA 01	obv	+ (Cross Keys) / 1	+ (Cross Keys) / 1
		rev	(Blank)	(Blank)
187	GMcA 02	obv	[-] [-] [-] / И: БУДЫ / ЛКИНЪ	[-] [-] [-] / I: BUDY / LKIN"
		rev	– – –	– – –
188	GMcA 03	obv	DYR – –[M]ERSKA / С 35 / Р. К. Р.	DYR – –[M]ERSKA / C 35 / P. K. P.
		rev	ZIABK / 28 V[1][8][75 / –	ZIABK / 28 V[1][8][75 / –
189	GMcA 04	obv	Л Д / Ф. ВИНО / КУРОВ / Н 1–5	L D / F. VINO / KUROV / N 1–5
		rev	N P / [O] P 12 H / 1825	N P / [O] P 12 H / 1825
190	GMcA 05	obv	П Д / : И: ПР / ОТОПО / Н 8	P D / : I: PR / OTOPO / N 8
		rev	– / [-][-][-][-]H / 1794	– / [-][-][-][-]H / 1794
191	GMcA 06	obv	Л Д / С. ЕРО / ХИНЪ / Н 4–	L D / S. ERO / KhIN" / N 4–
		rev	– Р – / П 12 Н / 1826	– P – / P 12 H / 1826
192	GMcA 07	obv	Л Д / Ф. ВИН[О] / КУРОВ / Н 12–	L D / F. VIN[O] / KUROV / N 12–
		rev	– – / О Р 12 Н / 1825	– – / O P 12 H / 1825
193	GMcA 08	obv	Л – / Е: ИВА / НОВЪ / - [-] 5	L – / E: IVA / NOV" / – [-] 5
		rev	– – / Т Н 12 / – –	– – / T H 12 / – –
194	GMcA 09	obv	Л Д / КОН / –НОВ / – 80	L D / KON / –NOV / – 80
		rev	N P / [–] Ф 12 Н / 1820	N P / [–] F 12 H / 1820
195	GMcA 10	obv	П Д / Г САМ / УИЛО / – 2 –	P D / G SAM / UILO / – 2 –
		rev	– / – – С К / 1794	– / – – C K / 1794
196	GMcA 11	obv	Л Д / [-]: Д: СА / [Н]ИНЪ / – 10	L D / [-]: D: SA / [N]IN" / – 10
		rev	N P / Н 12 Н / 1820	N P / H 12 H / 1820
197	GMcA 12	obv	Л Д / А: СИ[М] / ОНОВЪ / Н 55	L D / A: SI[M] / ONOV" / N 55
		rev	N P / Т Н 12 Н / 178–	N P / T H 12 H / 178–
198	GMcA 13	obv	/ – СКОР / ОГАТО / Н 65	/ – SKOR / OGATO / N 65
		rev	– – / N / F. W / 183–	– – / N / F. W / 183–
199	GMcA 14	obv	Л Д / ЗАХ / АРОВЪ / Н 74	L D / ZAKh / AROV" / N 74
		rev	N P / Н 12 Н / 1791	N P / H 12 H / 1791
200	PMcA 01	obv	– – / Т. КОЗ / ЛОВЪ / Н – –	– – / T. KOZ / LOV" / N – –
		rev	С П Б / – – – / 18[3]–	S P B / – – – /–18[3]–
201	AHM 01	obv	Л Д / В: ЩОГ / ОЛЕВ / N 6	L D / V: ShchOG / OLEV / N 6
		rev	N P / С HF 12 К / 17[–]2 (H F is a ligature)	N P / C HF 12 K / 17[–]2 (H F as a ligature)
202	AHM 02	obv	Д А / Н [–]О[–] / ДОВЪ / Н 62	D A / N [–]O[–] / DOV" / N 62
		rev	N P / Ме 12 Н / 1777	N P / Me 12 H / 1777
203	AHM 03	obv	/ Д. КОС / ТИНЪ / Н 25	/ D. KOS / TIN" / N 25
		rev	–[P][B] / – [H] 2 / M.C. / [1][8][-][-]	–[P][B] / – [N] 2 / M.C. / [1][8][-][-]
204	AHM 04	obv	Д / Ф / СИНЪ	D / F / SIN"
		rev	N P / 12 H / [-][-][-][-]	N P / 12 H / [-][-][-][-]
205	AMu 01	obv	Л Д / А: НАСУ / ХИНЪ / Н 95	L D / A: NASU / KhIN" / N 95
		rev	N P / I С Б 12 Н / 1821	N P / I S B 12 H / 1821

Part Two. Catalogue of lead seals (Cyrillic and Roman)

206	AMu 02	obv	Л Д / В. [П]И / КИНЬ / Н [-]
		rev	L D / V. [P]I / KIN" / N [-]
207	AMu 03	obv	- - / [-] [К] 12 [-] / 1821
		rev	- - / [-] [K] 12 [-] / 1821
208	AMu 04	obv	[-] Д / Б: ДЕМ / ИДОВЪ / Н 55
		rev	[-] D / B: DEM / IDOV" / N 55
			- - / P F 12 / 1821
			- - / P F 12 / 1821
		obv	Д. И / [Р]УСОВЪ / Н 44
		rev	D. I / [R]USOV" / N 44
			S P B / [S] S. R H / 1763
			S P B / [S] S. R H / 1763
209	AMu 05	obv	- - - / ЛСТ / ЯТ[-]В / Н [-][-]
		rev	- - - / LST / yAT[-]V / N [-][-]
			- - / 12 Н / [-]785
			- - / 12 H / [-]785
210	AMu 06	obv	- - / [-] ЧеР / НИКО[В] / Н 96
		rev	- - / [-] CheR / NIKO[V] / N 96
			- - / [-][-] 12 Н / 1812
			- - / [-][-] 12 H / 1812
211	AMu 07	obv	Л. Д. / И: ВАР / АКСИ / Н 14 [-]
		rev	L. D. / I: VAR / AKSI / N 14 [-]
			N P / А Ч 12 / 1819
			N P / A Ch 12 / 1819
212	AMu 08	obv	/ МЕС / НИКОВ / Н118
		rev	/ MES / NIKOV / N118
			- Р / W 12 Н / -825
			- P / W 12 H / -825
213	AMu 09	obv	Л Д / ЛЕВ[Ш]ЕВЪ / Н 37
		rev	L D / LEV[Sh]EV" / N 37
			N P / А Г 12 Н / 182-
			N P / A G 12 H / 182-
214	JM 01	obv	Л. Д. / Н. ШИ: / ЛОВЪ. / Н 51
		rev	L. D. / N. ShI: / LOV". / N 51
			N P / А Г 12 Н / 1827
			N P / A G 12 H / 1827
215	JM 02	obv	Л. - / [Щ]ЕР / БАКО / Н - - -
		rev	L. - / [Shch]ER / BAKO / N - - -
			S P B / N - - / F. W. / 1830
			S P B / N - - / F. W. / 1830
216	JM 03	obv	-РХ. / ДЕСЯ / АЛЕКСИИ / -ИЛКОВ
		rev	-RKh. / DESyA / ALEKSII / -ILKOV
			(Illegible)
			(Illegible)
217	JM 04	obv	П П П / А ПИСК / АРЕВЪ / Н 1
		rev	P I P / A PISK / AREV" / N 1
			Л П С / В. ТЮ / РИНЬ / Н I
			L P S / V. TyU / RIN" / N I
218	JM 05	obv	Л Д / М. СИМ / АНОВЪ / Н 82
		rev	L D / M. SIM / ANOV" / N 82
			N P / А Б 12 Н / 1810
			N P / A B 12 H / 1810
219	JM 06	obv	Л Д / К. САН[И] / ТИНЬ / [-] [-]
		rev	L D / K. SAN[I] / TIN" / [-] [-]
			S P B / NP - 2 / L. H. / 18- -
			S P B / NP - 2 / L. H. / 18- -
220	JM 07	obv	Л [Д] / [В]. ПРУД / ИНИНЬ / Н 83
		rev	L [D] / [V]. PRUD / ININ" / N 83
			S P B / NP . - 1 / J. H. / 1831
			S P B / NP . - 1 / J. H. / 1831
221	JM 08	obv	[Л] - / [-][Б][-][Н][Д] / [-]РОВЪ
		rev	[L] - / [-][B][-][N][D] / [-]ROV"
			- Но П - / - - / 184[-]
			- No P - / - - / 184[-]
222	JM 09	obv	- - - - / Н 40
		rev	- - - - / N 40
			- / [-]В
			- / [-]V
223	JM 10	obv	- Д / - - Р
		rev	- D / - - R
			С П Б / Н. 1 / [-][-] / 1836
			S P B / N. 1 / [-][-] / 1836
224	JM 11	obv	- - - / [-]ОВЪ / - 4 [1]
		rev	- - - / [-]OV" / - 4 [1]
225	KM 01	obv	(Illegible)
		rev	(Illegible)
			(Blank)
			(Blank)
		obv	S P B / A: H / 1745
		rev	S P B / A: H / 1745
226	KMo 01	obv	Л. Д. / Г. ЖУК / ОВЪ / Н 83
		rev	L. D. / G. ZhUK / OV" / N 83
			.N. P. / M M 12 Н / 179[-]
			.N. P. / M M 12 H / 179[-]
227	PM 01	obv	Л. Д. / В. ВОЛ / КОВЪ / Н 78
		rev	L. D. / V. VOL / KOV" / N 78
			С П Б / - П. I. / Д. Х. / 1830
			S P B / - P. I. / D. Kh. / 1830

122 Russian Cloth Seals in Britain

228	PM 02	obv	– [Н] / ИВ: СО[–] / РОВ/	– [H] / IV: SO[–] / ROV/
		rev	(An anchor with the letter C (= S) to its right. (? = St Petersburg, or St Petersburg Province)	An anchor with the letter S to its right. (? = St Petersburg, or St Petersburg Province)
229	PMn 01	obv	П. П. / Ф ЛАРІ / ОНОВЪ / Н 1	P. P. / F LARI / ONOV" / N 1
		rev	Л. П. С. / [Р]: ТЮР / ИНЪ / Н: І	L. P. S. / [R]: TyUR / IN" / H: I
230	RM 01	obv	Л Д / В: ВЕН / ЕДНКЪ / Н 52	L D / V: VEN / EDNKh / N 52
		rev	N P / E С 12 К / 1793	N P / E S 12 K / 1793
231	RN 01	obv	– Д / САФР / ОНОВЪ / Н 30	– D / SAFR / ONOV" / N 30
		rev	/ Т 12 [Н] / 1820	/ T 12 [H] / 1820
232	AJP 01	obv	* N [–] / * 42 *	* N [–] / * 42 *
		rev	N P / А Н 9 А О / 1759	N P / A H 9 A O / 1759
233	BP 01	obv	[Л] Д / МАЛ / [Л] [Ь] [Н]: / [[3]	[L] D / MAL / [L] ['] [N]: / [[3]
		rev	(Illegible)	(Illegible)
234	DP 01	obv	. П Д / Д ГЛА / ЗАНОВ / – –	. P D / D GLA / ZANOV / – –
		rev	S P B / [–] K [R] / 180–	S P B / [–] K [R] / 180–
235	DMP 01	obv	(Blank)	(Blank)
		rev	S P B / R : H / –747	S P B / R : H / –747
236	DMP 02	obv	Д: І К / МАСЛОВ / N 164	D: I K / MASLOV / N 164
		rev	S P B / S S. R. H / 1764	S P B / S S. R. H / 1764
237	DMP 03	obv	ГОСТОРГ. Н К. Т	GOSTORG. N K. T
		rev	ХОЛОДИЛЬНИК. С. К. / Г. П.	KHOLODIL'NIK. S. K. / G. P.
238	DMP 04	obv	Л Д. / С. СИНЯ / КОВЪ / Н 66	L D. / S. SINyA / KOV" / N 66
		rev	N. P / Т. Х. 12 К / 1793	N. P / T. Kh 12 K / 1793
239	DMP 05	obv	Л Д. / С. ВАР / ЗОВЪ / Н 14	L D. / S. VAR / ZOV" / N 14
		rev	N. P / Н Р 12 К / 1794	N. P / H P 12 K / 1794
240	DMP 06	obv	П. Н. О. / В. ТЮ / РИНЪ / Н	P. N. O. / V. TyU / RIN" / N
		rev	– . І. П. / А. УЛА / НОВЪ / Н [8]	– . I. P. / A. ULA / NOV" / N [8]
241	DMP 07	obv	КУДЕЛЬ / Іи СОРТЪ / ВОЛОГДА	KUDEL' / Ii SORT" / VOLOGDA
		rev	Г Г / ХИЛЛС И ВИШАУ / 1864	G G / KhILLS I VIShAU / 1864
242	DMP 08	obv	КУДЕЛЬ / 2 СОРТЪ / ВОЛОГДА	KUDEL' / 2 SORT" / VOLOGDA
		rev	Г Г / ХИЛЛС И ВИШАУ / 1864	G G / KhILLS I VIShAU / 1864
243	IP 01	obv	П. Д. / К. САМУ / ИЛОВ / Н 32	P. D. / K. SAMU / ILOV / N 32
		rev	S P B / – П. 3 / І. С. / 1830	S P B / – P. 3 / I. C. / 1830
244	IP 02	obv	П. Д. / С: НЕМ / ИЛОВ / Н 14[–]	P. D. / S: NEM / ILOV / N 14[–]
		rev	S P B / А Ш – – / 1803	S P B / A Sh – – / 1803
245	IP 03	obv	П. Д. / Ф. У. НИ / [Л]СКОЙ / Н 10	P. D. / F. U. NI / [L]SKOI / N 10
		rev	[S] [P] [B] / N Sh R / 1823	[S] [P] [B] / N Sh R / 1823
246	IP 04	obv	ФАБРИКА / Г. П. / ШВАБЕ / РИГА	FABRIKA / G. P. / ShVABE / RIGA
		rev	(Arms of the city of Riga, showing a gate surrounded by a double-headed eagle and surmounted by cross keys)	(Arms of the city of Riga, showing a gate surrounded by a double-headed eagle and surmounted by cross keys)
247	JP 01	obv	Л.Д. / И: ПЛЮ / ТНИК / Н 69	L.D. / I: PLO / TNIK / N 69
		rev	N P / [А] Г: 12 [К] / 1795	N P / [A] G: 12 [K] / 1795
248	NP 01	obv	Д Е / МИХАЛЕ / ВЬ / Н 230	D E / MIKhALE / V" / N 230
		rev	N P / I. F 12 H / 1770	N P / I. F 12 H / 1770
249	BR 01	obv	П Д / А. БОЛ / ОШЕВ / Н: 11	P D / A. BOL / OShEV / N: 11
		rev	[S] P B / A Ш: А Н / 1796	[S] P B / A Sh: A H / 1796

Part Two. Catalogue of lead seals (Cyrillic and Roman)

250	BR 02	obv	– Д / С. ВАР / ЗОВЪ / Н 14	– D / S. VAR / ZOV" / N 14
		rev	– / М М 12 Н / 1796	– / M M 12 H / 1796
251	BR(B) 01	obv	Д. М / ВАВИЛОВЪ / Н 47	D. M / VAVILOV" / N 47
		rev	N P / I C Z 12 H / [1]765	N P / I C Z 12 H / [1]765
252	BR(B) 02	obv	– / Б НА / ЛОВЪ / Н 20	– / B NA / LOV / N 20
		rev	S P B / M M R [H] / 181[–]	S P B / M M R [H] / 181[–]
253	MR 01	obv	Д [Н] / ЛАРИ / ВОНОВЪ / Н 184	D [N] / LARI / VONOV" / N 184
		rev	N P / I C 12 H / 1774	N P / I C 12 H / 1774
254	PR 01	obv	– – / ДЕМЬ / [Я][Н]ОВЪ / [–] 324	– – / DEM' / [yA][N]OV" / [–] 324
		rev	* N : P / I H 12 H / * 1786 *	* N : P / I H 12 H / * 1786 *
255	WR 02	obv	Д А / НЕѲЕ / ДОВЪ / No 32–	D A / NEThE / DOV" / No 32–
		rev	N P / H P 12 H / 1777	N P / H P 12 H / 1777
256	JS 01	obv	* N * / 23	* N * / 23
		rev	И. П. / И 12 МП / [1]759	I. P. / I 12 MP / [1]759
257	JS 01	obv	П Д / [–]. Ц[–] / [–]ИНЬ / Н 37	P D / [–]. Ts[–] / [–]IN" / N 37
		rev	SPB / H – 2 / W H / 1836	SPB / H – 2 / W H / 1836
258	JS 02	obv	П Д / А Р[Е] / [–]Е[В] / – –	P D / A R[E] / [–]E[V] / – –
		rev	– [–] / – F R H / [–][8]17	– – / – F R H / [–][8]17
259	JS 03	obv	Л Д / [Л] ГР[Е] / [–]НИК / Н 283	L D / [L] GR[E] / [–]NIK / N 283
		rev	S P B / – F R H / [1][8]17	S P B / – F R H / [1][8]17
260	JS 04	obv	. П Д / . Е. ЕРО / ХИНЬ / Н 43	. P D / . E. ERO / KhIN" / N 43
		rev	S.P.B / [–] F R [H] / –8[1]7	S.P.B / [–] F R [H] / –8[1]7
261	JS 05	obv	[П] Д / – [Х]РИ– / ИДСК / – [3]4	[P] D / – [Kh]RI– / IDSK / – [3]4
		rev	– / C H R H / 1817	– / C H R H / 1817
262	JS 06	obv	А. П / ДЕСЯЦКО / Ф К	A. P / DESyATsKO / F K
		rev	А. П / ЛНЯН БРАК / 3 ВД Р / 1832	A. P / LNyAN BRAK / 3 VD R / 1832
263	JS 07	obv	Л Д / В. ВОЛ / –ОВЪ / Н 78	L D / V. VOL / –OV" / N 78
		rev	N P / I C 12 / 1820	N P / I C 12 / 1820
264	JS 08	obv	/ЧЕБ / – ОКЪ / Н 86	/ChEB / – OK" / N 86
		rev	/ Ф 12 Н / 1824	/ F 12 N / 1824
265	JS 09	obv	Л. Д. / А. КОС / [Т]ИНЬ	L. D. / A. KOS / [T]IN"
		rev	N – / –[–][–] 12 / 182[–]	N – / –[–][–] 12 / 182[–]
266	JS 10	obv	/ Д[Е]ДО / ВНИКО / 7[9]	/ D[E]DO / VNIKO / 7[9]
		rev	N P / –Б 12 Н	N P / –B 12 H
267	JS 11	obv	Л Д / И ВИ[Н] / НИКО / [–] 20	L D / I V[IN] / NIKO / [–] 20
		rev	N P / А Б 12 К / 1805	N P / A B 12 K / 1805
268	JS 12	obv	Л Д / [–] КУЧ / КОВЪ / Н –2	L D / [–] KUCh / KOV" / N –2
		rev	N P / [–] C X 12	N P / [–] C X 12
269	JS 13	obv	Л: Д / СА / НИНЪ / [Н] [1] –	L: D / SA / NIN" / [N] [1] –
		rev	N P / Е C 12 H / 1800	N P / E C 12 H / 1800
270	JS14	obv	Д К / ЛАРIОНО / ВЪ / Н 18–	D K / LARIONO / V" / N 18–
		rev	N P / П S 9 H / 1764	N P / P S 9 H / 1764
271	JS 15	obv	Д К / ЛАРIОНО / ВЪ / Н 184	D K / LARIONO / V" / N 184
		rev	N P / Л [О] 12 Н / 1764	N P / L [O] 12 H / 1764
272	JS 17	obv	Л. Д. / [К] СИМ / [–]НОВ[–] / [Н] 7	L. D. / [K] SIM / [–]NOV[–] / [N] 7
		rev	N.P. / Н Р 12 Н / 179[–]	N.P. / H P 12 H / 179[–]

273	JS 18	obv	Д / ЕФИМ[Ъ] / ЯГОДН[И] / КОВЬ	D / EFIM" / yAGODN[I] / KOV"
		rev	С Н. / – С НАN – / [О][[–] / А[П]	C H. / – C HAN – / [O][[–] / A[P]
274	JS19	obv	Л.Д / С ЗАИЦОВЬ / 19	L.D / S ZAITsOV" / 19
		rev	[N] Р / – Ш 12 К / –796	[N] P / – Sh 12 K / –796
275	JS20	obv	Л.Д / А ПЕТУНОВЬ / 19	L.D. / A. PETUNOV" / N. 7[-]
		rev	N.P. / М Ѳ 12 / 178[-]	N.P. / M Th 12. / 178[-]
276	JS37	obv	– Д / НАВ- [Н] / СКОЙ / Н- 3	– D / NAV[N] / SKOI / N– 3
		rev	СП – / Н. П - / 84 / 1[8]41	SP – / N. P. – / 84 / 1[8]41
277	JS38	obv	– Д / П НАВ / НСКОЙ / Н13	– D / NAV / NSKOI / N13
		rev	СП – / Н. П - / 84 / 182[-]	SP – / N. P. – / 84 / 182[-]
278	JS39	obv	Л Д / А КУЧ / КОВЬ / Н62	L D / A KUCh / KOV" / N62
		rev	N Р / AV 9 Н / –81–	N P / AV 9 H / –81–
279	JS40	obv	– Д / КОНО/ ВАЛОВЬ / Н: 26	– D / KONO/ VALOV" / N: 26
		rev	СПБ / Н. П. 2 / В.	SPB / N. P. 2 / B.
280	JS49	obv	ЛД / П: ЛЕБ / ЕДЕВ / Н61	L D / P: LEB / EDEV / N 61
		rev	N Р / А Ш 12 К / –799	N P / A Sh 12 K / –799
281	JS64	obv	АРХ / ДЕСЯТН / ЕГОРЪ ТЕ / ВЛЕВЬ	ARKh / DESyATN / EGOR" TE / VLEV"
		rev	АРХ Б[Р] / ЗАБРАК / В ЛЕД / 1864	ARKh B[R] / ZABRAK / V LED / 1864
282	JS103	obv	ПЛПД / М. КАЛТ / УШКИ / Н. 2	PLPD / M. KALT / UShKI / N. 2
		rev	СПБ / F К 2 [Н] / –8[3][9]	SPB / F K 2 [H] / –8[3][9]
283	JSm 01	obv	– – / ЗЕМС / КОЙ / N 47	– – / ZEMS / KOI / N 47
		rev	N Р / PB 12 К / 1785	N P / PB 12 K / 1785
284	JT 01	obv	Л / З МАЛА / ѲЕЕВЬ / Н 21	L / Z MALA / FEEV" / N 21
		rev	N Р / А Б 12 Н / 1814	N P / A B 12 H / 1814
285	MT 01	obv	(two sables rampant standing either side of crossed arrows holding a bow beneath a crown)	(two sables rampant standing either side of crossed arrows holding a bow beneath a crown)
		rev	(two sables rampant standing either side of crossed arrows holding a bow beneath a crown)	(two sables rampant standing either side of crossed arrows holding a bow beneath a crown)
286	NMT 01	obv	П. Д. / Н: ШИ / ТИКО / Н 320	P.D. / N: ShI / TIKO / N 320
		rev	S Р В / W Н А N / 1822	S P B / W H A N / 1822
287	NMT 02	obv	[П] Д / А [Х]ОЛ / О[Ж]ИН / – 71	[P] D / A [Kh]OL / O[Zh]IN / – 71
		rev	S Р В / I C Z R / 178–	S P B / I C Z R / 178–
288	NMT 03	obv	Л Д / ХА / –ОВ / –84	L D / KhA / –OV / –84
		rev	S Р В / – [Б] R [[Н] / –817	S P B / – [B] R [[H] / –817
289	ST 01	obv	Л. Д. / К СИМ / АНОВ / Но 7	L. D / K SIM / ANOV / No. 7
		rev	N Р / Н 12 Н / 1797	N P / H 12 H / 1797
290	ST 02	obv	Д. Ѳ. / [Б] АВО / ШИНЬ / Н 4	D. Th. / [B] AVO / ShIN" / N 4
		rev	N Р / М Ѳ 12 / 178[-]	N P / M Th 12 / 178[-]
291	ST 03	obv	[Л]. Д. / И ШИП / АЧЕВЬ / Н 6	[L]. D / I ShIP / AChEV" / N 6
		rev	N Р / И Ч 12 К / 1800	N P / I Ch 12 K / 1800
292	ST 04	obv	[Л]. Д. / – – – А / [И]РОВЬ / Н 22	[L]. D / – – – A / [I]ROV" / N 22
		rev	/12 / /	/12 / /
293	ST 05	obv	Д. В. / ГОРIНЬ / Н 2[2]	D. V. / GORIN" / N 2[2]
		rev	N Р / M F 12 Н / 1764	N P / M F 12 H / 1764
294	ST 06	obv	Д. С / ВАР[-] / ОВ[Ъ] / Н 323	D. S / VAR[-] / OV["] / N 323
		rev	[N]Р / Н Р 12 Н / 1779	[N]P / H P 12 H / 1779
295	ST 07	obv	Л. Д. / [В]. СИЛ / – – НОВЬ / Н 17	L. D. / [V]. SIL / – – NOV" / N 17
		rev	N Р / В А 12 Н / 1789	N P / V A 12 H / 1789

Part Two. Catalogue of lead seals (Cyrillic and Roman)

296	ST 08	obv	- - / Е - - П / О - - - / Н322	- - / E - - P / O - - - / N 322
		rev	- Р / I [С] 12 Н / 1 - - [1]	- P / I [C] 12 H / 1 - - [1]
297	ST 09	obv	Д. Е. / МИХА / ЛЕВЬ / Н 230	D. E. / MIKhA / LEV" / N 230
		rev	N P / I F 12 H / [1] 1774	N P / I F 12 H / [1] 1774
298	ST 10	obv	Л Д / И: МЕР / КУЛОВЬ / - -	L D / I: MER / KULOV" / - -
		rev	N P / B A 12 K / 1800	N P / V A 12 K / 1800
299	ST 11	obv	Л.Д. / [-] СИМ / АНОВЬ / Н: - 7	L.D. / [-] SIM / ANOV" / N: - 7
		rev	N P / O H 12 K / 1792	N P / O H 12 K / 1792
300	EW 01	obv	[-] 2 Н / [-][-][-]Ш / [-]-[-]Ш / [-].[-].[-]	[-] 2 N / [-][-][-]Sh / [-].[-].[-].U.[-] / .[-].[-]
		rev	S P B / [-][-][-] / [-] / 17[9]9	S P B / [-][-][-] / [-] / 17[9]9
301	EW 02	obv	Л.Д. / Т. БАБ / ОНИН / Н 7 -	L.D. / T. BAB / ONIN / N 7 -
		rev	.N.P. / ПАС[-] / 1790	.N.P. / PAS[-] / 1790
302	EW 03	obv	П: Д / Е: ЛЕВ / Т[-]Е[В]. / Н 379	P: D / E: LEV / T[-]E[V]. / N 379
		rev	S P B / Г. Ф. К. Н / 1788	S P B / G. F. K. N / 1788
303	EW 04	obv	- - / Л: ДЕ[Н] / ИСОВЬ / Н 4	- - / L: DE[N] / ISOV" / N 4
		rev	- P / - A 12 H / 1820	- P / - A 12 H / 1820
304	EW 05	obv	- - / [-][-][-]Р / НИКОВЬ / Н 9[-]	- - / [-][-][-]R / NIKOV" / N 9[-]
		rev	- - / 1 Н 12 Н / [1]826	- - / 1 H 12 H / [1]826
305	EW 06	obv	Л.Д. / [Г] Л[-][-] / [-]И[-][И] / Н 69	L.D. / [G] L[-][-] / [-]I[-][I] / N 69
		rev	N. - / Т К 12 [Н] / 179[-]	N. - / T K 12 [H] / 179[-]
306	HAW 01	obv	/ ДЕСЯТС / МАКСИМЬ / [Ч]ЕРНЯ[Е]В	/ DESyATS / MAKSIM" / [Ch]ERNyA[E]V
		rev	АРХ. БР. / ОТБОРНЫ / 1 СОРТЬ / М. К. / 1848	ARKh. BR. / OTBORNY / 1 SORT" / M. K. / 1848
307	HAW 02	obv	/ ДЕСЯТ[С] / ГРИ. СО / ШКОВЬ	/ DESyAT[S] / GRI. SO / ShKOV"
		rev	АРХ. / ОТБОРН / 2 СОРТЬ / В ЛЕД / [1]842	ARKh. / OTBORN / 2 SORT" / V LED / [1]842
308	HAW 03	obv	Д: [А] / С Б[Ы][К]О / Вь / Н - -	D: [A] / S B[Y][K]O / V" / N - -
		rev	*N [Р]* / 1 [F] 12 H / 1775	*N [P]* / 1 [F] 12 H / 1775
309	HAW 04	obv	Д. [Я] / ВАВИ / ЛОВЬ / No 4	D. [yA] / VAVI / LOV" / No 4
		rev	.N.P. / I. R. 1.2 К / 177[-]	.N.P. / I. R. 1.2 K / 177[-]
310	HAW 05	obv	Д. I. / С. ЕЛИ / НСКОИ / Н 321	D. I. / S. ELI / NSKOI / N 321
		rev	.N : P. / I K 12 H / .1783.	.N : P. / I K 12 H / .1783.
311	HAW 06	obv	[-] МА / [Н] ОВЬ / Н. 83.	[-] MA / [N] OV" / N. 83.
		rev	N P / [-] К 12 Н / - - [7] 5	N P / [-] K 12 H / - -[7]5
312	HAW 07	obv	- - - / И. ТАР / АСОВ: / . Н 72	- - - / I. TAR / ASOV: / . N 72
		rev	- - / : А: Ш 12 К / 1795	- - / :A: Sh 12 K / 1795
313	HAW 08	obv	- - / К. Ря / БОВ / Н 50	- - / K. RyA / BOV / N 50
		rev	.N P . / C F 9 H / 1800	.N P . / C F 9 H / 1800
314	JW 01	obv	Д: Д / ЗЕМС / КО[-] / Н 51	D: D / ZEMS / KO[-] / N 51
		rev	С / 178 –	S / 178 –
315	JWa 01	obv	(Blank)	(Blank)
		rev	S P B / G C / 1749	S P B / G C / 1749
316	JWa 02	obv	Д: А / СИМАН / ОВЬ . N 3[5]	D: A / SIMAN / OV" . N 3[5]
		rev	S P B / Ф К Р Н / 1782	S P B / F K R H / 1782
317	JWh 01	obv	Л Д / Е. ИВА / НОВЬ / Н	L D / E. IVA / NOV" / N
		rev	/ Ѳ 12 Н / 1795	/ Th 12 H / 1795
318	JWh 02	obv	/ Н 4	/ N 4
		rev	/ 9 К / 1807	/ 9 K / 1807

126 Russian Cloth Seals in Britain

No.	Reference	Face	Transcription
319	MW 01	obv	Л. Д. / - - НА[Х] / - -ЕВЬ / - - - 7
		rev	- - / - - Р 1 / - - Н / 1838
320	TW 01	obv	[-][-][-] / НЕВЬ / Н -
		rev	С П Б / НЕН. 3 / М С / 1835
321	TW 02	obv	Л Д / М - - / ИХОВ / -2-
		rev	СП[Б] / IEH. / M. K. / 1[-][3]-
322	TWh 01	obv	/ А К[О][-]Ч / ИНЬ / - -
		rev	- - / Р F. 12 Н / - - / 1797
323	WEW 01	obv	. Л. Д. / И П[-]П / А[-]ЕВЬ
		rev	-
324	WEW 02	obv	Д / [-] ОЛ /[-][-]АНО / - / 1.
		rev	. W. K. / E C 12 H / 1801
325	WEW 03	obv	Л. Д. / Г. САР[Т]ИНЪ /
		rev	[-] Р / Но П / 18[-][-]
326	WEW 04	obv	Л. Д. / Г. НИК / ИФОРО / Н.
		rev	. N [-] / [-] P 12 [K] / .1801 .
327	WEW 05	obv	Л. Д. / - - У - - / - - - / - -
		rev	- - / Но - - / - - П / 18[-]7
328	SWi – 01	obv	- - / С [Б]Е[Р]NIKO / ВЪ / N 2[1]
		rev	N P / F L 12 H / 1763
329	SWr 01	obv	Д* / - - -КОВЬ / Но 8
		rev	- - К / - - 9Н / - - - 64

6.5. Anonymous [Recorded from incomplete or inaccurately reported source]

No.	Reference	Face	Transcription	Transliteration
a01	Anon. 01	obv	Л. Д. / В. А. ПИ / РОЖ[-][-] / –	L. D. / V. A. PI / ROZh[-][-] / –
		rev	N -. / F K 12 F / 1789	N -. / F K 12 F / 1789
a02	Anon. 02	obv	Л Д / Л. ЛО / А - - О / –	L D / L. LO / A - - O / –
		rev	(Illegible)	(Illegible)
a03	Anon. 03	obv	– Д / [Е] [Ш] И / ОЧЕВЬ / Н 2	– D / [E] [Sh] I / OChEV" / N 2
		rev	– / - - - 2 / 179[9]	– / - - - 2 / 179[9]
a04	Anon. 04	obv	* N * / * 25 *	* N * / * 25 *
		rev	- - / A N R A / 1760	- - / A N R A / 1760
a05	Anon. 05	obv	Д A / С АННIВ / Н 86	D A / S ANNIB / N 86
		rev	N P / Н Θ 9 Н / 1776	N P / H Th 9 H / 1776

Part Three. Appendices

7.1. Archangel Quality Control Officers (Initials АРХ, А.П.)

Interpretation	Seal transcription	Date	Seal accession number
Abramov, Petr	Абрамо[в], Петр	1872	CUPMS: 1999.52.3
Babikov, Vasilei	Бабиковъ, Василеи	1851	CUPMS: 1999.52.10
Bakhlanov, Vasilei	– –хлано, Василеи	1840	CUPMS: 1999.57.4
Bryukhanov, Vasilii	Брюхановъ, Василии	1847	CUPMS: 1999.56.3
Bryukhanov, Vasilii	Брюханов, Васил	1870	KIRMG. 2006.268
Bugaev, Fedor	Бугаев, Федоръ	1892	CUPMS: 1999.52.20
Bugaev, Fedor	Бугаев, Федоръ	19th c.	CUPMS: 1999.53.5
Bulychev, Aleksei	– –лычев, Алексеи	1869	ADMUS: A1988.297
[Bu]lychev, Aleksei	[Бу]лычевъ, Алексеи	1873	KIRMG. E585.03
Bulychev, Aleksei	– –лычевъ, – – – ксеи	19th c.	PERMG: 2000.243.11
Bulychev, Aleksei	Булычевъ, Алексеи	19th c.	KIRMG. 2006.259
Bulychev, Ivan	–улычевъ, Иванъ	1880	CUPMS: 1999.53.3
Bulychev, Ivan	Булычевъ, Иванъ	1874	CUPMS: 1999.53.9
Bulychev, Ivan	Булычевъ, Иванъ	1891	NMS:Hend.086
Bulychev, Vasilii	Булычевъ, Василеи	1877	ADMUS: M1995.160
Chernyaev, Maksim	[Ч]ерняевъ, Максимъ	1848	HAW 01
Dupaev, Yakov	Дупаевъ, Яковъ	1857	CUPMS: 1999.52.14
Erofeev	Ерофеевъ	1859	CUPMS: 1999.54.14
Farutin	Фарутинъ	1853	DUN: AHH.2005–16.05
Gribin, Aleksey	Грибин, Алексей	1853	DUN: AHH.2005–16. 02
Ivoninskoi, Stepan	Ивонинск –, Степанъ	1887	ADMUS: B1988.8
Ivoninskoi, Stepan	[И]вонискои, Степанъ	1902	CUPMS: 1999.216.1
Karpov, Mikhailo	Карпов, Михаило	1845	KIRMG. 2006.198
Karpov, Mikhailo	Карповъ, Михаило	1847	CUPMS: 1999.53.15
Kiselev, Grigorii	Киселевъ, Григории	1897	CUPMS: 1999.57.1
Klaft, Karpo	Клафт, Карпо–	1863	CUPMS: 1999.52.4
Kornakov, Ivan	Корна[–]овъ, Иванъ	1873	KIRMG. 2006.269
Kuktinsk– –, Ivan	Куктинск, Иванъ	1883	DUN: 1999.21 (4)
Lepikhin, Mikhail	Лепихинъ, Михаилъ	1846	KIRMG. 2006.255
Lepikhin, Pavel	[–]е[п]ихинъ, Павелъ	1881	NMS: Henderson.087
Lopotovskoi, Aleks.	Лопотовскои, Алек.	1838	CUPMS: 1999.55.3
Martinov, Petr	Марти, Петр	1883	JBC 12
Mart'yan(ov) / (ychev), Petr	Мартья, Петръ	1877	CUPMS: 1999.52.9
Murgin, Pavel	Мургинъ, Павелъ	1877	CH 01
Mut'yanov, Matvei	Мутьян, Матвеи	1879	LWMCH: 03
Naugol'noi, Aleksandr	Наугольнои, Алексан[д]	1847	CUPMS: 1999.54.20
Onisimov, Gavriilo	Онисимовъ, Гавриило	1898	CUPMS: 1999.57.3
Onisimov, Ivan	[О]нсимовъ. Иванъ	1880s	ADMUS: M1995.159
Orekhov, Aleksei	Ореховъ, Алексе	1839	DUN: AHH.2005–16.01
Ozyapkin, Aleksei	Озяпкинъ, Алексе	1839	ADMUS: DBA3393/d
Pyatk(ov), Mikhail	Пятк[– –], Михаил	1860s	CUPMS: 1999.217.1
Plotnikov, Petr	Плотниковъ, Петръ	1870	DUN: AHH.2005–16.04
Plutel'noi, Aleksandr	Плутельной, Александръ	1881	KIRMG. 2006.281
Popov, (Ivan)	Поповъ [Ива–]	1845	CUPMS: 1999.56.6
Popov-Vedenskii, – –ma	Поповъ-[–][е]дѣнскии,– –ма	1878	CUPMS: 1999.52.7
Popov-Vedenskii, Foma	Попо[–][–] – –дъ [–], Фома	1878	CUPMS: 1999.54.19
Pruskov, Andrei	Пр[у]сков, Андреи	1838	KIRMG. 2006.209
Pryanishnikov, Aleksandr	Прянишн, Александръ	1850	RB 06
Rogov Aleksandr	Роговъ, А[л][е]ксандръ	1887	ADMUS: B1987.23
Rykov, Nikolai	Рыко[въ], Николаи	1871	CUPMS: 1999.52.5

Sedel'nikov, Sergei	Седельн, Сергий	1871	CUPMS:1999.53.6
Sharypov, Mitrofan	Шары, Митрофа	1862	KIRMG. 2006.261
Sharypov, Mitrofan	Шары, Митрофа	1863	CUPMS: 1999.53.13
Sharypov, Mitrofan	Шары, Митрофа	1869	DUN: AHH.2005–16. 03
Sharypov, Mitrofan	Шарыпов, Митроф	1881	KIRMG. 2006.195
Sherinin, Nikol	Шер[и]н[и], Никол	1864	KIRMG. 2006.265
Shorsk[oi], Aleksandr	Шорск, Алекса	1839	KIRMG. 2006.213
Shubin, Semen	Шубинъ, Семенъ	1880	KIRMG. 2006.317
Shubin, Stepan	Шубинъ, Степанъ	1888	ADMUS: M1995.156
Shulyegin, Pavel	Шулъгин, Павелъ	19th c.	KIRMG. 2006.277
Shulgin, Dmitrii	Шулги–, Дмитре	1857	CUPMS: 1999.54.17
Shul'gin, Ivan	[Ш]ульгин	1871	KIRMG. 2006.316
Sobolev, Il'ya	Соболевъ, Илья	n. d.	FALKM. 2002.43.07
Sorokin, Efim	Сорокин, Ефимъ	1851	CUPMS: 1999.54.18
Soshkov, Grigorii	Сошковъ, Гри.	1842	HAW 02
Stepanov, Vasilei	Ст[е][–]анов, Василеи	1852	KIRMG. 2006.266
Stepanov	Степа[–]овъ	1813	GLDM:29.02
Sveshnikov, Mikhailo	Свешниковъ, Михаило	1857	CUPMS: 1999.53.4
[Sv]eshnikov, Mikhail[o]	–ешников, Михаил–	1844	DUN:1976.2267
Tevelev, Egor	Тевлевъ, Егоръ	1863	CUPMS: 1999.54.12
Tevelev, Egor	Тевлевъ, Егоръ	1874	CUPMS: 1999.54.13
Tevelev, Egor	Тевл[е]въ, Егоръ	1886	CUPMS: 1999.53.16
Tevelev, Egor	Тевлевъ, Егоръ	1894	CUPMS: 1999.57.5
Tevelev, Egor	Тевлевъ, Егоръ	1890s	CUPMS: 1999.53.10
Tevelev, Egor	[Т]евлевъ, Егоръ	1890s	CUPMS: 1999.55.4
Timkin, Vasilei	Тимкинъ, Василеи	1866	CUPMS: 1999.57.2
Vedenskoi, Matvei	Веднско, Матвеи	1840s	CUPMS: 2005.283
Vedenskoi, Matvei	Веденско[и], Матвеи	1844	ABDM: 072688
Vedenskoi, Matvei	Веденскои, Матвеи	1846	LCM: 86.72
Vedenskoi, Matvei	Веденск Матвеи	19th c.	KIRMG. 2006.257
Vedenskoi, Matvei	Веднскои, Матве[и]	1847	CUPMS: 1999.53.14
Vedenskoi, Matvei	Веденскои, Матвеи	1851	CUPMS: 1999.52.1
Vedyenskoi, Matvei	Веденско, Матвеи	n. d.	CUPMS: 1999.52.22
Zhukov, Petr	Жуковъ, Петръ	1864	CUPMS: 1986.983
Zhukov, Petr	Жуковъ, Петръ	1871	ARDG 01
Zhukov, Petr	Жуковъ, Петръ	1875	KIRMG. 2006.210
Zhukov, Petr	Жуков, Петръ	1881	KIRMG. 2006.275
Zvyagin, Vasilii	Звягин, Василии	1884	CUPMS: 1999.52.2

7.2. St Petersburg Quality Control Officers (Initials SPB / СПБ / SP)

Interpretation	Seal transcription	Date	Seal accession number
Andronov	Андроновъ	1838	TD 01
Antyukhin	Антюхи	1830	DUN: 1978.1430(5)
Aref'ev, N.	Арефьев–, Н	1830	FALKM. 2002.43.01
Aref'ev, N.	Арефьев–, Н	1837	KIRMG. 2006.288
Aref'ev, S	Аре[ф]ьевъ, С	1807	CRMCH 1991.38.8
Aref'ev	Ар[е][–]е[в]	1817	JS 02
Arlov, M. I.	Арловъ, М И	1830s	ABDM: 072683
Arlov	Ар[–]овъ	1830s	KIRMG. 2006.223
Arlov, I.	Ар[л]овъ	n. d.	KIRMG. 2006.314
Baboshin, F.	Бабошин, Ф	19th c	SFl 07
Balashev	Балашевъ, [–]	19th c	CRMCH: 1996.37.03
Belkov, V.	Бе[л]ков, В	1832	FALKM. 2002.43.05
Boloshev, A.	Болошев, А	1796	BR 01
Boloshev, M.	Болошевъ, М	1799	CRMCH 1990.3.24
Bolotin	Болотинъ	1774	GI 02
Bushev, I. D.	Бушевъ, И. Д.	1816	JC 02
Bushev, M.	Бушевъ, М	1797	NLA (HER) 23698
Bushev, I. V.	Бушевъ, И. В.	1826	NML. 2007.21.3
Bushev, I. M.	Бушевъ, И. М.	1820s	AJPC 07
Butylkin	Бутылки	1805	CRMCH 1990.29.3
Chernikov, A.	Чернико[в], А	19th c.	KIRMG. 2006.222
Chernikov, N.	Черниковъ, Н	1830	CUPMS: 1999.55.22
Chernyshov	Чернышо	1825	CRMCH: 2002.004.01
Chertkov	Чертковъ	1838	CRMCH 1991.60.1

Chupyatov, I.	Чупятов, И	1825	CRMCH: 2002.004.03
Chupyatov, I	Чупятов, И	1777	SFl 09
Chupyatov, S	Чупятовъ, С	1820s	CUPMS: 2005.286
Chupyatov	Чупятовъ	1836	DUN: 1989.66(1)
Churakov	Чураковъ	1781	MM: 2006. 14
Churakov, Ya.	Чураков, Я.	1792	SFl 20
Damanov, B	Даманов, Б	n. d.	CRMCH: 2002.004.04
Dedkov	Дедковъ	19th c	CUPMS: 2005.284
Dedovnikov	Дедонико	1838	KIRMG. 2006.197
Dedovnikov	Дедоник	n. d.	DUN: 1999.21 (1)
Dedovnikov	Дедоников	1830s	ABDM: 072695
Demidov	Демидовъ, [–]	1804	CRMCH 1991.3.21
Demidov	Демидовъ	1830s	CUPMS: 1998.6.1
Demyanov, E.	Дем[я]нов, Е	1830	CUPMS: 1999.53.42
Dmitr'ev	Дмитревъ	1787	CRMCH: 2002.12.3
Dolgopolov	До[л]гопо[л]овъ	1781	CRMCH 1990.3.13
Dolgopolov	Долгполов	1781	FF 06
Dolgopolov	Дол[–]опо	1803	OXFAS: 1998.106
Dorofeev	Дарафъевъ	1831	ADMUS: M1998.157
Drozhdin V	Дрождин, В.	1818	AC 01
Egor'evo, A.	Егорьево, А.	1833	SFl 04
Eremeev, I. M.	Еремеевъ, И. М.	1829	DUN: AHH.2005–16.09
Eremeev	Ере[м]–ев	n. d.	KINCH: 1339.1986.565
Eremeev, [I] M.	Еремеевъ. [И] М.	1830s	CUPMS: 1998.6.15
Erenevskoi, M	Ерен–евскои, М	1830s	KIRMG. 1999.214
Erenevskoi, M	Ер[–]–евско, М	1840s	KIRMG. 2006.290
Erokhin, A	Ерохинъ, А	1830s	KIRMG. 1999.213
Erokhin, A.	Ерохинъ, А	1783	KIRMG. 2006.298
Erokhin, E	Ерохинъ, Е	19th c.	JS 04
Erokhin, S	Ерохинъ, С	1830s	CUPMS: 1998.6.3
Fedotov. M.	Федотовъ, М	1833	CUPMS: 1999.52.24
Filatov, S	Филатов, С	1838	CUPMS: 1999.56.13.
Filatov, S.	Филатовъ, С	1838	CUPMS: 1999.55.8
Filatov, S.	Филатовъ, С	1831	CUPMS: 1999.54.38
Filatov	Фил[а]тов	1836	CUPMS: 1999.52.25
Garchukov	Га[рч]уков	1771	OXFAS: 1987.188
Glazanov, D.	Глазанов, Д	1800s	DP 01
Golubyatnikov	Голубятниковъ	1775	CRMCH 1991.29.03
Golubyatnikov	Голубятинковъ	1770s	AJPC 04
Gorbunov, M.	Горбунов, [М]	1800	WE 02
Gorbunov, V.	Горбуновъ, В	1833	CUPMS: 1999.53.17
Grechikhin / Grechanin	Греч– –[–]инъ, [–]	1830s	NMS: 29.10.93.F1 (183–)
Kaltushkin, M.	Калтушкн, М	1831	CUPMS: 1999.56.9
Kaltushkin, M.	Калтушкн, М	1831	CUPMS: 1999.53.18
Kaltushkin, P.	Кал[т]ушки, П	1833	CUPMS: 1999.53.19
Kaltushkin, P.	Калтушки, П	1833	FALKM. 2002.43.02
Kaltushkin, P	Калтушки, П	1830s	CUPMS: 1999.53.22
Kaltushkin, P.	Калтушки, П	1830s	CUPMS: 1999.54.32
Kaltushkin, P.	Калтушки, П	1840s	FALKM. 2002.43.03
Kaltushkin, P	Калтушкин, П	1839	CUPMS: 1999.52.35
Kaltushkin	Калтушки	1836	CUPMS: 1999.52.31
Karapkov, K.	Карапковъ, К.	1792	SFl 23
Kaverzin	Кав [–] [–]зинъ	1831	ABDMS: 072686
Kazlov, A.	Казловъ, А	1832	CUPMS: 1999.216.5
Kazlov, A	Казловъ, А	1830s	ADMUS: A1989.247
Khokhlov, T	Хо[–][–]овъ, Т	1838	DUN:1978.1430(3)
Khramtsov, U	Храмцов, У	1787	OXFAS: 1987.179
Khramtsov, U	Храмцовъ, У	1792	GRYEH: 1981.45.4
Khramtsov, U	Храмцовъ, У.	1801	NEBYM: A1299
Klyapin	Кл[я]п[и]нъ	n. d.	CRMCH: 2002.004.05
Klyuev	Клюевъ	1777	INVMG: 2003.120.059
Klyuev	Клюевъ –	1779	CRMCH: 1991.29.06
Klyuev	Клюевъ	1779	CRMCH: 1990.3.18
Klyuev	[К]люев	1770s	SFl 14
Klyuev	[–]люевъ	1779	SFl 17
Kochevskoy	Коче[в]скои, П	1829	CRMCH: 1996.32.01

Koptev, A.	Коптев, А	1832	CUPMS: 1999.52.42
Koptev	Ко[п]тевъ	1838	CUPMS: 2005.281
Kostin, D.	Костинъ, Д	1829	CUPMS: 1999.55.7
Kostin, D.	Костинъ, Д	n. d.	AHM 03
Kostin, M.	Костинъ, М	19th c.	KIRMG. 2006.340
Kostin, N.	Костинъ, Н	1830s	CUPMS: 1998.6.17
Kostin, S.	Костинъ, С	1833	SFl 24
Kostin, V.	Ко[с]тинъ, В	1801	CRMCH: 1991.29.02
Kozlov, T.	Козловъ, Т	19th c	PMcA 01
Kozulin, P.	Козули[н], П	1790	CRMCH 1990. 3.27
Kryukov	Крюковъ	1805	SF (SMR) LUD misc.MSF23230
Kudryaev, K.	Ку[–]ряев, К	1804	CRMCH 1992.11.2
Kudryaev, N.	Кудряев, Н	1794	SFl 27
Kudryaev, N.	Кудряевъ, Н	1835	ADMUS: A2000.212
Kudryaev, V.	Кудряев, В	1790s	CRMCH: 2002.12.1
Larionov, T.	Ларионов[ъ]	1832	CUPMS: 2005.289
Latyshev, G.	Латышев, Г	1820s	SFl 02
Latyshev, [–]	Латышевъ, [–]	1823	CRMCH 1990.29.2
Lgalin, P.	Лгалинъ, П	1789	CRMCH 1990.3.22
Lenteev, G.	Лентеевъ, Г	1831	CUPMS: 2007.91
Lobkov	Лобковъ, [–]	1838	CUPMS: 1999.57.10
Lozgin, M.	Лозгинъ, М	1790s	NLA (HER) 42590
Markov, M.	Марковъ, М	1837	LCM: 90.36/9
Martinov, E.	Мартино, Е	1831	LWMCH: 01
Martinov, E.	Ма[р]тин, Е	n. d.	ADMUS: M1998.166
Mashkov	Машковъ, [И]	1830s	CUPMS: 1999.54.21
Maslennikov	Масленков	1778	OXFAS: 1980.271
Maslenin, S.	Масленин, С	1830s	CUPMS: 1998.6.18
Maslov	Маслов	1764	DMP 02
Mesnikov, G.	Месников, Г	1832	DUN: AHH.2005–16. 13
Miloyagin	Милоягин	1810s	SFl 22
Morozov	Марозовъ	1776	NLA (HER) 25178
Morozov, K.	Ма[–]озо[в], К	1799	CUPMS: 1999.54.33
Morozov	Мор[о]зовъ	1840	FALKM. 2003.3.2
Navnskoi, P.	Навнскои, П	1829	NMS:Hend.090 (1829)
Navnskoi, [A]	Навнскои, [А]	1820s	CUPMS: 1998.6.12
Nadezhin, I	Наде[ж]ин, [И]	1833	ADMUS: M1995.163
Nadezhin, I	Надежин, И	1830s	CUPMS: 1999.54.25
Nechaev, I.	Нечаевъ, И	1798	CRMCH 1991.23.02
Nekhoroshev	Нехорошев	1818	CRMCH 1990.3.7
Nelyubov. L.	Нелюбов, Л	1821	ABDM: 072679
Nemilov	Немиловъ	1778	CRMCH 1992.11.1
Nemilov, B.	Нем[и]ловъ, Б	1805	SF. (SMR) COR 050
Nemilov, N.	Не[–]ило[в], Н	1821	SFl19
Nemilov, L.	Немиловъ Л	1830s	CUPMS: 1999.54.22
Nemilov, S.	Немилов, С	1803	IP 02
Novgorodtsov, E	Новгоро[д], Е	1802	NLA (HER) 42579
Novgorodtsov	Новго[–]дцовъ	1838	CUPMS: 1998.6.9
Novikov, I.	Новиковъ, И	n. d.	ADMUS: M1997.137
Novikov, I.	Новиков, И	19th c	CUPMS: 1999.52.41
Novotorzh, L.	Новоторж, Л	1797	CRMCH: 1990.3.17
Obraztsov	Образцовъ	1778	CRMCH 1991.04.1
Panfilov	[П]анфиловъ	1839	ADMUS: M1995.165
Panfilov	Панфиловъ	19th c	CUPMS: 1999.54.24
Papkov, M.	Папковъ. М	1823	SFl 26
Pashkov, P.	Пашков, П	1789	SFl 04
Petelin	Петелинъ	1770s	JC 09
Pogankin, D.	Паганки[н], Д	1799	CRMCH 1991.38.3
Pogankin	Пог[а]нкинъ	1833	CUPMS: 1999.52.28
Polovokhin, P.	Половохи, [П.]	1800	CUPMS: 1999.57.11
Poyakov, A.	Пояковъ, А	1790	OXFAS:. 1980.272
Poyakov, S.	Пояков, С	1824	SFl 11
Pozrekov	Поз[р]еков	1836	ADMUS: A1989.264
Pronin, V.	Пронинъ, В	1829	DUN: 1999.21.2
Protopopov, V.	Протопо(пов), В	1828	SFl 25
Prudinin	Прудининъ	1831	JM 07

Puzyrev, M.	Пу[-]ырев, М	1789	OXCMS.1985.214.1
Rudometov, A.	Руд[о]мето[в], А	1831	DUN: AHH.2005–16. 11
Ryabov, K.	Рябовъ, К	1831	ABDM: 072692
Ryabov	Рябовъ	1831	KIRMG. 2006.286
Rya[-]ov	Ря[-]овъ	1836	HARGM: 12706.10
Rybnikov, G	Рыб[-]иковъ	1841	KIRMG. 2006.292
Safronov, E.	Сафроновъ, Е	1836	CUPMS: 1999.54.35
Samoilov	Самоилов	1836	KINCM: 1339.1986.564
Samuilov, K.	Самуиловъ, К.	1830	IP 01
Samuilov	Самуил	18thc	FF 10
Sanitin, K.	Санитинъ, К	19thc	JM 06
Sanitin, K.	Санитинъ, К	n. d.	CUPMS: 1998.6.14
Sartin, G.	Сар[т]инъ, Г	19thc	WEW 03
Sedov	Седов	n. d.	CRMCH: 2002.12.4
Sedov	Седовъ	1787	MoL: 2006.7/4
S[e]dov, L. / S[u]dov, L.	С[-]довъ, Л	1814	CRMCH 1991.04.5
Selin, D.	Се[-]инъ	1830s	CUPMS: 1999.53.20
Selin, N.	Селинъ, Н	1832	CUPMS: 1999.56.8
Selin, S.	С[е]лин[ъ], С	1825	CRMCH: 1996.37.06
Selin	Селинъ	1833	CUPMS: 1999.52.32
Selin	Селинъ	1832	CUPMS: 1999.52.33
Shamin, A.	Шаминъ, А	1770s	NMS: PSin (1774)
Shamin	Шаминъ	1775	CRMCH: 2002.003.02
Shamin	[-]аминъ	1775	CRMCH 1996.037.02
Shcherbakov,	[Щ]ербако	1830	JM 02
Shcherbakov, P.	Щер[-]ако, [П]	1831	CUPMS: 1998.6.5
Shcherbakov, P.	Щербако, П	1831	CUPMS: 1998.6.4
Shcherbakov, P.	Щербако, П	1831	CUPMS: 1999.54.27
Shcherbakov, P.	Ще[-]бако, П	1830s	ABDM: 072684
Shchukin, G.	Щукинъ, Г	1787	NML. 2007.21.1
Shelkov	Шел[к]овъ	1800s	NLA (HER) 40934
Shelov, Ya.	Шеловъ, Я	1830	CUPMS: 1999.54.28
Sherapov, M.	Шерапо[в], М	1823	CRMCH 1991.04.2
Sheravskoi, I.	Шер[а]вскои	1841	CUPMS: 1999.52.34
Shetnov	Шетно[в][ъ], [Ф]	19thc	CUPMS: 1999.57.9
Shilov, G.	Шиловъ, Г	n. d.	CUPMS: 1999.52.30
Shilov, N.	Шиловъ, Н	1829	ADMUS: M1998.159
Shilov, Ya.	Шиловъ, Я	1831	ABDM: 072680
Shipachev	Шипачевъ	1781	CRMCH 1992.11.3
Shiryaev,	Ширяевъ, [С]	19th c.	GD 02
Shiryaev, Z.	Ширяевъ, З	1833	CUPMS: 1999.56.10
Shiryaev, S.	Ширяевъ, С	1833	CUPMS: 1999.52.26
Shi[t]ikov, T.	Ши[т]иков, Т	1820s	GRYEH: 1982.34.2
Shitikov, N.	Шитико, Н	1822	NMT 01
Shustov, R.	Шустовъ, Р	1831	CUPMS: 1999.57.6
Shvetsov, V.	Швецовъ, В	1800s	CRMCH 1991.04.4
Simanov	[С]имано[в]	1769	NLA (HER) 31883
Simanov	Сима–овъ	1775	CRMCH 1996.037.01
Simanov	Симановъ	1782	JWa 02
Simanov	Сим[-]новъ	1787	MoL: 2006.7/7
Simanov	–[и]манов	1770s	MoL: Q39
Simanov	Симановъ	19th c	CRMCH 1992.11.5
Simanov	Симанов, [В]	1800s	JC 06
Skorobogatov, G	Скороогатов, Г	1839	CUPMS: 1999.53.21
Skorobogatov	Скороогато	1830s	GMcA 13
Sobol'yanov, P.	Собьяновъ, П	1833	ADMUS: A1989.266
Somov	Сомовъ	1799	CRMCH 1990.29.4
Strunnikov	Стрнников	1780s	PD 9/01
Sukhorukov, F	Сухоруков, Ф	1831	DUN: AHH.2005–16. 10
Sukhorukov, F.	Сухоруко, Ф	1832	DUN: AHH.2005–16. 12
Sukhorukov. F.	Сухоруко[в], Ф	1830s	LCM: 90.36/12
Sukhorukov	Сухоруков, [Ф]	1830s	CUPMS: 1999.54.34
Svin'in, E.	Свиньи[н]	1798	CRMCH: 1990.3.6
Syromyat(nikov), I.	Сыромят, И	1815	CRMCH 1990.3.15
Tabalin, G.	Табалинъ, Г	1799	WE 04
Tarpchinov,	Тарпчинов	1830s	SF: 906/7241

Tarpchino(v), I.	Тарпчин, И	n. d.	CUPMS: 1998.6.7
Tarpchinov, M	Тар- -и[но]	1820s	KIRMG. 2006.291
Tarpchinov	Тарп[ч]инъ	1776	CRMCH: 1990.3.12
Tar(pchinov)	Тар	18th c	CRMCH 1992.11.8
Temkin, G.	Темкинь. Г	1831	CUPMS: 1999.56.11
Temkin, Z.	Темкинъ, З	1831	CUPMS: 1999.57.7
Temkin, Z.	Темкинъ, З	n. d.	CUPMS: 1999.54.36
Tolstikov, S.	То[л]стик	1835	NML. 2007.21.2
Ukropovskoi	Укропвскои	1838	CUPMS: 1999.55.6
Valaev	Валаевъ	1781	CRMCH 1991.38.5
Valin, B.	Валинъ, Б	1805	CRMCH 1991.04.3
Valin, P. Ya.	В[а]линъ, П. Я.	1822	AL 01
Varzov, I.	Варзовъ, И	1829	CUPMS: 1999.52.27
Varzov	Варзовъ	1837	CUPMS: 1999.54.29
Vasil'ev, I	Васильевъ, И	1815	JG 01
Vasilev	В[а]си[л]ев	1815	CRMCH: 1992.11.4
Vaulin	Ваул–н	1800s	KINCM: 2000.102.20
Vinokurov	Винокуров	1828	ADMUS: A2002.87.2
Vinokurov	Вино[к]уро[в]ъ	n. d.	DUN: 1999.21.3
Vinokurov G.	В- - кур- -	1830s	JBC 05
Vlasov, I.	Власов, И	1815	SFl 19
Volkov [L]	Волковъ, [Л]	1832	FORMG: 2006.24
Volkov, V.	Волковъ, В	1843	CUPMS: 1999.53.38
Volkov, V.	Во[–]ковъ, В	1821	KIRMG. 2006.229
Volkov, V.	Волковъ, В	1830	PM 01
Volkov	Во[–]ков	[1]838	FALKM. 2006.4.20
Volkov	Волковъ [В]	n. d.	KIRMG. 2006.285
Vorob'ev, A	Вор[о]бьевъ, А	1836	CUPMS: 1998.6.10
Vorob'ev, D	Вор[о]бьевъ, Д	1830	CUPMS: 1998.6.6
Vorob'ev	Воробьевъ	n. d.	ADMUS: A2002.87.4
Vorob'ev	Воробьевъ	1834	ADMUS: A2002.87.5
Vorob'ev	Воробьевъ	1841	KIRMG. 2006.218
Vorob'ev	Воро[б]ьевъ	1830s	ADMUS: M1987.781
Yaroslavtsov	[–]рославцовъ	1777	GL 02
Yurkovskii, A.	Юрковс, А	1816	NMS: (Stoney Hill) (1816)
Zaitsov	Заицовъ	1820s	KIRMG. 2006.283
Zaitsov	Заицовъ	1830s	CUPMS: 1999.57.8
Zamarin, G.	Замаринъ, Г	1839	CUPMS: 1999.52.29
Zamarin, G.	Замаринъ, Г	n. d.	ADMUS: M1996.66
Zarnov, N.	Зарновъ, Н	1823	CRMCH: 2002.003.01
Zhukov	Жук[о]в, [И]	1806	CRMCH 1991.60.3
Zinov'ev	[–]иновьевъ	1836	RB 03
Zolotarev	[З]о[л]о–арев	1775	CRMCH: 1990.3.29

7.3. Other Quality Control officers (Initials N.P., W.K., W.U.)

* Names in italics indicate seals on which WK or WU occur in place of NP.

Annibal, S	*Анниб, С*	*1775*	*CRMCH: 1990.3.5*
Annibal, S	*Анниб, С*	*1775*	*CRMCH: 1990.3.19*
Annibal, S	*Анниб, С*	*1775*	*CRMCH: 1990.3.20*
Annibal, S	*Анниб, С*	*1775*	*CRMCH: 1991.29.04*
Annibal	Анниб	1775	CRMCH: 1991.04.7
Annibal	Анниб	1776	Anon 06
Antonov	Антоновъ	1790s	WAW: 6F85F40
Aref'ev, N.	Арефьевъ, Н	1790	LWMCH: 02
Babonin, T.	Бабонин, Т	1790	EW 02
Babonin, T.	Бабонинъ, Т	1800	CUPMS: 1999.53.33
Bashchenkov, K.	Бащенковъ, К	1790	FALKM. 2000.4.10
Bazhenov. G.	Баженовъ, Г	1794	JBC 06
Bernikov	[Б][е]рпiковъ, С	1763	SWi 01
Bogdanov, D.	[Б][а]гданo[в], Д	1827	CUPMS: 1999.55.19
Budi[l]kin	Буди[–]кин	1830	SFl 15
Bykov. S	Быковъ, С	1775	HAW 03
Cheblokov., N.	Чеблоков, Н	1820s	CUPMS: 1999.54.50
Chelpanov, A.	Челпано[в], А	1799	CUPMS: 1999.53.29
Chernikov, A	Черников, А	1807	KIRGM: E525.02

Cherntsov	*Чернцовъ*	*1777*	*ADMUS: A 1988.298*
Chugadaev	Чугадаевъ	1778	PD 9/02
Chugadaev	Чугадаевъ	1782	FALKM. 2003.3.58
Davydov, P	*Давыдовъ, П*	*1822*	*ADMUS: A 1989.267*
Dedovnikov	Дедовнико	1818	KIRMG. 2006.307
Dedovnikov, A.	Дедовнико, А	1822	CUPMS: 1999.54.46
Dedovnikov	Д[е]довнико	n. d.	JS 10
Dedovnikov	Д[е]д–в– – –	n. d.	HARGM. 13606.10
Demikhlev	Демихлевъ	1775	NMS: 23.10.93.F3 (1775)
Demyanov, E.	Демяновъ, Е	1818	CUPMS: 1999.52.37
Demy'anov, E. B.	Демьян Е. Б.	1800	RB 01
Dem'yanov, S.	Демьянов, С	1806	CUPMS: 1999.56.14
Dem'yanov	Демьяновъ, [С]	1790	HARGM. 13606.15
Dem'yanov	Д[е]мьяновъ	1786	GL 01
Dem'yanov	Демьяновъ	1786	PR 01
Denisov, L.	Де[н]исовъ, Л	1820	EW 04
Elinskoi, S	Елинскои, С	1783	HFDMG: 1987–19/1
Elinskoi, S	Елинскои, С	1783	HAW 05
Eremeev	Ере[–]еевъ	1803	CUPMS: 1999.54.10
Eremeev	Ер–меев[ъ], М	1810s	KIRMG. 2006.301
Erokhin, S	Ерохин	1807	ADMUS: M1980.3582
Erokhin, S	Ерохин, С	1826	GMcA 06
Erokhin	Ерохинъ	1820s	CUPMS: 1999.54.4
Ershev	Ершевъ	1774	GGAT 01
Es'kov, A.	Еськовъ. А	1805	CUPMS: 1999.56.12
Fedorov, A. N.	Ф[е]до[р]ов, А. Н.	1793	CUPMS: 1999.53.39
Filatov	Филатовъ [–]	1810s	HARGM. 12706.6
Filatov, I	Филатовъ, И	19th c	LWMCH: 05
Filatov, P.	Филатовъ, П	1819	ADMUS: M1998.160
Fokin, F.	Фокинъ, Ф	1801	HARGM. 12706.2
Fokin, F.	Фокинъ, Ф	1800s	CUPMS: 1999.54.41
Garasov, I	Гарасов, И	1795	HAW 07
Gorin	Горінъ	1764	ST 05
Gruzinin	Гру[з]ини[н], [–]	1810s	ADMUS: A 1988.303
Gurov, S.	Гуровъ. С	19thc	CUPMS: 1999.53.31
Gurov, S.	Г[у]ровъ, С	1826	CUPMS: 1999.52.40
Istin, Vasilii	Истинъ, Васил	1774	KIRMG. 2006.292
Istin, Vasilii	Истин, Васил	1784	GRYEH: 1981.45.2
Ivanov, E.	Ивановъ, Е	1791	JH(L) 09
Ivanov, E.	Ив[а]новъ, Е	1794	CUPMS: 1999.53.23
Ivanov, E.	Ивановъ, Е	1801	HARGM. 12706.12
Ivanov, E.	Ивановъ, Е	n. d.	GMcA 08
Ivanov	Ивановъ	1794	CUPMS: 1999.54.40
Ivanov	Ива[н]овъ	1790s	JH(L) 11
Ivanov. S.	Ива–овъ, С	1820s	CUPMS: 1999.54.54
Kavelev, D.	Кавелевъ, [–]	1799	ADMUS: M1998.158
Kavelev. D.	Кавелевъ, Д	1802	AD 07
Kartsev	Карцевъ	1826	CUPMS: 1999.56.16
Khokhlov, Ya.	Хохловъ, Я	18th c.	KIRMG. 2006.237
Kladukhin, N.	Кладухин, Н	1826	CUPMS: 1999.54.56
Kladukhin, S.	Кладухи[н], С	1804	LCM: 90.36/10
Kolmiakov	Колміаков	1770	JBC 15
Kondrat'ev	[К]андратьевъ	1768	WALM: 2005–13-1
Kondrat'ev, A.	Кон[д]рать, А	1788	JC 03
Kononov, I	Кон[–]нов, И	1812	HARGM. 13606.7
Kononov, M.	Кононов, М	1797	GB 04
Kononov, M.	Кононов, М.	1800	CUPMS: 1999.57.12
Kononov, M.	К[о]нон[о]в, М	1804	KIRMG. 2006.208
Kononov	Кон–нов	1820	GMcA 09
Konovalov, K.	Канавалов, К	1806	KIRMG. 2006.231
Koptev, L.	Ко[п]тевъ, Л	1823	CUPMS: 1999.55.17
Koptev, L.	Коптевъ, Л	1825	CUPMS: 1999.54.45
Korolev, N	Каралев, Н	1803	HARGM. 13606.6
Korolev	Королев	1796	PD 9/03
Korolev	Королев	19th c.	MoL: 2006.7/5
Kostin, A.	Кос[т]инъ, А	1821	JS 09

Kostin L	Кос[т]инъ, Л	1824	CUPMS: 1999.55.18
Kostin, M.	Костинъ, М	1790s	KIRMG. 2006.339
Kostin, M.	Костинъ, М	1802	KIRMG. 2006.332
Kostin, L	Костинъ, [Л]	19th c	ADMUS: A1990.313
Kozlov	Козловъ	1805	JBC 08
Kozlov, E.	Козловъ	1820s	CUPMS: 1999.53.27
Kozlov	Козловъ	1820s	JBC 04
Krasikov	Красиков	1790s	HARGM: 13606.4
Krutoy	Крутои	1775	WE 06
Kuchkov, A.	Кучковъ, А	1802	CUPMS: 1999.217.3
Kuchkov, A.	Кучковъ, А	1820	KIRMG. 2006.330
Kuchkov, A.	Кучковъ, А	1826	KIRMG. 2006.305
Kuchkov, Ya	Кучковъ, Я	1794	ABDM: 072691
Kuchkov	Кучковъ	1793	CUPMS: 2007.90
Kuchkov	Кучковъ	n. d.	JS 12
Labishev, A.	Лабишевъ, А	1778	NLA (HER) 13603
Lakin, V	Лакин, В	1827	CUPMS: 1999.55.20
Larionov	Ларioновъ	1764	JS 14
Larionov	Ларioновъ	1764	JS 15
Larionov, V.	Лар[-]оновъ, В	18thc	GRYEH: 1981.74.2
Larivonov	Ларивоновъ	1774	MR 01
Lebedev, P.	Лебедев, П	1796	MM: 2006. 22
Lebedev, P.	Лебедевъ, П	1790s	ADMUS: M1998.161
Lebedev, (P).	Лебедев, (П)	1827	NMS: RM 9.11.94 (1827)
Leptev	Лепт-въ	1777	KIRMG. 2006.294
Levashev, S.	Левашев, С	1800	HARGM: 13606.5
Levashev, S.	Левашев, С	1802	KINCM: 2000.100.5
Levashev, S	Левашевъ, С	1800s	ADMUS: M1995.162
Levshev, M.	Левшевъ, М	1799	CUPMS: 1999.53.26
Levshev, M.	Левшевъ, М	1803	MH 05
Levshev	Левшевъ	1820s	AMu 09
Ligachev, I.	Лигачевъ, И	1820s	CUPMS: 1999.56.15
Livshev, M.	Лившевъ, М	1804	ADMUS: M1998.156
Lobkov	Лобковъ	1800s	AD 02
Lobkov, L.	Лобковъ, Л	1822	ADMUS: DBA3393/c
Luchnikov, I. Ya	Лучниковъ, И. Я.	n. d.	CUPMS: 1999.52.44
Makarevich, I	Макаревичъ, И	1818	CRMCH: 2002.004.06
Malafeev, Z.	Малафеевъ, З	1814	JT 01
Malenkoi	*Мал[е]нкои*	*1775*	*CRMCH 1991.38.2*
Malygin, T.	Малыгин, Т	1825	CUPMS: 1999.55.14
Malygin, T.	Малыгин, Т	1819	CUPMS: 1999.54.51
Martinov, E.	Мартино, Е	[17]92	HARGM: 12706.9
Martinov, E.	Мартино, Е	1806	JC 08
Merkulov, I	Меркуловъ, И	1800	ST 10
Merkulov, K.	Меркулов, К	1820s	GD 01
Merkulov, M.	Меркулов	1804	MM: 2006. 10
Merkulov, M.	Меркулов, М	1805	WK 01
Merkulov	[М]еркуло[в]	1821	DUN: AHH.2005–16.14
Mesnikov, I.	М[е]сников, И	1802	AD 10
Mesnikov	Месников	1810s	MM: 2006. 11
Mesnikov	Меснико[в]	1824	CUPMS: 1999.54.42
Mesnikov	Месников	1825	AMu 08
Mesnikov	Месников	n. d.	KIRMG. 2006.309
Mikhalev	Михалевъ	1770	NP 01
Mikhalev	Михалевъ	1774	ST 09
Mikhalev	Михалев	1793	CUPMS: 2007.92
Miloserdov, I.	Мило[–]е[р]до, И	19th c	CUPMS: 1999.54.9
Molchanov, A	Молчановъ, А	1803	ADMUS: M1996.67
Molchanov	Молчановъ	1806	KIRMG. 2006.299
Mosh[n]ikov	Мош[н]иков	n. d.	SFI 08
Myl'nikov, A.	Мыльнико, А	1800s	CUPMS: 1999.217.2
Nadezhin, I.	Надежинъ, И	1820s	CUPMS: 1999.54.8
Nadezhin, I.	Надежинъ, [И]	1800	WK 02
Nadezhin, I.	Надежинъ, И	1802	CUPMS: 2005.287
Namestovskoi	- -местовскои	1779	SFI 21
Namestovskoi	Намес-овскои	1780	MoL: Q40

Nalobin	Налобин	1760s	MH 04
Nasukhin, A.	Насухинъ, А	1821	AMu 01
Nefedov	НеѲедовъ	1777	WR 02
Nefedov	НеѲ[–]довъ	1778	MoL: 2006. 7/3
Nemilov, A.	Немиловъ	1820s	CUPMS: 1999.56.18
Nikiforov, G.	Никифор[–], Г	1796	GB 05
Nikiforov, G.	Никифоро, Г	1790s	CUPMS: 1999.54.39
Nikiforov, G.	Никифоро, Г	1801	WEW 04
Novotortsev	Новоторцов	n. d.	FALKM. 2003.3.3
Orekhov	Ореховъ	1785	ADMUS: A1988.290
Orlov, M. I.	Орловъ, М. И.	1814	HARGM: 12706.5
Palov, Z.	Палов, З	1796	HARGM: 12706.8
Petunov, A.	Петуновъ, А	1825	CUPMS: 1999.55.21
Petunov, [E].	Петуновъ, [E]	1820s	KIRMG. 2006.230
Pikin, M.	Пикинъ, М	1797	ADMUS: A1988.289
Pirozhnikov, I	Пирожни, И	1775	ADMUS: M1987.780
Pirozhnikov, I	Пиржни, И	1800	CUPMS: 1999.216.7
Pirozhnikov, I.	Пирожник, И	1802	AD 01
Pirozhnikov	Пиржни	1808	JBC 09
Pirozhnikov, L	Пирожнi, Л	1790	LCM: 94.27/1
Pirozhnikov	Пирожи[–]въ	1768	PERMG: 1992.140.3
Pirozhnikov, V. A.	Пирожн[и], В. А.	1788	JC 04
Pirozhnikov, V. A.	Пирож– – – , В. А.	1789	Anon 01
Pirozhnikov, V.	Пирожн, В	1779	DF 03
Plotnik, A.	Плотник, А	18th c	CUPMS: 1999.53.24
Plotnik, I.	Пл[о]тни[к], И	19thc	CUPMS: 1999.55.13
Plotnik, I.	Плотник, И	1795	JP 01
Plotnik, I.	Плотник, И	1811	KIRMG. 2006.333
Plotnik, I	Плотник, И	19th c	CUPMS: 1999.53.30
Plotnikov	Плотьников	1777	CRMCH: 1991.23.01
Plotnikov	Плотьников	1779	HFDMG: 1980–82
Plotukhov	Плотуховъ	1777	DUN: 1978.1430 (2)
Pogankin, L	Поганкинъ, Л	1802	CUPMS: 2005 285
Pogankin, L	Поганки , Л	1818	LCM: 90.36/7
Pogankin	По[–][а]нкн	1825	CUPMS: 1999.52.38
Pogankin	Поганки	1826	CUPMS: 1999.54.48
Polovokhin, P.	Половохи, П	1825	CUPMS: 1999.52.36
Polovokhin	Половохин	1819	RI 01
Primyakin	Примякинъ	1777	PRSMG: T1961
Pronin	Пронинъ, В	1826	CUPMS: 1999.54.7
Raskol'nikov	Рас[–][–]nіковъ	1770s	GL 04
Rastrepaev, I	Растрепае, И	1790s	DF 01
Romanov	Романовъ	1775	CUPMS: 2005.276
Ryabov, K.	Рябов, К	1800	HAW 08
Sanin	Санинъ	1800	JS 13
Sanin, – D	Са[н]инъ, – Д	1820	GMcA 11
Sanitin, K.	Санитинъ, К	1824	JBC 01
Sarafanin	Сарафани	1821	CUPMS: 1999.216.4
Sarynin	Сарыни[н]	1790	FALKM. 1997.13.9
Sarypin	Сарыпинъ	1785	CUPMS: 1999.57.13
Savostin	Савостинъ	1820s	CUPMS: 1999.54.49
Shchegolev, (P)	Щ[е]голев, [П]	1794	MM: 2006. 16
Shchegolev, V.	Ще[г]оле[в]	1794	KIRMG. 2006.297
Shchogolev, V	Щого[левъ], В	1794	MM: 2006. 23
Shchogolev, V.	Щоголев, В	1797	JH(L) 07
Shchogolev, V.	Щоголев, В	18th c.	AHM 01
Shchogolev, V.	Щоголев, В	1803	CUPMS: 1999.55.23
Shchogolev	Щоголев	1794	CUPMS: 1999.53.25
Shchogoleva P.	Щоголева, П	1810s	ADMUS: M1995.157
Shelepin	Шелепинъ	1780	AJPC 05
Sherapov, I.	Шерапо, И	1788	CUPMS: 1999.53.32
Shilov, N	Шиловъ, Н	1827	JM 01
Shipachev, I.	Шипачевъ, И	1800	ST 03
Shipachev, I.	Шипачевъ, И	1806	CUPMS: 1999.57.14
Shipachov	Шипачовъ	1818	KIRMG. 2006.303
Shipochev, A.	Шипочев	1797	GB 07

Shipochev, A.	Ши[п]очев	1799	DF 02
Shipochev, A.	Шипочевъ, А	1790s	KIRMG. 2006.232
Shipochev, A	Ши[п]очев	1802	HARGM: 12706.3
Shipochev	Шiп[о]чев	1806	FF 09
Shirapov, I	Ширапо[в], И	1791	LCM: 86.16
Shyrovskoi, I.	Шы[р]овско, И	1814	ADMUS: M1995.155
Shyrovskoi, I.	Шы[р]овско, И	1820s	CUPMS: 1999.54.2
Shyrovskoi, I.	Шыровско, И	1820s	CUPMS: 1999.54.3
Shyrovskoi	Шыр- -ско	1823	CUPMS: 1999.54.1
Shyrovskoi	Шыровско	n. d.	HARGM: 12706.11
Shyrovskoi, I	Ши[-]вскои	1800s	ABDM: 072694
Simanov, K	Си[-]анов[-], [К]	1790s	JS 17
Simanov, K	Симанов, К	1797	ST 01
Simanov [-]	Симановъ	1792	ST 11
Simanov, K	Симанов, К	1809	CUPMS: 2005.288
Simanov, M.	Симановъ, М	1810	JM 05
Simanov, M.	Симановъ, М	1820s	CUPMS: 1999.57.15
Simonov, A.	Симонов, А	1780s	GMcA 12
Sinyakov	Синя[-]ов	1812	MoL: 2006.7/7
Sinyakov	Синяковъ	1820s	CUPMS: 1999.56.17
Sinyakov	Синя[-]ов	1820s	CUPMS: 1999.55.10
Sivtsov, I.	Сивцовъ, И	1798	GB 02
Sivtsov, I.	Сивцовъ, И	1798	GB 06
Smirnov	Смирпо[в]	1765	AH 01
Sysoev	Сысоевъ	1776	PRSMG: T1963 (A146)
Sysoev	Сысоевъ	1777	CRMCH: 1990.29.1
Sysoev	Сысоевъ	1777	AJPC 03
Tamilin	Тамилинъ	1786	MM: 2006. 4
Tamilin, [L]	Тамилинъ, [Л]	1790s	WARMS / Slides 62
Tamilin	Т[а]м[-]лин	1793	MM: 2006. 19
Tarabukin	Тарабукин, [-]	1804	KIRMG. E585.06
Tarabukin	Тарабукин, [-]	1804	KIRMG. 1999.216
Tarasov	Тарасов	1793	MoL: 2006.7/6
Tarasov, I.	Тарасов, И	1795	HAW 07
Ukrotskoi, B.	Укротско, Б	1820s	CUPMS: 1999.54.47
Ul'yanov, S.	Ульянов, С	1814	MM: 2006. 15
Ul'yanov, S.	Ульянов, С	1805	KIRMG. 2006.337
Utochkin	Утачкинъ	1780	AJPC 06
Utochkin	Уточкинъ	1780s	HARGM: 13606.08
Valashev	Валашев, Н	1825	CUPMS: 1998.6.11
Varak[-], I.	Варак[-], И	1813	NMS: (Stoney Hill) (1813)
Varaksin, I	Варакси, И	1819	AMu 07
Varzov, S.	Варзовъ, С	1796	WALM: 2005–13–2
Varzov	Вар[-]зовъ	1779	ST 06
Vavilov	*Вавиловъ*	*1762*	*JH(L) 05*
Vavilov	*Вавиловъ*	*1762*	*JH(L) 06*
Vavilov	Вавиловъ	1779	NMS: 23.10.93.F1 (1779)
Vavilov	Вавиловъ	1770s	HAW 04
Verevkin, M.	Веревкинъ, М	1818	KIRMG. 1999.215
Vinnikov, I.	Винников, И	1813	CUPMS: 2005.282
Vinnikov, I. M.	Винникo, И. [М]	19th c	ADMUS: A1988.300
Vinnikov, I.	Ви[н]нико, И	1805	JS 11
Vinnikov, I. M.	Виннико, И. М.	1809	SF 869/7380
Vinnikov, I	Ви[н]нико[в], И	1809	CUPMS: 1999.53.34
Vinnikov, I. M.	Винник[-], И. М.	1826	JC 05
Vinokurov, F	Винокуров, Ф	1825	GMcA 04
Vinokurov, F	Вин[о]куров, Ф	1825	GMcA 07
Vinokurov	Ви[н][о]куро[в]	1807	KIRMG. 1999.217
Volkov, A.	Волковъ, А	1818	ADMUS: A1988.291
Volkov, L.	Волковъ, Л	1801	KIRMG. 2006.234
Volkov, V.	Волковъ, В	1820	JS 07
Volkov, V.	Волковъ, В	1820s	AL 02
Volkov	Волковъ	1820s	Anon. 05
Vorob'ev, D.	Вор[о]бьевъ, Д	1801	DUN: AHH.2005–16– 15
Vorob'ev	Воробьев[ъ]	1774	GI 01
Vorob'ev, S.	Воробьевъ, С	n. d.	AD 09

Vorob'ev	Воробьевъ	1802	AD 06
Zaitsov. F.	Заицовъ, Ф	n. d.	CUPMS: 2007.89
Zaitsov, S.	За[и]цов, С	1796	HARGM: 12706.4
Zaitsov, S.	Заицов, С	18th c	HARGM: 12706.7
Zaitsov, V.	Заицов[–], В	1809	CUPMS: 1999.55.12
Zaitsov, Ya.	Заицовъ, Я	1806	CUPMS: 1999.216.2
Zakharov, N.	Захаровъ, Н	1791	FALKM. 1997.13.10
Zakharov, N	Захаровъ, [Н]	1792	JBC 16
Zakharov	Захаровъ	1791	GMcA 14
Zamarin, T	Замаринъ, Т	1810s	HARGM: 13606.2
Zasorin, S.	Засори[н], С	1790s	JBC 10
Zemov	Земов	1775	SBYWM: ii.E.435
Zemskoi	Земскои	1777	CRMCH: 1990.3.9
Zemskoi	Земскои	1770s	CRMCH: 1990.3.16
Zemskoi	Земскои	1781	PAS / WAW C20717 (1781)
Zemskoi	Земскои	1782	NMS: Edi Bag 3 (1782)
Zemskoi	Земскои	1785	JSm 01
Zemskoi	Земскои	1780s	JW 01
Zemskoi	Земскои	1790s	CUPMS: 1999.53.28
Zhukov, T.	Жуковъ, Т	1793	MH 06
Zhukov, T.	Жуковъ, Т	1790s	KMo 01
Zimanov	Зимановъ, [Г.]	1826	CUPMS: 1999.55.9

7.3.1. Other Quality Control Officers (Provenance indeterminable)

Babanov, A.	Баба[н]ов	1787	MM: 2006. 5
Babonin, T.	Бабонинъ, Т	1802	AD 04
Babonin	Бабонинъ, [–]	1813	KIRMG. 2006.238
Balovanov, P	Баловановъ	n. d.	CUPMS: 1999.55.27
Balovanov, P	Баловановъ	n. d.	KGGM: DBK. 808d–vi
Bogomolov	Богомоло[в]	n. d.	CRMCH: 1996.32.03
Budylkin	Будылкинъ	n. d.	GMcA 02
Budnikov, E	Буднико[в]	n. d.	FALKM. 2003.3.3
Chelpanov	Чел[п]а[н]ов	1794	KIRMG. 2006.295
Chernikov	Черников	1812	AMu 06
Damanov, B.	Дамановъ, Б	n. d.	CRMCH: 2002.004.04
Demidov, B	Демидовъ, Б	1821	AMu 03
Dem'yanov, S.	Демьяновъ, С	1786	BRSMG: T.9395
Gavalgin	Гавалгин	n. d.	CRMCH: 1990.3.2
Ivanov, E.	Ивановъ, Е	1795	JWh 01
Kashevarov, A.	Кашеваро, А	n. d.	DUN: 1984.91
Kononov, N.	Кононо[в]. Н	1801	CUPMS: 1999.53.41
Krivoshein, F.	[–]ривоше– –	1798	NLA (HER) 31194
Larionov, F.	Ларіоновъ, Ф	n. d.	PMn 01
Lebedev, P.	Лебедев, П	18th c.	MM: 2006. 8
Ligachev	–игачевъ	19th c.	DUN 1999.21 (4)
Livshev, M.	Лившевъ, М	1812	MM: 2006. 12
Malygin	Малыгин	n. d.	HARGM: 13606.1
Manukhin, E.	Манухин, Е	1781	GGAT 03
Nadezhin, D. E.	Надеж[н], Д Е	1787	OXFAS:. 1998.105
Navatov	Наватовъ	n. d.	CRMCH: 1990.3.2
Nemtsov, A.	Нъм[ц]овъ	1826	CUPMS: 1999.54.53
Novotortsev	Новоторцов	n. d.	FALKM. 2003.3.3
Piskarev, A.	Пискаревъ, А	n. d.	JM 04
Plotnik	Пло[–]ник	1800s	CUPMS: 1999.53.40
Pogankin, A.	Поганкинъ, А	n. d.	CUPMS: 1999 55.27
Pogankin, A.	Пог[а][–][–]инъ, А	n. d.	KGGM: DBK.808d.vi
Protopopov	Пр[о] [о]по[в], [А]	19th c	NEBYM: Loan D2902a
Protopopov, I.	Протопо, И	1794	GMcA 05
Puzyrev, I	Пузырев, И	n. d.	MoL: 2006.7/1
Pyzhov, A.	Пыжовъ, А.	1827	KIRMG. 2006.306
Safronov	Сафронов	1820	RN 01
Samuilov, G	Самуило,	1794	GMcA 10
Shcherbakov, P	Щ[е]бако, П	n. d.	ABDMS: 072684
Sherapov	Шера[п]ов	1789	MoL: 2006.7/8
Shipochev	[Ш]ипочевъ	1790s	Anon 03

Shiryaev, S.	Ширяевъ, С	1808	KIRMG. 2006.300	
Sinyakov	Синяковъ, [А]	1826	CUPMS: 1999.216.6	
Soloukhin, D.	Солоухи, Д	1804	KIRMG. 2006.336	
Solovikhin	Саловихинъ	n. d.	SF 869/7053	
Tamilin	Тамилинъ	1777	CUPMS: 2005.290	
Tyurin, V	Тюринъ, В	n. d.	DMP 06	
Tyurin, V	Тюринъ, В	n. d.	BR 03	
Tyurin, V.	Тюринъ, В	n. d.	JM 04	
Tyurin, P.	Тюр[и]нъ, П	1794	KIRMG. 2006.334	
Tyurin	Тюринъ	n. d.	PMn 01	
Ulanov, A.	Улановъ, А	n. d.	FALKM. 1999.4.31	
Ulanov, A.	Улановъ, А	n. d.	DMP 06	
Valin	Валинъ	n. d.	BRSMG: O. 1749	
Varzov, S.	Варзовъ, С	1796	BR 02	
Var[–]ov	Вар[–]овъ	1820	KIRMG. 2006.226	
Vinnikov, I.	Винников, И	1789	JH(L) 08	

7.4. Dates of Russian flax and hemp seals

1	2	3	4	5
Date	Archangel	St Petersburg	Unidentified origin (NP)	Unidentified origin (Other symbols, names or illegible)
1740s	x	x	MM: 2006. 7	x
1741	x	MoL: 88.107/42	x	x
1745	x	KM 01	x	x
1747	x	BRSMG: T 9407; DMP 01	x	x
1749	x	JWa 01	x	x
1750s	x	x	CRMCH: 1991.38.10	MM: 2006. 13 (**W. U.**)
1752	x	x	CRMCH: 1990.3.8; AJPC 02; WE 01	x
1753	x	x	GLDM: 29.5; MM: 2006.1; AJPC 02	OXFAS: 1980.273 (**–P**);
1755	x	x	CD 01;	x
1756	x	x	BRSMG: O 4165	x
1757	x	x	x	HARGM: 12706.1 (**W.K.**)
1758	x	x	BRSMG: O 4164; DUN: 2002.37	JC 01 (**W.[U]**); JH(L) 03 (**W.U.**)
1759	x	x	MoL: 8543; WHITM: SOH 420.1; WHITM: SOH 420.2; AJP 01	IS 01 (**И.П**)
1760s	x	x	MH 04 (**N**)	x
1760	x	x	PC 01; WK 03	Anon 04 (–); JH(L) 02 (**W. K.**); JH(L) 04 (**W. K.**)
1762	x	x	NLA(HER) 39269	PRSMG: T1960 (A145)(–); JH(L) 05 (**W. K.**); JH(L) 06 (**W. K.**)
1763	x	AMu 04	SWi 01	x
1764	x	DMP 02	JS 14; JS 15; JS 16; ST 05	SWr 01 (– **K**)
1765	x	x	BR(B) 01; AH 01	x
1766	x	x	x	MH 03 (–)
1767	x	NLA (HER) 47349	TD 03; MH 02	x
1768	x	x	PERMG: 1992.140.3; WALM: 2005–13–1; WE 05	x

1769	x	NLA (HER) 31883; NLA (HER) 40538	x	x
1770s	x	CRMCH: 1991 27.1; CRMCH: 1991.38.6; SFl 14; NMS: P. Sin (1774); MoL: Q39; AJPC 04; JC 09	CRMCH: 1990.3.16; WHIT(W.A.) 9711601; HAW 04	CRMCH: 1991.38.11 (–)
1770	x	x	JBC 15; FF 05; NP 01	x
1771	x	OXFAS: 1987.188	x	x
1774	x	GI 02	KIRMG. 2006.293; GGAT 01; GI 01; MR 01; ST 09	x
1775	x	CRMCH: 1990.3.23; CRMCH: 1990.3.29; CRMCH: 1991.38.4; CRMCH: 1996.32.02; CRMCH: 1996.037.01; CRMCH: 1996.037.02; CRMCH: 1996.37.07; CRMCH: 1991.29.03; CRMCH: 2002.003.02	ADMUS: M1987.780; CRMCH: 1990.3.26; CRMCH: 1991.29.04; CUPMS: 2005.276; NMS: ex.23.10.93 F3; SBYWM: ii.E.435; WE 06; GL 03; RN 04; HAW 03	CRMCH: 1990.3.5 (**W. K.**); CRMCH: 1990.3.19 (**W. –.**); CRMCH: 1990.3.20 (**W. –.**); CRMCH: 1991.38.2 (**W. K.**); CRMCH: 1991.38.12 (–); CRMCH: 1991.04.7 (**W. K.**); FF 13 (–); AMu 05 (–)
1776	x	BRSMG: O.1421; CRMCH: 1990.3.12; CRMCH: 1990.3.28; NLA (HER) 25178	PRSMG: T1963 (A146); MM: 2006. 3; Anon 05	x
1777	x	CRMCH: 1991.29.01; INVMG: 2003.120.059; SFl 09; GL 02	CRMCH: 1990.3.9; CRMCH: 1990.3.25; CRMCH: 1990.29.1; CRMCH: 1991.23.01; DUN:1978.1430(2); KIRMG. 2006.294; PRSMG: T1961; AJPC 03; SFl 05; AHM 02; WR 02	ADMUS: A1988.298 (**W. K.**); CUPMS: 2005.290 (– –); RN 02 (–)
1778	x	CRMCH: 1991.04.1; CRMCH: 1991.04.6; CRMCH: 1992.11.1; OXFAS: 1980.271	MoL: 2006.7/3; NLA (HER) 13603; NLA (HER) 36633; PD 9/02; SFl 06	x
1779	x	CRMCH: 1990.3.18; CRMCH: 1991.29.06; SFl 17	CRMCH: 1991.38.7; HFDMG: 1980–82; NMS: ex.25.9.93 F1; DF 03; SFl 21; ST 06	x
1780s	x	ABDM: 072682; CRMCH: 1990.3.14; MM: 2006. 2; PD 9/01; NMT 02	HARGM: 13606.8; JC 12; GMcA 12; ST 02	JW 01(–)
1780	x	NLA (HER) 31097; NLA (HER) 51314	MoL: Q40; AJPC 05; AJPC 06; JH(L) 10	TD 02 (–)

1781	x	CRMCH: 1990.3.13; CRMCH: 1991.38.5; CRMCH: 1992.11.3; MM: 2006. 14 ; FF 03; FF 04; FF 06	GLDM: 29.3; NLA (HER) 22937; WAW C20717	GGAT 03 (–)
1782	x	FF 11; JWa 02	FALKM. 2003.3.58; NMS: Edi Bag 3	x
1783	x	KIRMG. 2006.298	FALKM. 2003.3.59; HFDMG: 1987–19/1; HAW 05	x
1784	x	CRMCH:1991.29.07	GRYEH: 1981.45.2	x
1785	x	CRMCH: 1991.29.05	ADMUS: A1988.290; CUPMS: 1999.57.13; NMS: H.NM.222; JSm 01; WAW 6F85F40	NMS: (Horseley Hill)(–)
1786	x	BRSMG: T 9395	MM: 2006. 4; GL 01; PR 01	SFl 29 (**П.Д.**)
1787	x	CRMCH: 2002.12.3; MoL: 2006.7/4; MoL: 2006.7/7; NML. 2007.21.1; OXFAS: 1987.179	x	MM: 2006. 5 (–); OXFAS: 1998.105 (–)
1788	x	x	CUPMS: 1999.53.32; LCM: 96.81; JC 03; JC 04; IP 05; EW 03	x
1789	x	CRMCH: 1990.3.22; CRMCH: 1991.60.2; CRMCH: 2002.004.08; OXCMS.1985.214.1; SFl 04	Anon 01; MM: 2006. 20; JH(L) 01; ST 07;	MoL: 2006.7/8 (–); JH(L) 08 (–)
1790s	x	CRMCH: 2002.012.1; OXFAS: 1980.272; NLA (HER) 42590	ADMUS: M1998.161; CUPMS: 1999.53.28; CUPMS: 1999.54.39; KIRMG. 2006.232; KIRMG. 2006.339; HARGM: 13606.4; NLA(HER) 52535; WARMS: Brailes (Slides 62); GB 03; GB 04; JC 07; JBC 10; DF 01; WG 01; JH(L) 11; KMo 01; JS 17; EW 06	Anon. 03 (–); CRMCH: 2002.005 (–); FALKM. 1997.13.11(–)
1790	x	CRMCH: 1990.3.27;	FALKM. 1997.13.9; FALKM. 2000.4.10; HARGM: 13606.15; LWMCH: Unaccess. 02; LCM: 94.27/1; EW 02	x
1791	x	x	FALKM. 1997.13.10; LCM: 86.16; NMS: P Sin (1791); JH(L) 09; GMcA 14	x

1792	x	GRYEH: 1981.45.4; SFl 20; SFl 23	HARGM: 12706.9; JBC 16; ST 11	x
1793	x	x	CUPMS: 1999.53.39; CUPMS: 2007.90; CUPMS: 2007.92; MoL: 2006.7/6; MM: 2006. 19; MH 06; RM 01; DMP 04	x
1794	x	AD 05; SFl 27; CK 01	ABDM: 072691; CUPMS: 1999.53.23; CUPMS: 1999.53.25; CUPMS: 1999.54.40; KIRMG. 2006.297; KIRMG. 2006.334; MM: 2006. 16; JBC 06; GMcA 05; GMcA 10; DMP 05	NLA (HER) 24811 (–); KIRMG. 2006.295 (–); MM: 2006. 23 (– **P**)
1795	x	GLDM: 29.1	KIRMG. 2006.331; JP 01	BRSMG: T 9396 (–); MM: 2006. 6 (**W. K.**); HAW 07 (–); JWh 01 (–)
1796	x	BR 01	PRSMG: T1962 (A144); HARGM: 12706.4; HARGM: 12706.8; MM: 2006. 22; WALM: 2005–13–2; GB 05; PD 9/03; JS 19	KIRMG. 2006.296 (–); MM: 2006. 7 (–); BR 02 (–)
1797	x	GRYEH:1981.53; NLA (HER) 23698	ADMUS: A1988.289; CRMCH: 1990.3.17; GB 07; JH(L) 07; ST 01	TWh 01 (–)
1798	x	CRMCH: 1990.3.6; CRMCH: 1991.23.02; NLA(HER) 34589	GB 02; GB 06; WK 04	NLA (HER) 31194 (–)
1799	x	CRMCH: 1990.3.24; CRMCH: 1990.29.4; CRMCH: 1991.38.3; CUPMS: 1999.54.33; DUMFM: 2001.32.2; JC 10; WE 04	ADMUS: M1998.158; CRMCH: 1990.3.1; CUPMS: 1999.53.26; CUPMS: 1999.53.29; DF 02	x
18th century	x	CRMCH: 1990.3.30; CRMCH: 1992.11.8; CUPMS: 2007.93; JC 11; FF 10; FF 16; EW 01	CUPMS: 1999.53.24; CRMCH: 1991.38.9; HARGM: 12706.7; KIRMG. 2006.237; LCM: 90.36/11; NEBYM: 1981.96.6; GB 01; JH(L) 12; AHM 01	CRMCH: 1990.3.3 (–); GRYEH:1981.74.2 (**WK**); HARGM: 13606.9 (–); MM: 2006. 8 (–); MH 01 (**WK**)
1800s	x	ADMUS:M1995.166; CRMCH: 1991.04.4; KINCM: 2000.102.20; NLA (HER) 40934; JC 06; SFl 10; DP 01	ABDM: 072694; ADMUS: M1995.162; CUPMS: 1999.54.41; CUPMS: 1999.217.2; AD 02; AD 03	ADMUS: DBA3393/b (–); ADMUS: M1998.168 (–); CRMCH: 1990.3.10 (–); CUPMS: 1999.53.40 (–); SFl 16 (–)

1800	x	CRMCH: 1990.3.4; CUPMS: 1999.57.11; MoL: 2006.7/2; WE 02	CUPMS: 1999.53.33; CUPMS: 1999.57.12; CUPMS:1999.216.7; HARGM: 13606.5; RB 01; WK 02; JS 13; ST 03; ST 10; HAW 08	x
1801	x	CRMCH: 1992.11.9; CRMCH: 1991.29.2; NEBYM: A1299	DUN: AHH.2005–16.15; HARGM: 12706.2; HARGM: 12706.12; KIRMG. 2006.234; WEW 04 (**N** –);	CUPMS: 1999.53.41 (–); DUN:1978.1430(4) ([**N**] [**P**]); WEW 02 (**W. K.**)
1802	x	NLA (HER) 42579	CUPMS: 2005.285; CUPMS: 1999.217.3; CUPMS: 2005.287; HARGM: 12706.3; KINCM: 2000.100.4; KINCM: 2000.100.5; KIRMG. 2006.332; AD 01; AD 04; AD 06; AD 07; AD 08	x
1803	x	OXFAS: 1998.106; IP 02	ADMUS:M1996.67; CUPMS: 1999.54.10; CUPMS: 1999.55.23; HARGM: 13606.6; MH 05	x
1804	x	CRMCH: 1990.3.21; CRMCH: 1992.11.2	ADMUS:M1998.156; KIRMG. 1999.216; KIRMG. 2006.308; LCM: 90.36/10; MM: 2006. 9; MM: 2006. 10; GGD 06	KIRMG. 2006.336 (–)
1805	x	CRMCH: 1990.29.3; CRMCH: 1991.04.3; SF (SMR) LUD misc. MSF23230; SF (SMR) COR 050	CUPMS: 1999.56.12; KIRMG. 2006.236; KIRMG. 2006.337; JBC 08; WK 01; JS 11	x
1806	x	CRMCH: 1991.60.3; KIRMG. 2006.299; WE 03	CUPMS: 1999.56.14; CUPMS: 1999.57.14; CUPMS: 1999.216.2; KIRMG. 2006.231; LB 01; JC 08; FF 02; FF 09	x
1807	x	CRMCH: 1991.38.8	ADMUS: M1980.3582; KIRMG. 1999.217; GGD 02	JWh 02 (–)
1808	x	x	CUPMS: 1999.57.17; JBC 09	KIRMG. 2006.300 (–); FF 14 (–)
1809	x	x	CUPMS: 1999.53.34; CUPMS: 1999.55.12; CUPMS: 2005.288; SF: 869/7380; AD 10	FF 18 (–)

1810s	x	SFl 22; BR(B) 02	ADMUS: A1988.303; HARGM: 12706.6; HARGM: 13606.2; KIRMG. 2006.301; MM: 2006. 11; AD 11; JG 02	x
1810	x	x	JM 05	x
1811	x	x	KIRMG. 2006.239; KIRMG. 2006.333	NMS:RM 18.6.96 (–)
1812	x	NLA (HER) 28048	HARGM: 13606.7; MoL: 2006.6	MM: 2006.12 (–); AMu 06
1813	GLDM: 29.2 (пенк. бра)	x	CUPMS: 2005.282; NMS: (Stoney Hill) (1813); SFl 15; SW 02;	CRMCH: 2002.012.4 (**Ш**); KIRMG. 2006.238 (–)
1814	x	CRMCH: 1991.04.5; NMS: RM 9.11.94/1814; SFl 01	ADMUS:M1995.155; HARGM: 12706.5; LCM: 94.27/2; MM: 2006. 15; JT 01	MM: 2006. 18 (– **P**);
1815	x	CRMCH: 1990.3.15; CRMCH: 1992.11.4; SFl 18; JG 01	x	x
1816	x	NMS: (Stoney Hill) (1816); JC 02	x	x
1817	x	CRMCH: 1991.38.1; JS 03; NMT 03		JS 02 (–); JS 05 (–)
1818	x	CRMCH: 1990.3.7; AC 01; FF 19	ADMUS: A1988.291; CUPMS: 1999.52.37; CRMCH: 2002.004.06; KIRMG. 1999.215; KIRMG. 2006.302; KIRMG. 2006.303; KIRMG. 2006.307; LCM: 90.36/7	LCM: 90.36/1 (–)
1819	x	x	ADMUS:M1998.160; CUPMS: 1999.54.51; RI 01; AMu 07	x
1820s	x	CUPMS: 2005.286; GRYEH:1982.34.2; KIRMG. 2006.283; KIRMG. 2006.291; MoL: 81.266/31; NML. 2007.21.3; SFl 02	ADMUS: A1988.299; ADMUS: DBA3393/a; CUPMS: 1998.6.12; CUPMS: 1999.53.27; CUPMS: 1999.54.2; CUPMS: 1999.54.3; CUPMS: 1999.54.4; CUPMS: 1999.54.8; CUPMS: 1999.54.44; CUPMS: 1999.54.47; CUPMS: 1999.54.49; CUPMS: 1999.54.50; CUPMS: 1999.54.52; CUPMS: 1999.54.54; CUPMS: 1999.55.10; CUPMS: 1999.55.11; CUPMS: 1999.56.15; CUPMS: 1999.56.17; CUPMS: 1999.56.18; CUPMS: 1999.57.15;	JL 02 (–)

1820s			KIRMG. 2006.230; KIRMG. 2006.310; MoL: 2006.7/5; AJPC 07; JBC 04; AD 12; GD 01; AMu 09; JS 09	
1820	x	HARGM: 13606.14	KIRMG. 2006.235; GMcA 09; GMcA 11; JS 07; EW 04	KIRMG. 2006.226 (–); KIRMG. 2006.330 (–[P]); RN 01 (–)
1821	x	ABDM: 072679; SFl 19	DUN: AHH.2005–16.14; CUPMS: 1999.55.25; CUPMS: 1999.216.4; KIRMG. 2006.227; KIRMG. 2006.228; KIRMG. 2006.229; KIRMG. 2006.304; KIRMG. 2006.335; AMu 01	AMu 02 (–); AMu 03 (–)
1822	x	AL 01; NMT 01	ADMUS: A1989.264; ADMUS: A1989.267; ADMUS: DBA3393/c; CUPMS: 1999.54.46; CUPMS: 1999.55.16; HARGM: 13606.3	x
1823	x	CRMCH: 1990.29.2; CRMCH: 1992.11.7; CRMCH: 1991.04.2; CRMCH: 2002.003.01; SFl 26	CUPMS: 1999.54.1; CUPMS: 1999.55.17; HARGM: 13606.12	CUPMS: 1999.54.55 (P); IP 03 (–)
1824	x	CRMCH: 1996.37.05; SFl 11; SFl 13	CUPMS: 1999.54.42; CUPMS: 1999.55.18; JBC 01; JS 08	x
1825	CUPMS: 1999.52.19	CRMCH: 1996.37.06; CRMCH: 2002.004.01; CRMCH: 2002.004.03	CUPMS: 1998.6.11; CUPMS: 1999.52.36; CUPMS: 1999.52.38; CUPMS: 1999.54.5; CUPMS: 1999.54.43; CUPMS: 1999.54.45; CUPMS: 1999.55.14; CUPMS: 1999.55.21; KIRMG. 2006.224; KIRMG. 2006.225; AL 02; GMcA 04; GMcA 07; AMu 08	x
1826	x	NLA (HER) 15270	CUPMS: 1999.52.40; CUPMS: 1999.54.7; CUPMS: 1999.54.48; CUPMS: 1999.54.56; CUPMS: 1999.55.9; CUPMS: 1999.56.16; KIRMG. 2006.233; KIRMG. 2006.305; JC 05; GMcA 06	CUPMS: 1999.54.53 (–); CUPMS: 1999.216.6 (–); MH 07 (–); EW 05 (–)

Part Three. Appendices

1827	x	CRMCH: 1990.3.11	ABDM: 072687; CUPMS: 1999.55.15; CUPMS: 1999.55.19; CUPMS: 1999.55.20; CUPMS: 1999.57.16 NMS: RM 9.11.94/1827; JM 01	KIRMG. 2006.306 (–)
1828	x	ADMUS: A2002.87.2; AB 02; SFl 25	ADMUS:M1995.157	x
1829	x	ADMUS:M1998.159; ADMUS:M1998.162; CRMCH: 1996.32.01; CUPMS: 1999.52.27; CUPMS: 1999.55.7; DUN:1999.21(2); DUN: AHH.2005–16.09; NMS: Henderson 090	x	x
1830s	CUPMS: 1999.52.13; CUPMS: 1999.53.11; CUPMS: 1999.56.1; KIRMG. 2006.327	ABDM: 072683; ABDM: 072695; ADMUS: M1987.781; ADMUS: A1989.247; CUPMS: 1998.6.1; CUPMS: 1998.6.3; CUPMS: 1998.6.15; CUPMS: 1998.6.17; CUPMS: 1998.6.18; CUPMS: 1999.53.20; CUPMS: 1999.53.22; CUPMS: 1999.54.21; CUPMS: 1999.54.22; CUPMS: 1999.54.23; CUPMS: 1999.54.25; CUPMS: 1999.54.26; CUPMS: 1999.54.32; CUPMS: 1999.54.34; CUPMS: 1999.57.8;	x	ABDM: 072684 (–); CUPMS: 1998.6.13 (–); KIRMG. 2006.289 (–); JBC 05 (–)
1830s		FALKM. 2002.43.06; KIRMG. 1999.212; KIRMG. 1999.213; KIRMG. 1999.214; KIRMG. 2006.223; NMS: 29.10.93 F1; LCM: 90.36/12; SF: 906/7241; SF: MISTLEY; JBC 05; GMcA 13; PMcA 01		
1830	x	CUPMS: 1998.6.6; CUPMS: 1999.53.42; CUPMS: 1999.54.28; CUPMS: 1999.55.22; DUN:1978.1430 (5); FALKM. 2002.43.01; GGD 01; SFl 12; JM 02; PM 01; IP 01	x	x

1831	ADMUS:M1998.163	ABDM: 072680; ABDM: 072686; ABDM: 072692; ADMUS:M1998.157; CUPMS: 1998.6.4; CUPMS: 1998.6.5; CUPMS: 1999.53.18; CUPMS: 1999.54.27; CUPMS: 1999.54.38; CUPMS: 1999.56.9; CUPMS: 1999.56.11; CUPMS: 1999.57.6; CUPMS: 1999.57.7; CUPMS: 2007.91; DUN: AHH.2005–16.10; DUN: AHH.2005–16.11; KIRMG. 2006.286; JM 07	x	LWMCH: 01 (–)
1832	CUPMS: 1999.54.31; JS 06	ABDM: 072685; CUPMS: 1999.52.33; CUPMS: 1999.52.42; CUPMS: 1999.56.8; CUPMS: 1999.216.5; CUPMS: 2005.289; DUN: AHH.2005–16.12; DUN: AHH.2005–16.13; FALKM. 2002.43.05; FORMG: 2006.24;	x	x
1833	CUPMS: 1999.54.30; CUPMS: 1999.58.1; KIRMG. 1999.211	ABDMS: 072681; ADMUS: A1989.266; ADMUS: M1995.163; CUPMS: 1999.52.24; CUPMS: 1999.52.26; CUPMS: 1999.52.28; CUPMS: 1999.52.32; CUPMS: 1999.53.17; CUPMS: 1999.53.19; CUPMS: 1999.56.10; FALKM. 2002.43.02; SFl 03; SFl 24; SFl 28	x	ABDM: 072693 (–)
1834	CUPMS: 1999.55.5	ADMUS: A2002.87.5; KIRMG. 2006.236	x	x
1835	CUPMS: 1999.52.16; DUN:AHH.2004.25; KIRMG. 2006.253	ADMUS: A2000.212; ADMUS: DMB 4217(b); CRMCH: 1991.37; NML. 2007.21.2; TW 01	x	x
1836	CUPMS: 1999.52.17; RB 02; JBC 02	ADMUS:M1998.167; CUPMS: 1998.6.10; CUPMS: 1999.52.25; CUPMS: 1999.52.31; CUPMS: 1999.54.35; DUN:1989.66(1); FALKM. 2002.43.04; HARGM: 12706.10; KIRMG. 2006.219; KINCM: 1339.1986.564; RB 03; JM 10; JS 01	x	CUPMS: 1998.6.16 (–);

1837	CUPMS: 1999.52.15	CUPMS: 1999.54.29; CUPMS: 1999.54.37; KIRMG. 2006.288; LCM: 90.36/9; JL 01; JS 22	x	NLA (HER) 10399 (–[П])
1838	CUPMS: 1999.52.18; CUPMS: 1999.55.3; KIRMG. 2006.209; KIRMG. 2006.252	ADMUS: DBA3393/f; CUPMS: 1998.6.9; CUPMS: 1999.53.35; CUPMS: 1999.55.6; CUPMS: 1999.55.8; CUPMS: 1999.56.13; CUPMS: 1999.57.10; CUPMS: 2005.281; CRMCH: 1991.60.1; DUN:1978.1430(3); FALK.2006.4.20; KIRMG. 2006.197; TD 01; MW 01; SW 01	x	HARGM: 13606.11 (–)
1839	ADMUS: DBA3393/d; DUN:AHH.2005–16.01; HARGM: 12706.13; KIRMG. 2006.213	ADMUS:M1995.165; CUPMS: 1999.52.29; CUPMS: 1999.52.35; CUPMS: 1999.53.21	x	x
1840s	CUPMS: 1999.57.4; CUPMS: 2005.283	FALKM. 2002.43.03; KIRMG. 2006.290; KIRMG. 2006.313; KIRMG. 2006.315; JM 08	x	x
1840	KIRMG. 1999.209	FALKM. 2003.3.2	x	x
1841	CUPMS: 1999.216.3	CUPMS: 1999.52.34; EXEMS: 69/2001.4; KIRMG. 2006.218; KIRMG. 2006.292; NLA (HER) 39393	x	x
1842	HAW 02	x	x	x
1843	KIRMG. 1999.208	CUPMS: 1999.53.38; KIRMG. 2006.220	x	
1844	ABDM: 072688; DUN:1976.2267	ADMUS: M1980.3639	x	x
1845	CUPMS: 1999.56.6; KIRMG. 2006.198; KIRMG. 2006.216; KIRMG. 2006.254; KIRMG. 2006.319	x	x	ADMUS: A1988.292 (–)
1846	KIRMG. 2006.255; LCM: 86.72; AB 01	ADMUS: A1988.296; CUPMS: 1999.52.48; KIRMG. 2006.207	x	x
1847	CUPMS: 1999.53.14; CUPMS: 1999.53.15; CUPMS: 1999.54.20; CUPMS: 1999.56.2; CUPMS: 1999.56.3	ADMUS: M1989.98; CUPMS: 1999.52.50; DUN: 1977.1048; KIRMG. 2006.341; PERMG:1992.142.1; JBC 07	x	x
1848	CUPMS: 1999.55.2; KIRMG. 2006.320; HAW 01	ADMUS: A1990.311; CUPMS: 1999.52.49; CUPMS: 1999.53.36; KIRMG. 2006.199; KIRMG. 2006.282	x	x
1849	KIRMG. 2006.196; KIRMG. 2006.256; JBC 11	x	x	PERMG: 1992.140.1 (–)
1850	KIRMG. 2006.276; RB 06	PERMG:1992.140.4	x	x

1851	CUPMS: 1999.52.1; CUPMS: 1999.52.10; CUPMS: 1999.54.18	ADMUS: A1989.265; CUPMS: 1999.52.46;	x	x
1852	KIRMG. 2006.266	x	x	x
1853	DUN: AHH.2005–16. 02; DUN: AHH.2005–16. 05; PERMG: 2001.754.6;	x	x	x
1854	KIRMG. 2006.326	x	x	x
1857	CUPMS: 1999.52.14: CUPMS: 1999.53.4; CUPMS: 1999.54.17: CUPMS: 1999.56.5	x	x	x
1859	CUPMS: 1999.52.6; CUPMS: 1999.54.14; KIRMG. 2006.258	x	x	x
1860s	CUPMS: 1999.217.1; KIRMG. 2006.208 (Volodga)	x	x	x
1861	KIRMG. 2006.260; KIRMG. 2006.267	x	x	x
1862	CUPMS: 1999.53.1; CUPMS: 1999.54.11; KIRMG. 2006.261; PERMG: 1974.18	x	x	x
1863	CUPMS: 1999.52.4; CUPMS: 1999.53.13; CUPMS: 1999.54.12; CUPMS: 1999.54.15; KIRMG. 2006.262; KIRMG. 2006.263	x	x	x
1864	CUPMS: 1986.983; KIRMG. 1999.207; KIRMG. 2006.265; DMP 07 (Vologda); DMP 08 (Vologda); KIRMG 2006.208 (Vologda)	x	x	x
1866	CUPMS: 1999.57.2	x	x	x
1868	ADMUS: A1990.315	x	x	x
1869	ADMUS: A1988.297; ADMUS: A1989.263; DUN: AHH.2005–16. 03; KIRMG. 2006.264; RB 04	x	x	x
1870s	KIRMG. 2006.273	x	x	x
1870	CUPMS: 1999.52.11; DUN: AHH.2005–16. 04; KIRMG. 2006.268	x	x	x
1871	CUPMS: 1999.52.5; CUPMS: 1999.53.6; CUPMS: 1999.54.16; KIRMG. 2006.316; ARDG 01; ARGD 02	x	x	x
1872	CUPMS: 1999.52.3	x	x	x
1873	CUPMS: 1999.56.7; KIRMG. 1999.210; KIRMG. 2006.269; GGD 03	x	x	x
1874	CUPMS: 1999.53.9; CUPMS: 1999.54.13; CUPMS: 1999.56.4	x	x	x
1875	KIRMG. 2006.210; JBC 13	x	x	x

1877	ADMUS: M1995.160; CUPMS: 1999.52.9: CUPMS: 1999.53.2; KIRMG. 2006.271; JBC 14; CH 01	x	x	x
1878	KIRMG. 2006.212; KIRMG. 2006.324; CUPMS: 1999.52.7; CUPMS: 1999.54.19	x	x	x
1879	DUN: AHH.2004.24; KGGM. 808f.xiii; LWMCH: 03	x	x	x
1880s	ADMUS: M1995.159; KIRMG. 2006.322	x	x	x
1880	CUPMS: 1999.53.3; CUPMS: 1999.53.7; CUPMS: 1999.53.12; KIRMG. 2006.211; KIRMG. 2006.317	x	x	x
1881	KIRMG. 2006.195; KIRMG. 2006.275; KIRMG. 2006.278; KIRMG. 2006.279; KIRMG. 2006.281; KIRMG. 2006.318; NMS: Henderson 087	x	x	x
1882	KIRMG. 2006.280; KIRMG. 2006.321	x	x	x
1883	DUN:1999.21(4); JBC 12	x	x	x
1884	CUPMS: 1999.52.2	x	x	x
1885	KIRMG. 2006.323	x	x	x
1886	CUPMS: 1999.53.16	x	x	x
1887	ADMUS: B1987.23; ADMUS: B1988.8	x	x	x
1888	ADMUS: M1995.156; KGGM 808.f viii	x	x	x
1889	ADMUS: DBA3393/g; RB 07	x	x	x
1890s	CUPMS: 1999.52.12; CUPMS: 1999.53.10; CUPMS: 1999.55.1; CUPMS: 1999.55.4	x	x	x
1891	NMS: Henderson 086	x	x	x
1892	CUPMS: 1999.52.8; CUPMS: 1999.52.20; CUPMS: 1999.53.8	x	x	x
1893	DUN: AHH.2005–16. 06	x	x	x
1894	CUPMS: 1999.57.5	x	x	x
1895	DUN: AHH.2005–16. 07	x	x	x
1897	CUPMS: 1999.57.1	x	x	x
1898	CUPMS: 1999.57.3	x	x	x

19th century	ABDM: 072690; CUPMS: 1999.52.23; CUPMS: 1999.53.5: CUPMS: 1999.55.26: KIRMG. 2006.214; KIRMG. 2006.257; KIRMG. 2006.259; KIRMG. 2006.272; KIRMG. 2006.277; KIRMG. 2006.325; PERMG:1992.140.2; PERMG: 2000.243.11; RB 05	CRMCH: 1992.11.5; CRMCH: 1996.37.03; CRMCH: 1996.37.04; CRMCH: 2002.004.02; CRMCH: 2002.004.07; CRMCH: 2002.012.2; CUPMS: 1998.6.7; CUPMS: 1999.52.41; CUPMS: 1999.52.45; CUPMS: 1999.54.24; CUPMS: 1999.54.36; CUPMS: 1999.57.9; CUPMS: 2005.284; KIRMG. 2006.217; KIRMG. 2006.221; KIRMG. 2006.222; KIRMG. 2006.314; SFl 07; JM 06; JS 04	ABDM: 072694; ADMUS: A1988.300; ADMUS: A1988.302; ADMUS: A1990.313; CUPMS: 1999.53.30; CUPMS: 1999.53.31; CUPMS: 1999.54.9; CUPMS: 1999.55.13; DUN: 1999.21 (5); HARGM: 13606.16; LWMCH: 05; MoL: 2006.7/5; WEW 03	DUN:1999.21(5) (–); HARGM: 13606.1 (–); KIRMG. 2006.329 (–); KIRMG. 2006.340 (–); LWMCH: 04 (–); NEBYM: Loan D2902(B) (–); WEW 05 (–)
1902	CUPMS: 1999.216.1	x	x	x
Date unclear	CUPMS: 1999.52.21; CUPMS: 1999.52.22: CUPMS: 1999.54.57; DUN: AHH.2005–16.08; EXEMS: 99/1932 (Vologda); FALKM. 2002.43.07; FALKM. 2002.43.08; KIRMG. 2006.215; KIRMG. 2006.270; KIRMG. 2006.274; KIRMG. 2006.328; GGD 04 (Vylegda)	ADMUS: A2002.87.4; ADMUS: M1996.66; ADMUS: M1996.137; ADMUS: M1998.166; ADMUS: M2007.38; CUPMS: 1998.6.14; CUPMS: 1999.52.30; CUPMS: 1999.52.43; CUPMS: 1999.54.6; DUN: 1999.21(1); DUN: 1999.21(3); KINCM: 1339.1986.565; KIRMG. 2006.284; KIRMG. 2006.285; KIRMG. 2006.312; NEBYM: Loan D2902(A); NMS:PSin 1a. 19.11.94; GD 02; FF 22; SFl 04; TW 02;	CRMCH: 1991.60.4; CUPMS: 1999.52.44; CUPMS: 1999.52.39; CUPMS: 2007.89; HARGM: 13606.10; KIRMG. 2006.309; PERMG: 2000.243.10; AD 09; SFl 08; GMcA 08; AHM 04; JS 10; JS 11; HAW 06	MH 01 (**WK**)
Source and date indeterminable	ABDMS: 072689; ABDMS: 072696; ADMUS: A1989.246; ADMUS: A1988.301; ADMUS: DBA 3393/e; ADMUS: M1995.161; BRSMG: O.1749; CRMCH: 1990.3.2; CRMCH: 1990.4.5; CRMCH: 1992.11.6; CRMCH: 1996.32.03;	CRMCH: 2002.004.04; CRMCH: 2002.004.05; CUPMS: 1999. 55.24; CUPMS: 1999. 55.27; CUPMS: 2007.87; DUN: 1978.1430 (1); DUN: 1984.91; EXEMS: 69/2001.5; FALKM. 1999.4.31; FALKM. 2003.3.3; HARGM: 12706.1;	HARGM: 12706.13; KGGM: 808 d–iv; KIRMG. 2006.311; KIRMG. 2006.338; MoL: 2006.7/1; MM: 2006. 21; NMS: Edi.ex.19.10.93.F1; NMS: Edi.ex.23.10.93.F3; PERMG:1992.140.10 (Penza); SF: 788/6542; SF: 869/7053;	Anon. 02; PD 9/04; FF 21; JG 03; GL 04; AHM 03; GMcA 02; BP 01; ST 04; ST 08; WEW 01

7.5. Initials of producers / exporters / agents
7.5.1. Initials of producers / exporters on Archangel seals

Initials	Number	Seal numbers and dates	
А Р (= A R) (1837– 1849)	11	CUPMS: 1999.52.15 (1837); CUPMS: 1999.53.14 (1847); CUPMS: 1999.53.15 (1847); CUPMS: 1999.54.20 (1847); CUPMS: 1999.56.3 (1847); DUN: 1976.2267 (1844);	KIRMG. 1999.209 (1840); KIRMG. 2006.196 (1849); KIRMG. 2006.255 (1846); KIRMG. 2006.319 (1845); LCM: 86.72 (1846)
А Ч (= A Ch)	1	CUPMS: 1999.52.22 (n. d.)	
Д П (= D P) (1886)	1	CUPMS: 1999.53.16 (1886);	
Е П (= E P) (1836– 1888)	44	ABDM: 072688 (1844); ABDM: 072690 (19th c); ADMUS: M1995.156 (1888); CUPMS: 1999.52.9 (1877); CUPMS: 1999.52.11 (1870); CUPMS: 1999.52.17 (1836); CUPMS: 1999.53.2 (1877); CUPMS: 1999.53.7 (1880); CUPMS: 1999.53.12 (1880); CUPMS: 1999.54.15 (1863); CUPMS: 1999.54.16 (1871); KIRMG. 2006 195 (1881); KIRMG. 2006 212 (1878); KIRMG. 2006 258 (1859); KIRMG. 2006 262 (1863); KIRMG. 2006 265 (1864); KIRMG. 2006 266 (1852); KIRMG. 2006 267 (1861); KIRMG. 2006 268 (1870); KIRMG. 2006 269 (1873); KIRMG. 2006 276 (1850); KIRMG. 2006 278 (1881);	CUPMS: 1999.55.26 (19thc.); CUPMS: 1999.56.4 (1874); CUPMS: 1999.56.6 (1845); CUPMS: 1999.57.2 (1866); CUPMS: 1999.57.4 (1840s); CUPMS: 1999.57.4 (1840s) CUPMS: 2005.283 (1840s); DUN: 1999.21 (4) (1883); DUN: AHH.2004.24 (1879); DUN: AHH.2005.16. 03 (1869); KIRMG. 1999.210 (1873); KIRMG. 2006 280 (1882); KIRMG. 2006 281 (1881); KIRMG. 2006 316 (1871); KIRMG. 2006.317 (1880); KIRMG. 2006.321 (1882); LWMCH: 03 (1879); PERMG: 1992.140.2 (19th c.); RB 02 (1836); RB 04 (1869); JBC 02 (1836); JBC 13 (1875)
Ф Р (= F R) (1851– 1892)	30	ADMUS: B1987.23 (1887); ADMUS: A1988.297 (1869); ADMUS: DBA3393/g (1889); ADMUS: M1995.160 (1877); CUPMS: 1999.52.3 (1872); CUPMS: 1999.52.5 (1871); CUPMS: 1999.52.6 (1859); CUPMS: 1999.52.8 (1892); CUPMS: 1999.53.1 (1862); CUPMS: 1999.53.6 (1871); CUPMS: 1999.53.9 (1874); CUPMS: 1999.53.10 (1890s); CUPMS: 1999.54.12 (1863); CUPMS: 1999.54.13 (1874); CUPMS: 1999.54.17 (1857);	CUPMS: 1999.54.18 (1851); CUPMS: 1999.55.1 (1890s); CUPMS: 1999.56.5 (1857); CUPMS: 1999.56.7 (1873); CUPMS: 1999.57.1 (1891); DUN: AHH.2005–16. 02 (1853); DUN: AHH.2005–16. 04 (1870); KGGM.808f viii (1888); KIRMG. 2006.210 (1875); KIRMG. 2006.260 (1861); KIRMG. 2006.261 (1862); KIRMG. 2006.264 (1869); KIRMG. 2006.271(1877); PERMG: 2001.754.6 (1853); RB 05 (19th c)
М К (= M K) (1845–1857)	8	CUPMS: 1999.52.10 (1851); CUPMS: 1999.53.4 (1857); KIRMG. 2006. 198 (1845); KIRMG. 2006. 254 (1845);	KIRMG. 2006. 256 (1849); KIRMG. 2006. 320 (1848); RB 06 (1850); HAW 01 (1848)
М П (= M P) (1832–1839)	10	CUPMS: 1999.52.16 (1835); CUPMS: 1999.52.18 (1838); CUPMS: 1999.52.21 (n. d.); CUPMS: 1999.52.23 (19th c.); CUPMS: 1999.54.31 (1832);	CUPMS: 1999.55.5 (1834); CUPMS: 1999.58.1 (1833); HARGM: 12706.13 (1839); KIRMG. 2006. 253 (1835); KIRMG. 2006. 327 (1830s)
Н С (= N S) (1893–1895)	2	DUN: AHH.2005–16. 06 (1893); DUN: AHH.2005–16. 07 (1895)	

Initials	Number	Seal Numbers and Dates	
В Д (= V D) (1831–1839)	12	ADMUS: M1998.163 (1831); CUPMS: 1999.52.13 (1830s); CUPMS: 1999.53.11 (1830s); CUPMS: 1999.54.30 (1833); CUPMS: 1999.56.1 (1830s); DUN: AHH.2004.25 (1835);	DUN: AHH.2005.16. 01 (1839); KIRMG. 1999. 211 (1833); KIRMG. 2006. 209 (1838); KIRMG. 2006. 252 (1838); KIRMG. 2006. 328 (n. d.); JS 06 (1832)
В ЛЕД (1838–1868)	16	ADMUS: A1990.315 (1868); CUPMS: 1986.983 (1864); CUPMS: 1999.52.1 (1851); CUPMS: 1999.52.14 (1857); CUPMS: 1999.54.11 (1862); CUPMS: 1999.54.14 (1859); CUPMS: 1999.55.2 (1848); CUPMS: 1999.55.3 (1838);	CUPMS: 1999.56.2 (1847); KIRMG. 1999.207 (1864); KIRMG. 1999.208 (1843); KIRMG. 2006.257 (19th c.); KIRMG. 2006.213 (1839); KIRMG. 2006.216 (1845); JBC 11 (1849); HAW 02 (1842)
Я К (= Ya K) (1862–1898)	19	ADMUS: A1989.263 (1869); CUPMS: 1999.52.4 (1863); CUPMS: 1999.53.5 (19thc); CUPMS: 1999.53.8 (1892); CUPMS: 1999.53.13 (1863); CUPMS: 1999.55.4 (1890s); CUPMS: 1999.57.3 (1898); CUPMS: 1999.57.5 (1894); DUN: AHH.2005–16. 08 (n. d.); KGGM. DBK.808.f –xiii (1879);	KIRMG. 2006.211 (1880); KIRMG. 2006.263 (1863); KIRMG. 2006.277 (19th c.); KIRMG. 2006.318 (1881); KIRMG. 2006.324 (1878); KIRMG. 2006.325 (19th c.); KIRMG. 2006.326 (1854); KIRMG. E585.03 (1873); PERMG: 1974.18 (1862)
Я П В (= Ya P V) (1839–1892)	19	ADMUS: DBA 3393/d (1839); ADMUS: B1988.8 (1887); ADMUS: M1995.159 (1880s); CUPMS: 1999.52.2 (1884); CUPMS: 1999.52.7 (1878); CUPMS: 1999.52.12 (1890s); CUPMS: 1999.52.20 (1892); CUPMS: 1999.53.3 (1880); CUPMS: 1999.54.19 (1878); KIRMG. 2006.259 (19th c);	KIRMG. 2006.275 (1881); KIRMG. 2006.279 (1881); NMS: Hend.086 (1964) (1891); NMS: Hend.087 (1963) (1881); ARDG 01 (1871); RB 07 (1889); JBC 12 (1883); JBC 14 (1877); CH 01 (1877)
Я С (= Ya S) (1820s)	1	CUPMS: 1999.52.19 (1820s)	

7.5.2. Initials of producers / exporters / agents on St Petersburg seals

Initials	Number	Seal Numbers and Dates	
А Б (1833/19th c)	2	CUPMS: 1999.52.26 (1833); CUPMS: 2005.284 (19th c.)	
А И Г (= A I G) (1831–1833)	6	ABDM: 072681 (1833); CUPMS: 1998.6.5 (1831); CUPMS: 1999.54.27 (1831);	CUPMS: 1999.54.38 (1831); CUPMS: 1999.56.10 (1831); DUN: AHH.2005–16. 11 (1831)
А П (= A P) (1835–1838)	5	CRMCH: 1991.37 (1835); CUPMS: 1998.6.1 (1830s); CUPMS: 1998.6.18 (1830s);	CUPMS: 1999.52.43 (n. d.); CUPMS: 1999.55.8 (1838)
Б А (= B A) (1846–1851)	3	CRMCH: 2002.004.02 (19th c.); CUPMS: 1999.52.46 (1851);	CUPMS: 1999.52.48 (1846)
В А (1848–1851)	2	ADMUS: A1989.265 (1851); ADMUS: A1990.311 (1848)	
В Н (1832)	1	CUPMS: 1999.216.5 (1832)	
С К (1800s)	1	SFl 16 (1800s)	
С Т (1836)	1	KIRMG. 2006.219 (1836)	
Д Х (= D Kh) (1832–1837)	7	ADMUS: M1987.781 (1830s); CUPMS: 1999.52.42 (1832); CUPMS: 1999.54.29 (1837); FALKM. 2002.43.04 (1836);	KINCM: 2000.102.20 (1800s); KIRMG. 2006.288 (1837); PM 01 (1830)
Е П (= E P) (1830s)	1	CUPMS: 1998.6.17 (1830s)	

Ф Д (= F D) (n. d.)	1	KIRMG. 2006.285 (n. d.)	
F W (1828–1839)	8	ADMUS: A2002.87.2 (1828): CUPMS: 1999.53.21 (1839); FALKM. 2002.43.05 (1832); KIRMG. 2006. 286 (1831);	SF 906/7241 (1830s); SF Mistley (1830s); GMcA 13 (1830s); JM 02 (1830)
Г Б (= G B) (1789–1838)	4	CUPMS: 1999.52.27 (1829); CUPMS: 1999.54.26 (1830s);	DUN: 1978.1430 (3) (1838.); SFl 04 (1789)
I B (1829)	1	DUN: AHH.2005–16. 09 (1829)	
I C (1830–1843)	3	KIRMG. 2006.220 (1843); SFl 24 (1833);	IP 01 (1830)
И Г (= I G) (n. d.)	1	CUPMS: 1999.54.6 (n. d.);	
I H (1830– 1841)	18	ABDM: 072686 (1831); ABDM: 072695 (1830s); ADMUS: A 1989.266 (1833); ADMUS: M1998.157 (1831); ADMUS: M1995.165 (1839); CUPMS: 1998.6.14 (n. d.); CUPMS: 1999.52.30 (n. d.); CUPMS: 1999.54.22 (1830s); CUPMS: 1999.54.23 (1830s);	CUPMS: 1999.54.37 (1837); CUPMS: 1999.55.6 (1838); CUPMS: 1999.56.13 (1838); CUPMS: 1999.57.7 (1831); KIRMG. 1999.214 (1830s); KIRMG. E585.01 (1830); NLA (HER) 39393 (1841); NMS: 29.10.93 F1 (1830s); SFl 12 (1830)
I I (19th c.)	1	NML. 2007.21.2 (1835)	
I. M. Б (1830s)	1	ABDM: 072683 (1830s)	
I P (1830– 1841)	8	ABDM: 072693 (1833); CUPMS: 1998.6.6 (1830); CUPMS: 1999.53.42 (1830) CUPMS: 1999.56.11 (1831);	CUPMS: 1999.57.8 (1830s); CUPMS: 2007.91 (1831); KIRMG. 2006.292 (1841); LCM: 90.36/9 (1837)
I S (1836/19th c.)	2	CUPMS: 1999.54.24 (19thc); CUPMS: 1999.54.35 (1836)	
J H ((1836)	2	RB 03 (1836); JM 07 (1831)	
L H (1830– 1833)	3	ADMUS: M1995.163 (1833); FALKM. 2002.43.01 (1830);	JM 06 (19thc)
M K (1836)	2	CUPMS: 1999.52.25 (1836); TW 02 (n. d.)	
M C (= M S) (1833–1838)	9	CUPMS: 1999.52.24 (1833); CUPMS: 1999.52.28 (1833); CUPMS: 1999.52.45 (19thc); CUPMS: 1999.52.47 (n. d.); CUPMS: 1999.53.35 (1838);	DUN: 1989.66(1) (1836); DUN: 1999. 21 (3) (n. d.); TW 01 (1835); JS 23 (1830s)
M S (1830s)	1	FALKM. 2002.43.06 (1830s)	
H K (1820s–1836)	3	CUPMS: 1998.6.10 (1836); KIRMG. 2006.283(1820s);	SFl 28 (1833)
Н Ш (1831–1832)	2	ABDM: 072680 (1831); DUN: AHH.2005–16. 13 (1832)	
П П (1840s)	1	KIRMG. 2006. 290 (1840s)	
П Ч (1831)	1	ABDM: 072692 (1831)	
П Ш (1830s)	1	ADMUS: A1989.247 (1830s)	
P K (1829–1838)	9	ADMUS: M1997.137 (n. d.); ADMUS: M1998.159 (1829); ADMUS: M1998.162 (1829); CRMCH: 1991.60.1 (1838); CUPMS: 1998.6.7 (19thc);	CUPMS: 1999.54.36 (19thc); CUPMS: 2005.281 (1838); DUN: 1999.21(2) (1829); SFl 03 (1833)
T L (1830)	1	CUPMS: 1999.55.22 (1830)	

В К (1830)	1	DUN: 1978.1430 (5) (1830)	
В Ч (= V Ch) (1843)	1	CUPMS: 1999.53.38 (1843)	
W H (1831–1839)	4	CRMCH: 1996.37.03 (19th c.); CUPMS: 1999.52.29 (1839);	LWMCH: 01 (1831); JS 01 (1836)
Я Ф (= Ya F) (1831)	2	CUPMS: 1998.6.3 (1830s); CUPMS: 1998.6.4 (1831)	

7.6. Initials and digits on Russian seals

7.6.1. Initials and digits on St Petersburg seals

Initials / numerals	Seal accession number
A G P H	NMS: (Stoney Hill) (1816)
А Г R H	NMS: RM 9.11.94 (1814); AL 01 (1822)
A I Г A H	SFl 26 (1820s)
A:H	KM 01 (1745)
А И Г Р Н	SFl 02 (1823)
A: K R: H	MoL: 81.266/31 (1820s); PD 9/01 (1780s)
A K A –	CRMCH: 2002.12.1 (1790s); SFl 27 (1794)
A P R H	AD 05 (1794)
А Ш R H	CK 01 (1794)
А Ш – –	IP 02 (1803)
A. V. I H	ADMUS: M1995.166 (1800s)
B C 1[–]	CRMCH: 1990.3.14 (1780s)
B. I. N.	CRMCH: 1990.3.6 (1798)
B K P [–]	SFl 22 (1810s)
B K R [H]	AC 01 (1818)
C E H N	CRMCH: 1996.037.02 (1775)
C F A	CRMCH: 1990.29.4 (1799)
C F P H	WE 02 (1800)
C Fe – A H	SFl 23 (1792)
C H A H	ABDM: 072679 (1821)
C H R H	GRYEH: 1982.34.2 (1820s)
C I F P H	GLDM: 29.01 (1795)
C S 1 [–]	CRMCH: 1990.3.15 (1815)
C T R H	GI 02 (1774)
C Z R H	MoL: 2006.7/7 (1787)
D H P H	CRMCH: 1990.3.23 (1775)
Д Н: Р: Н	CRMCH: 1991.04.1 (1778); CRMCH: 1991.38.5 (1781)
D H R H	OXCMS: 1985.214.1.(1789); OXFAS: 1980.272 (1790s)
Д Ш I H	SFl 18 (1815)
E C P H	CRMCH: 1992.11.2 (1804)
F B I N	SFl 07 (19th c.)
F. K 2	CUPMS: 1999.52.32 (1833)
F K 2 H	FALKM. 2002.43.02 (1833)
F K 2	FALKM. 2002.43.03 (1840s)
F. H. H	CRMCH: 1991.23.02 (1798)
F W P H	SFl 25 (1828)
F W R H	NML. 2007.21.3 (1826)
Ф [H] R H	FF 11 (1782)
Г В И Н	JG 01 (1815)
Г. Ф К. Н	EW 03 (1788)
G K. P K	CRMCH: 1990.29.3 (1805)
G K R H	OXFAS:1987.179 (1787)
I B P H	WE 03 (1806)
I C B N 2	CUPMS: 1999.53.22 (1830s); LCM: 90.36/12 (1830s)
I C [B] P H	CRMCH: 1992.11.4 (1815)

Initials / numerals	Seal accession number
I C Z A H	AJPC 04 (1770s)
I C Z R H	MoL: 2006.7/ 4 (1787)
I G K. P H	CRMCH: 1991.29.03 (1775)
И. Ф А Н	JC 02 (1816)
И Ф Р Н	SFl 19 (1821)
I H R H	JC 09 (1770s)
I.K: P H	CRMCH: 1991.38.6 (1770s)
И [K] R H	CRMCH: 2002.004.07 (19th c.)
[I] K I N	JC 06 (1800s)
[I] М Б А	CRMCH: 1990.3.11 (1827)
I M B R	AJPC 07 (1820s)
I M P H	CRMCH: 1991.04.2 (1823)
I M R H	GRYEH: 1981.45.4 (1792)
I R P H	CRMCH: 1990.3.30 (18th c.)
I R A H	GL 02 (1777)
I S H [Å]	CRMCH: 1991.38.4 (1775)
I.S.R.[H]	NLA (HER) 42579 (1802)
И Ч А	NEBYM: A1299 (1801)
J H P H	CRMCH: 1998.37.06 (1825)
K K A [H]	CRMCH: 1991.04.04 (1800s)
L G K P H	CRMCH: 1996.037.01 (1775)
L I W P H	CRMCH: 2002.12.3 (1787)
Л. З. I.Н	CUPMS: 1999.53.18 (1831); CRMCH: 2002.12.2 (19th c.)
Л. З. I. –	CUPMS: 1999.57.6 (1831);
Л. З. 2.Н	CUPMS: 1999.57.9 (19th c); DUN: AHH.2005–16.12 (1832)
М Б R H	FF 19 (1818)
M M P H	CRMCH: 1990.3.21 (1804); CRMCH: 1992.11.7 (1823)
M M R H	FF 6 (1781); BR(B) 02 (1810s)
M C A H	SFl 11 (1824)
M M B	GRYEH: 1981.53 (1797)
M P A H	OXFAS: 1987.188 (1771)
M C: P H	CRMCH: 1992.11.1 (1778); CRMCH: 1991.04.6 (1778)
М Ѳ Р	CRMCH: 1991.29.07 (1784)
М Ѳ Р Н	JC 10 (1799)
H 2 H	CUPMS: 1999.53.20 (19th c.)
H – 2	CRMCH: 1991.60.1 (1838)
Н. I	CRMCH: 1996.32.01 (1829)
Н. 3	CRMCH: 1996.37.03 (19th c.); TD 01 (1838)
[Н] П 3	FORMG: 2006.24 (1832);
Но П –	ADMUS: DMB 4217(b) (1835); JM 08 (1840s); WEW 03 (19th c.)
Н. –. 2	SFl 03 (1833)

Но П	ABDM: 072692 (1831); CUPMS: 1998.6.17 (1830s); CUPMS: 1999.52.45 (19th c.); CUPMS: 1999.53.38 (1843); CUPMS: 1999.54.28 (1830); CUPMS: 1999.54.38 (1831); CUPMS: 2005.286 (1820s); KIRMG. 2006.288 (1837); JBC 05 (1830s)
Но П 1	ABDM: 072680 (1831)
Но П 2	ABDM: 072681 (1833); ABDM: 072683 (1830s); ADMUS: A1989.247 (1830s); CUPMS: 1999.52.24 (1833); CUPMS: 1999.52.25 (1836); CUPMS: 1999.52.27 (1829); CUPMS: 1999.52.43 (n. d.); CUPMS: 1999.54.29 (1837); CUPMS: 1999.55.8 (1838); CUPMS: 2005.284 (19th c.); DUN: 1978.1430 (3) (1838); NMS: Henderson.090 (1829); KIRMG. 2006. 285 (n. d.); KIRMG. 2006. 290 (1840s); KIRMG. 2006. 315 (1840s)
Но П 3	ADMUS: M1996.66 (n. d.); CUPMS: 1998.6.1 (1830s); CUPMS:1998.6.3 (1830s); CUPMS:1998.6.5 (1831); CUPMS:1998.6.10 (1836); CUPMS:1999.52.26 (1833); CUPMS:1999.52.28 (1833); CUPMS:1999.54.25 (1830s); CUPMS:1999.54.26 (1830s); CUPMS:1999.54.27 (1831); CUPMS:1999.55.7 (1829); CUPMS:1999.56.10 (1833); CUPMS: 2005.289 (1832); DUN: 1978.1430 (5) (1830); DUN: 1989.66(1) (1836); DUN: 1999.21.(3) (n. d.); FALKM. 2002.43.04 (1836); KIRMG. 2006.197 (1838); KIRMG. 2006.283 (1820s)
Но П [3]	ADMUS: M1987.781 (1830s)
Но 2 –	KIRMG. 2006. 41 (1841)
Но 2	ADMUS: M1980.3639 (1844)
Н 3	KIRMG. 2006. 298 (1783)
Но –3	SFl 12 (1830)
Н. –3	KINCM: 1339.1986.564 (1836)
[N]. P 2	ADMUS: M1998.167 (1836)
N P – 1	JM 07 (1831)
– P 1	ABDM: 072686 (1831); MW 01 (1838)
No. – [–]	SF902/7241 (1830s)
No. – 2	KIRMG. 1999.213 (1830s)
N P –	ADMUS: A2002.87.4 (n. d.); ADMUS: M1995.165 (1839); CUPMS: 1999.54.24 (19th c.); CUPMS: 1999.57.8 (1830s)
N P – [3]	ADMUS: A2002.87.2 (1828)
N P – 2	ADMUS: A1989.266 (1833); ADMUS: DBA3393/f (1838); ADMUS: M1997.137 (n. d.); CUPMS: 1998.6.6 (1830); CUPMS: 1998.6.9 (1838); CUPMS: 1999.52.29 (1839); CUPMS: 1999.53.21 (1839); CUPMS: 1999.54.35 (1836); CUPMS: 1999.54.36 (19th c.); DUN: 1999.21(2) (1829); FALKM. 2002.43.01 (1830); KIRMG. 1999.212 (1830s); KIRMG. 1999.214 (1830s); KIRMG. 2006. 286 (1831); LCM: 90.36/9 (1837); GD 02 (n. d.); JM 06 (19thc)
N P 2	ABDM: 072693 (1833); ADMUS: M1995.163 (1833)
N P – 3	ABDM: 072685 (1832); ADMUS: A2000.212 (1835); ADMUS: M1998.159 (1829); ADMUS: M1998.162 (1829); CUPMS: 1998.6.14 (n. d.); CUPMS: 1998.6.15 (1830s); CUPMS: 1999.54.21 (1830s); FALKM. 2002.43.05 (1832); FALKM. 2002.43.06 (1830s)
N P 3	ADMUS: M1998.166 (n. d.); CUPMS: 1998.6.7 (19th c.); CUPMS: 1999.52.30 (n. d.); CUPMS: 1999.54.22 (1830s); CUPMS: 1999.54.23 (1830s); CUPMS: 1999.56.11 (1831)
N P –	ABDM: 072695 (1830s)
[N] P 2	ADMUS: M1998.167 (1836)
[N] P. 3	CUPMS: 2005.281 (1838)
Н П І Н	INVMG: 2003.120.059 (1777); SFl17 (1779)
Н Ш Р	CRMCH: 1990.3.7 (1818); IP 03 (1823)
О Р Р Н	CRMCH: 2002.004.03 (1825)
П 2	CUPMS: 1999.53.35 (1838); CUPMS: 1999.54.6 (n. d.); DUN: 1999.21(1) (n. d.)
П 3	KIRMG. 2006.284 (n. d.)
П П І [–]	CRMCH: 1991.29.06 (1779)
P. CI. H	CRMCH: 2002.003.02 (1775)
ПЕН	EXEMG: 60/2001.4 (1841)
ПЕНЬ	NML. 2007.21.2 (1835)
ПЕН 1	FALKM. 2003.3.2 (1840)
ПЕН 2	CRMCH: 1991.37 (1835); SFl 28 (1833)
ПЕН. 3	KINCM: 2000.102.20 (1800s); SFl 04 (1789)
(НЕН. 3)	TW 01 (1835)
ІЕН. (=ПЕН?)	TW 02 (n. d.)
P.F.A.H	CUPMS: 1999.54.33 (1799)
P F A	CRMCH: 1991.38.3 (1799)
P. I. N.	CRMCH: 1990.3.27 (1790)
П А С Р Н	CRMCH: 1990.3.22 (1789)
П І Н	SFl 14 (1779s)
П П І Н	CRMCH: 1990.3.18 (1779)

П Ш 2 Н	CUPMS: 1999.53.17 (1833); CUPMS: 1999.53.19 (1833); CUPMS: 1999.54.34 (1830s)	Т Н А Н	CRMCH: 1991.29.02 (1801); CRMCH: 2002.004.08 (1789); SFl 13 (1824)
П Ш 2	CUPMS: 1999.56.8 (1832)	Т Н Р	CRMCH: 1991.38.11 (1770s)
Р. 2	CUPMS: 1999.57.10 (1838); KIRMG. 2006.312 (n. d.)	Т L А Н	CRMCH: 1996.37.05 (1824); CRMCH: 2002.004.01 (1825)
Р – 3	CUPMS: 1999.57.7 (1831)	Ч А Н	WE 04 (1799)
Р В А Н	SFl 20 (1792)	Ш 2 Н	CUPMS: 1999.52.34 (1841)
R. Р Н	CRMCH: 1990.3.12 (1776)	B a . A	FF 10 (18thc.)
S H. 3	JL 01 (1837)	B a P [H]	CRMCH: 1991.04.3 (1805)
[S] R H	NLA (HER) 23698 (1797)	W H A [–]	CRMCH: 2002.003.01 (1823)
[S] S R H	AMu 04 (1763)	W. P. H.	SFl 05 (1777)
С У Р Н	MoL: 2006.7/2 (1800)	W S A H	SF (SMR) COR 050 (1805)
С Ч Р I	OXFAS: 1998.106 (1803)	Я С Р Н	CRMCH: 1991.38.8 (1807)

7.6.2. Initials and digits on Russian seals of uncertain provenance (NP, WK, WU, ПД, ИП)

Initials / numbers	Unidentified origin: N P	Unidentified origin: W K, W U, P D, I P
А Б 12 Н	CUPMS: 1999.54.51 (1819); JT 01 (1814); JM 05 (1810)	
А Б 12 К	JS 11 (1805)	
A G 12 [–]	ADMUS: A1988.291 (1818)	–
А Г: 12 Н	AMu 09 (1820s); JM 01 (1827)	–
A I B 12 H	PERMG: 140.3 (1768); GI 01 (1774)	
А Н 9 А О	AJP 01 (1759)	–
А Н 12 К	JH(L) 10 (1780)	–
А И 9 П 9	–	JC 01 (1758) W [U]
А К 9 Н	LWMCH: Unaccess. 05 (19th c)	–
А К 12	HARGM: 12706.6 (1810s)	–
А К 12 [Н]	HARGM: 13606.2 (1810s)	–
А К 12 Н	CUPMS: 1999.52.40 (1826); CUPMS: 1999.53.32 (1788); FALKM. 2003.3.58 (1782); MoL: 2006.7/3 (1778); WAW C20717 (1781); WK 02 (1800)	–
А К 12 [Н]	CUPMS: 1999.216.2 (1806)	–
А M I H	–	SFl 29 (1796) [P D]
A N 9 F F	–	JH(L) 02 (1760) [W K]
A N 9 Θ E	–	JH(L) 03 (1753) [W U]
A N 9 F [H]	–	JH(L) 04 (1760) [W K]
A N 9 P K	–	WHITM: 420.1 (1759) [W. K.]; WHITM: 420.2 (1759) [W. K.]
A N 12 [H]	WK 03 (1760)	–
A N 12 A	BRSMG:.O.4164 (1758)	–
А П 12	CUPMS: 1999.56.15 (1820s)	–
А Р 12	DF 01 (1790s)	–
А Р 9 К	CUPMS: 1999.54.10 (1803)	–
А Р 12 Н	CUPMS: 1999.53.26 (1799); HARGM: 12706.4 (1796); MM: 2006. 16 (1794)	–
А Р 12 [–]	ADMUS: A1988.302 (19th c)	–
A R 12	CUPMS: 1999.56.18 (1820s)	–
А С Х 12 Н	CUPMS: 1999.57.17 (1808)	–
А. Ч 12 Н	KIRMG. 2006.294 (1777); KIRMG. 2006.302 (1818); MM: 2006. 18 (1814); NLA (HER) 13603 (1778)	–
А. Ч 12 [–]	AMu 07 (1819)	–
А Ш 12	KINCM: 2000.100.4 (1802)	–
А Ш 12 К	AD 02 (1800s)	–

B 12 [K]	CUPMS: 1999.216.7 (1800)	–
B 12 H	ADMUS: DBA3393/c (1822)	–
B 12 [–]	CD 01 (1755)	–
C 12 H	ABDM: 072687 (1820s)	–
C C H	NMS: 25.9.93.F1 (1779)	–
C C 12 H	SBYWM: ii.E.435 (1775)	–
C F 9 H	HAW 08 (1800)	–
C H 12	CUPMS: 1999.56.17 (1820s)	–
C H 9	CUPMS: 1999.53.27 (1820s)	–
C F. K 9 K	CRMCH: 1991.29.04 (1775)	–
C F K 12 K	AJPC 05 (1780)	
C Fe. K 6	SFl 08 (n. d.)	–
C G F 12	MM: 2006. 11 (1810s); JBC 04 (1820s)	–
C H F 12 K	AHM 01 (18th c.) (HF is a ligature)	–
C H 12	CUPMS: 1999.54.54 (1820s)	–
C H 12 K	KINCM: 2000.100.5 (1802); AJPC 06 (1780)	–
C K 12	CUPMS: 1999.55.12 (1809)	–
C Z 12 H	HFDMG 1980–82 (1779); JC 03 (1788)	–
D G 6 H	SFl 06 (1778)	–
D H 6 K	CRMCH: 1990.29.1 (1777)	–
D H. 6 [K]	–	CRMCH: 1990.3.20 (1775) [W –]
Д Н 12 H	CUPMS: 2005.279 (1775)	–
D H 6 K	WE 06 (1775)	–
D H: 12 –	WHIT(W.A.) 9711601 (1770s)	–
E C 12 H	JS 13 (1800)	WEW 02 (1801) [W K]
E C 12 K	CUPMS: 1999.53.24 (18th c.); RM 01	–
E R 12	CUPMS: 1999.56.18 (1820s)	–
E R 12 H	HARGM: 13606.3 (1822)	–
E R 12 [H]	JG 02 (1810s)	–
F K 12 [H]	Anon 01 (1789)	–
F L 9 H	AH 01 (1765)	JH(L) 05 (1762) [W K]
F L 12 H	SWi 01 (1763)	–
F W 9 H	CUPMS: 1999.54.45 (1825)	–
F W 12 H	CUPMS: 2005.282 (1813)	–
F W 12 [–]	LCM: 90.36/7 (1818)	–
F W 12	CUPMS: 1999.54.8 (1820s)	–
Ф 9 H	CUPMS: 1999.54.56 (1826)	–
Ф K 12	LCM: 90.36/11 (18th c)	–
Ф K 12 H	HARGM: 12706.7 (18th c)	–
Ф K 12 [H]	CUPMS: 1999.57.13 (1785)	–
Ф 12 H	CUPMS: 1999.55.20 (1827); HARGM: 12706.7 (18th c.)	–
G I F 12 K	KIRMG. 2006.331 (1795}	–
Г 12 H	ADMUS: M1980.3582 (1807)	–
Г Б 12	CUPMS: 1999.54.4 (1820s)	–
H 12 H	JBC 01 (1824); JBC 06 (1794); JBC 09 (1808); AD 08 (1802); GMcA 11 (1820); GMcA 14 (1791)	–
H G K: 6 K	SFl 21 (1779)	–
H P I [K]	WARMS Brailes (Slide 62) (1790s)	–
H P 6 H	CRMCH: 1990.3.26 (1775)	–
H P 9 H	GL 03 (1775)	–
H P 12 K	JH(L) 12 (18th c.)	–
H P 12 H	KIRMG. 2006.293 (1774); FF 4.(1781); JS 17 ((1790s); ST 06 (1790s); WR 02 (1777)	–

H I [K] 12 H	MM: 2006. 3 (1776)	–
Н Ф 12 H	RI 01 (1819)	–
Н Θ 12 H	Anon 06	–
I A C 12 K	MM: 2006. 4 (1786)	–
I B 12 H	KIRMG. 2006.308 (1804)	–
И Б 12 H	ABDM: 072691 (1794)	–
I B 12 (–)	CUPMS: 1999.52.36 (1825)	–
I С Б 12 H	AMu 01 (1821)	–
I C 12	JS 07 (1820)	–
I.[C] 12 H	ST 08 (n. d.)	–
I C Z 12	NMS: Edi bag 3 (1782)	–
I C Z 12 H	GRYEH: 1981.45.2 (1784); BR(B) 01 (1765); GL 01 (1786)	–
I F E 12 [H]	NMS: H. NM 222(1785)	–
I. F. 12 H	PD 9/02 (1778); NP 01 (1770); ST 09 (1774)	–
И Ф 12 H	HARGM: 12706.5 (1814)	–
I Ф 12	LCM: 96.81 (1788)	–
I H 12 [H]	CUPMS: 1999.54.42 (1824)	–
I H 12 H	FALKM. 2000.4.10 (1790); AD 07 (1802); TD 03 (1767)	–
I H 12	CRMCH: 2002.004.06 (1818); AD 10 (1809)	–
I H R – –	SFl 15 (1813)	–
I I W 12 K	HARGM: 12706.2 (1801)	–
I I W 12	GB 04 (1790S)	–
I K 6 H	CRMCH: 1990.3.25 (1777)	–
I.K.12	FALKM. 1997.13.10 (1791)	–
I K 12 H	DUN: 1978.1430(2) (1777); HAW 05 (1783)	–
I М Б 12 [–]	CUPMS: 1999.52.37 (1818);	–
I М Б 12	CUPMS: 1999.54.50 (1820s);	–
I М Б – –	CUPMS: 1999.216.4 (1821)	–
I M 12 H	–	ADMUS: A1988.298 (1777) [W K]
I M K 12 H	PRSMG: T1963 (A146) (1776)	–
I R 6 K	–	CRMCH: 1991.38.2 (1775) [W K]
I R 12 K	HFDMG 1987–19/1 (1783); HAW 04 (1770s)	–
I S 12 H	ADMUS: M1987.780 (1775); CUPMS: 1999.54.47 (1820s); CUPMS: 1999.57.12 (1800); DUN: AHH.2005–16.15 (1801); KIRMG. 2006.307 (1818)	–
I S 12	CUPMS: 1999.55.11 (1820s)	–
И 12 М П	–	IS 01 (1759) [I P]
И. Ч 12	ADMUS: M1998.160 (1819)	–
И. Ч 12 K	ST 03 (1800)	–
И. Ч 12 H	MH 05 (1803)	–
K 9 H	CUPMS: 1999.56.16 (1826)	–
C K 12	CUPMS: 1999.55.12 (1809)	–
K 12 H	CUPMS: 2007.90 (1793); KIRMG. E858. 06 (1804)	–
K K 12 H	CUPMS: 1999.55.23 (1803)	–
Л Г 12 H	AD 03 (1800s)	–
L G K 6 K	–	CRMCH: 1990.3.19 (1775) [W –]
L G K 6 [K]	CRMCH: 1991.23.01 (1777)	–
L I W 12 K	–	GRYEH: 1981.74.2 (18thc) [W K]
L I W 12 [–]	WAW C20717 (1781)	–
М Б 9 H	MoL. 2006.6 (1812)	–
М Б 12 H	KIRMG. 2006.330 (1820)	–
М Б 12	ADMUS: M1995.157 (1828)	–

Me 12 H	AHM 02 (1777)	–
M F 12 H	ST 05 (1764)	–
M H 9 H	JH(L) 06 (1762)	–
M M 9 H	CUPMS: 1999.53.29 (1799)	–
M M 12	ADMUS: M1998.161 (1790s); AD 04 (1802)	–
M M 12 [–]	KIRMG. 2006.303 (1818)	–
M M 12 H	GLDM: 29.3 (1781); HARGM: 12706.8 (1796); NLA (HER) 16554 (1781); PRSMG: T1962 (A144) (1796); KMo 01 (1790s)	–
M C 12 –	CUPMS: 1999.55.16 (1822)	–
M Θ 1	LCM: 94.27/1 (1790)	–
M Θ 12	ST 02 (1780s)	–
M Θ 12 H	GB 02 (1790s); GB 06 (1798)	–
H 12 H	CUPMS: 1999.55.14 (1825); CUPMS: 1999.55.15 (1827); CUPMS: 1999.55.19 (1827); CUPMS: 1999.57.16 (1827); KIRMG. 2006.304 (1821)	–
[H]Г 12 H	CUPMS: 1999.55.18 (1824)	–
HF 12 (as ligature)	JH(L) 11 (1790s);	–
HP: 6. K (as ligature)	PRSMG: T1961 (1777)	CRMCH: 1990.3.5 (1775) [W K]; CRMCH: 1991.04.7 (1775)[W K];
HP 9 H (as ligature)	ADMUS: DBA3393(a) (1820s); DUN: 1978.1430 (4) (1801)	–
H P 12 H	ST 06 (1779)	
HP 12 H (as ligature)	CUPMS: 1999.54.39 (1790s)	–
HP 1[2] (as ligature)	CUPMS: 1999.53.28 (1790s); CUPMS: 1999.53.31 (19th c.)	–
HP: 12. K (as ligature)	ADMUS: M1998.156 (1804); ADMUS: M1998.158 (1799); JH(L) 07 (1797)	–
H Φ 12 H	RI 01 (1819)	–
H Θ 9 H	Anon. 06 (1776)	–
N 12 Ч	FALKM. 2003.3.59 (1783)	–
O H A I	NMS: P. Sin (1791)	–
O H 12 K	ST 11 (1792)	–
O P 12 [–]	CUPMS: 1999.54.2 (1820s)	–
O P 12 H	NMS: (Stoney Hill) (1813); GMcA 07 (1825)	–
[O] P 12 H	KIRMG. E585. 02 (1807); GMcA 04 (1825)	–
P B 9 H	WALM. 2005–13–2 (1796)	–
P B 12 H	ADMUS: M1995.162 (1800s); CUPMS: 1999.53.25 (1794)	–
P B 12 K	JSm 01 (1785)	–
P F 9	JC 08 (1806)	–
P F 12	CUPMS: 1999.55.13 (19th c.); HARGM: 12706.12 (1801)	–
P F 12 H	KIRMG. 1999.215 (1818); SF869/7380 (1809);	–
P [K] 12 H	CUPMS: 1999.52.38 (1825)	–
P K 1[2]	CUPMS: 1999.54.9 (19th c.);	–
P L 12 H	CUPMS: 1999.54.5 (1825)	–
P M 12 H	JBC 15 (1770); MH 02 (1767)	–
P N 12 H	GGAT 01 (1774)	–
P S 12 H	MH 04 (1760s)	–
П S 9 H	MH 04 (1760s)	–
P: 6 K	NMS: 23.10.93. F3 (1775)	–
P 12 K	NMS: RM 9.11.94 (1827)	–

Р 9 Н	FF 2 (1806)	–
П А С 12 [–]	JC 04 (1788)	–
П А С [–]	EW 02 (1790)	–
П С: 6	CRMCH: 1990.3.9 (1777)	–
П С: 6 Н	CRMCH: 1990.3.16 (1770s)	–
П С 12 К	LCM: 86.16 (1791)	–
П Ч 12 Н	KIRMG. 2006.305 (1826)	–
R P 9 K	DF 03 (1779)	–
S B 12 A O	WAW BB6B85 (1755)	–
S B. 12. F. S.	BRSMG: O.4165 (1756)	–
S S 12 H	WALM: 2005–13–1 (1768)	–
S 12 B	WE 01 (1752); AJPC: 01 (1752); AJPC 02 (1753)	–
S 12 H	LCM: 94.27/2 (1814)	–
С Б 12 Н	CUPMS: 2007.89 (n. d.)	–
С Ч 12 Н	CUPMS: 2005.287 (1802); MM: 2006.10 (1804)	–
[С]Ч 12 Н	WK 01 (1805)	–
T H 9 H	FF 9 (1806)	–
T H 12 H	MoL: 2006.7/6 (1793); JBC 10 (1790s); GMcA 12 (1780s)	–
T H 12 –	CUPMS: 1999.217.2 (1800s)	–
T H 12	CUPMS: 1999.54.41 (1800s); GMcA 08(n. d.)	–
T K 12 [H]	EW 06 (1790s)	–
T K 12 K	MH 06 (1793)	–
T L 12 H	CUPMS: 1999.57.15 (1820s)	–
T X 12 K	DMP 04 (1793)	–
T X 12 H	JH(L) 09 (1791)	–
T 12 H	CUPMS: 1999.54.48 (1826)	–
T Θ 12 H	JC 12 (1780s)	–
B a 12 K	ST 10 (1800); JH(L) 01 (1789)	–
B a 12 H	ST 07 (1789)	–
W H 12 H	AL 02 (1820s); Anon. 05 (1820s)	–
W S 12 H	MoL: 2006.7/5 (19thc)	–
Ш 12 Н	JBC 08 (1805); AD 06 (1802)	–
Θ 12 H	JC 07 (1790s)	–
Я В 6	CRMCH: 1991.38.7 (1779)	–

7.6.3. Initials and digits on seals of undetermined origin

Initials / numbers	Undetermined origin
А Б 9 Н	KIRMG. 2006.306 (1827)
A N R A	Anon 04 (1760)
А. Ч 12 [–]	KIRMG. 2006. 238 (1813)
А Ш 12 К	HAW 07 (1795)
C H 12	CUPMS: 1999.54.54 (1820s)
C K	SFl 16 (1800s)
D H 2 K	CUPMS: 2005.290 (1777)
E P 12	LCM: 36/1 (1818)
H 12 H	FF 13 (1775)
I C 12	CUPMS: 1999.54.53 (1826)
I H 12 H	EW 05 (1826)
I.K.12	TD 02 (1780)

Initials / numbers	Undetermined origin
K 12 K	MM: 2006. 5 (1787)
[H] 12 H	CUPMS: 1999.55.25 (1821)
H 12	KIRMG. 2006.300 (1808)
O. 9 H	PRSMG: T 1960(145) (1762)
P B 12 [–]	JH(L) 08 (1789)
P [H] 12	ADMUS: M1998.168 (1800s)
P F 12	AMu 03 (1821)
P F 12 H	TWh –01 (1797)
P K 12	KIRMG. 2006.296 (1796)
T H A H	CRMCH: 2002.004.08 (1789)
T 12 [H]	RN 01 (1820)
Θ 12 H	JWh 01 (1795)

7.7. Initials on first line of St Petersburg and unprovenanced seals
7.7.1. Initials on obverse (other than Л.Д (= L. D.)

Initials	Seal number	Seal Number
Д. А. (= D A)	CRMCH:1990.3.5 (1775); CRMCH:1990.3.19 (1775); CRMCH:1990.3.20 (1775); CRMCH:1990.3.25 (1777); CRMCH:1991.29.04 (1775); CRMCH:1991.38.6 (1770s); CRMCH:1991.38.7 (1779); CRMCH: 2002.003.02 (1775);	GRYEH:1981.45.2 (1784); MoL: 2006.7/3 (1778); MoL: 2006.7/7 (1787); JC 09 (1770s); PD 9/02 (1778); WR 02 (1777); JWa 02 (1782); Anon 06 (1776)
Д.В. (= D V)	CRMCH:1996.32.01 (1829); CRMCH:1996.037.01 (1775); NLA (HER) 36633 (1778);	OXFAS: 1980.271 (1778); GGAT 01 (1774)
Д: Г: (= D G)	CRMCH:1991.29.03 (1775);	
Д. Д. (= D D)	CRMCH:1990.3.7 (1818); CRMCH:1990.3.18 (1779); CRMCH:1991.29.06 (1779); INVMG: 2003.120.059 (1777);	JBC 15 (1770); SFl 14 (1770s); SFl 17 (1779); JW 01 (1780s)
Д [Д]	DUN: 1978.1430 (2) (1777)	
Д Е (= D E)	CRMCH: 2002.12.3 (1787); PERMG: 1992.140.3 (1768)	NP 01 (1770); ST 09 (1774)
Д. И. (= D I)	NLA (25178) (1776); WE 06 (1775); GL 02 (1777)	
Д [И]	FF 6 (1781) [D [I]];	
Д I (= D I)	HFDMG: 1987–19/1 (1783); WHIT(W.A.) 9711601 (1770s);	AMu 04 (1763); HAW 05 (1783)
Д. I. I (= D I I)	OXFAS: 1987.188 (1771)	
Д Ф (= D F)	NLS (HER) 39269 (1762)	
Д Θ (= D Th)	ST 02 (1780s)	
Д К (= D K)	PD 9/01 (1780s); SFl 06 (1778); MH 02 (1767);	JS 14 (1764); JS 15 (1764)
Д Л (= D L)	FALKM. 2003.3.58 (1782); HFDMG: 1980–82 (1779)	
Д L (= D L)	SBYWM: ii.E.435 (1775)	
Д Л I (= D L I)	CRMCH:1991.23.01 (1777)	
Д М (= D M)	CRMCH:1990.3.16 (1770s); WAW–C12717 (1781); BR(B) 01 (1765)	
Д: Н (= D N)	AJPC 06 (1780)	
Д: П (= D P)	BRSMG: O 1421 (1776)	
Д: [П] (= D [P])	MM 2006.4 (1786)	
Д С (= D S)	CRMCH:1991.38.9 (17[7]8); CRMCH: 2002.004.05 (n. d.); CUPMS: 2005.276 (1775);	GL 01 (1786); ST 06 (1779)
Д [S] (= D S)	CRMCH: 1990.29 1 (1777)	
Д Т (= D T)	PRSMG: T1961 (1777)	
Д [T]	WALM: 2005–13–2 (1768)	

Д 8 (= D 8)	PRSMG: T1963 (A146) (1776)	
Д [Я] (= D yA)	HAW 04 (1770s)	
Л. П. (= L P)	CRMCH:1990.3.2 (n. d.)	
Л. – П (= L – P)	FALKM. 1999.4.31 (n. d.)	
П Д. (= P D)	ABDM: 072679 (1821); CRMCH:1990.3.6 (1798); CRMCH:1990.3.7 (1818); CRMCH:1990.3.10 (1800s); CRMCH:1990.3.11 (1827); CRMCH:1990.3.15 (1815); CRMCH:1990.3.21 (1804); CRMCH:1990.3.27 (1790); CRMCH:1990.29.3 (1805); CRMCH:1990.29.4 (1799); CRMCH:1991.04.2 (1823); CRMCH:1991.04.3 (1805); CRMCH:1991.04.4 (1800s); CRMCH:1991.23.02 (1798); CRMCH:1991.27–1 (1770s); CRMCH:1991.29.02 (1801); CRMCH:1991.37 (1835); CRMCH:1991.38.3 (1799); CRMCH:1991.38.8 (1807); CRMCH:1991.60.1 (1838); CRMCH:1991.60.3 (1806); CRMCH:1992.11.2 (1804); CRMCH:1992.11.4 (1815); CRMCH:1992.11.5 (n. d.); CRMCH:1996.32.01 (1829); CRMCH:1996.37.05 (1824); CRMCH:1996.32.06 (1825); CRMCH:2002.003.01 (1823); CRMCH: 2002.004.01 (1825); CRMCH: 2002.004.03 (1825); CRMCH: 2002.004.07 (19thc); CRMCH: 2002.004.08 (1789); EXEMS: 69/2001.4 (1841); FALKM. 2003.3.2 (1840) (SPB); GRYEH:1981.45.4 (1792); GRYEH:1982.34.2 (1820s); KINCM: 1339.1986.564 (1836); MM: 2006. 2 (1780s); MoL: 81.266/31 (1820s); NLA (HER) 42579 (1802); NML. 2007.21.1 (1787);	NML. 2007.21.3 (1826); NMS: 19.10.93. F1 (n. d.); NMS: 29.10.93. F1 (1830s); NMS: (Stoney Hill) (1816); OXCMS.1985.214.1 (1789); OXFAS: 1980.272 (1790s); OXFAS: 1987.179 (1787); SF (SMR) LUD misc.MSF23230 (1805); RB 03 (1836); AJPC 07 (1820s); AC 01 (1818); JC 02 (1816); JC 06 (1800s); JC 11 (18th c); GD 02 (n. d.); FF 10 (18thc,); FF (n. d.); SFl.01 (1814); SFl.02 (1820s); SFl.03 (1833); SFl.04 (1789); SFl.07 (19thc); SFl.09 (1777); SFl.11 (1824); SFl.16 (1800s); SFl 18 (1815); SFl.20 (1792); SFl.22 (1810s); SFl.23 (1792); SFl.25 (1828); SFl.27 (1794); GMcA 05 (1794); GMcA 10 (1794); DP 01 (1800s); IP 01 (1830); IP 03 (1823); EW 01 (18th c); EW 03 (1788); JS 01 (1836); JS 02 (1817); NMT 01 (1822)
П [Д] (= P [D])	FALKM. 2003.3.2 (1840)	
ПЛПД ПиЛПД (= PLPD PiLPD)	CUPMS:1999.52.31(1836); CUPMS:1999.52.32(1833); CUPMS:1999.52.34(1841); CUPMS:1999.52.35(1839); CUPMS:1999.53.17(1833); CUPMS:1999.53.18(1831); CUPMS:1999.53.19(1833); CUPMS:1999.53.20(1830s); CUPMS:1999.53.22(1830s); CUPMS:1999.54.32(1830s);	CUPMS:1999.52.33(1832); CUPMS:1999.52.34(1841); CUPMS:1999.54.34(1830s); CUPMS:1999.56.8(1832); CUPMS:1999.57.6(1831); DUN: AHH2005-16-10 (1831) DUN: AHH2005-16-12 (1832) FALKM. 2002.43.02 (1833); FALKM. 2002.43.03 (1840s); LCM: 90.36/12 (1830s)

П П (= P P)	CRMCH:1992.11.6 (n. d.); CRMCH: 2002.004.04 (n. d.); CRMCH: 2002.12.4 (n. d.); DUN:1984.91 (n. d.);	FALKM. 1999.4.31 (n. d.); FALKM. 2003.03.03 (n. d.); MoL: 2006.7/1 (n. d.); PMn 01 (n. d.)
П I П	JM 04 (n. d.)	

7.7.2. Initials on reverse (other than N. P.)

Initials	Seal Number	Seal Number	
И П	IS 01 (1759)		
Л.П.С.	FALKM. 20003.03.03 (n. d.); JM 04 (n. d.)		
П Д	SF29 (1786)		
П. I C	CRMCH:1990.3.2 (n. d.)		
SPB	ABDM: 072681 (1833); ABDM: 072685 (1832); ADMUS: A1989.266 (1833); ADMUS: A2002.87.2 (1828); ADMUS: A2002.87.5 (n. d.); ADMUS: A2000.212 (1835); ADMUS: M1995.163 (1833); ADMUS: M1995.166 (1800s); ADMUS: M1997.137 (n. d.); ADMUS: M1998.162 (1829); ADMUS: M1998.166 (n. d.); ADMUS: M1998.167 (1836); BRSMG: O 1421 (1776); BRSMG: T 9407 (1747); CRMCH:1990.3.1 (1799); CRMCH:1990.3.4 (1800); CRMCH:1990.3.6 (1798); CRMCH:1990.3.7 (1818); CRMCH:1990.3.11 (1827); CRMCH:1990.3.12 (1776); CRMCH:1990.3.13 (1781); CRMCH:1990.3.15 (1815); CRMCH:1990.3.17 (1797); CRMCH:1990.3.22 (1789); CRMCH:1990.3.23 (1775); CRMCH:1990.3.24 (1799); CRMCH:1990.3.27 (1790); CRMCH:1990.3.29 (1775); CRMCH:1990.3.30 (18thc); CRMCH:1990.29.2 (1823); CRMCH:1990.29.3 (1805); CRMCH:1990.29.4 (1799); CRMCH:1991.04.1 (1778); CRMCH:1991.04.2 (1823); CRMCH:1991.04.3 (1805); CRMCH:1991.04.4 (1800s); CRMCH:1991.04.3 (1814); CRMCH:1991.04.6 (1778); CRMCH:1991.23.02 (1798); CRMCH:1991.27 –1 (1770s); CRMCH:1991.29.01 (1805); CRMCH:1991.29.02 (1801); CRMCH:1991.29.03 (1775);	CRMCH:1991.29.05 (1780s); CRMCH:1991.29.06 (1779); CRMCH:1991.29.07 (1784); CRMCH:1991.38.3 (1799); CRMCH:1991.38.5 (1781); CRMCH:1991.38.6 (1770s); CRMCH:1991.38.8 (1807); CRMCH:1991.60.1 (1838); CRMCH:1991.60.2 (1789); CRMCH:1991.60.3 (1806); CRMCH:1992.11.1 (1778); CRMCH:1992.11.2 (1804); CRMCH:1992.11.3 (1781); CRMCH:1992.11.4 (1815); CRMCH:1992.11.5 (n. d.); CRMCH:1992.11.7 (1823); CRMCH:1992.11.8 (18th c); CRMCH:1992.11.9 (1801); CRMCH:1996.32.01 (1829); CRMCH:1996.32.02 (1775); CRMCH:1996.037.01 (1775); CRMCH:1996.037.02 (1775); CRMCH:1996.37.03 (19th c); CRMCH:1996.37.04 (19th c); CRMCH:1996.37.05 (1824); CRMCH:1996.37.06 (1825); CRMCH:2002.003.01 (1823); CRMCH:2002.004.01 (1825); CRMCH:2002.004.02 (19thc); CRMCH:2002.004.03 (1825); CRMCH:2002.004.07 (19thc); CRMCH: 2002.12.1 (1790s); CRMCH: 2002.12.3.(1787); CUPMS: 1998.6.7 (19th c); CUPMS: 1998.6.9 (1838); CUPMS: 1998.6.14 (n. d.); CUPMS: 1998.6.15 (1830s); CUPMS: 1999.52.29 (1839); CUPMS: 1999.52.30 (n. d.); CUPMS: 1999.52.31 (1836); CUPMS: 1999.52.32 (1833); CUPMS: 1999.52.35 (1839); CUPMS: 1999.53.21 (1839);	CUPMS: 1999.54.21 (1830s); CUPMS: 1999.54.22 (1830s); CUPMS: 1999.54.23 (1830s); CUPMS: 1999.54.32 (1830s); CUPMS: 1999.54.33 (1799); CUPMS: 1999.54.36 (19th c); CUPMS: 1999.54.37 (1837); CUPMS: 1999.55.6 (1838); CUPMS: 1999.56.9 (1831); CUPMS: 1999.56.11 (1831); CUPMS: 1999.57.7 (1831); CUPMS: 1999.57.8 (1830s); CUPMS: 1999.57.9 (19th c); CUPMS: 1999.57.10 (1838); CUPMS: 2007.91 (1831); CUPMS: 2007.93 (18th c); DUN: 1992.21(2) (1829); FALKM. 2002.43.02 (1833); FALKM. 2002.43.03 (1840s); FALKM. 2002.43.04 (1836); FALKM. 2002.43.05 (1832); FALKM. 2002.43.06 (1830s); GLDM: 29.01 (1795); GRYEH: 1981.45.4 (1792); GRYEH: 1981.53 (1797); GRYEH: 1982.34.2 (1820s); HARGM: 13606.14 (1820); KINCM: 1339.1986.564 (1836); KINCM: 1339.1986.565 (n. d.); KIRMG. 1999.212 (1830s); KIRMG. 1999.213 (1830s); KIRMG. 2006.197 (1838); KIRMG. 2006.287 (1834); KIRMG. 2006.290 (1840s); KIRMG. 2006.292 (1841); KIRMG. 2006.299 (1806); KIRMG. 2006.312 (n. d.); KIRMG. 2006.314 (n. d.); LCM: 90. 36/9 (1837); LCM: 90.36/12 (1830s); MoL: 81.266/31 (1820s); MoL: 88.107/42 (1741); MM: 2006. 2 (1780s);

S.P.B *contd.*	MM: 2006. 14 (1781); NEBYM: A1299 (1801); NLA (HER) 25178 (1776); NLA (HER) 23698 (1797); NLA (HER) 34589 (1798); NLA (HER) 40934 (1800s); NLA (HER) 42579 (1802); NML. 2007.21.1 (1787); NML. 2007.21.2 (1835); NML. 2007.21.3 (1826); NMS: (Stoney Hill) (1816); NMS: P Sin 1a 19.11.94 1a (n. d.); OXFAS: 1980.271 (1778); OXFAS: 1987.272 (1790s); OXFAS: 1987.179 (1787); OXFAS: 1987.188 (1771); OXFAS: 1988.106 (1803); SF (SMR) COR 050 (1805); SF (SMR) LUD misc.MSF23230 (1805); RB 03 (1836); AC 01 (1818); JC 02 (1816); JC 06 (1800s); JC 09 (1770s); JC 10 (1799); JC 11 (18th c);	AD 05 (1794); GD 02 (n. d.); PD 9/01 (1780s); TD 01 (1838); WE 02 (1800); WE 03 (1806); WE 04 (1799); FF 03 (1781); FF 06 (1781); FF 10 (18th c); FF 11 (1782); FF 22 (n. d.); SFl 01 (1814); SFl 02 (1820s); SFl 03 (1833); SFl 07 (19thc); SFl 09 (1777); SFl 10 (1800s); SFl 11 (1824); SFl 12 (1830); SFl 18 (1815); SFl 9 (1821); SFl 20 (1792); SFl 22 (1810s); SFl 23 (1792); SFl 25 (1828); SFl 26 (1823);	SFl 27 (1794); JG 01 (1815); GI 02 (1774); CK 01 (1794); AL 01 (1822); AL 02 (1820s); GL 02 (1777); KM 01 (1745); JM 06 (19thc); JM 07 (1831); AMu 04 (1763); DP 01 (1800s); DMP 01 (1747); DMP 02 (1764); IP 01 (1830); BR 01 (1796); BR(B) 02 (1810s); JS 01 (1836); JS 03 (1817); JS 04 (1817); NMT 01 (1822); NMT 02 (1780s); NMT 03 (1817); EW (18th c); EW 03 (1788); JWa 01 (1749); JWa 02 (1782)
СПБ	ABDM: 072680 (1831); ABDM: 072683 (1830s); ADMUS: A1989.247 (1830s); ADMUS: DMB 4217(b) (1835); ADMUS: M1996.66 (n. d.); ADMUS: M1987.781 (1830s);	CUPMS: 1998.6.1 (1830s); CUPMS: 1998.6.3 (1830s); CUPMS: 1998.6.5 (1831); CUPMS: 1998.6.10 (1836); CUPMS: 1998.6.18 (1830s); CUPMS: 1999.52.24 (1833);	CUPMS: 1999.52.25 (1836); CUPMS: 1999.52.26 (1833); CUPMS: 1999.52.27 (1829); CUPMS: 1999.52.28 (1833); CUPMS: 1999.52.33 (1832); CUPMS: 1999.52.34 (1841);
	CUPMS: 1999.52.41 (19th c); CUPMS: 1999.52.43 (n. d.); CUPMS: 1999.53.17 (1833); CUPMS: 1999.53.18 (1831); CUPMS: 1999.53.19 (1833); CUPMS: 1999.53.22 (1830s); CUPMS: 1999.53.38 (1843); CUPMS: 1999.54.25 (1830s); CUPMS: 1999.54.26 (1830s); CUPMS: 1999.54.27 (1831); CUPMS: 1999.54.34 (1830s); CUPMS: 1999.55.7 (1829); CUPMS: 1999.55.8 (1838);	CUPMS: 1999.56.8(1832); CUPMS: 1999.56.10 (1833); CUPMS: 1999.57.6 (1831); CUPMS: 1999.216.5 (1832); CUPMS: 2005.284 (19th c); CUPMS: 2005.286 (1820s); CUPMS: 2005.289 (1832); DUN: 1992.21(1) (n. d.); DUN: 1992.21(3) (n. d.); FALKM. 2003.3.2 (1840); KINCM: 2000.102.20 (1800s); KIRMG. 1999,212 (1830s); KIRMG. 2006.283 (1820s);	KIRMG. 2006.284 (n. d.); KIRMG. 2006.285(n. d.); NMS: 29.10.93. F1 (1830s); SFl 04 (n. d.); SFl 28 (1833); JM 10 (1836); PM 01 (1830); PMcA 01 (19th c); RN 01 (1832); TW 01 (1835); TW 02 (n. d.)
SP	ABDM: 072695 (1830s); ADMUS:DBA3393/f (1838); CRMCH:1990.3.18 (1779); CRMCH:1991.38.4 (1775); CRMCH:1990.3.14 (1780s); CRMCH: 1996.37.07 (1775);	CRMCH: 2002.003.02 (1775); CRMCH: 2002.SF.14 (1770s); CRMCH: 2002.SF.17 (1779); CRMCH: 2002.SF.24 (1833); CUPMS: 1998.6.6 (1830); CUPMS: 1999.54.24 (19th c);	INVMG: 2003.120.059; KIRMG. 1999.214 (1830s); NMS: P Sin 1c 19.11.94 (1774); SF: 902/7241 (1830s)
СП	CRMCH:1990.3.7 (1780s); CUPMS: 1999.54.38 (1831);	EXEMS: 69/2001.4 (1841)	
W K	CRMCH:1990.3.5 (1775); CRMCH:1991.04.7 (1775); CRMCH:1991.38.2 (1775); GRYEH: 1981.74.2 (18thc);	HARGM: 12706.1 (1757); MM: 2006. 6 (1795); WHITM: SOH420.1 (1759); WHITM: SOH420.2 (1759);	WEW 02 (1801)
W U	MM: 2006. 13 (1750s); JC 01 (1758)		
W	CRMCH:1990.3.19 (1775);	CRMCH:1990.3.20 (1775)	

7.8. Post numbers / digits in final line of obverse

Post no.	Date	Surname of QCO	Seal identification	Origin
1	1787	Shchukin, G.	NML. 2007.21.1	SPB
1	1832	Selin	CUPMS: 1999.52.33	SPB
1	N. d.	Puzyrev I.	MoL 2006. 7/1	– –
1	1832	Selin	CUPMS: 1999.56.8	СПБ
1	1833	Selin	CUPMS: 1999.52.32	СПБ
1	N. d.	Larionov, F.	PMn 01	– –
1	N. d.	Tyurin, [R.]	PMn 01	– –
1	N. d.	Tyurin, V.	JM 04	– –
1	N. d.	Piskarev, A.	JM 04	– –
1	N. d.	Karel'ev	BRSMG: O.1749	– –
1	N. d.	Valin, K.	BRSMG: O.1749	– –
1	N. d.	Novotortsov	FALKM. 2003.2.3	ПП
2	1808	Pirozhnikov	JBC 09	NP
2	1826	Kuchkov	KIRMG. 2006.305	NP
2	1831	Kaltushkin, M.	CUPMS: 1999.53.18	SPB
2	1831	Kaltushkin, M.	CUPMS: 1999.56.9	SPB
2	1831	Filatov, S.	CUPMS: 1999.54.38	SPB
2	1838	Filatov, S.	CUPMS: 1999.55.8	СПБ
2	1838	Filatov, S.	CUPMS: 1999.56.13	– –
2	1838	Koptev	CUPMS: 2005.281	SPB
2	N. d.	Pogankin	KGGM: DBK.808d–vi	– –
2	N. d.	Balovanov, P.	KGGM: DBK.808d–vi	ЛП–
2	N. d.	Navatov	CRMCH: 1990.3.2	Л.П.
2	N. d.	Gavalgin, N.	CRMCH: 1990.3.2	П.I. С.
3	1813	Sedov	CRMCH: 2002.012.04	– –
3	1821	Nelyubov	ABDM:072679	SPB
3	1836	Samoilov	KINCM: 1339.1986.564	SPB
3	1836	Kaltushkin	CUPMS: 1999.52.31	SPB
3	1839	Kaltushkin, P.	CUPMS: 1999.52.35	SPB
3	1830s	Kaltushkin, P.	CUPMS: 1999.54.32	SPB
3	1841	Sheravskoi, I.	CUPMS: 1999.52.34	СПБ
3	1840s	Kaltushkin, P.	FALKM. 2002.43.02	SPB
3	N. d.	Pogankin, A.	CUPMS: 1999.55.27	ЛП
3	N. d.	Balovanov, P.	CUPMS: 1999.55.27	ЛПС–
4	1770s	Vavilov	HAW 04	NP
4	1780s	Avoshin, S.	ST 02	NP
4	1791	Zakharov, N.	FALKM. 1997.13.10	NP
4	1800	Nadezhin, I.	WK 01	NP
4	1804	Tarabukin	KIRMG. 1999.216	NP
4	1800s	Shelkov	NLA (HER) 40934	SPB
4	1820	Denisov, L.	EW 04	– P
4	1820s	Zaitsov	KIRMG. 2006.283	СПБ
4	1833	Gorbunov, V.	CUPMS: 1999.53.17	СПБ
4	N. d.	Budnikov, E.	BR 03	–
5	1818	Volkov, A.	ADMUS: A1988.291	NP
5	1823	Papkov, M.	SFl 26	–PB
5	1830	Shelov, Ya.	CUPMS: 1999.54.28	–ПБ
5	1831	Shilov, Ya.	ABDMS: 072680	СПБ
5	1831	Shustov, R.	CUPMS: 1999.57.6	СПБ
6	1775	Krutoi	WE 06	NP
6	1787	Khramtsov, U.	OXFAS. 1987.179	[S]PB
6	1792	Khramtsov, U.	GRYEM. 1981.45.4	SPB
6	1800	Shipachev, I.	ST 03	NP
6	1806	Shipachev, I.	CUPMS: 1999.57.14	–P
6	1820s	Labyshev, G.	SFl 02	SPB
6	1831	Sukhorukov, F.	DUN: AHH2005–16.10	SPB
6	1832	Sukhorukov, F.	DUN: AHH2005–16.12	СПБ
6	1830s	Sukhorukov, [F.]	CUPMS: 1999.54.34	СПБ
6	19th c	Khramtsov, U.	NEBYM: A1299	SPB
7	1778	Chugadaev	PD 9/02	NP
7	1783	Erokhin, A.	KIRMG. 2006.298	– –Б
7	1789	Puzyrev, M.	OXCMS: 1985.214.1	– – P
7	1780s	Strunnikov	PD 9/01	SPB

7	1797	Simanov, K.	ST 01	NP
7	1790s	Simanov, K.	JS 17	NP
7	1805	Ulyanov, S.	KIRMG. 2006.337	NP
7	N. d.	Zamarin, G.	ADMUS: M1996.66	– –
7	1790s	Tamilin	WARMS: Brailes (Slide 62)	N–
8	1787	Sedov	MoL 2006.7/4	SPB
8	1793	Fedorov, A. N.	CUPMS: 1999.53.39	[–]P
8	1794	Protopopov, I.	GMcA 05	– –
8	1794	Tyurin, P.	KIRMG. 2006.334	NP
8	1800s	Lobkov	AD 02	NP
8	1805	Es'kov, A.	CUPMS: 1999.56.12	NP
8	1810s	Gruzinin	ADMUS: A1988.303	NP
8	1822	Lobkov, L.	ADMUS: DBA3393/c	NP
8	1831	Shcherbakov, P.	CUPMS: 1998.6.4	– –
8	1838	Lobkov	CUPMS: 1999.57.10	SPB
9	1788	Kondrat'ev, A.	JC 03	NP
9	1788	Pirozhnikov, V. A.	JC 04	NP
9	1809	Zaitsov, V.	CUPMS: 1999.55.12	NP
9	1823	Koptev, L.	CUPMS: 1999.55.17	NP
9	1833	Kaltushkin, P.	FALKM. 2002.43.02	SPB
9	1833	Kaltushkin, P.	CUPMS: 1999.53.19	СПБ
9	1830s	Selin, D.	CUPMS: 1999.53.20	[–]PB
10	1768	Pirozhnikov	PERMG: 1992.140.3	NP
10	1776	Sysoev	PRSMG: T1963 (A146)	NP
10	1777	Sysoev	AJPC 04	NP
10	1787	Babanov, A.	MM: 2006.5	– –
10	1814	Ulyanov, S.	MM: 2006.15	NP
10	1820	Sanin, D.	GMcA 11	NP
10	1823	Nilskoi, F. U.	IP 03	– –
10	1832	Volkov, L.	FORMG 2006.24	– – B
10	1830s	Maslenin, S.	CUPMS: 1998.6.18	СПБ
11	1796	Boloshev, A.	BR 01	SPB
11	1799	Boloshev, M.	CRMCH: 1990.3.24	[S]PB
11	1801	Fokin, F.	HARGM: 12706.2	NP
11	1800s	Fokin, F.	CUPMS: 1999.54.41	NP
11	1830s	Tarpchino, M.	SF 906/7241	SPB
11	19th c	Tarpchin –	CUPMS; 1998.6.7	SPB
12	1788	Shipochev	LCM: 96.81	NP
12	1797	Shipochev, A.	GB 07	NP
12	1799	Shipochev, A.	DF 02	NP
12	N. d.	Zaitsov, F.	CUPMS; 2007.89	NP
13	1801	Kostin, V.	CRMCH: 1991.29.02	SPB
13	1829	Kostin, D.	CUPMS: 1999.55.7	СПБ
13	1829	Navnskoi	NMS: Henderson 090	–П–
13	1820s	Navnskoi	CUPMS: 1998.6.12	NP
14	1794	Varzov, S.	DMP 05	NP
14	1796	Varzov, S.	WALM. 2005–13–2	NP
14	1796	Varzov, S.	BR 02	–
14	1817	Alm—iman, P.	CRMCH: 1991.38.1	[S]PB
15	1774	Bolotin	GI 02	SPB
15	1790	Sharynin	FALKM. 1997.13.9	NP
15	1804	Kononov, N.	KIRMG. 2006.308	NP
15	1831	Dorofeev	ADMUS: M1998.157	[СП]Б
15	1841	P–leteev	EXEMS: 69/2001.4	СП
16	1823	Latyshev	CRMCH: 1990.29.2	SPB
16	1830s	Ereneevskoi, M.	KIRMG. 1999.214	SP
16	1840s	Ereneevskoi, M.	KIRMG. 2006.290	SPB
17	1778	Obraztsov	CRMCH: 1991.04.1	S– –
17	1810s	Zamarin, T.	HARGM: 13606.2	NP
17	1822	Davydov	ADMUS: A1989.267	NP
17	1839	Zamarin, G.	CUPMS: 1999.52.29	SPB
17	1830s	Zaitsov	CUPMS: 1999.57.8	SPB
18	N. d.	Vinokurov	DUN: 1999.21(3)	СПБ
18	N. d.	Mesnikov	KIRMG. 2006.309	NP
19	1796	Zaitsov, S.	HARGM: 12706.4	NP
19	18th c	Zaitsov, S.	HARGM: 12706.7	NP

19	1805	Kryukov	SF (SMR) LUD misc.MSF23230	SPB
19	1818	Dedovnikov	KIRMG; 2006.307	NP
19	1825	Pe[l]eshev	CUPMS: 1999.54.43	NP
19	N. d.	Dedov[nikov]	HARGM: 13606.10	NP
20	1776	Tarpchin	CRMCH: 1990.3.12	SPB
20	1789	Vinnikov, I.	JH(L) 08	– –
20	1795	– – innikov, I. M.	MM: 2006. 6	W K
20	1805	Vinnikov, I.	JS 11	NP
20	1813	Vinnikov, I.	CUPMS: 2005.282	NP
20	1810s	Na[-]lov, B.	BR(B) 02	SPB
20	1822	– o – ekov	ADMUS: A1989.264	NP
20	1822	Poz–ekov	HARGM: 13606.3	NP
20	1836	Pozrekov	ADMUS: M1998.167	[S]PB
21	1814	Malafeev, Z.	JT 01	NP
22	1790s	Poyakov, A.	OXFAS: 1980.272	[S]PB
22	1834	Vorob'ev	ADMUS: A2002.87.5	SPB
23	1775	Pirozhnikov	ADMUS: M1987.780	NP
23	1797	Bushev, M.	NLA (HER) 23698	SPB
23	1802	Pirozhnikov, I.	AD 01	NP
23	1819	Malygin, T.	CUPMS: 1999.54.51	NP
23	1825	Malygin, T.	CUPMS: 1999.55.14	NP
24	1779	Vavilov	NMS 25.9.93. F1	NP
24	1779	Vavilov	CRMCH: 1991.38.7	NP
24	1794	Kudryaev, N.	SFl 27	SPB
24	1816	Yurkovs– –	NMS (Stoney Hill)	SPB
24	1818	Drozhdin, V.	AC 01	SPB
24	1830s	Nemilov, L.	CUPMS: 1999.54.22	SPB
25	1799	Tabalin	WE 04	SPB
25	19th c	Kostin, D.	AHM 03	[SPB]
26	1799	Morozov, K.	CUPMS: 1999.54.33	–PB
26	1806	Konovalov, K.	KIRMG. 2006.231	NP
26	1810s	Miloyagin	SFl 22	SPB
27	1777	Klyuev	INVMG: 2003.120.059	SP
27	1798	Sivtsov	GB 02	NP
27	1798	Sivtsov	GB 06	NP
27	1818	Pogankin, L.	LCM: 90.36/7	NP
27	1825	Po[ga]nkin	CUPMS: 1999.52.38	NP
27	1826	Pogankin	CUPMS: 1999.54.48	NP
27	1820s	Ukrotskoi, B.	CUPMS: 1999.54.47	NP
27	1833	Pogankin	CUPMS: 1999.52.28	NP
28	1804	Kudryaev, K.	CRMCH: 1992.11.2	SPB
28	1804	Merkulov, M.	MM 2006.10	NP
28	1805	Merkulov, M.	WK 01	NP
28	1820s	Merkulov, K.	GD 01	NP
28	1826	Pronin, V.	CUPMS: 1999.54.7	NP
28	1829	Pronin, V.	DUN: 1999. 21(2)	SPB
30	1803	Eremeev	CUPMS: 1999.54.10	NP
30	1820	Safronov	RN 01	– –
30	1824	Poyakov, S.	SFl 11	SPB
30	1826	Gurov, S.	CUPMS: 1999. 52.40	NP
30	19th c	Gurov, S.	CUPMS: 1999. 53.31	NP
31	1820	Var[z]ov	KIRMG. 2006.226	NP
31	1829	Varzov, I.	CUPMS: 1999.52.27	СПБ
31	1820s	Bushev, I. M.	AJPC 07	SPB
32	1778	Nefedov	MoL: 2006.7/3	NP
32	1786	Dem'yanov, S.	BRSMG: T9395	– –
32	1790s	[O]rekhov	JC 07	NP
32	1802	Kostin, M.	KIRMG: 2006.232	NP
32	1814	Orlov, M. I.	HARGM: 12706.5	NP
32	1820s	Savostin, V.	CUPMS: 1999.54.49	NP
32	1830	Samuilov	IP 01	SPB
32	19th c	Arlov, I.	KIRMG: 2006.314	SPB
33	1790s	Zemskoi	CUPMS: 1999.53.28	NP
34	1799	Somov	CRMCH: 1990.29.4	SP[B]
34	1803	Molchanov, A.	ADMUS: M1996.67	SPB
34	1806	Molchanov	KIRMG. 2006.299	NP

35	1797	Pikin, M.	ADMUS: A1988.289	NP
35	1804	Pikin	MM: 2006.9	[N]P
37	1770s	Popov	CRMCH: 1991.38.6	S[–]B
37	1781	[D]olgopolov	CRMCH: 1990/3/13	SPB
37	1799	Levshev, M.	CUPMS: 1999.53.26	NP
37	1803	Levshev, M.	MH 05	NP
37	1820s	Levshev	AMu 09	NP
37	1804	Livshev, M.	ADMUS: M1998.156	– –
37	1812	Livshev, M.	MM: 2006.12	NP
37	1832	Be[l]kov, V.	FALKM. 2002.43.05	[S]PB
38	1788	Sherapov, I.	CUPMS: 1999.53.32	NP
38	1830	Volkov, V.	PM 01	СПБ
41	1830s	Eremeev, M.	CUPMS: 1998.6.15	SPB
42	1804	Kladukhin, S.	LCM: 90.36/10	NP
43	1817	Erokhin, E.	JS 04	SPB
43	1820s	Ivanov, S.	CUPMS: 1999.54.54	N[–]
43	1820s	Sinyakov, L.	CUPMS: 1999.56.17	NP
4[3]	1820s	Sinyakov	CUPMS: 1999.55.10	NP
43	19th c	Nelov, S.	LWMCH: Unacc. 04	– –
44	1763	[R]usov	AMu 04	SPB
44	1820s	Nadezhin, I.	CUPMS: 1999.54.8	N[P]
45	1804	Soloukhin, D.	KIRMG. 2006.336	– –
45	1814	So[–]o[–]kho, S.	LCM: 94.27/2	NP
45	1828	Shchogoleva, A. D.	ADMUS: M1995.157	NP
47	1762	Vavilov	JH)L) 05	WK
47	1762	Vavilov	JH(L) 06	WK
47	1765	Vavilov	BR(B) 01	NP
4[7]	1770s	Vavilov	HAW 04	NP
47	1785	Zemskoi	JSm 01	NP
48	1777	Plotukhov	DUN: 1978.1430 (2)	NP
49	1822	Valin, P. Ya.	AL 01	SPB
49	1820s	Erokhin, Ya.	CUPMS: 1999.54.4	NP
49	1830s	Erokhin, S.	CUPMS: 1998.6.3	СПБ
50	1800	Ryabov	HAW 08	NP
51	1777	Zemskoi	CRMCH: 1990.3.9	NP
51	1781	Zemskoi	WAW 20717 (PAS)	NP
51	1782	Zemskoi	NMS: Edi bag 3	NP
51	1780s	Zemsko[i]	JW 01	– –
51	1827	Shilov, N.	JM 01	NP
51	1829	Shilov, N.	ADMUS: M1998.159	SPB
52	1775	Malenkoi	CRMCH: 1991.38.2	W K
52	1780	Malinkoi	JH(L) 10	NP
52	1793	Venednkh, V.	RM 01	NP
52	1795	Venednkh, V.	KIRMG. 2006.331	NP
54	1799	Chelpanov, A.	CUPMS: 1999.53.29	NP
54	1809	Simanov, K.	CUPMS: 2005.288	NP
55	1789	Lgalin, P.	CRMCH: 1990.3.22	SPB
55	1780s	Simonov, A.	GMcA 12	NP
55	1821	Demidov, B.	AMu 03	– –
55	1830s	Demidov	CUPMS: 1998.6.1	СП [Б]
5[6]	1809	Vinnikov, I. M.	SF 869/7380	NP
5[6]	1826	Vinnikov, I. M.	JC 05	NP
56	19th c.	Vinnikov, I. [M.]	ADMUS: A1988.300	[N]P
57	1781	Churakov	MM 2006.14	SP[B]
57	1790s	Krasikov, [R.]	HARGM: 13606.4	NP
57	1800	Levashev, S.	HARGM: 13606.5	NP
57	1802	Levashev, S.	KINCM: 2000.100.5	NP
58	1791	Shirapov, I.	LCM: 86.16	NP
58	1789	Sherapov	MoL. 2006.7/8	– –
58	1828	Vinokurov	ADMUS: A2002.87.2	SPB
59	1793	Mikhalev, S.	CUPMS: 2007.92	NP
59	1836	Safronov, E.	CUPMS: 1999.54.35	SPB
59	1830s	Arlov, M. I.	ABDMS: 072683	СПБ
59	N. d.	Mashkov	CUPMS: 1999.54.21	SPB
61	1790s	Lebedev, P.	ADMUS: M1998.161	NP
69	1793	Kuchkov	CUPMS: 2007.90	NP

62	1794	Kuchkov, Ya.	ABDMS: 072691	NP
62	1802	Kuchkov, P.	CUPMS: 1999.217.3	NP
62	1808	Shiryaev, S.	KIRMG. 2006.300	– –
62	1820	Kuchkov, A.	KIRMG. 2006.330	–[P]
63	1796	T–godaev, F.	PRSMG: T1963 (A144)	NP
63	1831	Martinov, E.	LWMCH: Unacc. 01	– –
64	1794	Shchegolev	KIRGM: 2006.267	NP
64	1803	Shchogolev, V.	CUPMS: 1999.55.23	N[P]
65	1839	Skorobogatov, G.	CUPMS: 1999.53.21	SPB
65	1830s	Skorobogatov	GMcA 13	– –
66	1776	Marozov	NLA (HER) 25178	SPB
66	1793	Sinyakov, S.	DMP 04	NP
66	1799	Kavelev, D.	ADMUS: M1998.158	NP
66	1802	Kavelev, D.	AD 07	NP
67	1794	Shchegolev, [P.]	MM: 2006.16	[N]P
67	1769	Simanov	NLA (HER) 31883	SPB
68	1803	Dol[g]opo[lov]	OXFAS.1998.106	SPB
68	1833	Shiryaev, S.	CUPMS: 1999.52.26	СПБ
68	1833	Shiryaev, Z.	CUPMS: 1999.56.10	СПБ
69	1795	Plotnik, I.	JP 01	NP
69	18th c	Plotnik, A.	CUPMS: 1999.53.24	NP
69	1811	Plotnik, I.	KIRMG. 2006.333	NP
69	19th c	Plotnik, I.	CUPMS: 1999.53.30	NP
70	1775	Zo[l]otarev	CRMCH: 1990.3.29	SPB
70	1800	Dem'yanov, E. B.	RB 01	NP
70	1830	Demyanov, E.	CUPMS: 1999.53.42	SP[–]
70	1826	Zinov'ev	RB 03	SPB
71	1780s	Kholozhin	NMT 02	SPB
71	1830s	Erokhin, A.	KIRMG. 1999.213	SPB
72	1793	Tarasov	MoL 2006.7/6	NP
72	1795	Tarasov, I.	HAW 07	– –
72	18th c	R–dylev	CRMCH: 1990.3.30	SPB
72	1800s	Myl'nikov, A.	CUPMS: 1999.217.2	NP
72	1816	Bushev, I. D.	JC 02	SPB
72	1823	Tepin, V.	CRMCH: 1992.11.7	SPB
72	1830	Vorob'ev	CUPMS: 1998.6.6	SP[–]
72	1830s	Vorob'ev	ADMUS: M1987.781	СПБ
72	1841	Vorob'ev	KIRMG. 2006.218	– –
74	1791	Zakharov	GMcA 14	NP
75	1791	Ivanov, E.	JH(L) 09	NP
75	1794	Ivanov, E.	CUPMS: 1999.53.23	NP
75	1794	Ivanov	CUPMS: 1999.54.40	NP
[7]5	1801	Ivanov, E.	HARGM. 12706.12	NP
76	1833	Kostin, S.	SFI 24	SP
76	1800s	Plo[t]nik	CUPMS: 1999.53.40	– –
77	1838	Andronov	TD 01	SPB
78	1796	Korolev	PD 9/03	NP
78	1820	Vol–ov, V.	JS 07	NP
78	1821	Volkov, V.	KIRMG. 2006.229	NP
78	1843	Volkov, V.	CUPMS: 1999.53.38	СПБ
78	N. d.	Volkov	KIRMG. 2006.285	СПБ
[7]8	19th c	Korolev	MoL 2006.7/5	NP
79	1822	Dedovnikov, A.	CUPMS: 1999.54.46	NP
80	1794	Bazhenov, G.	JBC 06	–P
80	1820	Kononov	GMcA 09	NP
81	1775	Golubyatnikov	CRMCH: 1991.29.03	SPB
81	1770s	Golubyatnikov	AJPC 04	SPB
81	1800	Polovokhin	CUPMS: 1999.57.11	СПБ
81	1821	Save–tianov, P.	KIRMG. 2006.227	NP
81	1825	Polovokhin, P.	CUPMS: 1999.52.36	NP
82	1810	Simanov, M.	JM 05	NP
82	1826	Zimanov, [G.]	CUPMS: 1999.55.9	NP
82	1820s	Shi[t]ikov	GRYEH.1982.34.2	SPB
83	1793	Zhukov, T.	MH 06	NP
83	1798	Nechaev, I.	CRMCH: 1991.23.02	SPB
83	1798	Kononov, M.	GB 04	NP

83	1790s	Zhukov, G.	KMo 01	NP
83	1800	Kononov, M.	CUPMS: 1999.57.12	NP
83	1831	Prudinin	JM 07	SPB
84	1790	Bashchenkov, K.	FALKM. 2000.4.10	NP
85	1775	Romanov	CUPMS: 2005.276	NP
85	1792	Churakov, Ya.	SFl 20	SPB
85	1811	– – – vsko	KIRMG. 2006.239	NP
85	1814	Shyrovskoi	ADMUS: M1995.155	NP
85	1823	Shyrovskoi	CUPMS: 1999.54.1	NP
85	1820s	Shyrovskoi	CUPMS: 1999.54.2	NP
85	1820s	Shyrovskoi	CUPMS: 1999.54.3	NP
86	1775	Annib, S.	CRMCH: 1990.3.5	W. K.
86	1775	Annib, S.	CRMCH: 1990.3.19	W
86	1775	Annib, S.	CRMCH: 1990.3.20	W.
86	1775	Annib	CRMCH: 1991.04.7	W.K
8[6]	1775	Annib, S.	CRMCH: 1991.29.04	NP
86	1776	Annib, S.	Anon 06	NP
86	1824	Cheb – – ov	JS 08	– –
86	1820s	Cheblokov	CUPMS: 1999.54.50	NP
86	1830s	Chelkov	FALKM. 2002.43.06	SPB
88	1775	–rekhov	CRMCH: 1990.3.23	SPB
88	1790	Aref'ev, N.	LWMCH: Unacc. 02	NP
88	1824	Tolstikov, S.	CRMCH: 1996.37.05	SPB
88	1830	Aref'ev, N.	FALKM. 2002.43.10	SPB
88	1835	Tolstik[ov], S.	NML. 2007.21.2	SPB
88	1837	Aref'ev, N.	KIRMG. 2006,288	[–]B
89	1810s	Filatov	HARGM: 12706.6	NP
91	176[5]	Nalobin	MH 04	N–
91	1825	Koptev, L.	CUPMS: 1999.54.45	NP
92	1779	– – mestovskoi	SFl 21	NP
92	1780	Names[–]ovskoi	MoL. Q 40	NP
94	1825	Ko –lov	KIRMG. 2006.225	NP
95	1797	Novotorzh	CRMCH: 1990.3.17	SPB
95	1797	Nasukhin, A.	AMu 01	NP
95	1830	Antyukhin	DUN: 1978.1430(5)	–P–
96	1804	Demidov	CRMCH: 1990.3.21	SPB
96	1812	Chernikov	AMu 06	– –
97	1781	Valaev	CRMCH: 1991.38.5	SPB
98	N. d.	Vorob'ev	ADMUS: A2002.87.4	SPB
[–]8	1836	Vorob'ev, A.	CUPMS: 1998.6.10	СПБ
102	1791	Pa –kov, M.	NMS: P. Sin (1791)	NP
104	1821	Sarafanin, [G.]	CUPMS: 1999.216.4	NP
106	1820s	Chupyatov, S.	CUPMS: 2005.286	СПБ
108	1825	Petunov, A.	CUPMS: 1999.55.21	NP
113	N. d.	Sanitin, K..	CUPMS: 1998.6.14	SPB
114	1769	[K]opov	NLA (HER) 40538	SPB
114	1785	Orekhov	ADMUS: A1988.290	NP
115	1820s	Petunov, [E.]	KIRMG. 2006.230	NP
116	1774	Ershev	GGAT 01	NP
116	1778	Ershe[–]ov	NLA (HER) 36633	NP
118	1810s	Mesnikov	MM 2006.11	NP
118	1824	Mesnikov	CUPMS: 1999.54.42	NP
118	1825	Mesnikov	AMu 08	–P
[–]18	N. d.	Mesnikov	KIRMG. 2006.309	NP
121	1807	Aref'ev, S.	CRMCH: 1991.38.8	SPB
122	1824	Kostin, L.	CUPMS: 1999.55.18	NP
122	1826	Kladukhin, N.	CUPMS; 1999.54.56	N[P]
122	19th c.	Kostin, [L.]	ADMUS: A1990.313	NP
123	1819	Malygin, T.	CUPMS: 1999.54.51	NP
123	1830	Chernikov, N.	CUPMS: 1999.55.22	S– –
127	1777	Yaroslavtsov	GL 02	SPB
133	1765	Smirnov	AH 01	NP
136	1802	Novgoro[dtsev], E.	NLA (HER) 42579	SPB
137	1768	Kandrat'ev	WALM: 2005.13.1	NP
149	1806	Zhukov	CRMCH: 1991.60.3	SPB
151	1831	Lenteev, G.	CUPMS: 2007.91	SP–

155	1780	Utochkin	AJPC 06	NP
160	1776	– – – aev, Yakov	BRMSG: 01421	SPB
161	1800s	Shvetsov, V.	CRMCH: 1991.04.4	SPB
162	1787	Simanov	MoL 2006.7/7	SPB
163	1838	Chertkov	CRMCH: 1991.60.1	SPB
164	1764	Maslov	DMP 02	SPB
177	1770	Kolmiakov	JBC 15	NP
179	1799	Pogankin, D.	CRMCH: 1991.38.3	SPB
18[4]	1764	Larionov	JS 14	NP
184	1764	Larionov	JS 15	NP
184	1767	Larionov	MH 02	NP
184	1774	Larivonov	MR 01	NP
184	1785	Sarypin	CUPMS: 1999.57.13	NP
184	1840	Morozov	FALKM. 2003.3.2	СПБ
192	1805	Butylkin	CRMCH: 1990.29.3	SPB
192	1813	Budylkin	SFl 15	NP
195	1800	Gorbunov, [M.]	WE 02	SPB
197	1800s	Vaulin	KINCM: 2000.102.20	СПБ
202	1833	Egor'evo, A	SFl 03	– PB
207	N. d.	Raskolnikov	GL 04	NP
208	1778	Maslenkov	OXFAS: 1980.271	SPB
216	1775	Simanov	CRMCH: 1996.37.01	SPB
230	1770	Mikhalev	NP 01	NP
230	1774	Mikhalev	ST 09	NP
230	1775	D'emikhlev	NMS: 23.10.93.F3	NP
231	1777	Cherntsov	ADMUS: A1988.298	W.K
231	1825	Malygin, T.	CUPMS: 1999.55.14	NP
232	1770s	Petelin	JC 09	SPB
235	1829	Kochevskoi, P.	CRMCH: 1996.32.01	SPB
250	1777	Plotnikov	CRMCH: 1991.23.01	NP
250	1779	Plotnikov	HFDMG: 1980.82	NP
251	1777	Chupyatov, I.	SFl 09	SP–
251	1825	Chupyatov, I.	CRMCH: 2002.004.03	SPB
261	1794	–si–kovsk–	CK 01	SPB
280	1776	P[–]alev	MM 2006.3	[N]P
281	1781	Manukhin, E.	GGAT 03	– –
283	1817	Gr[e] – –nik	JS 03	– –
286	1778	Nemilov	CRMCH: 1992.11.1	SPB
286	1805	Valin, B.	CRMCH: 1991.04.3	S[–]B
289	1770s	–[i]manov	MoL. Q 39	SPB
295	1815	Vasilev, A.	CRMCH: 1992.11.4	SPB
308	1778	Labishev, A.	NLA (HER) 13603	NP
309	19th c	Balashev	CRMCH: 1996.37.03	SPB
314	1826	Bushev, I. M.	NML. 2007.21.3	SPB
320	1822	Shitikov	NMT 01	SPB
320	1827	Shi[t]ikov	CRMCH: 1990.3.11	SPB
321	1783	Elinskoi, S.	HAW 05	NP
32[1]	1783	Elinskoi, S.	HFDMG: 1987.19/1	NP
323	1779	Var[z]ov	ST 06	NP
324	1786	Dem'yanov	PR 01	NP
326	N. d.	Solovikhin	SF 809/7053	– –
327	1775	[M]oshnikov	CRMCH: 1990.3.26	NP
327	N. d.	Moshnikov	SFl 08	NP
328	1786	Dem'yanov	GI 01	NP
328	N. d.	Eremeev	KINCM: 1339.1986.565	SPB
330	1777	Tamilin	CUPMS: 2005.290	– –
332	1774	Istin, Vasil	KIRMG. 2006.293	NP
332	1784	Istin, Vasil	GRYEH.1981.45.2	NP
336	1777	Primyakin	PRSMG: T1961	NP
343	1823	Zarnov, N.	CRMCH: 2002.003.01	SPB
354	1780	Shelepin	AJPC 05	NP
375	18th c	Samuilov	FF 10	SPB
379	1788	Levt–ev	EW 03	SPB
403	1781	Shchipachev	CRMCH: 1992.11.3	SPB

Index of illustrations

	Seal Identification	*Dimensions (mm)*	
1a	CUPMS: 1999.53.11 obv	23 × 23	With kind permission of Fife Museums Service
1b	CUPMS: 1999.53.11 rev	23 × 23	With kind permission of Fife Museums Service
2	CUPMS: 1999.54.39 rev	22 × 20	With kind permission of Fife Museums Service
3	JC 01 rev	34 × 30	With kind permission of J. Cooper
4a	MM: 2006.01 obv	30 × 25	With kind permission of Malton Museum
4b	MM: 2006.01 rev	30 × 25	With kind permission of Malton Museum
5a	MM: 2006.13 obv	27 × 25	With kind permission of Malton Museum
5b	MM: 2006.13 rev	27 × 25	With kind permission of Malton Museum
6a	HARGM: 12706.1 obv	32 × 28	With kind permission of Harrogate Museums and Galleries, Harrogate Borough Council
6b	HARGM: 12706.1 rev	32 × 28	With kind permission of Harrogate Museums and Galleries, Harrogate Borough Council
7a	CUPMS: 1999.54.22 obv	20 × 20	With kind permission of Fife Museums Service
7b	CUPMS: 1999.54.22 rev	20 × 20	With kind permission of Fife Museums Service
8	JS 04 obv	22 × 20	From the author's collection
9	AJPC 04 rev	29 × 28	With kind permission of Dr A.J.P. Campbell
10a	JC 09 obv	24 × 22	With kind permission of J. Cooper
10b	JC 09 rev	24 × 22	With kind permission of J. Cooper
11a	MM: 2006.14 obv	23 × 20	With kind permission of Malton Museum
11b	MM: 2006.14 rev	23 × 20	With kind permission of Malton Museum
12a	CUPMS: 1999.52.29 obv	20 × 19	With kind permission of Fife Museums Service
12b	CUPMS: 1999.52.29 rev	20 × 19	With kind permission of Fife Museums Service
13a	CUPMS: 1998.6.6 obv	20 × 20	With kind permission of Fife Museums Service
13b	CUPMS: 1998.6.6 rev	20 × 20	With kind permission of Fife Museums Service
14a	CUPMS: 1999.52.24 obv	21 × 20	With kind permission of Fife Museums Service
14b	CUPMS: 1999.52.24 rev	21 × 20	With kind permission of Fife Museums Service
15a	FALKM. 2003.3.2 obv	22 × 20	With kind permission of Falkirk Museum
15b	FALKM. 2003.3.2 rev	22 × 20	With kind permission of Falkirk Museum
16a	CUPMS: 1999.52.37 obv	22 × 18	With kind permission of Fife Museums Service
16b	CUPMS: 1999.52.37 rev	22 × 18	With kind permission of Fife Museums Service
17a	CUPMS: 1999.54.46 obv	23 × 21	With kind permission of Fife Museums Service
17b	CUPMS: 1999.54.46 rev	23 × 21	With kind permission of Fife Museums Service
18a	KIRMG. 2006.305 obv	22 × 20	With kind permission of Fife Museums Service
18b	KIRMG. 2006.305 rev	22 × 20	With kind permission of Fife Museums Service
19a	CUPMS: 1999.53.18 obv	22 × 21	With kind permission of Fife Museums Service
19b	CUPMS: 1999.53.18 rev	22 × 21	With kind permission of Fife Museums Service
20a	CUPMS: 1999.56.8 obv	21 × 20	With kind permission of Fife Museums Service
20b	CUPMS: 1999.56.8 rev	21 × 20	With kind permission of Fife Museums Service
21a	CUPMS: 1999.55.27 obv	22 × 21	With kind permission of Fife Museums Service
21b	CUPMS: 1999.55.27 rev	22 × 21	With kind permission of Fife Museums Service
22a	CUPMS: 1999.53.29 obv	22 × 20	With kind permission of Fife Museums Service
22b	CUPMS: 1999.53.29 rev	22 × 20	With kind permission of Fife Museums Service
23a	CUPMS: 2005.282obv	23 × 20	With kind permission of Fife Museums Service
23b	CUPMS: 2005.282 rev	23 × 20	With kind permission of Fife Museums Service
24a	CUPMS: 1999.216.2 obv	21 × 18	With kind permission of Fife Museums Service
24b	CUPMS: 1999.216.2 rev	21 × 18	With kind permission of Fife Museums Service
25a	AMu 01 obv	22 × 20	With kind permission of A. Murray
25b	AMu 01 rev	22 × 20	With kind permission of A. Murray
26a	KIRMG. 2006.341	23 × 20	With kind permission of Fife Museums Service
26b	KIRMG. 2006.341 (detail)		With kind permission of Fife Museums Service
27a	ADMUS: A1998.296 obv	20 × 20	With kind permission of Arbroath Museum, Angus Council, Cultural Services

	Seal Identification	Dimensions (mm)	
27b	ADMUS: A1998.296 rev	20 × 20	With kind permission of Arbroath Museum, Angus Council, Cultural Services
28a	KIRMG. 2006.207	22 × 20	With kind permission of Fife Museums Service
28b	KIRMG. 2006.207	22 × 20	With kind permission of Fife Museums Service
29a	ADMUS: A1990.311 obv	24 × 22	With kind permission of Arbroath Museum, Angus Council, Cultural Services
29b	ADMUS: A1990.311 obv (detail)	24 × 22	With kind permission of Arbroath Museum, Angus Council, Cultural Services
30a	CUPMS: 1999.52.50 obv	22 × 20	With kind permission of Fife Museums Service
30b	CUPMS: 1999.52.50 rev	22 × 20	With kind permission of Fife Museums Service
31a	PERMG.1992.142.1 obv	29 × 22	Courtesy of Perth Museum and Art Gallery, Perth and Kinross Council, Scotland
31b	PERMG.1992.142.1 rev	29 × 22	Courtesy of Perth Museum and Art Gallery, Perth and Kinross Council, Scotland
32a	ADMUS: M1989.98 obv	25 × 22	With kind permission of Montrose Museum, Angus Council, Cultural Services
32b	ADMUS: M1989.98 rev	25 × 22	With kind permission of Montrose Museum, Angus Council, Cultural Services
33	ADMUS: M1995.161 obv	22 × 21	With kind permission of Montrose Museum, Angus Council, Cultural Services
34a	ADMUS: M1980.3639 obv	24 × 21	With kind permission of Montrose Museum, Angus Council, Cultural Services
34b	ADMUS: M1980.3639 rev	24 × 21	With kind permission of Montrose Museum, Angus Council, Cultural Services
35a	CUPMS: 1999.53.36 obv	23 × 23	With kind permission of Fife Museums Service
35b	CUPMS: 1999.53.50 rev	22 × 22	With kind permission of Fife Museums Service
36a	ADMUS: A1989.246a	22 × 22	With kind permission of Fife Museums Service
36b	ADMUS: A1989.246b	23 × 20	With kind permission of Fife Museums Service
37a	ADMUS: M1998.91a	23 × 20	With kind permission of Montrose Museum, Angus Council, Cultural Services
37b	ADMUS: M1998.91b	23 × 20	With kind permission of Montrose Museum, Angus Council, Cultural Services
38	HAW 01	27 × 27	With kind permission of Mr H A Weller
39	HAW 02	30 × 26	With kind permission of Mr H A Weller
40	KIRMG. 2006.209 rev	29 × 22	With kind permission of Fife Museums Service
41	KIRMG. 2006.210 rev	29 × 22	With kind permission of Fife Museums Service
42a	CUPMS: 1999.52.10 obv	30 × 29	With kind permission of Fife Museums Service
42b	CUPMS: 1999.52.10 rev	30 × 29	With kind permission of Fife Museums Service
43a	CUPMS: 1999.52.15 obv	28 × 23	With kind permission of Fife Museums Service
43b	CUPMS: 1999.52.15 rev	28 × 23	With kind permission of Fife Museums Service
44a	CUPMS: 1999.52.17 obv	26 × 20	With kind permission of Fife Museums Service
44b	CUPMS: 1999.52.17 rev	26 × 20	With kind permission of Fife Museums Service
45a	JS 06 obv	27 × 24	From the author's collection
45b	JS 06 rev	27 × 24	From the author's collection
46a	CUPMS: 1999.52.16 obv	24 × 22	With kind permission of Fife Museums Service
46b	CUPMS: 1999.52.16 rev	24 × 22	With kind permission of Fife Museums Service
47a	CUPMS: 1999.56.2 obv	29 × 26	With kind permission of Fife Museums Service
47b	CUPMS: 1999.56.2 rev	29 × 26	With kind permission of Fife Museums Service
48a	CUPMS: 1999.52.14 obv	31 × 27	With kind permission of Fife Museums Service
48b	CUPMS: 1999.52.14 rev	31 × 27	With kind permission of Fife Museums Service
49a	CUPMS: 1999.54.14 obv	30 × 28	With kind permission of Fife Museums Service
49b	CUPMS: 1999.54.14 rev	30 × 28	With kind permission of Fife Museums Service
50a	CUPMS: 1999.52.9 obv	27 × 27	With kind permission of Fife Museums Service
50b	CUPMS: 1999.52.9 rev	27 × 27	With kind permission of Fife Museums Service
51a	CUPMS: 1999.52.7 obv	27 × 25	With kind permission of Fife Museums Service
51b	CUPMS: 1999.52.7 rev	27 × 25	With kind permission of Fife Museums Service
52a	CUPMS: 1999.52.1 obv	36 × 29	With kind permission of Fife Museums Service
52b	CUPMS: 1999.52.1 rev	36 × 29	With kind permission of Fife Museums Service
53a	CUPMS: 1999.57.5 obv	25 × 25	With kind permission of Fife Museums Service
53b	CUPMS: 1999.57.5 rev	25 × 25	With kind permission of Fife Museums Service
54a	CUPMS: 1999.216.1 obv	25 × 25	With kind permission of Fife Museums Service
54b	CUPMS: 1999.216.1 rev	25 × 25	With kind permission of Fife Museums Service
55a	CUPMS: 1999.53.13 obv	28 × 27	With kind permission of Fife Museums Service
55b	CUPMS: 1999.53.13 rev	28 × 27	With kind permission of Fife Museums Service
56a	EXEMS: 99/1932 obv	27 × 24	With kind permission of the Royal Albert Museum, Exeter
56b	EXEMS: 99/1932 rev	27 × 24	With kind permission of the Royal Albert Museum, Exeter

	Seal Identification	*Dimensions (mm)*	
57	KIRMG. E585.04 rev	26 × 17	With kind permission of Fife Museums Service
58	FALKM. 2002.43.8 rev	24 × 22	With kind permission of Falkirk Museum
59a	FALKM. 2003.3.1 obv	28 × 27	With kind permission of Falkirk Museum
59b	FALKM. 2003.3.1 rev	28 × 27	With kind permission of Falkirk Museum
60a	HARGM: 13606.17 obv	30 × 28	With kind permission of Harrogate Museums and Galleries, Harrogate Borough Council
60b	HARGM: 13606.17 rev	30 × 28	With kind permission of Harrogate Museums and Galleries, Harrogate Borough Council
61a	WAVMS: A003.3 obv	19 × 18	With kind permission of Farnham Museum
61b	WAVMS: A003.3 rev	19 × 18	With kind permission of Farnham Museum
62a	GGAT 10a	21 × 20	With kind permission of GS
62b	GGAT 10b	21 × 20	With kind permission of GS
63a	FALKM. 1985.74.4a	23 × 20	With kind permission of Falkirk Museum
63b	FALKM. 1985.74.4a	23 × 20	With kind permission of Falkirk Museum
64	Arms (St Petersburg)		After Fon-Vinkler (1899)
65	DUMFM: 2001.32.2	24 × 24	Courtesy of Dumfries Museum
66a	CUPMS: 1999.53.37 obv	22 × 21	With kind permission of Fife Museums Service
66b	CUPMS: 1999.53.37 rev	22 × 21	With kind permission of Fife Museums Service
67a	ADMUS: A1998.292 obv	22 × 22	With kind permission of Arbroath Museum, Angus Council, Cultural Services
67b	ADMUS: A1998.292 rev	22 × 22	With kind permission of Arbroath Museum, Angus Council, Cultural Services
68	CUPMS: 1999.56.19	21 × 21	With kind permission of Fife Museums Service
69	KIRMG. 2006.364b	21 × 20	With kind permission of Fife Museums Service
70	CUPMS: 1999.58.2.	25 × 23	With kind permission of Fife Museums Service
71a	CUPMS: 1999.54.60 obv	23 × 19	With kind permission of Fife Museums Service
71b	CUPMS: 1999.54.60 rev	23 × 19	With kind permission of Fife Museums Service
72a	KIRMG. 2006.362 obv	31 × 18	With kind permission of Fife Museums Service
72b	KIRMG. 2006.362 rev	31 × 18	With kind permission of Fife Museums Service
73a	PERMG: 1992.140.10 a	19 × 18	Courtesy of Perth Museum and Art Gallery, Perth and Kinross Council, Scotland
73b	PERMG: 1992.140.10 b	19 × 18	Courtesy of Perth Museum and Art Gallery, Perth and Kinross Council, Scotland
74a	JS 18a	28 × 23	From the author's collection
74b	JS 18b	28 × 23	From the author's collection
75a	DMP 03a	19 × 18	With kind permission of D. Powell
75b	DMP 03b	19 × 18	With kind permission of D. Powell
76	Arms (Riga)		After Fon-Vinkler (1899)
77	Detail		After Fon-Vinkler (1899)
78	Watermark		From the author's sketch
79	IP 04	18 × 17	With kind permission of Ian Postlethwaite
80	ADMUS: A1988.287	19 × 17	With kind permission of Arbroath Museum, Angus Council, Cultural Services
81	WE 08	24 × 17	With kind permission of White's Electronics
82	PERMG: 2000.243.9	25 × 18	Courtesy of Perth Museum and Art Gallery, Perth and Kinross Council, Scotland
83a	GGD 01a	20 × 17	With kind permission of George Dickens
83b	GGD 01b	20 × 17	With kind permission of George Dickens
84a	ADMUS: M1998.94 obv	21 × 20	With kind permission of Montrose Museum, Angus Council, Cultural Services
84b	ADMUS: M1998.94 obv	21 × 20	With kind permission of Montrose Museum, Angus Council, Cultural Services
84c	ADMUS: M1998.94 rev	21 × 20	With kind permission of Montrose Museum, Angus Council, Cultural Services
85	ADMUS: M1998.95 obv	24 × 19	With kind permission of Montrose Museum, Angus Council, Cultural Services
86	ADMUS: B1988.9 obv	22 × 18	With kind permission of Montrose Museum, Angus Council, Cultural Services
87a	KIRMG. 2006.352 obv	21 × 20	With kind permission of Fife Museums Service
87b	KIRMG. 2006.352 rev	21 × 20	With kind permission of Fife Museums Service
88a	KIRMG. 2006.361 obv	19 × 18	With kind permission of Fife Museums Service
88b	KIRMG. 2006.361 rev	19 × 18	With kind permission of Fife Museums Service
89a	ADMUS: M1997.136a	23 × 20	With kind permission of Montrose Museum, Angus Council, Cultural Services

89b	ADMUS: M1997.136b	23 × 20	With kind permission of Montrose Museum, Angus Council, Cultural Services
90	KIRMG. 2006.367b	19 × 18	With kind permission of Fife Museums Service
91	CUPMS: 1999.52.19 rev	26 × 21	With kind permission of Fife Museums Service
92a	GLDM: 29.02 obv	22 × 20	With kind permission of Guildford Museum and Surrey Archaeological Society
92b	GLDM: 29.02 rev	22 × 20	With kind permission of Guildford Museum and Surrey Archaeological Society
93a	DMP 08 obv		With kind permission of D. Powell
93b	DMP 08 rev		With kind permission of D. Powell

Bibliography

Manuscript sources

DRO, N29a Dorset Record Office DC/BTB: N29a *Bridport harbour master's Logbook. A Register of all the Ships Entering Bridport Harbour from 1863 to 1911*.

RGIA, 19, 4, 104 Rossiyskiy gosudarstvenny istoricheskiy arkhiv Fond.19, Opis' 4, Delo 104 [Russian State Historical Archive, Archive 19, Inventory 4, File 104], *Ukaz donosheniy o brakovke* [Instruction on Reports of Bracking], St Petersburg.

RGIA, 19, 6, 1825–1885 Rossiyskiy gosudarstvenny istoricheskiy arkhiv Fond. 19, Opis' 6, 1825–1885 [Russian State Historical Archive, Archive 19, Inventory 6, 137], *Komitet: Komitet po nadzoru za brakom tovara, 1825–1885* [Committee for Supervising the Bracking of Goods, 1825–1885], St Petersburg.

RGIA, 19, 6, 136 Rossiyskiy gosudarstvenny istoricheskiy arkhiv Fond. 19., Opis'. 6, Delo 136 [Russian State Historical Archive, Archive 19, Inventory 6, File 136], *Zhurnal o brake pen'kovoy i l'nyanoy pakli na 1840y god* [Register of Hemp and Flax codilla Bracking for the year 1840], St Petersburg.

RGIA, 19, 6, 137 Rossiyskiy gosudarstvenny istoricheskiy arkhiv Fond. 19., Opis'. 6, Delo 136 [Russian State Historical Archive, Archive 19, Inventory 6, File 136], *Zhurnal o brake pen'kovoy i l'nyanoy pakli na 1842y god* [Register of Hemp and Flax codilla Bracking for the year 1842], St Petersburg.

RGIA, 19, 6, 138 Rossiyskiy gosudarstvenny istoricheskiy arkhiv Fond. 19., Opis'. 6, Delo 136 [Russian State Historical Archive, Archive 19, Inventory 6, File 136], *Zhurnal o brake pen'kovoy i l'nyanoy pakli na 1843y god* [Register of Hemp and Flax codilla Bracking for the year 1843], St Petersburg.

RGIA, 19, 6, 139 Rossiyskiy gosudarstvenny istoricheskiy arkhiv Fond. 19., Opis'. 6, Delo 136 [Russian State Historical Archive, Archive 19, Inventory 6, File 136], *Zhurnal o brake pen'kovoy i l'nyanoy pakli na 1844y god* [Register of Hemp and Flax codilla Bracking for the year 1844], St Petersburg.

StPII, 36, 1, 563 Sanktpeterburgskiy institut istorii (Rossiyskaya akademiya nauk) [St Petersburg Institute of History, Russian Academy of Sciences] Fond 36 (Vorontsovykh), Opis' 1, 563 (Perepiska) [Archive 36 (Vorontsovs), Inventory 1, MS 563 (Correspondence)].

StPII, 36, 1, 570 Sanktpeterburgskiy institut istorii (Rossiyskaya akademiya nauk) [St Petersburg Institute of History, Russian Academy of Sciences] Fond 36 (Vorontsovykh), Opis' 1, 570 (Vedomosti) [Archive 36 (Vorontsovs), Inventory 1, MS 570 (Registers)].

StPII, 36, 1, 578 Sanktpeterburgskiy institut istorii (Rossiyskaya akademiya nauk) [St Petersburg Institute of History, Russian Academy of Sciences] Fond 36 (Vorontsovykh), Opis' 1, 578 (*Istoricheskoe opisanie torgovli v Peterburg i Kronshtadte*) [Archive 36 (Vorontsovs), Inventory 1, MS 578 (An Historical Description of Trade in St Petersburg and Kronshtadt)].

StPII, 36, 1, 579 Sanktpeterburgskiy institut istorii (Rossiyskaya akademiya nauk) [St Petersburg Institute of History, Russian Academy of Sciences] Fond 36 (Vorontsovykh), Opis' 1, 579 (*O proizvodstve torga po arkhangel'skoy tamozhne v 1787 v1788 i v 1789m godakh*) [Archive 36 (Vorontsovs), Inventory 1, MS 579 (On the Production of Trade through Archangel Customs in 1787, 1788 and 1789)].

StPII, 36, 1, 582 Sanktpeterburgskiy institut istorii (Rossiyskaya akademiya nauk) [St Petersburg Institute of History, Russian Academy of Sciences] Fond 36 (Vorontsovykh), Opis' 1, 582 (*Vedomosti po arkhangel'skomu, kol'skomu i mezenskomu portam, 1792 goda*) [Archive 36 (Vorontsovs), Inventory 1, MS 582 (Registers of the Ports of Archangel, Kola and Mezen', 1792)].

Printed works

Adresnaya kniga 1844. *Adresnaya kniga Sanktpeterburgskogo birzhevogo kupechestva, gg. inostrannykh gostey, birzhevykh maklerov i brakovshchikov pri sanktpeterburgskom porte* [Address Book of St Petersburg and Foreign Merchants, Stockbrokers and Brackers at the Port of St Petersburg], St Petersburg.

Adresnaya kniga 1852. *Adresnaya kniga Sanktpeterburgskogo birzhevogo kupechestva, inostrannykh gostey, birzhevykh maklerov i brakovshchikov pri sanktpeterburgskom porte* [Address Book of St Petersburg and Foreign Merchants, Stockbrokers and Brackers at the Port of St Petersburg], St Petersburg.

Adresnaya kniga 1891–92. *Adresnaya kniga vsekh firm, zavodov, fabrik i masterskikh vsey Rossiyskoy Imperii* [Address Book of All Firms, Works, Factories and Workshops of all the Russian Empire], Moscow.

Adresnaya i spravochnaya kniga 1861. *Adresnaya i spravochnaya kniga dlya kuptsov* [Address Book and Guide for Merchants], St Petersburg.

Adresny ukazatel' Rigi 1912. [Directory of Riga Addresses, 1912], Riga.

Al'bom 1944. *Al'bom skhem zheleznykh dorog SSSR.* [Album of Diagrams of the Railways of the USSR], Moscow.

Aller, S. 1822. Aller, S *Ukazatel' zhilishch i zdaniy v Sankt-Peterburge ili adresnaya kniga s planom na 1823* [Directory of Residences and Buildings in St Petersburg or An Address Book with a Plan for 1823], St Petersburg.

Andreevskiy I. E., Arsen'ev K. K. and Petrushevskiy F. F. *et al.* (eds) 1892. ES, 13 (VII). *Entsiklopedicheskiy slovar'* [Encyclopaedic Dictionary], St Petersburg.

Andreevskiy I. E., Arsen'ev K. K. and Petrushevskiy F. F. *et al.* (eds) 1896. ES, 34 (XX). *Entsiklopedicheskiy slovar'* [Encyclopaedic Dictionary], St Petersburg.

Andreevskiy I. E., Arsen'ev K. K. and Petrushevskiy F. F. *et al.* (eds) 1902. ES, 69 (XXXV). *Entsiklopedicheskiy slovar'* [Encyclopaedic Dictionary], St Petersburg.

Andreevskiy I. E., Arsen'ev K. K. and Petrushevskiy F. F. *et al.* (eds) 1904. ES, 82 (XLIa). *Entsiklopedicheskiy slovar'* [Encyclopaedic Dictionary], St Petersburg.

Austin, R. 1987. Bale and Other Lead Seals, *The Scroll of the Maidenhead Archaeological and Historical Society* 3, no. 7 (Summer), 8–12.

Baeshchko, M. F. (ed.) 1957. *Spisok stantsiy zheleznodorozhnoy seti SSSR* [A List of Stations in the Railway Network of the USSR], Moscow.

Bogdanov, G. and Ruban, IV. 1779. *Istoricheskoe geograficheskoe i topograficheskoe opisanie Sankta-Peterburga* [A Historical, Geographical and Topographical Description of St Petersburg], St Petersburg.

Broytman L. and Dubin, A. 2005. *Ulitsa Vosstaniya* [Uprising Street], Moscow–St Petersburg.

Broytman L. and Krasnova E. 2005. *Bol'shaya morskaya ulitsa* [Great Marine Street], Moscow–St Petersburg.

Carter, H. R. 1919. *The Spinning and Twisting of Long Vegetable Fibres (Flax, Hemp, Jute, Tow and Ramie). A Practical Manual.* London.

Cocron, F. 1962. *La langue russe dans la seconde moitié du XVII siècle (Morphologie)*, Paris.

Comrie, B. and Stone, G. 1978 *The Russian Language since the Revolution*, Oxford.

Cox, A. 1996. *Lead alloy Objects*. In Coleman R., Excavations at the Abbot's House, Maygate, Dunfermline, *Tayside and Fife Archaeological Journal* 2, no. 67, Glenrothes.

Dal' V. 1912. *Tolkovy slovar' zhivogo velikorusskogo yazyka Vladimira Dalya* [Vladimir Dal's Dictionary of the Russian Language], 4 revised edn, Baudouin de Courtenay I. A. (ed.), 4 volumes, St Petersburg–Moscow.

Demkin, A. V. 1998a. *Vneshnyaya torgovlya Rossii cherez Peterburgskiy port 1764. Vedomost' ob eksporte rossiyskikh tovarov* [Russia's External Trade through the Port of St Petersburg, 1764: Bulletin on the Export of Russian Goods], Moscow.

Demkin, A. V. 1998b. *Vneshnyaya torgovlya Rossii cherez Peterburgskiy port 1764. Vedomost' ob importe inostrannykh tovarov* [Russia's External Trade through the Port of St Petersburg, 1764: Bulletin on the Import of Foreign Goods], Moscow.

Demkin, A. V. 1998c *Britanskoe kupechestvo v Rossii XVIII veka* [British Merchants in 18th-century Russia], Moscow.

Du Quesne-Bird, N. 1970. Five Russian Seals from Bristol, *Transactions of the Bristol and Gloucestershire Archaeological Society* 90, 226–7.

Du Quesne-Bird, N. 1972. 18th century Russian Bullae from Britain, *Numismatic Circular* 80, 276–7.

Durie, A. J. 1983. Russia's Role in the Industrialisation of Scotland, *Russia and The West in the eighteenth Century*, ed. A. G. Cross (Oriental Research Partners), Newtonville, Mass.

Durie, A. J. (ed) 1996. *The British Linen Company, 1745–1775*, Edinburgh.

Endrei, W. and Egan, G. 1982. The Sealing of Cloth in Europe, *Textile History* vol. 13 (I), 47–75.

Fon-Vinkler, II. 1899. *Gerby gorodov, guberniy, oblastey i posadov Rossiyskoy Imperii, vnesennye v polnoe sobranie zakonov s 1649 po 1900 god* [The Arms of Towns, Provinces, Regions and Trading Quarters of the Russian Empire entered in the *Complete Collection of Laws* from 1649 to 1900], St Petersburg.

Fabriki i zavody 1904. *Fabriki i zavody g. Moskvy i ee prigorodov. Adresnaya i spravochnaya kniga o fabrichno-zavodskikh, glavnykh remeslennykh zavedeniyakh i torgovo-promyshlennykh predpriyatiyakh* [Factories and Works in the City of Moscow and its Suburbs. An address Book and Guide to the Factories, Works and the Main Craft Establishments and Commercial and Industrial Enterprises], Moscow.

Gauldie, E. 1969. *The Dundee Textile Industry, 1790–1885, from the Papers of Peter Carmichael of Arthurstone*, (Scottish History Society), Edinburgh.

Grimm, J. and Grimm, W. 1854–1960. *Deutsches Wörterbuch von Jacob Grimm und Wilhelm Grimm*, 16 vols, Leipzig.

Hunt, N. C. 1955. The Russian Company and the Government, 1730–42, *Oxford Slavonic Papers* vol. VI, 27–6.

Indova, E. I. (ed) 1987. Zakonodatel'stvo, 1987, 1785 g. aprelya 21. Gramota na prava i vygody gorodam Rossiyskoy Imperii [1785, April 21. [Deed on the Rights of and Benefits to the Towns of the Russian Empire], Zakonodatel'stvo perioda rastsveta absolyutizma [Legislation in the Period of the Flourishing of Absolutism], *Rossiyskoe zakonodatel'stvo X–XX vekov* [Russian Legislation from the 10 to 20th centuries], vol. 5, Moscow.

Issledovaniya 1847. *Issledovaniya o sostoyanii l'nyanoy promyshlennosti v Rossii* [A Study of the State of the Flax Industry in Russia], Part 1, St Petersburg.

Jackson, G. and Kinnear, K. 1991. The Trade and Shipping of Dundee: 1780–1850, *Abertay Historical Society Publication no. 31,* Dundee.

Joffe M. and Lindenmeyr, A. 1998. Daughters, Wives and Partners: Women of the Moscow Merchant Elite. In West, J. L. and Petrov, I. A. (eds) *Merchant Moscow: Images of Russia's Vanished Bourgeoisie*, LOCATION?

Klepikov, S. A. 1978. *Filigrani na bumage russkogo proizvodstva XVIII–nachala XIX veka* [Watermarks on Paper Produced in Russia from the 18th and at the Beginning of the19th centuries]. Moscow.

Krestinin, V. 1792, *Kratkaya istoriya o gorode Arkhangel'skom* [A Brief History of the Town of Archangel], St Petersburg.

McCulloch J. R. 1869. *A Dictionary, Practical, Theoretical and Historical, of Commerce and Commercial Navigation*, ed. H. G. Reid, London.

MacGregor, A. 1985. A Russian Seal from Abingdon, *Post-Medieval Archaeology* 19, 156–7.

MacMillan, D. S. 1971. The Russia Company of London in the 18th Century: the effective survival of a 'Regulated: Chartered Company', *The Guildhall Miscellany* vol. IV, no. 1, October, 222–236.

Marryat, Capt. F. 1895. *Peter Simple*, London.

Myznikov, S. A., Levichkin, A. N., Sorokoletov, F. P. and Kuznetsova, O. D. 2006. *Slovar' oblastnogo vologodskogo*

narechiya, Po ruskopisi P A Dilaktorskogo 1902 g. [Dictionary of the Vologda Province Dialect, according to P. A. Dilatorskiy's MS of 1902], St Petersburg.

Ogneva, L. A. 1993. Kolletktsiya tovarnykh znakov (plomb) v sobranii Pskovskogo muzeya-zapovednika, *Zemlya Pskovskaya, drevnyaya i sovremennaya*, Tezisy dokladov k nauchno-prakticheskoy konferentsii [A Collection of Trade Marks (Seals) in the Pskov Museum of Local History, The Land of Pskov, Ancient and Modern. Proposed papers to be delivered at an academic and practical conference], Pskov.

Ogorodnikov, S. F. 1875. *Istoriya Arkhangel'skogo porta* [An History of the Port of Archangel], St Petersburg.

Ogorodnikov, S. F. 1890. *Ocherki istorii goroda Arkhangel'ska v torgovo-promyshlennom otnoshenii S.F. Ogorodnikova* [Outline of the Trade and Industrial History of the Town of Archangel], St Petersburg.

Perepis', 1890 1891. *S-Peterburg po perepisi 15 dekabrya 1890 goda.* [St Petersburg according to the Census of 15 December, 1890], St Petersburg.

Petrov, M. E. 1988. Tovarnye znaki kak istoricheskiy istochnik [Trade marks as an Historical Source] *Materyal'naya kul'tura Vostoka* [The Material Culture of the East], part. 2, 295–98, Moscow.

PG, Notes and Queries, *The Preston Guardian*, Saturday, August, 4, 1934.

Pitcher, H. 1977. *When Miss Emmie was in Russia. English Governesses before, during and after the October Revolution.* John Murray, London.

Pitcher, H. 1994. *Muir & Mirrilees. The Scottish partnership that became a household name in Russia*, Cromer.

Pokrovskiy, V. I. (ed.) 1902. *Sbornik svedeniy po istorii i statistike vneshney torgovli Rossii* [A Collection of Information on the History of and Statistics on Russian External Trade], vol. 1, St Petersburg.

Ponomareva, V. V. and Khoroshilova, L. B. 2009. *Mir russkoy zhenshchiny: sem'ya, professiya, domashnii uklad XVIII–nachalo XIX veka* [The World of the Russian Woman: family, profession, domestic structure XVIII–beginning XIX century], Novy Khrongraf, Moscow.

Pososhkov, I. 1911. *Kniga o skudosti i bogatstve* [A Book on Poverty and Wealth], Moscow.

Polnoe sobranie zakonov 1830. *Polnoe sobranie zakonov Rossiyskoy Imperii poveleniem gosudarya Imperatora Nikolaya Pavlovicha sostavlennoe. Sobranie pervoe s 1649 po 12 dekabrya 1825, 45 volumes* [Complete collection of the Laws of the Russian Empire, compiled on the order of the sovereign Emperor Nicholas I. First Collection from 1649 to December 1825], St Petersburg.

Rimmer, W. G. 1960. *Marshalls of Leeds Flax-spinners 1788–1886*, Cambridge.

Semenov, V. P. 1899. *Polnoe geograficheskoe opisanie nashego otechestva, 1: Moskovskaya promyshlennaya oblast' i Verkhnee Povol'zhe* [A Complete Geographical Description of our Country, 1: The Moscow Industrial Province and the Upper Volga], St Petersburg.

Semenov, V. P. 1907. *Polnoe geograficheskoe opisanie nashego otechestva, 14: Novorossiya i Krym* [A Complete Geographical Description of Our Country, 14: Novorossiya and the Crimea], St Petersburg.

Skhema Zh. D. 1910. *Skhema zheleznykh dorog Rossiyskoy Imperii* [Outline of the Railways of the Russian Empire], No 14, St Petersburg.

Solov'eva, T. A. 2004. *Angliyskaya naberezhnaya* [The English Embankment), St Petersburg.

Sanktpeterburgskie Vedomosti [St Petersburg Gazette], St Petersburg.

Stafford-Smith, J. (ed.) 1999. *In the mind's eye. The Memoirs of Dame Elizabeth Hill*, Sussex.

Steel, D. L. A. 1975. *The Linen Industry of Fife in the later 18th and 19th Centuries*, unpubl. PhD thesis, University of St Andrews.

Sullivan, J. 2000. Lead seals of Russian Origin in Fife, *Tayside and Fife Archaeological Journal* vol. 6, 211–227.

Sullivan, J. 2001. Lead Seals of Russian Origin: 1740s–c.1830, *The Searcher* no. 196, December, 12–13.

Sullivan, J. 2002. Lead Seals of Russian Origin: 1830–1908, *The Searcher* no. 197, January, 12–13.

Svedeniya 1870. *Svedeniya o l'nyanoy promyshlennosti i torgovle Pskovskoy gubernii* [Information on the Flax Industry and Trade in the Province of Pskov], St Petersburg.

Svyataya Rus' 2006. *Bol'shaya entsiklopediya russkogo naroda. Russkoe khozaystvo* [Holy Russia. Large Encyclopaedia of the Russian People. The Russian Economy] ed. Platonov, O. A., Moscow.

Tariff 1767 *A Tariff or Book of rates of the Customs to be levied, on goods imported and exported, at the port and frontier Customhouses, Translated from the Russian*, St Petersburg.

Uchastkina, Z. V. 1962. History of Russian hand paper-mills and their watermarks, *Monumenta chartae papyracea historiam illustrantia*, vol. XI, Hilversum.

Unbegaun, B. O. 1972. *Russian Surnames*, Oxford.

Varzar, V. E. 1912. *Spisok fabrik i zavodov Rossiyskoy Imperii* [A List of Factories and Works in the Russian Empire], St Petersburg.

Vneshnyaya torgovlya 1981. *Vneshnyaya torgovlya Rossii cherez Peterburgskiy port 1764.* [Russia's External Trade through the Port of St Petersburg, 1764], Moscow.

Warden, A. J. 1864. *The Linen Trade. Ancient and Modern*, London.

Whishaw, J. 1992 (1935). *A History of the Whishaw Family* (ed.) M. S. Leigh, London, repr.

Wilkinson, J. (ed.) 1994. *The letters of Thomas Langton, flax merchant of Kirkham, 1771–1788*, Chetham Society Series vol. 38, Preston.

Yablonskiy, P. O. 1895. *Adresnaya kniga goroda S-Peterburga na 1892g.* [Address Book of the City of St Petersburg for 1892], St Petersburg.

Zheleznye dorogi, Zheleznye dorogi Rossii [The Railways of Russia] (n.p., n.d.).